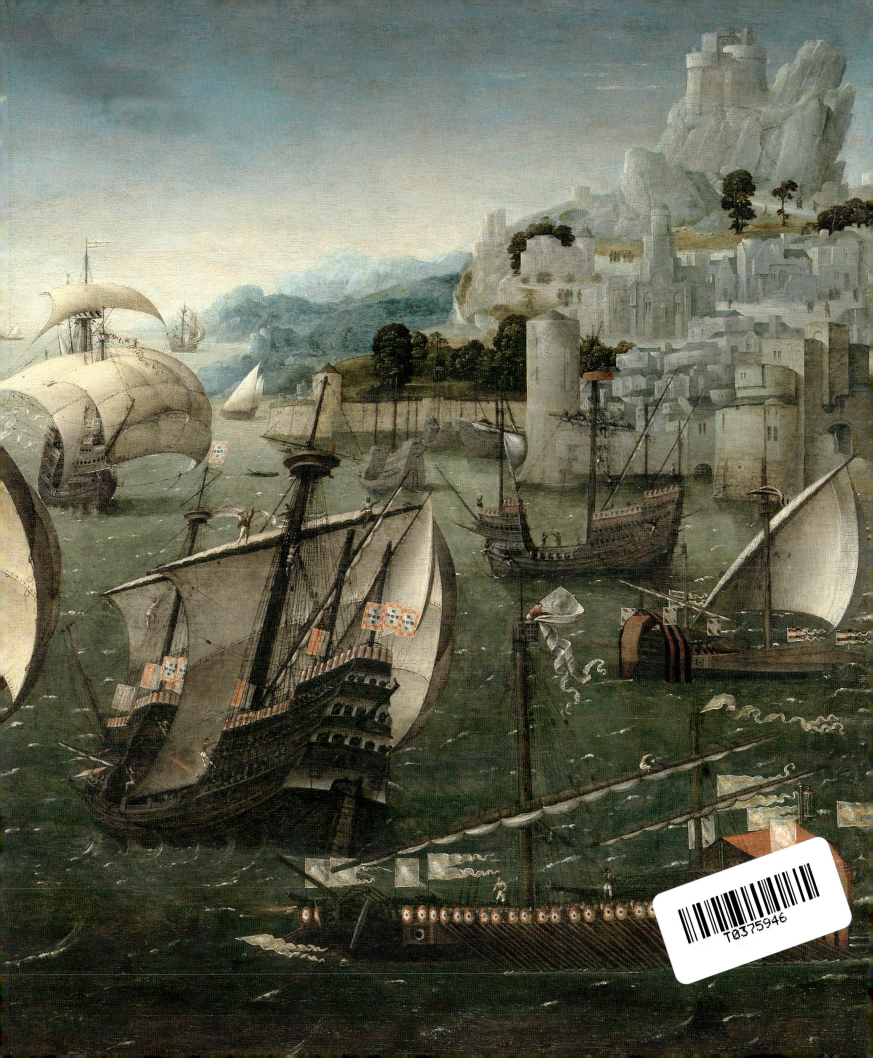

FOUR CENTURIES OF
BLUE & WHITE

FOUR CENTURIES OF
BLUE & WHITE

The Frelinghuysen Collection
of Chinese And Japanese Export Porcelain

BECKY MACGUIRE

with contributions by
ANGELA HOWARD
WILLIAM R. SARGENT

AD ILISSVM

AD ILISSVM

'By the banks of the Ilissus', where Socrates bathed his feet
in Plato's *Phaedrus*, 230b, remarking καλή γε ἡ καταγώγη
(This is a beautiful place to settle)

Copyright © the publisher and the authors of their respective texts 2023

Text by Becky MacGuire
Photography by David Schlegel
All rights reserved. No part of this publication may be transmitted in any
form or by any means, electronic or mechanical, including photocopy,
recording or any storage or retrieval system, without the prior permission
in writing from the copyright holder and publisher.

ISBN 978-1-915401-09-0

British Library Cataloguing in Publication Data
A catalogue record for this book is available from the British Library

Produced by Paul Holberton Publishing
WWW.PAULHOLBERTON.COM

Designed by Paul Sloman

Origination and printing by
E-graphic Srl, Verona, Italy

COVER:
Nos. 224, 213, 274 (front)
Nos. 52, 174, 224 (back)

This edition has been printed on certified
FSC® GardaMatt Ultra paper
and other controlled sources

CONTENTS

	Preface *William R. Sargent*	7
	Foreword *Rodney P. Frelinghuysen*	11
	Record of a Friendship *Angela Howard*	15
	Introduction *Becky MacGuire*	19
1	FAITH	25
2	IDENTITY	51
3	FOR THE TABLE	101
4	DRINKING AND POURING	129
5	FOR OTHER USES	165
6	FURNISHING AND DECORATION	185
7	FIGURES AND ANIMALS	207
8	TO EUROPEAN DESIGN	233
9	PLACES	265
10	SOUTHEAST ASIAN MARKET AND ZHANGZHOU	287
11	JAPANESE MARKET	297
12	MADE IN JAPAN	313
13	THAI MARKET	353
	COMPENDIUM	375
	Bibliography	413
	Index	423
	Photo credits	432

PREFACE

William R. Sargent

Blue and white appeared on the world stage as a marvel of material and misunderstood technology, a novelty of forms and designs never before seen. The painterly style of Chinese decorators and their motifs astonished every observer that chanced upon it. Exported from China in increasing quantities since the Yuan dynasty (1279–1368), blue and white porcelain was among the most popular of ceramics, dominating the ceramic world for four hundred years. It is a unique art form, held in high esteem by every country in the world that has had access to it, although the full breadth of these exported wares has never been given its due until now.

To step into the midst of Rodney Frelinghuysen's collection of blue and white is to be immersed in a sea of blues, an abundance of forms and centuries of ceramic technology, history, commerce, politics and religion reflected in the art that is Chinese export porcelain. I have had the great and singular pleasure of knowing many exceptional collectors of such porcelain in more than forty years in the field, and Rodney and I met at the beginning of my career through his association with the China Trade Museum in Milton, Massachusetts. We share happy memories of the many curators, dealers and collectors we have both known over these four decades.

Rodney's collecting comes, perhaps, naturally. His forebears include H.O. and Louisine Havemeyer, donors of Impressionist paintings and Asian art to the Metropolitan Museum of Art in New York. His father,

Peter H.B. Frelinghuysen, Jr. (1916–2011), was also an extraordinary collector of Chinese export porcelain whose collection—nearly as broad as Rodney's in markets, forms and designs—was almost exclusively polychrome. Sharing that tradition of collecting, Rodney

facing After Ding Guanpeng et al., *Huang Qing zhigong tu* (Qing Imperial Illustrations of Tributaries), c. 1750–65, Frelinghuysen collection

focused on blue and white. His passion for inclusivity has not abated in the years since he started. Thanks to the single-mindedness that is a prerequisite of a dedicated collector, the numbers are tipping towards a thousand examples. Rodney and his wife live in a home that was worthy, years ago, of inclusion in a book on color and interiors. Now it is a veritable *Porzellankabinett*.

Aside from the porcelain material itself, what makes blue and white so compelling is a balance of design and deftness of application created by a culture steeped in the use of brushes and calligraphic handling of ink that translated relatively seamlessly to painting with cobalt. Chinese ceramic artists were well trained from childhood to accomplish what they set out to do without error, knowing that there is no going back when brush is put to pot. Surviving mistakes are rare, and can be amusing, giving us insights into the work habits of decorators. Rodney undoubtedly appreciates the nuances of the vast variety of blues. The word 'blue' implies one color, but there are as many as seventy-two official shades of blue: Crayola alone offers nineteen different blue crayons. Decorators used the white 'canvas' of the porcelain and the panoply of blues available to their optimal benefit in creating works of art on a ceramic body. In the best examples, their painting rivals that of scroll painters. Indeed, central scenes are often surrounded by borders in the way that frames would surround a canvas. Dense or spare, dark or pale, positive or negative grounds, the decorative possibilities are endless.

Blue and white was collected assiduously around the world. In its simplest iteration a 'collection' might be a single piece, or perhaps a high shelf of grouped porcelains, while at its apogee are the Ardebil Shrine in Tehran, the Topkapı Palace in Istanbul, the Charlottenburg Palace in Berlin, the Santos Palace in Lisbon and so many others. Shipwrecks full of blue and white that never made it to their intended markets tell even more stories of what might have been. The trajectories of blue and white

reflect the confluence of ceramic technology, global trade expansion, a rising middle class, and changes in décor and dining habits. All, in part, were inspired by the creation of these wares, which doubled back and reinforced the production, distribution and consumption of Chinese export porcelain. However, the academic study of blue and white has not been with us for much more than a hundred years. Collecting as an exercise in connoisseurship and knowledge, rather than an accumulation for show (even while admiring individual pieces), is also a more recent concept.

In his self-deprecating acquisitiveness, Rodney shares *la maladie de porcelaine* with another great collector, Augustus the Strong (1670–1733), Elector of Saxony and King of Poland, as well as others who formed significant collections now housed in historic houses and museums around the world. His passion for porcelain is matched by his formidable library, reflecting the intellectual understanding he brings to the table. Books line multiple rooms and are always at hand for research and reference. Rodney is a connoisseur, a term not often used for good reason. It is a rare breed of collector who has the passion to collect at this level of understanding and appreciation. References to Chinese blue and white, as ubiquitous as the ceramics themselves, can be found in many publications. Domestic market wares, especially of scholarly taste, have been given due recognition. However, export blue and white wares have been explored in far fewer volumes by scholars, dealers and archaeologists. No publication approaches the near-encyclopedic range available in the Frelinghuysen collection.

Becky MacGuire's embracing discussion and erudite exploration of the material brings this unique and extraordinarily comprehensive collection to the public for the first time. In the tradition of encyclopedic books on specific aspects of Chinese export porcelain, this too will take its place as an indispensable reference and will become the first book to reach for when researching blue and white export. Herein is an expansive variety of patterns, forms and intended markets covering nearly four hundred years of production, in which both the Japanese export porcelain and the Chinese wares for the Thai market are of particular interest. The range of wares for Thai consumption in this collection is astonishing and has been little understood up to now. The compendium illustrating important additional pieces must not be forgotten, as it is impossible to list and describe every piece in this extensive collection. This volume is sure to focus our attention on blue and white while adding depth to the complex history of discourse on this art form.

We must thank T'ung Bun (deified by a Ming emperor as Feng Huo Hsien) and other Chinese kiln gods, as well as the potters and kiln masters, for the successful manufacture and firings of these ceramics that have survived production, shipping and centuries of use to engage us still. As we finish our reading of this volume, we might echo the sentiments of Ibn Battuta (1304–1369) of Morocco, who said of Chinese porcelain that it was "the most marvelous of kinds of pottery"

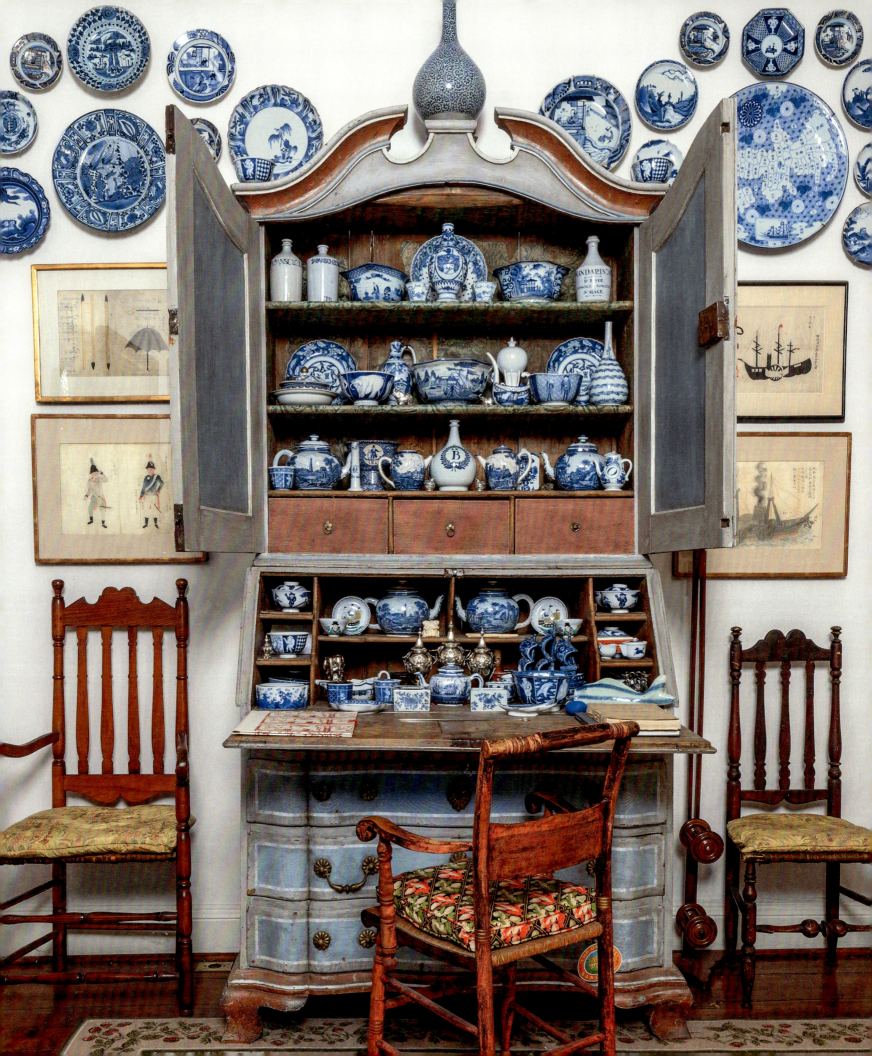

FOREWORD

Rodney P. Frelinghuysen

Under a glass table in our living room there is a small, round, blue and white porcelain box from one of the South China Sea shipwrecks belonging to our eldest daughter, Louisine, with a note reading, "from DSH, upon the occasion of her christening in April 1984." Not your usual baby present, for certain, but the choice of something hundreds of years old for a newborn perhaps tells you something about the depth of a relationship between remarkable friends and new parents.

My porcelain collecting began in 1964 on a rare Saturday when we were released from school and allowed to go into Boston. I went into Samuel L. Lowe's shop on Beacon Hill and bought an Imari bowl, which I still have. Later, I showed it with some pride to my parents, who were, I suspect, much less impressed with it than I was.

Like our careers in public service, my father and I also shared common collecting interests: US stamps, political memorabilia and Chinese export porcelain. He favored colored wares, and I, underglaze blue and white.

My father visited China with Senator Fulbright soon after Nixon's 1974 trip. As a private citizen, I was able to go in 1978 and 1979, before and after formal US relations were established. Only ten thousand tourist visas were issued each year. The China Trade Museum in Milton, Massachusetts secured two dozen for trustees, friends and supporters, and I had one of those. Our trip leader was H.A. Crosby Forbes, the museum's founder, and he, Paul Molitor and Missy Kalat, along with many other fellow travelers, all became great friends as a result.

There was virtually nothing to buy on the Chinese mainland, but my pair of oil lamps painted with the Thirteen Hongs (no. 317), still with their original glass globes, were found along Hollywood Road in Hong Kong during one of those trips. I returned to China in 2018 to find it much changed.

Earlier, inspired by a wonderful 1974–75 exhibition at the China Institute in New York, my father and I encouraged and contributed to a larger show at the Newark Museum. The museum exhibit opened in 1979, with David S. Howard delivering two lectures at the accompanying symposium at Stevens Institute of Technology. A star supporting cast included Clare Le Corbeiller, Arlene Palmer and H.A. Crosby Forbes.

For old-guard antique dealers Elinor and Horace Gordon, Matthew and Elisabeth Sharpe and Jim Galley, breaking bread in the Portuguese section of Newark was an eye-opener. The meal and show were a great success, public knowledge was heightened, and an extraordinary museum and state were well advertised!

Our 1981 honeymoon trip to Asia included Taiwan, Thailand and Hong Kong, with visits to the porcelain collection of the National Palace Museum in Taipei, antique shops near Somerset Maugham's legendary hotel in Bangkok and Jim Thompson's 'house on the klong'. A long-tail boat ride up the Chao Phraya River to the ancient Siamese capital of Ayutthaya allowed us to see palace treasures firsthand. We passed small shops full of blue and white porcelain along the way.

Two years later, Virginia and I were in London with my father, who led us to David Howard's shop at 1 Hay Hill in Mayfair. Peering in the windows, we beheld all things porcelain and armorial, a feast for the eyes!

Our long relationship with David and Angela Howard started in earnest when we climbed those steep stairs.

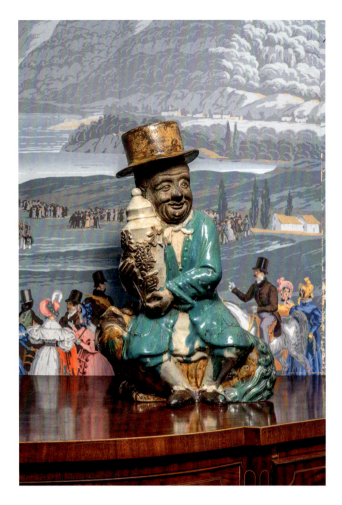

Figure of a Westerner seated on a Buddhist lion and holding a jar of *tieda* (medicinal or trauma wine), Shiwan ware, 19th century, Frelinghuysen collection

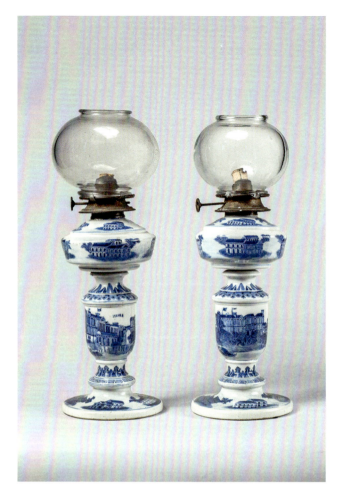

Pair of oil lamps with the hongs at Guangzhou (Canton), no. 317 from the collection

The remarkable Kangxi vase with Dutchmen climbing the ship's rigging (no. 204) was an acquisition from that inaugural visit.

On the same trip we visited Burghley House, pictured on several plates and a sauce tureen in my collection (no. 229), and met Lady Victoria Leatham. Seeing her recently discovered collection of Japanese porcelain was a revelation that introduced me to a new export market. I had collected Yokohama-e prints, but had never focused on the export porcelain made in Japan.

The Howards were instrumental in my acquisition of many, many wonderful pieces in this book. Each piece has a story, whether it came off their shelves or from a far-flung auction. Its shape, size, design, use, original owners—all would be well researched by David and Angela, as voluminous files and invoices attest.

Angela, especially, gave me confidence—laced with good humor—to buy things that were 'different'. She encouraged me to take risks and not be thwarted by deliberately ambiguous descriptions or the finality of auction jargon.

I have greatly benefited from the advice of many friends: Marie Bonadies, Kee Il Choi, Timothy Coram, Tom Dolan, Philip S. Dubey, Margi Gristina, Mr. Hong, Rodrigo Rivero Lake, Fred Nadler, Jan-Erik Nilsson, Khalil Rizk, Dennis Roach, Letitia Roberts, Kessarin Saebe and Alberto Santos.

Thanks to Bill Sargent for the kind words in his introduction and his many contributions to the China trade story. Caroline Allen spent many months editing this book, ensuring that both content and grammar were correct. Jessica Chang translated Chinese inscriptions

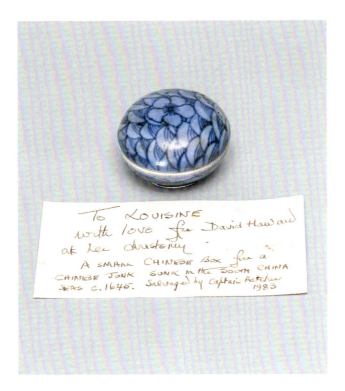

Box from the Hatcher Cargo, c. 1643, Frelinghuysen collection

on many pieces and is also due deep gratitude, as is my nephew, Cyrus Frelinghuysen.

Special thanks to David Schlegel for his photography. Hour upon hour he worked, often in the dark, bringing out the best face on a huge array of pieces. He is a perfectionist, and the book confirms that. Thanks are also owed to two very talented restorers, Clare Woodward in the UK and John Kovasckitz of Elkton, Maryland, whose skills and patience are unmatched.

In the many years I've been collecting, my much better half, Virginia Robinson, has been tested on many fronts by our focus on things beautiful. I am grateful for her incredible forbearance for well over forty years!

And, in a farmhouse full of porcelain on walls and shelves, where two daughters grew up and now four grandchildren play, I can say, as of this date, I'm the only one responsible for breakage.

To conclude, how fortunate I am to have known Becky MacGuire for so many years and to have her take the reins of a book that I've always envisioned in my own mind, a comprehensive book on blue and white porcelain. This book focuses on Chinese and Japanese pieces for export, primarily European or Western shapes, scenes and uses. I am very pleased by how much time she has dedicated to the research that went into every aspect of this book. Proud, as well, of the compendium, where we illustrate pieces that were utilitarian and mundane in the same volume as those made for extravagant households and grand religious institutions. She has been extraordinary in every respect, and what fun and debate we still have on selections.

Decades ago, David Howard bought me one of the Magic Fountain vases (no. 2). The wonderful mark on its base provides me with a closing message to any who read this book: "May infinite happiness embrace your affairs!"

RECORD OF A FRIENDSHIP

Angela Howard

The latter half of the 1970s was an exciting time to be collecting Chinese export porcelain. In 1974 my late husband, David Sanctuary Howard, opened his London gallery Heirloom & Howard and published his first volume of Chinese Armorial Porcelain, shortly followed by China for the West (1978) co-authored with John Ayers. In the United States, several exceptional exhibitions were held in that same period, with Crosby Forbes, founder and director of the China Trade Museum (Milton, Massachusetts), instrumental in promoting awareness of this cultural trade exchange between East and West, then approaching its bicentenary of American participation. It was against this background that Rodney Frelinghuysen was forming his collection of blue and white.

Returning from two visits to China, Rodney gave his support to a loan exhibition from New Jersey collections at the Newark Museum which opened in October 1979. As this included some sixty armorial pieces, David was invited to give two lectures at the inaugural conference. Although they had corresponded the previous year, it was the first time David had met either Rodney or his father Peter, and it would be the start of a friendship that has now spanned over forty years. Their passion for collecting (without doubt an inherited gene), together with a generosity in sharing that enthusiasm and a discerning knowledge of all their pieces, as well as cosmopolitan and stimulating views on topics from world events to politics and gardening, chimed exactly with David's own perspectives.

Our files documenting these forty years are weighty with interesting letters: from descriptions of rare objects spotted at lesser-known country salerooms or with minor dealers, to discussing bidding strategies for the grand sales at major auction houses in New York, London, Amsterdam and Monaco. Those auctions were never straightforward: each item dissected, discussed and researched at length—whether it would enhance the collection, or just be another example and therefore dismissed. Additional opinions on unusual pieces might occasionally be sought, with letters flying off to eminent colleagues. Correspondence accelerated with the advent of the fax machine, and pen sketches of new discoveries could be summarily dispatched with the expectation of a response within the hour.

David also collected blue and white personally (always based on the unusual, rare or historic; a bit of damage was viewed as being far from important), and many of these pieces found their eventual way to New Jersey with some deaccessioning following our move from London. There is no doubt that Rodney widened David's own knowledge and expertise with his growing interest in the nineteenth century and in Southeast Asian export, particularly Islamic and Thai market wares. Here Rodney was well ahead of his time, and this book will catalogue many such pieces for the first time. Japanese export was another area that they would explore together. However, armorial porcelain was undoubtedly a very specific early focus in this relationship. David loved to share his deep knowledge of coats of arms and their family histories, and would be excited to find something new, while Rodney was keen to collect every example possible—an ambition very nearly achieved! The Peers dish (no. 44 and p. 17) was the very first piece bought from David in 1978, while the Whistler punch bowl (no. 43), the only example known of this service and also from our own collection, was the last armorial piece to be included in the book.

David Howard and Rodney Frelinghuysen in 1990

The files also chronicle a lighter side. Meetings would take place when David was in New York, or on a longer visit to us in Bath or later West Yatton when either Rodney or his parents were in the UK. Memorable was the occasion of a personal tour of the Capitol in Washington and lunch with Rodney in the Members' Dining Room at the US House of Representatives. A photograph of David and Rodney, deep in animated discussion, captures well our stay in Morristown in January 1990, which I particularly remember for all the wonderful porcelain on display, for Ginny's kindness and patient forbearance of this obsession, and for six-year-old Louisine proudly showing me her 'own' collection of blue and white! A tradition sprang up for a rhyming exchange of annual festive greetings, with David sending an illustrated verse penned on the kitchen table on Christmas Eve. Before long the fax machine would growl into action again and a sheet of paper with Rodney's poetic reply would float to the floor as gently as a snowflake. With luck we would also be treated to drawings by Louisine and Sarah.

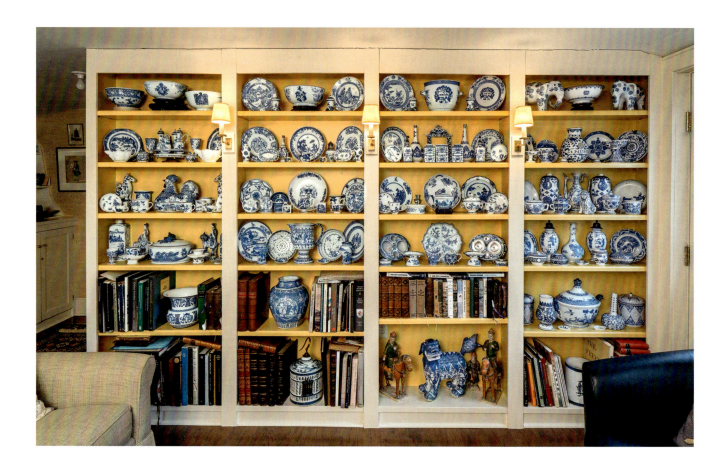

From New Jersey's snowy valleys, to Washington's steamy pitch
There is no time for parties, nor chance of getting rich
But from our Wiltshire downside, at the closing of the year
We wish you all the upside, an exciting new, New Year.
You may have to leave behind you, the Kangxi and late Ming
For long nights in the Chamber, where impassioned speeches ring
But I know that when you ponder, on the day's work late at night
What you see red over, yonder—is really blue & white.

 Christmas 1995, DSH

INTRODUCTION

Becky MacGuire

The clay is so fine and transparent that the whites outshine crystal and alabaster, and the pieces which are decorated in blue dumbfound the eyes, seeming a combination of alabaster and sapphires.[1]

Frei Bartolomeu dos Mártires,
Archbishop of Braga, 1563

First made in the heart of China in the fourteenth century, blue and white porcelain circulated throughout the world, journeying first by land and then by sea and exciting wonder and the desire to possess wherever it went. Its qualities of hardness and fineness, the brilliant contrast of its vibrant blues with its bright white ground and the pleasing proportions of its shapes had no equal. Almost four hundred years went by before a material of its quality could be produced anywhere else in the world.

It was Chinese potters in Jingdezhen, a market town (*zhen*) named for the Song dynasty emperor Jingde (r. 1004–07), who mastered the technology that enabled the creation of this wondrous material, building on a long tradition of sophisticated ceramic production in China.[2] Air-hardened pieces formed from highly refined clays were painted with cobalt pigment, some imported from Iran (Persia) and some mined in China, and then covered with a transparent glaze before firing. Using wood-fired brick kilns, the potters were able to achieve the extremely high temperatures necessary to fuse their clays into an almost glass-like material. Only cobalt blue was able to withstand these high temperatures with consistent results. Copper red could also be fired under the glaze but was difficult to control; the other enamel colors had to be applied over the glaze, requiring a second firing at a lower temperature.

Jingdezhen had advantages crucial to a successful porcelain manufacturing center: a geological history that left behind accessible stores of kaolin and *petuntse*, the two essential ingredients for porcelain clay; forests nearby to provide the wood needed for hundreds of kilns; an ample supply of skilled labor and major rivers within reach for the transport of finished wares.[3] Imperial wares traveled north to the capital while export porcelains went southeast to the coast. The first journeys of Chinese porcelain to the West were on camel back over the Silk Road, but as early as the first half of the fifteenth century, when the Ming admiral Zheng He took his enormous fleet as far as Africa, wares from Jingdezhen traveled aboard ships.[4] From the ports of the South China Coast porcelain could be disseminated around the world, and everywhere it went it carried with it powerful cultural influences. The global networks it traveled on, in turn, transmitted influences back to China.

Blue and white was the guiding principle of the Frelinghuysen collection from its start. And that discipline, rather than being restricting, was actually liberating, resulting in a collection of exceptional depth and breadth. It ranges from some of the first wares made in China to Western order in the sixteenth century—commissioned under seemingly impossible circumstances and despite enormous logistical challenges—right up to a

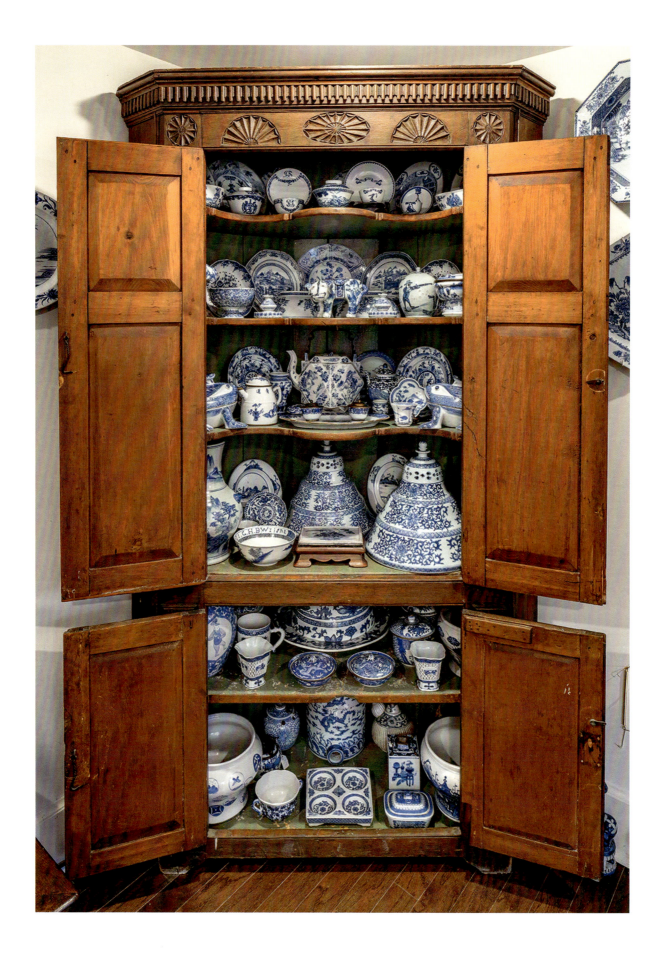

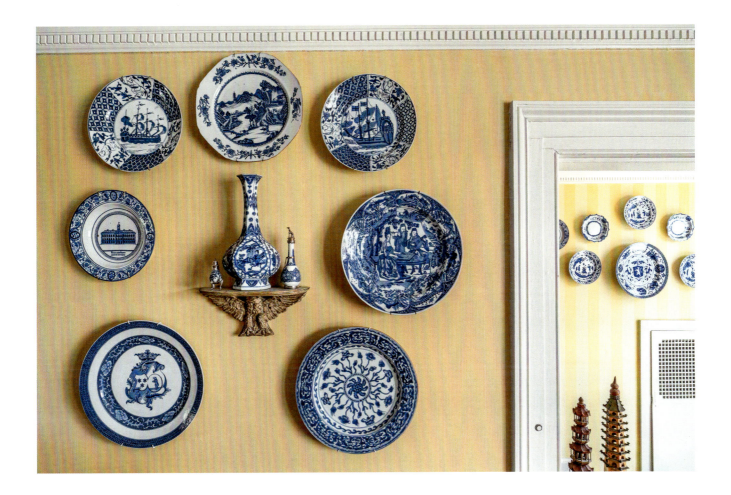

little-known group made for the Thai royal court in the 1880s. There is blue and white made for markets from Japan to Southeast Asia, the Middle East, Europe and America. This focus also inspired a serious exploration of Japanese blue and white export porcelain. The Japanese wares, highly influenced by the Chinese porcelain that had preceded them as well as by the Europeans who acquired them, provide an intriguing counterpoint to the Chinese, and the collection offers a rare opportunity to study the two side by side.

I was lucky enough to see Rodney's porcelains on several occasions over the years, but even for someone with considerable experience of such visits the collection was too large and too diverse to fully take in. Inevitably, the distraction of seeing a new find or handling an exciting piece kept me from a thorough study. It was not until Rodney and I sat down together to review our selections for this book that I began to truly appreciate the innumerable relationships of forms and patterns the collection encompasses and the panoply of cultures, traditions and eras it reflects. There are threads of Hinduism and Buddhism as well as of Islam and Christianity; the fashions and concerns of eighteenth-century Europe appear, as does the tea ceremony practice of seventeenth-century Japan; some porcelains speak to the development of Western cuisine and others reveal the taste of the elite in nineteenth-century Thailand or the customs of Indonesia.

Rodney's deep interest in history and his passion for the material drew him to categories that might well be overlooked by a collector only seeking the 'greatest hits' of Asian export porcelain. There are plenty of those, but there are other pieces that show us how these wares were used in daily life over the centuries and in a number of different parts of the world. We are both pleased to be including some more minor and some more utilitarian wares in the compendium, where the reader may find some intriguing shapes and designs not published elsewhere.

The main entries are divided into a series of thematic chapters which trace some of the different markets

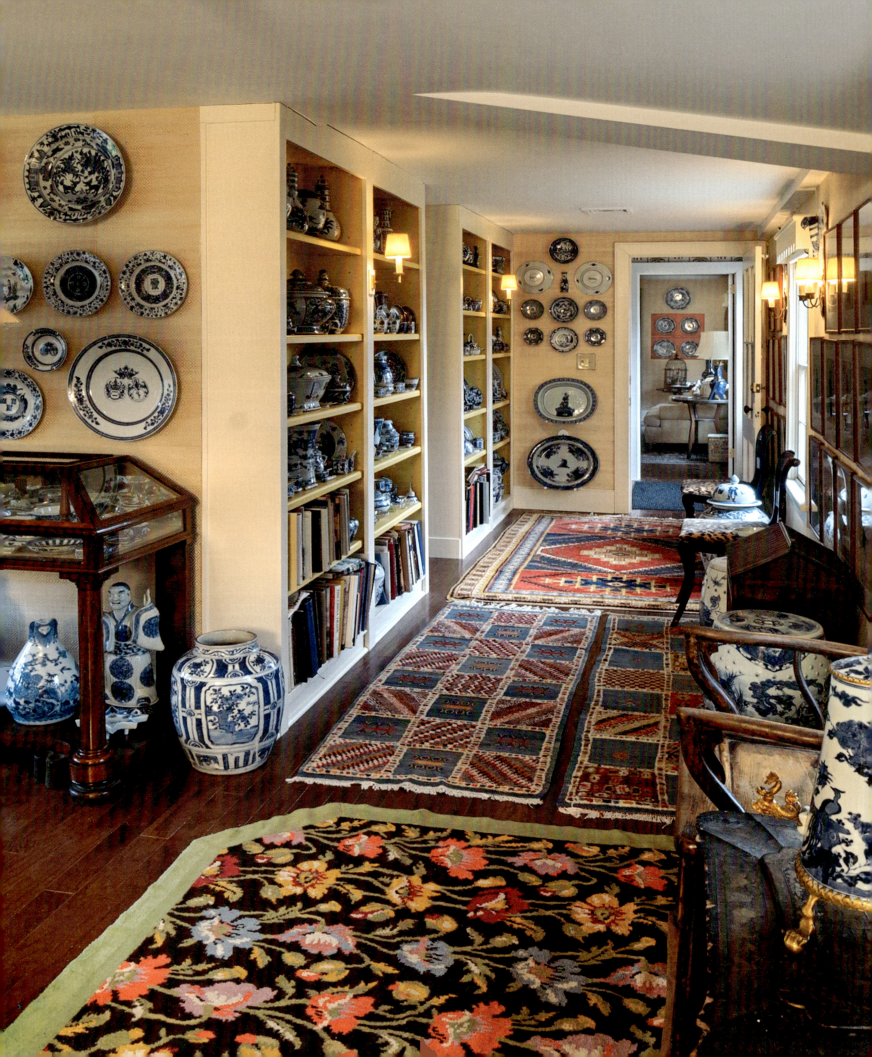

for export wares and reflect the changing relationship between Asian porcelain and its consumers over the four centuries of material presented. Each chapter begins with a short essay of historical context. References provided for each piece are not intended to be exhaustive lists of other published examples but rather are meant to lead any reader who would like to learn more to the sources we have particularly relied on, with an emphasis on those museum collections that are easily accessed online.

It has been an incredible privilege to work on this project and with this phenomenal group of porcelains. I am humbled by Rodney's trust in me and enormously grateful for the opportunity. What a joy it has been to spend time in close study of so many treasures, major and minor, and to learn so much from Rodney and from the collection. His extensive library not only made my research easier to accomplish but was a particularly crucial gift during our first months of work, when the pandemic lockdown had closed all the major academic libraries.

A large number of extraordinary friends and colleagues have made this project possible, giving generously of their time, expertise and guidance. I'm particularly indebted to Margi Gristina and Teresa Canepa for their ongoing support and to Bill Sargent for his always excellent judgment, his research and his wonderful preface. Angela Howard has been a terrific advisor throughout all, and her unparalleled knowledge of armorial porcelain is a significant addition to our book. Caroline Allen's meticulous editing and dedication to the project have made a huge contribution for which I am profoundly thankful.

Words alone could not begin to convey the import of the porcelains in this book; it is the outstanding photography of Dave Schlegel that brings the porcelain to life. How lucky we were to have my longtime colleague Dave contribute his technological skill and artist's eye to our photographs.

The perspective and knowledge of Christiaan Jörg, Ron Fuchs II, Lark Mason and Michael Bass have been invaluable and I am grateful to each of them. Another former colleague, Jessica Chang, provided us with thoughtful inscription translations. Thanks also to all those who helped with books, research and images, including Paulette Cushman, Mary Tavener Holmes, Rhiannon Knol, Amir Mohtashemi, Brigitte Nicolas, Clement Onn, Linda Pomper, Carleigh Queenth, Perrin Stein, Floris Vanderven and Patricia Bjaaland Welch. The conferences of Jorge Welsh and Luísa Vinhais were

inspiring and informative, as is the ongoing Global Interchange Forum run by Kee Il Choi, Anna Wu and Susan Eberhard. Paul Holberton and his talented and collegial team, especially editor Sarah Kane and designer Paul Sloman, have transformed our text and images into the handsome book you now hold.

The abiding and patient support of Peter, Casey, Clay, Diana and Tav has made it all possible.

With its remarkable scope, the Frelinghuysen collection reflects the myriad ways Asian blue and white has been traded, collected, lived with and loved around the world. It is my great pleasure to be sharing this collection with you, the reader, in the following pages.

1 Finlay 2007, p. 426.
2 Canepa 2019, p. 16.
3 Kerr 2012, pp. 33–41, for a comprehensive discussion of Jingdezhen and porcelain technology.
4 Carswell 2000, pp. 87–88.

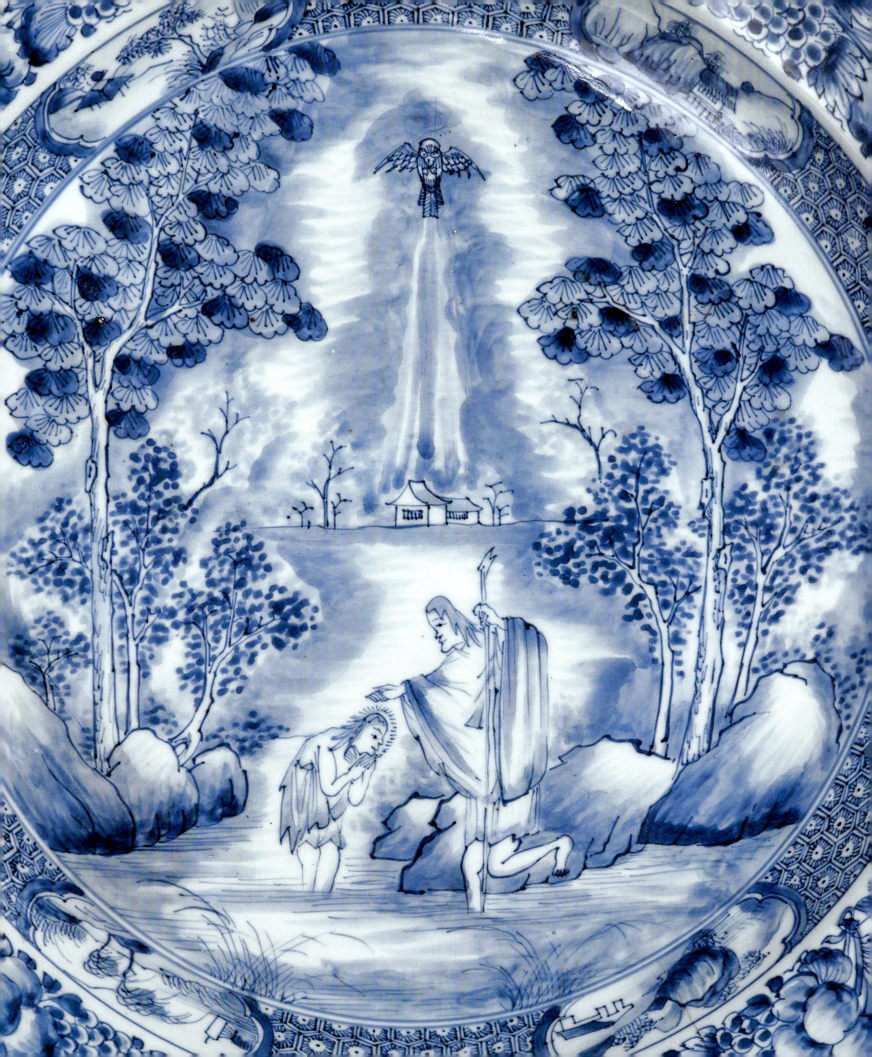

1.
FAITH

The Europeans who made the first perilous sea journeys around the vast continent of Africa and across the Indian Ocean, finally reaching Asia early in the sixteenth century, were driven by a potent mix of desires. There were clearly enormous profits to be made from direct trade in Asian goods. Eliminating the many middlemen who conveyed costly spices and silks to Europe was a powerful incentive. But this was intricately intertwined with their desire to spread the Catholic faith, a mix of motives underscored by the close partnership of church and state that sanctioned their voyages. The joint authority of royalty and the church sent Iberian ships on the first European trips across the seas, their ventures aided by advances in navigation and ship-building, fueled by a deep-seated rivalry with Islam after eight hundred years of Moorish rule, and further fired by Counter-Reformation zeal.

Spices and silks were the most lucrative commodities sought by the European voyagers, but Chinese porcelains were coveted rarities, unlike anything available elsewhere and treasured for both their exotic beauty and their technical superiority.[1] And wonderful Chinese porcelains survive to illustrate the remarkable interchange that took place as the cultures of East and West encountered each other. Many of the earliest pieces in the Frelinghuysen collection embody a fascinating mix of Western motifs with Chinese aesthetics and skill, a significant portion of these reflecting the Christian faith that colored early modern European life. Other pieces tell of the intermingling of Islamic and Chinese cultures that grew out of the thriving commercial networks connecting these two different worlds.

Catholic missionaries sailed aboard some of the earliest European trading ships and a few even preceded them, traveling to Asia overland as early as the thirteenth century. Eventually Jesuits, Franciscans, Dominicans and Augustinians from France, Italy, Spain and Portugal all established outposts in Asia and, while their success with conversion was nominal, they became important conduits of cultural exchange between East and West. They brought books and prints and paintings along with scientific knowledge and Western philosophy. They commissioned Japanese lacquer lecterns, personal altars and host boxes, Chinese silks for vestments and bronze bells for their churches.[2] Chinese porcelain with Christian motifs was ordered, whether for personal devotional use or for use at Mass, and, in an age animated by faith, another ready market for religious subject Chinese porcelain was provided by Catholic merchants, traders and administrators from Portugal and Spain, later joined by the Protestant Dutch.

The China that early modern Europeans reached was a country of vast territory, huge population and ancient history. It had long been a sophisticated society, featuring a cosmopolitan mix of peoples as early as the Tang dynasty (618–907), by which time Buddhism had been practiced for some centuries. Buddhism had traveled from India via the Silk Road, joining the indigenous Confucianism and Daoism. Central Asian traders and workers settled in Tang China as did Christians of the Church of the East, known as Nestorians. Tang dynasty pottery tomb figures of foreign grooms and merchants survive to tell this story, as do Nestorian tombstones and the late eighth-century

Nestorian monument known as the Xi'an Stele, carved with a Christian cross above a long description of church practices and leaders.

This thread of multi-culturalism continued intermittently in China through the Song dynasty (960–1279), and was then greatly intensified under the Mongols of the Yuan dynasty (1279–1368).[3] Shamanists themselves (although a few elite Mongol women were in fact Christian), the Mongols ruled over an empire that eventually stretched from China across Central Asia to Eastern Europe.[4] They greatly facilitated trade with Central and South Asia and the Arabian Peninsula and also actively recruited Muslims for their government. Muslim merchants settled in important Chinese trading ports such as Quanzhou in Fujian province.[5] The intrepid Arab explorer, Ibn Battuta, toured China in the 1340s and wrote an arguably more accurate account of his travels than Marco Polo, who had visited fifty years earlier. Ibn Battuta wrote of both Quanzhou and Guangzhou (Canton) along the coast, "There is a pottery market and from it [pottery] is carried to the other countries of China and to India and to Yemen."[6]

Gleaming, high-fired, white porcelain, brilliantly painted in underglaze cobalt blue, was mastered by the Chinese kilns at Jingdezhen in the fourteenth century, and it quickly became a highly desirable trade commodity. No one else in the world was able to produce it, nor would they for four hundred years. Some cobalt used at Jingdezhen, called *hui qing*, or 'Muslim blue', came from Iran (Persia), while local cobalt was mined in Yunnan.[7] The underglaze technique—painting air-hardened clay with pigment before glazing and firing—developed over time in China, probably derived from decorated pottery and stoneware made in northern kilns which traveled south to Jingdezhen with the migration of workers.[8]

Yuan dynasty China enjoyed a thriving trade in blue and white porcelain, which was exported by land and sea throughout Southeast Asia and on to India, the Arabian Peninsula, Turkey, the coast of Africa and Egypt.[9] When China returned to Chinese rule under the Ming (1368–1644), this trade continued to flourish, despite the initial isolationism of the new dynasty.[10] The Yongle emperor (r. 1402–24), son of the first Ming emperor, sponsored the extraordinary voyages of Chinese Muslim admiral Zheng He, who sailed with his enormous fleet and crew across the Indian Ocean and on to the Persian Gulf and the coast of Africa.[11] Yongle and later the Xuande emperor (r. 1426–35) dispatched quantities of blue and white porcelains on the Zheng He voyages to be dispensed as diplomatic gifts. The cargo for the seventh voyage in 1433, for example, included over 400,000 ceramics from Jingdezhen, many of them blue and white.[12]

Cultural influences flowed in both directions along the well-traveled Ming dynasty trading routes. Foreign tastes had already been apparent in Yuan Chinese porcelain when quantities of the large blue and white dishes favored by the Islamic kingdoms were produced. In Ming China, designs and forms inspired by Islamic textiles, metalwork and pottery began to appear in porcelain made for both the export and the domestic markets.[13] Ming wares with foreign decoration included those made for Muslim eunuchs at the court of the Zhengde emperor (r. 1506–21), who commissioned blue and white porcelain inscribed with Quranic texts in Persian and Arabic.[14]

By the first decades of the sixteenth century, when the Portuguese finally reached Asia after progressing from Hormuz to Melaka (Malacca) via Goa, the potters of Jingdezhen were quite used to supplying porcelains shaped and decorated to foreign tastes. And among the very first porcelains commissioned by the early Portuguese visitors were pieces with Christian motifs.[15] Arranging their orders through Chinese merchants in Melaka, Portuguese traders commissioned a series of large blue and white dishes displaying around the rims the armillary sphere device of King Manuel I (r. 1495–1521), the royal coat of arms and the Greek holy monogram IHS.[16] This decoration, which encircles Chinese dragons or Buddhist lions, could not be a more perfect reflection of the blend of church and state that defined the Catholic kingdoms of Europe and underpinned the Asian trading ventures. The 1493 bull of Pope Alexander VI that became known as 'The Doctrine of Discovery' put it thus:

Wherefore, as becomes Catholic kings and princes … you have purposed with the favor of divine clemency to bring under your sway the said mainlands and islands with their residents and inhabitants and to bring them to the Catholic faith … that inasmuch as with eager zeal for the true faith you design to equip and despatch this expedition, you purpose also, as is your duty, to lead the peoples dwelling in those

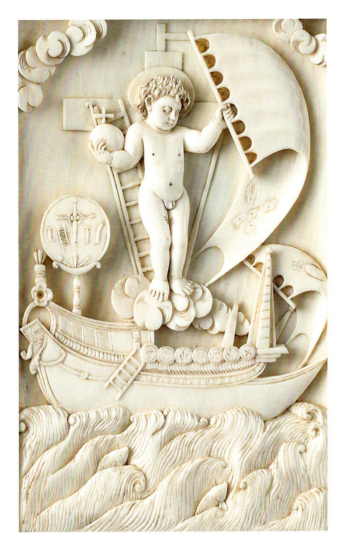

Portuguese or Spanish School (Macao or Manila),
The Christ Child as Navigator,
Ivory plaque, early 17th century,
Asian Civilisations Museum, Singapore

islands and countries to embrace the Christian religion ... by the authority of Almighty God conferred upon us in blessed Peter and of the vicarship of Jesus Christ, which we hold on earth, do by tenor of these presents, should any of said islands have been found by your envoys and captains, give, grant, and assign to you and your heirs and successors, kings of Castile and Leon, forever, together with all their dominions, cities, camps, places, and villages, and all rights, jurisdictions, and appurtenances, all islands and mainlands found and to be found, discovered and to be discovered[17]

This papal bull 'gave' the Spanish the lands west of the Cape Verde Islands, an understanding that the Portuguese succeeded in clarifying—to their advantage—directly with the Spanish a year later in the Treaty of Tordesillas. That treaty, which 'gave' Portugal the other half of the globe, was then sanctioned by Pope Julius II in 1506.

The Portuguese, with their large ships and superior cannon, subdued Goa on the west coast of India by 1510 and soon set to work with religious conversion and the building of churches. Franciscans arrived in 1517, and in 1542, just two years after the Society of Jesus had been founded, the Jesuit Francis Xavier arrived.[18] Xavier, a Spaniard, had been dispatched from Rome as the pope's apostolic nuncio, or ambassador, to 'the Indies'. Armed with the Jesuit vow to conduct ministry in every corner of the world, Xavier traveled with engravings, paintings and carvings as well as bibles, prayer books and liturgical objects. Art was to be used to "delight, to teach and to move."[19]

Xavier had a successful stay of several years in Goa before moving on to the Molucca Islands and then Japan, where he landed in 1549. Again, he was successful in establishing a small mission. But eager to attain China, the grandest prize of all, Xavier left Japan for Shangchuan Island off the Guangdong coast, where the Portuguese, forbidden from entering China at the time, had a small outpost and a thriving trade with both Chinese and Japanese merchants.[20] Xavier was hosted on the island by the Portuguese merchant Jorge Álvarez, but died there in 1552 before he could reach China. That same year Álvarez managed to procure about a dozen blue and white bottles from Jingdezhen inscribed with his name and the date. A rare survivor from this group is in the collection (no. 19).

Meanwhile the Spanish had also reached Asia, sailing around the tip of South America. After a few skirmishes with the Portuguese in the Spice Islands they moved on to the Philippines, securing a coastal settlement there in 1565. By 1580 a diaspora of Chinese in Manila was supplying the resident Spanish with religious articles such as carved ivories, crucifixes and paintings. Bishop Salazar of Manila wrote to the King of Spain in 1590 extolling the "marvelous work with both the brush and chisel," adding, "considering the ability of these people in reproducing the images which come from Spain, I believe that soon we shall not even miss those made in Flanders."[21] There were similar workshops around the Jesuit missions in Japan. Macao, where the Portuguese had succeeded in establishing a Chinese foothold in

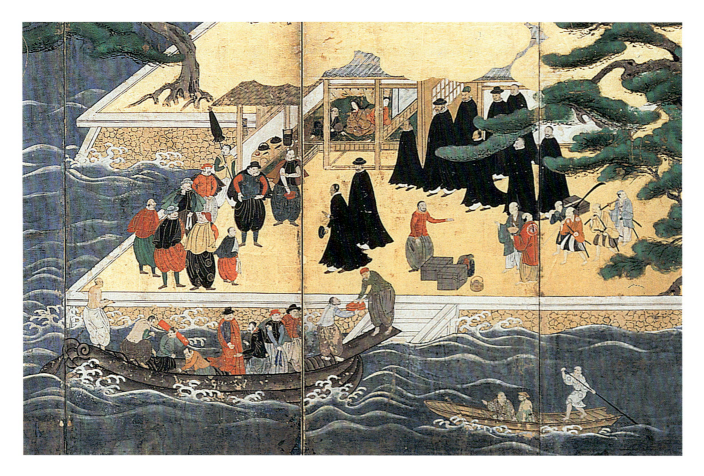

Japanese School, *Arrival of the Southern Barbarians*,
(Portuguese Traders at Nagasaki) (detail),
Ink, color and gold leaf on paper, early 17th century,
Private collection

1557, was also home to a community of artisans catering to the Christian market, while other Christian works of art for European consumption were made in Fujian province.[22] The Jesuit community in Macao even became directly involved in the trade in order to fund its mission, a further entanglement of commerce and religion. By 1585 it had obtained a one-third share in the silk carried on the annual 'black ship' to Japan. The cargo one Portuguese ship carried from Goa to Macao in 1658 was shared equally by the Chinese Jesuits, the Japanese Jesuits and the Portuguese merchant Simão de Souza.[23]

The Jesuits, with their Renaissance humanist philosophy, their intellectualism, their belief in art as a teaching tool and their preference for conversion through conversation, not coercion, were particularly well suited to gaining ground in Asia. Their engagement with Chinese society, albeit limited, and for a time with Japanese society, made them probably the most effective channel of East–West cultural interchange in the period. Matteo Ricci, born in Italy in 1552, the year Xavier died, was to become one of the most influential Jesuits in China. He made an impression at the Imperial court with his knowledge of astronomy and his gifts of telescopes and clocks, and became proficient enough in Chinese to debate with scholars.[24] In the early eighteenth century, the Kangxi emperor (r. 1662–1722) enlisted a group of skilled Jesuits to work at court on paintings, enameled metalwork, enameled porcelain and clocks, including the Italian Jesuit Giuseppe Castiglione, known as 'Lang Shining' (1668–1766), who was to become a well-known artist under three emperors. This work, often undertaken dawn to dusk in near servitude, did not directly support the Jesuit mission, but the brethren well understood that favor at court allowed their missionary work to continue elsewhere in the country.[25]

But long before the heyday of the Kangxi court, the Protestant Dutch had begun to arrive in Asia. The first Dutch trading ship to reach the Spice Islands landed in 1595, almost exactly a century before the Kangxi emperor's famous 1692 Edict of Toleration allowing Christian worship. The Dutch East India Company, known as the VOC—the initials of its name in Dutch, Vereinigde Oostindische Compagnie—and often called the first multinational joint stock corporation, was formed in 1602. Though lacking the close partnership of church and royal rule that characterized the Asian trading ventures of the Iberians, called the *Padroado* in Portugal and the *Patronato Real* in Spain, the VOC was similarly empowered by the Dutch state to engage in military exploits and to administer territory.[26] With their improvements in navigation and weaponry and their smaller, more nimble ships, the Dutch soon became the dominant European presence in Asia. They were to be the main European trading partner for Asian works of art throughout the seventeenth century.

The commercial nature of the VOC meant perhaps less prestige than the royal ventures of Spain and Portugal, and the Dutch also lacked the high-minded missionaries who were so influential at the Chinese court. But springing from a more open and fluid society with much more widely diffused wealth, the VOC also had a vast home market for Asian goods. And by representing completely commercial, non-threatening interests, Dutch merchants were able to establish themselves in China to just the necessary degree.[27] In Japan, their lack of interest in religious conversion led directly to their exceptionally long tenure, as discussed in Chapter Eleven.

The Dutch, however, did order some religious subject porcelain like their fellow Europeans from Catholic countries. A small number of examples can be assigned with certainty to Dutch traders. Christiaan Jörg has discovered that the engraved illustrations by Jan Luyken (1649–1712) in Dutch Lutheran bibles were the source for a well-known group of mid-century pieces painted in *grisaille* or colors with three different scenes from the life of Christ (the Nativity, Crucifixion and Ascension). The title page of several editions of these bibles featured the portrait of Martin Luther that was also produced in *grisaille* porcelain of the 1740s.[28] In blue and white, a large dish painted with the Baptism of Christ in the collection (no. 8), one of a well-known group, is clearly decorated after Delft and was almost certainly a Dutch order. The

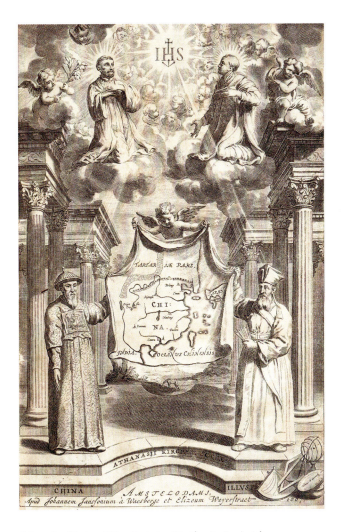

Athanasius Kircher, *China illustrata*, 1667 (frontispiece): Adam Schall von Bell and Matteo Ricci hold a map of China with Ignatius Loyola, Francis Xavier and the Jesuit emblem above, Frelinghuysen collection

small tea pieces depicting the Crucifixion (no. 318) may also have been made for the Dutch market. Other religious subject Chinese blue and white in the collection was ordered by Jesuits or Franciscans and bears their insignia (nos. 7, 9 and 319–321). The two large Magic Fountain vases (no. 2) are part of a small group of ewers and vases made in the Jiajing (1522–66) to Wanli (1573–1620) period with this Christian iconography. Several examples have been found in Japan, where by 1596 there were 124 churches and 134 Jesuit missionaries, one or more of whom may well have ordered them, whether for personal or ritual use.[29]

In nearly all of these porcelains, whether they record the Christian presence in Asia or reflect the interactions between China and the Islamic world, we see the hand

Teabowl base with Christian cross motif (no. 318)

of the Chinese artisans who made them. Borders might display motifs from the traditional Chinese vocabulary or shapes might be from the classic Chinese repertoire. Foliage and flowers are drawn from the painter's experience; a pagoda might rise in a European landscape. In this way, these wares are a near-perfect embodiment of the cultural exchanges between Asia, Islam and Europe that arose through both commerce and religion.

1 Jörg 2007, p. 56, for a discussion of the profitability of spices versus porcelain; see Canepa 2016 for a comprehensive account of European trade in Chinese silk and porcelain and Japanese lacquer.
2 Canepa 2016, pp. 332–56, for a number of examples of Japanese lacquer for Christian devotional use.
3 Gerritsen 2020a, p. 92.
4 Chong 2016, pp. 136–67.
5 Vainker 1991, pp. 138–39.
6 Carswell 2000, p. 56. Carswell notes that Ibn Battuta's travel account was written in Arabic and, though translated into French in 1859, has only been available in English since 1994. Still less known than the writings of Marco Polo, in Carswell's view it is more detailed, more accurate and more comprehensive.
7 Gerritsen 2020a, p. 163.
8 Ibid., chapter 5 (pp. 88–113), where the author outlines her argument for the movement of ceramic technology from Cizhou to Jizhou and then to Jingdezhen in Song and Yuan China.
9 Carswell 2000, p. 17, where the author includes a map of all the sites where significant Yuan blue and white has been found.
10 Hansen 2000, chapter 10 (pp. 369–407), for an account of Ming political, social and commercial life.
11 Carswell 2000, p. 81.
12 Gerritsen 2020a, p. 118.
13 Carswell 1985, p. 29.
14 Lion-Goldschmidt 1978, pp. 130–31.
15 Santos 2007, pp. 94–200, for a comprehensive survey of the Portuguese 'first orders'.
16 Jörg 2007, pp. 63–64, where the author quotes from a 1528 letter from Jorge Cabral, captain of Malacca, noting his porcelain orders from "the Chins right here in Malacca because money or goods can be entrusted to them and they return with them."
17 Reid 2015, section I, part I (an English translation of the Inter caetera of Pope Alexander VI).
18 Bailey 1999, pp. 5–6.
19 Ibid., p. 8, where the author discusses various influences on Jesuit beliefs in the power of art, including Cicero and St. Augustine, citing Leon Batista Alberti's belief in his 1435 treatise On Painting that "art had an extraordinary ability 'to delight, to teach, and to move' (delectare, docere, movere)."
20 Canepa 2016, p. 27, where the author quotes from Portuguese Jesuit Belchior Nunes Barreto's 1555 account of Shangchuan Island.
21 Clarke 2013, p. 28.
22 Ibid., p. 27, for the artisans of the Fujian coast; see also Bailey 2015, pp. 92–93, for workshop activity in Manila, Macao, Japan and China.
23 Hong 2021, p. 47.
24 Hansen 2000, p. 393; Canepa 2016, p. 103.
25 Bailey 2015, p. 93.
26 Corrigan, Van Campen and Diercks 2015, p. 32.
27 Gommans 2015, pp. 32–36, for a discussion of this difference.
28 Jörg 2002, pp. 171–75.
29 Okamoto 1972, p. 25.

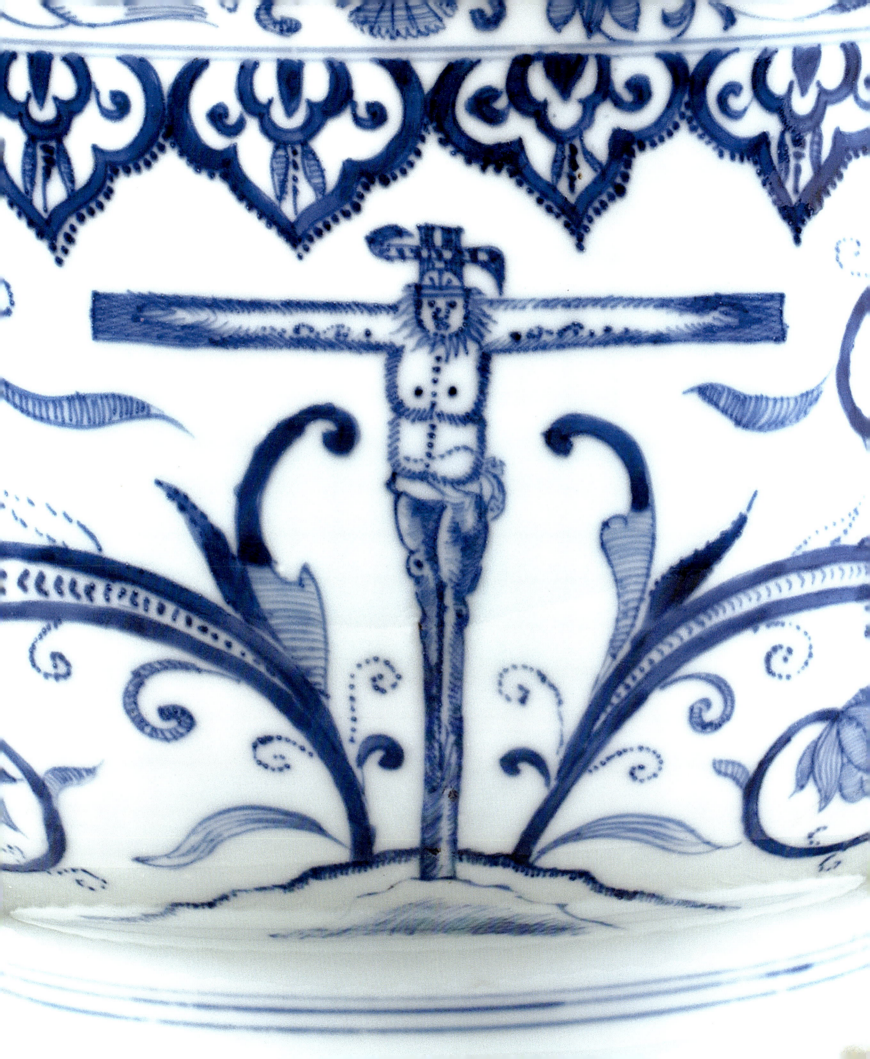

1.
CHRISTIAN EWER

**Zhengde (1506–21) to Jiajing (1522–66) period,
first half 16th century**
6 ⅜ in. (16.2 cm) high

The bulb mouth of this small ewer sits atop a pear-shaped body with short pedestal foot; its plain base is glazed. A slender arched handle is opposite the curving spout which is joined to the body by a scrolled strut. On the front a Christian cross impaled with three nails of the Passion is rendered in a checkerboard pattern. The opposite side is painted with a squatting winged figure within a half-sun or flowerhead and above scrollwork. In form the ewer relates closely to a well-known group of slightly larger ewers dating to the first half of the sixteenth century and with apocryphal Xuande period (1426–35) marks.

The double-crossbar form of the Christian cross on the ewer—sometimes called Persian cross or St. Thomas cross—is associated with the Church of the East Christians, some of whom followed the teachings of the theologian Nestorius (d. c. 450) and were called by others Nestorians. Nestorians were in China for a time during the Tang dynasty (618–907) and again in the Yuan dynasty (1279–1368), when they settled in a number of cities including the cosmopolitan trading port of Quanzhou on the South China Coast (home also to a sizeable Muslim community). A thirteenth-century Nestorian tombstone found in Quanzhou is carved with a squatting winged angel reminiscent of the figure on this ewer, though wearing Mongol dress.

By the Ming dynasty, however, when this ewer was made, Nestorians had again disappeared from China. The last physical or documentary evidence of Chinese Nestorian communities dates to the 1330s and '40s. There were, however, many Church of the East Christians in the Middle East and in India—where in the sixteenth century they would increasingly encounter the Portuguese and their *Padroado*. In January 1549 St. Francis Xavier wrote from India to King João III of Portugal asking him to encourage better treatment of the St. Thomas Christians (as they were then known in India).

Chinese blue and white was, of course, well known—and desirable—in India and the Middle East by the sixteenth century, and the longstanding trading relationships between the two regions may explain the curious winged figure that appears on the side of this ewer. Though its wings suggest a Christian angel and, when considered together with the ewer's cross, an angel seems the most likely motif, it relates closely to depictions of Garuda. A demi-god with a bird-beak nose, Garuda originated in ancient Hinduism. If the Chinese potter who decorated this vase was provided with a drawing made in India, then Garuda characteristics may have influenced the angel's depiction. However, Garuda was also adopted by Buddhism, notably in Tibet, Nepal and Indonesia, and in sixteenth-century East Asian works of art was often portrayed squatting with wings spread and arms raised. It is also possible that the Chinese potter simply added the more familiar Garuda characteristics to a conventional Christian angel portrayal.

A patterned St. Thomas cross with stepped pedestal base is common imagery in the early bibles and liturgical writings of Syriac Christians (which include St. Thomas Christians). The distinctive Christian iconography of this ewer and its historical context may indicate most plausibly that a Church of the East Christian in India commissioned it. A ewer of closely related form painted with the armillary sphere of King Manuel I circa 1519–20 provides evidence of Portuguese orders of this type being executed early in the century. St. Thomas Church stone carvings from the Portuguese era survive in southern India with both Church of the East crosses and the Hindu-influenced winged angel motif. A St. Thomas Christian may well have given a Portuguese trader a commission specifying a patterned cross and an angel influenced by a Hindu Garuda. There were many Church of the East Christians in Syria, too, another trading center of the period. Whatever its origins, the ewer speaks to the fascinating cultural interchange of the later Ming period.

REFERENCES Pope 1956, pl. 98 (29.434) (Ardebil Shrine ewer); Strober 2013, pp. 160–61 (related ewer); Gardiner Museum (G99.1.1) (related ewer); Chong 2016, pp. 26–27 (term Nestorian); Guy 2010, pp. 160, 164, 173–74 (Nestorians in China; Quanzhou); Costelloe 1992, pp. 232–46 (St. Francis letters); Freer Gallery of Art (F1911.428) (Chinese stone Garuda c. 1500); Morgan Library (MS M.235 fol.) and Biblioteca Vaticana (Borg. sir.169) (similar crosses in Syriac manuscripts); Pinto de Matos 1998, pp. 134–35 (armillary ewer); Perczel 2016 (Nestorian carvings in India)

PROVENANCE Heirloom & Howard Ltd, Wiltshire, 2017; Sotheby's New York, 14 March 2017, lot 14; the collection of Bernard and Josephine Chaus; Sotheby's Hong Kong, 21–22 May 1979, lot 54

2.
TWO MAGIC FOUNTAIN VASES

**Jiajing (1522–66) to Wanli (1573–1620) period,
second half 16th century
16 and 16 ⅜ in. (40.6 and 41.6 cm) high**

Each of these large, heavily potted vases is painted front and back with a Renaissance-style fountain. Two streams of water flow from bird heads on the slender upper section; two more from monster masks on the central standard, all falling into the large main basin from which two final streams splash on the ground. A *qilin* rests on the fountain's stepped base in front of its four legs and a pennant flies at top. On the neck of the first vase is a blue patterned band with two large auspicious characters meaning happiness and longevity; it has a four-character *Wan fu you tong* mark on its base (May infinite happiness embrace your affairs). The second vase is unmarked; its mouth (which has probably been cut slightly) has a white metal mount.

The completely foreign fountain decoration on the vases (albeit accompanied by a Chinese auspicious animal) is also found on a well-known group of more finely potted ewers dating to the Jiajing period (1522–66) and now in a number of public and private collections. There are also two finely potted Jiajing bottle vases recorded in the pattern. The group varies in the details of its fountains and borders; the animal is most often a *qilin* but occasionally an elephant or horse.

Scholars have long speculated on the origins of the Magic Fountain decoration, though following Linda Pomper's persuasive research it is agreed to be Christian. A fountain often symbolized the Virgin Mary, and the design's similarity to that of the famous late fifteenth- or early sixteenth-century Hunt of the Unicorn tapestry—the unicorn here a *qilin*—has been noted. The Fountain of Life or Fountain of Waters closely associated with baptism and rebirth is another possible subject, as is the Four Rivers of Paradise. The Four Rivers, as described in the Book of Genesis, flowed out of the Garden of Eden; they might well be represented by the four distinct streams of water which appear on all of these vessels, the stag often shown drinking from the Rivers now a *qilin*.

The European religious orders that were to become so active in China had not yet established their East Asian outposts in the mid-sixteenth century when these Magic Fountain vessels were first made. They were, however, settled in Goa and, from 1549, in Japan, and could have commissioned Chinese porcelain from either location. By the latter decades of the century there was a significant Christian presence in the Philippines as well. The number of examples that have survived may indicate they were ordered by a religious institution, though over the ensuing century the vessels became rather widely scattered. Magic Fountain pieces have been found in such diverse locations as Japan, Indonesia, the Imperial Ottoman collection at the Topkapı Palace, the Ardebil Shrine collection assembled by Shah Abbas before 1611 and the Netherlands, as seen in a well-known still life by Willem Kalf (1619–1693).

A Magic Fountain ewer in the Victoria and Albert Museum also has the *Wan fu you tong* mark and appears to have slightly more grayish blue cobalt and a slightly heavier clay body than many of the other ewers. The two large bottle vases here relate closely to Wanli period wares and may reflect the ongoing use of a design that had found a ready audience among the Christian community in Asia.

REFERENCES Pomper 1995, pp. 51–78 (discussion); Canepa 2016, pp. 265–66, 270–71 (discussion); Krahl 1986a, pp. 453, 654–56, 814 (Topkapı Palace ewers); Pope 1956, pl. 99 (29.423) (Ardebil Shrine ewer); Pinto de Matos 2019, p. 162 (vase); British Museum (PDF.689) (vase); Metropolitan Museum of Art (37.80.2) (unicorn tapestry); Victoria and Albert Museum (C.105-1928) (ewer)

PROVENANCE Heirloom & Howard Ltd, Wiltshire, 1994; Phillips London, June 1994, lot 456 (left). Richard Peters Antiques, London, 2012 (right)

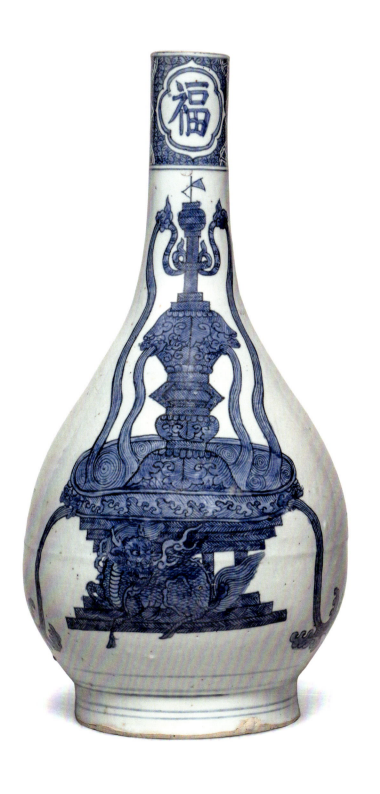
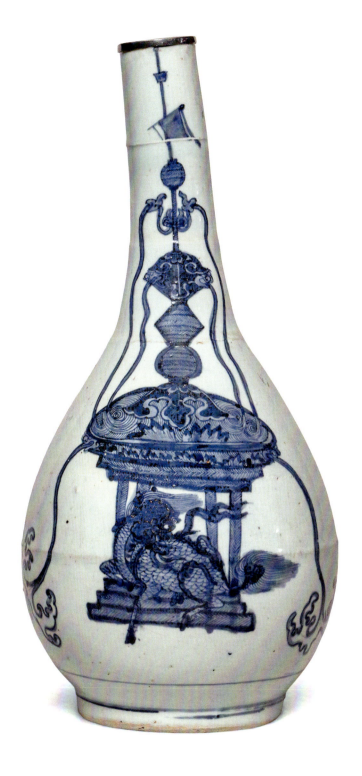

3.
INSTRUMENTS OF THE PASSION BOTTLE

Tianqi (1621–27) to Chongzhen (1628–44) period, c. 1620–45
12 ¼ in. (31.1 cm) high

This sturdily potted bottle has straight sides and a flat, unglazed base. Two of its sides are painted with an empty Crucifixion cross, the ladder leaning against it indicating that Joseph of Arimathea has taken away the body of Christ. Instruments of the Passion shown include a crown of thorns encircling the cross, a scourge made of rushes lying in the foreground and the cockerel that, as Jesus had predicted, crowed after Peter had denied him three times. A small dog with a lit candle in his mouth probably signifies the Dominican order—its name comes from *Domini canes* or dogs of the Lord—though some scholars believe it may represent the light of faith, which would be in keeping with the Resurrection theme of the bottle's other two sides. There a heavenly host of angels plays horns and drums amidst swirling clouds while below a Chinese house with open doorway is probably meant to depict the empty tomb. A small group of bottles with this decoration has been identified in public and private collections, all based on a European glass model and with short cylindrical necks (now missing on this example). Dominicans were active in the Philippines from the early seventeenth century; the largely Spanish order opposed the largely Portuguese Jesuits in the Chinese Rites controversy of the period, a divisive debate over the tolerance of Confucian and Buddhist practices in Christian converts.

REFERENCES British Museum (1963,0520.7) (very similar bottle); Leidy and Pinto de Matos 2016, pp. 120–23 (very similar bottle); Lu 2012, pp. 94–95 (discussion of British Museum bottle)

PROVENANCE Heirloom & Howard Ltd, London, 1988; Sotheby's London, November 1988, lot 530

4.
CHRISTIAN FLASK

**Chongzhen (1628–44) to Kangxi (1662–1722) period,
c. 1640–1720**
7 ¾ in. (19.7 cm) high

Of flattened bottle form with a tall tapering neck, this flask is painted in front with a village scene showing a large cross standing among trees. Small buildings are at back right; on the left is a church with a tall steeple topped by a cross. The sides have flowering vine and on the back is a flowering plant; the base is unglazed. A small group of these flasks is recorded, including a pair at Hampton Court Palace and two in the Augustus the Strong collection at Dresden. Though traditionally dated circa 1635–45, recent scholarly examination has prompted a potential redating to the late seventeenth century (or as late as 1720). At any of these times there were missionaries and priests as well as Christian traders active in Asia who might have ordered a set of these flasks.

REFERENCES Royal Collection Trust (RCIN 1058) (near-identical pair); Staatliche Kunstsammlungen Dresden (PO 7033) (near-identical flask); Jörg and Würmell 2019 (dating discussion)

PROVENANCE The Chinese Porcelain Company, New York, 1991

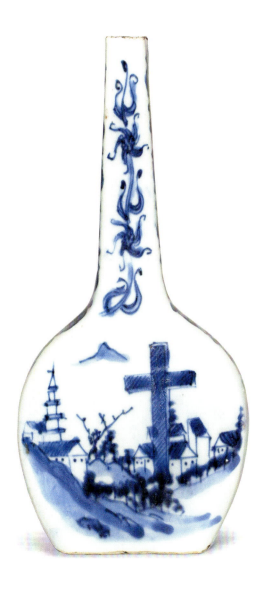

5.
CRUCIFIXION JAR AND COVER

Kangxi period (1662–1722), c. 1690
10 in. (25.4 cm) high

Painted on the front of this jar is the crucified Christ, a plaque on the upper crossbar inscribed *INRI* for Jesus of Nazareth, King of the Jews. The cross rises from rocks which sprout enormous tulips on curling stems. A large chrysanthemum head decorates the cover, and the base has an artemisia leaf mark. Detail on the Christ figure and cross suggests a print source, while the scale and rendering of the tulips probably indicates textile inspiration, perhaps one of the Chinese silk vestments or altar cloths that were being made for Christians in Asia at this time. A small group of jars is known with this distinctive decoration; all are of a simplified baluster form except two U-shaped examples, this one and another just like it illustrated by Maria Antónia Pinto de Matos, both of which have eighteenth-century ormolu mounts.

REFERENCES Pinto de Matos 2011a, p. 296 (near-identical jar); Sargent 2012, p. 309 (round version with cover); Metropolitan Museum of Art (1970.218) (round version)

PROVENANCE Heirloom & Howard Ltd, London, 1983; Sotheby's Monaco, 13 February 1983, lot 263

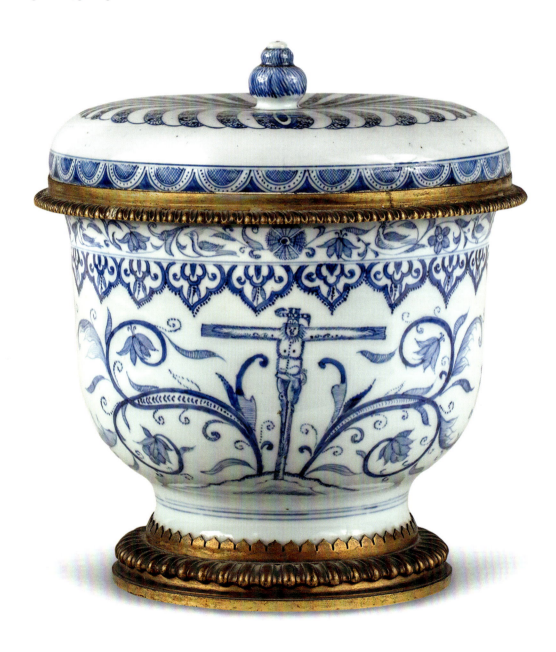

6.
HOLY HOUSE OF NAZARETH CUP

Kangxi period (1662–1722), c. 1690–1710
4 ⅞ in. (12.4 cm) wide

This very unusual oval cup is finely potted in a grayish ware and set with a pair of ear-shaped handles. Its exterior is plain; the interior inscribed in block capitals *TERRA / DELLA S. CASA / DI NAZARET* (Earth from the Holy House of Nazareth), referring to the simple, one-room stone house where the Virgin Mary was born and raised and where the Annunciation took place. By tradition, the house was transported by a host of angels from the Holy Land to the town of Loreto in Italy, where it remains to this day. In fact, its stones were brought to Italy in the thirteenth century by Italian crusaders. An immense sanctuary was then built around it; it has been a major pilgrimage site ever since—and a subject for works of art. An Italian maiolica holy water bowl dated 1728 in the Victoria and Albert Museum depicts the Virgin and Child riding atop the Holy House as it crosses the sea. Though some maiolica wares sold to pilgrims at Loreto were said to include dust from the Holy House in their bodies, this cup was probably intended to hold earth gathered from the House, which has a dirt floor. Its Italian inscription is quite rare in Chinese export porcelain; it may have been ordered by an Italian missionary in China as a gift for a pilgrim friend. The cult of Loreto was celebrated at the Jesuit missions of South America, and the Litany of Loreto was recited at Jesuit schools in Japan. In 1699 prayers of the House of Nazareth at Loreto were added to the Catholic breviary, another possible inspiration for this apparently unique commission.

REFERENCES Victoria and Albert Museum (C.135-1938) (maiolica Holy House dish); Staatliche Kunstsammlungen Dresden (PO 6886) (bowl with related handles); Bailey 1999 (cult of Loreto in Jesuit missions)

PROVENANCE The Chinese Porcelain Company, New York, 1996

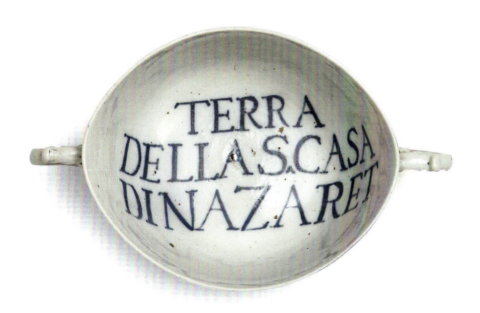

7.
FRANCISCAN JAR AND COVER

Kangxi period (1662–1722), late 17th century
11 ¾ in. (29.8 cm) high

The swelling sides of this jar are decorated with three large cartouches of baroque scrollwork. One contains the insignia of the Franciscan order, showing the bare arm of Jesus crossing the sleeved arm of St. Francis before a cross which rises from clouds. Another contains a large standing crane, a Franciscan symbol of care and vigilance, while the third cartouche is blank. Gadroon borders at top and bottom probably echo baroque silver, and a dished cover has a domed center and pointed knop. Franciscans established a mission in Goa in 1517 and were active in New Spain from 1524; they established themselves in Macao in 1580. By the time the Kangxi emperor was on the throne there were Franciscan outposts in Japan and Indonesia, as well. The small group of jars known with this decoration could have been ordered for any of these sites.

REFERENCES Pinto de Matos 1998, pp. 182–83 (a pair of more slender jars in identical pattern); Chong 2016, pp. 179, 197 (Franciscans in Asia)

PROVENANCE Rodrigo Rivero Lake, Mexico City, 1987

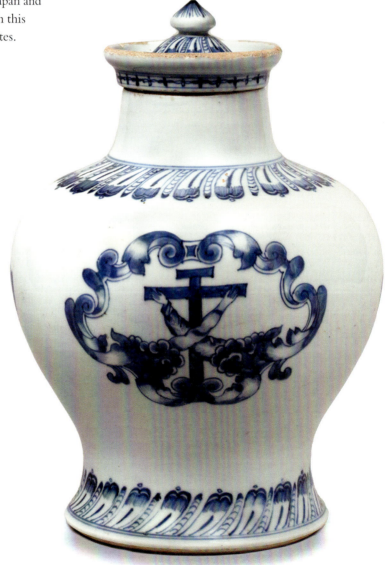

8.

LARGE BAPTISM DISH

Kangxi period (1662–1722), c. 1720
20 in. (50.8 cm) diameter

In the center Jesus Christ stands in the River Jordan, head bowed, as John the Baptist reaches out with his right hand. A dove in the sky above them issues a ray of light representing the Holy Spirit. The rim is painted with a wide border of lush fruiting vine in Delft style interspersed with small putti; a spread-winged eagle, possibly meant to be another dove, is at the top. Below, a cartouche is inscribed *Mat. 3.16*, referring to the Bible verse in the Gospel of Matthew that describes the Baptism of Christ, when "he saw the spirit of God descending like a dove, and lighting upon him." A group of dishes is known in this pattern and of this same large scale, undoubtedly a single order. Although Chinese porcelains with Christian symbols had been commissioned by Europeans for two centuries by the time they were made, these probably represent the first with a biblical scene—possibly reflecting a cultural difference between the Iberians of the earlier orders and the Dutch and English who were so active in the China trade at this time.

REFERENCES British Museum (1963,0422.13) (near identical dish); Howard 1997, p. 109 (another example); Leidy and Pinto de Matos 2016, p. 132 (another)

PROVENANCE Fred B. Nadler Antiques, Bay Head NJ

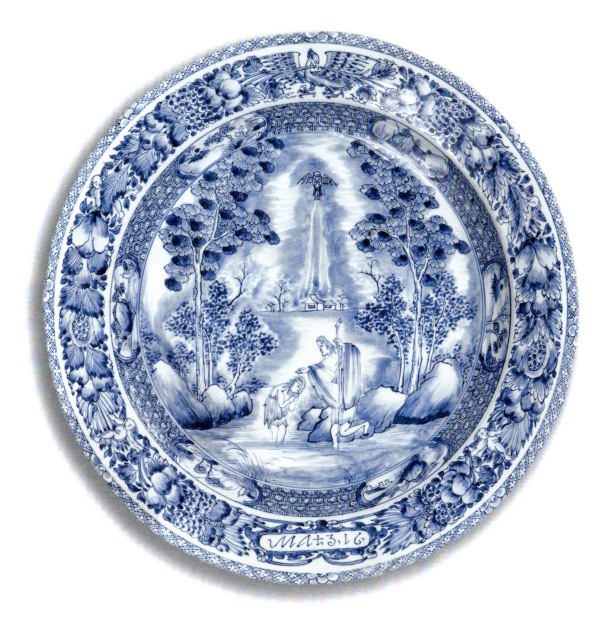

9.
HOLY WATER FONT

Qianlong period (1736–95), c. 1740
9 in. (22.8 cm) high

The rounded body and lid of this font are fluted and painted with peonies. A crested backplate is inscribed *IHS*, the first three letters of the name Jesus in its usual transliteration from the original Greek, with a cross rising above and three Holy Nails below, together forming the emblem of the Society of Jesus (known as the Jesuits). Fonts such as this were made to contain holy water and often placed at doorways, so that a believer could make the sign of the cross after dipping his or her fingers. In this small scale and with its fragile lid this font was most likely made for personal use within a monastery.

REFERENCES Sargent 2012, p. 310 (very similar font); Pinto de Matos and Dias 1996, p. 52 (another similar)

PROVENANCE Heirloom & Howard Ltd, Wiltshire, 2022; Cohen and Cohen, London, 2022

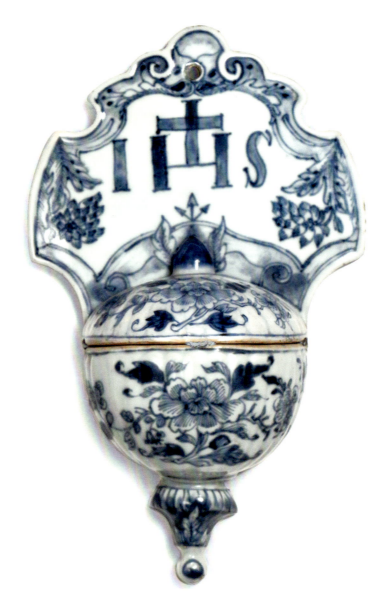

10.
SACRED HEART PLAQUE

Guangxu period (1875–1908), c. 1900
15 × 9 ¾ in. (38.1 × 24.8 cm)

This very unusual plaque is painted with a large Christian cross, a glowing blue heart at its center. A gleaming crescent moon is at top left and a shining sun at top right; earth with the suggestion of plants is below. An inscription on the upright member translates as *The Sacred Heart of Jesus*; the cross member inscription translates as *May the sun and the moon be the witnesses*. Although they were a distinct minority, there were both Catholic and Protestant communities in China at this time, many supported by American and European missionaries who greatly grew in number in the very late nineteenth and early twentieth centuries. Christian works of art made in Asia in the period include a large group of Vietnamese mother-of-pearl inlaid rosewood crosses and a curious group of Japanese bronze crosses cast with a seated Buddhist figure at their centers. Other Guangxu period Chinese porcelain examples are three large, finely molded devotional figures of the Christ Child with *famille rose* enameling thought to have been made for a residence or religious institution in Macao. This depiction of the Sacred Heart cross does not seem to be recorded.

REFERENCES Chong 2016, p. 246 (Vietnamese cross) and p. 203 (bronze cross); Howard and Ayers 1978, p. 622 (Christ Child)

PROVENANCE Heirloom & Howard Ltd, Wiltshire, 2003; Sotheby's London, February 2003, lot 204

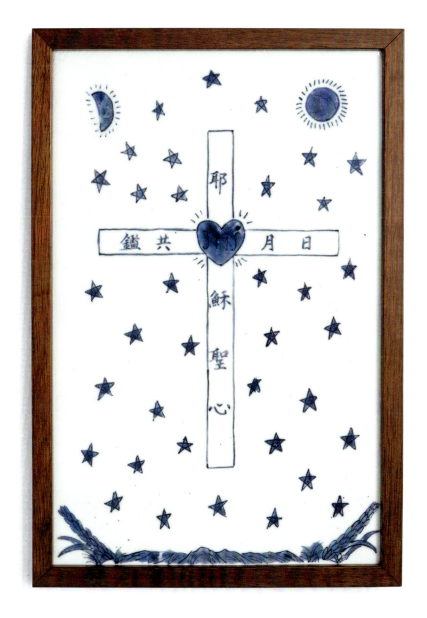

11.
CRESCENT-SHAPED KENDI

**Hongzhi (1487–1505) to Zhengde (1506–21) period,
late 15th–early 16th century**
7 ¼ in. (18.4 cm) wide

A number of Chinese blue and white *kendi* of this model are recorded, all with crescent bodies, tall cylindrical necks and bulb mouths. Each has raised ribs along its curving sides, four small feet, a short nozzle at one end and small finials atop each crescent point (the last now lacking in this example). It has been suggested that some may have been made for the powerful Muslim officials at the Zhengde emperor's court (1506–21), but it is more likely they were trade ceramics made for Islamic communities in the Philippines and Southeast Asia. A group of *kendi* of this form, some with similar and some with varying decoration, was found in the shipwreck of an Asian vessel off the Philippines known as the *Santa Cruz* and datable to the late fifteenth or early sixteenth century. The crescent shape was of course meaningful in the Islamic world.

Prototypes of the form, probably based on earlier leather waterbags, are known in Islamic metalwork from as early as the twelfth century. Boat-shaped begging bowls (*kashkul*) were used by wandering dervishes of the Ottoman Empire; the waves that decorate the lower sections of many of these *kendi* may suggest they were modeled in boat form.

REFERENCES Leidy and Pinto de Matos 2016, pp. 82–85 (earlier example and metalwork prototype); Jörg 1997, p. 36 (similar flask); Orillaneda 2020, paras 2–3 (*Santa Cruz* examples); Metropolitan Museum of Art (2019.300) (*kashkul*)

PROVENANCE Heirloom & Howard Ltd, Wiltshire, 2022; Christie's New York, 22–23 September 2022, lot 979

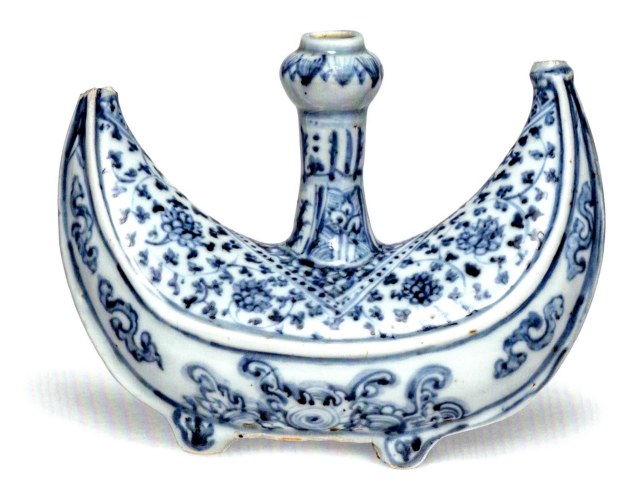

12.
TOMBAC-MOUNTED FLASK

Jiajing period (1522–66), mid-16th century
10 ¾ in. (27.3 cm) high

The slightly flattened, pear-shaped porcelain body of this flask is painted on each side with a writhing dragon over waves within a molded pointed panel. In both form and decoration it is very similar to a Jiajing period ewer in the Topkapı Palace collection, but here the long slender spout and handle have been cut and given covers of tombac, a brass and copper alloy. The covers are linked by chains to tombac mounts at the neck and rim, and there is a high-domed tombac cover. Tombac was often used in Indonesia, while the double-spouted flask form is particularly associated with the Ottoman Empire. Like a Wanli period (1573–1620) blue and white jar with metal double-spouts also in the Topkapı Palace, this piece represents Chinese porcelain adapted for use in the Islamic world.

REFERENCES Krahl 1986a, p. 656 (Topkapı Palace Jiajing ewer); Roxburgh 2005, pp. 359, 363 (Topkapı Palace Ming flask and Ottoman double-spouted flask)

PROVENANCE Imperial Oriental Art, New York, 2019

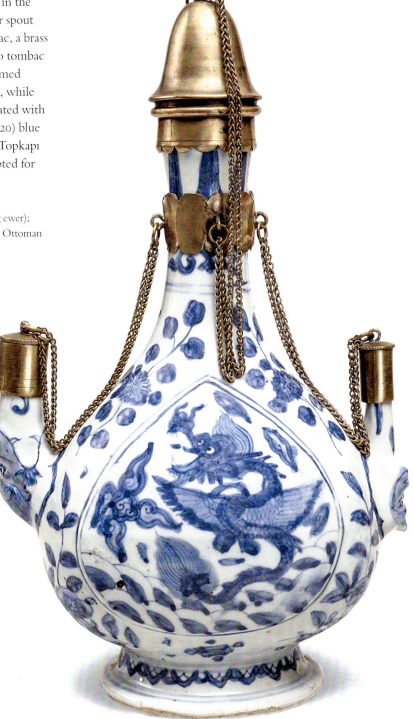

13.
CENSER

Wanli (1573–1620) to Chongzhen (1628–44) period, first half 17th century
4 in. (10.3 cm) diameter

The rounded body is painted with slightly overlapping *ruyi* heads beneath a band of floral decoration on the shoulders. Six small spouts encircle a central opening which now has a pierced metal cover for use as a censer. On the base is a mark reading *Song bai chang qing* (An affection as long-lasting as the pine and cypress). A piece of very similar form and size but decorated with fish and with a Jiajing reign mark (1522–66) was exhibited by S. Marchant & Son. It had a small central spout, which this piece may also have once had. Many multi-spouted vases of more upright form were made in sixteenth- and early seventeenth-century Iranian fritware, when displaying individual stems was fashionable, possibly inspiring this Chinese model.

REFERENCES Marchant 1998, no. 9 (very similar form); Victoria and Albert Museum (1032-1883) (Persian multi-spouted vase)

PROVENANCE Heirloom & Howard Ltd, Wiltshire, 2022; Dreweatts, Berkshire, 18 May 2022, lot 138

14.
BUDDHIST DISH

Kangxi period (1662–1722)
8 ¾ in. (22.5 cm) diameter

Guanyin sits on a throne before a *mandorla* in the center of this dish. A female and a male acolyte flank the throne, and lotus is growing at its base, while swirling clouds rise from behind. The rim of the dish is molded with petal-shaped panels which are painted with foliage. Although the scene portrayed on this dish is Buddhist, its form indicates a European destination, where most likely the exoticism of the Asian iconography would have appealed.

REFERENCES Groninger Museum (1987.0048) (near-identical dish)

PROVENANCE Christie's New York, 29 January 1985, lot 77; the collection of Angus MacCuaig Percival, New York; Heirloom & Howard Ltd, London, 1981

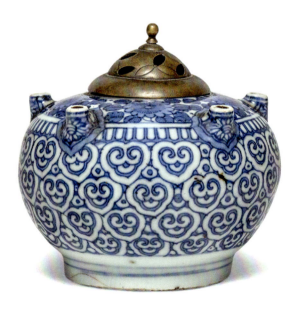
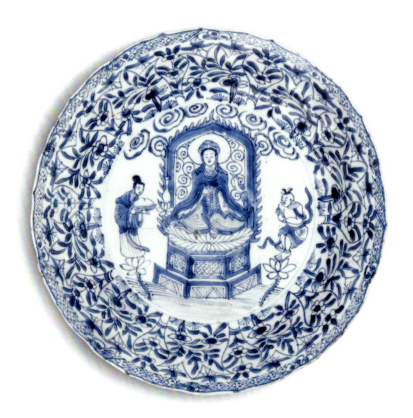

15.
DATED TEMPLE EPITAPH TILE

Qianlong period (1736–95)
Dated 27th year of Qianlong reign (corresponding to 1763)
12 ¼ × 9 ⅞ × 2 ⅛ in. (31.1 × 25.1 × 5.4 cm)

At the top of this large tile is a ribbon-tied double gourd issuing two large leaves; half-lotus heads decorate the bottom. At right an inscription reads *Da Qing Qianlong er shi qi nian shi er yue li* (Erected on the 12th month of the 27th year of the great Qing); at center (Our late father Cheng Daosheng, Shuzi, Shuliu); at left (Enshrined by sons Songling Zhaoling Bailing and grandson Tiangui); and across the top (Situated in the south-west direction facing north-east), probably representing either the placement of this tile in the tomb or the placement of the deceased within a family tomb. This porcelain memorial to a beloved parent reflects the many uses found for blue and white porcelain.

REFERENCES British Museum (1997,0721.1–14) (Korean epitaph tiles and discussion of the practice); Butler and Canepa 2022, pp. 264–65 (Chinese epitaph tile dated 1654)

PROVENANCE Heirloom & Howard Ltd, Wiltshire, 2022; John Nicholson's Auctioneers, Surrey, 2 March 2022, lot 860

16.
QURANIC TILE

Kangxi (1662–1722) to Qianlong (1736–95) period,
18th century
8 ⅝ × 7 ⅞ × 1 in. (22 × 20 × 2.5 cm)

In the center of this tile an inscribed diamond is within a circle enclosed by scrollwork. Outside the circle is a field of stylized flowering vine. The Arabic inscription quotes from the seventy-second *surah* (chapter) of the Quran, *ayat* (verse) numbers eighteen to twenty, which read:

18: And that the places of prostration belong to God; so do not call on anyone along with God.
19: And that when the servant of God stood to call to Him they were almost on him in swarms.
20: Say, "I call only to my Lord and I do not associate anyone with Him."

A tablet of larger size but exactly this decoration, though perhaps a bit more finely rendered, is in the collection of the British Museum, whose curators suggest it may have been made for a shrine. It has a Zhengde reign mark (1506–21) in a line below the inscribed and decorated square and an unglazed bottom rim so that it could be slotted into a stand.

REFERENCES British Museum (PDF,B.687) (tablet of near-identical pattern)

PROVENANCE Heirloom & Howard Ltd, Wiltshire, 2021; Plakas Auctions, London, 21 October 2021, lot 213

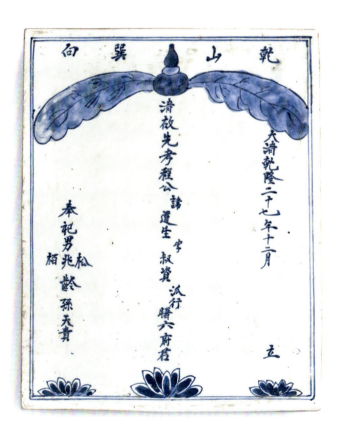

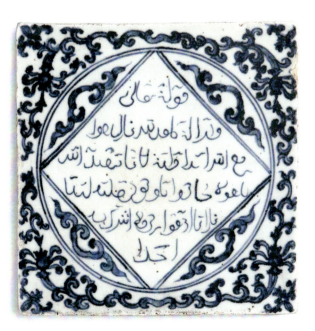

17.
ISLAMIC OIL LAMP AND COVER ON FIXED STAND

Qing dynasty (1644–1911), 18th–19th century
7 ½ in. (19 cm) wide

Derived from a Middle Eastern metalwork model, this lamp has a rounded body with long broad spout. A slender handle extends down to the fixed dished stand; both stand and body are painted with a scrolling vine pattern. A precursor lamp form with tall pedestal base was known in Seljuk and Iranian (Persian) metalwork of the thirteenth and fourteenth centuries. A very similar blue and white porcelain lamp in the National Palace Museum in Taiwan, also with a small loop at the top of its handle, is decorated with a variant vine pattern and has a Xuande reign mark in a line on its body. This lamp has an apocryphal Qianlong reign mark on its base. Both may well have been made for the Islamic community in Southeast Asia.

REFERENCES National Palace Museum (K1B005957N000000000PAB) (very similar oil lamp); Metropolitan Museum of Art (53.204.2) (Persian bronze oil lamp)

PROVENANCE Sotheby's New York, 1985 (online sale); the collection of Mildred and Rafi Mottahedeh, New York

18.
PAIR OF MOSQUE LAMPS

Kangxi (1662–1722) to Qianlong (1736–95) period, 18th century
12 in. (30.5 cm) high

These lamps were made to hang from three chains attached to metal rims which would rest under each wide mouth. Their pointed finials would thus face the viewers below and the piercings at bottom would emit light additional to that coming from the mouths or through the semi-transparent porcelain. Mosque lamps were used in the Middle East in large numbers, probably first made in glass in the thirteenth century but by the sixteenth century more frequently found in metal. A small number were made in Middle Eastern ceramic centers; a seventeenth-century Iznik example in the Metropolitan Museum of Art is also of conical form, although a waisted shape with wide flaring mouth was more common. Regardless of material, a glass liner would hold oil inside that could be

lit with a cotton wick. Hanging lamps did not just illuminate the sometimes vast interior spaces of a mosque, they also symbolized divine light; many are inscribed in Arabic with the first part of the *Ayat an-Nur* (Verse of Light), *God is the Light of the heavens and the earth*. Three other Chinese porcelain mosque lamps of this form and decoration have appeared on the art market, all with the same curious lotus decoration on their sides, a decidedly Buddhist motif. They could have been ordered as a set by traders from the Islamic communities of Southeast Asia, India or the Middle East—or for a mosque in China. There were mosques in Quanzhou, a center of Muslim traders in the Yuan dynasty (1279–1368), and multiple mosques were built in the Ming dynasty (1368–1644). Many Muslims were Ming loyalists so they were not in favor when the Qing rulers assumed power, but nonetheless there were sizeable Islamic communities in China throughout the eighteenth century when these lamps were made.

REFERENCES Vinhais and Welsh 2014, pp. 238–39 (near-identical lamp); Metropolitan Museum of Art (30.95.162) (Iznik ceramic lamp); David Collection, Copenhagen (42/1966) (Chinese *cloisonné* lamp). With thanks to William R. Sargent for his research.

PROVENANCE The Chinese Porcelain Company, New York, 2000 (one). The collection of David S. Howard, London (one)

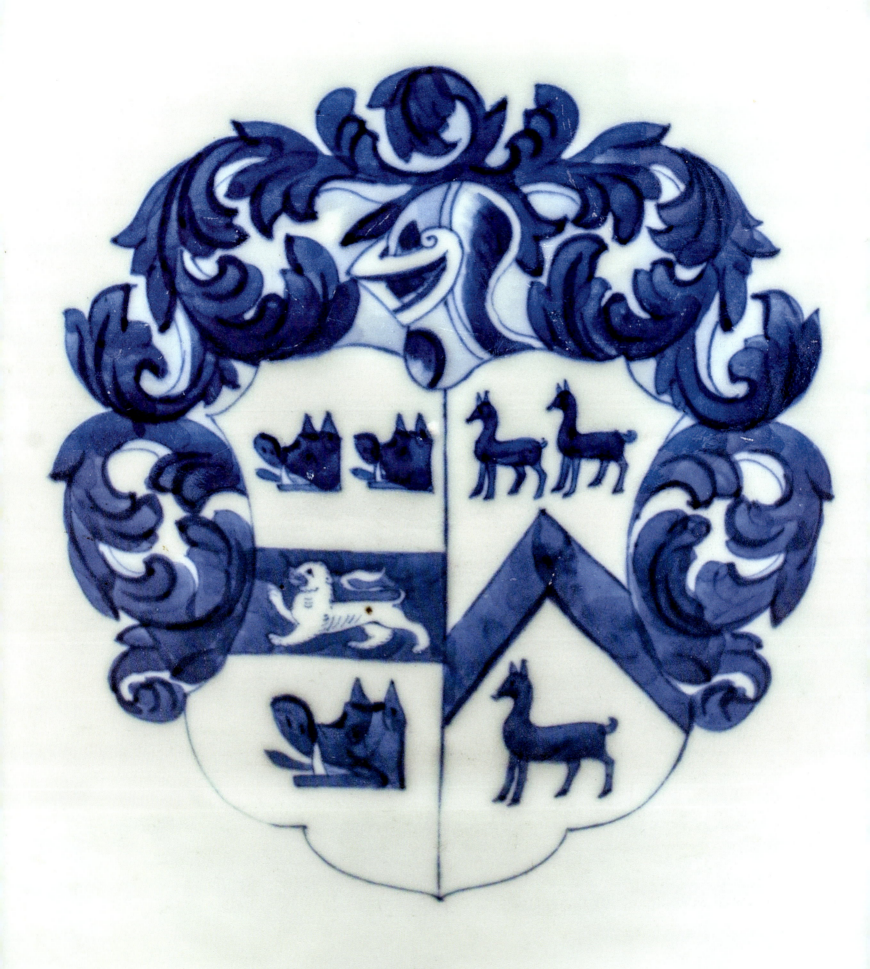

2.
IDENTITY

Angela Howard

A sense of identity is a fundamental instinct, interwoven with the need or desire to create, acquire and possess—whether the evidence be a fingerprint on a Neolithic shard, the name of the potter and painter on an ancient Greek amphora, a hallmark on silver, or a unique mark of ownership on the personal objects of those for whom they were made. Such symbols are found on many items of porcelain made throughout the four centuries encompassed by this book, from faith-based motifs to recognizable buildings and locations, but where the principal purpose of decoration is to personalize the object with a name, initials or armorial bearings, then these serve to identify their original commissioner much more closely. Armorial porcelain, in particular, can be dated through its heraldry and placed with certainty in its historical context. The Frelinghuysen collection had an early focus on these wares and it is a particular area of strength.

The emergence of heraldry during the twelfth century came at a time of considerable change for European feudal society. A rudimentary form of visual identity expressing territorial allegiance became, during the late medieval period, no longer just a means of distinguishing between friend and foe on the battlefield but was increasingly associated with more personal concepts of family, ancestry and inheritance with the addition of differing personal charges to the shield. In England, these armorial bearings were regularized and codified by the heralds who were given a royal charter in 1484, while each European country had its own laws. During the following centuries such marks of personal possession and social status were applied to numerous decorative objects such as seals, glass and silver as well as ceramics and sets of tableware. The charges, or symbols, on a shield are unique to its owner and his descendants, and can be deciphered to reveal marriages, ancestors, children and other life events.

By the early sixteenth century, Portuguese navigators had discovered the sea route to India, reaching China in 1513 and opening up a new era of direct trade with Europe. As recounted in the previous chapter, the first porcelains to be commissioned with identifiable European emblems were decorated with royal insignia that reflected Christian faith. Three personalized orders for Portuguese captains and merchants were made in the 1542–52 decade, including a rare bottle (no. 19) dated 1552 and inscribed with the name of Captain Jorge Álvarez.[1] Their Spanish competitors followed a Pacific route to Asia—the luxury cargoes of the large Manila galleons reaching Seville from the Philippines via Acapulco. The only known underglaze blue armorial order with Spanish arms, made about 1590 for a viceroy of Peru, was probably acquired through this route.[2] The thrones of Portugal and Spain were united under Philip II of Spain between 1580 and 1640, during which time an armorial pilgrim flask (no. 20) was made with the quarterly arms of the kingdoms of Castile and León, its design almost certainly copying coinage. Six further Portuguese services are recorded during the Iberian Union, ordered during expeditions to India and Macao.[3] However, by the early seventeenth century, following an embargo on Dutch ships trading at Lisbon—a major incentive for the founding of the Dutch East India Company (VOC)—Portugal had lost its supremacy to the Dutch Republic. It would be almost another hundred years before Chinese porcelain personalized with European heraldry was ordered again.

Following its incorporation in 1602, the VOC shipped vast quantities of blue and white porcelain back to the Netherlands, dominating the European trade during most

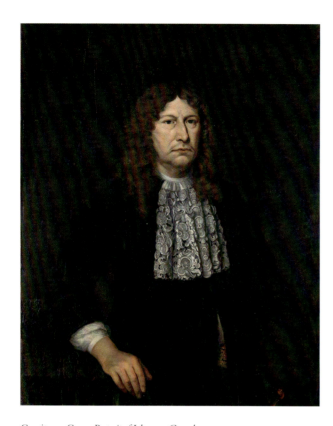

Gerrit van Goor, *Portrait of Johannes Camphuys, Governor-General of the Dutch East Indies,* oil on canvas, 1685, Rijksmuseum, Amsterdam

of that century. England, whose own East India Company (EIC) had been founded in 1600, established a pivotal trading post at Madras in 1641 but was buying much of its porcelain through Amsterdam. The accession of William and Mary to the throne in 1689 brought the start of a sustained period of political stability and economic prosperity, particularly in the City of London amongst the wealthy and influential merchant houses. Refinement of dining habits brought new cuisines and ways of presentation to the fashionable table, laying the foundations of the eighteenth-century Chinese export dinner services. A revived East India Company became the first to establish a trading post in Guangzhou (Canton) in 1715, giving Britain a dominant position which it was to hold for the century that followed. All commissions for personalized wares were through the 'private trade', discussed further in Chapter Eight.[4]

An analysis of all armorial services for the British and Dutch markets provides insight into the overall numbers ordered and the proportion of those decorated only in underglaze blue. Britain was by far the largest importer of armorial wares during the eighteenth century; just over four thousand sets or services are currently recorded and illustrated in *Chinese Armorial Porcelain*, with a further 680 listed by repute.[5] This is more than ten times the number ordered by the Dutch Republic, the next largest market, while Portugal, Sweden and France each commissioned fewer than 350 armorial services, mostly in polychrome, and Spain less than eighty. Of these four thousand British services, some 632 have rims of underglaze blue, of which just seventy-eight (about 2 percent of the total) are completely decorated in this palette. No fewer than sixty-eight of these are represented in the Frelinghuysen collection.

In the Netherlands, approximately 455 services, including a number of minor variants for the same families, are recorded in *Chinese Armorial Porcelain for the Dutch Market*, where the author notes that 60 percent of all services were made between 1730 and 1760, the period of direct trade through Batavia (Jakarta).[6] This reflects the fact that the majority were ordered for officers and colonial administrators of the VOC and brought home on retirement from Batavia. In underglaze blue decoration, thirteen services were made for nine families between 1690 and 1730, with a further eighteen ordered in the years 1735–52 for thirteen families. By the middle of the century, interest in underglaze blue armorial porcelain had dwindled away and there were no further orders. Examples of all but four of the Dutch blue and white armorial services are in this collection. It is the first time that almost the entire output of underglaze blue armorial services for both Britain and the Netherlands, as well as a significant number for Portugal, have been illustrated and published together: the assembling of a remarkable and documentary group.

Armorial services of the late Kangxi period, when underglaze blue was the predominant palette, are well represented overall in the collection. The Portuguese, whose nine orders made between 1545 and 1635 had been the first non-royal personalized Chinese porcelain, began commissioning armorial wares again, with six sets recorded between 1690 and 1720 (just two are dated much later, to 1750 and 1790). These tend to display a preference for densely packed borders in an intense blue, with scrolling acanthus leaves and an armorial cartouche in the baroque style. Among them are a very large dish made probably for Rodrigo da Costa (no. 25), a nobleman who became viceroy of Portuguese India, and a dish made for António de Albuquerque Coelho de Carvalho (no. 29), who held governorships in Brazil and Angola.[7] Linked to these in

English School, *East India Company Shipyards on the Thames near Deptford Creek,* oil on canvas, c. 1660, National Maritime Museum, Greenwich

design is a fine Italian service (no. 28) ordered through Lisbon, now known to have been made for Lorenzo Ginori of Florence (1647–1710).[8] The Dutch Kangxi services are less overtly baroque in style than the Portuguese; some incorporate the fruits and vegetation of Batavia such as passion fruit and banana leaves, from where many were ordered. Prominent among these was a set of fine plates made for Johannes Camphuys (no. 22), almost certainly ordered between 1684 and 1691 while he was governor-general of Batavia.

The profile of the seventy-eight British blue and white services is rather different. Commissions during the first quarter of the century related mainly to orders made by the captains and supercargoes of the EIC, administrators in India, and the London merchants and investors on whom so much of the trade depended. But unlike other European orders, they are spread throughout each decade of the century—peaking between 1720 and 1740 and roughly overlapping the Yongzheng period with twenty-one services, rising again between the decades 1750–80 (thirty-five services), with the resurgence of nine further commissions at the turn of the nineteenth century owing much to the popularity of the ubiquitous Fitzhugh design, including an extensive service made for John Roberts (no. 65), chairman of the East India Company and resident of Macao.

The first British armorial porcelain brought from China was not tableware at all but a set of garden pots of three different shapes, two of which are illustrated here (no. 26), made for the immensely wealthy EIC shipbuilder Sir Henry Johnson. The complex quarterly arms show his marriage to the daughter of Baron Lovelace but predate her inheritance of her grandmother's title, indicating they must have been ordered between 1693 and 1698, the earliest English commission by several years. The heraldry on the Johnson jardinières underlines a salient point which explains the very large number of British armorial services. There was a far greater mobility of social classes in England than in other European countries, and it was regarded as an advantage rather than a disgrace for a nobleman to marry the daughter of a wealthy London merchant or for the fifth son of an impoverished country baronet, such as Harry Gough, to become one of the most successful of all the early China traders. It linked the aristocracy, the merchants and the entrepreneur backers of the East India Company in a highly successful partnership of economic liberalization based on free trade and profit. Gough had first visited Guangzhou

in 1692 at the age of eleven and rose to become chairman of the East India Company. He brought back from China no fewer than ten armorial services before 1730 for his own and his wife's families, two of which were in underglaze blue (no. 39 and detail p. 50) while the others incorporated iron-red enamels.

Making a choice between ordering an underglaze blue service or one decorated in polychrome was not necessarily a mutually exclusive decision. A number of the earlier services, particularly those made for governors of India, were produced in two or even three palettes, one being underglaze blue. Governor Harrison of Madras ordered four services between 1715 and 1718 of which two were blue and two were in *famille verte* enamels, one of each having full arms and the other just the crest (no. 34), while Sir Robert Cowan, governor of Bombay, also ordered identical services in both iron-red and underglaze blue (no. 41). A recently discovered 1722 letter from Cowan to his Guangzhou agent requests sixty plates and twenty dishes "… with my own arms which is the Saltire & hart & hand for crest…."[9] Clearly there was a price differential, relating not just to the complexity of decoration but also to the number of processes and firings, as is evident from rare extant documentation for two services made for Sir Charles Peers, a lord mayor of London. In November 1731 he was invoiced for 255 pieces of an underglaze blue service with his crest on the rim (no. 44) costing an average of one shilling each, while a month later a fine service with full arms in *famille rose* enamels with a gilded rim arrived on a second ship, invoiced at an average of three shillings each for 525 pieces.[10] This practice of ordering similar services in different palettes seems a particularly British predilection which continued well into the century. In addition to the above, more than twenty of the blue and white examples in this collection have a polychrome counterpart of the same date.

There are also some notable examples among Dutch and Swedish orders, the common thread being East India Company connections. The inventories of Adriaan Valckenier, who spent his entire career in the Indies, list variants of fourteen armorial sets, both in polychrome and underglaze blue (no. 47), ordered from Batavia before 1740.[11] His compatriot Abraham Abeleven ordered identical tea services in *grisaille* and underglaze blue (no. 50) while cashier-general in Batavia in 1740. Nine well-documented armorial services were made between 1755 and 1760 for the prominent Swedish merchant family of Grill. The three in underglaze blue (no. 53) are particularly notable for their creative rococo designs.

The underglaze blue palette had limitations in its use on armorial services as well as considerable strengths. Heraldry is essentially a medium for pageantry and color. In monochrome this could be achieved by the Chinese painters with some dexterity by creating light and shade with the brush as well as hard and soft lines. This is very evident on a plate of about 1720, painted in a dark inky blue, made for Sir Matthew Decker (no. 38), a London merchant and banker. Although Sir Matthew also had a *famille verte* service with an identical shield of circular form, it is the blue service, with its fine flowers on the rim, that gives a more satisfying appearance of depth and refinement. Flower painting on blue and white services reached heights of artistry during the 1730s, exemplified perhaps by a punch bowl with the arms of Whistler (no. 43), which has delicately painted magnolia in a soft blue that is so distinctive from the strong hues of the Kangxi era. The coat of arms illustrates the second, European, way of indicating colour in monochrome with the use of hatching lines following heraldic convention—from its vertical lines the background of the Whistler shield is shown to be red. The method became widely used when engraved bookplates were found to be a convenient and easy way of sending artwork to China, proving especially successful on *grisaille* services. A blue and white exemplar is the Sykes plate (no. 58) where the armorial cartouche very successfully copies a fine rococo bookplate.

Conversely, one of the strengths of underglaze blue lies in the fact that throughout the century these services could only be produced at Jingdezhen—where the blue was able to be fired at high temperatures—rather than transported in a partially completed state to have enamels added in the muffle kilns at Guangzhou, which became the practice after the late 1730s. Amongst the British blue and white services, in particular, this led to a prevalence of finely painted central Chinese landscapes and figures, a style that contrasts with the *famille rose* services which by mid-century were following European, mainly Meissen-inspired, floral designs. A number of such rural and mountain views can be seen in the pages that follow, all distinctively different from each other. Often, the heraldry has been carefully inserted into the Chinese border, such as on a dish with the crest of Udney (no. 355) or another with the full arms of Dundas (no. 353), indicating a high degree of attention by the painter. Of particular note are the Garland plate (no. 338), with a scene of a lady riding a buffalo in a rice field, and a punch bowl made for the Lyons family of Antigua (no. 51),

with its scene of five rams on an island possibly an allusion to the Harman impalement which has heraldic rams.

Not every commissioner wanted Chinese scenes, and two distinctive groups, made towards the end of the century, are remarkable for their unique European border patterns. Three armorial services (no. 60) were made about 1775 for the three senior partners of the banking firm of Prescott, Grote, Culverden & Hollingsworth in Threadneedle Street. They are linked by the same distinctive and unusual border design reminiscent of Renaissance-style ironwork, perhaps even inspired by ornamental railings at the firm's premises in the heart of London. The second group of two services were made a decade later, about 1785–90, both for Irishmen, each with an original design. The platter made for Peter Metge (no. 63), a baron of the Irish exchequer, displays his neoclassical shield supported by the figure of Justice on a plinth, with his chain of office serving as the border. A similar concept was used for the fine and unusual service of James Caulfeild, Earl of Charlemont (no. 64), one of the founding knights of the Order of St. Patrick in 1783. The border design is taken from the collar of the order, with the badge itself pendant from the upper rim.

Most exceptional of all may be the saucer dish ordered in 1752 for Horatio Walpole (no. 52) by his brother, an EIC captain, of which only a handful are known. It embodies virtually all of the elements that separately create identity within a historical context for a Chinese armorial service. The unique design of this dish contains a triple cross-cultural reference—combining the Chinese painting of a Japanese Kakiemon design with a European coat of arms, unusually placed on the reverse. This is finely cross-hatched and itself copies a rococo bookplate with the arms of Walpole impaling Cavendish. Horatio was a nephew of the prime minister, Sir Robert Walpole, and a

Pierre Subleyras, *Portrait of Horatio Walpole (1723–1809), 2nd Baron Walpole of Wolterton,* oil on canvas, c. 1746, Leeds Art Gallery

parliamentarian until he inherited a barony in 1757. He and his wife, Lady Rachel Cavendish, daughter of the Duke of Devonshire, were from the upper echelons of society. To its multicultural associations must therefore be added the cross-fertilization of the aristocracy, the East India Company, politics and the China trade.

1 Castro 2007, pp. 252–54, for three design variants of the known Jorge Álvarez bottles; see also Pinto de Matos and Dias 1996, pp. 31–39, for the earliest Portuguese armorial services.
2 Díaz 2010, pp. 87–91, for a plate in the *kraak* style, the only piece known of this service, with the arms of García Hurtado de Mendoza, 4th Marquis of Cañete, viceroy of Peru 1590–96, and his wife, Teresa de Castro, who died on the return voyage to Spain. The same arms appear on their tomb.
3 Castro 1988 and 2007 for all Portuguese armorial services.
4 Howard 1994, pp. 10–34, for a comprehensive account of the private trade in Britain.
5 Howard 1974 and 2003, together with a third volume in progress, for all British armorial services mentioned in this chapter.
6 Kroes 2007, p. 14, for an analysis of Dutch services, and this volume for all Dutch armorial services mentioned in this chapter.
7 Castro 2007, pp. 108, 111, for the Coelho and Costa services.
8 Ginori Lisci, Lucini and Perotto 1988, pp. 25–33, with two variants illustrated (arms on the rim and in the center).
9 Teggin 2020, p. 320 (PRONI, Cowan Papers, D654/B/1/1AA, f. 137v).
10 Le Corbeiller 1973, pp. 52–54, for a blue and white plate and the invoice.
11 Kroes 2007, p. 646, appendix 1, for a listing of all the Valckenier armorial services.

19.
JORGE ÁLVAREZ BOTTLE

Jiajing period (1522–66), dated 1552
8 ¼ in. (21 cm) high

This remarkable bottle was made for Portuguese merchant Jorge Álvarez, one of just three special orders of Chinese porcelain executed for a private individual before the last quarter of the sixteenth century. Ten Álvarez examples are recorded, all of a classic Chinese pear shape (*yuhuchun*) but with varying decoration around their lower bodies. On each, two bands encircle the base of the neck with the inscription (upside down) *ISTO MANDOU FAZER JORGE ALVAREZ N / A ERA DE 1552 REINA*. This example has a four-character mark on its base reading *Wan fu you tong* (May infinite happiness embrace your affairs); it is decorated with a formal pattern of scrolling vine, and its neck has been cut down and mounted in metal. Just one Álvarez bottle has survived with a complete neck. The decoration on other known pieces varies considerably: two with Buddhist lions, three with *qilin* in landscape, one with deer in landscape, two with ducks or fish and waterweeds and one with scrolling gingko vine; the decoration on one is not recorded.

The inscription on these bottles may be translated as 'Jorge Álvarez ordered this to be made in the year 1552 of the reign [of King João III].' Álvarez was a Portuguese ship captain who, like most Europeans who made their way to Asia in the sixteenth century, was something of an adventurer. He has sometimes been confused with another Portuguese captain of the same name who reached China in 1513 but died before these bottles were made. The Álvarez who ordered the porcelain visited Japan in the fall of 1547, writing a full account of the people and customs he encountered there which was eventually translated and printed in many languages, becoming quite influential. His experiences were no doubt enhanced by the friendly relations he seems to have established with the Japanese he met: "[T]he more noble among them invite us to dine with them and to pass the night in their homes. It is though they want to take us to their hearts."

Álvarez gave his account of Japan to the Jesuit Francis Xavier when they met in Melaka (Malacca) in December 1547; it encouraged Xavier to visit Japan, where he indeed found a receptive audience for his teachings. At some point Álvarez settled on Shangchuan Island, just off the coast of Guangdong province and a Portuguese trading outpost prior to the establishment of Macao in 1557. Shangchuan Island—its name from the Portuguese São João (St. John)—was home to about two hundred Portuguese, and Chinese junk traders would call regularly. The recent excavation at the island's Huawanping site of blue and white shards from this period with Christian cross motifs confirms the practice of special orders placed with the junk traders.

It was on Shangchuan Island that Francis Xavier awaited permission to finally enter China. Xavier was hosted there by Jorge Álvarez, a man he described as "a Portuguese merchant, a friend of mine." In October 1552 Xavier wrote from the island to a fellow priest in Goa: "I arrived at this harbor of Sancian, which is thirty leagues from the city of Canton. I am daily waiting for the arrival of a man who is to take me there." And again, in November, "Eight days from now I am expecting a merchant who is to take me to Canton." But, sadly, the great Jesuit died on 3 December 1552, never having reached China. By some accounts Álvarez had left for Melaka before Xavier was taken ill; by most accounts Xavier died in his bamboo hut. Vases like this one survive to speak of these extraordinary characters in the first era of direct Sino-European trade.

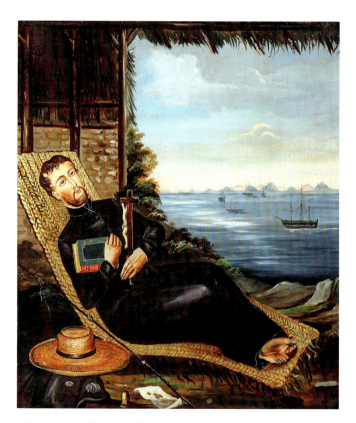

Chinese School, *The Death of St. Francis Xavier on Shangchuan Island*, oil on canvas, c. 1850, Musée de la Compagnie des Indes, Lorient

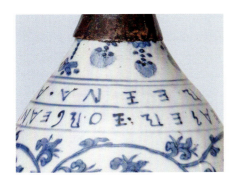

REFERENCES Walters Art Museum (49.1616a) (complete neck; Buddhist lions; *Wan fu you tong* mark); Victoria and Albert Museum (237-1892) (waterweeds; Ming mark); Pope 1956, pp. 57–58 (Chehel Sotūn example; *Wan fu you tong* mark); Museu do Centro Cientifico e Cultural de Macau (3818 DEP) (*qilin*); Pinto de Matos 2019, no. 63 (*qilin*); Pierson 2013, p. 47 (inscription); Willis 2012, pp. 392, 396 (Álvarez letter); Van Campen and Eliëns 2014, p. 18 (Shangchuan trading); Xiao 2021, pp. 60–61 (Shangchuan shards); Costelloe 1992, pp. 178, 447, 449 (letters of Francis Xavier)

PROVENANCE Santos London, 2016; Sotheby's London, 14 May 2008, lot 543; Bonhams London, 7 December 1990, lot 46

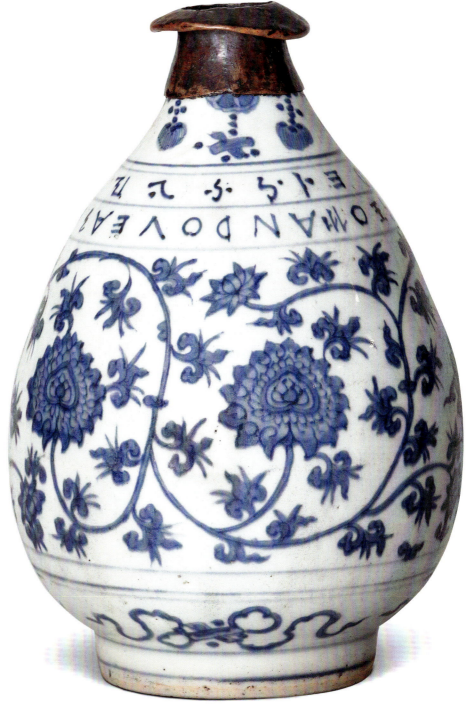

20.
FLASK WITH SPANISH ROYAL ARMS

Wanli (1573–1620) to Chongzhen (1628–44) period, c. 1575–1640
9 ⅜ in. (23.8 cm) high

This flask is one of a puzzling group of perhaps twenty of this form that all display the arms of Castile and León quartered by a cross within a dotted frame. Its shape derives originally from the Middle East, and the blue dotted band that edges both sides of the round body may imitate the nail heads of a metal or leather pilgrim bottle, though by the fifteenth century this form had been adopted for Chinese ceramics. Tulips issue from the armorial roundel and flowering plants grow from rocks on the narrow neck (now cut down and with gold mount). On the back of this flask and approximately seven others of the group, a seated scholar and his attendant are depicted in a garden; others show a standing scholar or flowering plants instead.

Both the source of the armorial design on the flasks and the identity of the individual or institution that commissioned them remain a mystery. No solid documentation or archaeological evidence has been found, although scholar Cinta Krahe has suggested that the two pieces noted in a 1674 Spanish royal inventory of porcelain from "India of Portugal" and described as "small round jug … with a coat of arms in blue and white colours" may be two of the bottles. However, neither royalty nor aristocracy in Spain favored armorial porcelain in this period; the only sixteenth- or seventeenth-century Spanish armorial order recorded is a dish made for García Hurtado de Mendoza, viceroy of Peru. And though the armorial design has long been attributed to a Spanish coin minted in Mexico between 1573 and 1619, William R. Sargent argues persuasively that the floral and figural decoration of the bottles is typical of Jingdezhen Transitional period porcelain. Teresa Canepa notes similarities in design to porcelains of the first half of the seventeenth century, including a group found on the *Nuestra Señora de la Limpia y Pura Concepción* which sank in 1641. Sargent also suggests the royal emblem on a map, document or book frontispiece as a possible design source.

Intriguingly, five of the flasks recorded are either in Japan or were long in Japanese collections, including this flask, which has a Japanese wax export label and a Japanese fitted lacquer stand. Small numbers of Spanish missionaries were active in Japan in the first quarter of the seventeenth century; five Dominicans and two Augustinians arrived in 1602, joining a few Franciscans and Spanish Jesuits who had remained after the 1597 Nagasaki martyrdom. The shogunate broke relations with Spain in 1624, but the final isolation order was not for another fifteen years.

Throughout this whole period the Spanish were well established in the Philippines, where four churches had been built in the late sixteenth century. Spanish clergy and friars

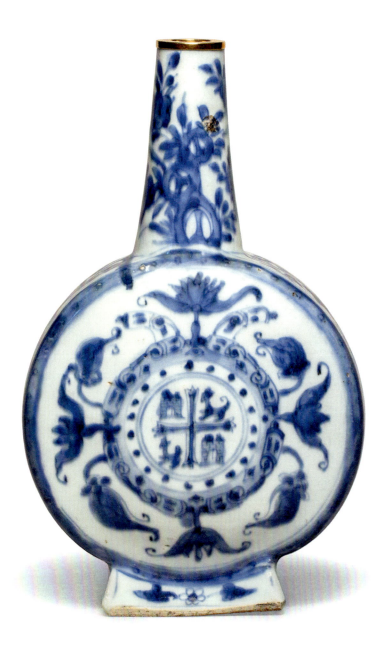

order by a church or monastery—which might even have been made in several batches—could explain the variations in these flasks and their relatively large number.

REFERENCES Canepa 2016, pp. 277–79 (discussion and Krahe reference); Leidy and Pinto de Matos 2016, pp. 106–07 (this version); Sargent 2012, pp. 348–51 (this version and discussion); Díaz 2010, pp. 74–79; Canepa 2019, pp. 276–79 (Mendoza dish); Okamoto 1972, pp. 65–67 (missionaries in Japan)

PROVENANCE Heirloom & Howard Ltd, Wiltshire, 2009; Christie's New York, 21 January 2009, lot 16

21.
FLUTED DISH WITH ARMS OF DE PINTO

Kangxi period (1662–1722), c. 1680–90
8 ½ in. (21.6 cm) diameter

The lightly fluted rim of this dish is decorated with a wide border of petal-shaped panels filled with blossoming boughs. Two sketchily painted branches decorate the back. In the center a large coat of arms with five crescents (which on some pieces are inverted) is flanked by blue scrollwork; three ostrich feathers issue from the helmet as crest. The De Pintos were a Jewish family originally from Portugal and Spain; they settled first in Rotterdam and then Amsterdam before establishing themselves in a magnificent palace in The Hague in the second half of the seventeenth century. Probably made for Isaac de Pinto (1652–1712), the order seems to have comprised a number of dishes of this shape in different sizes; no other forms are recorded.

REFERENCES Kroes 2007, p. 107 (discussion of family and dish); Pinto de Matos 2019, pp. 14–15 (another dish); Castro 2007, p. 103 (three variants)

PROVENANCE Heirloom & Howard Ltd, London, 1981

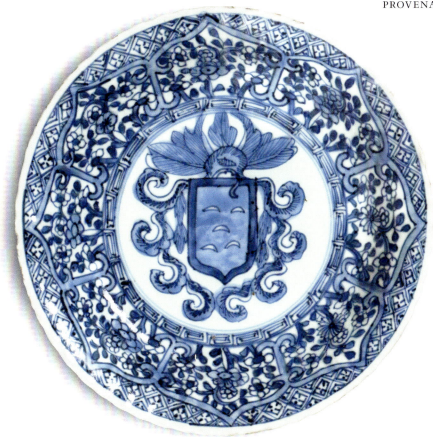

22.
TWO PLATES WITH ARMS OF CAMPHUYS

Kangxi period (1662–1722), c. 1685
9 ⅞ and 10 ⅛ in. (25.1 and 25.7 cm) diameter

Johannes Camphuys of Haarlem joined the VOC in 1654, becoming head of its trading station at Dejima in Japan in the 1670s. His set of fine plates was almost certainly ordered between 1684 and 1691 while he was governor-general of Batavia, where he remained after retirement that year. Camphuys was particularly interested in the Asian world, assimilating into the life and culture of the region and building a house and gardens in the Japanese style. He was known to enjoy Asian food and about the same time commissioned a *famille verte* sweetmeat set; almost certainly both sets were the earliest Chinese porcelain made with Dutch arms. The plates are notable for the whiteness of the body and the brightness and clarity of the blue, while the flattened shape seems certain to have been taken from a pewter model. The armorial decoration appears to have been copied from a seal since the heraldic mantling or scrollwork around the shield is unusually reversed as white on a cross-hatched blue, giving a dramatic effect. The wide rim is finely painted with ladies in gardens while the reverse is almost as intricately decorated with exotic flowers and plants, clearly betraying the botanical interest of this cultured man. —*A.H.*

REFERENCES Kroes 2007, pp. 105, 114–15; Corrigan, Van Campen and Diercks 2015, pp. 100–03 (*famille verte* sweetmeat set and discussion)

PROVENANCE Heirloom & Howard Ltd, London, 1982; Christie's London, November 1982, lot 414 (one). Heirloom & Howard Ltd, Wiltshire, 1998 (one)

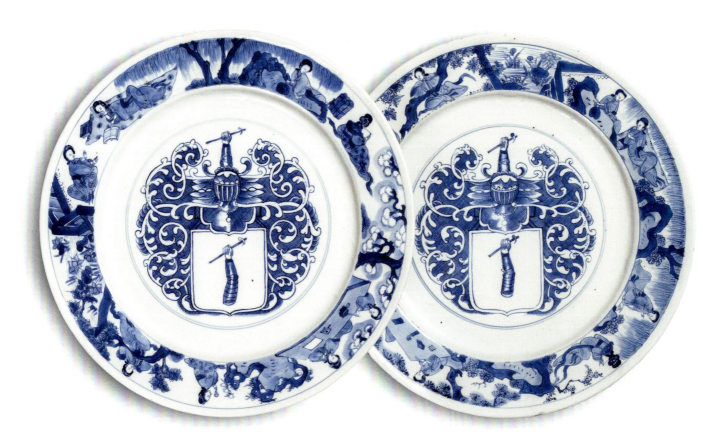

23.

PAIR OF LARGE PLATES INSCRIBED 'BEVERE'

Kangxi period (1662–1722), c. 1685–95
10 ⅜ in. (26.3 cm) diameter

Among the very first personalized orders commissioned from Jingdezhen by Dutch traders was a set of plates most likely made for Gerard de Bevere, a member of the Court of Justice in Batavia in 1684. The plates are inscribed *BEVERE* on the reverse, the only instance of such an inscription to come to light so far. In form the plates are modeled on European silver or pewter of the period, very like the Camphuys plates discussed opposite (no. 22) and a group of plates with similar scenes drawn from well-known Chinese novels or dramas. Here, one plate shows a gentleman observing a lady seated on rocks and the other has a boy reaching for a toy held by his mother. Figural vignettes on the rims are separated by varying patterns.

REFERENCES Jörg 1993, pp. 200–01 (pair plates and discussion); Sargent 2012, p. 131 (pair plates and discussion); Jörg 1997, p. 255 (plate model)

PROVENANCE Sotheby's New York, March 1984, lots 498–99

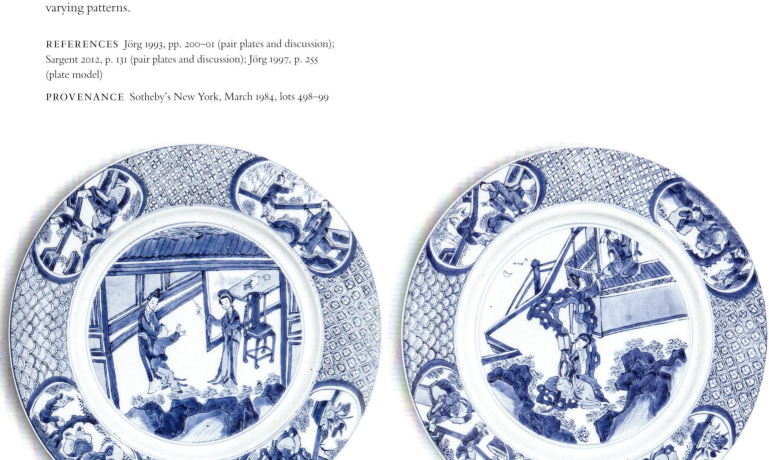

24.

BOWL WITH ARMS OF FAXON OR LOVELL OR FISHER (?)

Kangxi period (1662–1722), c. 1690
13 ⅜ in. (34 cm) diameter

The heraldry in the center of this large, deep bowl presents an enigma. The arms are reversed, probably copying a seal matrix, and the animals misunderstood—making identification uncertain. If foxes, they could represent Faxon/Faassen. A cup and saucer are also recorded, attributed to Lovell which has squirrels. Other than this bowl, four massive blue and white covered jars are known, decorated with Chinese court scenes from the Tang dynasty; above left of the Xuanzong emperor's head is incongruously placed a small European coat of arms. The mystery is compounded by the appearance of a single *famille verte* dish of similar date in an English private collection, with Chinese ladies and the same small reversed coat of arms enameled on the upper rim; the animals are possibly demi-lions. This is tentatively identified as Fisher, a possible commissioner being Robert Fisher, later 4th Baronet of Packington. Without further provenance, attribution remains enigmatic. —*A.H.*

REFERENCES Lunsingh Scheurleer 1974, p. 76 and pl. 74, also Kroes 2008, pp. 105–06 (Keramiekmuseum Princessehof 34¾-inch jar); Sargent 2012, pp. 355–56 (Peabody Essex Museum 26-inch jar); Jackson-Stops 1988, no. 176 (Petworth House jar); Scone Palace, Scotland, size unknown; Howard 2003, p. 738 (Lovell cup and saucer, unillustrated); Howard forthcoming (*famille verte* dish)

PROVENANCE The collection of David S. Howard, Wiltshire, 1990

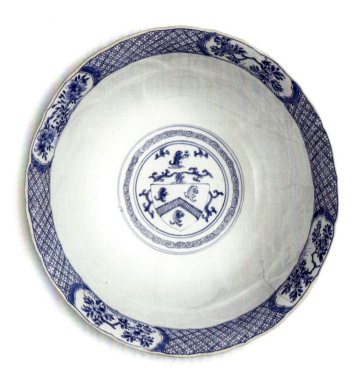

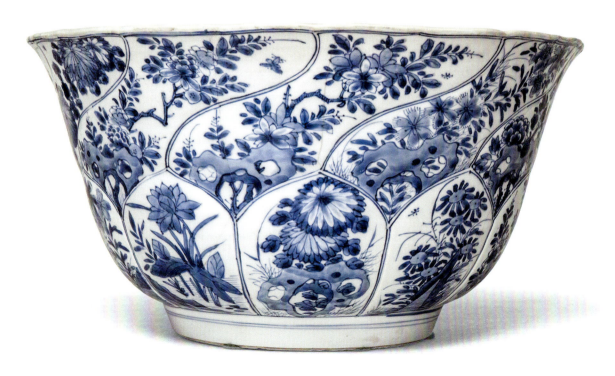

25.
LARGE DISH WITH ARMS OF COSTA

Kangxi period (1662–1722), c. 1690–1700
17 in. (43.2 cm) diameter

The wide rim of this very large dish is densely painted with bands of scrolling stylized acanthus leaves and flowerheads, probably after Delft, which encircle the arms of the Portuguese Costa family. The shield shows six bifurcated rib bones (a play on the name Costa) with crossed ribs above a helmet as the crest. It was probably made for Dom Rodrigo da Costa, a nobleman who between 1690 and 1712 was governor of Madeira and subsequently Brazil, and finally viceroy of Portuguese India. This dish was made as part of a set—possibly with accompanying ewers—that included a large, deeply scalloped basin now in the collection of the Fundação Oriente, Lisbon. —A.H.

REFERENCES Pinto de Matos 1998, pp. 206–07 (basin); Castro 2007, p. 111 (dish and basin)

PROVENANCE Santos London, 2018; Cabral Moncada Leilões, Lisbon, 12 December 2018, lot 166

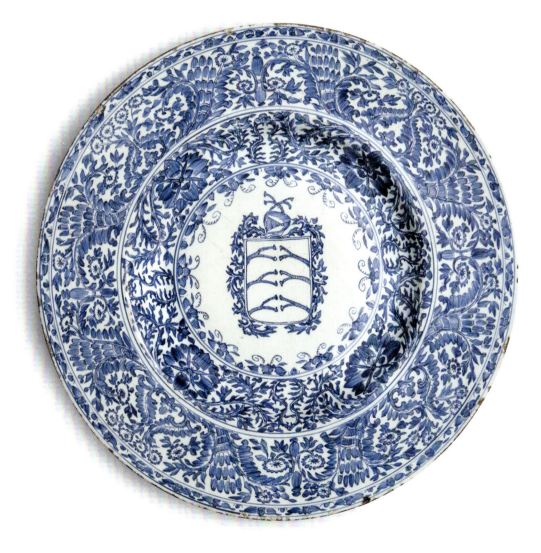

26.
TWO JARDINIÈRES WITH ARMS OF JOHNSON

Kangxi period (1662–1722), c. 1693–98
13 ½ and 11 in. (34.3 and 28 cm) wide

These garden pots—the first British armorial porcelain made in China—were ordered for Sir Henry Johnson, a fourth-generation shipbuilder whose father had bought the East India Company's docks at Blackwall on the River Thames in 1655, becoming the main supplier of East Indiamen, the large ships that operated under charter to the EIC. His younger brother, William, was an EIC factor in Bengal until 1683 and later supercargo on the *Wentworth* (named after Henry's wife) in the 1699–1700 China trading season. The quarterly arms are complex and boldly painted in an intense blue on one panel. They show Sir Henry to have already been knighted (1685) and give the name of his parents as well as indicating his 1693 marriage to Martha, daughter of the 3rd Baron Lovelace, revealing also the names of her mother and maternal grandmother, Baroness Wentworth. The latter is crucial evidence as Martha would inherit her grandmother's title in 1697 but there is no coronet of a baroness, providing a *terminus ante quem* for the dating.

Only circular and hexagonal jardinières were known until 1993 when a square one was consigned to a London auction by an elderly lady who lived in Aldeburgh in Suffolk where the Johnson family had had a country mansion. She had been given it many years earlier by the local vicar who had found it in his greenhouse on the edge of the former Johnson estate. Repaired and heavily riveted it may

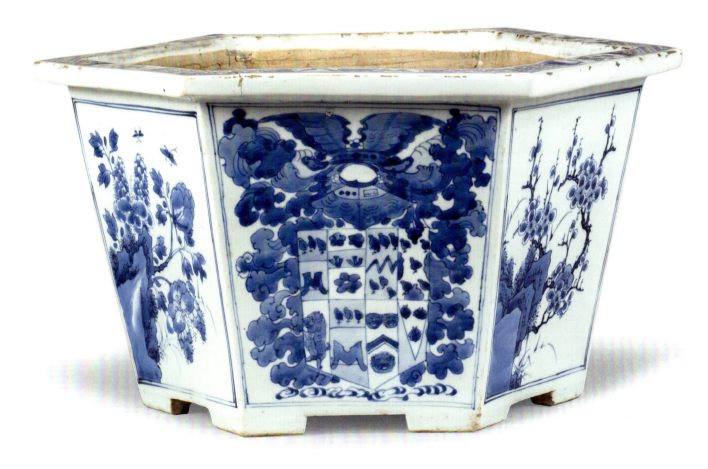

now be, but the first piece of armorial porcelain ever to reach England had survived over three hundred years in a garden shed at the very location for which it had been made. —A.H.

REFERENCES Howard 1974, p. 164; Howard 2000, p. 32 (square pot); Le Corbeiller and Frelinghuysen 2003, pp. 14–15 (Metropolitan Museum of Art example and their use)

PROVENANCE Heirloom & Howard Ltd, Wiltshire, 1993; Phillips London, November 1993, lot 17 (square). Heirloom & Howard Ltd, London, 1983 (hexagonal)

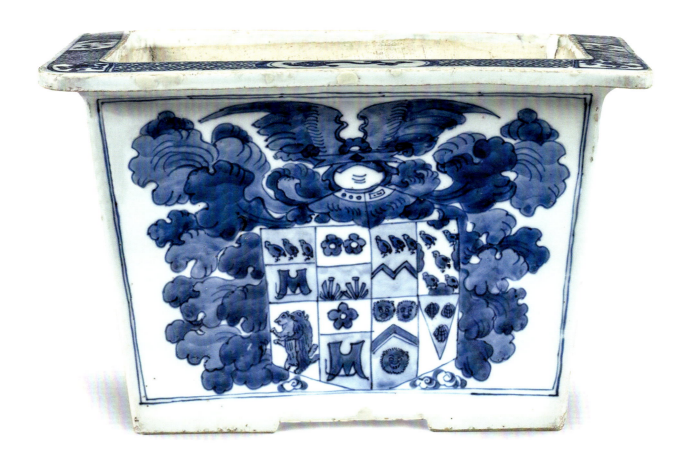

27.

PAIR OF VASES AND COVERS WITH ARMS OF LANCASTRE

Kangxi period (1662–1722), c. 1690–1700
8 ⅜ in. (21.3 cm) high

On the front of each small ovoid vase the arms of the Lancastre family are painted with a large eagle crest. The arms are surrounded by a profusion of grapevine in an inky blue and above a petal-molded band bordering the pedestal foot. On each base is a *lingzhi* fungus mark. The powerful and wealthy Lancastre family are best remembered for the remarkable porcelain-encrusted ceiling in their Santos Palace in Lisbon, which was acquired in 1629 by Dom Francisco Luís Lancastre. Their English name came from the 1387 marriage of a daughter of John of Gaunt, Duke of Lancaster, to King João I of Portugal. These vases were most likely ordered by Luís de Lancastre (1644–1704), 4th Count of Vila Nova de Portimão. Left-hand vase with replacement cover.

REFERENCES Castro 2007, pp. 112–13 (for three orders); Pinto de Matos 1998, pp. 210–11 (another vase); Lion-Goldschmidt 1984–85, pp. 79–93 (Santos Palace)

PROVENANCE Heirloom & Howard Ltd, London, 1979; Sotheby's London, 13 November 1979, lot 91 (one). Peter Mack Brown Antiques, Washington DC (one)

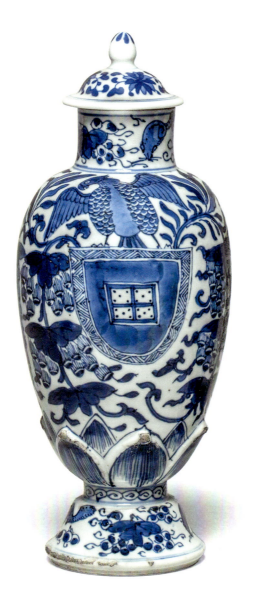
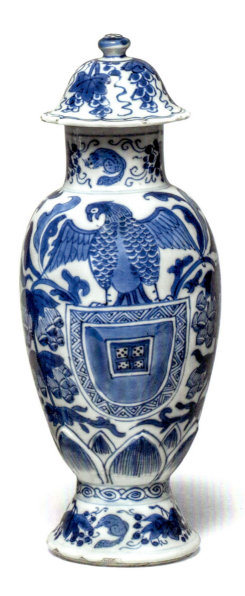

28.
DISH WITH ARMS OF GINORI

Kangxi period (1662–1722), c. 1698
13 ¾ in. (34.9 cm) diameter

This dish is linked to the Coelho (no. 29) and Costa (no. 25) services by its identical (albeit narrower) border, and was once also thought to be Portuguese. However, family documentation has shown that it was made for the Florentine Lorenzo Ginori (1647–1710), an international banker with commercial interests in Goa, Macao and Lisbon, where he was consul until 1688. The service, known to have been ordered through Portuguese missionaries in Goa and delivered to Lisbon, probably together with the two Portuguese services, arrived in Florence via Livorno in March 1699 for his marriage to Anna Maria Minerbetti. Its delivery coincided with refurbishment of the Palazzo Ginori where these arms can still be seen carved in stone on the facade. Lorenzo's son, Carlo Andrea Ginori, would found the Doccia porcelain manufactory in 1735. —*A.H.*

REFERENCES Ginori Lisci, Lucini and Perotto 1988, pp. 25–33 (English translation with two variants illustrated); Le Corbeiller 1973, pp. 34–35 (for a dish with arms on the rim, erroneously thought to be Portuguese)

PROVENANCE Heirloom & Howard Ltd, Wiltshire, 2016; Czerny's International Auction House, Liguria, 22 October 2016, lot 88

29.
PLATE WITH ARMS OF COELHO

Kangxi period (1662–1722), c. 1698–1710
9 in. (22.9 cm) diameter

The wide, densely packed borders in a bright cobalt blue on this plate relate to the Costa (no. 25) and Ginori (no. 28) services. The arms are heraldically interesting since the differing number of rabbits (or *coelhos* in Portuguese) on various pieces are said to identify different sons. According to Nuno de Castro, the set with seven rabbits (as this plate) was made for António de Albuquerque Coelho de Carvalho (1655–1725), the fourth generation of a family of Portuguese colonial administrators since the 1590s, who held governorships in Brazil and Angola. António had two illegitimate children who also followed careers in Macao, Goa and Brazil. The eldest was also António (1682–1745), governor of Macao 1718–19, who had the misfortune to lose his right arm in a fight just before his wedding in 1710 to a wealthy Macanese girl. His younger brother José was a soldier in Macao. They too had similar services, with six and four rabbits respectively, which were probably ordered a decade later. —*A.H.*

REFERENCES Pinto de Matos 1998, p. 209; Castro 2007, pp. 108–10 (three variants with different numbers of rabbits)

PROVENANCE Kee Il Choi, Jr., New York, 1992

30.

TWO LARGE DISHES: ARMS OF TALBOT AND OF SAYER IMPALING TALBOT

Kangxi period (1662–1722), c. 1705 and 1722
17 and 18 ⅞ in. (43.2 and 48 cm) diameter

These two very large dishes have the same border design, reflecting a very early style of the turn of the eighteenth century, although were made twenty years apart for a father and daughter, the baroque cartouche around the arms on the second dish betraying its later date. Both services included dishes with a ribbed edge (seen on the second dish) after a silver form. The first service, the earliest in underglaze blue for the English market, was made for William Talbot (1659–1730) while Bishop of Oxford; renowned for his extravagant ways, he would later be remembered for his wealth rather than his spiritual example. His son Charles ordered a further three services. The later dish, copied in the same style, was made for the marriage in 1723 of William's daughter Catherine Talbot (1690–1734) to Exton Sayer, a lawyer and vicar general to his father-in-law, then Bishop of Durham, who entered parliament in 1726. His untimely death in 1731 was the result of a riding accident. —*A.H.*

REFERENCES Howard 1974, p. 164 for both services (the Sayer/Talbot service incorrectly dated); Krahl and Harrison-Hall 1994, pp. 44–45 (Talbot dish, a different bookplate and portrait); British Museum (Franks.734.+) (Talbot dish)

PROVENANCE Heirloom & Howard Ltd, London, 1982; Christie's London, 1 November 1982, lot 416 (left). Heirloom & Howard Ltd, Wiltshire, 2022; Christie's New York, 2 February 2022, lot 25; the collection of E. Martin Wunsch, New York (right)

31.
PLATE WITH ARMS OF PELGROM

Kangxi period (1662–1722), c. 1705–10
8 in. (20.3 cm) diameter

A waterbird rests on a small outcropping growing with lush flowers in the center of this dish. The wide border shows four large shells issuing leaves, masks and scrolls; the back has three ribbon-tied symbols on the rim and a twin fish mark in the center. At the top is the coat of arms of Jacob Pelgrom, a Huguenot from Rouen who fled to Amsterdam and made a career with the VOC in Asia. The crest of a pilgrim is a play on his name. At least sixty plates and dishes are known with closely related decoration, in several sizes, most of them with lotus heads instead of shells in their borders. This slightly better-painted version with the shells is known in at least a half dozen examples; it was probably a second order. Pelgrom had posts in Bengal from 1689 to 1705; he was in Batavia from 1708 until his death in 1713.

REFERENCES Kroes 2007, pp. 107–09 (variations and discussion); Metropolitan Museum of Art (25.64.5) (this pattern)

PROVENANCE Heirloom & Howard Ltd, Wiltshire, 2019; Duke's Auctioneers, Dorset, 11 November 2019, lot 96; the collection of Anthony du Boulay; Bluett & Sons, London, 1972 (one of a pair)

32.
PLATE WITH ARMS OF BACELAR

Kangxi period (1662–1722), c. 1710
8 ¾ in. (22.2 cm) diameter

Much like the De Pinto, Costa and Coelho dishes (nos. 21, 25 and 29), this example, made for a Portuguese in the same period, is densely packed with foliate patterning. Here, the coat of arms is almost indiscernible within the surrounding decoration. The flat rim is painted with grapevine bearing large fruit in an inky blue; in the center, smaller grapevine encloses the arms of Pedro Vaz Soares Bacelar (b. 1680). Bacelar was an infantry captain in India and eventually governor of Mombasa fort. He had another set of Chinese plates made of very similar pattern but in iron-red and gilt, much more clearly painted and in a more European style, very likely ordered a bit later.

REFERENCES Castro 2007, p. 107 (heraldry and blue and white); Galerie Fournery n.d. (iron-red and gilt plate)

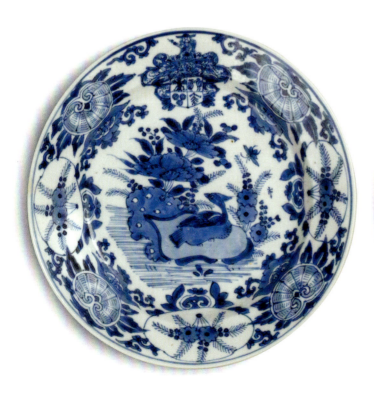
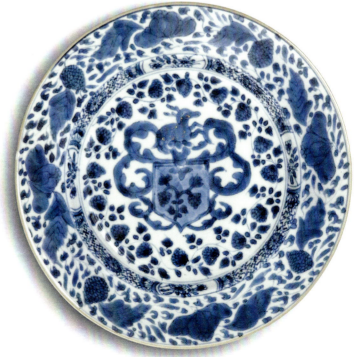

33.

TWO PLATES WITH VAN BLEIJSWIJK ARMS AND RELATED PLATE

Kangxi period (1662–1722), c. 1708–15
8 ¾ in. (22.2 cm) diameter

The first plate is boldly painted in an edge to edge design with the arms of Van Bleijswijk and Van Hemert accollé. A tasseled banner beneath the arms is inscribed *Bleijswijk/van Hemert* in script. At bottom left a plate of similar conception has been painted with large tropical leaves and fruits in place of acanthus scroll and the arms of Van Bleijswijk accollé with another (unidentified) suspended on curling stems. At bottom right is a non-armorial plate of closely related pattern, displaying the kind of exotic fauna Dutch traders would have experienced in Batavia. Abraham van Bleijswijk of Delft married Anna van Hemert in 1708. A brewer himself, Abraham had relations in the VOC, including a brother.

REFERENCES Sargent 2012, p. 358; Kroes 2007, pp. 109–11; Lunsingh Scheurleer 1974, no. 261

PROVENANCE Heirloom & Howard Ltd, London, 1985 (top). The Chinese Porcelain Company, New York, 1998 (left). Heirloom & Howard, Wiltshire, 2000 (right)

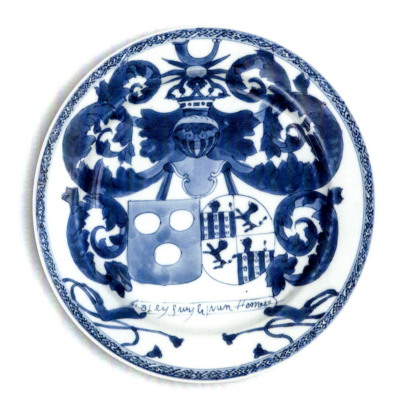

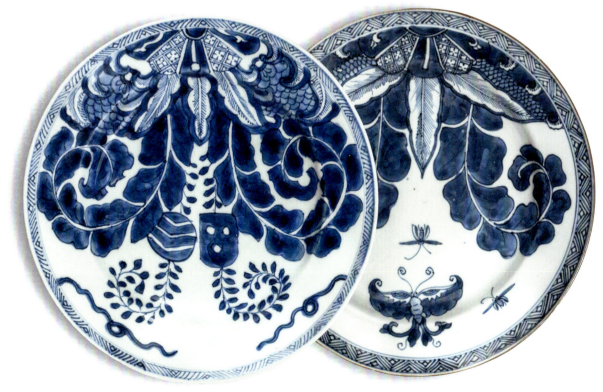

34.
DISH WITH CREST OF HARRISON

Kangxi period (1662–1722), c. 1718
13 ⅞ in. (35.2 cm) diameter

This dish is from one of four associated early services made in three years—two in *famille verte* and two in a pale underglaze blue—for Edward Harrison (1674–1732), who was governor of Madras 1711–17. A further six services were ordered in the 1720s for his heiress daughter Audrey, who married Lord Lynn, later Viscount Townshend. The first underglaze blue service, made about 1715, contains a remarkable error—the armorial is drawn in outline with heraldic instructions which have been copied onto the porcelain; only one piece is known to exist and is in the Metropolitan Museum of Art, New York. The second *famille verte* service, in an identical design showing the shield only, was produced more successfully in full color. The other two services feature just the crest of Harrison on the upper rim. Here, in an unusual design influenced by Japanese porcelain, a crane and a tortoise, both auspicious creatures symbolizing longevity, stand on a riverbank under pine and bamboo, beneath a Japanese *mon*; the rim features crane, deer and sacred fungus. —A.H.

REFERENCES Howard 2003, pp. 125–26 (two blue and white services); Howard 1974, p. 187 (two *famille verte* services); Metropolitan Museum of Art (1974.195) for the earlier blue and white dish with error, illustrated Le Corbeiller and Frelinghuysen 2003, p. 18

PROVENANCE The collection of David S. Howard, Wiltshire

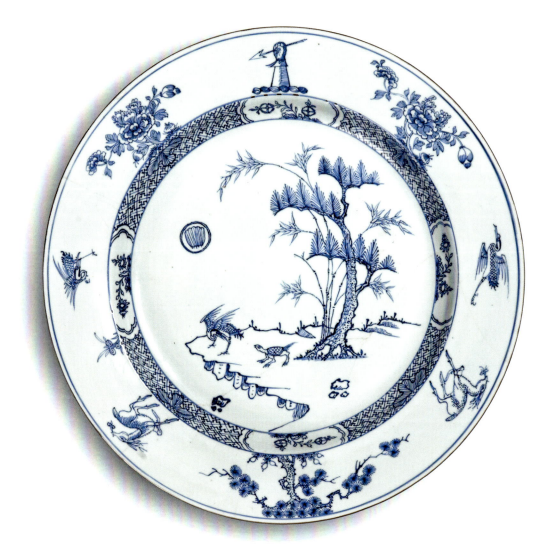

35.

THREE PLATES WITH ARMS OF POTKEN

Kangxi period (1662–1722), c. 1718–20
9 ½ in. (24.1 cm) diameter

A simple shield in the center of each of these plates is painted with a cooking pot or cauldron, shown upside down on two. The arms are enclosed by a wide floral wreath border, and the flat rim is decorated with flowers growing on delicate stems. There is an underglaze blue lozenge mark on the reverse. These undoubtedly punning arms (*sprekend wapen* in Dutch) are probably of the Potken family (although they have sometimes been attributed to the Portuguese family of Caldeira, also a pun on the name). Most likely the plates were made for Gerardus Potken (1695–1762), who spent his adult life in Colombo, capital of Ceylon (now Sri Lanka).

REFERENCES Kroes 2007, pp. 111–12; Castro 2007, pp. 105–06 (as Caldeira)

PROVENANCE Heirloom & Howard Ltd, Wiltshire, 1990 (top). The collection of Peter H.B. Frelinghuysen, Jr.; Heirloom & Howard Ltd, Wiltshire, 1990 (center and bottom)

36.
LARGE PLATE WITH ARMS OF FEITH

Kangxi (1662–1722) to Yongzheng (1723–35) period, c. 1720–30
10 ¼ in. (26 cm) diameter

The arms of the Feith family of Gelderland are painted in the center of this large plate within mantling of leafy scrollwork in a deep, inky cobalt. On the rim, a scrolling vine bears both fruits and lotus blooms; three floral sprays decorate the reverse. The dish is from a table service made for Arnold Hendrik Feith (1686–1751), a lawyer who held a number of civic posts as well as being a VOC director for the province of Gelderland. It seems the service was heavily used; the only other recorded survival is a dish published by Jochem Kroes.

REFERENCES Kroes 2007, p. 113

PROVENANCE Heirloom & Howard Ltd, Wiltshire, 2008; Christie's Amsterdam, 20–21 May 2008, lot 196

37.
LARGE PLATE WITH ARMS OF VAN DER STEL

Kangxi (1662–1722) to Yongzheng (1723–35) period, c. 1720–30
10 ¼ in. (26 cm) diameter

This dish shares the same border design as the Feith dish in the previous entry. In its center the arms are displayed on a round shield beneath a coronet and within a baroque cartouche more usually associated with French orders. Although several Dutch families had closely related arms, five members of the Van der Stel family were active in the VOC, including Willem Adriaan van der Stel (1664–1733), a governor of the Cape Colony, and Adriaan van der Stel, a governor of Amboina (now Ambon) in Indonesia.

REFERENCES Lunsingh Scheurleer 1974, no. 260; Kroes 2007, p. 112

PROVENANCE Heirloom & Howard Ltd, London, 1988; Christie's London, 2 November 1988, lot 371

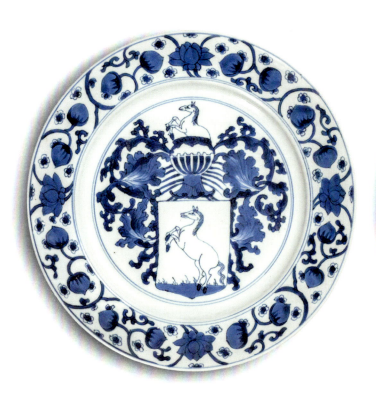
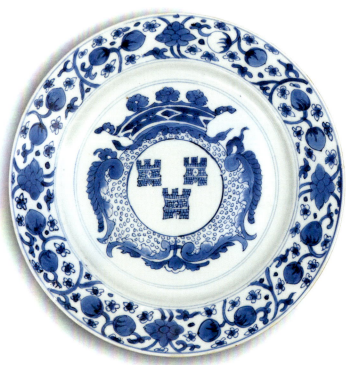

38.

PLATE WITH ARMS OF DECKER IMPALING WATKINS

Kangxi period (1662–1722), c. 1720
8 ⅞ in. (22.5 cm) diameter

This plate was made for Sir Matthew Decker (1679–1749), a Dutch-born London economist, merchant, banker and director of the East India Company, whose business acumen brought great wealth and honors. In 1711 he married Henrietta Watkins and in 1716 was created a baronet, shown by the hand in the top left of the circular arms on this plate, and also on a slightly earlier identical service in *famille verte* enamels, much of which descended to the Earls of Pembroke and is today at Wilton House, Salisbury. Sir Matthew amassed a large collection of Dutch paintings at his house in Richmond, where he also cultivated exotic fruits including the first pineapple grown in England. His grandson, Richard, 7th Viscount Fitzwilliam, founded the Fitzwilliam Museum in Cambridge, bequeathing his grandfather's paintings which form the core of the museum's Dutch holdings. The pineapples that embellish the museum's front railings are a tribute to Sir Matthew. —*A.H.*

REFERENCES Howard 1974, p. 167

PROVENANCE Sotheby's Sussex, March 1999, lot 4; the collection of E. Clive Rouse, Buckinghamshire

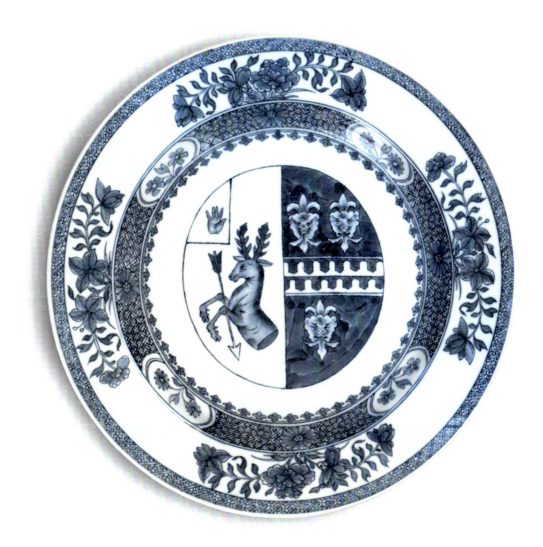

39.
JARDINIÈRE AND PLATE WITH ARMS OF GOUGH IMPALING HYNDE

Yongzheng period (1723–35), c. 1728
11 ½ in. (29.2 cm) wide; 9 ½ in. (24.1 cm) diameter

Harry Gough (1681–1751), fifth son of a country baronet, first visited Guangzhou (Canton) with his uncle in 1692 at the age of eleven, becoming known as 'Amy Wang' or 'the white-haired boy'. By 1705 he had command of a merchantman; then followed a typical career route as a merchant and captain, making numerous voyages to China before retiring home to become a lawyer and member of parliament and finally serving as chairman of the East India Company a number of times between 1737 and 1750. This jardinière (the only one known) and plate represent the two different underglaze blue services he brought back from China; he ordered another eight incorporating iron-red enamels for either his own family or that of his wife, Elizabeth Hynde, all before 1730. —*A.H.*

REFERENCES Howard 1974, p. 166

PROVENANCE Heirloom & Howard Ltd, Wiltshire, 2010 (jardinière). Heirloom & Howard Ltd, London, 1986; Christie's London, 19 November 1986, lot 22 (plate)

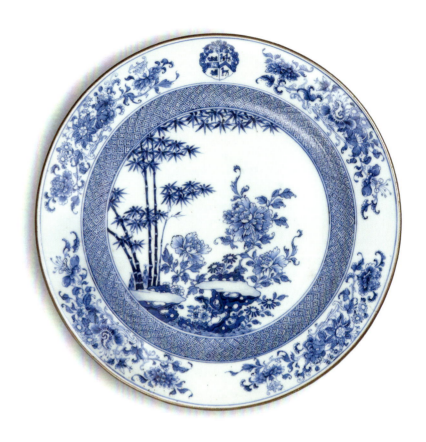

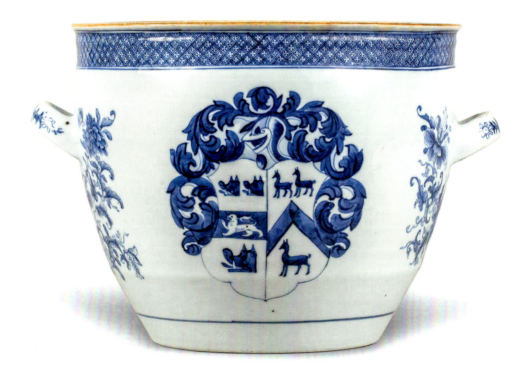

40.

BOWL WITH ARMS OF LOWTHER IMPALING ADAMS

Yongzheng period (1723–35), c. 1728
10 ¼ in. (26 cm) diameter

The arms of Lowther impaling Adams are painted on the front of this punch bowl; the dragon crest of Lowther is on the opposing side. In between are delicately rendered leafy clusters of peony and other spring blooms, repeated in the center of the interior beneath a band of diaper at the rim. This bowl—the only piece recorded with this decoration—and an armorial table service with an identical cartouche in colored enamels and gilt made about the same time were most likely ordered by the Reverend Richard Lowther, who married Margaret Adams. His brother, Sir William Lowther, 1st Baronet, had a son, John Lowther, who was governor of Surat and could have facilitated the order.

REFERENCES Howard 2003, p. 127 (this bowl); Howard 1974, p. 210 (enameled service)

PROVENANCE Heirloom & Howard Ltd, Wiltshire, 2022; Sotheby's New York, 24 January 2022, lot 1758; Freeman's, Philadelphia, April 2001

41.

PLATE WITH ARMS OF COWAN

Yongzheng period (1723–35), c. 1722–28
8 ¾ in. (22.2 cm) diameter

This plate is from one of four Cowan services made to the order of Sir Robert Cowan, an Ulster merchant employed by the East India Company in India from 1719 and governor of Bombay 1729–34. Although only two plates in underglaze blue are recorded, an identical service was ordered with iron-red enamels, much of which survives at Mount Stewart in Northern Ireland, the house built after Cowan's death in 1737 by his sister and heir, and her husband Alexander Stewart—funded by the 'Cowan inheritance' of East India stock which would also found a political and noble dynasty. Recent research has uncovered a letter of 1722 from Cowan to the free trader John Scattergood, requesting (with three orders for other clients) "… three Corge [60] of plates and one [20] of dishes with my own arms which is the Saltire & hart & hand for crest …." —A.H.

REFERENCES Howard 2003, pp. 141, 126; Teggin 2020 (for the EIC career of Sir Robert Cowan which references the Cowan Papers in the Northern Ireland Record Office)

PROVENANCE Heirloom & Howard Ltd, London, 1987

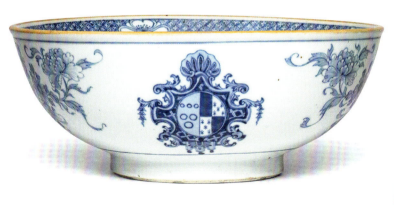

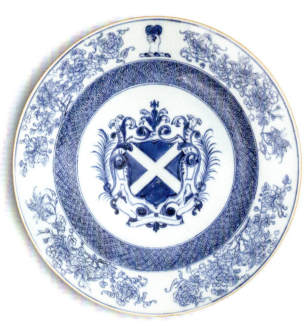

42.
BOWL WITH ARMS OF GOLD IMPALING THAYER

Yongzheng period (1723–35), c. 1728
10 ⅝ in. (27.3 cm) diameter

Painted very much in the manner of the Lowther/Adams bowl above (no. 40), this example, too, is the only one known from what may have been a small set of bowls. In front is a large coat of arms for Gold impaling Thayer; the sides, back and interior feature large clusters of finely painted peonies and lilies. Previously unrecorded, the bowl was probably made for a Gold of Somerset who married a daughter or niece of Humphrey Thayer, inspector general of duties on coffee, tea and chocolate in 1732.

REFERENCES Howard forthcoming; Howard 1974, p. 168 (Gold/Bulkeley service)

PROVENANCE Heirloom & Howard Ltd, Wiltshire, 2009

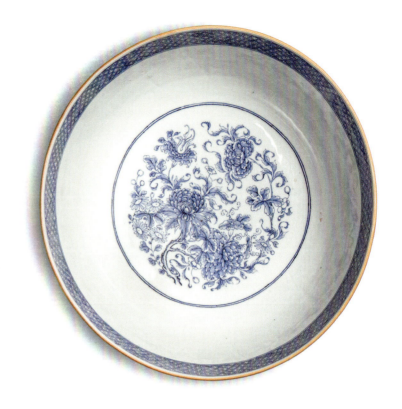

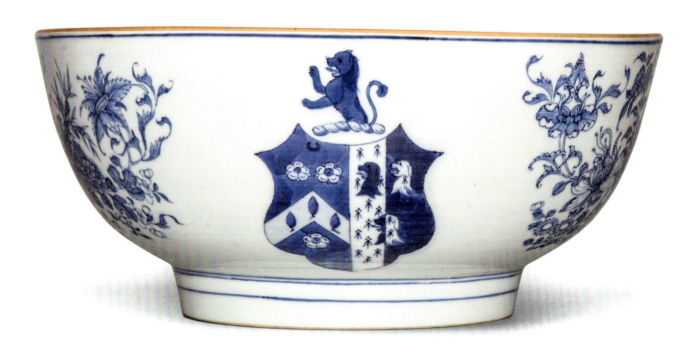

43.

BOWL WITH ARMS OF WHISTLER

Yongzheng period (1723–35), c. 1730
10 ¼ in. (26 cm) diameter

The design of this punch bowl is reminiscent of the Lowther/Adams and Gold/Thayer bowls (nos. 40 and 42) bowls, but here we see an even greater degree of sophistication. A large coat of arms of Whistler—its fine lines probably indicating a bookplate model—is placed in front while the sides are painted with gnarled branches of tree peony and magnolia. In the center is a finely rendered clump of lotus and reeds; the rim is washed in brown above an inner border in the style of French faience. The same arms appear on a colored enamel tea service and dinner service of similar date. Like the Lowther/Adams and Gold/Thayer bowls, this bowl is the only example of its kind and may have been ordered as part of a small set of bowls.

REFERENCES Howard 2003, p. 436 (this bowl, but incorrectly dated); Howard 1974, pp. 210, 254 (enameled services)

PROVENANCE The collection of David S. and Angela Howard, Wiltshire, 2022

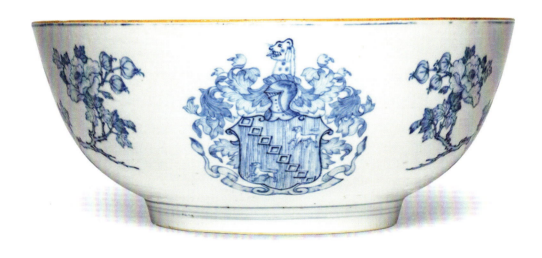

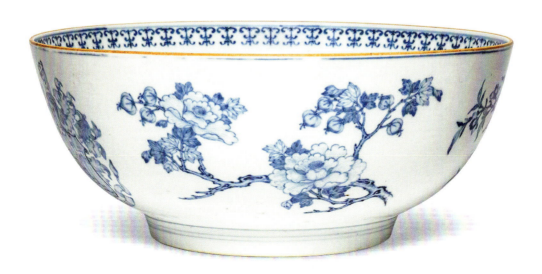

44.
LARGE DISH WITH CREST OF PEERS

Yongzheng period (1723–35), c. 1731
18 in. (45.7 cm) diameter

In December 1731 and January 1732 two Chinese armorial porcelain services left Guangzhou (Canton) for England on separate ships destined for the Peers family. Both were made for Sir Charles Peers, a successful salt merchant who had been chairman of the East India Company in 1714 and lord mayor of London the following year. This dish is from a 255-piece blue and white service with the crest of Peers; the other service of 525 pieces, decorated in colored enamels with a gilded rim, displayed the full coat of arms, the cost of each piece averaging three times as much. Most unusually, both original invoices survive and are still in the possession of the family. This blue and white service was sent via Madras on the country ship *Canton Merchant*, the invoice dated "Canton, 19th November 1731." —A.H.

REFERENCES Howard 1974, pp. 174, 249; Howard 1994, p. 67; Le Corbeiller 1973, pp. 52–54 (blue and white invoice)

PROVENANCE Heirloom & Howard Ltd, London, 1978

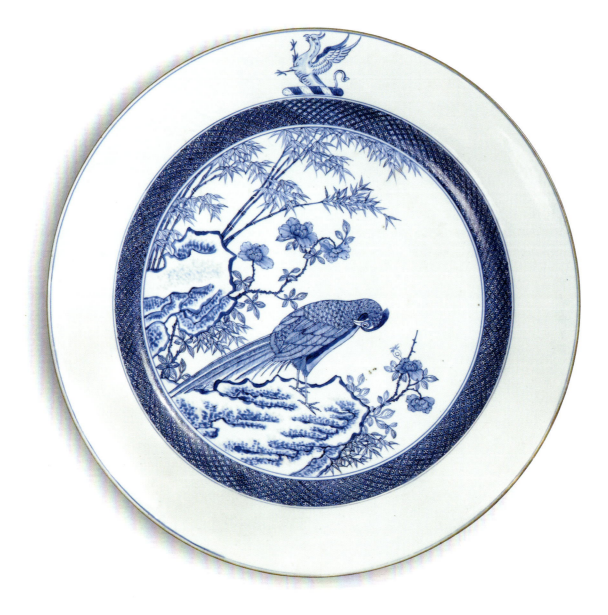

45.

PAIR OF PLATES WITH ARMS OF LETHIEULLIER

Yongzheng period (1723–35), c. 1730
8 ¾ in. (22.2 cm) diameter

In the center of these finely painted plates is the coat of arms of Lethieullier, though on the right-hand plate the shield's three parrot heads have been omitted in error. An inner arabesque border encircles the arms; the rims are painted with flower sprays with the parrot crest at top. Huguenots originally based in Brabant, with origins in the sugar and textile trade, the Lethieulliers became highly successful London merchants, directors of the Bank of England and civic leaders. John Lethieullier (1659–1737) was a merchant buyer of porcelain; at least six services were made for the family in the 1720s (see nos. 325 and 328–329).

REFERENCES Howard 1974, p. 174 (these plates); Howard 1994, p. 33 (Lethieullier family)

PROVENANCE A.R. Broomer Ltd, New York, 1989; the collection of Julia and John Curtis; the collection of P.B. Cooke, Yorkshire

46.

BASIN WITH CREST OF WOLFF, CROACHROD OR PEMBERTON

Yongzheng (1723–35) to Qianlong (1736–95) period, c. 1735–38
10 ⅛ in. (25.7 cm) diameter

A delicate border in the style of Rouen faience decorates the rim of this basin, repeated at the base. The identity is uncertain based on just a crest, but two earlier services were made for the same commissioner in about 1715 in underglaze blue (with silvered crest) and *famille verte*. The other pieces known from this service—a mask-spout ewer on a pedestal base and a shaped oblong basin on tripod feet—share the baroque forms of faience from the first half of the eighteenth century. —A.H.

REFERENCES Howard 1974, p. 605 (with dating amended by A.H.)

PROVENANCE Heirloom & Howard Ltd, London, 1983

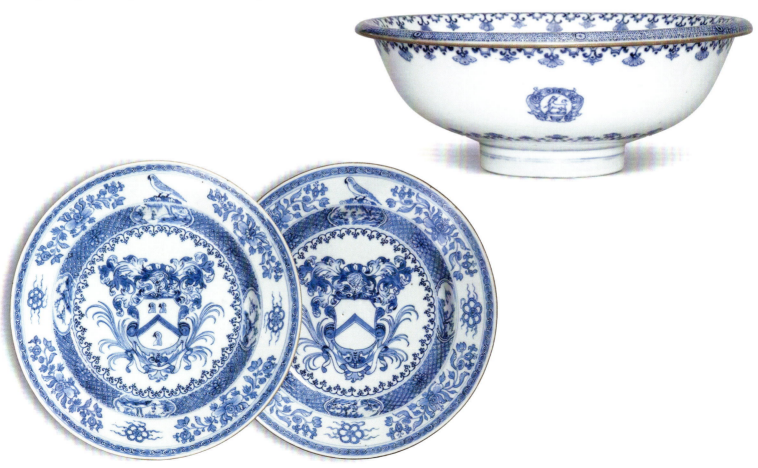

47.
SAUCER DISH AND BUTTER TUB WITH ARMS OF VALCKENIER

Qianlong period (1736–95), c. 1735–40 (dish) and c. 1750–60 (tub)
10 and 5 ⅛ in. (25.4 and 13 cm) diameter

The influential Valckenier family of Amsterdam included many members who served with the VOC; the most important of them was Adriaan Valckenier (1695–1751), who after arriving in Batavia in 1715 became councillor (1733–37) and then governor-general (1737–41) of the Dutch East Indies. He ordered no fewer than fifteen armorial services in the 1730s, six of them in blue and white, but four of the blue and white services (one a table service and the others for tea, coffee and chocolate) were lost in the 1741 shipwreck of the East Indiaman *Amsterdam*. This butter tub is from a small order probably made by Adriaan's son, Adriaan Isaac Valckenier (1731–1785), presumably to supplement the earlier surviving service, which must have been still in use. Varying slightly in detail and made in soft-paste porcelain, this later set comprised hot water plates (unusual at this date), sauceboats and, as evidenced by this example, butter tubs.

REFERENCES Kroes 2007, pp. 184–86 (blue and white Valckenier services) and p. 646 (listing of all Valckenier services)

PROVENANCE Christie's Amsterdam, March 1984 (saucer dish). Heirloom & Howard Ltd, Wiltshire, 1996 (butter tub)

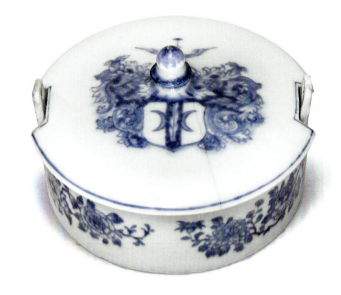

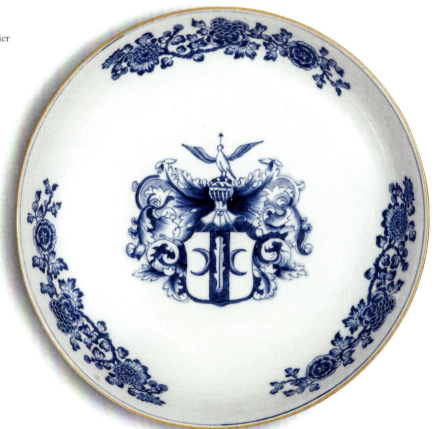

48.
TWO OCTAGONAL PLATES: ARMS OF DE HAZE AND OF DE HAZE WITH SONMANS ACCOLLÉ

Qianlong period (1736–95), c. 1738–41
8 ⅞ in. (22.5 cm) diameter

These plates are almost identically decorated with large lotus blooms, each of its petals painted with a lotus sprig on a ground of whorls. In the center of the bloom are the arms of De Haze on one and of De Haze and Sonmans accollé on the other. The De Haze family were leading citizens of Middelburg; Elias de Haze (1689–1752), who ordered both these sets of dishes, held various VOC posts in Indonesia, residing in Batavia after 1734. In 1738 he was married there to Sara Sonmans, who died in 1741, thus providing a firm date parameter for the order.

REFERENCES Kroes 2007, pp. 193–95; Howard and Ayers 1978, p. 444

PROVENANCE Sotheby's New York, 30 January 1985, lot 268 (left: De Haze). Heirloom & Howard Ltd, Wiltshire, 2016; Guest & Gray, London, 2016 (right: De Haze and Sonmans)

49.

GUGLET WITH ARMS OF SUTHERLAND QUARTERLY

Qianlong period (1736–95), c. 1740
9 ⅝ in. (24.4 cm) high

On the front of this guglet—which would have been made with a matching circular basin—is a large coat of arms and the motto WITHOUT FFAR [*sic*] for Sutherland quarterly, Baron Duffus. Scattered floral sprigs decorate the remainder. It was ordered by Eric Sutherland, son of Kenneth, 3rd Lord Duffus and his Swedish wife, Charlotte Siöblad; its design drawn from the bookplate of his father. David Howard suggests that the order may have been placed through family connections in the Swedish East India Company.

REFERENCES Howard 2003, p. 426 (this guglet)

PROVENANCE The collection of David S. Howard, London, 1989

50.

SAUCER WITH ARMS OF ABELEVEN

Qianlong period (1736–95), c. 1740
5 ⅝ in. (14.3 cm) diameter

This finely painted saucer was part of a tea service probably made for Abraham Abeleven (1714–1776), cashier-general of the VOC in Batavia in 1740. Abraham was born and died in Batavia; his father Arnoldus was also a VOC director. He had a *grisaille* tea service of identical pattern. Both services feature a rope-twist border encircling the coat of arms and an *AA* cypher within floral clusters on the back.

REFERENCES Kroes 2007, pp. 260–61 (*grisaille* service)

PROVENANCE Heirloom & Howard Ltd, Wiltshire, 2010

51.
BOWL WITH ARMS OF LYONS IMPALING HARMAN

Qianlong period (c. 1736–95), c. 1753–55
10 ¼ in. (26 cm) diameter

The Lyons family, of Anglo-Norman origin, had emigrated from Ireland and owned estates on the island of Antigua where four generations had served on the Council. This bowl was made for John Lyons (1731–1775) and his wife Jane Harman, also of Antigua. The finely rendered scene of five rams on an island on this punch bowl, painted in an inky cobalt blue, may allude both to their island residence and to the Harman impalement which contains heraldic rams. —A.H.

REFERENCES Howard 2003, p. 419

PROVENANCE Heirloom & Howard Ltd, Wiltshire, 1990

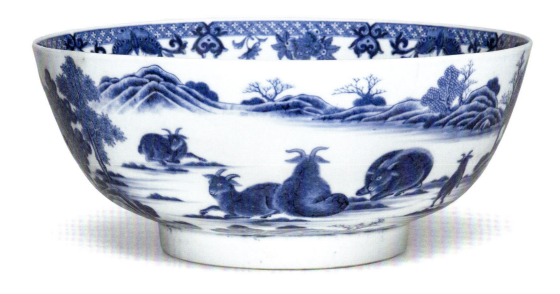

52.

SAUCER DISH WITH ARMS OF WALPOLE IMPALING CAVENDISH

Qianlong period (1736–95), c. 1752
8 ¼ in. (21 cm) diameter

Most unusually this saucer dish displays its coat of arms on the back, meticulously painted after a rococo bookplate. It is from a set of dishes in two sizes of which few are known, made for Horatio Walpole (1723–1809) who married Lady Rachel Cavendish in 1748. The porcelain was ordered through his younger brother Richard, a captain in the EIC, who reached Whampoa on 12 June 1752 in command of the East Indiaman *Houghton*. The molded form is also very unusual while the design of this armorial dish is unique, derived directly from Japanese porcelain. Walpole succeeded to his father's barony of Walpole in 1757 and was eventually created Earl of Orford. —A.H.

REFERENCES Howard 1997, p. 62; Howard 1974, p. 585; Impey 2002, p. 117 (Japanese prototypes)

PROVENANCE Heirloom & Howard Ltd, London, 1979

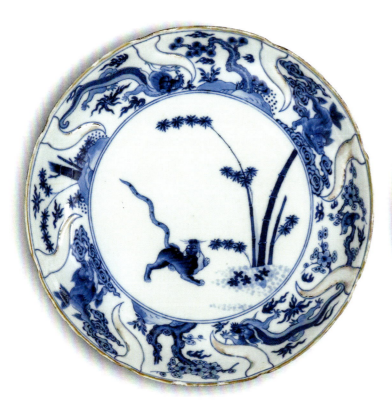 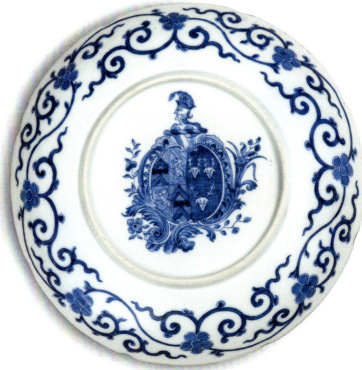

53.

THREE PLATES AND PAIR OF KNIFE HANDLES FOR THE GRILL FAMILY

Qianlong period (1736–95), c. 1755–69
8 ⅞, 9 ⅞ and 9 in. (22.5, 25.1 and 22.8 cm) diameter;
4 ⅞ in. (12.4 cm) long

REFERENCES Kroes 2012; Hornstrand 2013; Le Corbeiller 1973, pp. 57–58; Le Corbeiller and Frelinghuysen 2003, p. 25

PROVENANCE The Chinese Porcelain Company, New York, 1995 (knife handles). The collection of David S. Howard (top plate). Heirloom & Howard Ltd, London, 1985 (bottom left). Kee Il Choi, Jr., New York, 1986 (bottom right)

Nine well-documented armorial services, including three in underglaze blue, were made 1755–65 for the Grill family, goldsmiths by trade who emigrated from Germany to Amsterdam and on to Sweden in the mid-eighteenth century where they were active in the Swedish East India Company. All were ordered through Jean Abraham Grill (1736–1792), who made his first trip to Guangzhou (Canton) in 1755–56 where he returned between 1760 and 1769 as supercargo and assistant at the Swedish factory. The services are notable for their imaginative rococo designs, probably drawn by Christian Precht. The plate with a more conventional armorial design was probably ordered for Anthonie Grill of the Dutch branch; the plate with scalloped rim and pseudo-armorial crest of a heron holding a grasshopper (or *grillo*—a pun on the name) was for Jean Abraham himself, while the plate with *anhua* rim and two cranes was probably for the wedding of his uncle Johan Abraham Grill who married Christina Fischer in 1758.
—A.H.

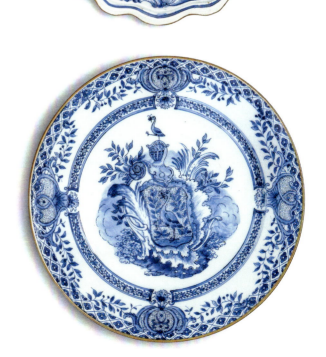

54.
LOTUS DISH WITH ARMS OF TOUSSAIN

Qianlong period (1736–95), c. 1750–52
10 ⅜ in. (26.3 cm) diameter

This sturdily potted dish represents a variation on the lotus shapes that were fashionable in the middle decades of the eighteenth century. The center is finely painted with a Chinese riverscape, while each 'petal' displays a large flower sprig. The arms of Reijnier Toussain (1719–1785) are at the top. Toussain was a VOC supercargo at Guangzhou (Canton) 1749–52. In 1752 he sent two boxes of private goods home on the *Amstelveen*; they may have contained his very large dinner service, which comprised tureens, pancake plates, sauceboats, butter tubs, many plates and seven lotus dishes, of which this is one.

REFERENCES Kroes 2007, pp. 196–97

PROVENANCE Heirloom & Howard Ltd, Wiltshire, 1990

55.
LARGE DISH WITH ARMS OF VAN DER DOES ACCOLLÉ WITH VAN STEIN VAN GOLLENESSE

Qianlong period (1736–95), c. 1755–57
15 ⅛ in. (38.4 cm) diameter

In the center of this large, meticulously painted dish are the arms of Gerard van der Does (b. 1737) and his wife Anthonia Dorothea (van) Stein van Gollenesse, who were married in Batavia in 1755. Gerard died about 1757 and Anthonia remarried so, as with the De Haze/Sonmans service (no. 48), the heraldry provides a firm date for the porcelain. Only a small number of pieces seem to have survived from this dinner service.

REFERENCES Kroes 2007, pp. 190–91

PROVENANCE Philip S. Dubey Antiques, Baltimore

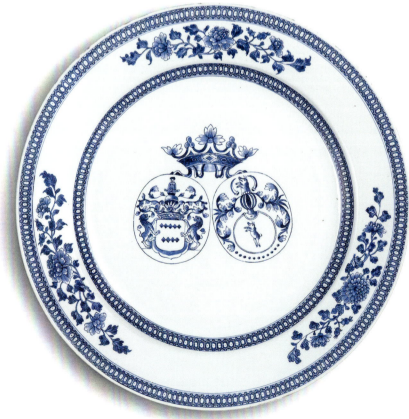

56.

JUG WITH ARMS OF JOHNSTONE

Qianlong period (1736–95), c. 1755
8 ¾ in. (22.2 cm) high

Modeled with a wide mouth and stout baluster body, this jug is boldly painted with a large coat of arms for William Johnstone, second son of Sir James Johnstone, 3rd Baronet of Westerhall. In 1760 William married Frances Pulteney who a few years later inherited the fortunes and estates of her cousins William Pulteney, 1st Earl of Bath, and his brother. At that time Johnstone changed his name to Pulteney; when he inherited the family title in 1794, he became known as Sir William Pulteney, 5th Baronet. A very wealthy landowner, William's properties included estates in what is now western New York state where the small towns of Pulteney, Pulteneyville and Bath are vestiges of this history.

REFERENCES Howard 1974, p. 583

PROVENANCE Heirloom & Howard Ltd, Wiltshire, 2016

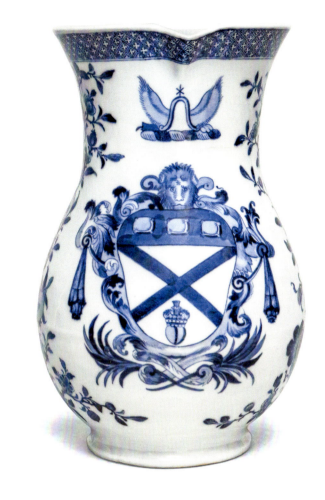

57.

TWO-HANDLED BOWL WITH ARMS OF DALRYMPLE

Qianlong period (1736–95), c. 1775
7 ⅝ in. (19.4 cm) long

Of an unusual lobed oval form with pedestal foot and a pair of loop handles, this bowl is painted along its exterior with floral swags. Inside, the coat of arms of Dalrymple is painted with the motto *FIRME*; there is a cluster of flowers in the center. A fleur-de-lis for difference in the arms indicates a sixth son. William Dalrymple (1739–1777), sixth surviving son of Sir James, 2nd Baronet of Hailes, served with the East India Company in Madras, where he died. Part of the service remains at Newhailes, the former family house in East Lothian, Scotland, including an identical bowl.

REFERENCES Howard 2003, p. 432 (this bowl)

PROVENANCE Heirloom & Howard Ltd, London, 1985

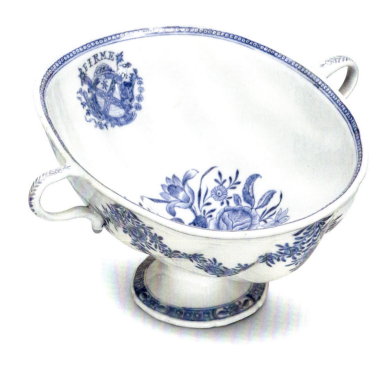

58.
PLATE WITH ARMS OF SYKES

Qianlong period (1736–95), c. 1755
9 in. (22.9 cm) diameter

From one of two services (the other *grisaille*) meticulously copied from a fine, signed bookplate in the high rococo style, this plate was made for Richard Sykes of Sledmere House in Yorkshire where much remains on display in a magnificent dining room. Sykes was a merchant in the Baltic trade who also ordered a slightly earlier service through the Swedish East India Company. His letters to Gothenburg in the 1750s anxiously inquire "if the fleet from Sweden has arrived" and "if there is any china on board" for him. He extensively renovated the house at this time, and a detailed inventory of 1755 records "53 dozen plates" of blue and white 'china' amongst other shapes, though the decoration not specified. —A.H.

REFERENCES Howard 1974, p. 583 (this service) and p. 383 (Sykes impaling Hobman service for quotations from the letter books at Sledmere); Howard 2003, p. 232 (*grisaille* service); Howard 2013–14, pp. 59–60 (discussion and dining room at Sledmere House)

PROVENANCE Heirloom & Howard Ltd, London, 1981; Christie's London, 8 June 1981, lot 200 (part)

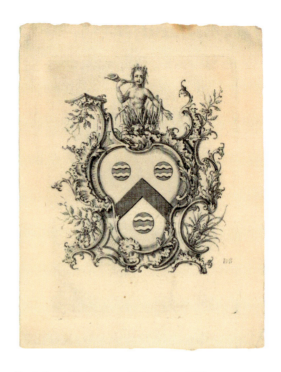

Bookplate with the arms of Sykes, signed WS [William Stephens] (Franks Collection 28722), David S. Howard collection

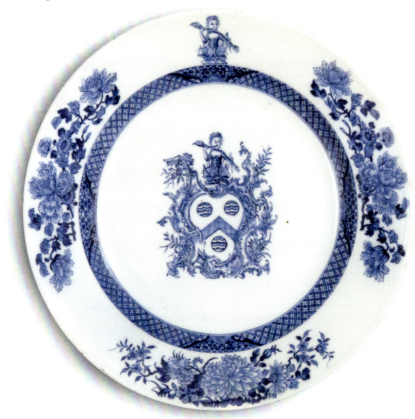

59.
DISH AND SAUCEBOAT WITH STAND WITH ARMS OF GREVEN AND GRONARDT ACCOLLÉ

Qianlong period (1736–95), c. 1750–60
13 ¾ in. (34.9 cm) diameter (dish);
8 ½ in. (21.6 cm) long (stand)

A distinctive inner border of peony heads with scrolling, leafy stems reserved on a dotted blue ground encircles the arms on this dish and is repeated on the sauceboat foot and stand. The arms of Casparus Greven and Anna Jacoby Lea Gronard(t) are shown against asymmetrical rococo mantling in the center. Casparus and Anna were married in Batavia some time between 1750 and 1758. A large portion of their dinner service—including five tureens with stands, many plates and saucer dishes and a cruet set—remained together until it came to auction in New York in 1984.

REFERENCES Sargent 2012, p. 375; Kroes 2007, pp. 191–93

PROVENANCE Sotheby's New York, January 1984, lot 102 (dish). James Galley, Lederach PA, 2002 (sauceboat and stand)

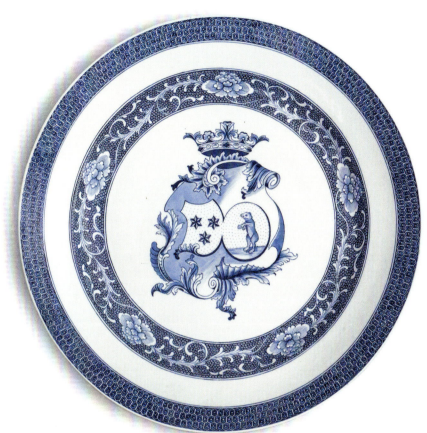

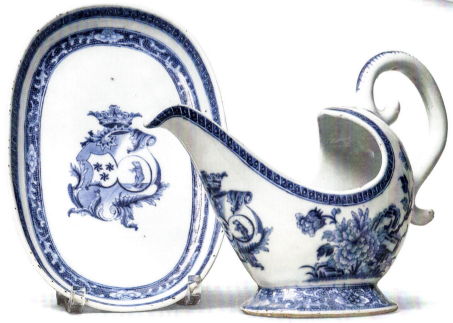

60.
PLATE AND BASIN WITH ARMS OF THE GROTE FAMILY AND SAUCER DISH WITH ARMS OF PRESCOTT IMPALING LONG

Qianlong period (1736–95), c. 1775
9 ⅛ in. (23.2 cm) diameter (plate); 11 ¼ in. (28.5 cm) wide (basin); 11 ½ in. (29.2 cm) diameter (dish)

These dishes, linked by their unique border design, were ordered for three directors of the same financial company. In 1766 George Prescott of Theobalds Park in Hertfordshire formed a London banking partnership with Andrew Grote, a former Hamburg merchant from Bremen. By 1775 Prescott had died and his son, George William, had joined the firm, as had Joseph, son of Andrew Grote and Ann Adams. The octagonal plate was made for Andrew; the basin with the arms of Grote quartering Adams was for Joseph; and the saucer dish for George William who married Sarah Long. The unusual European border on the services may even derive from ironwork at the firm's premises in Threadneedle Street. —A.H.

REFERENCES Howard 1974, p. 603

PROVENANCE The collection of J.A. Lloyd Hyde, Old Lyme CT (plate). Heirloom & Howard Ltd, Wiltshire, 1999; the collection of E. Clive Rouse, Buckinghamshire (basin)

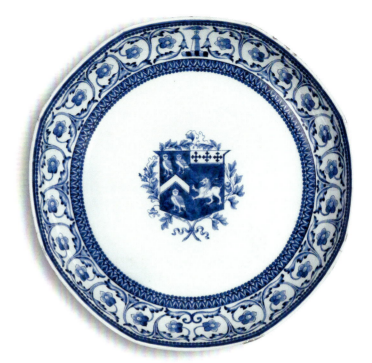

61.
VERY LARGE MUG WITH ARMS OF HUGHES

Qianlong period (1736–95), c. 1790
8 in. (20.3 cm) high

This massive mug is painted in front with the coat of arms of Admiral Sir Edward Hughes (1720–1794), Admiral of the Blue and commander-in-chief in the East Indies, flanked by supporters holding pennants and encircled by the motto of the Order of the Bath, the Hughes motto *FORWARD* below (its first 'R' rendered upside down and reversed). Sir Edward had a long and distinguished career, accumulating considerable wealth, much of which he gave to charity late in life. He was installed a Knight of the Bath in 1778. This mug—one of a set of three—was part of a large blue and white dinner service; a *famille rose* dinner and tea service was made a few years earlier.

REFERENCES Howard 1974, pp. 711–12; Christie's New York, 23 January 2007, lot 93 (the other two mugs); Howard 2003, p. 496 (*famille rose* service); Tudor-Craig 1925, p. 65 (illustration of the *famille rose* dinner service and matching Worcester dessert service).

PROVENANCE Heirloom & Howard Ltd, Wiltshire, 2020; Christie's New York, 23 January 2020, lot 140; the collection of Edward A. Eckenhoff, Washington DC; Heirloom & Howard Ltd, Wiltshire, 2008

62.
PLATE WITH ARMS OF DA SILVA

Qianlong (1736–95) to Jiaqing (1796–1820) period, late 18th century
9 ⅛ in. (23.2 cm) diameter

A chain of flowerheads borders the curving rim of this plate; in the center the arms of Silva are shown within a small oval; all show traces of gilt. The arms—probably taken from a seal or seal ring—show a galero with the three tassels of a canon on each side. Three Portuguese clerics have been proposed as the original owner of this service, but they were either of the wrong rank for its arms or the wrong era for its manufacture. The shapes used for its serving pieces clearly date to the late eighteenth century, and Manuel Joaquim da Silva (1744–1808) is a very likely candidate. He was a canon of Lisbon Cathedral before being ordained a bishop in 1793, providing a potential *terminus ante quem* for the service.

REFERENCES Howard and Ayers 1978, p. 382 (this plate); Pinto de Matos 1998, pp. 186–87 (vegetable tureen)

PROVENANCE Sotheby's New York, 30 January 1985, lot 237; the collection of Mildred and Rafi Mottahedeh, New York

63.
A MAZARINE PLATTER WITH ARMS OF METGE QUARTERING LYON

Qianlong period (1736–95), c. 1785
11 ⅛ in. (28.2 cm) wide

In a most unusual design, this large platter (its accompanying strainer is not shown) is painted with a large figure of Justice standing on a column initialed *PM*, supporting the shield with her right hand and holding the Scales of Justice aloft in her left. The platter is from a dinner service made for Peter Metge, an Irish politician, judge and baron of the Irish exchequer of Huguenot origin. Like the Caulfeild dish opposite (no. 64), Metge's chain of office is used as a unique border.

REFERENCES Howard 1974, p. 604

PROVENANCE Ralph M. Chait Galleries, New York, 2011

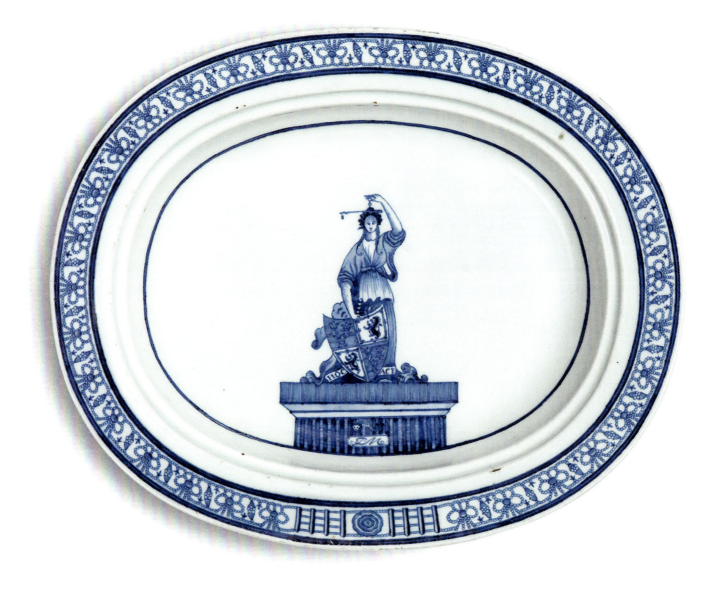

64.

PLATTER WITH ARMS OF CAULFEILD

Qianlong period (1736–95), c. 1785
13 in. (33 cm) wide

The dinner service for Irish Statesman James Caulfeild, created Earl of Charlemont in 1763, follows a similar concept to the Metge service opposite (no. 63). The earl was a founding knight of the Order of St. Patrick in 1783 and the border design of this fine service is copied from the collar of the order, with the badge itself pendant from the upper rim. The unusual heraldic style, with its whimsical and oversized dragon supporters, is from a design by Charles Catton the Elder, RA, coach-painter to King George III; his book *The English Peerage* was illustrated with the arms of the English nobility drawn in similar vein and published in 1790. —*A.H.*

REFERENCES Howard 1974, p. 604

PROVENANCE Elinor Gordon, Villanova PA, 1980; Sotheby's New York, 8 November 1980, lot 632

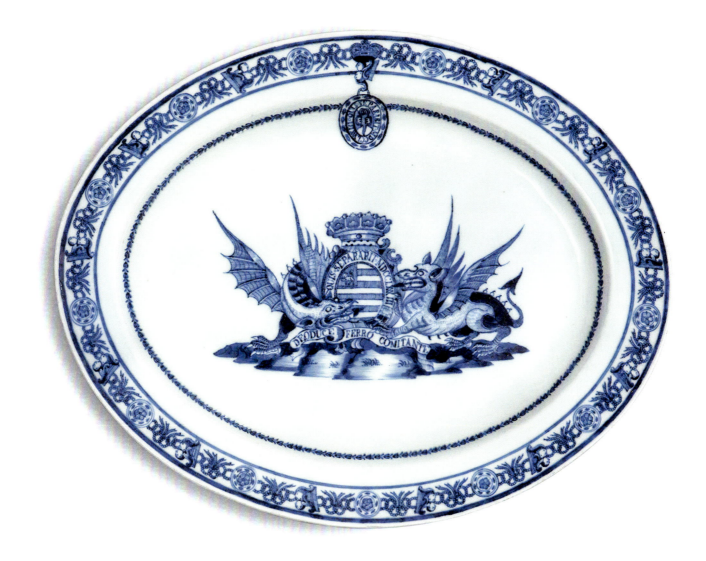

65.
BIDET WITH CREST OF ROBERTS

Jiaqing period (1796–1820), c. 1800
20 ½ in. (52.1 cm) long

This most utilitarian yet rare of armorial objects was made for one of the most important characters of the East India Company in the later eighteenth century, John Roberts of Bonington (1738–1810). His paschal lamb crest is in the center of the bidet, which is decorated in the 'Fitzhugh' pattern. Roberts was almost continuously a director of the Company between 1764 and 1808, being chairman in 1776 and 1802. A large matching table service has this crest, while two enameled services display his full arms with those of his wife; a service was also made for his daughter and her husband, while an earlier one of circa 1738 was ordered by his father. Roberts resided in Macao for many years where he had a second family by the name of Johnson, who eventually inherited his English estates and all the porcelain. —*A.H.*

REFERENCES Howard 1974, pp. 269, 664, 698, 717, 976; Howard 2003, p. 540; Howard 1997, p. 125 (a non-armorial bidet)

PROVENANCE Heirloom & Howard Ltd, Wiltshire, 1990

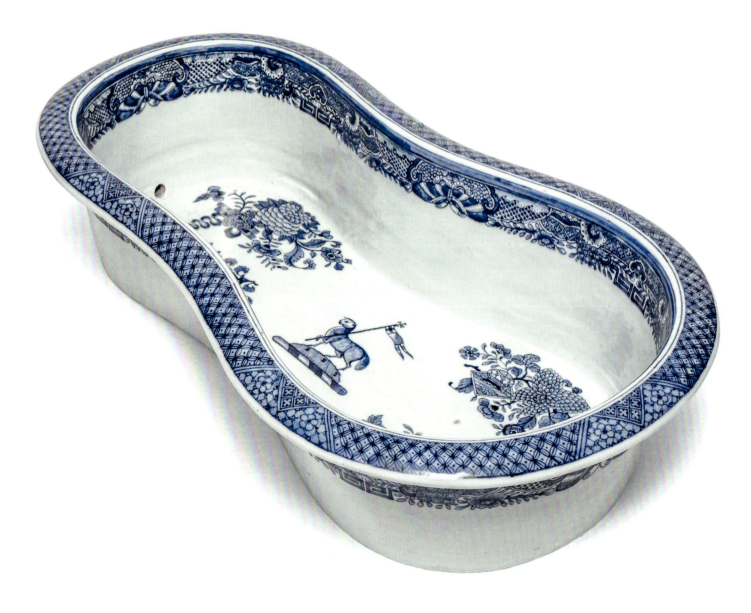

66.
LARGE DISH WITH ARMENIAN MONOGRAM

Qianlong period (1736–95), c. 1780
15 ⅝ in. (39.7 cm) diameter

Of octagonal outline with an inner and outer border of diaper trellis edged in spearheads, this dish is in the style of numerous porcelains made for the British and American markets in the last two decades of the eighteenth century. But, most unusually, in its center is an Armenian monogram within a heart. At this time Eastern Armenia was ruled by Persia (Iran) while Western Armenia was part of the Ottoman Empire. Many Armenians settled in Constantinople (Istanbul), where some were involved in the China trade, while there was also a large Armenian diaspora in Europe. The identity of the Armenian who commissioned this dish—undoubtedly part of a dinner service—has not been discovered.

REFERENCES Manginis 2012, pp. 14–16; Chong 2016, pp. 54–55 (late 17th- to early 18th-century Safavid dish with Armenian monogram)

PROVENANCE Jan-Erik Nilsson, Stockholm, 1987

67.
WELL-AND-TREE PLATTER INSCRIBED 'MNMEHTA'

Guangxu period (1875–1908), c. 1900
17 ½ in. (44.4 cm) wide

This dish bears the name of Merwanjee Nanabhoy Mehta (1857–1928), a Parsi from Mumbai (Bombay) who settled in Kolkata (Calcutta) and started importing goods from China to India; his trading empire later extended from Europe to Japan. He established offices in Guangzhou (Canton) in 1897 and at the time of his death was said to be one of the wealthiest men in the Raj. His service represents the continuity of a very long tradition of ordering personalized porcelain in China and may also have served to advertise his business. The reverse bears an oval inscribed *TAOK LOONG*, possibly for a retailer in Mehta's network. —*A.H.*

REFERENCES Mukharji 2019 (M.N. Mehta story)

PROVENANCE Heirloom & Howard Ltd, London, 1988; Sotheby's London, 1 November 1988, lot 539

68.
TWO PLATES INSCRIBED 'PRESENTED BY FUNG PAK-LIU'

Guangxu period (1875–1908), c. 1900
8 ⅝ in. (21.9 cm) diameter

Fung Pak-Liu (d. 1943) was a teacher who with partner Li To-Ming, owner of a porcelain shop, founded a company in Guangzhou (Canton) in 1906 to trade rattan, porcelain, silk and other Chinese goods with the West. Li & Fung is today a global conglomerate, with Pak-Liu's grandson as its chairman. In 1881 Dr. G.H. Bateson Wright was appointed headmaster of Central School in Hong Kong (later Queen's College), a prestigious secondary school for the Chinese community; Arthur Winbolt Brewin was Hong Kong's Secretary of Chinese Affairs who retired in 1912; his name lives on in the Brewin Trust Fund for Hong Kong widows and orphans. These identically decorated plates—each part of a set and painted in a bright cobalt blue with a typical Chinese riverscape—must have been commissioned by Fung as thanks for support he had received from two mentors. A 'Canton *famille rose*' plate in the Peabody Essex Museum is similarly inscribed, reading *Mr. R.S. White/July 1906/From Loo Chung Hung*.

REFERENCES Li & Fung n.d., paras. 1–2 (company history); Sargent 2012, pp. 270–71 (related *famille rose* pieces and references); Howard 1974, p. 58; Howard 2003, p. 685 (another Wright piece from this collection and another related *famille rose* piece)

PROVENANCE The Chinese Porcelain Company, New York, 2006; Sotheby's New York, 7 April 2006 (Wright). Heirloom & Howard Ltd, Wiltshire, 1990; Phillips London, 7 November 1990, lot 158 (Brewin)

3.
FOR THE TABLE

A large proportion of the Chinese porcelain that made its way to Southeast Asia, India, the Middle East and Europe was used for the serving and eating of food. Chinese blue and white elevated the banquets of princely Renaissance Europe and of Ottoman sultanates; it graced the tables of great canal houses in Amsterdam and of grand country houses in England. And as Chinese export porcelain was increasingly made to order in the seventeenth and eighteenth centuries, its forms became more and more reflective of dining customs in its far-off destinations.

Variations in food practices had a direct effect on the shapes of porcelain made at Jingdezhen for export. In Europe, we can point to a wide assortment of factors that played into an evolving cuisine: factors as diverse as the printing press (for the dissemination of recipes), social wealth and political stability (for the establishment of kitchen routines) and, of course, the global maritime trade (which brought new ingredients).[1] The availability of spices, salt and sugar played a huge part, and exotic Asian foods not only provided new taste sensations but also served to display geopolitical reach, wealth and status. Sweet oranges that had traveled all the way from Japan to Goa and then on to Lisbon were among the delicacies reserved exclusively for the royal Portuguese court.[2] Annemarie Jordan Gschwend quotes an Italian visitor to the court of King João III (r. 1521–57) who noted, "Not even Roman banquets of antiquity had so many products brought from such distances."[3]

A global spice trade had existed long before the development of the European sea routes to Asia, but the long and difficult journeys from their origins (mostly in Indonesia) to Europe meant that spices were extremely expensive. Venetians monopolized this early trade, which came via a combination of Islamic merchants in the Indian Ocean and overland routes.[4] Contrary to the oft-told tale, spices were not sought because Westerners were facing rancid meat.[5] Salt and vinegar had long been known as preservatives, and those wealthy enough to afford the exclusive spices were also wealthy enough to obtain fresh meat.[6]

But spices were used both to flavor food and to perfume rooms, linens and clothing. Ginger, musk, cinnamon and other aromatics could be placed in special pierced containers, like the gold pomander ball shaped as a pomegranate and enameled in pink and white that belonged to Catherine of Austria (1507–78), Queen of Portugal after her marriage in 1525 to King João III.[7] The extremely high prices in Europe for pepper, cloves, nutmeg, cardamom, cinnamon and other spices from Asia did ease as they began arriving directly on Portuguese and then Dutch ships, but they were still costly imports. By the seventeenth century, the use of exotic spices in the cuisine of prosperous households was so pervasive that the VOC (Dutch East India Company) spice trade became crucial to its profits.[8]

Salt also remained expensive in the early modern period. Obtained in numerous places around the globe from sea water or from the underground deposits of ancient seabeds, salt was a necessity for human health as well as for food preservation.[9] It was taxed and regulated in many nations, including in China where the salt tax was an important revenue stream for the Imperial government.

Sugar, more a pleasure than a necessity, hailed originally from the islands of the South Pacific and was first refined in India. It thrived, Europeans discovered, in

climates like that of the Caribbean and Madeira. Carried to continental Europe as crude crystals, it was refined largely in the Dutch Republic, which by the 1660s was supplying more than half of Europe's sugar.[10] Far more versatile than the honey it supplanted, sugar was not only a key ingredient in European cookery, flavoring savory dishes as well as dried fruits and nuts and elaborate desserts: it was also used—fortified with wax, plaster or cloth—to form elaborate sculptures for the banquet table, like the "triumph of sugar, representing a ship, finely worked with its decks and inner rooms in fullest detail" that was presented to Cosimo III de' Medici, Grand Duke of Tuscany, at a dinner in Amsterdam in 1678.[11]

All of these prized ingredients—spices, salt and sugar—were offered in special containers on the European dining table. In elite households, these containers were often formed of precious materials. Catherine of Austria had a small rock crystal elephant from India mounted with a medieval salt cellar from her mother's collection.[12] Leading artists were commissioned to design precious salts which survive today either as objects or in drawings, like those of Benvenuto Cellini, Giulio Romano and Hans Vredeman de Vries.[13] So naturally, once Chinese porcelain became available, this desirable material was also used. Salt cellars were among the Chinese porcelain looted by the Dutch from Portuguese ships in 1621, and had already been mentioned as worthy forms to order from China in a VOC memorandum of 1607.[14] Early VOC orders also included small mustard pots. Mustard, made from ground mustard seed and vinegar, was particularly popular in the Dutch Republic.[15]

European glass and metalwork inspired most of the forms that were ordered from China for seventeenth-century dining. Shapes were conveyed through drawings or via carved wooden models, as noted in several 1630s VOC orders.[16] These wooden models must have been crucial, as the Dutch had no Chinese base at this time but were working from Batavia (Jakarta) or, for a time, from Taiwan, and thus had to rely on Chinese middlemen—often the 'pirates' or unsanctioned traders of the powerful Zheng family—in order to obtain goods from Jingdezhen. And Chinese potters were accustomed to following foreign models, since they had been doing so for their Southeast Asian, Indian and Iranian trade since the fourteenth century.[17]

Food practices in the Islamic world occasioned different requirements. Large dishes with curving sides were used to serve grand meals in palaces from Istanbul (Constantinople) to Indonesia, where common delicacies were skewered meat, a mix of sweet and savory tastes, flatbreads and spicy stews.[18] These large dishes were used both to hold the hot stews, kept warm with domed metal covers, and also to hold small bowls of individual foodstuffs. By the fourteenth century, when the Jingdezhen kilns began producing blue and white, a highly developed trading network was already in place between the Middle East and China, facilitated by Muslim merchants.[19] This trade included large celadon and white-glazed dishes, which in due course were superseded by Yuan and Ming blue and white as found in the fabled kitchens of the Ottomans' Topkapı Palace.[20]

As the seventeenth century progressed, and especially once the Jingdezhen kilns were revived by the Kangxi emperor in 1684, the repertoire of Chinese porcelains made for the European table regularly included small jugs, butter dishes, bowls, flasks, beakers, mugs and basins with ewers.[21] But the most basic of all dining requirements was for plates and dishes. Cynthia Viallé quotes the 1607 VOC memorandum, which reads: "Furthermore, a batch of fine wares, flat and large like our country's pewter plates which are used daily at table." And later, "… a batch of coarse flat wares can be brought … which are so large that a Dutch cheese can be carried on one to table."[22] Archaeological evidence shows us that small sets of Chinese porcelain dishes and also of bowls were in use in more prosperous seventeenth-century households and not only in the Dutch Republic. Dishes of similar pattern to some Dutch finds have been located in datable contexts in places as far-flung as Lisbon, the Middle East, Indonesia and New Spain.[23] By the end of the century and in the first decade or so of the eighteenth century a special European order of Chinese porcelain for the table would very likely comprise matching sets of plates and larger dishes.

It was not until the 1730s that large porcelain dinner services featuring numerous tureens and other covered serving dishes began to be ordered routinely from Chinese kilns. This new array of serving pieces reflected a new complexity in cooking that was sweeping Europe. Emanating from the influential French royal court, the new cuisine emphasized sauces and casseroles, with

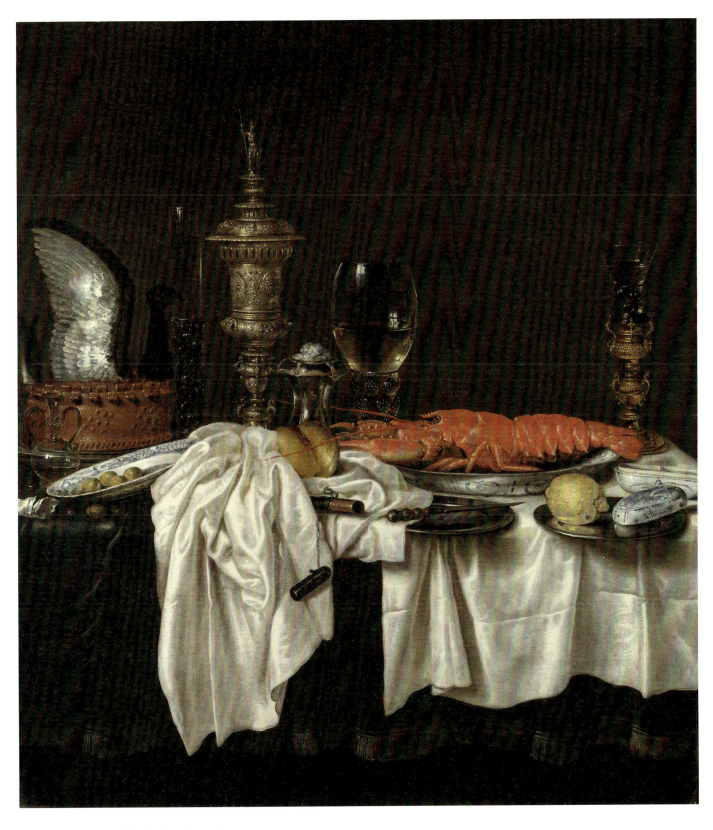

Willem Claesz. Heda, *Still Life with a Lobster*, oil on canvas, 1650–59, National Gallery, London

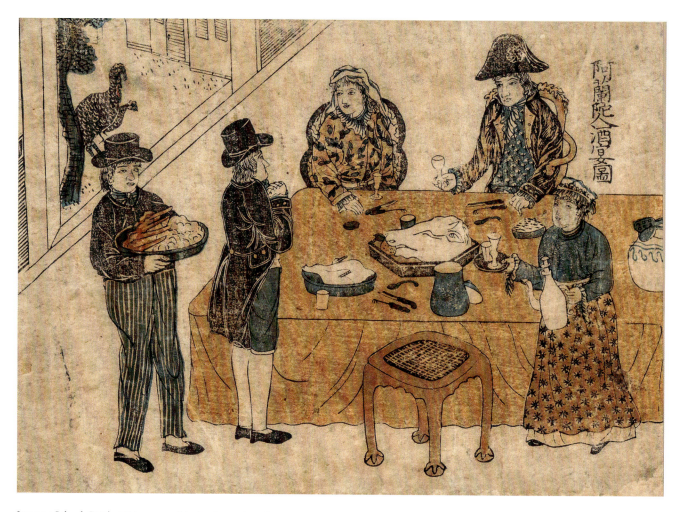

Japanese School, *Dutch at Dinner*, woodblock print, early 19th century, Frelinghuysen collection

more subtle and natural flavorings than the heavily spiced foods of the late Renaissance. A small group of mid-seventeenth-century French chefs had inspired this revolution, led by François La Varenne, whose 1651 cookbook *Le Cuisinier françois* set down the new practices in print.[24]

Before this new cuisine developed, wealthier households had very occasionally owned dinner services of more than just flat dishes, like the 1573 faience set of Duke Albert V of Bavaria, which included salts, candlesticks and a cooler, or the 1665 silver set of the Count of Oldenburg, which included posset pots, ewers and candlesticks.[25] But it was when the new French cookery took hold, changing dining practices throughout Europe, that the large dinner service with numerous serving receptacles, all in a matching pattern, became de rigueur for wealthy households.

By this time the VOC, which had entirely dominated seventeenth-century European trade with Asia, had been joined by trading ventures from England, France and Sweden, while the Portuguese and the Spanish also remained active. Wealthy households in all these countries ordered dinner services, the shapes of their pieces usually following European silver or faience and evolving over the decades as design trends changed. In some cases it was regional differences in either taste or dining practices that dictated shapes: for example, rococo forms were favored much longer in Portugal than in England.[26]

The eighteenth-century Chinese porcelain dinner service for a European order could include several hundred pieces, typically comprising at least sixty dinner plates, twenty-four soup plates and twenty platters of various sizes as well as sauceboats, salts, serving bowls,

and multiple sauce and soup tureens. A grander service might include candlesticks, fruit baskets, strawberry dishes, centerpieces and bottle coolers.[27] Regardless, the most imposing pieces were the soup tureens. Soup tureens were first made in silver in the 1690s to accommodate the soups and casseroles of the new cuisine.[28] Indeed, *Le Cuisinier françois* listed fifty-eight different soups.[29]

The wealthiest patrons might commission a service with special order decoration, perhaps their coat of arms or a favored European subject. But the East India Companies also carried back large numbers of assorted pieces in fashionable generic patterns. This porcelain was auctioned in Amsterdam or London to 'china' wholesalers who would compose appealing combinations of pieces of matching pattern to sell on as services.[30]

The Frelinghuysen collection includes a remarkably comprehensive array of pieces made for the dining table, including a notable number of early salts (nos. 69–71), mustard pots (no. 73), spice boxes (nos. 74–76), cruet jugs (nos. 80–81) and pickle dishes (no. 95). Numerous plates and chargers range in date from late Ming to the twentieth century, representing different eras, different markets and different tastes. The collection's many tureens (nos. 86, 88–93 and 379–381) allow us to follow the evolution of European taste through the decades of the eighteenth century, right up to pre-Victorian England with the unusual graduated set made in the form of George IV or William IV silver (no. 96).

1 Chilton 2019, pp. 13, 19, 84.
2 Crespo and Gschwend 2018, pp. 17–18.
3 Crespo and Gschwend 2018, p. 20, where Gschwend quotes Giuseppe Bertini's *O Livro de Cozinho de Maria de Portugal e a cozinho de corte em Bruxelas e em Lisboa ao tempo das suas núpcias com Alexandre Farnese*.
4 Toussaint-Samat 1994, p. 505.
5 Finlay 2010, p. 271.
6 Toussaint-Samat 1994, p. 110.
7 Crespo and Gschwend 2018, p. 25.
8 Corrigan, Van Campen and Diercks 2015, p. 66.
9 Toussaint-Samat 1994, pp. 457–78, for a brief history of salt in human life.
10 Aronson n.d.a, p. 1.
11 Finlay 2010, p. 272.
12 Crespo and Gschwend 2018, p. 39.
13 Ibid., p. 170.
14 Van Campen and Eliëns 2014, pp. 42, 44.
15 Crespo and Gschwend 2018, p. 172.
16 Canepa 2019, p. 309.
17 Jörg 1997, p. 252.
18 Carswell 2000, pp. 23–24.
19 Ibid., p. 59.
20 Finlay 2010, pp. 152–56, and Hart 2015, p. 23.
21 Sargent 2012, p. 76.
22 Viallé 2014, p. 42.
23 Ostkamp 2014, pp. 53–85, for a comprehensive discussion of archaeological finds and many shipwreck finds.
24 Chilton 2019, p. 13.
25 Lunsingh Scheurleer 1974, p. 110.
26 Chilton 2019, pp. 85, 89.
27 Jörg 1989, p. 252.
28 Chilton 2019, p. 40.
29 Ibid., p. 33.
30 Jörg 1997, p. 252, for the VOC; Howard 1994, pp. 30–31, 33, for the British East India Company practice.

69.
PAIR OF HEXAGONAL SALTS

Wanli period (1573–1620), c. 1610
5 ⅞ in. (14.9 cm) high

These salts are among the earliest European forms made at Jingdezhen for export, derived from a European silver salt model first made in the 1580s. Their hexagonal sides are painted with landscapes, flowering plants and ribbon-tied symbols above stepped bases applied with lion masks and short curving feet. The salts mentioned in a VOC (Dutch East India Company) memorandum of 1607 were likely of this type. Dutch silver hexagonal salts are depicted in a 1600 Dutch engraving and a 1627 Dutch painting; the form was also made in tin-glazed earthenware. A 1548 Portuguese inventory cited by Denise Leidy and Maria Antónia Pinto de Matos lists a "salt cellar from India in fine porcelain [that] is valued at 100 reis," though its design is not specified. The recorded Chinese porcelain examples of this model vary slightly in decoration, some with auspicious animals or vases of flowers instead of landscape and flowering plants. All would likely have been used with a small liner to hold the expensive commodity.

REFERENCES Victoria and Albert Museum (C.566-1910) (very similar salt); Canepa 2016, pp. 294–97 (Dutch and Chinese works of art and discussion); Corrigan, Van Campen and Diercks 2015, pp. 149–50 (very similar salt and VOC orders); Leidy and Pinto de Matos 2016 (very similar salt and Portuguese inventory)

PROVENANCE Heirloom & Howard Ltd, London, 1984

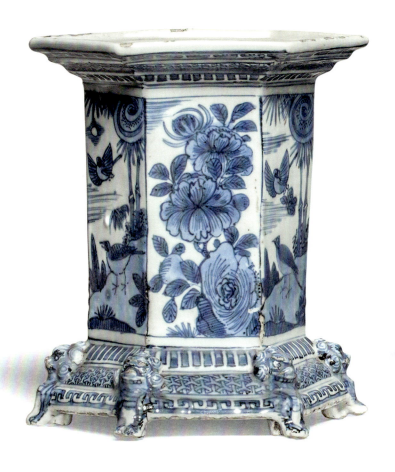
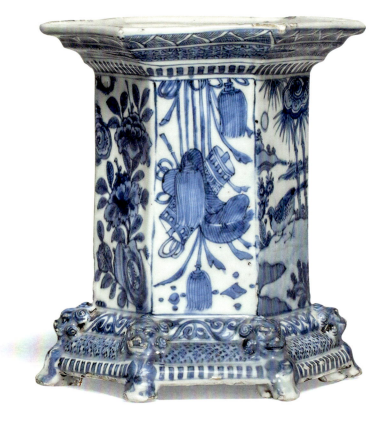

70.
TRIANGULAR SALT

Chongzhen period (1628–44), c. 1635–40
5 ⅞ in. (14.9 cm) high

The standing salt was an imposing and important feature of the Renaissance dining table— made in precious materials like gold, rock crystal and enamel—and that tradition continued into the seventeenth century, when Dutch silversmiths took the form to its apex. This rare porcelain model seems to have been inspired by a small group of large, triangular silver salts made in Amsterdam circa 1600. Paintings that depict these salts include the famous *Sense of Taste* by Peter Paul Rubens and Jan Brueghel the Elder (1618), a still life by Pieter Claesz (c. 1627), and *Breakfast Still Life* by Maerten Boelema de Stomme (1642). Like this porcelain salt, the silver examples have three legs topped by ball finials and they rest on three ball feet. Two of them include a small silver-gilt classical figure standing on the dome shape at bottom center. In the porcelain salt here the dome is simply topped by a rounded finial. A very similar salt, with slightly varying decoration but likely made in the same mold, is in the collection of the Peabody Essex Museum in Salem. It seems to be the only other recorded example of this form.

REFERENCES Corrigan, Van Campen and Diercks 2015, pp. 149–51 and Sargent 2012, pp. 76–77 (very similar salt); Jörg et al. 2003, p. 18 (salt with closed sides; Groninger Museum 1988.0041)

PROVENANCE Heirloom & Howard Ltd, Wiltshire, 2013; Polly Latham Asian Art, Boston

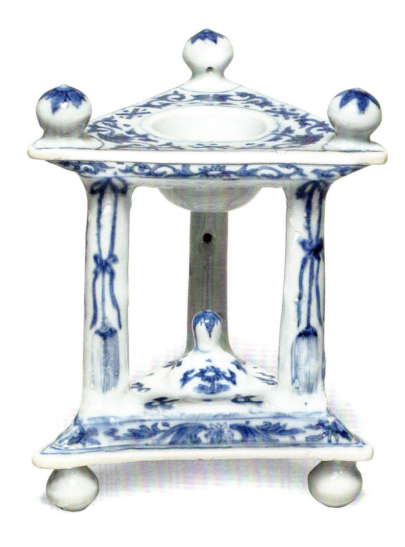

71.
PAIR OF FOOTED SALTS

Qianlong period (1736–95), c. 1740–60
4 ½ in. (11.4 cm) high

These salts are formed as rimmed, circular bowls decorated with continuous garden scenes showing flowering plants and willow trees. A patterned band borders the rims of the bowls, which are raised on unusual tripod bases deeply grooved to simulate wood grain and painted in inky cobalt blue. A small group of Chinese salts in this somewhat eccentric form (with slightly varying decoration) is recorded, all derived from Meissen porcelain. Round, rimmed salts with baroque scroll pedestal bases were designed for the very grand Sulkowski service made at Meissen 1735–38.

REFERENCES Litzenburg and Bailey 2003, p. 219 (Reeves collection example); Vinhais and Welsh 2014, pp. 78–79 (identical model); Sotheby's London, 6 March 2001, lot 43 (Sulkowski prototype)

PROVENANCE Heirloom & Howard Ltd, London, 1980 (one). Sotheby's New York, December 1992, lot 271 (one)

72.
TWO PAIRS OF SALTS

Kangxi (1662–1722) to Qianlong (1736–95) periods,
c. 1765 (the second)
3 ¼ in. (8.3 cm) wide, each

The first pair is modeled with dished tops shaped as fruits and issuing leaves which form an irregular rim, all supported on a pedestal base with molded lotus-petal border. The second pair is oval with galleried rims holding separate porcelain inserts after a silver model. Together, the two pairs demonstrate the change in European taste over the decades of the century, as exuberant and naturalistic ornament gave way to a more restrained neoclassical taste.

REFERENCES Victoria and Albert Museum (170-1893) (single closely related to the first); Groninger Museum (2021.0352.A) (pair near identical to the second)

PROVENANCE The Chinese Porcelain Company, New York, 1990 (oval pair)

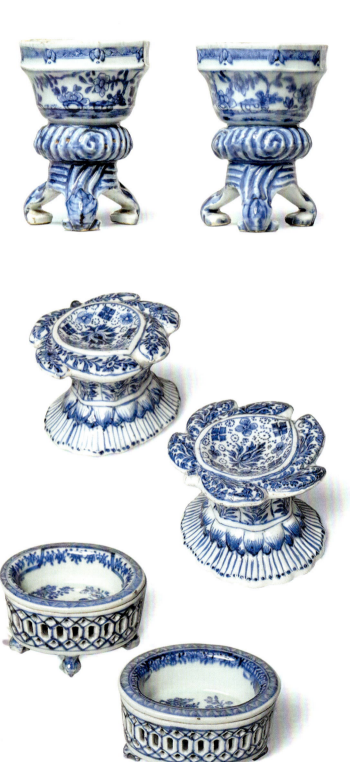

73.
PAIR OF MUSTARD POTS

Chongzhen period (1628–44), c. 1635–40
5 ¾ in. (14.6 cm) high

The globular bodies of these pots are decorated with roundels of Chinese fishermen or farmers, while gadroon borders encircle the shoulders and the bases. Mustard pots were among the first large commercial orders of the VOC, which provided wooden models to the Chinese merchants in 1635 and 1638. Teresa Canepa illustrates a Dutch tin prototype of circa 1575–1625; they were also made in European earthenware. A number of Chinese porcelain examples were made, some decorated with Transitional-style narrative scenes and others with roundels of either auspicious animals or figures. Mustard pots were salvaged from the Hatcher Cargo of 1643–46; they were often given silver mounts in Europe. Mustard pastes made from ground seeds were known in the ancient world—including in China—and were in common use in Europe by the Renaissance era.

REFERENCES Canepa 2019, pp. 308–12 (two with variant decoration); Canepa 2016 (closely related pot and tin pot); Howard and Ayers 1978, pp. 56–57 (closely related pot); Sheaf and Kilburn 1988, p. 58 (Hatcher Cargo pots)

PROVENANCE The Chinese Porcelain Company, New York, 1993

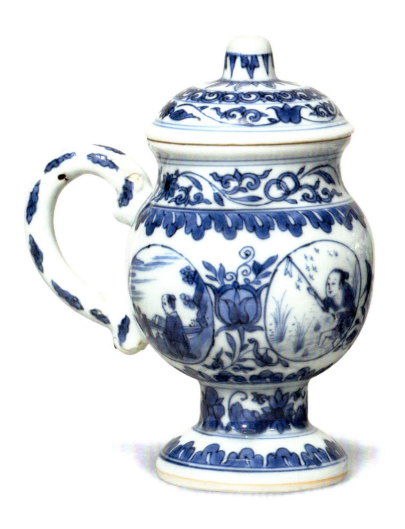
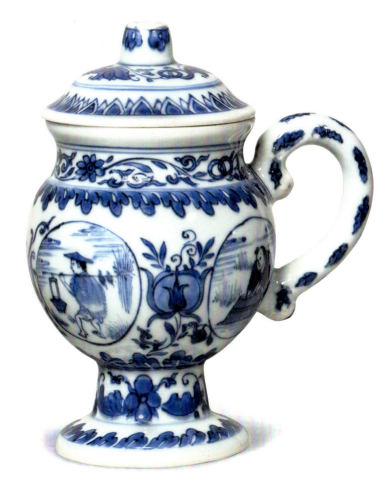

74.
PAIR OF SPICE BOXES

Kangxi period (1662–1722)
5 ¼ in. (13.3 cm) wide

Spices drove much of the early European China trade's profits, and naturally these costly luxuries were offered in special containers at the table. Corrigan, Van Campen and Diercks illustrate a Dutch silver ship-form spice box of circa 1600 inscribed in Dutch on its side, "When maritime commerce flourishes, thanks to God's blessing, it feeds many mouths and brings triumph to our country …." This oval porcelain pair has two inner compartments, one further divided, so that each box can hold small quantities of three different spices. They are painted in typical Kangxi style with slender stems bearing a variety of flowers. Their separately made covers are pierced to take the later metal hinges and modeled with gadroon edges after European silver.

REFERENCES Corrigan, Van Campen and Diercks 2015, pp. 66–67; Vinhais and Welsh 2014, pp. 60–61 (near-identical pair); Royal Collection Trust (RCIN 50223) (French silver spice box c. 1702–14 of very similar form)

PROVENANCE Heirloom & Howard Ltd, Wiltshire, 2016; AAG Auctioneers, Amsterdam, 11 April 2016, lot 135

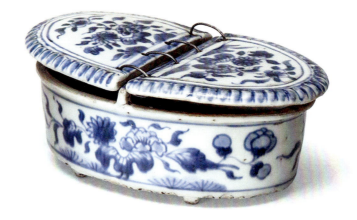

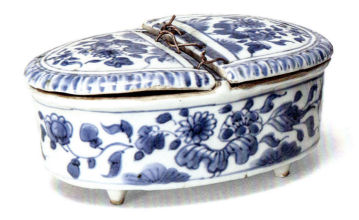

75.
COMPARTMENTED SPICE BOX

Kangxi (1662–1722) to Yongzheng (1723–35) period, c. 1720–30
4 ⅜ in. (11.4 cm) wide

This oval box has rounded sides above a short pedestal foot. It is 'penciled' on each side with stems of lily; the lilies are repeated on the cover below an unusual squirrel knop. Slightly more refined than the earlier pair in the previous entry, this box also opens to two compartments, one of which is further divided into two. This box and the pair in the following entry demonstrate that the practice of serving spices in this way continued for several decades into the eighteenth century.

REFERENCES Metropolitan Museum of Art (1982.127) (very similar box, lacking cover)

PROVENANCE Heirloom & Howard Ltd, Wiltshire, 2022; Drove House Antiques, Wiltshire, 2022

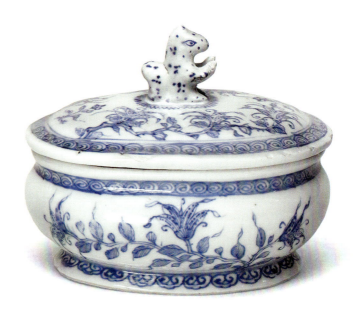

76.

PAIR OF TRIPLE SPICE BOXES

Yongzheng (1723–35) to Qianlong (1736–95) period, c. 1730–40
5 ¼ in. (13.3 cm) wide

The remarkable shape of this pair of spice boxes is derived from prototypes produced by the French ceramics factories at Saint-Cloud and Rouen in the 1720s and '30s. Each body is in three petal-shaped sections and supported by three animal paw feet; the conforming cover is surmounted by a basket-form knop. Spice boxes of this model were made for the extraordinary Chinese dinner service ordered for King Louis XV of France in the 1730s and decorated with his royal arms. The collection of Benjamin F. Edwards III included a French royal triple spice box, the same model with floral decoration in colored enamels, a European faience version and one of the blue and white boxes here.

REFERENCES Rondot 1999, p. 160 (French faience models); Christie's New York, 26 January 2010, lots 20–22 (Benjamin F. Edwards III examples)

PROVENANCE Heirloom & Howard Ltd, Wiltshire, 2018; Bukowskis, Stockholm, 7–8 December 2018, lot 910 (left). Heirloom & Howard Ltd, Wiltshire, 2010; Christie's New York, 26 January 2010, lot 21; the collection of Benjamin F. Edwards III (right)

77.
TWO PORRINGERS

Kangxi period (1662–1722)
6 ⅛ and 5 ½ in. (15.6 and 14 cm) wide

Of squat rounded form with ring foot and brown-washed, slightly everted rim, each porringer is decorated with flowering vine and set with a single shaped handle, one flat with a pierced pattern and the other open at the center. While this shape is most often associated with European pottery, there were metalwork bowls of similar profile with single flange handles made in China from at least the Song dynasty (960–1279) and in ceramics from the Yuan dynasty (1279–1368).

REFERENCES Sotheby's London, 14 May 2008, lot 107 (Yuan metal prototype); Ashmolean Museum (EA1956.1326) (Song ceramic prototype)

PROVENANCE Edward Sheppard, New York, 1983 (top). The Chinese Porcelain Company, New York, 1990 (bottom)

78.
PAIR OF ECUELLES AND COVERS

Kangxi period (1662–1722)
5 ¾ in. (14.6 cm) wide

The lightly molded sides of these bowls are flanked by flat, pierced handles and edged in a band of blue trellis pattern; their covers are decorated to match and with flat knops. Each has the incised Augustus the Strong inventory mark N54 with triangle (the symbol used for white wares). Bowls of this model were used to serve bouillon, which was often taken at breakfast in the period; their covers would keep the broth warm.

REFERENCES Staatliche Kunstsammlungen Dresden (PO 847) (near-identical bowls); Chilton 2019, p. 137 (bouillon drinking)

PROVENANCE Peter Mack Brown Antiques, Washington DC, 1984

79.
TWO FOOTED BOWLS AND COVERS

Kangxi period (1662–1722)
5 and 5 ⅝ in. (12.7 and 14.3 cm) high

The first bowl has loop handles, its rounded cover and body decorated with panels of cross-hatched fruiting boughs; the second flange handles, its more upright bowl and slightly domed cover painted with Transitional-style tulips. Christiaan Jörg illustrates several two-handled covered bowls of this scale, noting that while they are often called sugar bowls they may well have held sticks of cinnamon (or indeed other condiments).

REFERENCES Jörg 1982b, p. 63 (jug in pattern of first); Jörg 1982b, p. 62 (very similar to second); Jörg 1997, pp. 111, 173 (cylindrical versions)

PROVENANCE Kee Il Choi, Jr., New York, 1987 (smaller). van Halm & van Halm, London (larger)

80.
PAIR OF DOUBLE-NECKED CRUET JUGS

Kangxi period (1662–1722), c. 1700–10
8 ¼ in. (21 cm) high

The pear-shaped bodies of these cruets are painted on each side with an abundantly flowering tree; narrow (slightly differing) borders are at the foot and mouth; one has European metal mounts. The interiors are divided so that each jug could serve both vinegar and oil. The short-lived Medici factory of Florence made a blue and white double-necked cruet jug in soft-paste porcelain around 1575–87, and Venetian glass factories were producing them by the second half of the seventeenth century. By that time the form—used in its earliest incarnations for holy water and wine—had become commonplace on the more prosperous dining tables of the Netherlands, France and Germany.

REFERENCES Metropolitan Museum of Art (79.2.319) (cruet in this pattern); Jörg 1997, p. 257 (cruet of similar form); Victoria and Albert Museum (5759-1859) (Medici porcelain cruet); Lu 2012, pp. 118–19 (discussion)

PROVENANCE Navin Kumar Gallery, New York, 1987 (one). Kenneth R. Brown Antiques, Allentown NJ, 1990 (one)

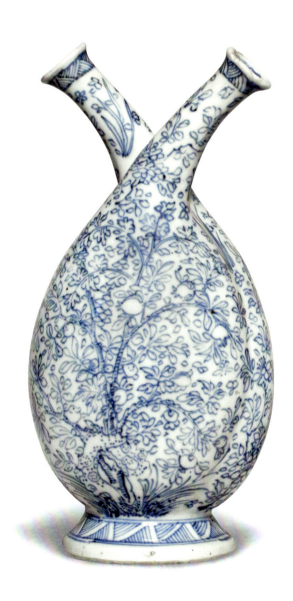
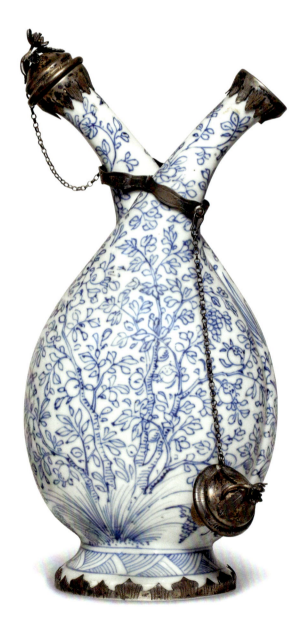

81.

FOUR-PIECE CRUET SET WITH MATCHING STAND

Yongzheng (1723–35) to Qianlong (1736–95) period, c. 1735–40
8 ⅝ in. (21.9 cm) high

The set comprises three slender baluster vessels with spouts, two of them with loop handles, and a shorter baluster jar. Each has a cover (the jar cover mismatched) and is raised on a short pedestal foot; they fit into a two-level fitted porcelain stand with wood supports and wood pedestal base. The jars and the top tier of the porcelain stand are each painted with a continuous riverscape, small boats on the water and a pagoda visible in the distant hills. Cruet sets of two or three small jugs on a conforming porcelain tray were made fairly regularly in export porcelain of the first half of the eighteenth century; larger sets are rare. A 'Chinese Imari' set with six rounded jugs on a circular porcelain tray was in the collection of Benjamin F. Edwards III. Interestingly, a Japanese lacquer stand of similar model, its two-level round tray with a central pole handle, was made in the first quarter of the nineteenth century to hold a Dutch glass decanter set, quite possibly for a patron in Japan, where foreign objects were often prized at the time.

REFERENCES Pinto de Matos 2019, no. 229 ('Chinese Imari' set); Christie's New York, 20 January 2004, lot 23 (Benjamin F. Edwards III example); Jörg 1993–94, p. 10 (Japanese lacquer decanter stand, now in the Suntory Museum, Tokyo)

PROVENANCE Heirloom & Howard Ltd, Wiltshire, 1991; Sotheby's London, 5 November 1991, lot 40

82.

TWO EARLY PLATES

Wanli period (1573–1620), c. 1600
8 and 8 ¼ in. (20.3 and 21 cm) diameter

Blue and white plates of this size and form were a widespread export product of the Jingdezhen kilns in the Wanli period. They have been found in sites ranging from Macao to Acapulco to Amsterdam; they were clearly in demand for dining around the world. The first depicts two deer under pine trees, a composition found within various borders in the period. A more unusual scene of houses among trees and plants decorates the second. The houses are shown in two rows derived from the Chinese painting tradition of flattened vertical depictions.

REFERENCES Canepa 2019, pp. 96–97 (very similar to first); Canepa 2016, pp. 138–39 (variant bordered deer plates); Metropolitan Museum of Art (44.14.1) (Wanli landscape dish)

PROVENANCE Sands of Time Antiques, Washington DC, 2011 (deer). Heirloom & Howard Ltd, Wiltshire, 2011 (houses)

83.

PLATE WITH DUCK POND

Kangxi mark and period (1662–1722)
8 ¼ in. (21 cm) diameter

A peaceful scene in the center of this plate shows two ducks swimming on a pond with overhanging grasses and waterweeds in the foreground. The rim is painted with various trees in an inky blue; on the back rim are four clumps of flowering plants or grasses with a six-character Kangxi mark in the center. Both Asian and Islamic cultures generally used dishes with curving rims at the table; all of these flat-rim plates were most likely intended for Western markets, and it is unusual to find the model with an Imperial reign mark.

PROVENANCE Heirloom & Howard Ltd, Wiltshire, 2014

84.
TWO OCTAGONAL PLATES AFTER EUROPEAN SILVER

Qianlong period (1736–95), c. 1745–50
7 ¾ in. (19.7 cm) diameter

Unusually modeled with flat glazed bases and crimped piecrust rims, these small plates are directly derived from European silver models made in both France and England in the first half of the eighteenth century and also widely produced in Whieldon ware. The bases show twelve tiny spur marks; they would have been fired on supports in the kiln to prevent the flat bottoms from sticking. Decorated with similar floral borders, one depicts two Chinese figures in a garden and the other a Chinese riverscape. Each is part of a set of six.

REFERENCES Kips 2019 (similar and spur marks discussion); Groninger Museum (1992-0082) (near identical to left)

PROVENANCE EastWest Gallery, Dorset, 2011 (with figures)

117

85.
PLATE WITH GARDEN SCENE

Kangxi period (1662–1722)
8 ¼ in. (21 cm) diameter

This plate is painted with an edge to edge garden scene showing two Chinese ladies standing beside weathered rocks, one holding a hoe and the other a sprig of flowers. Two tables at their side hold food dishes and a flower vase, while a maple tree hangs overhead. On the base is a twin fish mark; two flowering boughs decorate the back rim. This wide, flattened shape is derived from the European pewter plates in common use in the period; the tall, elegantly coiffed Chinese ladies, called *Lange Lijzen* (Long Elizas) in the Dutch Republic, were a very popular export subject.

REFERENCES Jörg 1997, p. 255 (closely related plate and discussion)

PROVENANCE Heirloom & Howard Ltd, Wiltshire, 2018; Oriental Art Europa, London

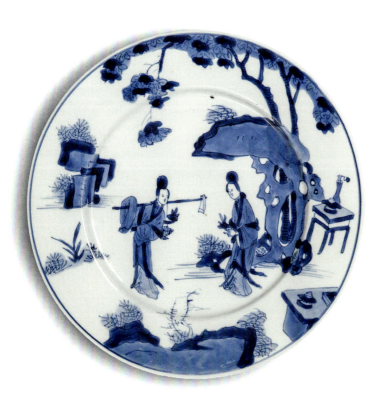

86.
SHIP'S TUREEN

Kangxi period (1662–1722), c. 1720
16 in. (40.6 cm) diameter

The body extending to a fixed stand, this tureen has a domed cover with large button knop above, decorated with a symmetrical arrangement of large lotus blooms issuing leafy peony sprigs and within trellis borders. A very small number of ship's tureens were made in Chinese porcelain, designed to remain steady onboard a rocking ship. The model was made slightly more often in Japan. See no. 283 for an example in a Japanese porcelain dinner service.

REFERENCES Groninger Museum (1996.1240 and 1979.0027) (this model in Japanese porcelain)

PROVENANCE The collection of David S. Howard, Wiltshire, 1991

87.
DISH COVER

Yongzheng period (1723–35), c. 1730–35
11 in. (27.9 cm) diameter

Very few dish covers (also called meat covers) were made in Chinese export porcelain. The silver models they were derived from undoubtedly proved more practical for keeping the contents of large dishes warm. David S. Howard illustrates two crested dish covers made circa 1726, noting that the form was only made for a short period in the 1725–35 period and that it was "[p]erhaps the rarest form in the porcelain dinner services made in China" Later in the century, a Chinese porcelain dinner service made for Dom Gaspar de Saldanha de Albuquerque included several shaped dish covers in Chinese painted enamel. This example is decorated inside with two large blossoming boughs and a central flower sprig roundel.

REFERENCES Howard 1997, p. 104 (armorial); Vinhais and Welsh 2014, p. 88 (*famille rose* and silver gilt)

PROVENANCE Heirloom & Howard Ltd, Wiltshire, 2009

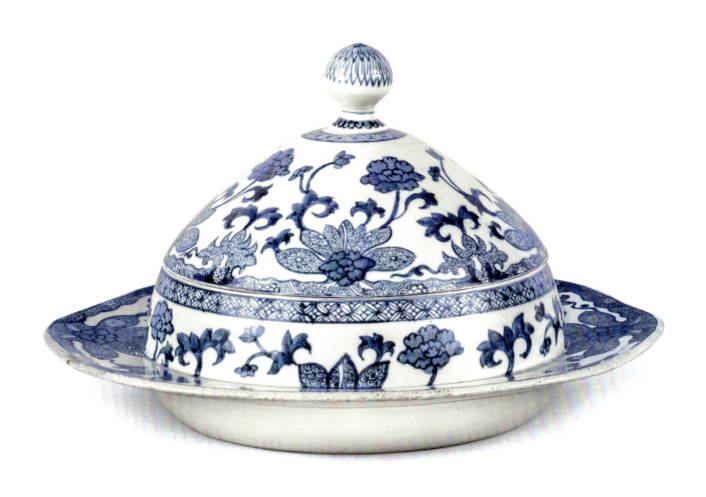

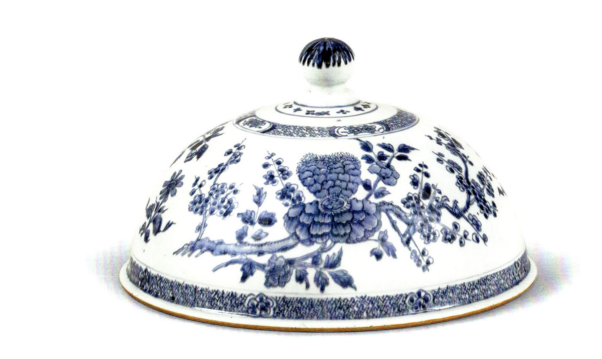

119

88.
SNAKE-HANDLED TUREEN

Yongzheng period (1723–35), c. 1730
12 ⅞ in. (32.7 cm) wide

Like much export porcelain of the second quarter of the eighteenth century, this tureen is modeled after Rouen faience which, in turn, was derived from a silver form. Shallow, with a shaped oblong outline, the tureen is finely painted with clusters of flowers, bamboo and willow within diaper-pattern borders. Its most distinctive feature is a knop in the form of a partially coiled snake. The shape is also known in *famille verte* enamels but never seems to appear with matching plates or serving pieces; these tureens may have been made as stand-alone pieces rather than as part of large dinner services.

REFERENCES Howard and Ayers 1978, pp. 552–53 (*famille verte* example); Beurdeley 1962, p. 173 (*famille verte* with underdish)

PROVENANCE Heirloom & Howard Ltd, Wiltshire, 1992; the collection of Dennis Roach, Los Angeles

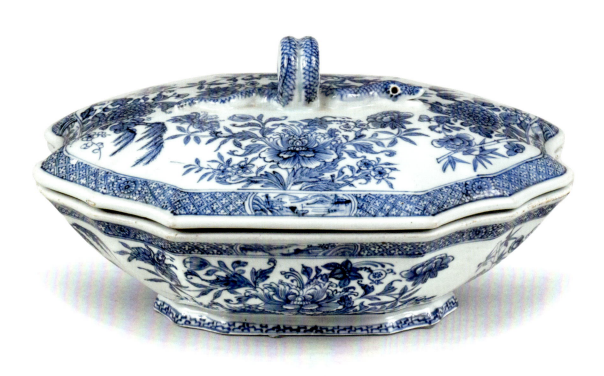

89.

TUREEN WITH BOAR-HEAD HANDLES

Qianlong period (1736–95), mid-18th century
16 ¾ in. (42.5 cm) wide

Exuberantly modeled with projecting boar-head handles and curving dolphin legs, this tureen features molded asymmetrical rococo cartouches on each side painted with landscape views. The conforming molded-edge cover has a blue flower-bud knop and is painted with further mountainous landscape. A small number of porcelain tureens of this model have appeared on the art market; a closely related tureen base, but with scrolled legs, was published by Maria Antónia Pinto de Matos. They may have been part of one or two large dinner services. Their unusual model is derived from silver tureens by leading makers like Thomas Germain (1673–1748), who fashioned elaborate tureens to serve as the focal point of elite European dining tables.

REFERENCES Pinto de Matos 2019, no. 97 (very similar tureen base); Detroit Institute of Arts (59.18) (related Thomas Germain tureen c. 1733–34)

PROVENANCE Heirloom & Howard Ltd, London, 1982; Sotheby's London, 2 November 1982, lot 52

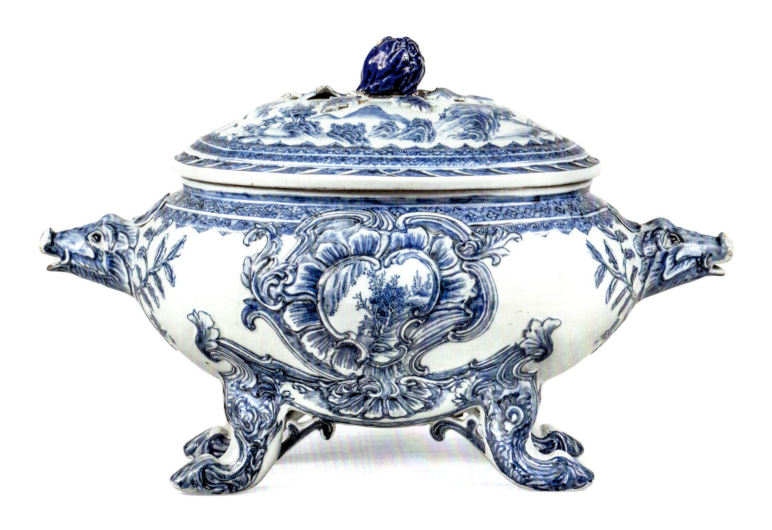

90.
ROCOCO TUREEN

Qianlong period (1736–95), c. 1755–75
15 in. (38.1 cm) wide

Of rococo form with molded scallop and ruffle borders and asymmetrical applied cartouche, this tureen has an unusual high blue knop in the shape of a pumpkin stem. It is painted with flower clusters and supported on four blue scroll feet. A small group of tureens of this somewhat extraordinary form is known, most in blue and white but several with coats of arms, at least one with gilt decoration and one in *rose camaïeu*. All are derived from faience models made in Germany, France or Sweden. Their eccentric covers have been referred to as *chapeaux chinois*.

REFERENCES Sargent 2012, p. 141 (near identical tureen with stand); Sargent 2014, pp. 252–53 (another)

PROVENANCE Heirloom & Howard Ltd, Wiltshire, 2014; Christie's London, 16 April 2014, lot 32

91.
TUREEN WITH CROWN KNOP

Qianlong period (1736–95), c. 1765–75
14 in. (35.6 cm) wide

Modeled after prototypes made at the Meissen factory in the 1730s and '40s, this tureen—like those in the preceding and following entries—reflects the growing influence of European ceramics on Chinese export porcelain of the eighteenth century. Meissen, where the manufacture of high-fired, hard-paste porcelain was first mastered in Europe, led ceramics fashion until the latter decades of the century, and both forms and decoration from Meissen were adopted in China. Here, a blue crown knop sits on a high shaped cover while handles are modeled as Native Americans with tall feather headdresses. The sides are painted in Meissen style with waterbirds in a European landscape.

REFERENCES Winterthur Museum (1992.0035) (*famille rose* version); Howard and Ayers 1978, pp. 551–52 (related model); Metropolitan Museum of Art (42.205.151 and 42.205.132) (Meissen prototypes)

PROVENANCE Heirloom & Howard Ltd, Wiltshire, 1993

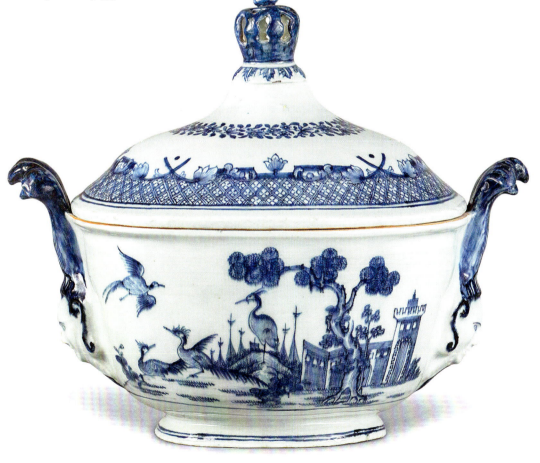

92.
PAIR OF SAUCE TUREENS WITH STANDS

Qianlong period (1736–95), c. 1780
9 in. (22.9 cm) wide (each stand)

Modeled after English creamware, these oval tureens and their matching stands are edged in openwork scallops. The sloping covers have large flower-sprig knops. Each piece is painted with a Chinese landscape showing a large riverside villa within border or ground of diaper trellis pattern. Wedgwood and others made baskets and reticulated vessels to show off the skill of their potters and the capabilities of their material. Here, we see a neoclassical European form that retains almost wholly Chinese decoration.

PROVENANCE Heirloom & Howard Ltd, London, 1979; Sotheby's London, November 1979, lot 71

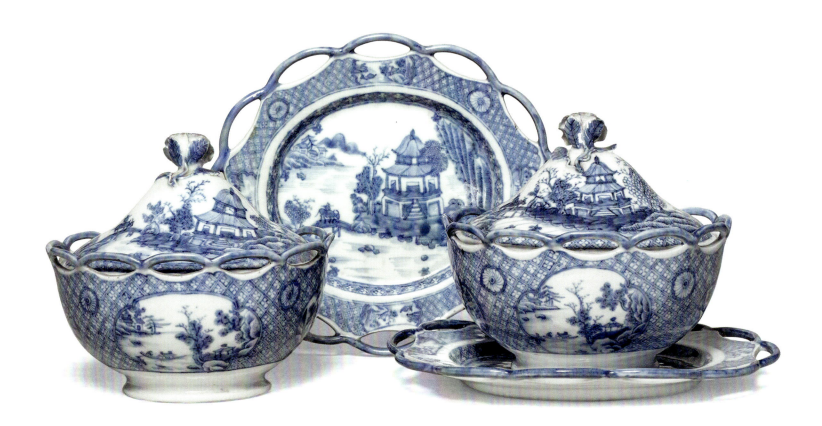

93.

GAME PIE TUREEN

Qianlong period (1736–95), late 18th century
10 ⅜ in. (26.3 cm) wide

The oval tureen is molded in high relief on each side with a pair of billing doves who rest on drapery suspended from molded ring handles at each end. Its cover is applied with a large rosebud-sprig knop. This kind of relief decoration is associated with the faience made at the Marieberg factory in Sweden in the late eighteenth century (see no. 168) and may, in turn, have inspired the oval caneware game pie tureens with molded decoration and rabbit finials made by Wedgwood and others in the nineteenth century.

REFERENCES Art Institute of Chicago (1912.297a-c) (Wedgwood game pie tureen)

PROVENANCE Heirloom & Howard Ltd, Wiltshire, 1990; Sotheby's London, 29 May 1990, lot 16

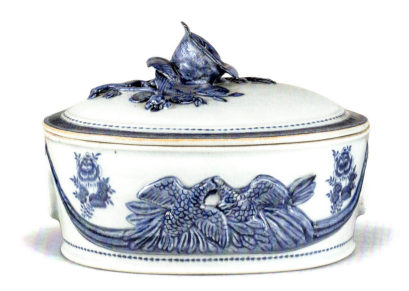

94.

BUTTER TUB

Qianlong period (1736–95), third quarter 18th century
4 ½ in. (11.4 cm) wide

Oval with fluted sides and cover, this butter tub has a pair of upright tab handles and a large blue knop in the unusual form of a reclining cow. David S. Howard suggests that the upright handles on butter tubs may imitate those on a wooden dairy bucket. Numerous butter tubs with whimsical knops were made in Delftware; they were sometimes made as part of Chinese porcelain dinner services. At least 235 were in the cargo of the East Indiaman *Geldermalsen*, sunk in 1751; they were in seven different design variations.

REFERENCES Jörg 1986, pp. 86–87 (*Geldermalsen*); Howard 1994, p. 134 (variant butter tubs); Sheaf and Kilburn 1988, pp. 35–37 (Nanking Cargo variants)

PROVENANCE Heirloom & Howard Ltd, Wiltshire, 1993

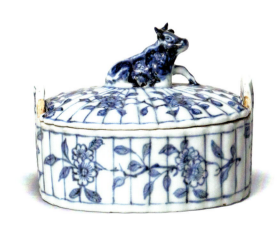

95.
PAIR OF DOLPHIN AND THREE-SHELL PICKLE STANDS

Qianlong period (1736–95), c. 1755–70
5 ¾ in. (14.6 cm) high

Each of these pickle stands consists of three shell-form dishes decorated with flower clusters and centered by a blue dolphin, his upturned tail serving as a handle. A small group of such stands was made in export porcelain, all derived from mid-eighteenth-century triple-shell examples made at Bow and other early English factories. They were made in both colored enamels and blue and white. Here, the decoration is floral like the Bow prototype; other blue and white examples are painted with landscapes.

REFERENCES Sargent 2012, p. 147 (very similar with landscape); Sargent 2014, p. 239 (*famille rose* version); Adams and Redstone 1981, p. 118 (Bow model); Smithsonian Institution (CE.70.597) (related Bow pickle stand)

PROVENANCE Heirloom & Howard Ltd, Wiltshire, 1991; Christie's London, 22 April 1991, lot 14 (one). Santos London, 2012 (one)

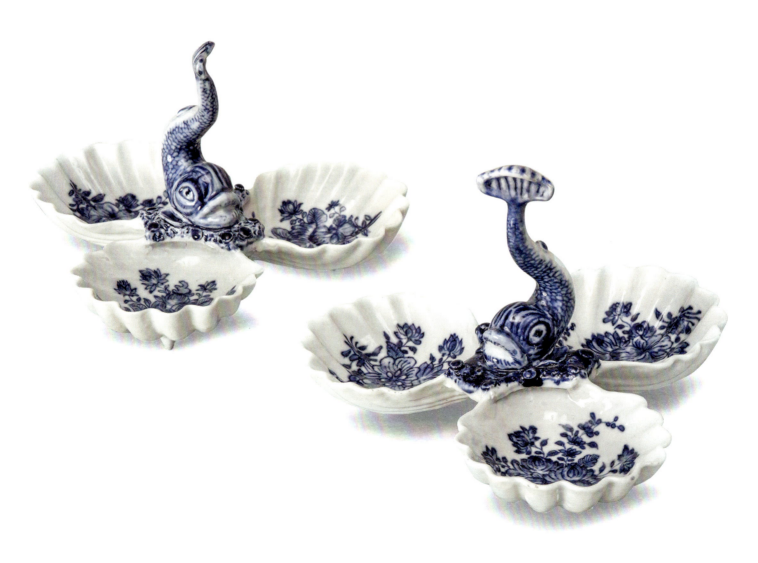

96.
SET OF SIX GRADUATED VEGETABLE TUREENS

Daoguang period (1821–50)
4 ¼ to 11 in. (10.8 to 27.9 cm) wide

Modeled after English silver entrée dishes with detachable handles, this unusual set of tureens has molded C-scroll handles and applied beaded borders in the style of George IV or William IV examples. The decoration on each cover is a continuous scene of the Pavilion of Prince Teng in Nanchang, a famous landmark erected in the Tang dynasty (618–907) and immortalized in an epic by poet Wang Bo (650–676). It was a particularly popular subject in Thailand, where metal rims like those on the two medium-sized tureens were also popular. Altogether, the tureens embody a fascinating mixture of English design, Chinese tradition and Thai taste.

REFERENCES Christie's New York, 29 March 2021, lot 138 (silver version by Paul Storr dated 1808)

PROVENANCE Sotheby's New York, 15 October 1993, lot 161; collection of Mrs. J.W. Griffith, Dallas; Marie Whitney Antiques, Tolland MA

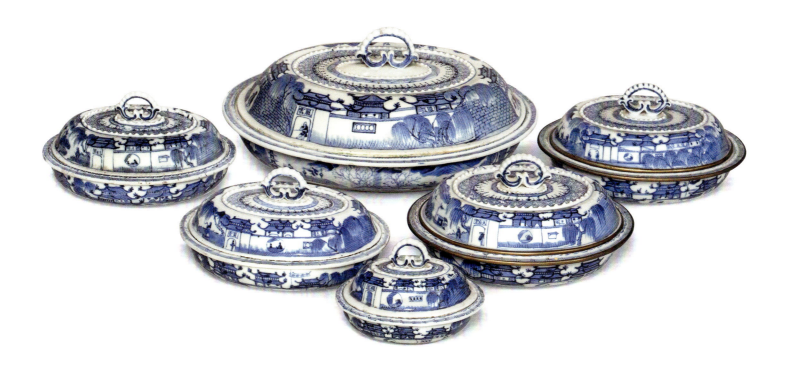

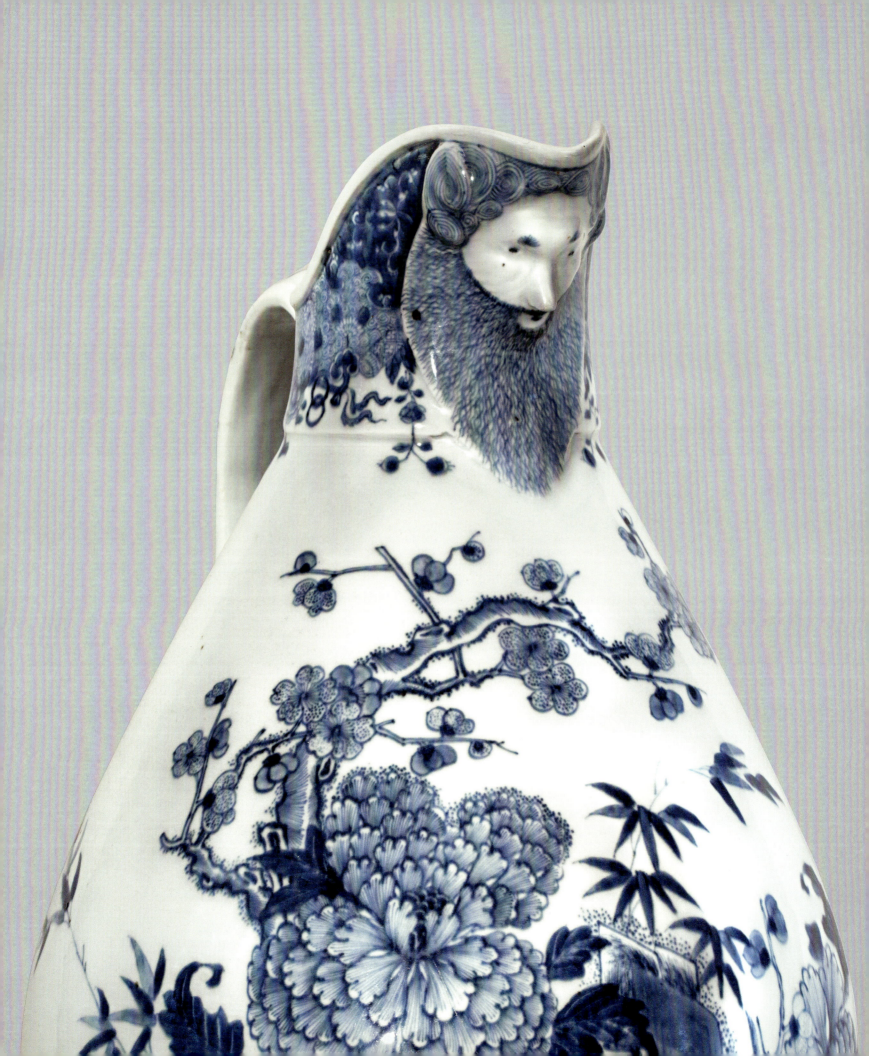

4.
DRINKING AND POURING

Blue and white vessels for liquids formed a significant part of Jingdezhen's export porcelain output. Ewers and jugs were among the earliest of these wares, some used to pour water for washing and some for the pouring of wine or other libations to drink. Then, in the first half of the seventeenth century, when European companies first began larger scale, commercial trade in Chinese porcelain, mugs, tankards and beakers comprised a good portion of their commissions. Later, as the tea, coffee and chocolate brought to the European world by global trade and cultural interchange took hold, vessels for the serving of these drinks were produced in great numbers in China, while tea itself, of course, grew to underpin the entire China trade. Punch, meanwhile, was the libation of choice for gatherings of European gentlemen from the late seventeenth century onwards, particularly in England and Scotland, and many magnificent punch bowls were made in Chinese export porcelain.

Pouring vessels with spouts were known in China in ancient times, and survive in some numbers in Tang (618–907) and Song dynasty (960–1279) ceramics.[1] But many of the shapes that much later became part of the standard export porcelain repertoire, like the *kendi* discussed in Chapter Twelve, grew out of the great mingling of Islamic and Chinese decorative vocabulary that developed during the Yuan dynasty (1279–1368). The Mongol rulers of the Yuan, the first non-native Chinese dynasty, practiced Tibetan Buddhism but had a nonsectarian outlook and recruited foreign Muslims for their Imperial government. Yuan emperors also facilitated trade and travel—and thus cross-cultural interactions—between China and Central Asia.[2]

The ritual ablutions practiced by Muslims before prayers, as well as a general reverence for cleanliness, led to an extensive use of ewers and their accompanying basins in Islamic lands. In the Western world, related Christian practices included baptism, foot-bathing and the sprinkling of holy water, while ewers and basins were used for washing in both the bedroom and dining room. Hand-washing was a crucial part of European dining, as the use of forks was not widely adopted until the early eighteenth century. With only spoons and knives as utensils, it was accepted practice to grasp food with the hands for cutting or for picking up. Even King Louis XIV (r. 1643–1715) ate with his hands.[3] Servants, standing nearby, would bring ewers and basins to the table for hand-cleaning between courses. At the Portuguese royal court, sumptuous ewer sets were placed on the sideboard for the ceremonial washing of hands before and after the meal, the '*água-às-mãos*'.[4] Even as this custom waned in the eighteenth century, ewers and basins continued to be provided in bedrooms for personal washing, many made of Chinese porcelain.

Jugs and ewers were also widely used to pour liquids to drink, and so were bottles.[5] While jugs and ewers made in Chinese porcelain tended to copy metalwork shapes, bottles—used for storing as well as pouring liquids—very often followed European glass models.[6] Goblets for the enjoyment of these drinks were first made in the Kangxi period (1662–1722) and were also modeled after European

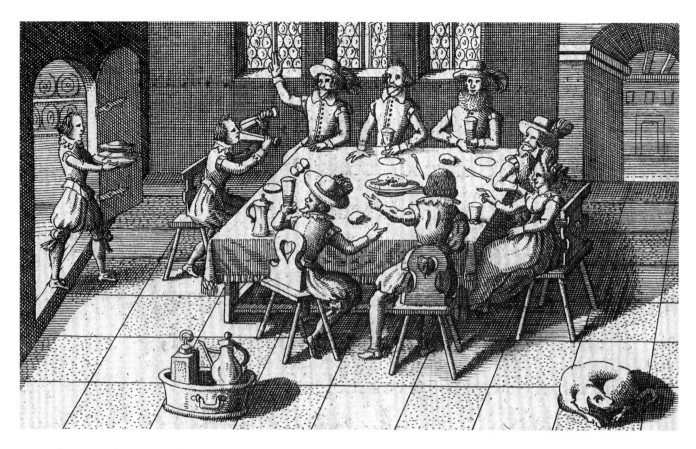

Peter Rollos I, *Men and a Woman Served a Meal,*
engraving, c. 1650, Private collection

glass shapes. Beakers shaped after European metalwork had been made earlier, as evidenced by the VOC (Dutch East India Company) orders for "drinck beeckers" in the 1630s.[7] Mugs and tankards for the drinking of beer were also inspired by their European metalwork counterparts.[8] Beer-brewing, like wine-making, was an ancient trade in many parts of the world, including in China. In medieval Europe, beer was served in relatively rough vessels made of pitch-coated leather, unglazed earthenware or wood. Even King James I of England (r. 1603–25) had on occasion used a wooden beer mug.[9] Eventually, in the seventeenth century, pewter mugs and tankards became common for all but the poorest households.

In China, blue and white porcelain mugs shaped after Central Asian metalwork were made for a time in the fifteenth century, but evidently were not popular and their production soon dwindled.[10] But in the seventeenth century, once the VOC became sufficiently established in Asia to commission special porcelain shapes, mugs and tankards were soon added to the Jingdezhen repertoire.

The fashion for tea-drinking that began to grow in seventeenth-century Europe and exploded in the eighteenth century had a direct effect on beer consumption. In England, tea overtook beer to such a degree by the middle of the century that brewers protested, and tin workers—whose livelihoods depended on the pewter mug and tankard trade—denounced the potteries that made tea wares. Chinese porcelain was, of course, the preferred material throughout Europe for the preparation, serving and sipping of the highly fashionable tea.

Tea had long been cultivated and enjoyed in China. A classic treatise on tea written by Lu Yu in the Tang dynasty covered the proper methods of cultivation, brewing and drinking of tea as well as its associated legends and history.[11] It was first imported to Europe commercially by the VOC in the early seventeenth century, but it remained a relatively rare commodity until the 1660s.[12] Like the exotic spices that had come before it, tea was initially only consumed in the most

Jug after Indian metalwork (no. 109)

elite households in Portugal and the Dutch Republic, shipped via Macao or Batavia (Jakarta).[13] The 1662 arrival in England of King Charles II's Portuguese bride, Catherine of Braganza, is often credited with bringing tea-drinking to England. It is worth remembering, too, that King Charles spent part of his exile in the household of his brother-in-law, William II, Prince of Orange, and would have been quite familiar with both tea and Chinese porcelain.

A few English merchants had imported tea from Holland in the 1650s; in 1657 the first London establishment to sell tea to the public opened.[14] Ten years later, the East India Company began importing tea directly from China and soon saw its commercial potential: in 1686 they noted, "as the Chyne Trade is becoming more promising, Teas and Spices are, in future, to form Part of the Company's Imports and not to be articles of Private Trade."[15] Towards the end of the seventeenth century, the English government took notice, exacting a specific import duty on dry tea, a tax that was later to increase dramatically and cause much grief in the American colonies. Nonetheless, by the end of the eighteenth century, tea comprised 60 percent of the East India Company's commerce. The English, who had traded from Xiamen (Amoy) since 1672, adopted the local word *tay* or *tee*, not the Mandarin *cha*, and that is the name that took hold throughout the Western world.

Meanwhile, the VOC continued to transship tea and other goods from their Batavia headquarters. But they watched with envy as both the English company and the Ostend company (which joined in the China trade in 1722) made highly profitable shipments of tea directly from China. In 1729 the Dutch managed to establish themselves at Guangzhou (Canton), and for the ensuing decades they enjoyed excellent commerce in both tea and tea porcelains. In 1751, for example, the VOC shipped more than two hundred thousand tea wares back to the Dutch Republic.[16]

Initially, the equipage at the European tea table was mismatched, as evidenced by numerous English family portraits of the late seventeenth and early eighteenth centuries. The teapot might be European silver or Yixing pottery and a hot water kettle brass or silver, while the sugar bowl and, especially, sets of teabowls and saucers were most often of Chinese porcelain. From the early 1720s, matching tea services were used, typically comprising a teapot, tea canister, sugar bowl, cream jug, waste bowl, spoon tray and a dozen teabowls and saucer; the larger pieces also had accompanying underdishes.[17] As with dinner services, the wealthiest patrons ordered special sets with their coats of arms or favored European subject decoration, while sets in generic patterns were made up by the various trading companies or European retailers.[18]

Chinese porcelain tea services were sometimes made with accompanying cups and pots for coffee-drinking and/or chocolate-drinking.[19] A single saucer could serve as underdish for either a teabowl, teacup or a coffee cup (typically a little taller) or indeed a chocolate cup (taller still, and often with a pair of handles).[20] A coffee pot was taller and narrower than a teapot, while a chocolate pot had a rounded lower body to accommodate the stirring of the sediment.

These two exotic drinks also came to Europe in the seventeenth century through the fast-developing global trade. As a 1659 London newspaper put it, "Theire ware also att this time a Turkish drink to be sould, almost in evry street, called Coffee, and another kind of drink called Tee, and also a drink called Chacolate, which was a very hearty drink."[21] Coffee-drinking was a

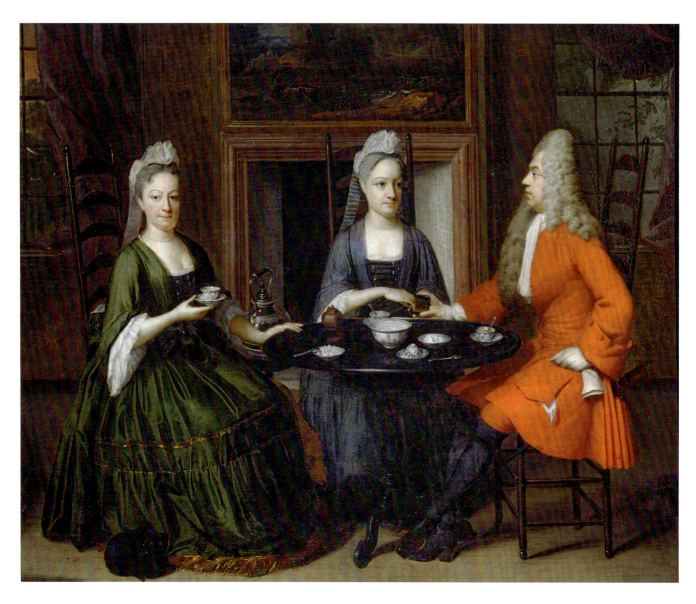

English School, *Two Ladies and an Officer Seated at Tea*, oil on canvas, c. 1715, Victoria and Albert Museum, London

long-established practice in the Muslim lands of Central Asia. Coffee beans were grown almost exclusively in Yemen until about 1690, when the enterprising Dutch managed to source some plants to cultivate in Sri Lanka (Ceylon) and Batavia. In the 1720s the French planted coffee in Martinique, and by the mid-eighteenth century the great coffee plantations of Brazil were underway. European travelers to Turkey may well have first brought home tales of coffee early in the seventeenth century. By the end of the century hundreds of coffeehouses thrived in cities across Europe, where tea and chocolate were also served. Excavations at the site of Clapham's, for example,

a coffeehouse active in Cambridge, England from 1765 to 1773, revealed thirty-eight teapots as well as teabowls and saucers and waste bowls.[22]

Chocolate-drinking came not from Asia, but from South America, traveling to Europe via the Spanish Empire, though this was not necessarily well understood by contemporary observers. In 1652 Captain John Wadsworth published a translation of an earlier Spanish work calling it *Chocolate; or, An Indian Drinke*. Wadsworth's book extolls the health benefits and curative powers of chocolate, and indeed all three drinks were first acclaimed for these kinds of properties—when

they weren't being decried as corrupting influences. While in South America chocolate was a savory drink used in Mayan and Aztec religious ceremonies, the Spanish sweetened it and added milk, sometimes flavoring it also with cinnamon and other spices, as they still occasionally do today. Special accessories for the enjoyment of hot chocolate, like silver-mounted coconut cups or Chinese porcelain *mancerinas*—large, shell-shaped *trembleuse* saucers to hold cups of various materials—were particularly favored in New Spain. Chocolate-drinking in general was much more prevalent within the Spanish Empire than elsewhere, and chocolate and coffee were both preferred to tea.

During the eighteenth century, tea-drinking gradually evolved from the elite practice it had been on arrival in Europe to a widespread custom increasingly associated with domesticity and the female realm. In the male world, punch-drinking was preferred. Punch also came to Europe from overseas; it originated in India, where it was encountered by British East India Company employees. Many believe the word 'punch' was derived from the Hindi word for five, *paanch*, because of its five key ingredients: citrus, sugar, spirits (rum or brandy), spices and water or wine.[23]

While beer and ale were for every day and gin— cheaply available from the Netherlands—was for the masses, gentlemen drank punch, often shared in clubs, taverns and various societies as well as in private homes.[24] Quaffed from goblets, punch was served in large, rounded bowls—very often made in Chinese export porcelain. Dedicatory and celebratory punch bowls suitable for these gatherings and societies could be commissioned from China, or one could order an extra-large bowl in the latest decorative style, as the example published here (no. 129).

Wine-drinking was an ancient practice in many parts of the world, including in China, where wine was most often made from rice, not grapes. In Europe, grape cultivation and wine-making were long-established by the seventeenth century and wine-drinking was widespread. Fortified wines, first made in Portugal in the second half of the century, became particularly fashionable among the elite in England. Wine accoutrements ordered in Chinese porcelain included goblets (nos. 118 and 382), funnels (no. 115) and monteith bowls (no. 120).

Drinking and pouring vessels from all of these eras and for all of these uses are represented in the Frelinghuysen collection, which has a particularly notable range of jugs of both Middle Eastern and European form (nos. 105–114) and a variety of mugs and tankards (nos. 97–98, 101–102 and 391–393) as well as bottles and beakers after European glass. In its teapots, coffee pots and other pieces for the tea table we see the evolution of styles across two centuries, as well as the varying tastes within the different foreign markets (including that of Thailand in Chapter Thirteen) of those who used Chinese porcelain for the enjoyment of these special drinks. Punch-drinking is represented by the unusually large bowl in the neoclassical taste discussed above as well as by the several finely painted armorial bowls in Chapter Two (nos. 40, 42–43 and 51), while the continuing importance of the tea trade is illustrated by a canister of monumental size dating to the late eighteenth century (no. 130).

1 Pope 1956, p. 87.
2 Leidy and Pinto de Matos 2016, p. 72.
3 Finlay 2010, pp. 265–67.
4 Crespo and Gschwend 2018, pp. 55, 144.
5 Jörg 1997, p. 31.
6 Ibid., p. 259; Leidy and Pinto de Matos 2016, p. 122.
7 Jörg 2016, p. 18.
8 Jörg 1997, p. 75.
9 Finlay 2010, pp. 262–63.
10 Lion-Goldschmidt 1978, pp. 91, 93.
11 Carpenter 1974, for an English translation of Lu Yu's *The Classic of Tea*.
12 Corrigan, Van Campen and Diercks 2015, pp. 237–38, 244.
13 Loureiro 1998, p. 57; Corrigan, Van Campen and Diercks 2015, pp. 236, 238.
14 Sargent 2012, p. 14.
15 Howard 1994, p. 14.
16 Jörg 1989, p. 44.
17 Ibid., p. 45.
18 Ibid.
19 Loureiro 1998, p. 118.
20 Jörg 1989, p. 45.
21 Finlay 2010, p. 273.
22 Hall 2015, p. 25.
23 Conroy n.d., p. 1.
24 Chilton 2019, p. 132.

97.
TANKARD WITH COVER

Chongzhen period (1628–44)
9 ⅜ in. (23.8 cm) high

Tankards—made to take covers, unlike mugs—were also among the first Dutch special orders of porcelain to export. Like their European pewter or stoneware prototypes, they were essentially cylindrical and taller than the rounded mugs. A tankard and cover in this same pattern but with ormolu rim mount and thumbpiece was memorialized by Dutch artist Willem Claesz. Heda (1594–1680) in his 1638 *Breakfast Still Life*; Corrigan, Van Campen and Diercks illustrate a very similar tankard with Dutch silver cover. This form is found more often with Transitional-style narrative decoration, but very rarely with original cover in any pattern. See no. 150 for a vase in this pattern.

REFERENCES Corrigan, Van Campen and Diercks 2015, pp. 264–67 (tankard and painting)

PROVENANCE Heirloom & Howard Ltd, Wiltshire 1990; Sotheby's London, 29 May 1990, lot 11

98.
TWO PEAR-SHAPED MUGS

Chongzhen period (1628–44)
7 and 6 in. (17.8 and 15.2 cm) high

Beer mugs of this European ceramic form were among the very first export pieces ordered by the Dutch East India Company at the start of their great commercial venture in the 1630s. Teresa Canepa quotes from a VOC (Dutch East India Company) letter of 3 July 1635 that specified "new and rare porcelains like beermugs," noting that it probably referred to this type. Most examples known have the paneled *kraak*-style decoration of these two, although a smaller number were made with Transitional-style figures or landscape. Shards of both types have been found at the Shibaqiao kiln in Jingdezhen.

REFERENCES Canepa 2016, pp. 295, 299–300 (very similar mug); Pinto de Matos and Kerr 2016, pp. 56–57 (similar mug with stoneware prototypes)

PROVENANCE Heirloom & Howard Ltd, London, 1987 (larger). Heirloom & Howard Ltd, London; the collection of Dennis Roach, Los Angeles (smaller)

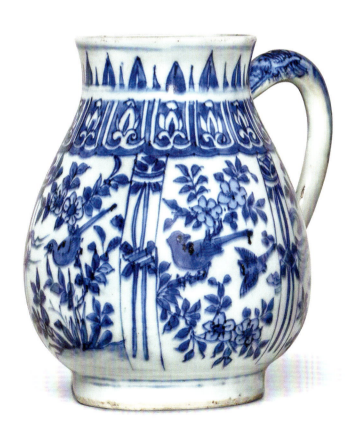
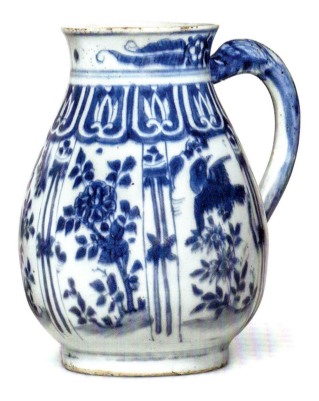

99.
TWO BEAKERS

Chongzhen period (1628–44), c. 1640
6 ¾ and 6 ⅛ in. (17.1 and 15.6 cm) high

Beakers (*drinck beeckers*) are mentioned in VOC (Dutch East India Company) letters of the 1630s; they were among the earliest European forms the Dutch requested from Chinese potters. Ordered in several sizes, they had unglazed inner rims to take covers. An example now in the Groninger Museum collection displays a similar form and closely related decoration to the two here, with formalized European-style borders of pendant vine and fruits derived directly from Dutch metalwork of the period. Printed pattern books used by silversmiths would have provided a convenient design source to accompany a wooden model or pewter prototype to China. Teresa Canepa illustrates a Willem Claesz. Heda painting of 1633 showing the silver model, noting that these beakers were sometimes used in Dutch churches to serve consecrated wine.

REFERENCES Jörg 2016, pp. 17–21 (silver and porcelain examples with discussion); Canepa 2016, pp. 301, 307 (silver prototype and painting)

PROVENANCE Heirloom & Howard Ltd, Wiltshire, 2019; Rob Michiels Auctions, Bruges, 27–28 April 2019, lot 994 (larger). Heirloom & Howard Ltd, Wiltshire, 2019; Rob Michiels Auctions, Bruges, 15–16 February 2020, lot 719 (smaller)

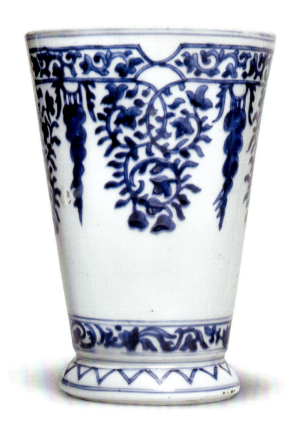
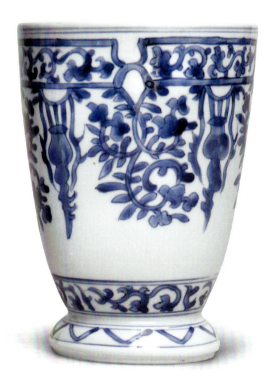

100.
TWO BEAKERS WITH COVERS

Kangxi period (1662–1722), c. 1690
8 ¼ in. (21 cm) high

Both beakers are of cylindrical form and designed to take a cover, the first having a high-domed cover and the second slightly domed. Each has a shaped knop and is decorated with a symmetrical arrangement of floral motifs. Beakers with covers of this type may have been used for hot drinks. They were made in some number in the period; the cargo recovered from an Asian vessel that sank off the coast of Vietnam circa 1690, known as the *Vung Tau* Cargo, contained at least two dozen of the second model.

REFERENCES Victoria and Albert Museum (C869&A-1910) (near identical to second); Christie's Amsterdam, 7–8 April 1992, lots 29–39 (*Vung Tau* Cargo examples)

PROVENANCE Santos London, 2012 (left). Heirloom & Howard Ltd, Wiltshire, 2011; Sotheby's New York, 25 January 2011, lot 104; the collection of Charles Ryskamp, New York; The Chinese Porcelain Company New York, 1995 (right)

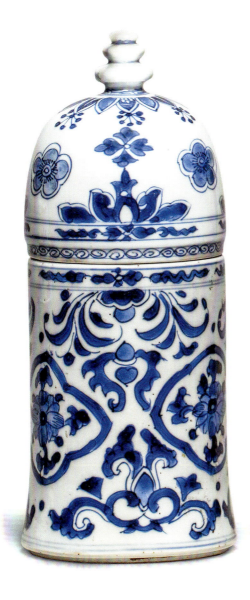
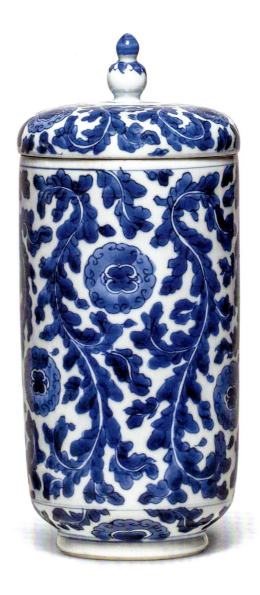

101.

THREE METAL-MOUNTED TANKARDS

Kangxi period (1662–1722)
6 ⅞, 6 ½ and 6 in. (17.5, 16.5 and 15.2 cm) high

Demand for beer mugs continued through the seventeenth century and into the eighteenth, as the survival of numerous examples attests. Yet they were still a foreign luxury product, reflected in the costly ormolu and silver mounts given to these examples. The first two are spiral-fluted; the third has a ribbed lower body glazed in *café au lait*. All of these decorative elements required more work of the potter, and would have added cost.

REFERENCES Musée National des Arts Asiatiques–Guimet (G1979+) (very similar to first); Le Corbeiller 1973, p. 20 (very similar to third); Pinto de Matos and Kerr 2016, p. 82 (this *café au lait* tankard) and p. 83 (similar tankard without mounts)

PROVENANCE Heirloom & Howard Ltd, London, 2020; Christie's New York, 23 January 2020, lot 124 (center and right); the collection of Edward A. Eckenhoff, Washington DC; formerly collections of Charles Perry, Atlanta (center) and John M. Davis, Harwinton CT (right)

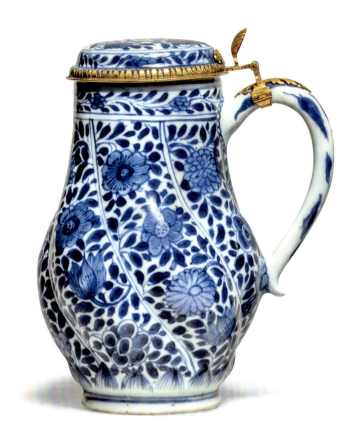

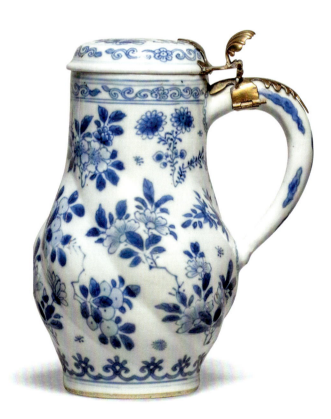

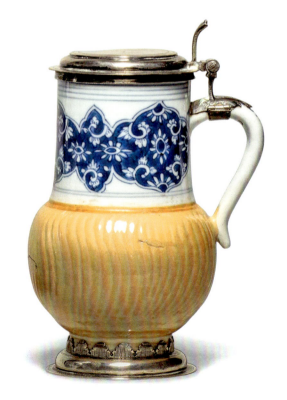

102.
TWO SMALL TANKARDS WITH COVERS

Kangxi period (1662–1722)
5 ⅜ and 5 in. (13.6 and 12.7 cm) high

Representing two different variations on the smaller covered tankard form, these examples each retain their original cover. The first is modeled with a serpent handle; the second has a small blue Buddhist lion as its knop. Both are decorated with the flowering plants so typical of Kangxi period porcelain and both feature lightly molded horizontal bands, as their stoneware prototypes often did. Covered mugs related to the first were found in the shipwreck dated circa 1690 and known as the *Vung Tau* Cargo.

REFERENCES Pinto de Matos and Kerr 2016, p. 101 (the first) and p. 78 (similar to the second)

PROVENANCE Thistle Gallery, Hamilton, Bermuda (left). Heirloom & Howard Ltd, London, 1980 (right)

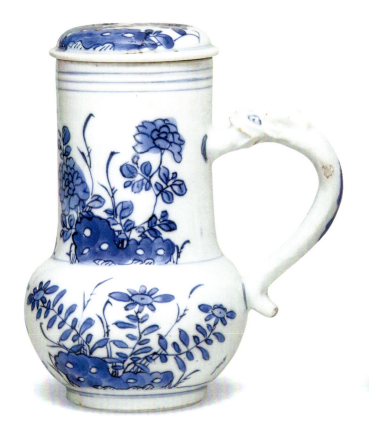
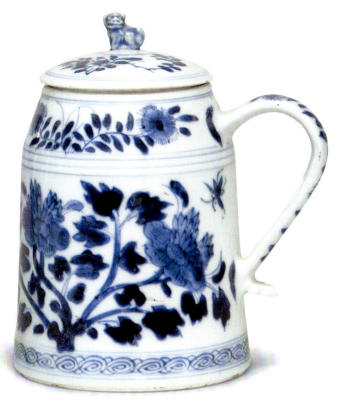

103.

TWO SQUARE BOTTLES

Tianqi (1621–27) to Chongzhen (1628–44) period
8 ½ in. (21.6 cm) high

Each of these bottles has a short, grooved cylindrical neck above slightly sloping shoulders, the straight sides painted with various plants growing from rocks or water. Square bottles with sloping shoulders were among the very first European special orders of Chinese porcelain, modeled after a common European glass form of the period. A bottle of this type with arms attributed to the Portuguese commander Álvaro Vilas Boas e Faria is dated circa 1590–1610. The grooved neck imitating the threads on a glass bottle seems to develop a decade or two later.

REFERENCES Pinto de Matos 1998, pp. 158–59 (Boas bottle); Little 1983, p. 42 (bottle with grooved neck); Canepa 2019, pp. 316–18 (discussion of the square bottle form)

PROVENANCE Heirloom & Howard Ltd, London, 1989; Christie's London, 23–24 October 1989, lot 5180; the collection of R.E. Summerfield, Esq.

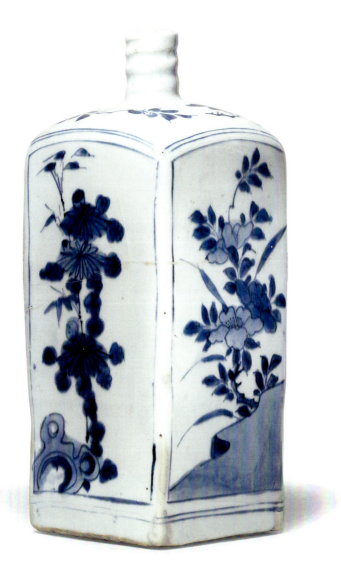
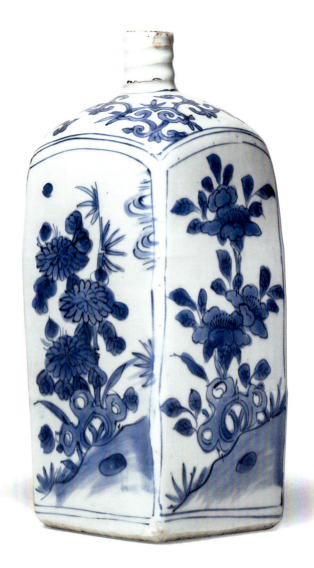

104.

PAIR OF WINE BOTTLES

Kangxi (1662–1722) period, c. 1670–1700
9 ⅛ in. (23.2 cm) high

This very unusual pair of bottles is modeled after European glass wine bottles. Each has a tall, narrow, lipped neck above sloping shoulders and is painted overall with a symmetrical arrangement of peony and chrysanthemum vine. Wine, like beer, was consumed regularly in the period, in part due to a lack of safe water. Developments in European glass technology led to the proliferation of glass wine bottles in the seventeenth century (replacing portioning straight from the barrel). The VOC promoted vineyards at their Cape Town outpost as early as 1652 and sent wine shipments to Batavia (Jakarta). But glass must have proved more practical and cost-efficient, as this form was very rarely made in Chinese porcelain.

REFERENCES Victoria and Albert Museum (c.382-1993) (1660s glass bottle); Corning Museum of Glass (2011.2.5) (c. 1690 glass bottle); Aronson n.d.b (VOC vineyards)

PROVENANCE Heirloom & Howard Ltd, London, 1984; Christie's London, 6 July 1984, lot 421

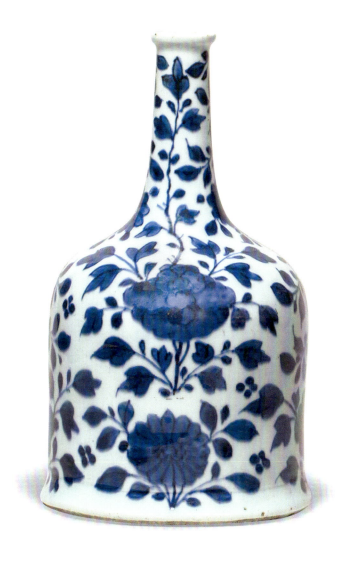
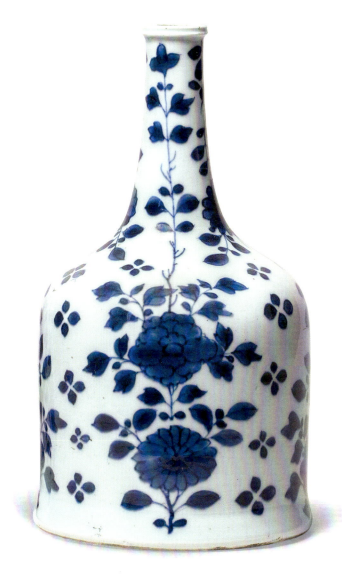

105.
PEACH-FORM EWER

Chongzhen (1628–44) to Shunzhi (1644–61) period
7 ½ in. (19 cm) high

Modeled as a peach with short pedestal foot, this ewer's handle and spout are in the form of branches joined to the body by leaves. A cup-form mouth is shaped as a lotus bud while sprays of fruiting and flowering peach are painted on the sides. A group of these ewers is known, all seemingly made from the same molds but with varying fruits and slightly varying borders. Related 'Cadogan' teapots of peach form were found in the shipwreck dated circa 1643 and known as the Hatcher Cargo. Wanli period (1573–1620) ewers with pomegranate bodies and similar stem spouts, though more sketchily painted, may have been a precursor to this model.

REFERENCES Sargent 2012, p. 78 (two closely related ewers); Christie's Amsterdam, 14 March 1984, lot 422 (Hatcher Cargo pot); Strober 2013 (Wanli pomegranate ewers)

PROVENANCE Heirloom & Howard Ltd, Wiltshire, 2015; Christie's London, 30 April 2015, lot 83

106.
PAIR OF SMALL JUGS

Kangxi period (1662–1722), early 18th century
6 ¾ in. (17.1 cm) high

These small jugs are each of faceted baluster form and raised on a hexagonal foot, the body decorated with a molded lotus-bloom panel, the curving spout and handle with stylized flames or clouds. Hexagonal ewers of this general form were made at Jingdezhen as early as the mid-sixteenth century, probably based on Middle Eastern metalwork. Christiaan Jörg suggests that this type may have been used as cruet jugs, though matching jars for mustard or spices have not been recorded.

REFERENCES Jörg 1997, pp. 111–12 (near-identical jug); Canepa 2016, pp. 298–99 (related jug)

PROVENANCE The Chinese Porcelain Company, New York, 1989

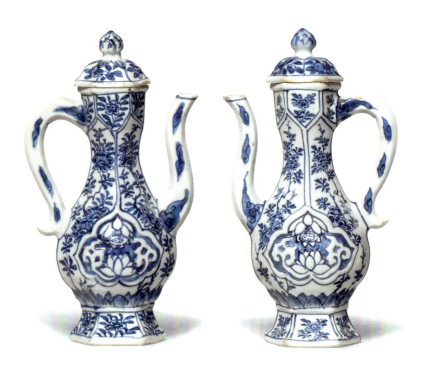

107.
PAIR OF JUGS

Chongzhen (1628–44) to Kangxi (1662–1722) period
8 ¼ in. (21 cm) high

Cup-shaped mouths and beak spouts are above short necks joined to the ovoid bodies by high curving handles. Bands of flowering vine encircle the bodies at midsection, and all is supported on short splayed bases. Modeled after European stoneware jugs of the sixteenth and seventeenth centuries, this shape was transmitted through Transitional period wine jugs to become this more elegant form, the medium of porcelain allowing more slender handles and finely shaped mouths.

REFERENCES Victoria and Albert Museum (372-1903) (near-identical jug); Butler and Canepa 2022, pl. III.2.10 (closely related jug); Canepa 2019, pp. 300–01 (stoneware model)

PROVENANCE Heirloom & Howard Ltd, Wiltshire, 1992; Sotheby's London, 3 November 1992, lot 4

108.
PAIR OF PUZZLE JUGS

Kangxi period (1662–1722)
8 in. (20.3 cm) high

This tin-glazed earthenware form was well known in both the Dutch Republic and England by the Kangxi period, and it continued to be made in Delftware into the eighteenth century. With a pierced neck that would seemingly allow its contents to spill out, its conceit was a hollow spout leading to a rounded, hollow rim where three applied flower-form sucking spouts allowed the liquid to be drunk. Painted with typical Kangxi scenes of Chinese ladies in gardens, these jugs were made in some number and must have been popular in both England and the Netherlands.

REFERENCES Le Corbeiller 1973 (near-identical jug); Musée National des Arts Asiatiques–Guimet (G3094+) (very similar jug)

PROVENANCE The Chinese Porcelain Company, New York, 1988

109.
PEAR-SHAPED JUG

Kangxi period (1662–1722), c. 1680–1710
11 in. (27.9 cm) high

Of flattened, faceted pear shape with hexagonal foot and mouth and curving spout opposite a high arched handle, this jug is painted in a vibrant cobalt blue on each side with flowering plants growing from weathered rocks. It is modeled on a South Asian metalwork form and may have been made for the Indian or Middle Eastern market, accompanied by a basin for washing.

REFERENCES Victoria and Albert Museum (1581-1876) (near-identical jug); David Collection, Copenhagen (17-2011) (Indian metalwork jug c. 1650–1700)

PROVENANCE Heirloom & Howard Ltd, Wiltshire, 2016; Rob Michiels Auctions, Bruges, 23–24 April 2016, lot 282

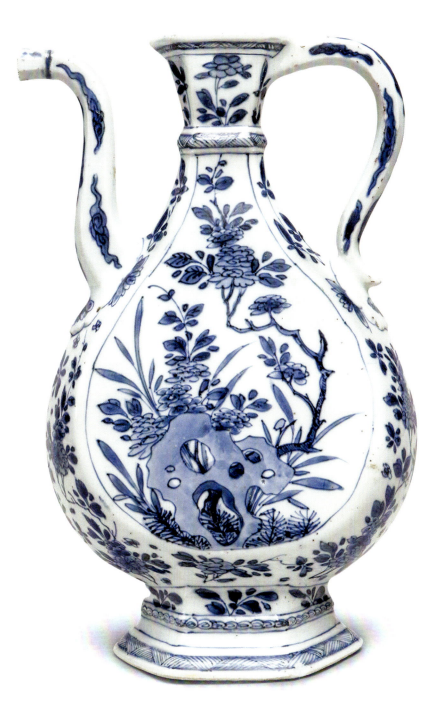

110.

HELMET JUG

Kangxi period (1662–1722)
8 ⅝ in. (21.9 cm) high

This jug reflects an intriguing mixture of European and Asian design elements. In form it echoes European baroque metalwork (which was, in turn, derived from classical Roman prototypes) with its high curving spout and tall pedestal foot. Its handle has been carefully molded in an angular scroll form. Beneath a horizontal band of ribbing on the body are two cartouches containing ferocious Buddhist lion heads, a purely Chinese symbol but used here as a European portrait head, like the putto heads found on some Transitional export porcelain. All is painted in a particularly vibrant cobalt blue.

REFERENCES Canepa 2016, pp. 300–01 (putto heads)

PROVENANCE Sotheby's New York, January 1994, lot 684

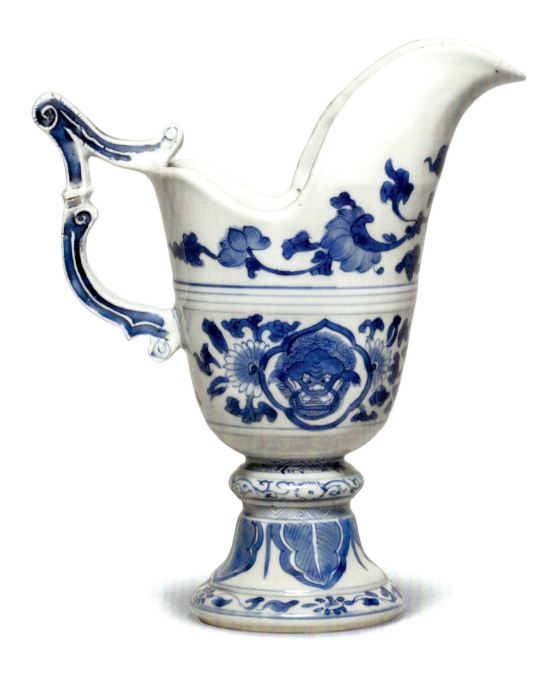

111.

PAIR OF LARGE HELMET JUGS

Kangxi period (1662–1722), c. 1710
11 ⅜ in. (28.9 cm) high

This sturdily potted helmet jug model is perhaps the best known of the export porcelain jugs, in part as it was used for several iconic Chinese armorial dinner services. Five are known in a 'Chinese Imari' palette with the arms of James Brydges, 1st Duke of Chandos. Drawn directly from European tin-glazed earthenware, the form was originally conceived in baroque silver. A particularly European element is the portrait head modeled under the spout, which was probably meant to signify a Native American, like the figures allegorical of America in representations of the Five Continents of this period.

REFERENCES Howard 1994, pp. 208–09 (*famille verte* pair); Ferguson 2017–18, p. 39 (Chandos jug)

PROVENANCE The Chinese Porcelain Company, New York, 1995

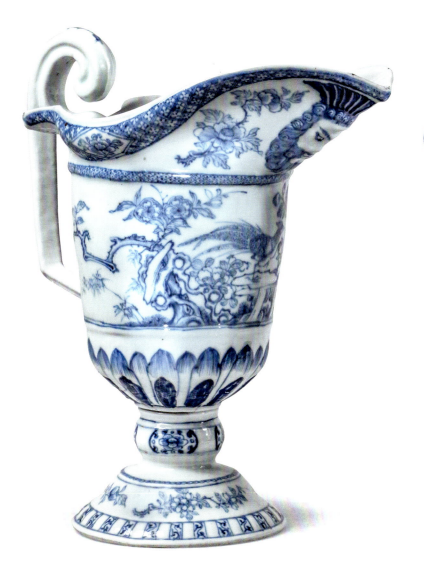
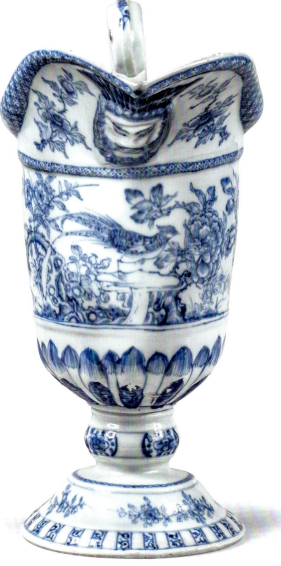

112.
LARGE JUG

Kangxi period (1662–1722), c. 1700
9 ½ in. (24.1 cm) high

The form of this jug, like that of the previous entry, is derived from European metalwork, the molded horizontal bands on its body simulating the joints of its metal prototypes. It was made to accompany a large shallow basin with a slightly raised central ring where the jug could stand without tipping. Jug and basin sets for washing were found in both dining rooms and bedrooms of the period.

REFERENCES Sargent 2012, p. 124 (near-identical pair); Jörg 1997, p. 256 (this model with basin)

PROVENANCE Heirloom & Howard Ltd, London, 1987

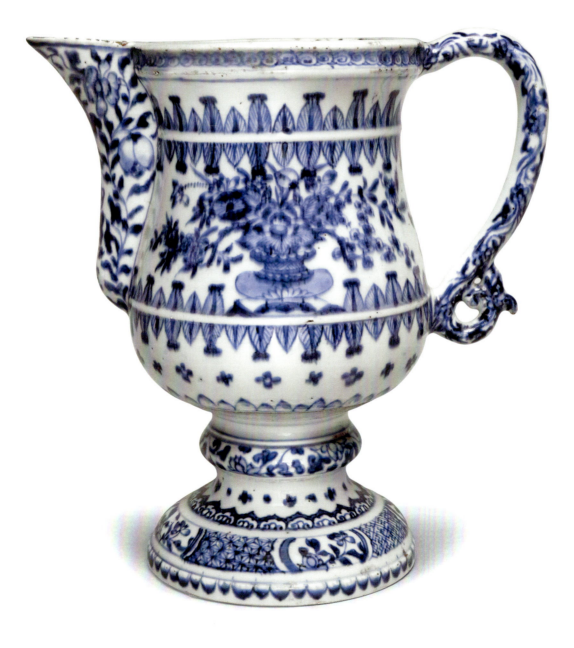

113.

PAIR OF SQUARE JUGS

Yongzheng (1723–35) to Qianlong (1736–95) period, c. 1725–40

9 in. (22.9 cm) high

This pair of jugs is of an unusual form in export porcelain. Their squared baluster bodies have grooved corners and are applied with high arched handles opposite long bird-beak spouts. A cluster of lilies on each side is beneath a lambrequin border which is repeated on their slightly domed covers. Details are highlighted in gilt. This decoration is reminiscent of Rouen and similar French factories, one of which likely provided this model.

PROVENANCE Heirloom & Howard Ltd, Wiltshire, 2015; Bonhams London, 25 February 2015, lot 7

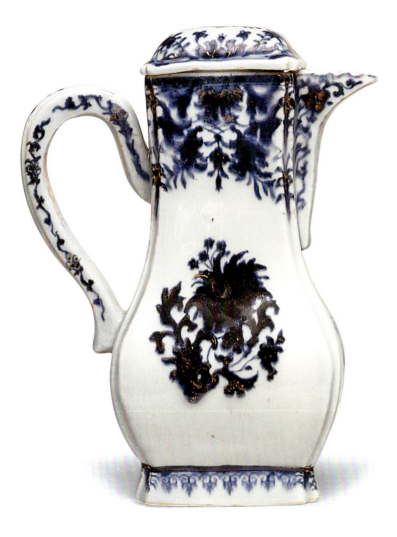
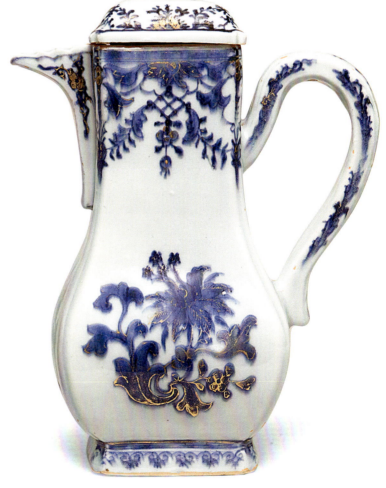

114.
FLUTED BALUSTER JUG

Yongzheng period (1723–35), c. 1730
7 ¾ in. (19.7 cm) high

This rounded model of jug was made more often at Jingdezhen than the square type of the previous entry. In this example, fluting around the lower body adds interest to the form, which is much more often simply rounded. Jugs of this shape were sometimes made to accompany Chinese armorial services of the period, often mounted in Europe with a silver hinge and thumbpiece to secure their lids. This model was made in *famille verte* and 'Chinese Imari' as well as blue and white.

REFERENCES Howard 1994, p. 210 (armorial example); Staatliche Kunstsammlungen Dresden (PO 5488) (Imari example); Victoria and Albert Museum (C.629-1909) (related Rouen jug)

PROVENANCE Heirloom & Howard Ltd, London, 1989

115.
TWO WINE FUNNELS

Kangxi period (1662–1722)
4 ⅞ and 4 ¼ in. (12.4 and 10.8 cm) high

A fairly rare occurrence in Chinese export porcelain, the wine funnel—like the cupstands in no. 115—likely proved too fragile when put to use in Europe. The few examples recorded include a number with *café au lait* decoration; they may have been one large order or series of orders. The first example here, its bowl painted with flowering plants growing from weathered rocks, is quite unusual.

REFERENCES Jörg 1997, pp. 258–59 (very similar example); Staatliche Kunstsammlungen Dresden (PO 2412) (similar example)

PROVENANCE Heirloom & Howard Ltd, Wiltshire, 1995; Christie's Amsterdam, 18 October 1995, lot 28; the collection of Jacob Gieling, Utrecht (left). The Chinese Porcelain Company, New York, 1996; Christie's New York, 19–20 January 1996, lot 118 (right)

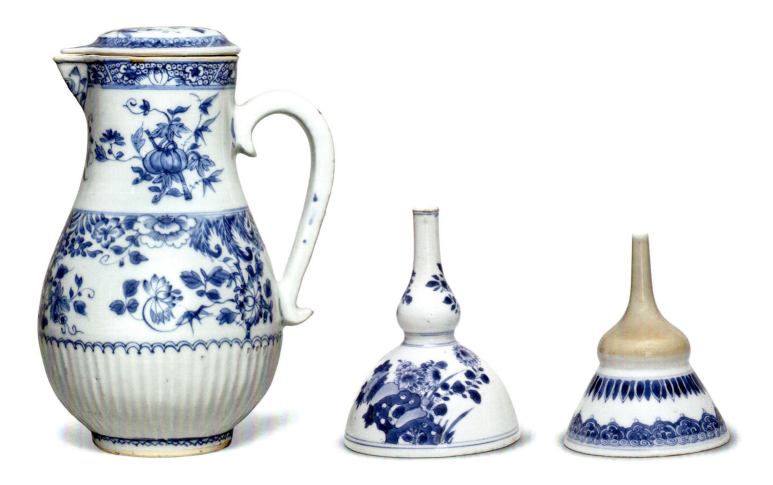

116.
TWO CUPS WITH STANDS

Qianlong period (1736–95), mid-18th century
6 ¼ and 5 ¼ in. (15.9 and 13.3 cm) diameter

A form long known in Chinese metalwork, ceramics and lacquer, the cup with cupstand was not long-lived in Chinese export porcelain, probably due to its inherent breakability. Porcelain cupstands—without matching cups and of shell shape—did continue to be made for the Manila galleon trade; called *mancerinas*, they were used in New Spain to hold chocolate cups made of silver or of silver-mounted coconut. The two porcelain examples here, each with matching cup, are rare survivals.

REFERENCES Metropolitan Museum of Art (2015.500.1.72) (Ming lacquer cupstand); Sargent 2014, pp. 84–85 (*mancerina*)

PROVENANCE James Galley, Lederach PA, 1989

117.
THREE PAIRS OF GOBLETS

Kangxi period (1662–1722), c. 1690–1710
4 ¾, 5 ⅞ and 6 ¼ in. (12.1, 14.9 and 15.9 cm) high

The first of these pairs of goblets has overall lotus scroll, the second conical bowls featuring auspicious antiques above pedestal bases with a band of *café au lait* and the third lightly fluted bowls penciled with flowering grasses and raised on tall stems. Goblets, like beakers, were clearly requested regularly by European traders for a time, though by the early eighteenth century Chinese porcelain versions were overtaken by European glass. Christiaan Jörg suggests that the less common small-sized goblets may have been used for gin.

REFERENCES Jörg 1997, p. 264 (small goblet); Howard 1994, p. 187 (near identical to third); Christie's Amsterdam, 7–8 April 1992, lots 23–28 and 42–49 (*Vung Tau* Cargo examples)

PROVENANCE The Chinese Porcelain Company, New York, 1996; Christie's New York, 19–20 January 1996, lot 119 (left). The Chinese Porcelain Company, New York, 1992 (center)

118.

PAIR OF JUGS WITH CHILONG HANDLES

Qianlong period (1736–95), c. 1770–80
10 ¾ in. (27.3 cm) high

This pair of jugs was made at a time when European factories had developed a range of porcelain-type wares and Chinese porcelains no longer led ceramic fashions. Made to use with round basins which would fit into wooden bedroom washstands, these jugs were likely practical accessories for a wealthier middle-class household. Their *chilong*-form handles and overall decorative motifs are often found in *famille rose* and gilt vases of this period, though in those examples the panels more often contain Chinese family scenes, not the birds seen here.

REFERENCES Howard 1994, p. 207 (this form in colored enamels)

PROVENANCE Heirloom & Howard Ltd, Wiltshire, 1994; Christie's London, 7 April 1994, lot 418 (one). Philip S. Dubey Antiques, Baltimore, 2016 (one)

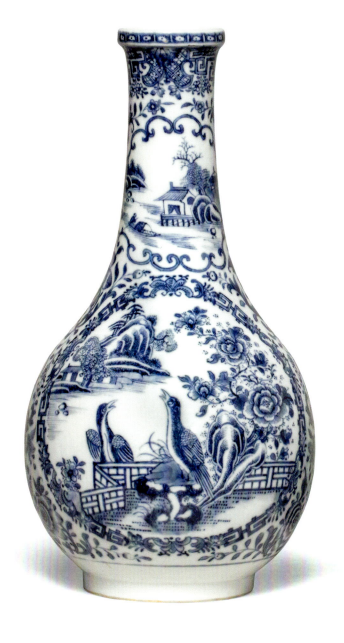
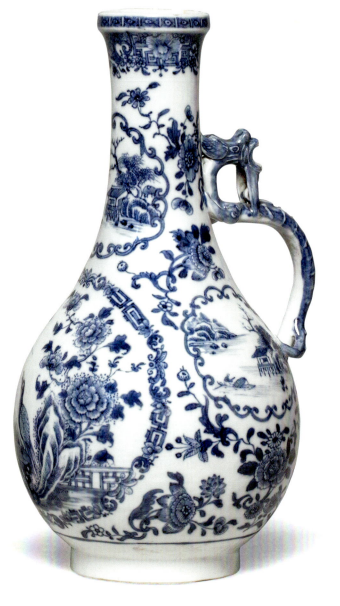

119.

LARGE JUG WITH MASK SPOUT

Qianlong period (1736–95), c. 1740–50
13 ½ in. (34.3 cm) high

A large number of these imposing jugs are known, decorated in colored enamels as well as blue and white. All modeled with a bearded head under the spout and a fat, pear-shaped body, they were derived from a European ceramic form. Often called beer jugs, Ronald W. Fuchs II notes that they would likely have been used also for ale, cider or punch. He quotes an English traveler to Southeast Asia who wrote in 1665: "I never came ashore, but I drank very immoderately of Punce, Rack, Tea &, which was brought up in great China-jugs holding at least two Quarts."

REFERENCES Fuchs 2005, pp. 146–47 (*famille rose* example); Leidy and Pinto de Matos 2016, pp. 150–53 (very similar jug)

PROVENANCE Matthew & Elisabeth Sharpe Antiques, Conshohocken PA

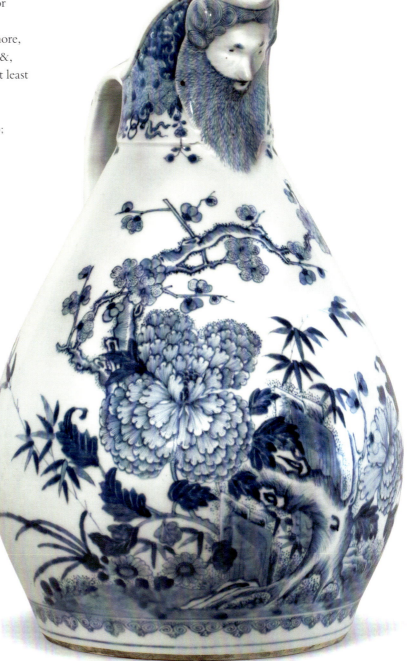

120.

MONTEITH BOWL

Kangxi period (1662–1722), c. 1710–20
12 ¾ in. (32.4 cm) diameter

One of the most intriguing forms produced at Jingdezhen for the export market, monteith bowls were made to chill wine glasses, which would be suspended in ice water from its notches. The shape was based on an English silver model (which sometimes featured a removable upper rim for use as either a monteith or a punch bowl). Its unusual name came from an eccentric Scot who wore cloaks with deeply notched hems; it was used from at least 1721, when it appears in an English diary. A small group of very similar bowls is known but with varying exterior decoration showing cartouches of different beasts against a chrysanthemum-vine ground. Here, we have scroll-edged cartouches of antiques or flowering plants against a more Westernized ground of peony vine. The antiques are repeated within a palmette border in the center of the interior; the base has a lotus-sprig mark.

REFERENCES Sargent 2012, pp. 125–26 (animals); Victoria and Albert Museum (564-1907) (animals); Metropolitan Museum of Art (1978.503) (related form with flowers); Fuchs 2005, p. 128 (diary)

PROVENANCE Philip S. Dubey Antiques, Baltimore, 2013; Pook & Pook Auctioneers, Downington PA, 12 October 2013, lot 287; Northeast Auctions, Portsmouth NH, 16 August 2003, lot 613; Matthew & Elisabeth Sharpe Antiques, Conshohocken PA

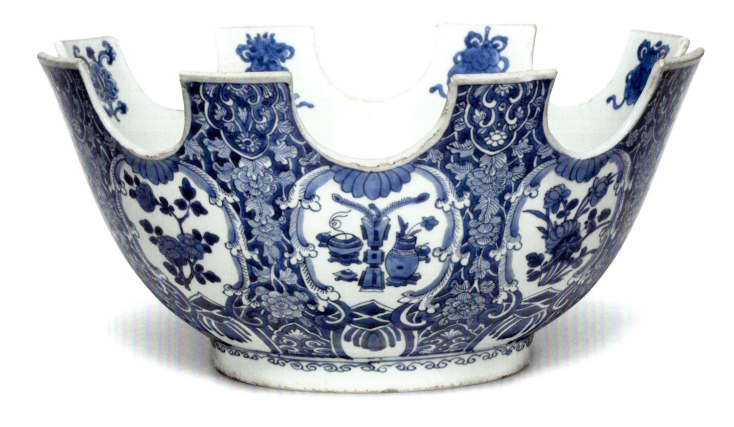

121.
LARGE HOT WATER POT

Kangxi period (1662–1722)
10 in. (25.4 cm) wide

Painted in a particularly vibrant cobalt blue, this pot is decorated on each side with a pheasant perched on rockwork beside blossoming prunus. Its shape is derived from the much smaller Chinese wine pot or tea pot. Large rounded blue and white pots with overhead handles were found in the Hatcher Cargo, a shipwreck datable to 1643, and have been called wine pots. Pots of this scale are also referred to as punch pots. But there seems to be no evidence of their use for punch or wine in Europe at this time. Tea was still quite expensive in Europe during the Kangxi period, and it is unlikely that this very large pot was used to brew tea, either. A pot of this scale was most likely used for hot water at the tea table. A painting dated circa 1720 of an English family at tea shows the typical practice of using a large silver pot to replenish the hot water in a small teapot, an Yixing teapot in this case. Silver, pewter or brass are much more practical materials for a large pouring vessel, and few large-scale pots like this were made in Chinese porcelain.

REFERENCES Howard 1994, p. 142 (wine pot from the Hatcher Cargo); Tate Gallery (no4500) (*An English Family at Tea* by Joseph Van Aken)

PROVENANCE The Chinese Porcelain Company, New York, 1996; Christie's New York, 19–20 January 1996, lot 121; the collection of Mrs. Thornley W. Hart, Lawrence NY

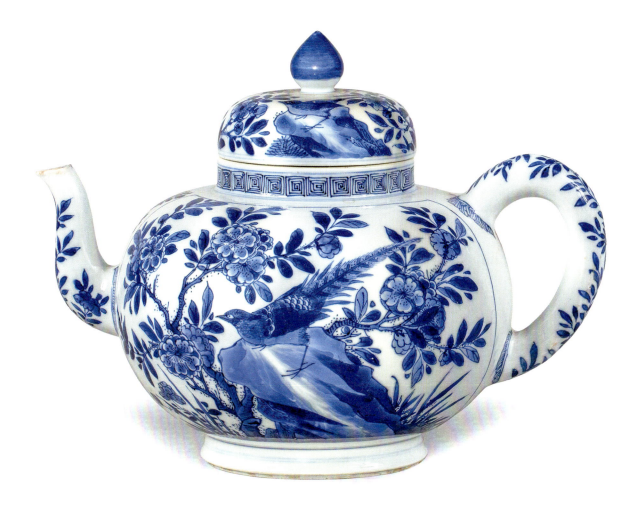

122.

PAIR OF TEA CANISTERS

Kangxi period (1662–1722), c. 1680–1700
4 ¼ in. (10.8 cm) high

Of rectangular form with short squared necks, these canisters feature the same flowering plants on their sides and the same fretwork borders around their necks but varying river scenes front and back. They represent an early version of the tea canister. As tea-drinking became ubiquitous in the eighteenth century and full tea services began to be made in export porcelain, the canister developed into the much more familiar baluster and then shouldered rectangular form. The present model was undoubtedly derived from multipurpose seventeenth-century rectangular canisters of very similar outline but about twice as tall. Teresa Canepa illustrates a circa 1700 Dutch tortoiseshell and silver tea caddy of this shape and size, noting that a 1693 Kensington Palace inventory recorded "[t]wo very fine flatt bottles with Covers for tea."

REFERENCES Canepa 2019, pp. 322–25 (Transitional canisters and tortoiseshell caddy)

PROVENANCE Heirloom & Howard Ltd, Wiltshire, 1998 (left). Heirloom & Howard Ltd, Wiltshire, 2019; David Lay Auctions, Cornwall, July 2019, lot 57 (right)

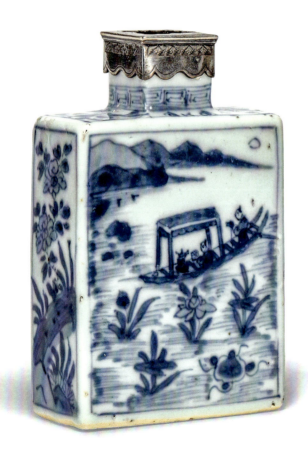
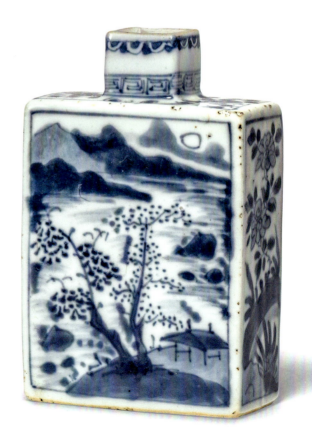

123.
FLASK-FORM TEAPOT

Kangxi period (1662–1722)
6 ½ in. (16.5 cm) high

The unusual form of this teapot, with its disk-like body, is derived from Islamic ceramic and metalwork flasks of the Middle East and India. These flasks had inspired Chinese pilgrim bottles in pottery and then porcelain (see no. 20), but in the Kangxi period the shape was adapted for a small group of molded teapots. In this example each side is molded with a multi-petaled flowerhead, its center painted with a lively flowering plant, while a rounded handle and spout are decorated with flowering vine. The cover, collar and base are of square form.

REFERENCES Groninger Museum (1904.0154) (near-identical teapot); Pinto de Matos 2019, no. 74 (very similar pot with variant molding); Freer Gallery of Art (F1941.10) (13th-century metalwork)

PROVENANCE Guest & Gray, London, 2015

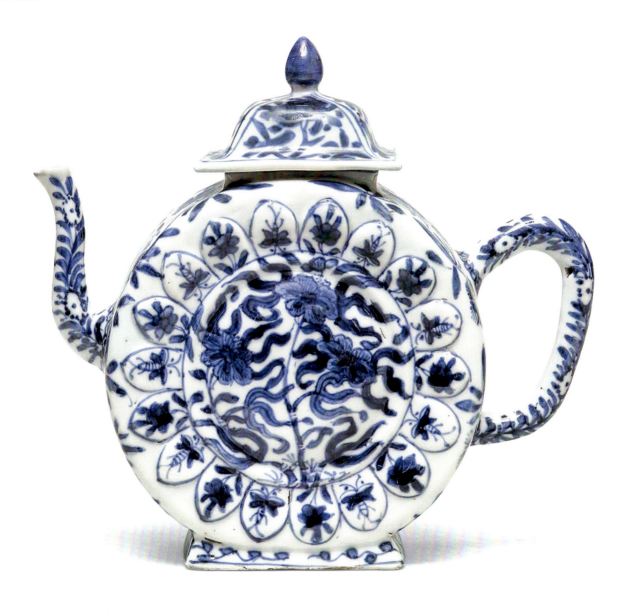

124.
SUGAR CASTER

Kangxi period (1662–1722), c. 1700
6 ⅜ in. (16.2 cm) high

A relatively small number of sugar casters were made in Chinese porcelain, all modeled directly after European silver with high-domed covers pierced in symmetrical patterns. Hinged mounts added in Europe would allow the cover to open easily for refilling. The form is recorded in the 'Chinese Imari' palette and *famille verte* enamels as well as blue and white. Here, the cylindrical body is decorated with typical Kangxi period flowering plants. A caster dated circa 1700–20 with the arms of the Sampaio e Melo family has the same cylindrical body and additional short legs; in the 1730s a baluster body developed.

REFERENCES Victoria and Albert Museum (M.25:1,2-1974) (English silver-gilt caster c. 1686–87); Groninger Museum (1899.0358) (very similar pair); Leidy and Pinto de Matos 2016, pp. 178 (armorial caster); Pinto de Matos 2019, no. 88 (baluster casters)

PROVENANCE Heirloom & Howard Ltd, London, 1988

125.
SUGAR CASTER AND CREAM JUG

Yongzheng (1723–35) to Qianlong (1736–95) period, c. 1730–40
6 in. (15.2 cm) high (the caster)

This unusual set comprises a baluster-form sugar caster with matching cream jug. Each is decorated with a shaped panel containing a scene of Chinese ladies in a garden, one playing a *jin*. The jug has been carefully modeled with a bearded-mask spout and a scrolled handle; each piece has a blue peach-sprig knop. When matching Chinese porcelain tea services began to be made in the 1720s and '30s, the typical form for sugar was the small, wide bowl which could accommodate lumps of the sweetener chipped off the less expensive loafs or cones that had become available. Sugar consumption in England increased more than four-fold between 1700 and 1800.

REFERENCES Lunsingh Scheurleer 1974, no. 349 (typical 18th-century tea service)

PROVENANCE Santos London, 1991

126.
FOOTED TEAPOT

**Yongzheng (1723–35) to Qianlong (1736–95) period,
c. 1720–40
5 in. (12.7 cm) high**

This distinctive teapot form, with its tall pedestal foot and curving dragon-head spout, was made only for a short time in the 1720s and '30s. An example enameled with the arms of the Duc de Chaulnes (1676–1744) is dated circa 1725; an armorial service ordered for King Louis XV of France in 1732 (with further pieces added in 1733 and 1738) and also decorated in colored enamels and gilt included a teapot of this form. Here, the pot is delicately penciled on each side with blossoming and fruiting trees. A small Buddhist lion sits on the cover as a knop.

REFERENCES British Museum (Franks.808.+) (French armorial teapot); Christie's New York, 27 January 2013, lot 491; the collection of Benjamin F. Edwards III (teapot with French royal arms)

PROVENANCE Heirloom & Howard Ltd, Wiltshire, 2015; R & G McPherson Antiques, London

127.

COFFEE POT WITH TWIST HANDLE

Kangxi period (1662–1722), c. 1700
10 ½ in. (26.7 cm) high

Coffee-drinking was quite fashionable by the close of the seventeenth century, creating a need for pots to serve the popular drink. European silversmiths had developed the tall, conical form earlier in the century; it was made in Japanese porcelain for Dutch traders by circa 1680 (see no. 268). There seems to have been a short time at the opening of the eighteenth century when the Jingdezhen potters had not yet settled on the coffee pot form that was to become universal. This model has several features that were to be abandoned: a scrolling strut joining its spout to the body, a twist handle and a curving base on short foot. As with the Europa and the Bull pot in no. 198, these features likely proved too burdensome and too costly to make.

REFERENCES Jörg 1997, p. 275 (octagonal coffee pot and discussion)

PROVENANCE Heirloom & Howard Ltd, London, 1983; Christie's London, 9 November 1983, lot 186

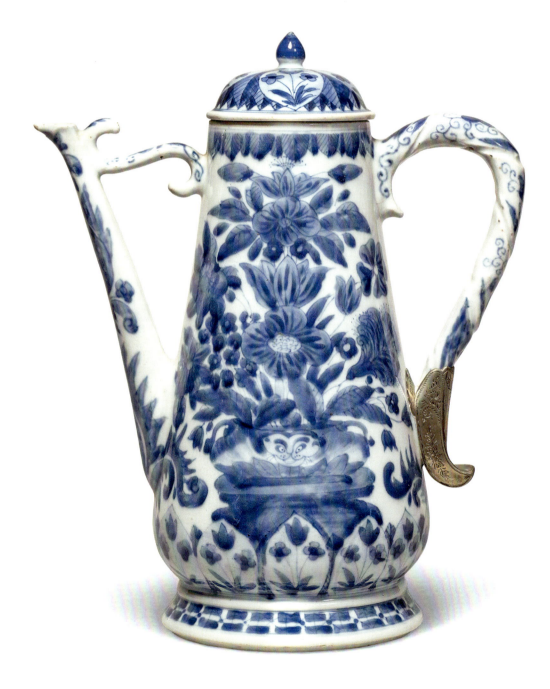

128.

COFFEE POT WITH BIRD SPOUT

Qianlong period (1736–95), c. 1740
10 ⅞ in. (27.6 cm) high

Of purely conical form, this coffee pot features an expressive bird-head spout opposite a scrolling ear-form handle. A Chinese riverscape is carefully painted around the sides, with details repeated on the domed cover below a gilded blue peach knop. This 'lighthouse' shape, derived from English silver coffee pots of the Queen Anne period (c. 1700–15), became the norm and was used at Jingdezhen for export porcelain throughout the eighteenth century.

REFERENCES Fuchs 2005, pp. 114–15 (near-identical coffee pot)

PROVENANCE Heirloom & Howard Ltd, Wiltshire, 2009

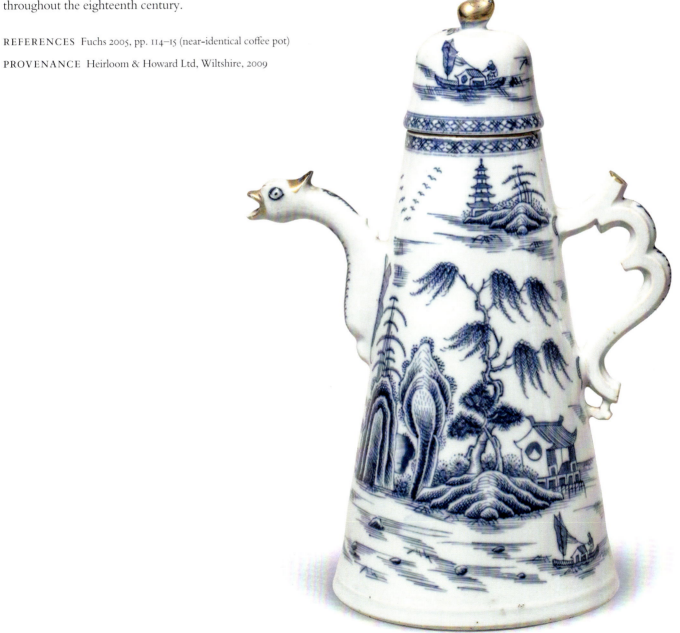

129.

LARGE PUNCH BOWL

Jiaqing period (1796–1820), c. 1800
16 ¾ in. (42.5 cm) diameter

Decorated in the neoclassical style, this large bowl is painted on its exterior with four formalized flowerhead roundels beneath a deep tasseled border. The border is repeated on the interior above a fifth flowerhead in the center; all elements have been highlighted in gilt. By the time this bowl was made, neoclassical ornament had supplanted the baroque and rococo styles of the earlier export porcelain era. It may well have been ordered by an American; the American China trade became quite active following the end of the War of Independence in 1783, and wealthy Americans like Mehitable Adams (1760–1824) ordered Chinese porcelain in this taste.

REFERENCES Gordon 1977, p. 143 (Mehitable Adams tea service)

PROVENANCE Harry Barnett Antiques, San Francisco

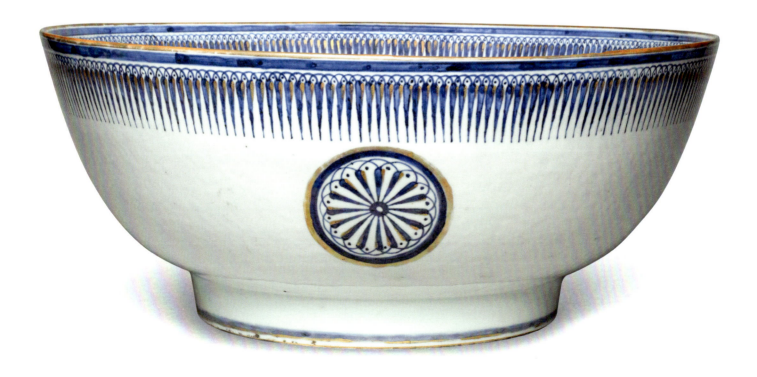

130.

VERY LARGE TEA CANISTER

Jiaqing period (1796–1820)
17 ½ in. (44.5 cm) high

The straight sides of this canister are painted with a continuous mountain landscape showing small figures outside mountain huts. An elaborate collar decorates the flat top. By the Jiaqing period, exotic Chinese riverscapes replete with the willow trees and craggy mountains that had first appeared in mid-eighteenth century blue and white had become quite standard decoration. Finely painted versions, like that in a dinner service of circa 1810 with the crest of Cooper, were made alongside more rudimentary renderings on more functional wares. The English 'country ship' *Diana* that sank in 1817 in the Malacca Straits had in its cargo numerous blue and white platters with similar riverscapes as well as a group of plain white tea canisters of this form (though not quite as large) and similar metal canisters used for both camphor and tea.

REFERENCES Mudge 1986, p. 183 (jar with very similar scene); Howard 2003, p. 599 (Cooper service); Christie's Amsterdam, 6–7 March 1995, lots 73–178 (platters) and lots 777–89 (*Diana* Cargo white canisters); Ball 1995 p. 123 (metal tea canister) and pp. 150–52 (metal camphor canister)

PROVENANCE Heirloom & Howard Ltd, Wiltshire, 2013; Woolley & Wallis, Salisbury, 13–14 November 2013, lot 151

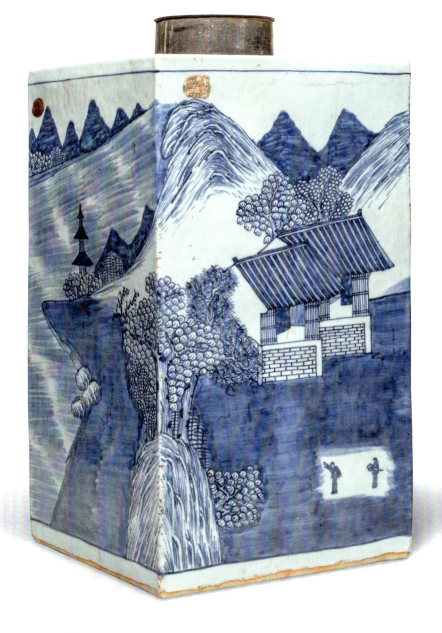

5.
FOR OTHER USES

Foreigners ordered porcelains from the kilns at Jingdezhen for purposes that went well beyond the serving of food and the drinking and pouring of liquids. Chinese blue and white graced desks, held flowering plants, stored tobacco, spices or medicines and elevated personal grooming practices around the globe. Eventually, almost anything that could be made of ceramic was made in Chinese porcelain. And Westerners were not alone in their desire to utilize this wondrous material in every conceivable way. In his famous letter of 1712 detailing operations at Jingdezhen, the Jesuit Père d'Entrecolles described a miniature organ of fourteen pipes ordered by a Chinese Imperial prince and a set of slabs for terrace walls ordered by a Chinese emperor. Both proved impossible for the potters to make—the slab order finally leading provincial officials to petition the Imperial court for relief, saying it could not be done.[1]

But many specially designed and highly functional articles for both the domestic and foreign markets were created with the skills of the Jingdezhen potters. Among the earliest of these articles made for Europeans were apothecary or drug jars. The use of various natural substances as medicine had been an ancient practice in the West, codified in the Roman period, when writers like Dioscorides and Pliny the Elder compiled authoritative accounts of all medicinal plants then known. During the Middle Ages, this knowledge was kept alive within monasteries and supplemented by learning from the Arab world.[2] By the sixteenth century, apothecaries and pharmacies were found in palaces and prosperous monasteries as well as in the hospitals and shops of towns and cities, creating a demand for ceramic containers to hold their many medicinal wares.[3] Numerous producers of tin-glazed earthenware in Italy, Spain and Portugal (and eventually throughout northern Europe, too) produced the familiar cylindrical, wide-mouthed drug jars, their rims everted so a waxed cloth could be tied round the top. Modeled after earlier Persian and Syrian pottery drug jars, they were called *albarelli* in Italy, possibly based on an Arabic term,[4] and 'Damascus bottles' in Spain.[5] European potteries also produced syrup jars or wet drug jars for liquid potions, set with spouts and handles and often with a short pedestal foot.

The Western ships that established the Maritime Silk Route in the sixteenth century had onboard pharmacies, and naturally the Europeans who were trading in Asia turned to Asian potters to supply the necessary drug jars. Chinese porcelain drug jars were found amongst the remains of the pharmacy on the Spanish ship *San Diego*, which sank in Manila Bay in 1600, as noted by Teresa Canepa.[6] Asian outposts established by the Portuguese, the Spanish and then the Dutch featured pharmacies, too. Oliver Impey suggests that a very rare Arita porcelain drug jar with baroque decoration may have been ordered by a Portuguese in Japan just before the 1639 expulsion of the Portuguese from that country.[7] And Christiaan Jörg discusses the *chirugijnwinkel*, or 'surgeon's shop', maintained by the VOC (Dutch East India Company) in their Batavia (Jakarta) headquarters.[8]

New medicinal plants—the intended ingredients for many of these jars—were a part of the thriving Asian–European trade. By the early sixteenth century,

Italian School, *The Pharmacy*, fresco, 15th century,
Castello di Issogne, Val d'Aosta

pharmaceutical plants from Southeast Asia were being sent to the Portuguese court via their viceregal establishment in Goa. In 1529 Catherine of Austria, wife of King João III of Portugal, had her apothecary compile the more than 2,500 useful remedies known at the time, presumably incorporating these new Asian plant derivatives.[9]

Given the need for multiple drug jars both in the pharmacies of Europe and for Europeans abroad, it is perhaps surprising that these vessels do not seem to have been made in larger numbers at Jingdezhen or Arita. The Chinese had certainly been familiar with the practice of using medicinal plants since ancient times, and recorded their *materia medica* as early as the Han dynasty (206 BCE–220 CE). They probably also used ceramic vessels for the storage of drugs and potions.[10] Many Chinese drug jars made for Europeans may have been plain white pedestrian ware, like the *San Diego* examples mentioned earlier and a Japanese group found in the 1697 wreck of the *Oosterland*. Jörg records annual VOC orders of two to three thousand "porcelain bottles, pots, pots for salves and preserves" from the Arita kilns in the 1650s, but also notes that it is impossible to know how many of these "bottles" were actually intended for wine or oil rather than medicines. He also observes that only a tiny handful of half-sized, very rudimentarily decorated Japanese *albarelli* have been found in either Amsterdam or Japan.[11]

At the European potteries, drug jars began to be inscribed in the mid-fifteenth century with the names of their contents. Still, many sets remained blank, providing the apothecary with greater flexibility—blank jars could be affixed or hung with a label or even cold-painted with one. In Chinese porcelain, not only were far fewer drug jars made but only a very few were inscribed, presumably as part of sets in which each jar would proclaim its intended remedy. Only two Chinese partial drug jar sets seem to have survived: a group of five *albarelli* from the Kangxi

period (1662–1722) with angel heads above their labels and inscribed THER★ES merag, ELECT★IND, DIADHOEN, CONS★cass★fistul and DIACARTH[12] and the three wet drug jars from the first half of the seventeenth century in the Frelinghuysen collection painted with herbal plants and inscribed LIMONVM, MIVAC I TENEOR and St. NIPHEE (no. 131).

The collection also includes a single jar dating to the first half of the seventeenth century and inscribed A★EVPHRAGE (no. 132) and a mid- to late seventeenth-century example with a variation on the winged angel head of the set discussed above (no. 133). Just three other seventeenth-century single Chinese drug jars are recorded, all now in the RA collection; they are inscribed S.RHODOM,[13] V★PLVMBI,[14] and A★BORRAG.[15]

All of these labeled drug jars are blue and white and, assuming each was originally made as part of a set, they represent just seven known sets—of which the Frelinghuysen collection features three. (Outside its purview is a *famille verte* set known only by a large eighteenth-century jar inscribed Aq★Portulac★.[16])

The collection's wide range of material encompasses porcelains used for many other activities of daily life. Pieces specially made for the practices of personal grooming—practices that were perhaps less pedestrian when Chinese porcelain was employed—include one of the earliest-known shaving bowls (no. 140), spittoons (no. 139), bordaloues (no. 417), chamber pots (no. 416) and an armorial bidet (no. 65). Accessories made for the writing table include several inkstands adapted with ormolu fittings from porcelains made for other uses (nos. 137 and 412–413).

English School, *The Dextrous Trimmer or Pool Pill Garlick Left in the Suds*, engraving, 1751, The Stapleton Collection

Functional pieces made in blue and white for food preparation are also featured, most made after the 1730s, when *famille rose* would have been chosen for more exalted uses. These include strainers (nos. 144–145), pudding molds (no. 146) and three very rare butter churns (no. 147). Other vessels and containers were designed for all kinds of purposes, including to hold photographs and to keep pet birds (nos. 420–421). A few architectural elements are even represented (nos. 418–419), reminiscent of that long-ago emperor's request for terrace walls made of Jingdezhen porcelain.

1 Nilsson 2010, p. 16.
2 Petrovska 2012, pp. 1–5.
3 Drey 1978, pp. 7, 21.
4 Sargent 2012, p. 119.
5 Canepa 2016, p. 291.
6 Ibid., p. 291; see also p. 293 where the author illustrates a Zhangzhou *albarello* from the wreck alongside a Spanish maiolica prototype.
7 Impey 2002, pp. 42–43. This fascinating piece, now in the Ashmolean collection, was also published by Jörg 2003, pp. 213–14, who notes Impey's theory.
8 Jörg 2003a, p. 209.
9 Crespo and Gschwend 2018, p. 24.
10 Drey 1978, p. 172.
11 Jörg 2003a, pp. 209, 214–15, 218.
12 The Kangxi albarelli are now found, respectively, in the British Museum (1963, 0422.6); sold Christie's South Kensington on 13 November 2003, lot 477; the Peabody Essex Museum (1993, E83995); the Potteries Museum & Art Gallery, Stoke-on-Trent; and the Virginia Museum of Fine Arts (73.38).
13 Pinto de Matos 2019, no. 39 (formerly in the Mottahedeh collection and published by Howard and Ayers 1978, p. 58).
14 Pinto de Matos 2019, no. 18.
15 Pinto de Matos 2011a, no. 76.
16 Drey 1978, pp. 175–76.

131.

A SET OF THREE APOTHECARY JARS

Wanli (1573–1620) to Shunzhi (1644–61) period, first half 17th century
9 ¼, 9 ¾ and 8 ½ in. (23.5, 24.8 and 21.6 cm) high

With spouts and scrolled handles (now lacking on the third) painted as blue bamboo sections, the ovoid bodies of these three wet-drug jars are painted with leafy flowering vine probably meant to signify their herbal contents. Under each spout is a scroll-edged cartouche labeled to identify the jar's medication; they read LIMONVM, MIVAC I TENEOR and *St.* NIPHEE. Each jar has an upper border of stiff leaf tips above a band of flowerheads; the stiff leaf tips are repeated on the pedestal foot (now lacking on the third jar). The 'Limonum' jar would have held lemon oil (*citrus limonum* in Latin). Lemon trees originated in South Asia; from ancient times lemon oil was widely used as a topical treatment in both East and West. The 'Mivac i teneor' label may indicate contents to be carried elsewhere; *teneo* is Latin for 'I hold' and *Mivaci teneor* can mean 'I'm meant to be carried away'. 'St. Niphee' most likely refers to the water lily (*nimphea* or *nymphea*). Lily-infused water, which contains tannins, was used for gastrointestinal upset. A maiolica apothecary jar made in the northern Netherlands circa 1630 is labeled *A NIMPHEAE*. The stiff leaf tip border these jars share is found on many seventeenth-century blue and white wares; here it alternates with half-flowerheads very like those seen in the border of a seventeenth-century drug jar in the Virginia Museum of Fine Arts.

REFERENCES Du Boulay 1984, p. 200 (this MIVAC I TENEOR jar); Christie's Amsterdam, 20 December 2006, lot 343 (maiolica jar); Virginia Museum of Fine Arts (73.38) (17th-century Chinese jar)

PROVENANCE Rodrigo Rivero Lake, Mexico City, 1987 (LIMONVM and *St.* NIPHEE). Heirloom & Howard Ltd, London, 1983; Christie's London, 22 June 1981, lot 111 (MIVAC I TENEOR)

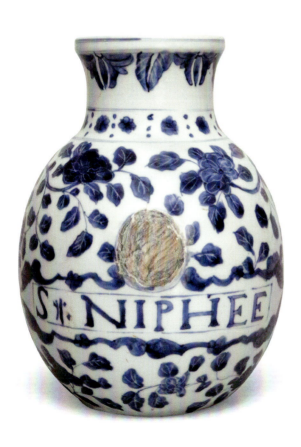

132.

APOTHECARY JAR

**Wanli (1573–1620) to Shunzhi (1644–61) period,
first half 17th century**
7 ½ in. (19 cm) high

Though very similar to the set of jars in the previous entry, this example was made to contain dried herbs or an herbal paste rather than a liquid solution. Its ovoid body is painted with an overall pattern of leafy flowering vine; leaf veins and petal details have been left in the white. It would have been modeled with a short neck which is now lacking. On the front, a scroll-edged horizontal cartouche is labeled A★EVPHRAGE; the base is bordered with a band of half-flowerheads in blue triangles. *Euphrasia officinalis*— often called 'eyebright'— is a flowering herb long used for the treatment of eye ailments. Like all of these apothecary jars, this example would have been made as part of a set. A jar of matching form and pattern is inscribed A★FUMARIE, most likely indicating some kind of smoked herb contents. Maria Antonía Pinto de Matos illustrates a jar of very similar form but more complex design labeled A★BORRAG.

REFERENCES Christie's London, 6 April 1998, lot 38 (A★*FUMARIE* jar); Pinto de Matos 2019, pp. 196–97 (A★*BORRAG* jar)

PROVENANCE Heirloom & Howard Ltd, Wiltshire, 1992; Sotheby's London, 3 November 1992, lot 2

133.

APOTHECARY JAR

Chongzhen (1628–44) to Kangxi (1662–1722) period, 17th century
8 in. (20.3 cm) high

The design on this drug jar displays a sophistication not seen on the earlier examples discussed above (nos. 131–132). Its rounded body is painted with an overall flowering vine pattern below a short neck bordered in stiff leaf tips. On the front, a rectangular label is bordered in fretwork; drapery swags and a sprig of berries are suspended from a tab beneath it. A jar in the RA collection has a very similar tab and berry sprig beneath its label. This jar features a demi-angel figure on a scrolled platform above the label; the label reads *OL*MIRTHI**. The demi-angel figure is very similar to the winged angel head found above the labels on a well-known set of apothecary jars dated 1660–80 and inscribed *THER.ES merag*, *DIACARTH*, *DIADHOEN* and *ELECT.IND*. Sets with this Christian motif may well have been made for the pharmacies of monasteries or convents. The *OL* inscribed on this jar is an abbreviation for *OLIO* (oil); *MIRTHI* is myrtle. Myrtle leaves and berries had many medicinal uses.

REFERENCES British Museum (1963,0422.6) (*THER.ES merag* jar); Virginia Museum of Fine Arts (73.38) (*DIACARTH* jar); Sargent 2012, pp. 118–19 (*DIADHOEN* jar); Pinto de Matos 2019, pp. 196–97 (RA collection jar)

PROVENANCE Rodrigo Rivero Lake, Mexico City

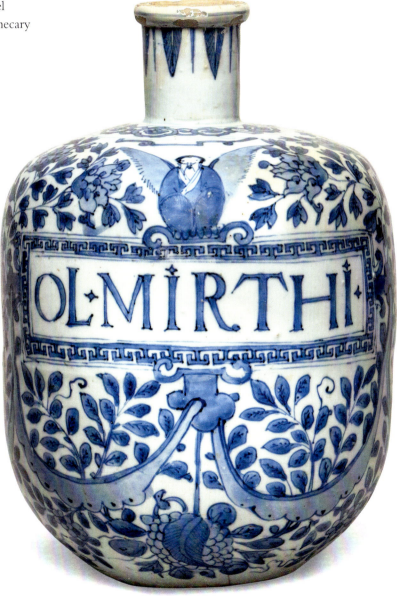

134.
PAIR OF APOTHECARY JARS

Kangxi period (1662–1722)
7 ½ in. (19 cm) high

This pair of drug jars is of classic *albarello* form with wide mouth above a waisted neck designed to hold the leather cord that would tie on a waxed cloth cover. Their straight sides are slightly rounded at the corners and top; the flat base is glazed. A border of cobalt blue flowering vine is at top, bottom and corners; otherwise the sides are plain, allowing the apothecary to label each jar's contents, if desired. Interestingly, an eighteenth-century tin-glazed earthenware (probably Delft) apothecary jar inscribed *P. CALIS* is of this same form and pattern, as is a later eighteenth-century Japanese example—a reflection of the continuous transmission of design influences through the trading networks of the period.

REFERENCES Victoria and Albert Museum (c.21-1928) (Delft example); Groninger Museum (1967.0461) (Japanese version)

PROVENANCE Heirloom & Howard Ltd, Wiltshire, 2013; Christie's London, November 2013, lot 1093 (one). Heirloom & Howard Ltd, Wiltshire, 2014; Hawkes Asian Art, Somerset (one)

135.

SET OF FIVE LABELED JARS

Yongzheng (1723–35) to Qianlong (1736–95) period,
c. 1720–40
4 ½ to 6 ½ in. (11.4 to 16.5 cm) high

This unusual set is comprised of three rectangular jars, two with round mouths and one open at the top, and a pair of small, shouldered square bottles. The bottles have European silver tops with flower finials. Each has a rectangular label with scrolled corners; the labels are issuing roses or smaller blossoms. In this very small scale, it seems likely that these jars were intended for personal use, possibly for a dressing table, to hold unguents, lotions and perfumes. The blank labels allowed their user to assign each jar's contents.

REFERENCES Groninger Museum (2013.0466) (near identical to rectangular pair)

PROVENANCE Heirloom & Howard Ltd, Wiltshire, 2016; Rob Michiels Auctions, Bruges, 23–24 April 2016, lot 370 (center and outer pair). Heirloom & Howard Ltd, Wiltshire, 2021; Robert McPherson Antiques, Friesland (other pair)

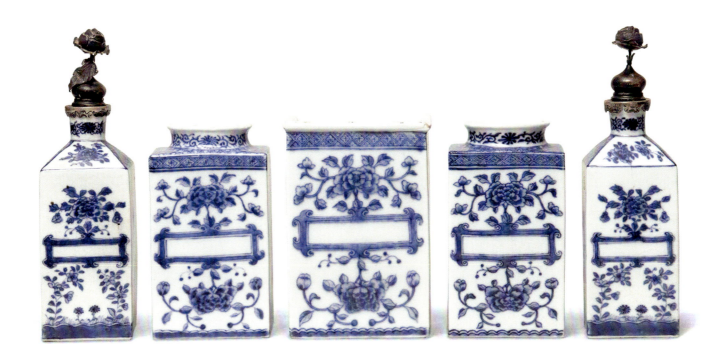

136.

BRUSH-HOLDER TABLE SCREEN

Wanli period (1573–1620)
5 ⅞ in. (14.9 cm) high

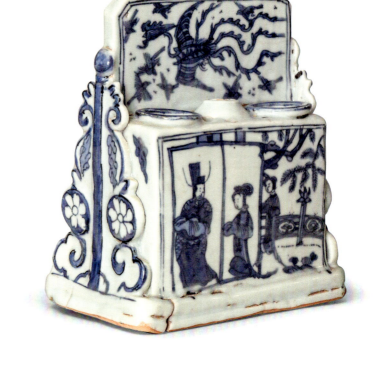

On one side, a rectangular compartment with three apertures for brushes and ink is decorated with a narrative scene. The screen above it is painted with a phoenix in flight. The other side is formed as a solid screen and applied with a high-relief figure of Gui Xing, an acolyte of the god of literature particularly revered by scholars. All is flanked by shaped bracket supports decorated with flowerheads and leaves; there is a short platform base. This useful accessory for the scholar's desk seems to have been made in a number of variations in the Wanli period, all of basically the same form but with varying decoration, and all for the domestic market.

REFERENCES Philadelphia Museum of Art (1923-45-1) (closely related example); Ashmolean Museum (1978.848) (example of similar concept); Lion-Goldschmidt 1984, p. 201 (with two relief figures)

PROVENANCE Heirloom & Howard Ltd, Wiltshire, 1990; Christie's London, 29 October 1990, lot 5

137.

DOUBLE SPICE BOX MOUNTED AS AN INKSTAND

Kangxi period (1662–1722) and later
7 ¼ in. (18.4 cm) wide

Complete inkstands were made in Chinese export porcelain in the Qianlong period (1736–95), but other porcelains were also adapted from their original purpose for use on the European desk. Here, a rectangular, double-compartmented box painted along its sides with typical Kangxi chrysanthemum and peony was no doubt made to hold spices on the dining table. At some later point—perhaps when ground spices at meals had become old-fashioned—the box was mounted in ormolu and its original covers were replaced with Chinese porcelain lids of the 1760s, probably taken from *pots de crème*. In this way the Chinese blue and white could still be both functional and enjoyed.

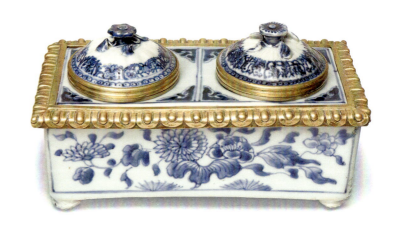

REFERENCES Winterthur Museum (1958.1529) (Qianlong period porcelain inkstand with original fittings)

PROVENANCE Heirloom & Howard Ltd, Wiltshire, 2019; Woolley & Wallis, Salisbury, 21 May 2019, lot 489

138.

TWO JARDINIÈRES

Kangxi period (1662–1722)
7 ½ and 12 ⅜ in. (19.1 and 32.1 cm) high

Chinese and Europeans alike were fond of potted plants in the early modern period, a time when flowers like peonies and chrysanthemums that now seem commonplace in the West were first imported from Asia for cultivation. By the second quarter of the eighteenth century, Chinese export porcelain jardinières were made in some number but they were still somewhat rare during most of the Kangxi period. These two represent classic Kangxi jardinière forms. The first has tall, tapering sides and is painted with a pheasant perched on rockwork before a lattice fence; the second is hexagonal, each side with a different flowering plant. The shape of the second and its depictions of flowering plants are very similar to those of a jardinière made for shipbuilder Sir Henry Johnson in the mid-1690s; it may well have been made in the same workshop (see no. 26).

REFERENCES Du Boulay 1984, p. 261 (variant hexagonal form); Jörg 1997, p. 149 (*famille verte* similar to top)

PROVENANCE Philip S. Dubey Antiques, Baltimore (top). Heirloom & Howard Ltd, Wiltshire, 2014; John Nicholson Auctioneers, Surrey, 2 April 2014, lot 457 (bottom)

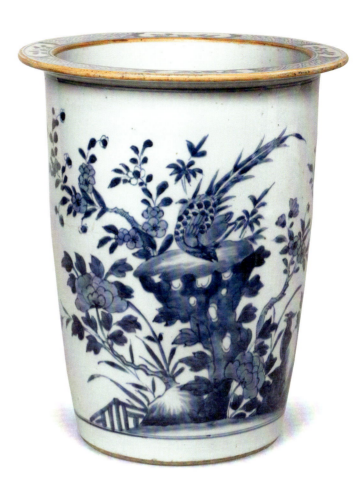

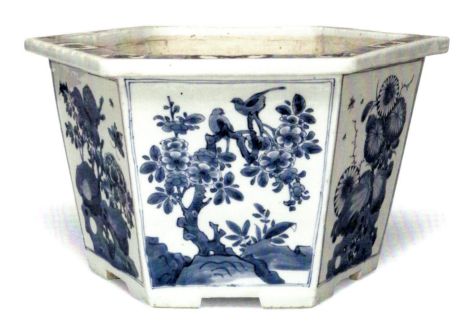

139.

FOUR SPITTOONS

Wanli (1573–1620) and Kangxi (1662–1722) period
3 ¼, 3 ½, 4 ¼ and 5 ¼ in. (8.3, 8.9, 11 and 13.3 cm) high
(left to right)

All have rounded bodies and flaring mouths; two have handles. The first (Wanli period) is painted with cranes and was most likely made for the domestic market. The three Kangxi examples are painted with landscape or flowering boughs; each has a wide, decorated inner rim. Spittoons were made for export in Japan in the seventeenth century and in China beginning around 1700. The *Geldermalsen*, a VOC ship that sank in 1752, had an order of 299 spittoons, or cuspidors, aboard. The Chinese had long used spittoons; Marco Polo (1254–1324) commented on their use at the Chinese court: "[E]very one of the chiefs and nobles carries always with him a handsome little vessel to spit in whilst he remain in the hall of Audience—for no one dares spit on the floor of the hall …."

REFERENCES Howard 1994, p. 228 (*Geldermalsen* example); Jörg 1997, p. 118 (octagonal example); Honour 1961 (quote)

PROVENANCE Heirloom & Howard Ltd, London, 1989; the collection of David S. Howard, London (two). The Chinese Porcelain Company, New York, 1990 (hexagonal)

140.

SHAVING BOWL

Chongzhen (1628–44) to Shunzhi (1644–61) period, c. 1635–55

12 ½ in. (31.8 cm) diameter

In the center of this bowl, a Chinese farmer stands near two small houses holding a branch or farm implement. The inner and outer borders are painted with further rural landscape containing other farmers, farmhouses and deer. A very similar shaving bowl in the Keramiekmuseum Princessehof depicts a farmer in like pose but holding a leafy branch. Two basins of this date but without notches share these distinctive borders, one in the Freer Gallery of Art with a Chinese gentlemen's picnic in the center and one in the Museu Medeiros e Almeida in Lisbon with a crab-fishing scene. On both of these basins small crosses are visible on some of the rooftops; they are present on the shaving bowl here but rendered very indistinctly. On all of these pieces, a straight bridge with a ladder at each end and fish underneath appears on the rim—a depiction very unlike the typical Chinese arched bridge and which suggests a European design source. Shaving bowls were first ordered commercially from Japan in 1662 and from China in 1669; the two shaving bowls discussed here were likely an early private order of the form, possibly from a set of six.

REFERENCES Lunsingh Scheurleer 1974, pl. 48 (Princessehof bowl); Little 1983, p. 11 and Freer Gallery of Art (F1977.12) (basin); Jörg 2003a (Japanese orders); Howard and Ayers 1978, p. 134 (Chinese orders, quoting Volker 1959, p. 156)

PROVENANCE Kee Il Choi, Jr., New York, 1987

141

ROUND FOOTED BOX AND SHAPED SQUARE BOX

Kangxi period (1662–1722)
6 and 7 ½ in. (15.2 and 19 cm) high

The first box is squat and round with a pedestal foot; its sides are lightly molded with petal-shaped panels and painted with scrolling lotus, and there is a *lingzhi* fungus sprig inside. The other box is of square outline with a domed stepped cover and overall scrolling vine. Both were probably used in Europe for a variety of purposes, although the second is closely related to an eighteenth-century Delftware form called *tafeltabaksdoos* (table tobacco box), designed to keep tobacco moist. Tobacco-smoking came from the Spanish Americas; by 1700 England was importing twenty million pounds of tobacco from their Maryland, Virginia and Carolina colonies per year, half of which was sold on to the Dutch Republic. Like tea-drinking, this popular practice was accompanied by appropriate accessories in the wealthier households.

REFERENCES Staatliche Kunstsammlungen Dresden (PO 2548) (very similar to first); Aronson n.d.c (Delft tobacco box)

PROVENANCE Heirloom & Howard Ltd, Wiltshire, 1992; Christie's Amsterdam, 4 November 1992, lot 96 (left). Heirloom & Howard Ltd, London, 1987; Sotheby's London, 28 April 1987, lot 445 (right)

142.
PAIR OF CYLINDRICAL JARS WITH COVERS

Kangxi period (1662–1722)
7 ⅞ in. (20 cm) high

Both the bodies and the slightly domed covers of these jars are decorated with a somewhat unusual pattern. Borders of large, blue-ground triangles contain foliate scroll and are reserved on a field of penciled cracked ice pattern. They have later metal rims and inset feet bordered in triangles; the bases with ribbon-tied lozenge marks. Straight-sided jars of this scale were sometimes called ginger pots in Europe, though like the covered vessels in the two previous entries they were probably put to various uses. The collection formed by Augustus the Strong (1670–1733) at the Saxon court includes several jars of this form and pattern.

REFERENCES Staatliche Kunstsammlungen Dresden (PO 1225) (very similar jar)

PROVENANCE Imperial Oriental Art, New York

143.
FOUR SPOONS

Kangxi (1662–1722) to Qianlong (1736–95) period, 18th century
6 to 7 ¼ in. (15.2 to 18.4 cm) long

This set comprises a pair of strainer spoons with blue diaper-pattern borders, a very similar single strainer spoon and a smaller spoon or ladle. The perforations of the strainers are picked out in blue motifs while the bowl of the spoon is decorated with a flowerhead, a blossom at its center. All have floral handles. Like the large strainer in the following entry, these spoons reflect the more functional role that blue and white export porcelain took during the course of the eighteenth century.

REFERENCES Staatliche Kunstsammlungen Dresden (PO 7734) (near identical to pair); Groninger Museum (1899.0389) (near identical to spoon)

PROVENANCE The Chinese Porcelain Company, New York, 1992 (far left) and 1990 (second). Heirloom & Howard Ltd, Wiltshire, 2000 (far right)

144.
THREE STAR-SHAPED STRAINERS

Qianlong (1736–95) period
7 ⅝ in. (19.4 cm) wide (pair); 8 in. (20.3 cm) wide (single)

This trio of strainers comprises an eight-pointed pair with loop handles and a seven-pointed single. The pair has straight legs issuing from monster masks and short rims edged in blue trellis pattern, while the single has a rounded rim and animal-paw feet. On both, the perforations are decorated with flowerheads; the single has a more elaborate piercing pattern in its center. The star-shaped form has sometimes been referred to as a cheese strainer while round versions have been called fruit or strawberry strainers. They may well have served both purposes—and perhaps others, as well.

REFERENCES British Museum (Franks.246) (near identical to single); Asian Civilizations Museum, Singapore (2015-00202) (very similar pair); Vinhais and Welsh 2014, pp. 134–35 (near identical pair)

PROVENANCE Heirloom & Howard Ltd, Wiltshire, 2010; Sotheby's New York, 23 January 2010, lot 27; the collection of Elinor Gordon, Villanova PA (one of pair). Santos London, 2012 (one of pair). Matthew & Elisabeth Sharpe Antiques, Conshohocken PA, 1986 (single)

145.

THREE ROUND STRAINERS

**Kangxi (1662–1722) to Qianlong (1736–95) period,
18th century**
10 ⅛ and 4 ¾ in. (25.7 and 12 cm) wide

This very unusual pair of small strainers would have been placed over teacups to strain any stray leaves from the pot. Each is delicately painted with a bouquet of spring flowers and set with a pair of blue twist hook handles. The larger strainer has a band of floral decoration around its rim and a pair of projecting flat handles. It was made to take a cover, so probably was used to drain something warm over a medium-sized bowl or pot. Christiaan Jörg reports that the VOC (Dutch East India Company) ordered strainers 1787–89. The fairly utilitarian nature of this piece speaks to the place of blue and white as the eighteenth century went on and Chinese enameled wares or European porcelain served more elevated purposes.

REFERENCES Jörg 1982a, p. 177 (Dutch orders); Vinhais and Welsh 2014, pp. 40–41 (small peach-form strainer)

PROVENANCE Heirloom & Howard Ltd, Wiltshire, 2010; Sotheby's New York, 23 January 2010, lot 27; the collection of Elinor Gordon, Villanova, PA (larger). Heirloom & Howard Ltd, London, 1981 (one smaller). Heirloom & Howard Ltd, Wiltshire, 1993 (one smaller)

146.

TWO PUDDING MOLDS

Qianlong period (1736–95), second half 18th century
3 ¾ in. (9.5 cm) diameter

These two small molds share essentially the same thickly potted body with spiral-twist fluting and a thick, straight rim. One is painted with scattered flower sprigs and a floral border; the other has a trellis-pattern border and sketchily painted vine along its ribs. Egg-based custard puddings had been known since Roman times but evolved greatly in the eighteenth century, especially in England. Modeled after English creamware, a very limited number of these Chinese molds were made; locally available alternatives must have been preferred.

REFERENCES Howard and Ayers 1978, p. 574 (near identical to left-hand mold)

PROVENANCE Heirloom & Howard Ltd, Wiltshire, 2010; Sotheby's New York, 23 January 2010, lot 27; the collection of Elinor Gordon, Villanova PA (left)

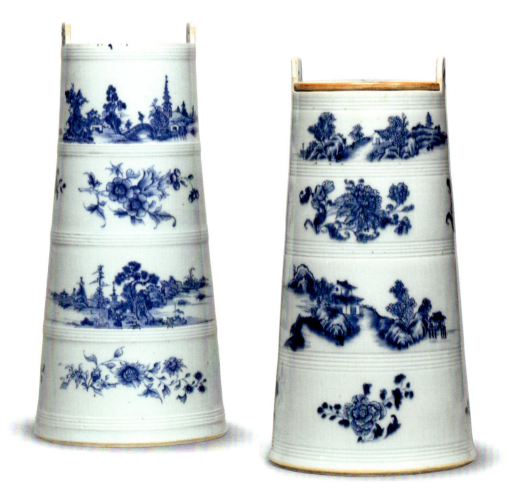

147.

THREE BUTTER CHURNS

Qianlong period (1736–95), c. 1760–80
11 ½, 10 ½ and 22 ¾ in. (29.2, 26.7 and 57.8 cm) high

Each of these churns (two very similar and a single, very large one) is molded with horizontal ribs to imitate the metal banding of a wooden churn; on the large churn these are particularly pronounced and highlighted in blue. All are decorated with flower sprays which, on the smaller two, alternate with Chinese landscape views. The churns would have been supplied with porcelain covers (one extant here) centered by large holes to accommodate a paddle for stirring cream into butter. The two smaller have upright tab handles, which may have been a feature of the larger before its rim was given a wooden mount. Though porcelain churns were undoubtedly impractical and Chinese examples are quite rare, William R. Sargent quotes a 1917 cookbook extolling them: "Porcelain butter churns are very handy for small family use, and by saving all the sour milk and cream during the week one may have quite a nice pat of fresh butter for Sunday use"

REFERENCES Sargent 2012, p. 140 (pair near identical to smaller); Winterthur Museum (59.1342) (*famille rose* version)

PROVENANCE Heirloom & Howard Ltd, Wiltshire, 2013 (first of the smaller). James Galley, Lederach PA, 1989 (second of the smaller). Matthew & Elisabeth Sharpe Antiques, Conshohocken PA, 1985; Ralph M. Chait Galleries, New York (per label) (very large)

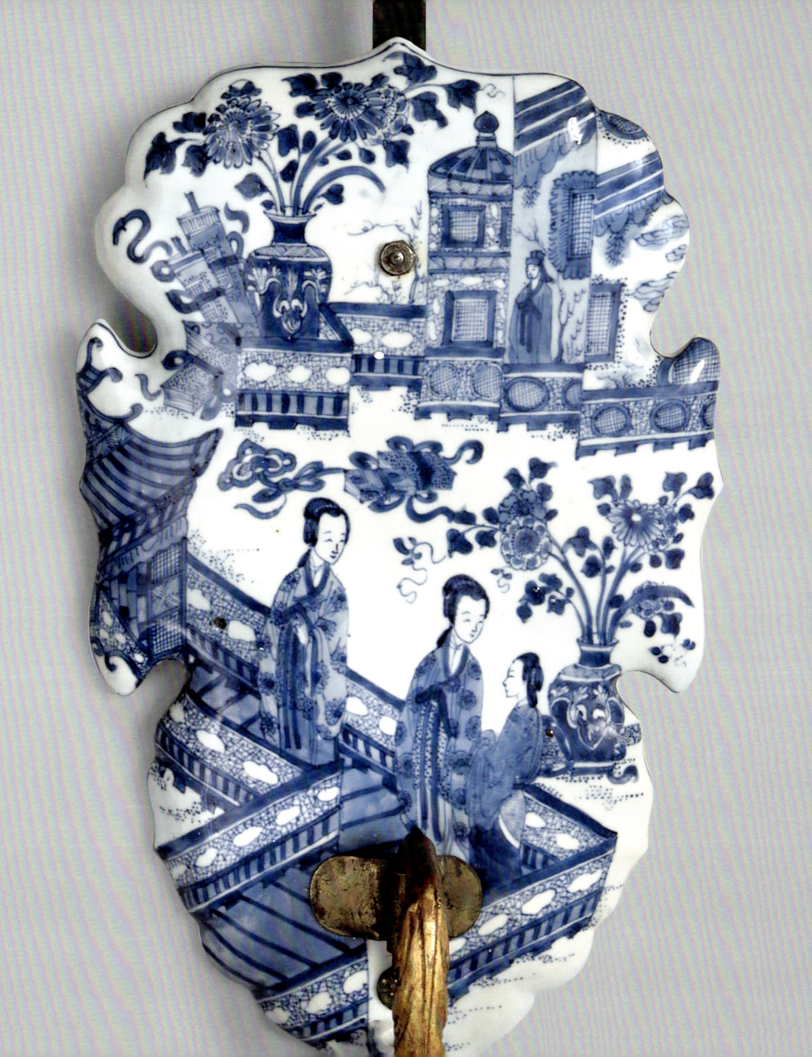

6.
FURNISHING AND DECORATION

Chinese porcelain has been a part of the embellishment of interiors almost everywhere around the world where wealth has accumulated. From European baroque palaces to Indonesian Buddhist temples, from Islamic shrines to merchants' houses in Amsterdam and Africa, and from Spanish colonial cathedrals to Gilded Age mansions, Chinese porcelain has enriched interior settings. A global luxury product well before the European Maritime Silk Route developed, Chinese ceramics made their way on Asian ships to Japan, Southeast Asia and beyond and also overland in some numbers to India and the Middle East via Bactrian camel (the fragile cargo encased in a mixture of sand, earth and flour that was then hardened).[1] From there, limited numbers went on to Europe. But it was the development of the European sailing routes in the sixteenth century that unleashed a supply of the precious commodity large enough to enable its display as a demonstration of prestige and power around the world.

This great flood of porcelain coincided with the great age of blue and white production at the Jingdezhen kilns, and it is blue and white that covered walls and filled niches in the peak era of Chinese porcelain as European room embellishment. The renowned *Porzellankabinette* (porcelain cabinets) of the seventeenth- and eighteenth-century European elite represent the height of this phenomenon, and they were teeming, for the most part, with blue and white. A version of this style was revived in the later nineteenth century as one thread of eclecticism. And today, glossy magazines still show us the occasional interior with Chinese porcelain arrayed on a wall, while high-end companies turn out wallpaper and fabric decorated with Chinese blue and white, proving that the fashion endures, albeit as a shadow of the great *Porzellankabinette*.

When it first appeared in Europe, Chinese porcelain was regarded as very rare exotica from a far-off part of the world, and it was collected for royal or aristocratic *Kunstkammern* alongside other precious rarities of art or nature. Not just wealth, but also access was necessary for its acquisition, and thus it is no surprise that Catherine of Austria (1507–1578), Queen of Portugal after her marriage in 1525 to King João III, is credited with one of the first sizeable collections of Chinese porcelain in Europe, totaling several hundred pieces.[2] Catherine displayed her acquisitions in the royal palace in Lisbon, gave porcelain to relatives or as diplomatic gifts, and hosted prestigious banquets with Chinese porcelain displayed on buffets and sideboards as well as in use on the table.[3] Perhaps the first collection maintained in a dedicated room was that of Portuguese aristocrat Teodósio I, 5th Duke of Braganza, who amassed 324 pieces at his Vila Viçosa Palace according to a 1563 inventory.[4]

In the Middle East, the large Yuan and Ming dynasty blue and white dishes that were held in great esteem were also used for the serving of food.[5] But the legendary gift of Shah Abbas to the Ardebil Shrine in 1611 is a notable example of the use of porcelain as display, in this case for the greater glory of Sheikh Safi al-Din Ardebili (d. 1334), spiritual founder of the Safavid dynasty. Chinese ceramics stretched up the wall at the shrine in a complex arrangement of multiple wall niches, each shaped to hold one piece. In both the Islamic kingdoms of the Middle East and in India, Chinese porcelain was displayed in these purpose-built niches within rooms

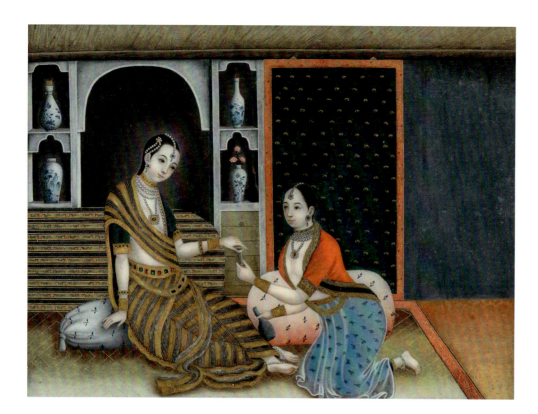

Chinese School, *Two Seated Ladies in a Chīnīkhāne*, reverse painting on glass, c. 1800, Fitzwilliam Museum, Cambridge

known as *chīnīkhāne* (Persian for Chinese room).⁶ This distinctive interior fashion continued in India well into the eighteenth century.⁷

Meanwhile, in the seventeenth century a considerable supply of Chinese porcelain became available as VOC (Dutch East India Company) ships began to ply Asian waters in ever greater numbers. And the Dutch elite led the fashion for masses of Chinese porcelain as interior embellishment that was to spread through Europe. Amalia van Solms-Braunfels (1602–1675), wife of Frederik Hendrik, Prince of Orange, not only assembled an impressive collection but also incorporated its display in Asian-style rooms, where wall coverings of silk or lacquer, furnishings and porcelain formed a unified whole. The wives of other members of the Dutch nobility grouped Chinese porcelain on shelves in special rooms, as did Aletheia Howard, Countess of Arundel (1585–1654), who had a 'Dutch Pranketing (banqueting) Room' built at her London house, Tart Hall, and accumulated an impressive array of 496 pieces of *blanc de Chine* and *kraak* ware.⁸ But Amalia van Solms's concept of the wholly integrated *Porzellankabinett* took aristocratic collecting to another level and an influential one. The marriages of her four daughters—to the Count Palatine of Simmern-Kaiserslautern, the Count of Nassau-Dietz, the Prince of Anhalt-Dessau, and the Elector of Brandenberg—helped to spread the fashion through the German princely world. Amalia's grandchildren included Frederick I of Prussia (1657–1713), who further elevated the room decoration at Oranienburg in Brandenburg with the help of a Dutch architect, and William of Orange (1650–1702), who with his wife Queen Mary II (1662–1694) was to lead this fashion in England.⁹

But the most prestigious European court in the later seventeenth century was undoubtedly that of King Louis XIV (r. 1643–1715), who was not immune to *la maladie de porcelaine*. Although the Dutch–German porcelain room was never really adopted in France, the unified interiors of coordinated fabrics, wall coverings and furnishings created by court painter Charles Le Brun (1619–1690) at the Château de Vaux-le-Vicomte certainly influenced the new immersive style of the eighteenth-century *Porzellankabinette*. And Chinese porcelain was certainly acquired and displayed by the elite in France, often mounted in French silver or ormolu.¹⁰ An inventory of the Grand Dauphin's collection taken in 1689 listed almost four hundred pieces of Chinese porcelain, mostly blue and white,¹¹ while the king's pleasure palace for Madame de Montespan, the

Trianon de Porcelaine, certainly reflected a fascination with the new exotic style. Built in 1670–71, the Trianon featured rooms tiled in blue and white (albeit of European faience); its roof was covered in similarly colored painted lead and embellished with vases made of painted copper. Though it was razed in 1687, from this wholly chinoiserie building can be traced the Chinese-style garden pavilions and follies that followed in the eighteenth century.[12]

Another extraordinary incorporation of Chinese porcelain in architecture was the celebrated ceiling at the Santos Palace in Lisbon, created between 1664 and 1687 with more than three hundred sixteenth- and seventeenth-century blue and white dishes (and several in colored enamels) secured by iron hooks to a steep, pyramidal ceiling of carved giltwood.[13] This was a unique method of display for the impressive collection of Chinese porcelain that had been partly formed by the Portuguese royal family and later added to by the Lancastre family, the seventeenth-century owners of the palace.[14]

But it was not just royalty and the aristocracy who embellished interiors with Chinese porcelain in the seventeenth century. In the Dutch Republic, with its prosperous burgher class, porcelain was displayed prominently atop large cupboards or along wall moldings in the houses of wealthy citizens, as seen in paintings such as *La Visite* of 1630–35 (Musées Royaux d'Art et d'Histoire, Geneva). Jan van Campen quotes a 1662 Dutch account that describes "houses here that are so abundantly furnished with ... paintings and East Indian ornaments that they resemble royal palaces rather than merchants' houses."[15] Through study of period inventories, Van Campen has shown that these displays were not scattered throughout a house but were concentrated in dedicated rooms, lending them greater effect.[16]

Though it is difficult to assign motivation in retrospect, it seems clear that the prominent display of Asian luxuries, whether in a royal palace or a burgher's townhouse, was closely related to the cultivation of image. Beyond its visual appeal as a uniquely fresh, bright and hard material, fashioned in shapes of great balance and painted with fascinating figures and flora, Chinese porcelain also signified wealth, power and geopolitical reach.[17] A display of one's connoisseurship and sophistication was also important to image, and from this we can even perhaps trace a competitive nature to the collecting of this period.[18]

Competitiveness may well have played a part in what was probably the greatest European collection of Chinese porcelain, that of Augustus the Strong (1670–1733). In 1709, hoping to form an alliance against the Swedish king, Augustus traveled to Oranienburg to meet with Frederick I, King in Prussia, and Frederick IV, King of Denmark. There he would have seen the thousands of Chinese wares in the Oranienburg Palace collection, most displayed quite sumptuously in the large *Porzellankabinett* with its lavish ceiling painting, *The Triumph of Porcelain* (Augustinus Terwesten, 1697).[19] Eight years later, Augustus was to make his notorious trade with Frederick I of six hundred cavalrymen (or dragoons) for 151 pieces of Frederick's Chinese porcelain, including the sixteen large floor vases that became known as 'soldier' or 'dragoon' vases.

The almost thirty thousand pieces of Chinese and Japanese porcelain that Augustus was eventually able to acquire were certainly more than a porcelain room's worth. In fact, he planned an entire building around the display of his Asian and German porcelain in the (never completed) Japanese Palace. The letters and invoices that survive between Augustus and his advisor and procurer, the Italian Count Lagnasco, confirm that décor was often a paramount consideration, noting a desire for "ornamental pieces" and recording comments like, "… can be used on a mantelpiece."[20]

In later seventeenth-century England, where Dutch influence had already been transmitted by aristocrats like the Countess of Arundel, the new monarchs Queen Mary II and her Dutch husband King William III became leading proponents of the style. After assuming the throne in 1689, they created magnificent rooms and galleries around Chinese porcelain at Hampton Court and Kensington Palace. French Huguenot designer Daniel Marot had already worked with Mary on the Dutch royal palace of Het Loo, and his 1702 engravings of walls incorporating lacquer, mirrors and massed porcelain "in Dutch style" were to become enormously influential.[21] Shortly after the queen's untimely death at the age of thirty-two, a 1697 Kensington Palace inventory listed 787 pieces of Chinese and Japanese porcelain.[22]

On the Continent, this royal style reached its peak at the Charlottenburg Palace in Berlin, where the famed porcelain room was designed for Frederick I of Prussia in about 1703. An incredible confection of Chinese blue and white (as well as some colored ware), giltwood mirrors, painted surfaces and sculptural chinoiserie figures, the room incorporated some of the Chinese pieces and

Daniel Marot, "Fireplace and Painted Wall," from *Novae cheminae*, etching, after 1703, Rijksmuseum, Amsterdam

giltwood brackets that had been in the magnificent *Porzellankabinett* at Oranienburg.[23]

In Spain, Philip V (1682–1746), the first Bourbon King of Spain, had a room at the Royal Alcázar of Madrid lined with Chinese lacquer panels before 1721 and used it to display the Asian objects he had inherited from his father, the Grand Dauphin of France.[24] Particularly notable porcelain rooms were created at the Margravine Sibylla Augusta's Schloss Favorite at Rastatt (1710–27), the Neues Palais at Arnstadt (1729–34) and the Empress Maria Theresa's Schönbrunn Palace in Vienna (1743–60). Extravagant and fanciful chinoiserie garden pavilions were erected at the Swedish royal summer palace of Drottningholm (1753–69) and at Frederick the Great's Sanssouci Palace at Potsdam (1770–72). These garden pavilions or follies, while not brimming with blue and white like the *Porzellankabinette* that preceded them, did incorporate Chinese porcelain and works of art as decoration as well as Chinese lacquer, paper and silk wall coverings and, typically, chinoiserie figures of wood or plaster as architectural elements.

The incredible transformation of the Royal Pavilion in Brighton commissioned by the Prince Regent (later King George IV of England) in 1815 could be considered the ultimate culmination of garden folly style. Its fantastical smorgasbord of chinoiserie, Gothic and Islamic elements of interior and exterior architecture and furnishings was adorned with a rich mixture of works of art, including Chinese wallpaper, enormous Chinese porcelain pagodas, ormolu-mounted Chinese ceramics, English mahogany and parcel-gilt furniture, Indian ivory-veneered furniture and Chinese pictures on glass and paper. The Royal Pavilion could also be considered a forerunner of nineteenth-century eclecticism. In the later decades of the century, this eclecticism—enhanced by the opening of Japan in 1853 that inspired the *Japonisme* style—found James Abbott McNeill Whistler and John Singer Sargent painting elegant ladies holding blue and white vases, a modern iteration of the same demonstration of connoisseurship practiced by monarchs centuries earlier. Collecting Kangxi blue and white became such a fashionable craze in the 1870s that the British press mocked it as 'Chinamania'.

Whistler was creator of the ultimate manifestation of the eclectic revival style: the Peacock Room, now at the Freer Gallery of Art, Washington DC, which he designed for shipping magnate Frederick Leyland in 1876–77. Truly a *Porzellankabinett* or *chīnīkhāne* with a modern sensibility, the room is lined with an arrangement of giltwood niches displaying a collection of Kangxi period (1662–1722) blue and white porcelain. The walls are painted a deep blue-green and embellished by Whistler with massive gilt peacocks.

Interestingly, the houses of prosperous merchants along the Swahili coast of East Africa in this same period displayed nineteenth-century Chinese porcelain massed on the walls in careful arrangements somewhat reminiscent of the Santos Palace ceiling. The photograph album of Sir John Kirk, British consul at Zanzibar in the 1870s and '80s, records interiors in this style in Lamu and Mombasa, Kenya.[25] Chinese porcelain had been known along the African coast for centuries—even before Zheng He's voyages of the early fifteenth century reached Malindi and Mogadishu.[26]

But, of course, the use of Chinese porcelain as decorative ornamentation went far beyond the particularly intensive display of the *Porzellankabinett* or *chīnīkhāne*, and over the centuries of porcelain flowing

from Jingdezhen to all parts of the world it became an element of nearly every interior style. Some pieces were entirely divorced from their original function: a five-piece garniture derived from a Chinese altar set would, in the West, grace a mantelpiece or tall cupboard; a large Chinese storage jar might decorate a console table (no. 148). Other forms were used identically in East and West—flower vases, for example, which are well represented in the Frelinghuysen collection (nos. 149–150, 152 and 155–157).

Lighting was a particularly important component of interior furnishings in the era before gas or electric fixtures, and Chinese porcelain made very desirable lighting elements for European rooms. The collection includes porcelain candlesticks, chambersticks and an exceptional pair of wall sconces (nos. 151 and 164–166), all fashioned after European metalwork.

It is worth noting that the vast quantities of Chinese porcelain that climbed the walls of European porcelain rooms were largely made as functional pieces—small bowls, dishes, jars, teapots, *kendi*—all put to use as decoration. In fact, it could be argued that almost every piece in the Frelinghuysen collection originally served as adornment, in one way or another, as they were all produced to elevate daily surroundings and the practices of daily life.

James McNeill Whistler, *Harmony in Blue and Gold: The Peacock Room*, oil paint and gold leaf on canvas, leather, mosaic tile, glass and wood, 1876–77, Freer Gallery of Art, Washington DC

1 Carswell 2000, p. 76.
2 Canepa 2014, p. 18.
3 Ibid., pp. 20–21.
4 Canepa 2016, p. 320.
5 Carswell 2000, pp. 23–24.
6 Pergamon Museum 2012 (an exhibition of seventeenth- and eighteenth-century Islamic paintings depicting Chinese blue and white).
7 Alafouzo, Liu and Gaeta 2021, pp. 80–81.
8 Bischoff 2014, pp. 171–72.
9 Chilton 1992, p. 13.
10 Ibid., p. 14.
11 Watson and Whitehead 1991, pp. 13–52.
12 Bischoff 2014, pp. 174–75.
13 Lion-Goldschmidt 1984, p. 11.
14 Pomper 2021, p. 1.
15 Van Campen 2018–19, p. 129.
16 Ibid., p. 129.
17 Ibid., p. 131.
18 Van Campen 2014, p. 203.
19 Broomhall and Van Gent 2016, pp. 262–63.
20 Simonis 2018, pp. 2–3.
21 Chilton 1992, p. 15.
22 Royal Collection n.d., p. 1.
23 Chilton 1992, p. 15.
24 Krahe and López 2019, p. 292.
25 Meier 2009, pp. 10–13.
26 Carswell 2000, pp. 59, 87; Finlay 2010, p. 164.

148.
LARGE FOOTED JAR

Chongzhen period (1628–44)
15 in. (38.1 cm) high

Four round scenes of scholars or officials in landscape decorate the sides of this jar, joined by small panels of landscape and all on a field of scrolling vine bearing tulip, lily and carnation blooms. The jar's exaggerated baluster shape is reminiscent of Delft of the period. Katharine Butler and Teresa Canepa note that the flowers on this group of jars are those highly fashionable varieties that had come to the Dutch Republic from Turkey and Asia, suggesting that they may be the kind of "Dutch paintings, flower or leafwork" requested on porcelains in a VOC (Dutch East India Company) letter of 1635. (The jar would have been made with a cover.)

REFERENCES Butler and Canepa 2022, pl. III.2.9; Staatliche Kunstsammlungen Dresden (PO 3242) (related jar)

PROVENANCE Philip S. Dubey Antiques, Baltimore

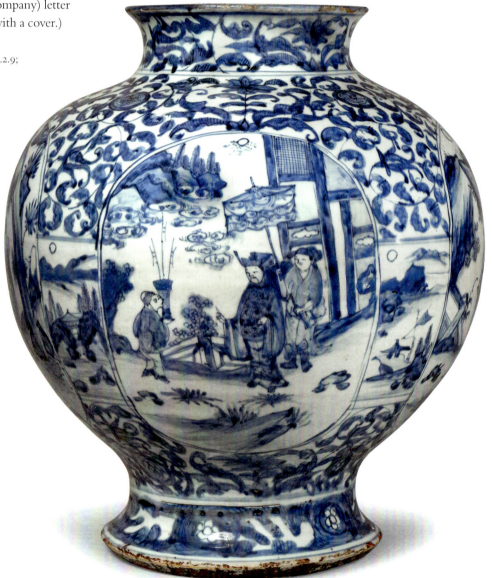

149.
WALL VASE

Chongzhen period (1628–44)
6 ⅜ in. (16.8 cm) high

Made with a flat, glazed back for hanging on the wall, this small vase is painted in inky tones of cobalt with a single songbird perched on a branch of blossoming peony growing from rocks, a typical Transitional period subject. The form seems to have been made with varying decoration; an example in the Butler collection shows a scholar standing in landscape. There is an apocryphal six-character Chenghua reign mark on the back.

REFERENCES Butler and Canepa 2022, pl. III.2.84; Staatliche Kunstsammlungen Dresden (PO 7020)

PROVENANCE Dallas Auction Gallery, September 2014, lot 222

150.
BOTTLE VASE

Chongzhen (1628–44) to Kangxi (1662–1722) period, c. 1640–80
9 ⅞ in. (25 cm) high

A simple arrangement of conjoined panels, each containing a single flower or fruit motif, decorates the sides of this vase, while on the neck are two stylized leafy flowerheads very reminiscent of Transitional period porcelains. A Chongzhen period tankard of very similar pattern is in a Dutch museum and another is depicted in a 1638 still-life painting by Willem Claesz. Heda. See also the tankard in no. 97.

REFERENCES Canepa 2016, p. 205 (Dutch museum tankard and painting)

PROVENANCE Heirloom & Howard Ltd, Wiltshire, 2016; Bonhams Edinburgh, 13 July 2016, lot 144

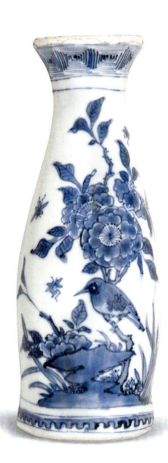
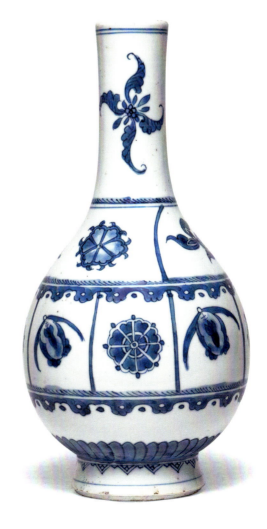

151.
LARGE CANDLESTICK

Chongzhen period (1628–44), c. 1640
11 ¼ in. (28.6 cm) high

This candlestick is based on a northern European metalwork form seen in Renaissance painting and common in the Netherlands in the late sixteenth century. That form, however, may have been inspired in turn by Ottoman metalwork examples with very similar proportions, their sturdy bases a practicality that kept them from tipping over. Chinese porcelain versions of the fifteenth century imitated this shape; in the seventeenth-century porcelain models, the angular base of the Turkish prototype has been rounded.

REFERENCES Canepa 2016, pp. 309–10 (discussion); Howard 1994, p. 217 (near-identical stick); Metropolitan Museum of Art (66.4.1) (Iznik stonepaste imitating metalwork); Carswell 2000, p. 82 (Xuande porcelain)

PROVENANCE Michael Dunn Antiques, Claverack NY, 1988

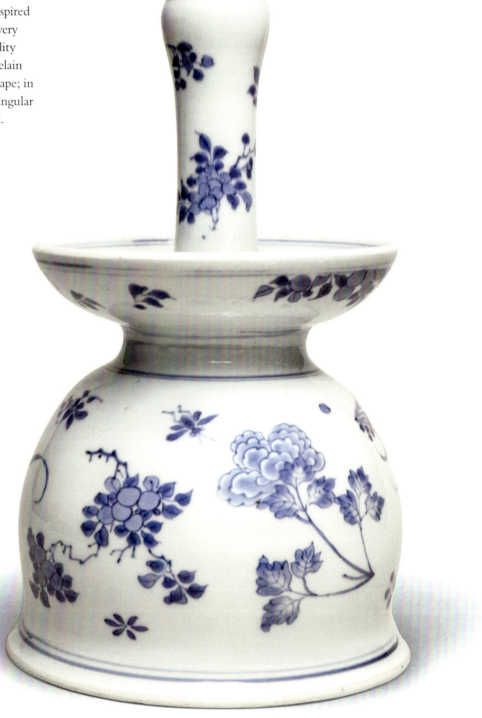

152.

PAIR OF VASES AFTER VENETIAN GLASS

Kangxi period (1662–1722), c. 1700
9 ⅛ in. (23.2 cm) high

The innovative forms and techniques of Venetian glassmakers were widely copied throughout Europe, including in the glass workshops that developed in late seventeenth-century England and the Dutch Republic. This vase form, with its distinctive pair of crimped handles, was then made in Chinese blue and white porcelain of slightly varying sizes but all decorated with dense scrolling foliage.

REFERENCES Sargent 2012, pp. 122–23; Howard 1994, pp. 234–35

PROVENANCE The Chinese Porcelain Company, New York, 1988

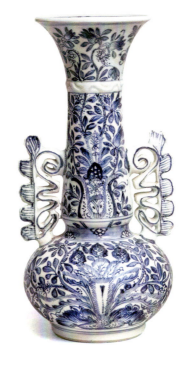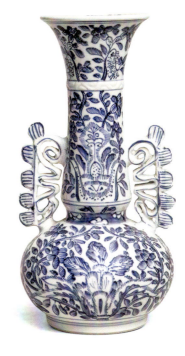

153.

TWO LARGE GOBLETS WITH COVERS

Kangxi period (1662–1722), c. 1690
9 and 9 ⅝ in. (22.9 and 24.4 cm) high

From the cargo of a Chinese junk known as the *Vung Tau* that sank in 1690 in Vietnamese waters, these large cups or goblets are modeled after Dutch glass of the period. By this time, Jingdezhen potters were practiced at adopting the models that the VOC had begun sending in the 1630s.

REFERENCES Jörg and Flecker 2001, pp. 65–66 (discussion and engraved glass prototype at the Rijksmuseum); Le Corbeiller and Frelinghuysen 2003, p. 10 (very similar covered goblet)

PROVENANCE Heirloom & Howard Ltd, Wiltshire, 1992; Christie's Amsterdam, 7–8 April 1992, lots 3 (part) and 855 (part); the *Vung Tau* Cargo

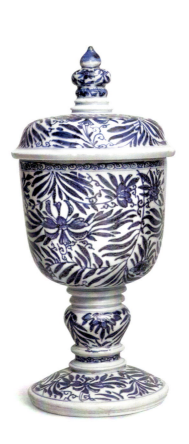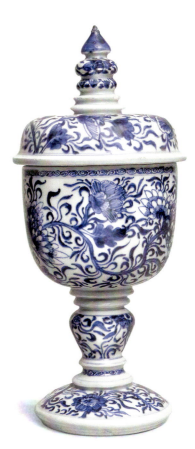

154.
TWO-HANDLED JAR WITH COVER

Kangxi period (1662–1722)
11 ⅛ in. (28.3 cm) high

Of pear shape with dome cover and a pair of high, arching handles, this jar is painted on each side with a large, shaped panel of fan-shaped vignettes and ribbon-tied symbols. Writing of a near-identical vase in the Rijksmuseum, Christiaan Jörg remarks, "This shape is rather rare and seems to have been made exclusively for the Dutch market after a Western silver model for only a very short period."

REFERENCES Jörg 1997, p. 262 (the Rijksmuseum example)

PROVENANCE Heirloom & Howard Ltd, Wiltshire, 2011; Sotheby's New York, 25 January 2011, lot 104; the collection of Charles Ryskamp, New York; The Chinese Porcelain Company, New York, 1995

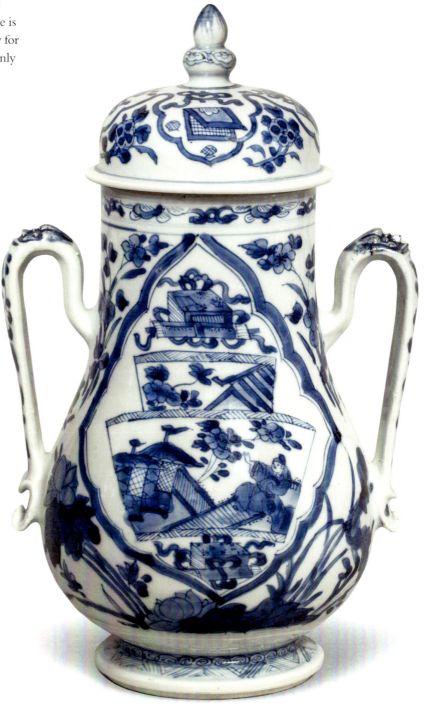

155.

LARGE BLUE-GROUND VASE

Kangxi period (1662–1722)
23 in. (58.4 cm) high

This large vase is unusual in both its form and decoration. Beneath a deep, patterned *ruyi*-head collar, the slender baluster body is a lustrous cobalt blue, decorated only with a few scattered leaf and flower sprigs. A few bamboo sprays decorate a washy blue band on the neck, and a band of basketweave pattern encircles the body just above a straight foot. There do not seem to be any published examples of this somewhat eccentric decoration.

PROVENANCE R & G McPherson Antiques, London, November 2011

156.

PAIR OF VASES WITH G MARK

Kangxi period (1662–1722)
12 in. (30.5 cm) high

This pair belongs to a small group of vases known with the unusual G initial mark, some *famille verte* and some of bottle shape. Their form, with long slender neck above a squat hexagonal body, may be derived from earlier Iranian (Persian) or north Indian metalwork. A vase of this form, but with floral and symbol decoration, was in the Ardebil Shrine collection of Shah Abbas. A blue and white pair of near-identical form and decoration was in the Julia and John Curtis collection, while a very similar G-marked pair, but in *famille verte* enamels, is in the Rijksmuseum, as is a blue and white bottle vase and a pair of *famille verte* bottle vases with the same G mark. Some have speculated that the G may imitate the mark of a yet-unidentified Delft factory, but Christiaan Jörg posits that they most likely represent the initial of the trader who ordered them, just like the well-known group of seventeenth-century initialed Japanese porcelain apothecary bottles (see no. 263).

REFERENCES Pope 1956, pl. 109 (Ardebil vase); Jörg 1997, pp. 165, 259–60 (*famille verte* bottle vases); Christie's New York, the collection of Julia and John Curtis, 16 March 2015, lot 3584 (near-identical pair)

PROVENANCE Heirloom & Howard Ltd, Wiltshire, 1992; Sotheby's Sussex, 5 February 1992, lot 618

157.

PAIR OF MINIATURE VASES WITH AK MARK

Kangxi period (1662–1722)
4 ¼ in. (10.8 cm) high

These small baluster vases are decorated with a pattern of stylized lily blooms. On their bases is inscribed *No-1/AK* in imitation of the mark of the prestigious Delftware factory known as De Grieksche A, owned by Adrianus Kocx from 1686 to 1701. Presumably, a Delft pair had been sent to China to be copied and were, down to their marks.

REFERENCES Metropolitan Museum of Art (1995.43a, b) ('Greek A' flower vase)

PROVENANCE Heirloom & Howard Ltd, Wiltshire, 2019; Rob Michiels Auctions, Bruges, 27–28 April 2019, lot 412

158.

DISH WITH ENAMELED BACK

Kangxi period (1662–1722)
8 ⅜ in. (21.3 cm) diameter

Stylized leaves and blooms are painted in underglaze blue in the center of this dish, while the rim is decorated with flowering vine. But in a very unusual departure, the back of the dish is enameled in the *famille verte* palette of translucent enamels with fruit sprigs within a key-fret border. Combinations of cobalt blue and *café au lait* or other monochrome glazes are better known, and usually seen in closer proximity. On the base is an auspicious mark in the form of an iron-red rabbit.

PROVENANCE Polly Latham Asian Art, Boston, 2014

159.
DISH WITH LOTUS MEDALLION

Kangxi period (1662–1722), c. 1670–80
13 ⅞ in. (35.2 cm) diameter

A large lotus-shaped medallion in the center of this dish is painted in particularly inky cobalt blue with a symmetrical arrangement of lush peony blooms. On the curving sides are a *ruyi* head and a spade border; the back is decorated with a flaming pearl and three ribboned symbols; the dish rests on a channeled footrim. Katharine Butler and Teresa Canepa have identified a group of 1670s dishes with this fairly wide-channeled footrim, possibly the output of a particular private kiln. A very similar dish is found in the famous porcelain-encrusted pyramidal ceiling of the Santos Palace in Lisbon, created with wares collected by the Portuguese royal and Lancastre families in the later Ming period.

REFERENCES Butler and Canepa 2022, p. 374 (channeled footrims); Canepa 2019, pp. 30–31 (Santos Palace ceiling)

PROVENANCE van Halm & van Halm, London, 2021

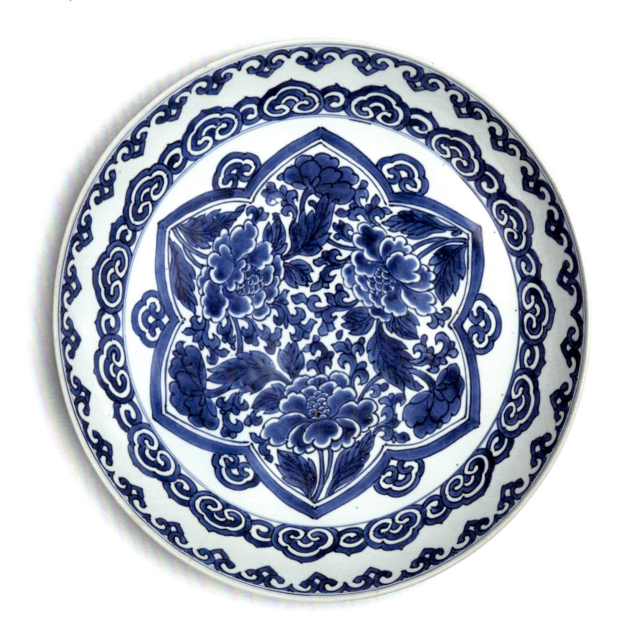

160.
JAR WITH PALMETTES

Kangxi period (1662–1722)
9 ¾ in. (24.8 cm) diameter

The bulbous sides of this squat jar are boldly painted with a formal arrangement of scrolling palmettes very reminiscent of Indian textiles—textiles which would have been familiar by this time not just to South Asians but also to European traders. (The jar would have been made with a cover, now replaced in Chinese carved wood.)

REFERENCES The Textile Museum Collection at George Washington University (2017.14.1) (Coromandel coast palampore or bedcover)

PROVENANCE Avery & Dash Collections, Stamford CT, 2018

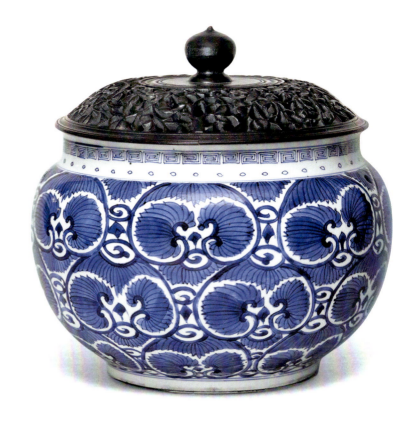

161.
MELON-FORM VASE

Kangxi period (1662–1722)
8 ¼ in. (21 cm) high

A long cylindrical neck rises from the squat melon-form body of this small vase. Its lobed base is unglazed. On the neck are columns of tiny geometric motifs, while each lobe is painted with slender flower or fruit stems. The shape of the vase is similar to that of hookah bases, but it lacks the ridge they require to be functional. The regularity of its decoration is related to Islamic patterns, but the flower and fruit stems also seem akin to the European-style tulips and lilies used prolifically on Transitional period export wares. Overall, this unusual vase is a true reflection of the multiple cultural influences that were at play in Kangxi period porcelains.

PROVENANCE The Chinese Porcelain Company, New York, 1995

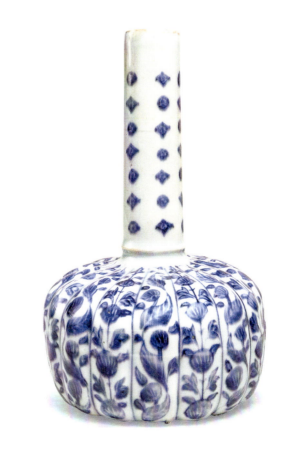

162.
PAIR OF DISHES WITH RADIATING FLOWER STEMS

Kangxi period (1662–1722), c. 1700
13 ½ in. (34.3 cm) high

A central flowerhead roundel issues radiating flower stems in the center of each dish, the thin, curving stems with tiny leaves. A border of dense lotus scroll fills the flat rims; the backs are painted with prunus boughs and artemisia leaf marks. Three slightly larger dishes in this exact pattern appear in the renowned collection at the Topkapı Palace in Istanbul that was assembled by sultans of the Ottoman Empire. While many pieces in the Topkapı collection reflect Islamic taste, they were not necessarily made exclusively for that market, and in fact many of the same patterns and forms found in its collection were collected contemporaneously elsewhere around the world.

REFERENCES Krahl 1986b, p. 1040
(near-identical Topkapı Palace examples)

PROVENANCE The Chinese Porcelain Company, New York, 1999; Sotheby's New York, January 1999, lot 5

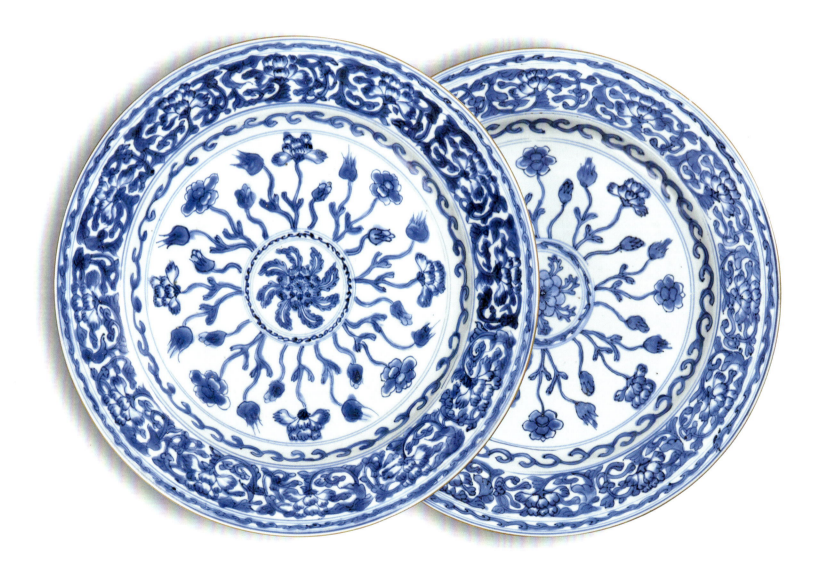

163.
LARGE SPIRAL-FLUTED DISH

Kangxi period (1662–1722)
15 ½ in. (39.4 cm) diameter

In the center of this large dish a pair of phoenixes fly amidst lush peony blooms, while on the spiral-fluted rim panels further peonies alternate with scenes of monkeys at play in pine trees. Lotus and peony blooms alternate on the back side; in the center is an artemisia leaf mark within a double circle. This exuberant form, modeled after baroque silver and known in a small group of examples, would have required extra effort by the potter and extra care in the kiln.

REFERENCES Howard and Ayers 1978, p. 64 (smaller version)

PROVENANCE A.R. Broomer Ltd, New York, 1992

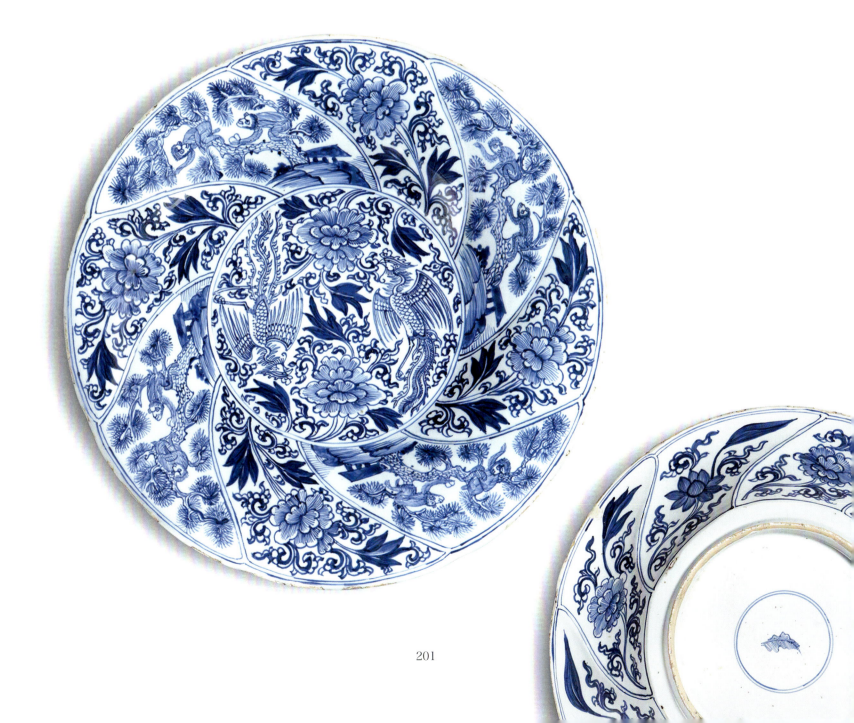

164.
PAIR OF SCONCES WITH SHADES

Kangxi period (1662–1722), c. 1690–1710
16 in. (40.6 cm) high (excluding candle arm)

This extraordinary pair must have been part of a unique set commissioned for a very grand Dutch or English house or palace. Another is recorded, of variant shape and identical pattern. The baroque cartouche form of the sconces reveals their origin in European metalwork, probably Dutch silver or brass, while the shades are shell-shaped.

The sconces are painted with two ladies and a maidservant walking on an angled bridge or pathway in what appears to be a palace compound. Some of the buildings in the background seem to have stone sides and curious rounded rooftops, while flowering bushes decorate the garden or courtyard. A closely related pattern appears on a small group of large floor-standing vases, including one in the Augustus the Strong collection at Dresden and a pair at Petworth House in England, and on a number of other larger-scale pieces, including a pear-shaped wall cistern sold at Christie's in 1983.

In an age before electricity, lighting was an extremely important part of a room's décor, and wall-lights for an elite room were a significant element of its overall scheme, often made of desirable materials like silver, rock crystal or gilt bronze. These Chinese porcelain sconces must have made a strong impression in the household of their patron.

REFERENCES Groninger Museum (1995.0122) (closely related sconce); Staatliche Kunstsammlungen Dresden (PO 1137) ('soldier' vase); Du Boulay 1984, p. 199 (wall cistern)

PROVENANCE Heirloom & Howard Ltd, Wiltshire, 2012; Sotheby's London, 16 May 2012, lot 328 (left). Heirloom & Howard Ltd, Wiltshire, 2018; Oriental Art Auctions, Gelderland, 9 April 2018, lot 47 (right)

203

165.

PAIR OF CANDLESTICKS

Qianlong period (1736–95), c. 1740
7 ⅞ in. (20 cm) high

Modeled after English or Dutch metalwork of the first decades of the eighteenth century, these sticks feature baluster standards rising from octagonal dished bases. They are decorated with diaper trellis pattern alternating with flower sprigs. A set of four in the same pattern was published by Ronald W. Fuchs II, who notes that although candlesticks were among the first European forms made at Jingdezhen, first ordered by the VOC (Dutch East India Company) in 1639, "they were still relatively uncommon in the 18th century."

REFERENCES Fuchs 2005, p. 157 (near-identical set of four)

PROVENANCE Philip S. Dubey Antiques, Baltimore, 2020

166.

THREE CHAMBERSTICKS

Qianlong period (1736–95), c. 1775–80
5 ¼ and 3 ¾ in. (13.3 and 9.5 cm) high

A single with standard in the form of a bamboo section, its handle an arching *chilong* serpent, and a pair with flower-bud nozzles, their handles formed as stems. All have scalloped, dished bases decorated with landscape. A fair number of variations of the type with *chilong* handle are known in *famille rose* enamels; an example dated to circa 1775 with the arms of Earle with Gay quarterly in pretence is of the same model as this pair.

REFERENCES Howard 1994, p. 219 (*chilong* type); Howard 1974, p. 641 (armorial example)

PROVENANCE The collection of David S. Howard, London, 1989 (single). Richard Gould Antiques, Santa Monica, 1989 (pair)

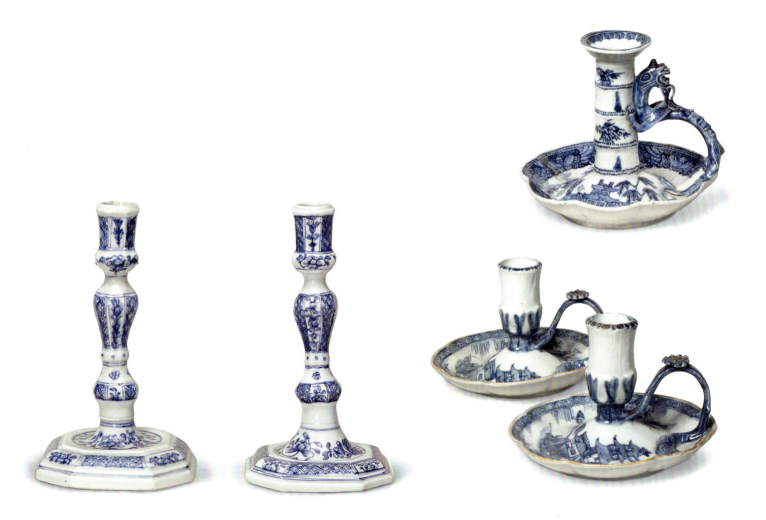

167.
PAIR OF LARGE URNS WITH COVERS

Qianlong period (1736–95), c. 1775–85
15 ¾ in. (40 cm) high

Of neoclassical form, these urns feature large rose sprigs in high relief on each side linked by blue drapery swags. The extravagant form was first made by the Marieberg faience factory in Sweden in the 1770s; then in China for the European market in both colored enamels and blue and white, reflecting the new fashion for neoclassical style and demonstrating the dominance of European ceramic styles in this period.

REFERENCES Metropolitan Museum of Art (51.86.38a, b, .39a, b) (blue and white pair); Winterthur Museum (1965.2890) (*famille rose* version)

PROVENANCE James Galley, Lederach PA, 1998

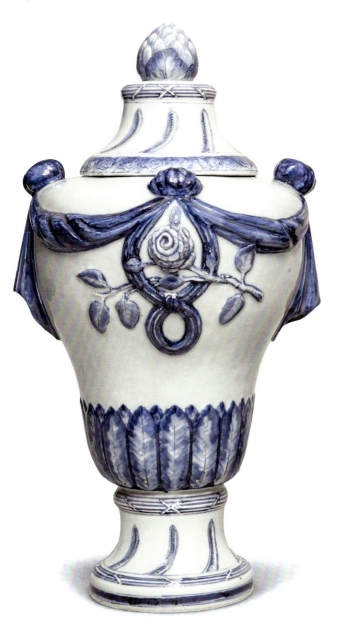
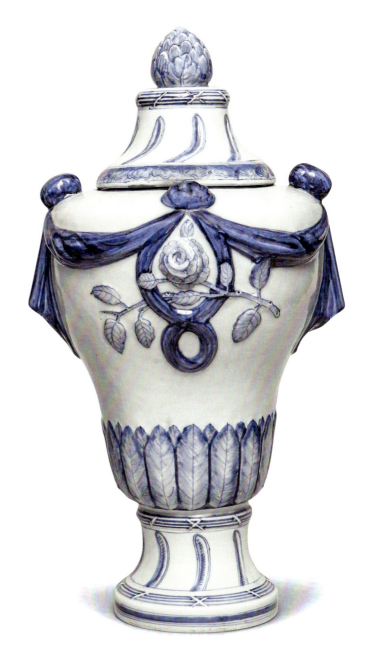

7.
FIGURES AND ANIMALS

For millennia, cultures all around the world have assigned special meaning to animals. Animals were inextricably bound with life: wild animals were to be feared and battled, while domesticated animals provided or helped produce food or offered comfort and amusement. Ancient peoples crafted images in both animal and human form, often imbued with magical powers.

In China, the practice of burying the dead with all the necessities of daily life led to a great facility with ceramic sculptures of both figures and animals. As in ancient Egypt, this custom began with actual sacrifice but was replaced by effigies. By the Han dynasty (206 BCE–220 CE), Chinese potters were producing skillful tomb sculpture in the form of people, animals, granaries and more. Chinese tomb pottery continued to be made until the early seventeenth century but its height was reached during the Tang dynasty (618–907), a period of artistic and intellectual flowering.

This facility with ceramic sculpture, although developed at pottery kilns, may well have underpinned the aptitude of potters at Jingdezhen, where sculptural porcelain in the form of both animals and people was being made in some numbers by the second half of the sixteenth century. At this time they were decorated in either underglaze blue or with translucent green, yellow, blue and brown glazes. The diplomatic gift in 1590 of Ferdinand I de' Medici, an avid collector of Chinese ceramics, to Elector Christian I of Saxony included three pieces of such colored ware: a phoenix-form ewer, a crayfish pouring vessel and a small boat-form oil lamp with a figure on top (all still in the State Art Collections at Dresden today).[1]

Some three hundred and fifty miles to the south of Jingdezhen, potters at the Dehua kilns began to produce small sculptural porcelains in significant numbers in the seventeenth century.[2] This high-fired, white Dehua porcelain, known as *blanc de Chine* in the West, was produced in central Fujian province, handy to the major export ports of the Fujian coast. It became part of the panoply of coveted export wares.

Meanwhile, by the eighteenth century, blue and white figures and animals were being produced at Jingdezhen for both the home and the foreign markets, and there was much overlap between the two. Figures of the Daoist immortals could be featured on a domestic altar in China or admired as exotic curiosities in the West. Guanyin, the Buddhist bodhisattva associated with mercy, was a common devotional figure in Chinese households as well as a figure often exported. From at least the sixteenth century, Guanyin—who in earlier periods was known as Avalokiteśvara and had been shown as a somewhat androgynous male—was often depicted as Songzi Guanyin,[3] the sender of sons, in the form of a woman holding a baby boy. The affinity of this Guanyin (which may have first emerged under Franciscan influence in the fourteenth century)[4] with the Madonna and Child was used to advantage by the Jesuits in China, who set aside the crucified Christ imagery that many Chinese found distasteful in order to put forward the Madonna.[5] And for Westerners Songzi Guanyin seemed to have a special appeal, judging by the numbers that were exported. Presumably, Guanyin was appreciated as a figure who, while intriguingly exotic, exhibited a relatable maternal tenderness.

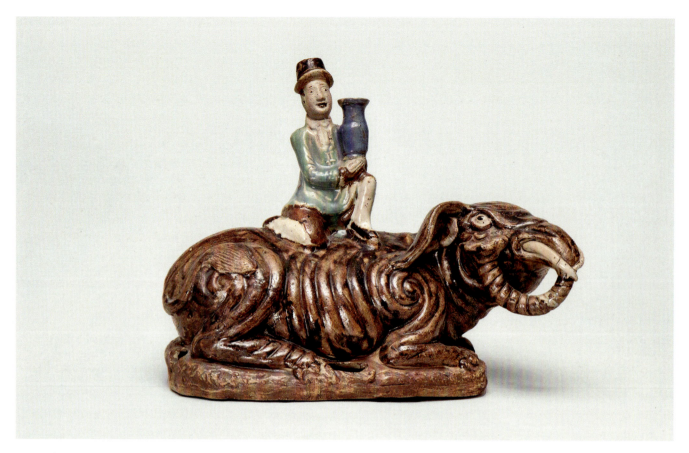

Figure of a Westerner seated on an elephant and holding a jar, Shiwan ware, 19th century, Frelinghuysen collection

Like Daoist and Buddhist figures, depictions of animals often had special meaning in China that became muddled or lost when they traveled overseas. Both elephants and lions, for example, were of particular significance in Buddhism, and both are well represented in the Frelinghuysen collection (nos. 170, 172–173, 175–176, 189, 438, 440 and 445). Elephants were native to East Asia, but lions were not; their imagery had traveled from India along with Buddhist beliefs. Lions were said to flank the throne of Buddha to protect *dharma* (religious and moral law)—thus the ubiquitous pairs of Chinese guardian lions.[6] The elephant was especially auspicious, as it was believed to be the last incarnation of the Gautama Buddha before he became human. White elephants were particularly propitious, and especially revered in Thailand.

Neither lions nor elephants were found in Europe, of course, although lions had inhabited the Balkans and Greece in the pre-Christian era. For Westerners, these animals were among the most iconic of the exotic fauna that was a large part of their fantastical view of 'Cathay'. Such animals were often reported in early travel accounts of China, starting with Marco Polo, who wrote of "bats the size of vultures … bears the size of buffaloes, camelopards, gentle in their manners, pheasants with tail feathers ten palms long, and a crane with wing feathers full of eyes, round like those of a peacock, but of a gold colour and very bright …."[7] Actual Asian animals were captured and shipped back to Europe as curiosities; a magnificent set of tapestries woven at Tournai in 1504–20 depicts Vasco da Gama's triumphant return to Portugal, with caged animals being unloaded on the docks.

While most wild Asian animals were quite foreign to early modern Europeans, Easterners and Westerners alike valued and made great use of horses (no. 180) and shared an affection for cats (nos. 173, 182, 186 and 443) and dogs. A cat nightlight made to scare away mice was easily understood by all. However, the renowned seventeenth-century visitor to China Johan Nieuhof completely mistook the small dogs that were later exported to the

Athanasius Kircher, "Vera tigridis forma", from *China illustrata*, 1667, Frelinghuysen collection

Chinese embroidered altar frontal, silk, late 18th to early 19th century, Frelinghuysen collection

West and called Pekinese. He described them as "Cats with long hair Milk-white having large ears like a Spaniel: the gentlewomen keep them for their pleasure; for they will not hunt after or catch mice, it may be for being too high fed."[8]

Chinese porcelain figures made for export could be drawn from European life as well as from a magical realm of Asian deities and chinoiserie fantasies, in what William R. Sargent characterizes as the "two streams" of Chinese production.[9] The first export porcelain human figures were probably the depictions of European traders and their families made at Dehua in the seventeenth century. At the very end of the century, Chinese potters at Jingdezhen made such novelties as the blue and white satirical figure based on English delft known as 'Mr. Nobody' (no. 183). Most eighteenth-century Chinese porcelain human figures made for export were decorated with enamel colors, whether they represented Chinese court figures or, more rarely, Westerners. As these figures were among the most costly export porcelains, it is not surprising that they were desired in the *famille rose* enameling that was more fashionable at the time. Still, a significant number of blue and white Chinese deities and animals continued to be made for various markets, including for the United States (no. 186) and Thailand (nos. 187–190), and no doubt continued to delight and amuse their owners.

1. Marx, Bauman and Bowen 2007–08, pp. 65–70.
2. Sargent 2012, p. 442.
3. Chong 2016, p. 138.
4. Ibid., pp. 137–38.
5. Bailey 1999, p. 89.
6. Kerr 2016, p. 28.
7. Honour 1961, p. 12.
8. Ibid., p. 19.
9. Sargent 2012, p. 442.

168.
SEATED FOREIGN ATTENDANTS

Wanli mark and period (1573–1620)
5 ¼ in. (13.3 cm) wide

Foreign servants and attendants were portrayed in Chinese ceramic sculpture as early as the Tang dynasty (618–907), with its well-known tomb pottery models of foreign grooms. Usually Central Asians, these foreigners were always depicted in subservient postures, often—as we see here—bearing large trays or jars (the upper part of this pair's jar now lacking). These figures are distinguished from Chinese types by their large, kohl-rimmed eyes; dark eyebrows; bulbous noses and slightly curled long hair, as well as by their naked torsos, aprons and short capes.

Reflecting the Chinese belief in the Middle Kingdom as the center of the world, all other nations mere tributaries, these subservient figures continued to be made in the later seventeenth and eighteenth centuries, often then in the form of Europeans. The present piece may have been made as a decorative amusement for the Imperial household, perhaps used as a flower vase, reinforcing the figures' role as working servants.

REFERENCES Sargent 2012, p. 452 (Kangxi period foreign attendants)

PROVENANCE Heirloom & Howard Ltd, London, 1989; Sotheby's London, 12 December 1989, lot 288

169.

LARGE BUDDHIST ANIMALS DISH

Wanli period (1573–1620)
14 in. (35.6 cm) diameter

In the center of this large dish, an elephant and a bushy-tailed lion flank a waterfall that emerges from cliffs above. Four trigrams decorate the rim, perhaps indicating that the dish had a mate displaying the other four *bagua* (eight trigrams). On its base is a two-character pseudo seal mark; its back rim is decorated with four floral roundels and scattered cloud motifs. Though natural enemies, elephants and lions share auspicious meaning in Buddhist iconography. The elephant, final incarnation of the Buddha before his birth, represents wisdom and the lion, Buddha's protector, represents strength. Waterfall imagery may hail from Hinduism, in which it symbolized cleansing and purity; in Chinese iconography a waterfall can indicate an abundance of prosperity. An earlier dish of this subject is in the Ardebil Shrine collection; another is in the RA collection. Both of these feature prunus bough borders.

REFERENCES Pope 1956, pl. 91 (Ardebil Shrine dish); Pinto de Matos 2019, no. 8 (RA collection)

PROVENANCE Polly Latham Asian Art, Boston, 2018; Sotheby's New York, 24 March 2018, lot 1556; Christie's New York, 15 September 2011, lot 1474

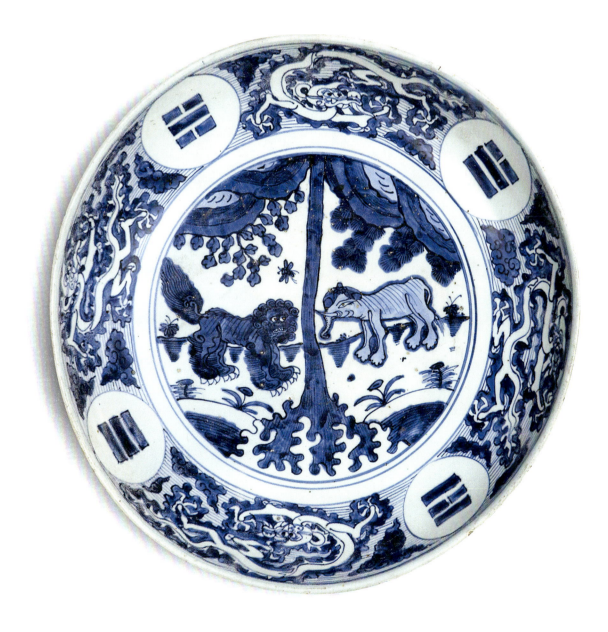

170.

FROG KENDI

Wanli period (1573–1620), c. 1600
6 ¾ in. (17.1 cm) high

Probably the most prevalent animal forms from the late Ming period are a group of zoomorphic *kendi*, or water-pouring vessels. Known in frog, elephant, crayfish, squirrel, lion and water buffalo forms, these *kendi* were collected during this period in a variety of regions, from the Philippines and Southeast Asia to the Middle East and Europe. This diverse group shares *kraak*-style details, while phoenix and dragon *kendi* were made earlier in the Wanli period for a brief time. A green-glazed cat *kendi* was in the collection at the Ardebil Shrine by 1611. Recorded frog *kendi* all have skin strewn with blossoms but vary slightly in detail: some handles are rounded, like this example, while others are hexagonal with variant decorative motifs. Teresa Canepa notes that a frog *kendi* was found in the shipwreck of the Portuguese *nau* named *Santo Alberto*, dated to 1593.

REFERENCES Jörg 1997, pp. 44–45 (phoenix); Pope 1956, pl. 120 (cat); Canepa 2019, pp. 166–67; Metropolitan Museum of Art (2009.107); British Museum (1948,0415.1 and PDF,A.669)

PROVENANCE Sebastian Asian Art & Antiques, Jakarta, 2022

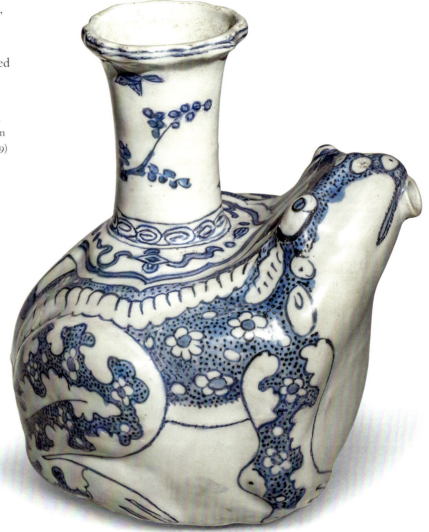

171.
ELEPHANT KENDI

Wanli period (1573–1620), c. 1600
7 ⅞ in. (20 cm) high

Elephants were apparently the most favored *kendi* form; their widespread popularity is attested to by their appearance in such diverse places as the Imperial Ottoman collection at the Topkapı Palace (where one of ten has the arms of the Portuguese Almeida or Melo family), the collection assembled by Shah Abbas before 1611, a still life by Adriaen van Utrecht dated 1636, and the inventories of King Philip II of Spain (taken 1698 to 1507) and Amalia van Solms-Braunfels (taken 1654–68), all reported by Teresa Canepa. Like the frog *kendi* in the previous entry, these elephants vary slightly in decorative details and very slightly in form, but all seem to have been made by a small set of very similar molds.

REFERENCES Canepa 2019, pp. 168–71; Jörg 1997, p. 68; Krahl 1986a, pp. 729–30 (various examples including Almeida)

PROVENANCE Heirloom & Howard Ltd, Wiltshire, 2021; Christie's Paris, 9 June 2021, lot 33; Galerie Duchange, Paris

172.
KRAAK JAR WITH AUSPICIOUS ANIMALS

Wanli period (1573–1620), c. 1610–20
17 in. (43.2 cm) high

The hexagonal sides of this baluster jar feature four large bracket-lobed panels, each containing an auspicious animal: a Buddhist lion, two different *qilin* and a Buddhist elephant (see detail, p. 206). The panels are separated by symbols suspended from ribbons, all on a ground of blue fish-scale. Small roundels of birds decorate the neck. Teresa Canepa, writing of a slightly larger Wanli jar with five animal panels in the Lurie collection, notes that depictions like these may well have been derived from ink-cake designs, which were circulated in woodblock printed books. Ink-cake designs would have provided compositions particularly appropriate to shaped panels (or indeed to circular dishes).

REFERENCES Canepa 2019, pp. 186–87 (related jar and ink-cake designs); Victoria and Albert Museum (3-1897) (closely related jar)

PROVENANCE Kee Il Choi, Jr., New York

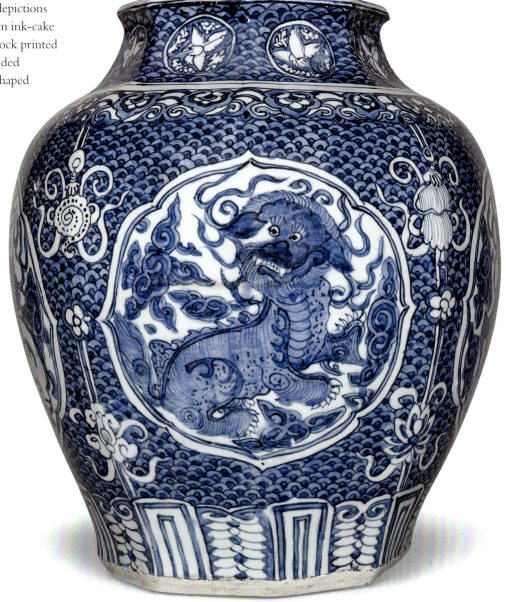

173.

SEATED CAT

Wanli period (1573–1620)
8 ¾ in. (22.2 cm) high

This amusing cat probably had a purely decorative purpose, though it has been suggested that it may have been used as a lantern or nightlight, its open eyes and mouth emitting light. In form and style it relates closely to a ewer in the shape of a seated tiger dating to the same period and now in the collection of the Peabody Essex Museum. Like the ewer, the decorative details on this cat—flame motifs on the legs (which relate to a rare lion *kendi*); tasseled *ruyi*-head collar ornament—place it firmly in the late Ming period.

REFERENCES Sargent 2012, p. 105 (tiger ewer); Pinto de Matos 2019, p. 38 (lion *kendi*)

PROVENANCE Heirloom & Howard Ltd, London, 1985; Sotheby's London, 16 July 1985, lot 33

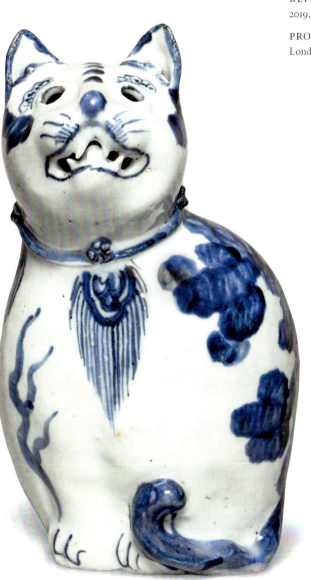

174.
LARGE KRAAK DISH WITH ELEPHANT

Wanli period (1573–1620), c. 1610–20
17 in. (43.2 cm) diameter

This very large dish features the deep paneled border of ribbon-tied symbols, fruit and flower sprigs edged in variously patterned grounds that is so characteristic of the seventeenth-century trade ware known as *kraak* porcelain. In its center is a Buddhist elephant bearing an offering of books; he stands on a rocky island within a stormy sea. As with the jar in the previous entry, this depiction may well have come from an ink-cake design or other woodblock print source. Sebastiaan Ostkamp discusses a very similar *kraak* dish, its elephant bearing a lotus emitting rays of light, a large central shard of which was recovered in an Amsterdam dig.

REFERENCES Ostkamp 2011, cover and p. 23 (near-identical dish); Canepa 2019, pp. 212–25 (dishes of this border); Pinto de Matos 2011a, no. 11 (vases with elephants)

PROVENANCE Wilson Galleries, Santa Fe NM, 1984; Hansen Galleries, Santa Barbara CA, 1978

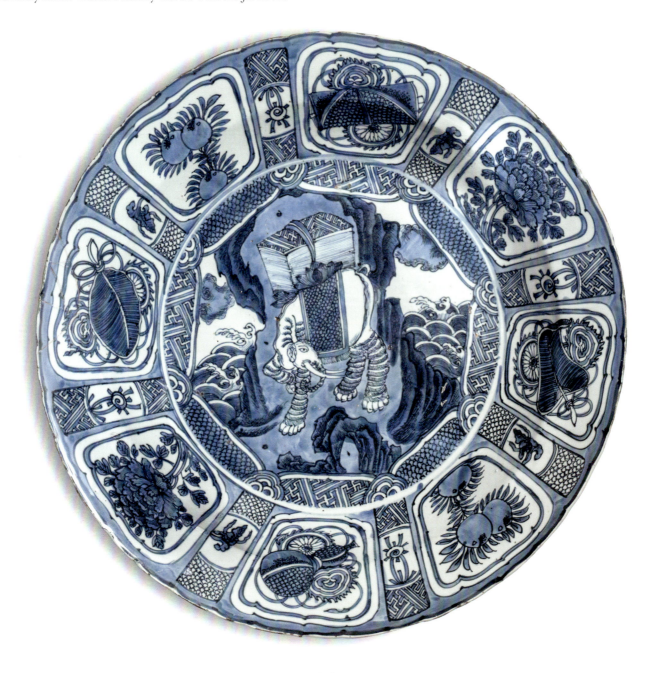

175.

SEATED ELEPHANT

Wanli period (1573–1620)
5 ¾ in. (14.6 cm) high

A very unusual model, this elephant is depicted seated, facing forward, his trunk curled under his chin and a short blue tail curling around his haunches. His wrinkly hide is picked out in lines of medium blue edged in darker blue and forming a spiral at his front shoulders. An uneven surface beneath his feet and body suggests that he was probably adhered originally to a base of some kind. His modeling and color date him to the Wanli period; his coat details are very like those of a Wanli crouching tiger in the RA collection. But there do not seem to be comparable models recorded.

REFERENCES Pinto de Matos 2019, pp. 40–41 (tiger)

PROVENANCE Heirloom & Howard Ltd, London, 1979; Sotheby's London, December 1979, lot 148

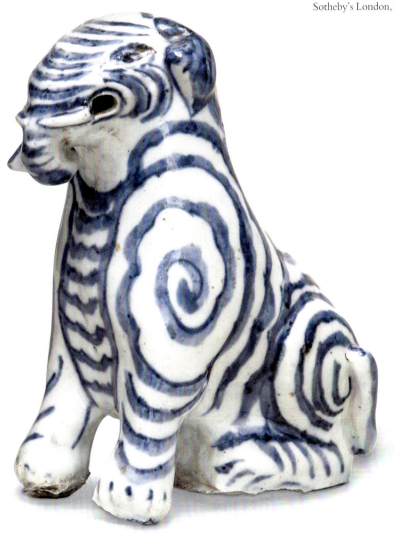

176.
LARGE DISH WITH BIRD

**Tianqi (1621–27) to Chongzhen (1628–44) period,
c. 1620–45**
14 ¼ in. (36.2 cm) diameter

This dish is unusual for the period in its edge to edge pictorial composition. It depicts a large bird standing beside flowering and fruiting plants; he reaches up as if to peck at a berry. Sketchy branches decorate the back, which shows chatter marks and some sand adhering to the foot. Eva Strober illustrates a similarly painted dish, but with a lion, noting that its "quick and expressive" painting style may indicate that it was made for the Japanese market. A bowl in the Kunstmuseum Den Haag of similar date has a closely related scene of birds painted around its exterior. All of these pieces may have been made either in a kiln at Jingdezhen using less refined techniques or a provincial kiln.

REFERENCES Strober 2013, p. 204 (lion dish); Kunstmuseum Den Haag (formerly Gemeentemuseum) (0319957) (bowl)

PROVENANCE J.A.N. Fine Art, London, 2018; Spink & Son Ltd, London

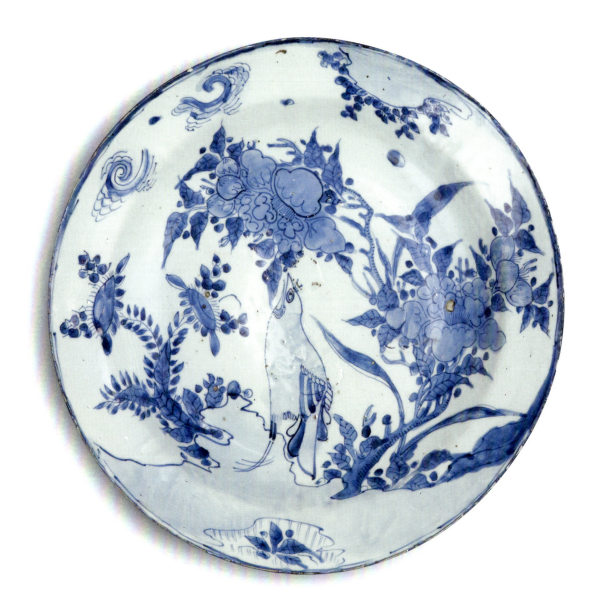

177.

PAIR OF SONGBIRD CANDLESTICKS

Qianlong (1736–95) to Jiaqing (1796–1820) period, late 18th–early 19th century

6 ¼ in. (15.9 cm) high

These small birds are modeled with heads turned up and wings folded, perched on rockwork beside flower buds that could have been used either as candleholders or as small vases. Bird models were a well-known part of the Jingdezhen repertoire in the eighteenth century; their use in these functional objects emphasizes the many decorative possibilities of Chinese porcelain in the period.

REFERENCES Sotheby's New York, 22 May 1980, lot 281; the collection of Bernice Chrysler Garbisch (*famille rose* songbirds)

PROVENANCE Heirloom & Howard Ltd, Wiltshire, 1991; Sotheby's London, 5 November 1991, lot 36

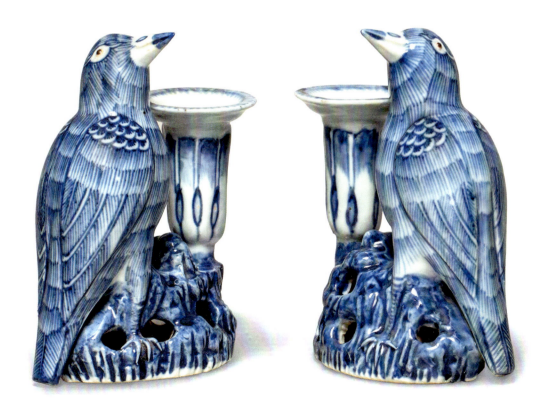

178.
TWIN IMMORTALS OF HARMONY

Shunzhi (1644–61) to Kangxi (1662–1722) period, second half 17th century
9 ⅛ in. (23.2 cm) high

A relatively early rendition in blue and white of a type that later became ubiquitous in *wucai* (five color) enamels, these boys represent the Hehe Erxien (Twin Immortals of Harmony), sometimes called the Hehe boys. Daoist immortals originating in Tang dynasty legend, the Hehe twins came to symbolize long-lasting marriages and are often associated with lotus. This pair relate in color, modeling and ornament to other Wanli figures and animals; the modeling of their expressive faces, hands and sturdy legs indicates a fresh approach to the type. Many of the Hehe twins in *wucai* enamels may well be relatively modern, as William R. Sargent argues convincingly, noting the complete lack of archaeological, shipwreck, documentary or provenance evidence for seventeenth- or early eighteenth-century examples.

REFERENCES Sargent 2012, pp. 477–79 (*wucai* examples and discussion)

PROVENANCE Imperial Oriental Art, New York, 2019

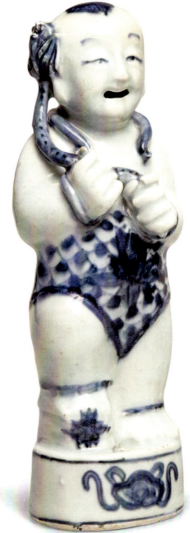
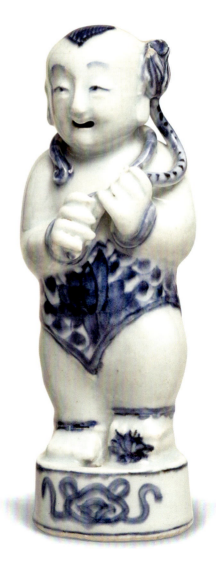

179.
LEOPARD LOTUS DISH

Kangxi period (1662–1722)
10 ¾ in. (27.3 cm) diameter

One of a pair, this dish is in a classic shape of the period (seen also in nos. 54 and 207), its rim in the form of lotus petals. Here, a striding leopard is painted in the center, also repeated three times on the rim, the other panels decorated with flowering bushes. This rendering of the wild beast—seen walking to the left, his head turned towards us and his tail curled high at right—is very like that on a number of Japanese market dishes (*ko-sometsuke* wares) of the mid-seventeenth century. A small group of very similar Chinese dishes is known, some depicting tigers and some leopards.

REFERENCES Curtis 2006, p. 79 (*ko-sometsuke*); Pinto de Matos 2011a, p. 267 (RA collection)

PROVENANCE Heirloom & Howard Ltd, Wiltshire, 2003; Bonhams London, 18 March 2003, lot 33

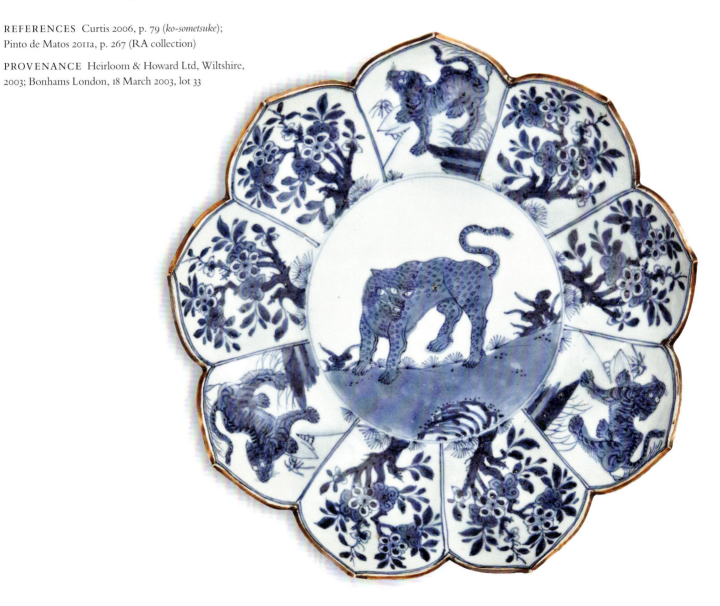

180.
TWO SPOTTED HORSES

17th–18th century
8 ¼ and 7 ⅛ in. (21 and 18.1 cm) high

The Chinese were always in need of horses, which were essential for transportation, warfare and some hunting and agriculture, and sought them from their Central Asian and Middle Eastern trading partners in the Yuan and Ming dynasties. Piebald horses were known in China as early as the Tang dynasty, when one formed part of a group given by a general to the Xuanzong emperor (r. 712–56). These two examples feature a soft blue and a sturdy modeling found in many seventeenth- and eighteenth-century animal models. Similarly sturdy Kangxi period biscuit-glazed horses, but with riders, were in the Copeland collection (now at the Peabody Essex Museum).

REFERENCES Krahl 2015, p. 8 (horse trade); Cohen and Motley 2008, p. 188; Du Boulay 1984, p. 296 (later *famille rose* pair); Sargent 1991, p. 67 (biscuit-glazed)

PROVENANCE Heirloom & Howard Ltd, Wiltshire, 2016; Rob Michiels Auctions, Bruges, 23–24 April 2016, lot 505 (left). Sotheby's New York, 20–21 October 1989, lot 449; the collection of John T. Dorrance, Jr.; the collection of J.A. Lloyd Hyde, Old Lyme CT (right)

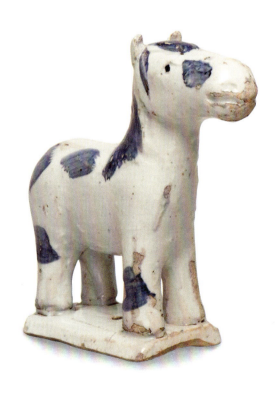
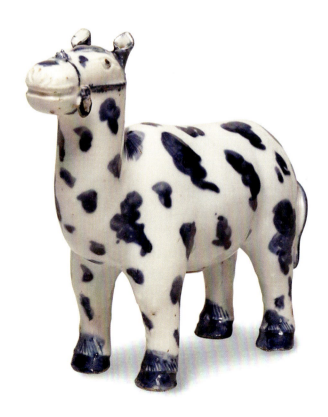

181.

PAIR OF FOREIGN ATTENDANT CANDLEHOLDERS

Kangxi (1662–1722) to Qianlong (1736–95) period, 18th century
11 ½ in. (29.2 cm) high

Like the Wanli period figure group (no. 168), these figures represent foreigners in a subservient position. Their curly eyebrows and beards, their bulbous noses and short jackets are familiar Chinese shorthand for South Asian or Indonesian workers. Candleholders made of this form, the trays the foreigners hold over their heads to serve as drip pans, were made more often in opaque enamel glazes. The drip pans in this pair are porcelain that has been cold-painted to match the metal pricket sticks (which may have been added later to reinforce low porcelain nozzles).

REFERENCES Sargent 2012, p. 452 (*famille verte*); Christie's New York, 10–11 January 2012, lot 293 (*famille rose*)

PROVENANCE Heirloom & Howard Ltd, Wiltshire, 2014; Freeman's, Philadelphia, 7 October 2014, lot 225

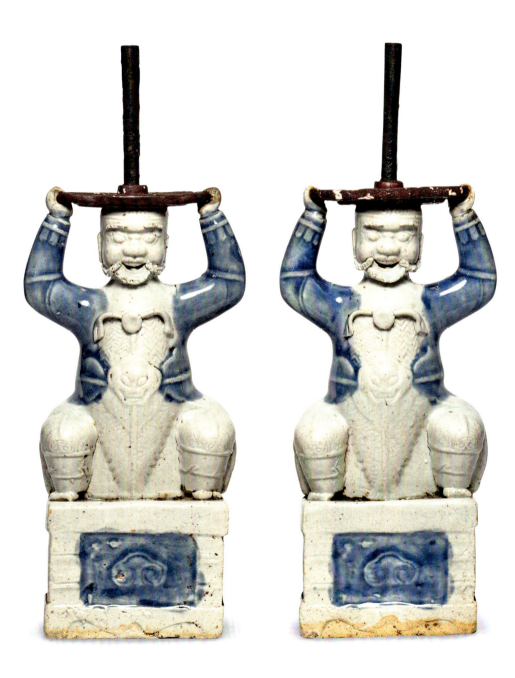

182.
TWO CAT NIGHTLIGHTS

Jiaqing period (1796–1820) (left) and Kangxi period (1662–1722) (right)
8 ¼ and 7 in. (21 and 17.8 cm) wide

Recumbent cat models were made as early as circa 1600: a green-glazed cat vessel in this position was at the Ardebil Shrine by 1611. A blue and white cat nightlight was found in the salvaged Asian trading vessel cargo known as the Hatcher Cargo and datable to circa 1643. By the Kangxi period this form was put to use as a nightlight. The Jesuit priest Père d'Entrecolles wrote from Jingdezhen in 1712: "I have seen a cat painted after life, in the head of which a little lamp was put to illuminate the eyes, and was assured that in the night the rats were terrified by it." The popularity of cat nightlights is affirmed by their continued production throughout the eighteenth and early nineteenth centuries. A sponged version like the later example here is in the collection of the Peabody Essex Museum.

REFERENCES Pope 1956, pl. 120 (green cat vessel); Christie's Amsterdam, 14 March 1984, lot 279 (and cover) (Hatcher); Sargent 2012, pp. 468–69 (sponged)

PROVENANCE Heirloom & Howard Ltd, Wiltshire, 2013; J.A.N. Fine Art, London, 2013 (left); A & J Speelman Ltd, London 1996 (right)

183.
MR. NOBODY

Kangxi period (1662–1722), late 17th century
8 ⅞ in. (22.5 cm) high

This curious satirical figure is one of a very small group made in the 1680s after English tin-glazed earthenware. They are the first completely European figures made at Jingdezhen, though so-called *blanc de Chine* models of Westerners had been made earlier in the century at Dehua. The stubby, bearded figure holds a goblet and a wine ewer; his collar and sleeves are painted to indicate lace or embroidery, and his separately modeled hat opens to a hollow vessel (although there is no spout for pouring). The character of 'Nobody' (here, a punning reality) or 'Everyman' was familiar throughout Europe by this time, signifying the hapless, average man stumbling through life. English delft models of him—and the Chinese versions that followed—were probably taken from the frontispiece for a popular play titled *No-body, and Some-body* published in 1606. Patricia Ferguson records the 1739 purchase of a similar figure by the 4th Earl of Dysart for Ham House in Surrey: "A Blew and White China Figure (Deliv'd Ly Dysart)"; the figure is visible in a 1904 photograph of the 'Duchess's Private Closet'.

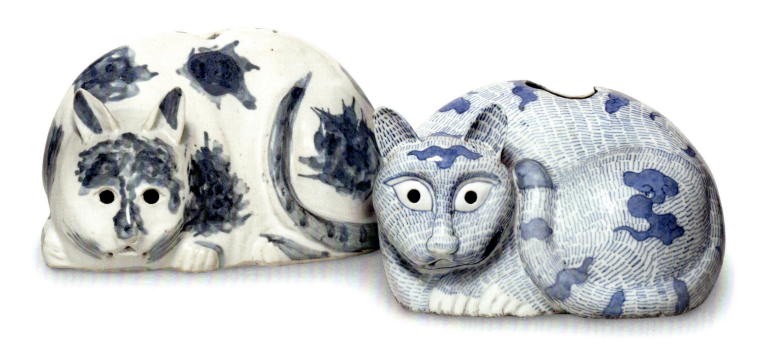

Christiaan Jörg has documented two further figures described in a 1778 Amsterdam auction catalog as "2 peculiar little Dwarfs with their wine kettle and rummer." But fewer than a half-dozen Chinese models survive; they must have been a unique order for a good-humored English trader.

REFERENCES Howard and Ayers 1978, pp. 577–78 (Mottahedeh example and an English delftware figure dated 1682); Sargent 2012, pp. 446–47 (with frontispiece); Victoria and Albert Museum (C.7-1951) (Chinese) and (C.4-1982) (English delftware); Ferguson 2013, p. 320 (Ham House example); Jörg et al. 2003, p. 24

PROVENANCE Heirloom & Howard Ltd, Wiltshire, 2013; Christie's New York, 27 January 2013, lot 410; the Sherwood collection

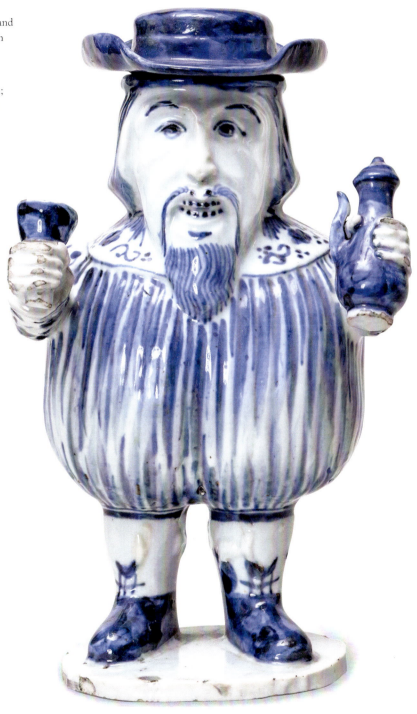

184.

DOUBLE HERRING PLATTER

Qianlong period (1736–95), c. 1775
9 ½ in. (24.1 cm) wide

Christiaan Jörg reports that in 1773 the Dutch East India Company's 'Requirements' included a narrow dish for one herring and a wider version for two, and he cites the orders and prices of these dishes in several different seasons. All featured a narrow lambrequin border as in this example. Fewer two-fish versions have survived. Interestingly, the dishes were originally inspired by Delft prototypes and then later themselves inspired a transfer-printed Spode earthenware pattern.

REFERENCES Jörg 1982a, pp. 179–80; Howard and Ayers 1978, p. 85 (Chinese and Delft)

PROVENANCE The collection of David S. Howard, London, 1989

185.

PAIR OF RECUMBENT GOATS

Jiaqing (1796–1820) to Daoguang (1821–50) period
4 ½ in. (11.4 cm) wide

Modeled with their forelegs tucked beneath them and their heads turned back, these goats have hooves, eyes and curly horns picked out in underglaze blue while their bodies and beards are left white. Though common domesticated animals in China, as elsewhere, goats are not depicted frequently in Chinese art or ceramics.

REFERENCES Howard and Ayers 1978, p. 604; Cohen and Motley 2008, pp. 186–87

PROVENANCE Marie Whitney Antiques, Tolland MA, 1985

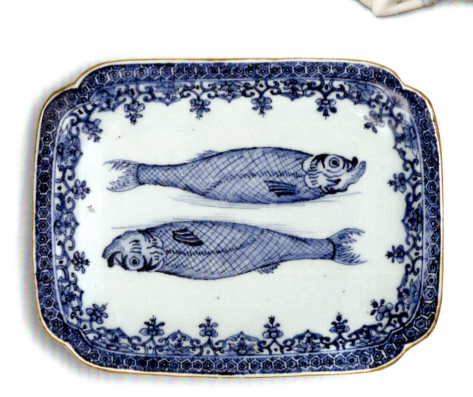

186.

TWO CAT URINALS

Daoguang period (1821–50), c. 1830–50
8 ⅝ and 10 in. (21.9 and 25.4 cm) long

Of very similar form, each recumbent cat has his tail looped over his back to form a handle; his head is modeled separately to serve as a cover. One is sponged overall to indicate fur; the other has patches in shades of blue. Both cats have eyes left in the biscuit with pupils glazed brown. Sponged pottery was enormously popular in the United States in the nineteenth century. A very similar Chinese export urinal was in the collection of Dr. Thomas Rodney Brinckle (1804–1853) of Philadelphia and given by his descendants to Winterthur.

REFERENCES Winterthur Museum (1964.0147 A, B)

PROVENANCE Christie's New York, 21 January 1998, lot 145

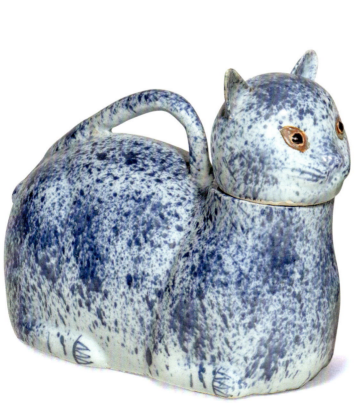

187.

TWO FLORAL DEER

Tongzhi (1862–74) to Guangxu (1875–1908) period
10 ¾ in. (27.3 cm) high

Modeled in mirror image standing on slab bases, each stag has one hoof resting on a rock while his body is partially supported by a weathered stump growing *lingzhi* fungus. Their coats are strewn with floral sprigs, one slightly varying from the other. This model was very likely made for the Thai market. Elinor Gordon published a very similar stag (his body painted with landscape) in 1977, dating it to the Kangxi period. Another single stag, also with floral decoration, is in the collection at Bangkok's Wat Pho temple, known as the Temple of the Reclining Buddha.

REFERENCES Gordon 1977, pl. XIII; Punya Bordi 2002, pl. 3 (Wat Pho example)

PROVENANCE CopperRed Antiques, Bangkok, 2009 (left). Butterfield & Butterfield, San Francisco, 8 April 1987, lot 846; the collection of Michael Taylor, San Francisco (right)

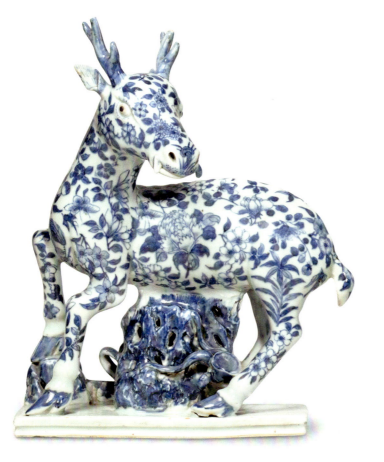
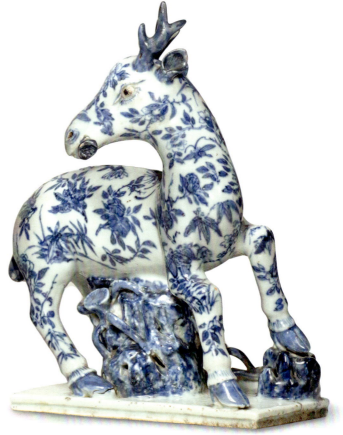

188.

SET OF THREE LARGE LOHAN

Guangxu period (1875–1908)
17 ½ in. (44.5 cm) high

The Eighteen Lohan (or Arhats) of Buddhism were the original followers of the Gautama Buddha who, having mastered the four stages of enlightenment, had reached Nirvana. Often depicted in Chinese painting, usually as unworldly characters with shaved heads, gaunt figures and loose robes, they seem to have been made less frequently in Jingdezhen porcelain than the Eight Immortals were. These large-scale models with their particularly expressive faces and decorated robes were very likely made for the Thai market that flourished in the later nineteenth century.

PROVENANCE Heirloom & Howard Ltd, Wiltshire, 2010; Duke's Auctioneers, Dorset, 22–24 September 2010, lot 130; the collection of Timothy and Fran Lewis, Melplash Court, Dorset

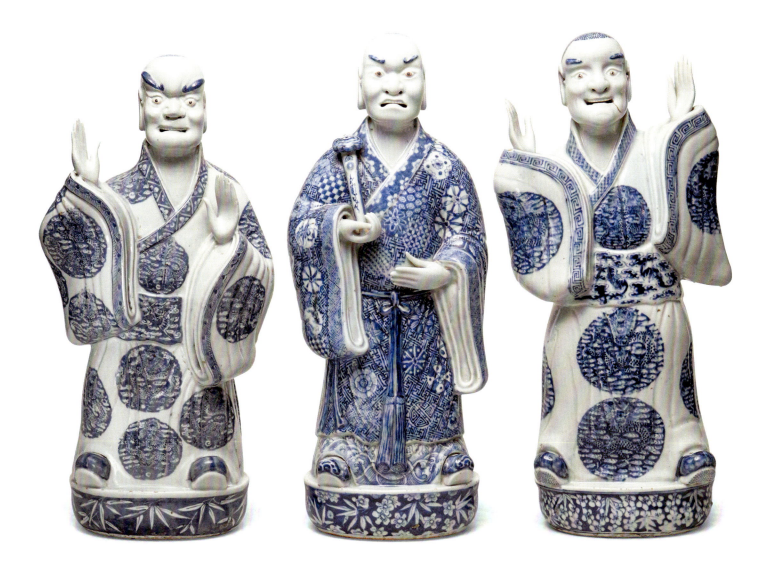

189.

PAIR OF LARGE ELEPHANTS BEARING PAGODAS

Guangxu period (1875–1908)
20 ¾ in. (52.7 cm) high

These very large elephants stand foursquare on separately fired bases carrying on their backs separately fired two-stage pagodas. The pagoda roofs feature flame ornaments flanked by small animals, and clumps of iris are painted over all. The long tradition of war elephants in Asia (particularly in India and Southeast Asia)—beasts that bore howdahs on their backs to carry warriors equipped with bows and arrows—probably inspired this model. By this period, though, an elephant with pagoda was no doubt more an amusing conceit than a symbol of warfare. A similar single elephant from the collection of Gordon T. Little is painted with views of the city of Nanchang, very like the animal tureens made for the Thai market in this period. It is likely that the whole group was made for Thailand, where Chinese blue and white porcelain was much coveted in the later nineteenth century.

REFERENCES Christie's New York, 26 January 2006, lot 125 (G.T. Little elephant)

PROVENANCE The Chinese Porcelain Company, New York, 1991

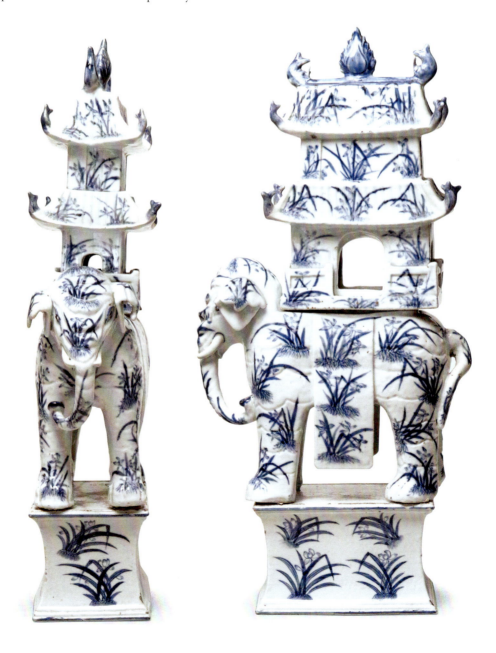

190.

PAIR OF STAG TROPHY HEADS

Tongzhi (1862–74) to Guangxu (1875–1908) period
14 in. (35.6 cm) high

These stag heads are a curious mixture of Asian iconography with the European hunting tradition of trophy heads. And in a further cultural interchange, they were probably intended for the Thai market. Spotted deer were auspicious animals in China, representing wealth and nobility and often depicted grazing on the sacred fungus of immortality. But this large-scale rendition of the deer as trophy heads, with their removable antlers, oakleaf garlands and neoclassical backplates, is closely associated with the Thai market. A pair was in the collection of Jim Thompson, an American collector of Thai art who resided in Bangkok from the 1940s until his disappearance and presumed death in 1967. Another pair was in the collection of Fran and Tim Lewis, collectors of Thai market Chinese porcelain who were partly based in Bangkok in the 1990s.

REFERENCES Warren 1968, p. 22 (Thompson pair); Duke's Auctioneers, Dorset, 22–24 September 2010, lot 120 (Lewis pair)

PROVENANCE Marie Whitney Antiques, Tolland MA, 1984

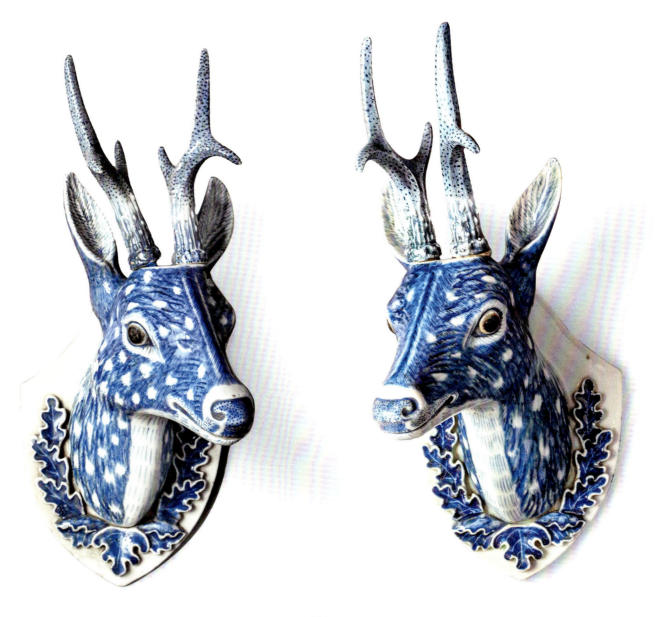

8.
TO EUROPEAN DESIGN

As we have seen, Europeans began to commission specially decorated Chinese porcelain quite soon after establishing a direct, Asia-based, trading relationship with China. The sixteenth-century 'first orders' made by Portuguese through Chinese agents—initially from their outposts in Melaka (Malacca) or Shangchuan Island and then from their base in Macao—represent the first Chinese porcelain made to European design. The Spanish, who soon joined their Iberian neighbor in Asia, establishing themselves in Manila in 1571, did not seem to have the same appetite for special order Chinese porcelain. And once the Dutch superseded the Portuguese as China's dominant European trading partner in the first decades of the seventeenth century, they focused initially on ordering table wares in Western shapes rather than on commissioning special designs.

A few European motifs crept into seventeenth-century wares made for the VOC (Dutch East India Company), but it was not until the last decade of the seventeenth century, when the kilns at Jingdezhen were flourishing again under the newly established Qing dynasty, that the Dutch began to order both armorial porcelain and other Western designs. The English, who had joined in the trade by this time, also began to order armorial porcelain, and in Chapter Two we have seen examples in this collection of early armorial porcelain made for important personages from both countries.

As Christiaan Jörg and Michael Flecker point out, the Asian vessel (now known as the *Vung Tau*) that sank in about 1690 laden with blue and white for the Dutch settlement in Batavia (Jakarta) contained only two European design patterns.[1] But once the possibilities of this kind of commission took hold, it was limited only by the China traders' imaginations. Over the next century, a seemingly endless array of European subjects was painted onto Chinese porcelains by Jingdezhen potters and by enamelers in Guangzhou (Canton). These special orders naturally reflected the fashions, the concerns, the interests and sometimes the eccentricities of their European patrons. With very few exceptions, they were private orders, created to the taste of the well-connected who had direct access to Chinese export goods or to the well-heeled patrons of specialist 'china' shops. They are thus a much more direct reflection of the elite taste of European society than the generic patterns brought back as stock by the large trading companies. As David Howard notes of the private trade, "… in spite of its numerical insignificance, because it was based on the requirements of the most fashionable markets of the time, its artistic and historical importance is out of all proportion to its numbers."[2]

European subject Chinese porcelain was a tiny percentage of the total trade in porcelain, which in itself was a small percentage of the overall volume in Chinese goods. Jörg estimates that porcelain represented no more than 5 percent of the VOC official trade in the post-1729 period when the Dutch operated from Guangzhou.[3] Howard estimates a similar 5–10 percent for the British East India Company, noting that private trade porcelains were certainly no more than one quarter of that. This merchandise would, of course, have included all the armorial wares as well. Some of these private goods were destined for individuals, armorial services being the obvious example, while others were acquired to be

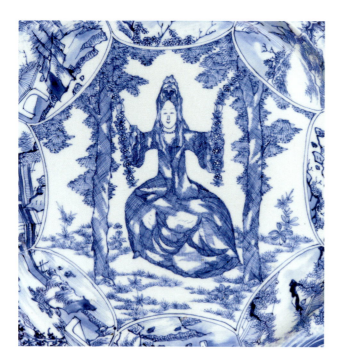

'Air' dish after Henri II Bonnart print (no. 199)

sold on by enterprising East India Company personnel, who would take careful note of profitable trends in the fashionable china shops of London or Amsterdam.[4] In some cases, these traders were probably commissioned by shop owners to procure certain patterns or shapes from China.[5]

The Jingdezhen kilns were well accustomed to creating porcelains for foreign markets by the time European merchants arrived in any number. They had been supplying blue and white to Southeast Asia, India, Iran and the Arabian Peninsula since the Yuan dynasty, when a network of Islamic merchants facilitated a flourishing trade.[6] It was largely shapes that were specifically tailored to these markets, though some decoration was as well.[7] Alongside traditional Chinese motifs, wares made for these markets sometimes displayed palmette motifs (no. 160) or other stylized, symmetrical, flora-based patterns. Sometimes they even included inscriptions in foreign scripts.[8] The kilns were, after all, commercial enterprises and they were keen to provide what their customers wanted.

But Westerners took the concept of specially designed porcelain decoration to another level, largely with the use of the printed image. We have seen in Chapter One how early European missionaries made conscious use of religious imagery in their attempt to bridge the cultural divide between East and West, and how this imagery was occasionally applied to porcelains, whether for personal devotion or to inspire new converts. In the era of the great trading companies, the full possibilities of the European print for the transmission of design were realized. Of course, other design sources were also relied on, whether coins, medals, European ceramics and enamels or specially created drawings. There were many sources at hand for this private trade; as Clare Le Corbeiller put it, "… books, pictures and personal possessions that [were] carried East as part of the paraphernalia of a captain or supercargo [could serve]."[9]

But the printed image, whether a copy of a famous painting, a bookplate, or a pattern book, was ubiquitous. The fifteenth-century development of European print-making and then of movable type had had an enormous cultural impact. By the sixteenth century, books and images were no longer the sole province of wealthy households or religious institutions but could be widely disseminated, spreading both knowledge and imagery.[10] Unsurprisingly, this technology was developed much earlier in China, where woodblock printing on paper was known in the seventh century and movable type from the eleventh century.[11] There was a parallel phenomenon of design sourcing in China, where printed materials like the famous *Mustard Seed Garden Manual* (published in 1679), classic novels and plays, pattern books of ink-cake designs or even an illustrated encyclopedia could inspire porcelain decoration.[12]

In a fascinating example of cultural transmission through printed images, Ronald W. Fuchs II has shown how a Chinese woodblock print of circa 1712 found its way onto nineteenth-century English pottery. Based on a view of the Kangxi emperor's summer palace that had been painted by court artist Wang Yuanqi, the Chinese woodblock print image was engraved by Jesuit Matteo Ripa and published in London in 1753 and 1810. The brothers John and William Ridgway then used this image—little changed from the Chinese painting of a century earlier—on a wide range of transfer-printed blue and white pearlware, naming their pattern 'India Temple'.[13]

In late seventeenth- and eighteenth-century Europe, print shops naturally turned out what they expected to sell well, reflecting the fashions and concerns of their clientele and providing China traders with just the sort of designs they were likely to want painted onto their special order porcelains. Very often, these subjects were

French School, *The March to Prints*, from the series 'Caricature des caricatures', lithograph, 18th century, Bibliothèque Nationale de France, Paris

drawn from the classical mythology of Greece and Rome, whether reproducing a famous painting or a book illustration. The myths supplied moral lessons, high drama and half-draped beauties—and they were well known. As Hervoüet and Bruneau have written, "… the exploits and the love affairs of the gods were familiar to all who had learned to read; as much a part of the culture as the feats of entertainment or sport stars today."[14] The Hervoüet collection, probably the largest and most comprehensive collection of European subject Chinese porcelain ever formed, contained approximately twice as many mythological subject porcelains as its next largest category, marine subjects, despite the latter's obvious resonance with China traders.[15]

The Frelinghuysen collection features a strong selection of European subject porcelains from the late seventeenth and early eighteenth centuries, reflecting the preponderance of blue and white for these designs in that early period. Interestingly, very few porcelains with Western imagery were made in the *famille verte* or 'Chinese Imari' palettes which were also available; Jörg posits that this might have been due to certain Jingdezhen kilns specializing in European-style decoration.[16] For the China trade merchant, obtaining these early blue and white European subject wares would have required both effort and patience. The design had to be taken to Jingdezhen by a Chinese agent who would negotiate with an appropriate kiln the price, the number and the type of pieces to be produced. The finished wares had to be carefully packed and then transported to Guangzhou for the following trading season. By the middle decades of the eighteenth century, when

workshops specializing in opaque, overglaze, colored enamels had been established at Guangzhou within easy reach of the foreign merchants who wanted special order wares, this novel and appealing, though more expensive, option inevitably prevailed. However, some designs were made in both *famille rose* and blue and white, and the collection contains examples of these as well, including the so-called 'Pompadour' pattern (no. 461), the botanical pieces after Maria Sibylla Merian (nos. 211, 456 and 464) and the 'Pronk' porcelains (nos. 209–210).[17]

'Pronk' porcelain was among the very few European design patterns to be part of the official orders of a large trading company. As meticulously documented by Christiaan Jörg, in 1734 the VOC hired the Amsterdam portrait and landscape painter Cornelis Pronk to create patterns for Chinese porcelain.[18] Pronk produced four watercolor designs for the official output of the Company (two of which survive in the collection of the Rijksmuseum). These four patterns were used for a small group of high-style forms, mostly as part of a limited number of dinner services. A few closely related porcelains were produced at about this same time, many displaying the very distinctive Pronk-designed motifs (nos. 457 and 459). These may have been designed by Pronk for the private orders of Company directors, or they may have been created by other local artists or Chinese workshops imitating his style.

The cost of producing the official Pronk wares outweighed their profitability for the VOC, and the venture was abandoned in 1740. But many other special order porcelains were made, reflecting a similarly fascinating mixture of European subjects and Chinese design elements, like the group based on French fashion prints (nos. 198–201, 449 and 452–453). Intriguing examples of cultural interchange are also seen in the several pieces that echo Japanese *namban* decoration (nos. 202–203), as well as in a group of porcelains that imitate wares from various European ceramic factories (nos. 204, 215 and 467–472). Others, like the very rare Eight of Spades plate (no. 213) and *Air Nouveau* plate (no. 214) in the collection, were simply one-off, personal orders reflecting the taste—and perhaps the eccentricity—of their eighteenth-century European patrons.

1. Jörg and Flecker 2001, p. 35 (Canal House garnitures and *L'Empire* beaker covers).
2. Howard 1994, p. 10; see also pp. 13–34 for a comprehensive account of the private British China trade.
3. Jörg 1989, p. 32.
4. Howard 1994, p. 29.
5. Ibid., p. 33.
6. Jörg 1997, p. 28.
7. Carswell 2000, p. 24.
8. Jörg 1997, p. 88.
9. Le Corbeiller 1973, p. 9.
10. Thompson 2003, p. 1.
11. Tribeca n.d., p. 1.
12. Canepa 2019, p. 29. In addition to this general discussion, Canepa has identified a number of specific Chinese printed design sources for the Lurie collection late Ming porcelains.
13. Fuchs 2021, pp. 53–63, for the full story of the transmission of this imagery.
14. Hervouët 1986, p. 292 (author's translation).
15. Hervouët 1986, still the most comprehensive record of the many different categories and versions of European subject decoration on Chinese porcelain.
16. Jörg 1997, p. 273.
17. Ibid.
18. Jörg 1980, the Groninger Museum exhibition catalogue which remains the definitive study of Pronk porcelains.

191.
VASE WITH EUROPEAN RURAL LANDSCAPE

Chongzhen period (1628–44), c. 1635–44
8 ½ in. (21.6 cm) high

A band around the midsection of the vase is decorated with European landscape featuring small farm buildings, very like the scenes on the large Kraak bowl (no. 193). Here, we have in the other sections floral motifs in hybrid European-Asian style associated with Transitional period style.

REFERENCES Staatliche Kunstsammlungen Dresden (PO 7056); the collection of Julia and John Curtis, Christie's New York, 16 March 2015, lot 3527

PROVENANCE Heirloom & Howard Ltd, Wiltshire, 1993

192.
TWO AUGUSTINIAN-RELATED DISHES

Wanli period (1573–1620), c. 1575–1600
14 ¼ in. (36.2 cm) diameter

The distinctive border on these dishes closely resembles that on a small group of dishes and jars decorated in the center with the large double-headed eagle of the Order of St. Augustine. The Augustinian order had been granted the use of their Hapsburg-related eagle device by Philip II of Spain (r. 1556–98), Hapsburg ruler of the Spanish Empire, who empowered the Augustinians to evangelize the Spanish Americas. Many porcelains with this decoration are associated with either Macao, where the order operated a monastery in the 1580s, or New Spain, where Augustinians were extremely active, establishing sixty-two priories by 1562. A large shard from one of the jars was found in the wreck of the *Concepción*, which sank in 1638 en route from Manila to Acapulco. Here (and on a number of other recorded dishes), instead of the double-headed eagle device, we have a pair of Buddhist lions set in a landscape of lushly flowering plants.

The present dishes, the related dishes with double-headed eagles and the similarly decorated jars all share the very unusual border motif that appears to be rows of conjoined buildings. William Sargent has written convincingly about

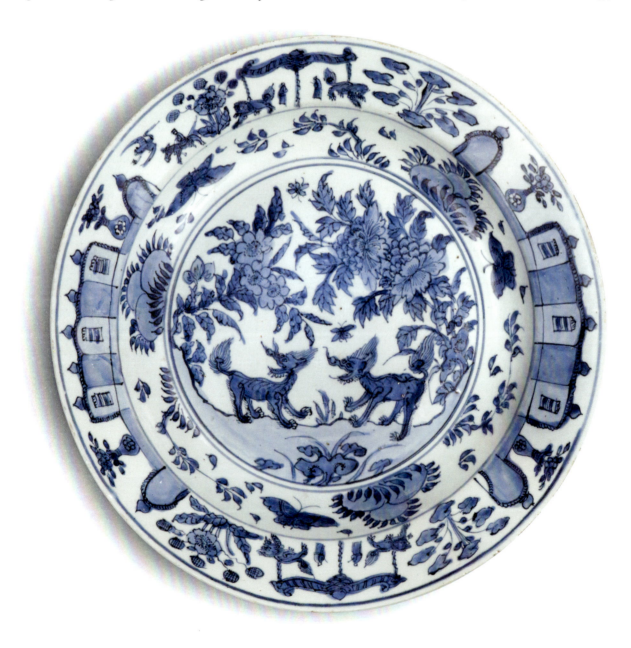

these buildings, demonstrating that they echo colonial church architecture of the Americas. Not yet identified is the unique scene that alternates with the buildings (found on some related dishes only and none of the jars, which have peacocks instead). It depicts a pair of lion-like animals chained to a curving horizontal beam supported by a central post; a pair of attendants with whips or poles flank the central post. There are no known antecedents for this scene in Chinese iconography, and it seems almost certain that it was drawn from a European engraving, very likely associated with Augustinian thought. Maria Antónia Pinto de Matos posits that all of the decoration on this unusual group of pieces was intended as "an allegory of Augustinian spiritual conquest extending over three continents," with the buildings representing St. Augustine's *De civitate Dei* (On the City of God). When discussing the challenges of human self-control in his *Sermo 180*, Augustine quoted James 3:8: "You can tame wild animals; can you not tame your tongue?"—an intriguing iconographic possibility for this curious motif and one which would add meaning to the dishes' central scene.

REFERENCES Sargent 2012, pp. 67–68; Sargent 2010, pp. 53–66; Leidy and Pinto de Matos 2016, pp. 112–19

PROVENANCE Heirloom & Howard Ltd, Wiltshire, 2012; Sotheby's London, 16 May 2012, lot 96 (one). Santos London, 2012; Sotheby's London, November 2012 (one)

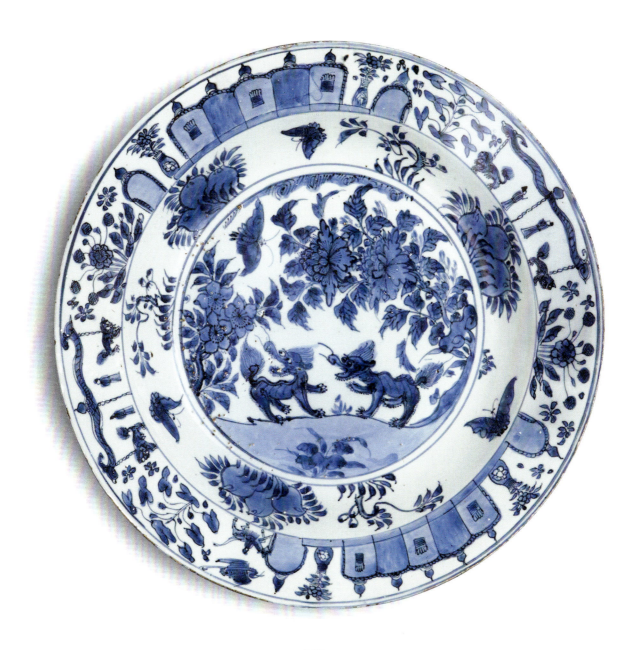

193.
LARGE KRAAK BOWL

Chongzhen period (1628–44), c. 1635–40
14 ¼ in. (36.2 cm) diameter

Rural landscape views with small European buildings decorate the center of this bowl as well as the panels around its interior and exterior sides, where they alternate with scenes of a Chinese scholar and his boy attendant. A gadroon border in the style of Western silver encircles the central roundel, while the panels are divided by tulips, carnations and lilies—flowers that came to Europe from Turkey and China and that were then, in turn, requested as porcelain decoration by the Dutch East India Company. These flower depictions, with their curving stems and numerous slender tendrils, may have been inspired by mid-seventeenth-century Dutch embroidery.

REFERENCES Canepa 2019, pp. 262, 270 (discussion of flowers and closely related bowl)

PROVENANCE Heirloom & Howard Ltd, Wiltshire, 1994

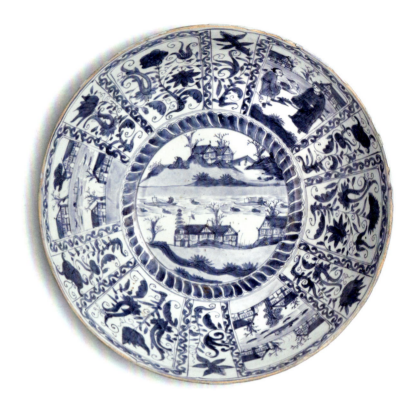

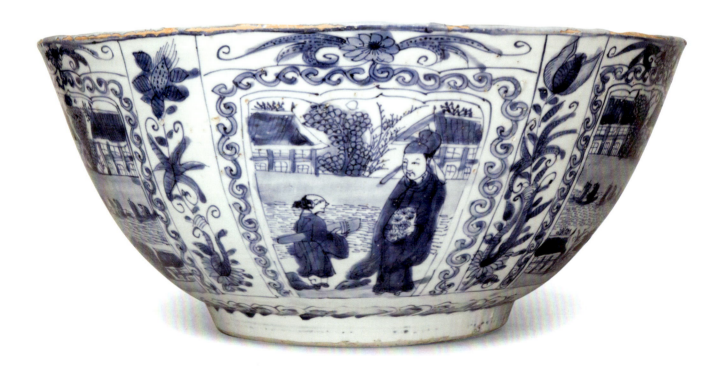

194.

PAIR OF SMALL FOOTED JARS

Wanli (1573–1620) to Chongzhen (1628–44) period, c. 1610–30
4 ¾ in. (12.1 cm) high

These small jars, their form derived from European maiolica, are each applied on the shoulders with three winged, curly-haired cherub heads. Here, flowering plants separate the cherub heads, but a small group of very similar jars is known with Instruments of the Passion depicted instead, suggesting that all the jars may have been made to the taste of the Christian community active in Asia in the first decades of the seventeenth century.

REFERENCES British Museum (Franks.1397.a); Canepa 2016, p. 292; Chong 2016, p. 156

PROVENANCE The Chinese Porcelain Company, New York, 1990

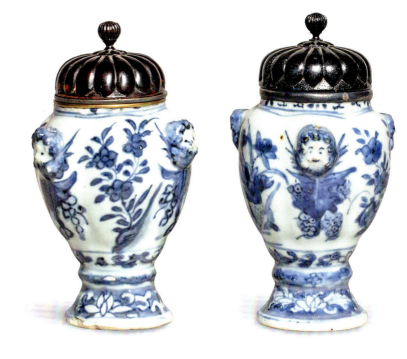

195.

PAIR OF SMALL SEASONS EWERS

Kangxi period (1662–1722), late 17th century
6 ⅛ in. (15.6 cm) high

Putti emblematic of the seasons decorate these small ewers, which may have been from a set of four to use as cruet jugs for oil, vinegar and sauces on the dining table. One putto holds a sickle, symbolizing fall harvest, while the other holds a spray of flowers for spring. Christiaan Jörg describes a very similar jug in the Musées Royaux d'Art et d'Histoire in Brussels (which has its original cover) as "a rare example of late 17th-century *chine de commande* in underglaze blue."

REFERENCES Jörg 1989, pp. 48–49 (near-identical ewer)

PROVENANCE Sotheby's London, May 1988, lot 151 (one). Santos London, 1985 (one).

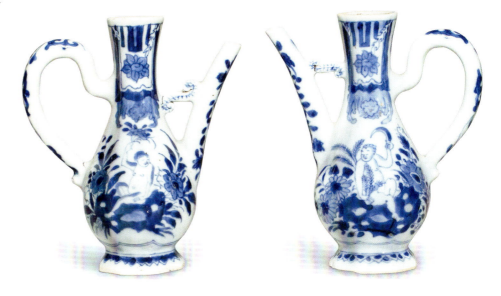

196.

DISH WITH EUROPEANS RAISING HATS

Kangxi period (1662–1722), late 17th century
10 ⅜ in. (26.4 cm) diameter

This early European subject is derived from a more standard composition of the period that portrays a pair of Chinese ladies flanking the potted flowers. Here, two gentlemen stand with their servants beside them, one holding a wine goblet. They are clearly meant to be Europeans, as indicated by their frock coats, their shoes (possibly clogs) and—especially—by the way one raises his hat to the other, a custom that was the subject of some fascination to Chinese observers (and here misunderstood to be done from the back, rather than the front, of the hat). The base has an apocryphal six-character Chenghua mark.

REFERENCES Groninger Museum (1994.0033); Zebregs & Röell n.d. (for a bottle with the female version of this subject and the initials of Joan van Hoorn [1653–1711], a VOC governor-general)

PROVENANCE The Chinese Porcelain Company, New York, 1988

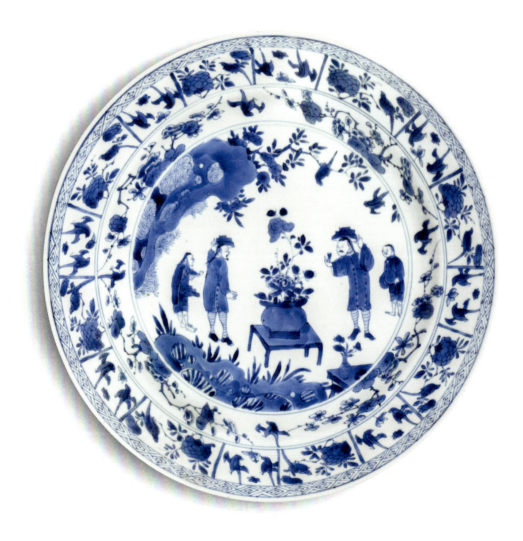

197.

LARGE BACCHUS DISH

Kangxi period (1662–1722), late 17th century
14 ⅞ in. (37.8 cm) diameter

A group of large dishes with this mythological decoration is known, all in the shape of a European silver salver and perhaps intended to serve glasses of wine. The boldly painted, wide grapevine border encircling the central scene may have been copied from either silver engraving or the decoration on a Delft prototype; the gadroon edge is certainly after silver.

Bacchus, the Roman god of wine and, by extension, revelry, was a popular figure in the seventeenth-century Dutch Republic. The cross-hatching seen on the god's large wine jug and the window behind him indicate a Dutch print source for the scene.

REFERENCES British Museum (1963,0423.2); Victoria and Albert Museum (C.66-1963); Howard 1994, p. 40

PROVENANCE Heirloom & Howard Ltd, London, 1987; Christie's Amsterdam, December 1987, lot 68

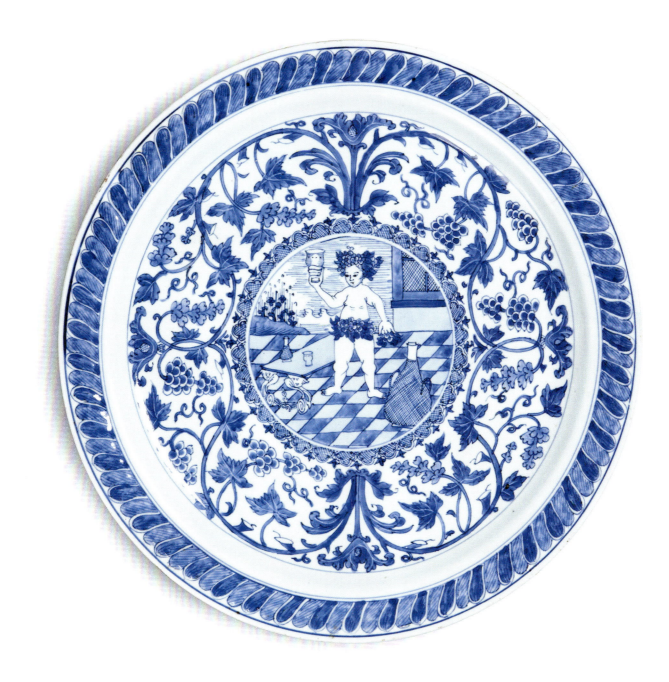

198.

JAR WITH EUROPEAN HUNTRESSES

Kangxi period (1662–1722), late 17th century
10 in. (25.4 cm) high

On the sides are painted fashionable European women with hair dressed *à la Duchesse de Fontanges* (1661–1681), one holding a falcon, one with a rabbit and one with a musket, her small dog beside her. The women stand amongst flowering bushes growing from weathered rocks in the Chinese style, but—like their apparel—these are depicted with cross-hatching, clearly revealing their origin as a European engraving, possibly by the well-known Bonnart brothers of Paris, who were active in the last quarter of the seventeenth century.

REFERENCES Hervouët 1986, p. 68 (this jar); Howard 2000, p. 41 (this jar, a detail)

PROVENANCE Heirloom & Howard Ltd, London, 1983; Christie's London, 8 June 1983, lot 350

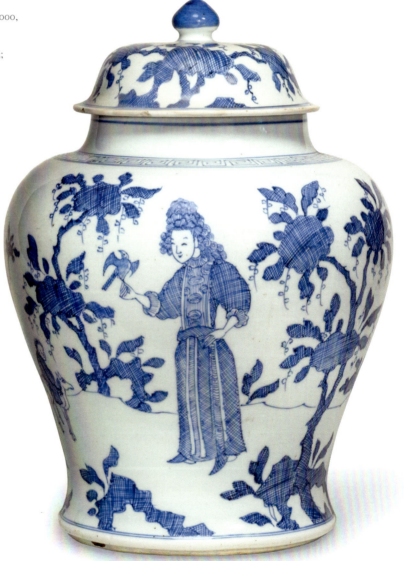

199.

FOUR ELEMENTS DISH

Kangxi period (1662–1722), c. 1700–10
13 ⅜ in. (34 cm) diameter

A woman wearing the latest French fashions, her hair dressed *à la Fontanges,* sits on a garlanded swing suspended from trees, although the petal-shaped panels that encircle her are decorated with entirely Chinese landscape views. The central scene is taken directly from the depiction of *L'Air* (Air) in the 'Four Elements' series published by Henri II Bonnart circa 1678–1700 (and also probably engraved by him). The Bonnart brothers' prints were popular in both France and the Dutch Republic, where pirated editions were available. This subject also appears on the jar in the following entry.

REFERENCES British Museum (1922,0410.163) (the engraving); Hervouët 1986, p. 118 (this subject on a jar)

PROVENANCE Sotheby's New York, December 1992, lot 318

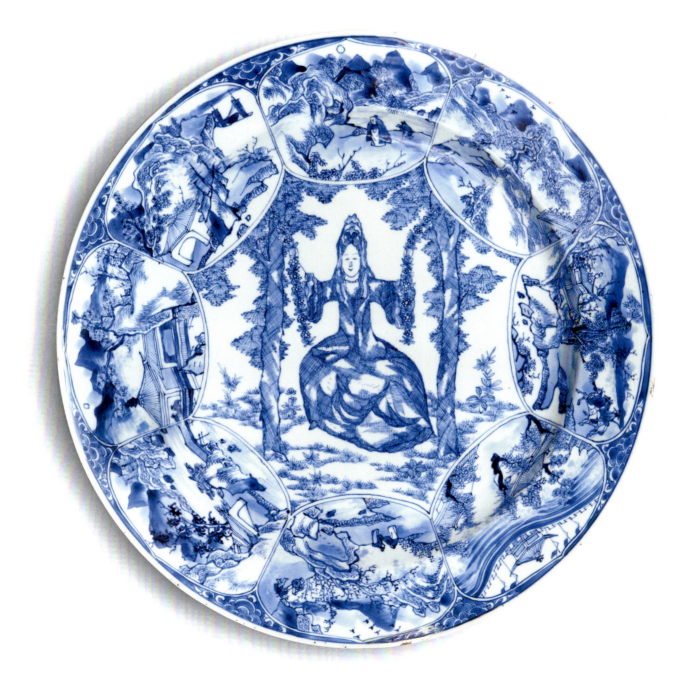

200.
MUSIC PARTY DISH

Kangxi period (1662–1722), c. 1700–10
13 ½ in. (34.3 cm) diameter

Like the previous entries, this dish is decorated after a Bonnart brothers engraving, in this case *Simphonie du tympanum, du luth et de la flûte d'Allemagne*, which bore a verse lauding the joys of music when all play on time, and noting how even sweeter it is when Love conducts. And like the dish featuring Air (no. 199) it is a hybrid of European and Chinese design, its central scene closely following a French print source, down to the cross-hatching on the musicians' fashionable attire, while its border decoration is entirely Chinese. On the back are sketchily painted maple boughs.

The Bonnart brothers' prints were popular in the Dutch Republic, where pirated copies were available, and all of this group was likely commissioned by Dutch traders. Maria Antónia Pinto de Matos notes that Delft tiles are known with this same subject.

REFERENCES Pinto de Matos 2019, pp. 250–51; Howard and Ayers 1978, p. 77; British Museum (1996,1103.96) (the engraving)

PROVENANCE Fred B. Nadler Antiques, Bay Head NJ, 1989

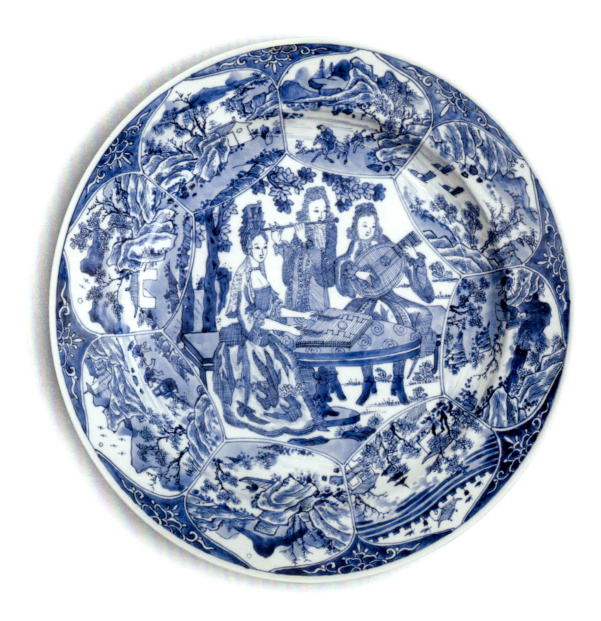

201.
LARGE JAR AFTER FRENCH FASHION PRINTS

Kangxi period (1662–1722), c. 1700–10
12 ⅝ in. (32.1 cm) high

Four large roundels decorate a field of flowering vine on this baluster jar, each featuring a fashionable Frenchwoman after an engraving by the Bonnart brothers of Paris. The subjects are drawn from different print series: Air from the 'Four Elements' (as in the previous entry), Smell from the 'Five Senses', and Thalia and Euphrosyne from the 'Three Graces'. Drawings for the Bonnart brothers' studio were created by Robert Bonnart, while his brothers Nicolas I and Henri II engraved and published them. (The jar would have been made with a cover.)

REFERENCES Howard and Ayers 1978, pp. 79–80 (including three of the engravings); Victoria and Albert Museum (C.114-1963)

PROVENANCE Heirloom & Howard Ltd, London, 1980; Phillips London, 5 March 1980, lot 249

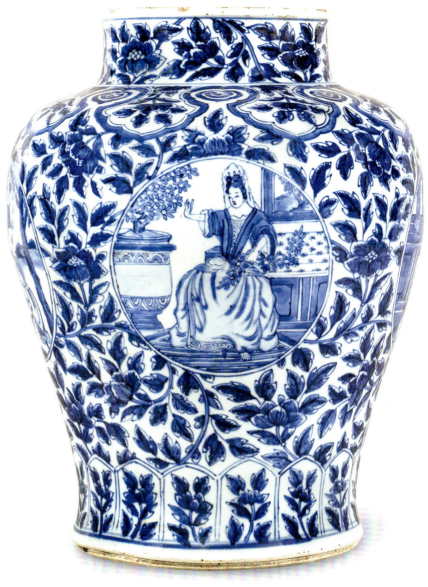

202.

LARGE VASE WITH 'NAMBAN' SCENES

Kangxi period (1662–1722)
20 ¾ in. (52.7 cm) high

This remarkable vase is painted with curly-haired Europeans in Asia. In a continuous scene around the lower register, a Western ship approaches a rocky shore, workers high in the masts furling the sails, while a trader approaches in a pony cart to greet the ship and two others converse on an arched bridge. On the trumpet-shaped neck above, a trader rides through an arched gate, his servant shading him with a parasol, while others watch from windows and one stands holding open the gate to the traders' compound. This decoration seems to be virtually unique on porcelain, known only on several other large-scale blue and white pieces found in the shipwreck of a Chinese junk that sank off the Indonesian island of Bintan carrying wares datable to the first two decades of the eighteenth century.

The subject matter of the vase is reminiscent of the famous gold-ground Japanese screens of the late sixteenth to mid-seventeenth century known as *namban* ('Southern Barbarian') screens, as Teresa Canepa and Alexandra Curvelo have written, although here the figures appear to be seventeenth-century Dutchmen, rather than the sixteenth-century Portuguese with their billowing trousers depicted on the Japanese screens. Canepa and Curvelo note the similarity of the vase's scenes to a rare Chinese coromandel screen of the later seventeenth century.

Although Western ships are found occasionally on Kangxi period porcelains, as are portrayals of a Dutch figure or two, the sweeping ambition of this composition, with its many fascinating details, is unparalleled. Who might have commissioned the small group and the exact source of its pattern remain unknown.

REFERENCES Howard 2000, p. 32 (this vase); Gardellin 2016, p. 20 (Bintan shipwreck); Canepa and Curvelo 2009, p. 102 (this vase); Sotheby's New York, 17 March 2009 (coromandel screen)

PROVENANCE The collection of Dennis Roach, Los Angeles; Heirloom & Howard Ltd, London, 1983; Sotheby's London, June 1983, lot 118

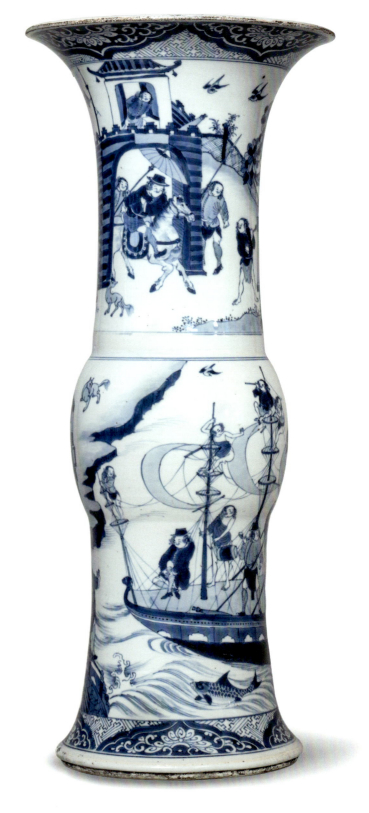

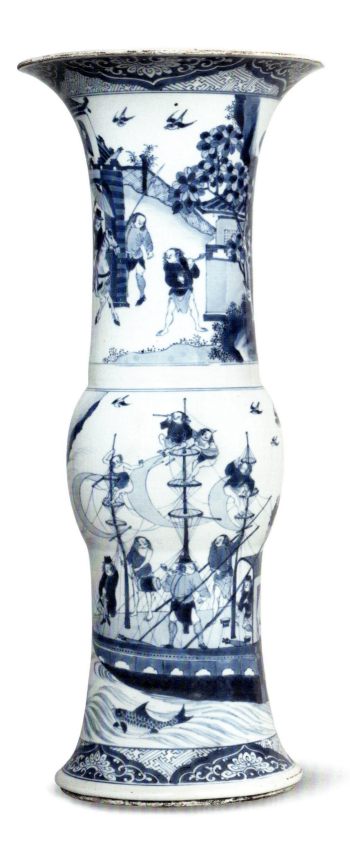
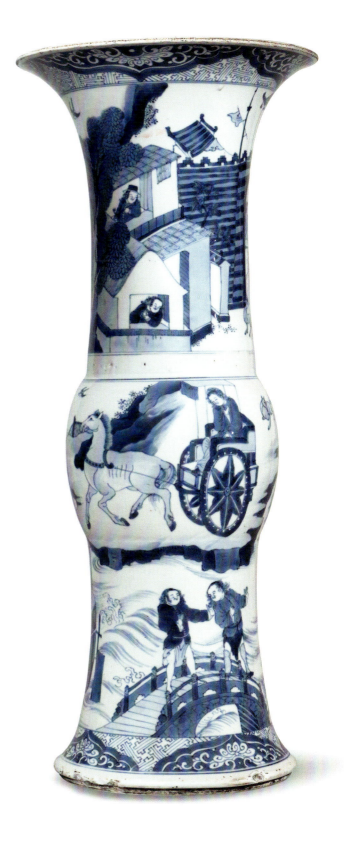

203.
THREE DISHES WITH 'NAMBAN' SHIPS

Kangxi period (1662–1722)
10 ¾ in. (left) and 10 ½ in. (right and top)
(27.3 and 26.7 cm) diameter

The borders on these dishes are typical Kangxi period decoration, while the European ships in the centers are reminiscent of the depictions of 'black ships' or 'treasure ships' found on Japanese porcelains of this period. The pattern may have been ordered by Dutch traders familiar with Japanese wares.

REFERENCES Groninger Museum (1918.0109); Howard 1994, p. 46

PROVENANCE Robert McPherson Antiques, Friesland, 2021 (top). Heirloom & Howard Ltd, Wiltshire, 1981; Sotheby's London, June 1981, lot 90 (bottom left). Kee Il Choi, Jr., New York, 1987 (bottom right)

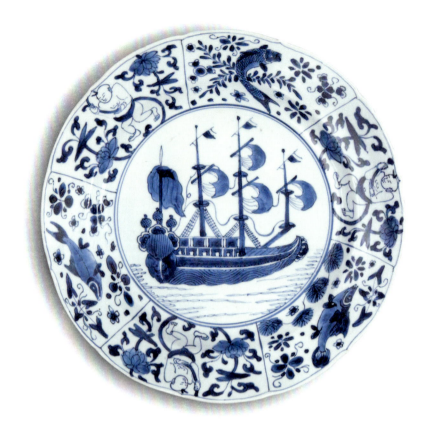

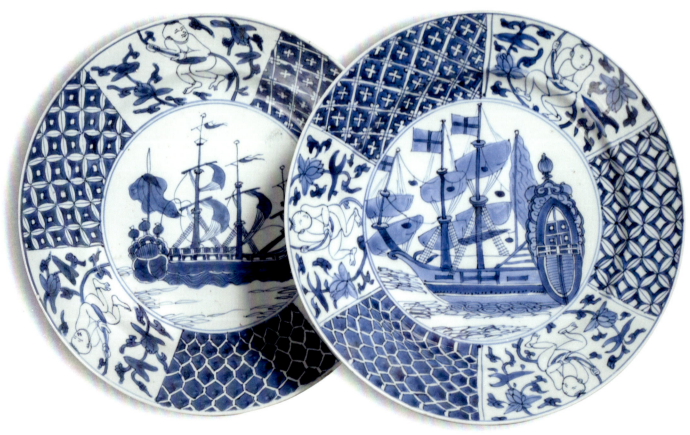

204.

PAIR OF LARGE PLATES AFTER DELFT

Kangxi period (1662–1722), c. 1710–20
10 ⅝ in. (27 cm) diameter

In a scene copied directly from Delftware, a group of cloaked figures stand conversing in a rural landscape, its curious trees imitating the sponging technique used on the European tin-glazed earthenware. The left-hand dish has an incised inventory mark from the collection of Augustus the Strong, Elector of Saxony, reading *N:499*, as do the several plates remaining in the collection at Dresden and the example in the Victoria and Albert Museum in London. The right-hand plate is marked *N:504*. All marks feature the wavy line that indicated blue and white in the royal Saxon inventory (the online publication of which is forthcoming).

REFERENCES Howard and Ayers 1978, p. 84 (left dish); Staatliche Kunstsammlungen Dresden (PO 1501); Victoria and Albert Museum (C.663-1917)

PROVENANCE Heirloom & Howard Ltd, London, 1980; Christie's London, November 1980, lot 194 (one). Heirloom & Howard Ltd, Wiltshire, 1994; Christie's London, May 1994, lot 68 (one)

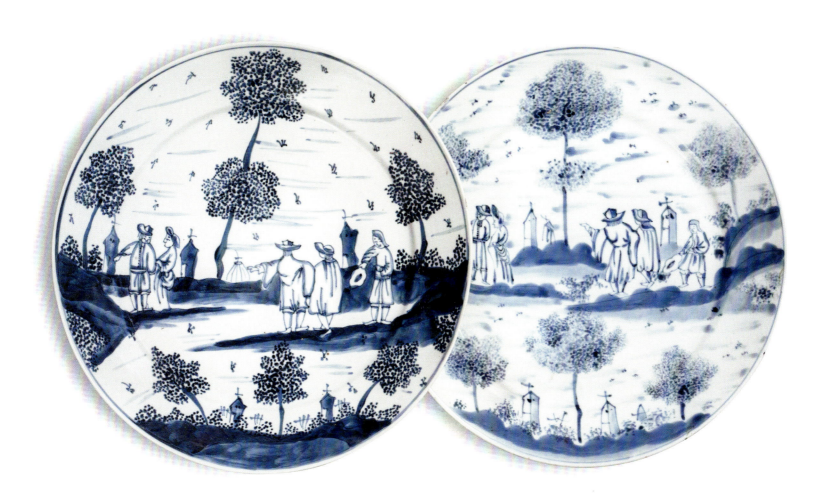

205.
EUROPA AND THE BULL COFFEE POT

Kangxi period (1662–1722), c. 1700
11 ¼ in. (28.6 cm) high

The new fashion of coffee-drinking in late seventeenth-century Europe inspired coffee pots made of silver or Delftware, and a Delft model inspired this form. A European rural scene continues around the octagonal sides, showing workers in the fields and farm buildings beyond, while around the upper section two roundels within a deep patterned border depict Europa and the Bull. The Abduction of Europa was a popular subject in European painting, and a print after one of these paintings no doubt inspired this decoration. This relatively complex form seems to have been made for a very limited time—it was no doubt difficult to achieve—and it is only known in this blue and white pattern.

REFERENCES Jörg 1997, p. 275; Howard 1994, p. 154; Victoria and Albert Museum (C.71:1, 2-1963)

PROVENANCE Heirloom & Howard Ltd, London, 1980; Sotheby's London, 18 March 1980, lot 12

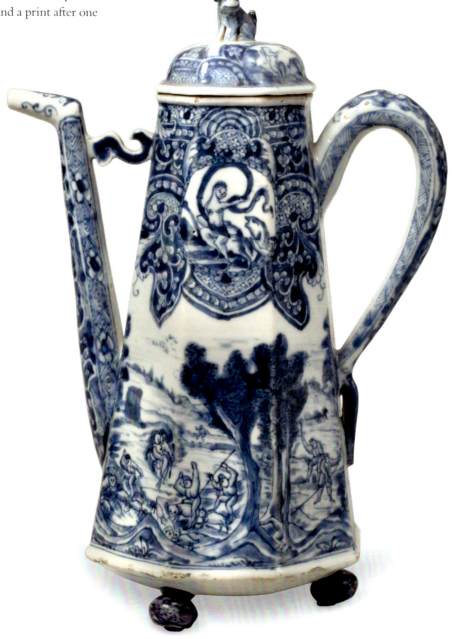

206.

MYTHOLOGICAL LARGE TRAY AND TEAPOT

Kangxi period (1662–1722), early 18th century
17 ⅛ and 7 ¼ in. (43.5 and 18.4 cm) wide

The source of this scene has been identified as an engraving by Sébastien Leclerc for Isaac de Benserade's 1676 adaptation of *Les Métamorphoses d'Ovide* depicting Dircetis, who has been turned into a half-woman, half-fish, and her wicked sister Naïs, who is entirely fish. A small group of teapots of this form is known with the subject, while the tray may be unique.

REFERENCES Sargent 2012, p. 296; Howard 1994, p. 145; British Museum (1917,1208.70.149) (the engraving)

PROVENANCE Santos London, 1984 (tray). Heirloom & Howard Ltd, London, 1986 (teapot)

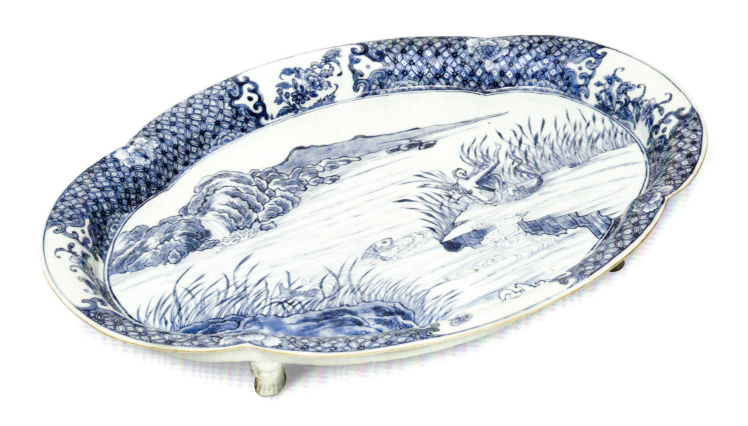

207.
MYTHOLOGICAL LOTUS DISH

Qianlong period (1736–95), c. 1750–60
11 in. (27.9 cm) diameter

The center of this dish depicts the death of Phaethon, who had taken the reins of the sun god's chariot despite being warned that it would be too difficult to control. When his erratic riding scorched the earth and dried up rivers, the river gods turned for help to Zeus, who sent a fatal thunderbolt towards the foolish Phaethon, seen here face down on the riverbank surrounded by the distressed river gods. This rendering of the Fall of Phaethon is taken directly from a print by Johannes Teyler that was published in his *Opus Typochromaticum* (1688–98), where it appears as one part of a larger composition.

REFERENCES Motley n.d. (discussion); Rijksmuseum (RP-P-1939-42) (print); Groninger Museum (1997.0635)

PROVENANCE The collection of David S. Howard, London, 1989

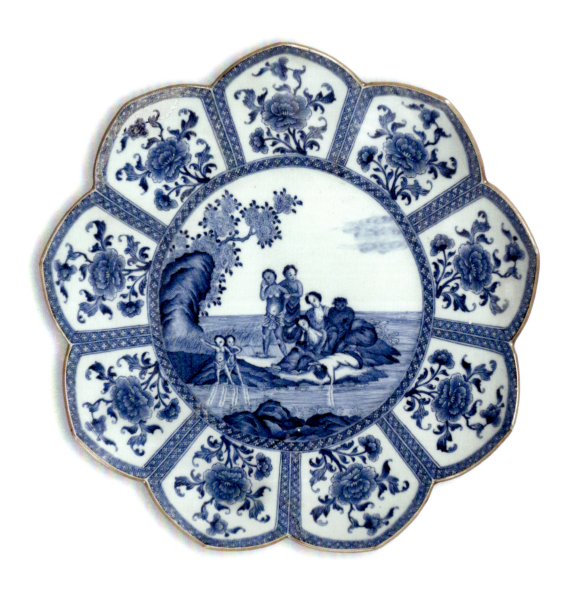

208.

SIREN TEABOWL AND SAUCER AND L'EMPIRE DE LA VERTU CUP WITH COVER

Kangxi period (1662–1722), late 17th century
5 ⅜ and 3 ¼ in. (13.5 and 8.3 cm) diameter

These pieces share inscriptions in French, though they were probably destined for the Dutch Republic, where French was spoken in aristocratic circles of the period. The teabowl and saucer read *GARDES VOUS DE LA SIRENE*, a reference to the sorceress Circe in Homer's *Odyssey*, while the covered cup is inscribed *L'EMPIRE DE LA VERTU EST ETABLI JUSQU'AU BOUT DE L'UNIVERS* (The Empire of Virtue extends to the ends of the Universe), likely reflecting Dutch pride in their global empire. *L'Empire* covers were found in the cargo of the *Vung Tau*, a Chinese junk which sank circa 1690 en route to Batavia, but neither subject's print source has been identified.

REFERENCES Hervouët 1986, p. 312 (Siren); Le Corbeiller and Frelinghuysen 2003, p. 21 (*L'Empire*)

PROVENANCE Edward Sheppard, New York, 1984 (Siren). Heirloom & Howard Ltd, Wiltshire, 1997; Sotheby's Amsterdam, 17 November 1997 (*L'Empire*)

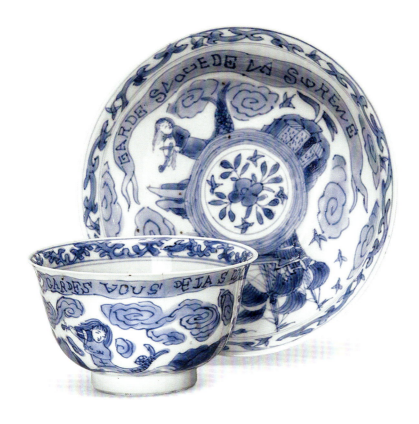
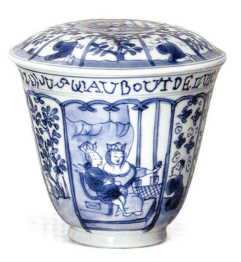

209.
PRONK ARBOR PLATE

Qianlong period (1736–95), c. 1738
9 ¼ in. (23.5 cm) diameter

One of Cornelis Pronk's four official VOC designs, the Arbor drawing was sent off to Batavia (Jakarta) in 1738 and the pattern was made in China as dinner services in both colored enamels and blue and white. Its central scene of a mother surrounded by boys, her maidservant offering her a rose, is—like the Hand Washing's central elements (see no. 208)—drawn from familiar Chinese porcelain decoration, but in Pronk's fanciful chinoiserie interpretation the group is placed around an entirely European clipped topiary arbor, the flowering bushes at its sides possibly originating in China but painted here in a wholly European style.

REFERENCES Jörg 1980, pp. 32–34; Sargent 2012, pp. 282–83

PROVENANCE Kee Il Choi, Jr., New York

210.
PRONK HAND WASHING CISTERN

Qianlong period (1736–95), c. 1738
22 ¾ in. (57.8 cm) high

Dutch artist Cornelis Pronk (1691–1759) was hired in 1734 by the VOC (Dutch East India Company) to design patterns for Chinese porcelain, a nearly unique (and ultimately unsuccessful) commercial experiment intended to increase profits by creating highly fashionable and desirable wares. Pronk created four official designs for the Company; each was then commissioned at Jingdezhen in a different variety of shapes and colorways. About a half dozen other patterns that display the same distinctive border patterns and painting style as the official Pronk designs are assumed to have been private orders either created by him or by another artist in his style. The Hand Washing was probably one of the four official VOC designs (documentation is incomplete), although unlike the others—known as *La Dame au Parasol*, the Doctors' Visit and the Arbor—the Hand Washing was

apparently made only in this monumental water fountain form. Examples are known in *famille rose* and 'Chinese Imari'; two others in blue and white are recorded (in the Mottahedeh collection and in the Virginia Museum of Fine Arts, 76.28a-b).

The Hand Washing scene seems to be drawn largely from the artist's imagination, with a wholly chinoiserie rendering of the two ladies and their boy servant drawn from imagery he had no doubt seen on Chinese porcelains in the Dutch Republic. An ominous snake in the grass below the figures (also seen on the Doctors' Visit fountains) curls around a hole in the front for a spigot; a large, matching basin would have been placed below the fountain.

REFERENCES Jörg 1980, pp. 32–34; Howard and Ayers 1978, pp. 292–95; Sargent 2012, pp. 274–93

PROVENANCE The Chinese Porcelain Company, New York, 1990

257

211.
BOTANICAL PLATE

Qianlong period (1736–95), c. 1740
9 ⅛ in. (23.2 cm) diameter

Maria Sibylla Merian (1647–1717) was a botanist and naturalist whose study of flowers and insects—especially caterpillars—was extremely influential. In 1705, after two years in the Dutch West Indies, she published her best-known work, *Metamorphosis insectorum Surinamensium*, but the pattern on this plate is drawn from volume three of her *Raupenbuch* (Caterpillar Book), published shortly after her death. The beautifully rendered details of iris, lily, butterfly and caterpillars are taken from four different plates in the *Raupenbuch*, while the origin of the pattern's baroque-style acanthus-scroll border is unknown, as is who ordered it and why. It is found in both *famille rose* and underglaze blue dishes.

REFERENCES Jacob-Hanson 2000, pp. 174–83; Sargent 2012, p. 245; Leidy and Pinto de Matos 2016, p. 136

PROVENANCE Heirloom & Howard Ltd, London, 1980; Sotheby's London, 18 November 1980, lot 15

212.

LARGE BOTANICAL DISH

Qianlong period (1736–95), c. 1750–70
14 in. (35.6 cm) diameter

The unusual design for these dishes is taken from Pierre Pomet's *A Compleat History of Druggs*, published in London in 1712 after the 1694 French version, *Histoire générale des drogues*. Pomet was chief pharmacist to King Louis XIV of France. Like the Merian plate in the previous entry, the elements of this pattern are drawn from different plates in the book; the nutmeg and clove are in one and the 'pine apple' in another. Nutmeg and cloves were lucrative commodities of Euro-Asian trade while the pineapple was a noted luxury, first seen by Europeans in South America and eventually cultivated in royal European greenhouses. Suzanne Findlen Hood notes plates in this pattern found in Virginia sites of circa 1750 and quotes a 1769 VOC order for 1,383 dishes "with the pineapple"—likely this pattern.

REFERENCES Hood 2017, pp. 234–35

PROVENANCE The Chinese Porcelain Company, New York, 2000; Christie's London, 15 November 2000, lot 311

213.

EIGHT OF SPADES PLATE

Qianlong period (1736–95), mid-18th century
8 ⅝ in. (21.9 cm) diameter

Like the dish with a song verse described in the following entry, this plate is from a unique set that must have been a one-time private order. Each plate in the set is painted with an eight of spades playing card within an inner and outer band of cell diaper pattern. Dutch collector Jonkheer Henri van Sypesteyn, founder of the Kasteel-Museum Sypesteyn, acquired thirteen of the plates (which were perhaps originally a set of sixteen or more) in 1896; eleven remain in the museum today. One was traded to the Groninger Museum and another (the present plate) to Belgian collectors François and Nicole Hervouët; no others have been recorded.

Card-playing—and its associated gambling—were extremely popular leisure activities in eighteenth-century Europe, and many elaborately decorated decks of cards were produced. Why this set of plates only displays one card is not known. Curiously, though, the same playing card appears on a *famille rose* teabowl and saucer of the Yongzheng period (1723–35). Cartomancy, the art of fortune-telling through playing cards, was widespread in eighteenth-century Europe, and in its practice the eight of spades portended outcomes ranging from healing grace to sickness to material rewards, depending on the cards around it. If this porcelain's commission was related to cartomancy then surely its meaning was material rewards; or perhaps its original owner had simply won an enormous bet when the eight of spades was played.

REFERENCES Hervouët 1986, p. 206; Lunsingh Scheurleer 1974, no. 282; Eldred's Auction Gallery, 12 January 2023, lot 34 (Yongzheng example)

PROVENANCE Heirloom & Howard Ltd, London, 1987; Sotheby's London, 3 November 1987, lot 851; the collection of François and Nicole Hervouët; Kasteel-Museum Sypesteyn; Jonkheer Henri van Sypesteyn (1857–1937)

214.
AIR NOUVEAU PLATE

Qianlong period (1736–95), mid-18th century
9 ½ in. (24.1 cm) diameter

A very small and curious group of saucer dishes are decorated with what seem to be verses from French love songs, titled *Air Nouveau 2* (two known), *Air Nouveau 4* (this example), and *Air Reveillez vous* (two known). They share identical form and borders and must have been one unique private order. Maria Antónia Pinto de Matos notes that the language used seems to be provincial, perhaps even from Brittany, where the Compagnie des Indes was based, while Christiaan Jörg remarks on the skill displayed by the Chinese painter who had to copy a completely unfamiliar script onto porcelain.

REFERENCES Jörg 1997, p. 276 (*Air Nouveau 2*); Pinto de Matos 2019, p. 248 (*Air Nouveau 2* and *Air Reveillez vous*; Keramiekmuseum Princessehof (04836) (*Air Reveillez vous*)

PROVENANCE Heirloom & Howard Ltd, Wiltshire, 1998; Sotheby's London, 17 June 1998, lot 431

215.

PAIR OF BOTTLE VASES WITH ENGLISH RURAL SCENES

Jiaqing (1796–1820) period
10 ¼ in. (26 cm) high

This very unusual pair of vases is each decorated with three roundels of bucolic scenes, one with a hatted lady strolling with her son and daughter, one with peacock and peahen, and the third with two children leaning against a rustic fence. The scenes appear to be copied from a print source and are highly reminiscent of late eighteenth-century Worcester porcelain; their circular nature may indicate that they were copied from a favorite English porcelain plate pattern.

REFERENCES Victoria and Albert Museum (C.173-1921 and C.166&A-1921) (Worcester)

PROVENANCE Silk Road Antiques Ltd, Hong Kong, 1979; S. Marchant & Son, London (one). Santos London 2017; Cabral Moncada Auctions; the collection of Contessa Luisa Feltrinelli Doria, Milan, no. 261p (per label); the collection of Sousa e Holstein, Dukes of Palmela (per label) (one)

216.
PORTRAIT BOX AND COVER

Jiaqing period (1796–1820), c. 1810
2 ⅜ in. (6 cm) diameter

In the form of a Chinese seal-paste box, this unusual piece clearly derives from a small group of *famille rose* boxes that feature profile portrait busts of King Charles IV of Spain copied from a silver eight-*reale* coin minted in Mexico in 1808, the coin's inscription encircling the portrait. Here, however, the portrait appears to be a pony-tailed gentleman, the inscription is indecipherable and, instead of the coat of arms of Spain on the base, a peach has been painted. The peach is repeated inside the box; the gentleman's body almost appears to be a peach, too. Whether this version was requested by a China trader or a freelance initiative by the potters at Jingdezhen is a mystery.

REFERENCES British Museum (1947,0719.8.a-b) (underglaze blue); Sargent 2014, pp. 138–39 (*famille rose*)

PROVENANCE Heirloom & Howard Ltd, Wiltshire, 2006; Sotheby's London, 8 November 2006, lot 479

9.
PLACES

The first imagery of China to come to the European world was no doubt in the form of tales passed from one merchant to another, tales that traveled from the Islamic traders of Central Asia to cosmopolitan centers like Kozhikode (Calicut) and Istanbul (Constantinople) to the silk merchants of Venice and Genoa. Then, beginning in the fourteenth century, a tiny number of very early travelers to Asia wrote accounts of the exotic lands they had seen, accounts that were devoured in Europe, while a slow trickle of Asian textiles and ceramics solidified the European image of the 'East Indies' as places of great riches and all kinds of rarities.[1]

Interactions between East and West became more common with the development of the Maritime Silk Route in the sixteenth and seventeenth centuries, but this did nothing to dilute the romantic European vision of the 'Indies'. Italian, Spanish and Portuguese adventurers added to the travel literature, as did the Augustinian, Dominican, Franciscan and especially Jesuit missionaries who reached Asia in this period. Early missionary accounts, while more scientific than early travel adventures, also extolled the exotic and wondrous flora, fauna, architecture, religious practices and benevolent rulers of 'Cathay'.

Dutch traveler Johan Nieuhof, a VOC (Dutch East India Company) official based in Batavia (Jakarta), wrote the earliest firsthand report on China to be accompanied by illustrations largely created *in situ*. He had joined the 1655–57 Dutch embassy to Beijing, where the VOC sought permission to trade on the South China Coast.[2] Nieuhof's detailed and observant account of the many extraordinary sights he encountered on his trip was published in several languages in the 1660s, accompanied by 149 black and white plates, an unusually large number for the age of copper-plate etching. His visual imagery of China, which was inserted into other books on Asia as well as disseminated in his own, was enormously influential, becoming fixed in the Western imagination and inspiring much eighteenth-century chinoiserie decoration.

One of the most wondrous aspects of China for the rest of the world was, of course, its porcelain, and a number of early writers speculated on the place and process of Chinese porcelain production. Marco Polo (1254–1324) reported that "the most beautiful vessels and plates of porcelain … very shining and beautiful beyond measure" are "made in great quantity in this province [of Fujian]." He was writing at the time about Quanzhou, an important Yuan dynasty port where trade was controlled by Muslim merchants.[3] Quanzhou—called Zaiton or Zayton by Westerners, from which the word 'satin' derives—was a primary point of export for Jingdezhen ceramics. Polo wrote that the porcelain process involved great mounds of mud and earth that were aged for thirty or forty years, which transformed them into the 'magical' clays for porcelain.[4]

Fifty or sixty years later, the intrepid Moroccan traveler Ibn Battuta also reported that porcelain was made in either Quanzhou or, alternatively, Sin Kalan (Guangzhou, called Canton by Westerners), naming the two important export ports. But he added that "[in] the earth there … the fire ignites like charcoal … they apply the fire to it three days," noting that "it is carried to India and to the other climes so that it even reaches our country in the Maghreb."[5]

A little more than three hundred years later, when Johan Nieuhof visited China, porcelain production was

Plaque inscribed *View of the imperial kiln at Jingdezhen, Jiangxi province, made by Gujianshi, painted by Wen Huan*, grisaille-decorated porcelain, 19th century, Frelinghuysen collection

no less a subject of fascination. The VOC embassy actually made it to Raozhou in Jiangxi province, just south of Jingdezhen, which they knew to be significant, as "… about 18 miles distant to the East in the country the fine porcelain bakeries are situated," adding, "… we saw a fine occasion to contract for some rare porcelain, but we were lacking appropriate samples … which was a pity."[6] Nonetheless, Nieuhof recorded the porcelain production process somewhat accurately, noting the pulverization of clays, the mixing with water, the air-drying of fashioned vessels and the multi-day firing. And finally, some fifty years later, the Jesuit priest Père François Xavier d'Entrecolles spent extended time in Jingdezhen. He was head of the French Jesuit mission in Jiangxi province from 1706 to 1719 and carefully observed the many complex stages in porcelain production, recording them in his famous letters of 1712 and 1722.[7]

This European fascination with the stages of Chinese porcelain manufacture was not dissimilar to the Chinese Imperial practice of recording the processes of significant Chinese industries. In 1696 the Kangxi emperor, consciously echoing a Song dynasty (960–1279) tradition, had his court painters create the *Yuzhi Gengzhi tu* (Illustrations of Plowing and Weaving), a set of forty-six paintings detailing the production of rice and silk.[8] The images were printed and published in 1712 and eventually became favored subjects for the export painting workshops of Guangzhou.

Mid-eighteenth-century Guangzhou was developing into a burgeoning center of the export arts. The Imperial decree of 1757 limiting European trade to Guangzhou turned this long-established port into an even more settled community of foreigners, a community eager to order and shop for Chinese porcelain, lacquer, pictures, pewter and silks.[9] Picture workshops flourished where one could buy colorful albums depicting life in China, including the exotic industries of silk, porcelain and tea.

Curiously, though, many pieces of blue and white porcelain created for the export market reflected the idealized European vision of 'Cathay'—the pagodas, the craggy mountains, the lush flora, the curious boats, the wise sages and the elegant ladies—only a very small number depicted iconic places of the China trade itself. Despite the number of Chinese export paintings of sights

that Western traders encountered on their journeys—the Guangzhou waterfront, the Dutch Folly Fort, Whampoa Anchorage, Bocca Tigris—a relatively small number of porcelains show these subjects. Similarly, the exotic industries of tea and porcelain that drove so much China trade wealth were only very rarely painted on porcelain.

All of these rare subjects are represented in the Frelinghuysen collection, including the depiction of a bustling Jingdezhen kiln site with pots drying on racks in the sun and flames shooting from a brick chimney in the background (no. 217). A rare set of dishes is decorated with the stages of tea production, from planting seeds to picking leaves to a tea merchant's arrival to packing the dried tea into baskets for shipping (no. 224).

Other pieces show scenes from the journey that porcelain took from Jingdezhen to the coast for export and beyond. The internal journey naturally took place almost entirely on waterways, beginning with a 56-mile (90-km) trip southwest via the Chang River to Poyang Lake. Poyang Lake, the largest freshwater lake in China, was a central hub fed by three major rivers; the town of Wucheng on its western shore was an important entrepôt. From Wucheng, Imperial porcelain went north along the Changjiang (Yangzi) River until it met the Grand Canal to Beijing, while other porcelain went south via the Gan River, eventually reaching the South China Coast.[10] Both Quanzhou, the port mentioned by Marco Polo and Ibn Battuta, and Guangzhou were important trading centers from as early as the Song dynasty (960–1279).[11] Quanzhou, being more northerly (opposite modern-day Taiwan) was naturally the point of departure for trade with Japan, while Guangzhou was the trading point for the Europeans based in Manila, Melaka (Malacca) and Batavia as well as for the considerable Chinese trade with Southeast Asia.

Inside China, state administration was highly organized, with multiple layers of the Imperial government, from towns to counties to prefectures to provinces. A rare set of plates in the collection (no. 219) depicts the regional checkpoints that goods would

Chinese School, *An Imperial Command is Brought to Jao Chou [Raozhou]*, ink and colors on paper, 18th century, Frelinghuysen collection

pass through as they made their way across Jiangxi province. A view of Poyang Lake inspired by export album depictions decorates one dish (no. 218), while the Guangzhou city wall (no. 221) and the Dutch Folly Fort (no. 220) are seen on others. Scenes of Batavia (no. 225) and of Fort William in Kolkata (Calcutta) (no. 227) round out the Western trading company sites.

Other topographical subjects for Chinese export porcelain included places of its ultimate destination, as represented in the collection by a garniture from the *Vung Tau* shipwreck thought to show Amsterdam canalside buildings (no. 226). Depictions of beloved places in these destinations were also commissioned, whether country houses and palaces (nos. 229–230), houses of worship (no. 228) or new American territories (nos. 231–232). This diverse range of topographical material in the collection reflects the extensive and long-lasting reach of the export porcelain that was made in Jingdezhen.

1 Honour 1961, pp. 5–29. Honour's work remains a comprehensive summary of the evolving European view of Asia through the centuries.
2 Ibid., pp. 18–19.
3 Vainker 1991, p. 138.
4 Carswell 2000, p. 58.
5 Ibid., p. 54.
6 Little 1983, p. 16.
7 Carswell 2000, p. 51; Kerr 2012, p. 38.
8 Hay 1995, p. 37.
9 Choi 2018, p. 123.
10 Gerritsen 2020a, p. 136.
11 Vainker 1991, p. 138.

217.
PORCELAIN PRODUCTION TUREEN STAND

Qianlong period (1736–95), c. 1770–80
14 ¾ in. (37.5 cm) wide

The scene on this dish is of a busy porcelain kiln compound, pots drying on racks at the center, potters working at wheels in sheds at back right, painters and decorators at work in other sheds and kiln workers carrying pots or mixing clays in the courtyard. At the rear, smoke rises from a kiln chimney. Given the importance of Jingdezhen's kilns to the China trade—and their exotic appeal—it is surprising that this subject does not appear with any regularity on export porcelain. The stages of porcelain production (as well as of tea, silk and rice cultivation) were certainly favored subjects in the export painting workshops of Guangzhou (Canton). There are a number of pieces known from what appears to have been one unique blue and white dinner service with this scene.

REFERENCES Winterthur Museum (1967.1495) (near-identical stand); Groninger Museum (1988.0187) (tureen); Sargent 2012, pp. 142–43 (tureen and stand)

PROVENANCE AntikWest, Gothenburg, 1988

218.

POYANG LAKE SAUCER DISH

Kangxi period (1662–1722)
8 ¼ in. (21 cm) diameter

While at a glance this dish depicts a generic Chinese river scene—two figures in a small boat passing by the gate of a city wall, a pagoda on the opposite riverbank—in fact it is a portrayal of Poyang Lake, the large body of water near Jingdezhen that was crucial to its commerce, with its connections to both the Gan and Yangzi rivers. All wares traveling from Jingdezhen were taken along Poyang Lake; this step of their journey was portrayed in Chinese pictorial series illustrating the stages of porcelain production. A typical view was found in a set of eighteenth-century album leaves published by Walter Staehelin, who titled the plate *An Imperial Command is Brought to Jao Chou* (see p. 267), noting that in Jesuit Père d'Entrecolles's influential 1712 letter he described the busy traffic between Jingdezhen and Jao-chou (Raozhou), a lakeside district eighteen miles away. The back rim has two bamboo branches; an apocryphal six-character Chenghua mark is on the base.

REFERENCES Groninger Museum (2011.0061) (very similar dish); Staehelin 1966, pl. 1 (album picture)

PROVENANCE Heirloom & Howard Ltd, Wiltshire, 2014

219.
SET OF FOUR JIANGXI PROVINCE CHECKPOINT PLATES

Guangxu period (1875–1908)
10 ⅜ in. (26.4 cm) diameter

These very unusual dishes depict four different checkpoints for the regulation of Chinese commerce by Chinese Imperial government agents. There were many layers of bureaucracy in Qing China; beneath the Jiangxi provincial government there were fourteen prefectures and about eighty counties. Anne Gerritsen quotes from the *Ta Tsing Leu Lee* (code of laws):

In every city, public market, and village district, where there is a commercial agent stationed and authorized by the government, and in every sea-port and reach of a river ... these agents shall ... be required to keep an official register ... [of the] quality and quantity of the goods imported or introduced into the market ...

The checkpoint agents were also responsible for collecting the all-important tax revenues. Jiangxi merchants conducted important trade in tea and grain as well as in porcelain from Jingdezhen. Each of these dishes depicts a tax district checkpoint, or *fu*, within the province, all south of Poyang Lake and Nanchang, the provincial capital: Ruizhou Fu (present-day Gao'an), just west of Nanchang, location of some foreign businesses in the Guangxu period (top left); Yuanzhou Fu (present-day Yichun), southeast of Poyang Lake and Nanchang (top right); Fuzhou Fu, due south of Poyang Lake (bottom left); Nanan Fu (present-day Ganzhou), south of Fuzhou, close to the Gan River (bottom right).

Each tax district is named at the top of the scene and its various city gates are also labeled. In addition, the Catholic church in Fuzhou (*Tianzhutang*) is labeled, and its district checkpoint (*Wangdangqia*) as well as that of Nanan (*Shangheqia*) are named.

This curious subject matter for porcelain dishes may well have been at the request of a provincial official, perhaps part of a larger set comprising more of the Jiangxi checkpoints.

REFERENCES Gerritsen 2014a, p. 91 (regulation of commerce); Gerritsen 2020b, p. 13 (provincial government and trade)

PROVENANCE Heirloom & Howard Ltd, Wiltshire, 2001; Peter Wain, Anglesey, Wales, 2001 (Ruizhou and Yuanzhou); Heirloom & Howard Ltd, Wiltshire, 2022; Tajan, Paris, 4 February 2022, lot 131B (Fuzhou and Nanan)

220.

DUTCH FOLLY FORT PLATTER

Qianlong period (1736–95), c. 1780–90
14 ⅝ in. (37.1 cm) wide

This platter is decorated with another iconic China trade view, the island fort on the Pearl River known as the Dutch folly fort. The pattern seems to have been used on only two dinner services of similar date. The Dutch fort lay quite near the Guangzhou (Canton) waterfront; another fort a mile away was known as the French folly fort. Both had been built by the Chinese but were later taken over by foreigners, though they were not used particularly actively. William Sargent quotes Swedish traveler Gustav Ekeberg (1716–1784), who wrote:

On the two small islands … there is a pair of small fortresses … preserved by high stone-walls, which seem to have been erected more for decoration than real use, because neither these nor the walls which enclose the town would seem to be of the least protection in times of war.

REFERENCES Sargent 2012, pp. 145–46; Vinhais and Welsh 2016, pp. 306–13 (two very similar dishes and a variant dish)

PROVENANCE Lynda Willauer Antiques, Nantucket MA, 1994

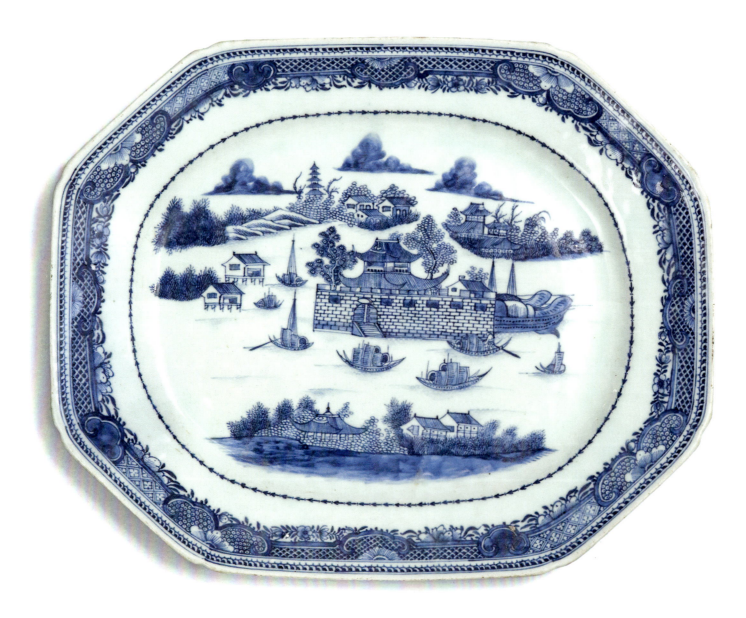

221.

GUANGZHOU (CANTON) CITY WALL PLATTER

Qianlong period (1736–95), c. 1775–85
11 in. (27.9 cm) wide

Like the porcelain production piece described above (no. 217), this platter seems to come from a unique dinner service decorated with an iconic China trade view. Although the foreign factories or 'hongs' of Guangzhou are not seen from this viewpoint, the city is easily identifiable by its landmarks: the Flowery Pagoda at left, the Mohammedan Tower (Guangta) at center and the Five-Story Watchtower (Zhenhai Lou) at right. Despite being depicted in many export paintings of the late eighteenth and nineteenth centuries, this subject is rare on Chinese porcelain. H.A. Crosby Forbes notes that this depiction, with its layered two-dimensional composition, is more Chinese than Western, suggesting that it was likely copied from a Chinese print.

REFERENCES Forbes 1978, pp. 784–87 (tureen stand); Sargent 2012, pp. 144–45 (tureen and stand)

PROVENANCE James Galley, Lederach PA, 1985

222.

HONGS OF GUANGZHOU (CANTON) GARDEN SEAT

Guangxu (1875–1908) to Republic (1912–49) period
17 ⅜ in. (44.1 cm) high

A continuous scene on the sides of this seat shows the Guangzhou waterfront as it appeared in the late eighteenth century and the first decades of the nineteenth century. On the flat top is the inner courtyard of a hong, a flag flying beside its gate. This classic view of the Guangzhou foreign factories, or hongs—the buildings where Western merchants lived and worked during the trading season—is well known from China trade painting and is found on a varied group of punch bowls made in the later eighteenth century but few other Chinese porcelains. A very rare pair of dishes dating to circa 1830 in the collection of Peter H.B. Frelinghuysen, Jr. was enameled in colors with views of Whampoa Anchorage and of the hongs.

REFERENCES Christie's New York, 24 January 2012, lot 104 (dishes from the collection of Peter H.B. Frelinghuysen, Jr.)

PROVENANCE Eldred's Auction Gallery, Dennis MA, July 2004, lot 376

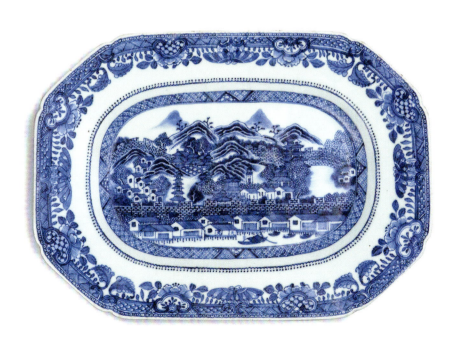
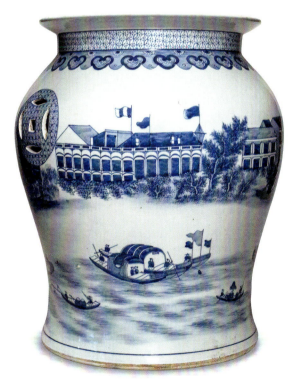

223.

CABOT-PERKINS HOT WATER DISH

Jiaqing period (1796–1820), c. 1812
9 ¾ in. (24.8 cm) diameter

From a dinner service made for Dr. Samuel Cabot and Elizabeth Perkins of Boston, who married in 1812, this dish is decorated with a unique pattern depicting a seven-stage Chinese pagoda. The pagoda is shown within four clusters of flowers and ornament typical of the 'Fitzhugh' patterns first made circa 1785 and particularly popular in the United States. Although the pagoda had been an iconic image of China ever since the work of Dutch artist Johan Nieuhof (1618–1672) was disseminated late in the seventeenth century, this image probably signified the pagoda at Whampoa Anchorage to the Cabots. Whampoa would have greeted every Western merchant at the end of his long journey, and Elizabeth's father, Thomas Perkins, was a successful Boston China trader.

REFERENCES Museum of Fine Arts Boston (53.2084 and 2085) (pair of plates given by direct Cabot descendants)

PROVENANCE Northeast Auctions, Portsmouth NH

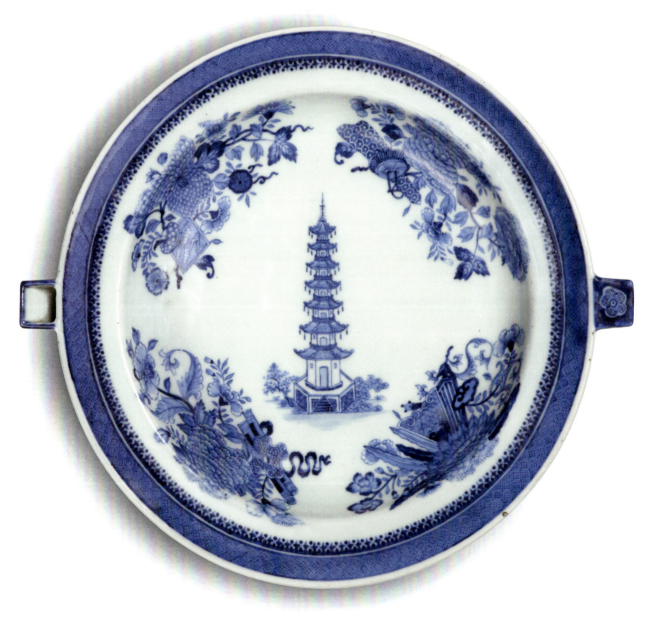

224.
SET OF EIGHTEEN TEA PRODUCTION DISHES

Qianlong period (1736–95), c. 1740–60
8 to 15 ⅛ in. (20.3 to 38.4 cm) diameter

In the 1690s the Kangxi emperor, following a tradition established in the Song dynasty (960–1279), asked his court artists to portray the processes of two significant Chinese industries. These depictions were called *Yuzhi Gengzhi tu* (Illustrations of Ploughing and Weaving). The *Gengzhi tu* series outlining stages of rice and silk cultivation was then expanded by the Qianlong emperor to include porcelain production; woodblock prints disseminated the imagery. The export artists of Guangzhou (Canton) created watercolor sets with romanticized views of these industries, which were of course subjects of fascination to their Western clientele. Tea, porcelain and silk were all desirable products closely associated with China; tea had become the driving commercial force of the China trade by the early eighteenth century.

Only rarely, though, did these themes appear as decoration on porcelain. Some small *famille rose* tea services depict merchants in a tea warehouse; a rare punch bowl in the Peabody Essex Museum is enameled with scenes of tea production. These blue and white dishes, with their exuberant rococo borders after Delft, seem to have been part of a unique dinner service. Kee Il Choi, Jr. has shown that at least nine of their compositions follow closely the depictions of tea cultivation in a Chinese watercolor album at Drottningholm Palace in Sweden, likely acquired in the mid-eighteenth century as its famous Chinese pavilion was being built. As the export art painting workshops typically repeated popular subjects, there were likely other very similar albums. A number of other pieces from the service are in Dutch public collections, including a large tranche featuring a pair of large round tureens at the Keramiekmuseum Princessehof, and it seems quite likely that a Dutch merchant commissioned this blue and white

service. Each is numbered with an Arabic numeral; twenty-three numbers have been identified in the series. But their numerical order does not form a logical progression in the tea cultivation process. In the Jingdezhen workshop, where a set of numbered prints or drawings were surely sent, the painters must have become confused about the order of the unfamiliar numerals as they focused their attention on rendering these scenes onto the rounded surfaces of dishes, tureens, salts and saucebeats. For a salt from the service, see no. 464; for a Japanese plate in the pattern, see no. 281.

REFERENCES Choi 1998, pp. 510–15 (blue and white, *famille rose*, album); Pinto de Matos 2019, no. 96 (RA collection set); Sargent 2012, pp. 137–38 (blue and white) and pp. 260–62 (punch bowl)

PROVENANCE Heirloom & Howard Ltd, Wiltshire, 2018; Christie's New York, 17 January 2018, lot 103; a private American collection

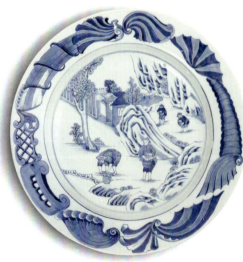
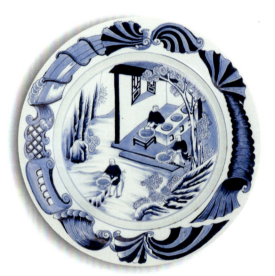

276

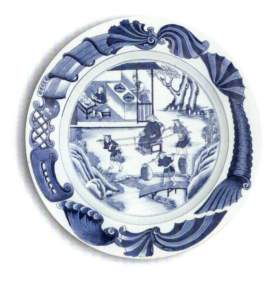
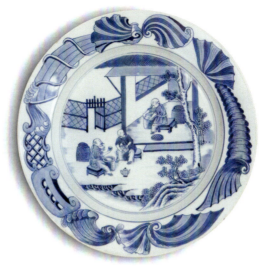
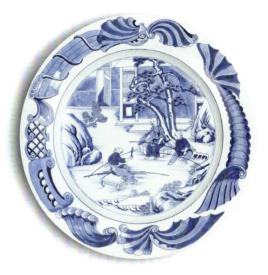
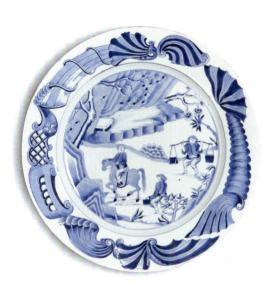
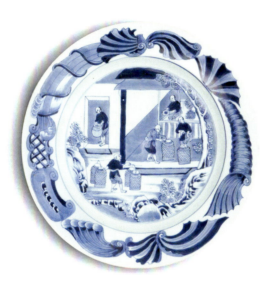
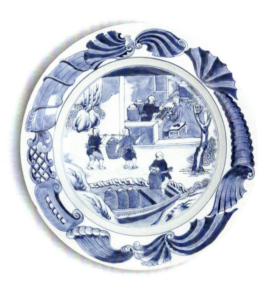
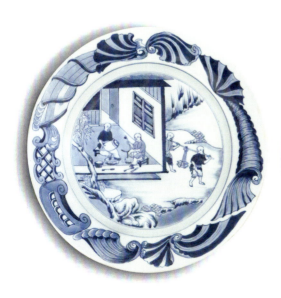
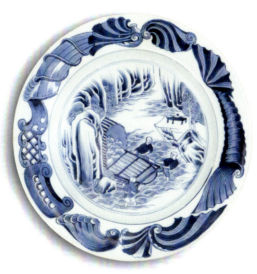
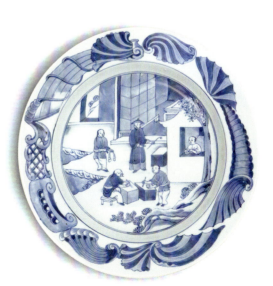

277

225.

BATAVIA NEW GATE PLATE

Kangxi period (1662–1722), c. 1690
8 ⅜ in. (21.3 cm) diameter

Dutch artist Johan Nieuhof traveled to China with the Dutch embassy of 1655–57; his firsthand renderings of the many exotic sights encountered on that visit were published and widely distributed in Europe. Nieuhof lived in Batavia (Jakarta), Indonesian headquarters of the VOC (Dutch East India Company), from 1660 to 1667; seventeen views he drew of the city were engraved by Johannes Kip and published posthumously in 1682, titled *Zee en lantreize, door verscheide gewesten van Oostindien* (Sea and Land Travel through Various Regions of the East Indies). This dish is decorated with the scene entitled *De Nieuwe Poort* (The New Gate), a Batavia city gate with an innovative drawbridge.

REFERENCES Vinhais and Welsh 2016, pp. 30–31 (dish and engraving); Van Campen and Eliëns 2014, p. 241 (Nieuhof)

PROVENANCE Heirloom & Howard Ltd, Wiltshire, 2012

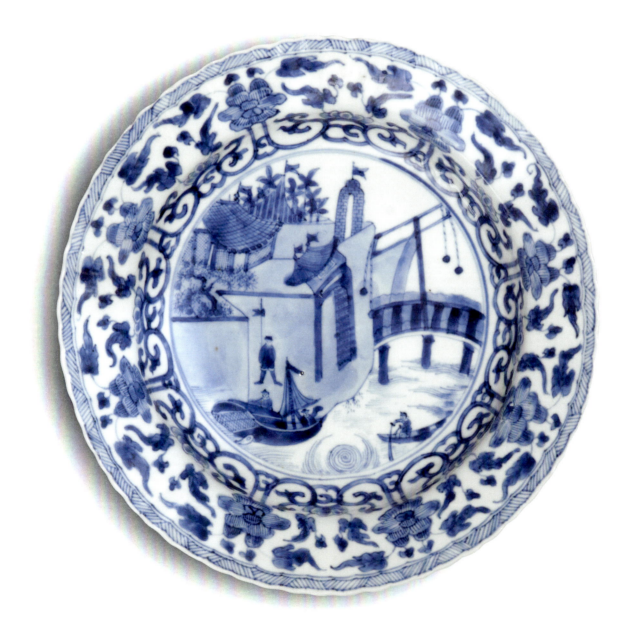

226.

CANAL BUILDINGS GARNITURE

Kangxi period (1662–1722), c. 1690
13 ¼ in. (33.6 cm) high

Rows of petal-shaped panels decorate each piece of this garniture, which comprises a pair of *gu*-shaped vases and three baluster vases with covers. The panels in front depict adjoining canalside buildings with vegetation opposite, while at the back they alternate with a fruit and floral motif, a small pagoda and flowering plants. The garniture and other pieces in this pattern were recovered from the wreck of an Asian vessel headed to Batavia (Jakarta), its cargo perhaps destined to go on to Amsterdam, though some believe the scenes depict Thai canalside buildings.

REFERENCES Jörg and Flecker 2001, pp. 42–49 (discussion of the 'Canal Houses' pieces in the *Vung Tau* Cargo); British Museum (1992,0605.1-5) (another garniture)

PROVENANCE Heirloom & Howard Ltd, Wiltshire, 1992, Christie's Amsterdam, 7–8 April 1992, lot 542; the *Vung Tau* Cargo

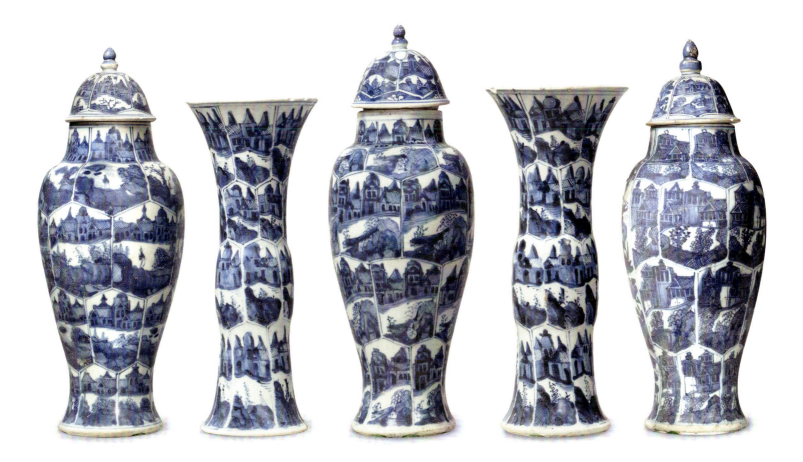

227.

FORT WILLIAM VEGETABLE TUREEN

Qianlong (1736–95) to Jiaqing (1796–1820) period, c. 1795
11 ⅛ in. (28.3 cm) wide

India was an important stopover and trans-shipment point for Europeans from the time of Vasco da Gama's landing near Calicut in 1498, but very few Chinese export porcelains depict India. In 1690 the English established a trading post at Calcutta (present-day Kolkata) and in 1696 the original Fort William was erected. By the time this tureen was made, 'country ships' were making regular journeys from the China coast to the British warehouses on Calcutta's Hooghly River and Fort William had been rebuilt under Robert Clive, becoming a vast complex. The small number of surviving pieces with this decoration were likely part of one service commissioned by an English trader.

REFERENCES Howard 1997, p. 20 (dish and related engraving)

PROVENANCE Christie's New York, 24 January 1992, lot 52

228.

SEVILLE CATHEDRAL PLATE

Qianlong period (1736–95), c. 1750–70
9 in. (22.9 cm) diameter

A Chinese lady poles a sampan away from a riverbank growing lush blossoms, ducks paddling beside her and an exotic bird flying overhead. At right is a very large European building with a large dome and numerous small towers. Luísa Vinhais and Jorge Welsh demonstrate convincingly that this building represents the Sacristía Mayor of Seville Cathedral after a print by Louis Meunier (b. 1630) that was included in *Différentes vues des palais et jardins de plaisance des rois d'Espagne*. The book's plates were widely copied throughout Europe; the Chinese pattern was made in plain blue and white and also blue and white with colored enameling.

REFERENCES Vinhais and Welsh 2016, pp. 149–57 (*famille rose* and blue and white pieces; engravings and photograph of the cathedral)

PROVENANCE Bodhisattva collection, Oviedo FL, 2019

229.
BURGHLEY HOUSE SAUCE TUREEN AND PLATE

Qianlong period (1736–95), c. 1745–50
6 ¾ in. (17.1 cm) wide and 9 in. (22.9 cm) diameter

These pieces come from a unique dinner service painted with a view of the northwest front of Burghley House, built by William Cecil (1520–1598), treasurer to Queen Elizabeth I and the 1st Lord Burghley. This view varies from the finely rendered *grisaille* image on a Chinese punch bowl that remains at Burghley and also from the views on a group of mid-eighteenth-century English delft pieces, but it could have been taken from an intermediate source or from a yet-unidentified print. As a significant monument of Elizabethan architecture and history, Burghley was the subject of a number of different prints.

Interestingly, Burghley House had strong connections with Asian export porcelain from its inception. Four pieces of Wanli period (1573–1620) blue and white mounted in London silver-gilt were collected by the 1st Lord Burghley (and are now at the Metropolitan Museum of Art). Two inventories created towards the end of the seventeenth century, in 1688 and in 1690 ('The Devonshire Schedule'), document numerous Dehua (*blanc de Chine*) pieces and an important group of Japanese export wares acquired by John Cecil, 5th Earl of Exeter (known as Lord Burghley until 1678), and his wife, Lady Anne Cavendish (a daughter of the 3rd Earl of Devonshire).

REFERENCES Sargent 2012, pp. 7, 139 (Burghley Wanli pieces and this service); Vinhais and Welsh 2016, pp. 73–79 (this service); Metropolitan Museum of Art (44.14.1, .2, .3 and .5) (Burghley Wanli); Castile 1986, pp. 20–25, 28, 102–03 (Burghley porcelain collection, the inventories and the *grisaille* punch bowl)

PROVENANCE Heirloom & Howard Ltd, Wiltshire, 2018; Stockholms Auktionsverk, Stockholm, 5 December 2018, lot 438 (tureen). Heirloom & Howard Ltd, Wiltshire (plate)

230.
TULLGARN PALACE PLATTER

Jiaqing period (1796–1820), c. 1800
15 ⅝ in. (39.7 cm) high

The commanding front of Tullgarn Palace (Tullgarns Slott) is painted in the center of this platter, above the inscription *TULLGARNSSLOTT/ANNOM.DCC.XCVI*. On the rim are the coats of arms of Östergötland (right), Holstein-Gottorp (left) and the Swedish military (top and bottom). The platter comes from a dinner service ordered by Prince Frederik Adolf, Duke of Östergötland (1750–1803), in 1796, though he had died by the time it arrived in Sweden in 1805. The service remained at Tullgarn as property of the Swedish royal collection; 180 pieces are still there, though a small number have circulated on the art market.

REFERENCES Vinhais and Welsh 2016, pp. 135–37; Wirgin 1998, p. 161

PROVENANCE The Chinese Porcelain Company, New York

231.
TWO TERRITORY OF NEW MEXICO DISHES FROM A PROVINCIAL KILN

Xianfeng (1851–61) to Tongzhi (1862–74) period, c. 1851–65
5 and 6 ⅜ in. (12.7 and 16.2 cm) diameter

Each saucer dish is naively painted with a large spread-winged bird clutching three arrows in his right claw and a half-wreath in the other, an indecipherable motto of New Mexico (CRESCIT EUNDO) in a banderole above. Though once interpreted as a rendition of the state seal of New Mexico and dated circa 1915, this depiction lacks the smaller eagle with cactus and snake that was a significant part of that seal. New Mexico became a territory of the United States in 1848; by 1851 the territorial government was using an eagle with arrows and an olive branch as its symbol. The smaller eagle motif—derived from the symbol of Mexico—was added during the 1860s. The provincial nature of these dishes would seem to confirm this dating, as the kilns at Jingdezhen were destroyed by warfare in 1853 and not rebuilt until 1862.

REFERENCES Keramiekmuseum Princessehof (OKS 1976.143); Padilla 2012, paras 3–5 (state seal history); Mudge 1986, p. 217

PROVENANCE James Galley, Lederach PA, 1987 (smaller)

232.
TERRITORY OF NEW MEXICO DISH

**Xianfeng (1851–61) to Tongzhi (1862–74) period,
c. 1855–65**
10 ⅞ in. (27.6 cm) diameter

This unusual dish repeats some of the same symbolism as the two in the previous entry—a spread-winged bird clutches arrows and a half-wreath—though here the bird has become a phoenix and is surrounded by a lotus border. A dish in the Mottahedeh collection was perhaps the intermediate version; of the same shape, size and border, it retains the motto and more eagle-like bird. These two variant dishes are in Jingdezhen porcelain, demonstrating the fluidity of designs produced in China for export. The flourishing trade along the Santa Fe Trail between New Mexico and Missouri that followed the Mexican-American War (1846–48) brought prosperity to the new territory, apparently leading to the commission of Chinese porcelain decorated with its emblem.

REFERENCES Howard and Ayers 1978, p. 512 (Mottahedeh dish)

PROVENANCE Santos London, 2015

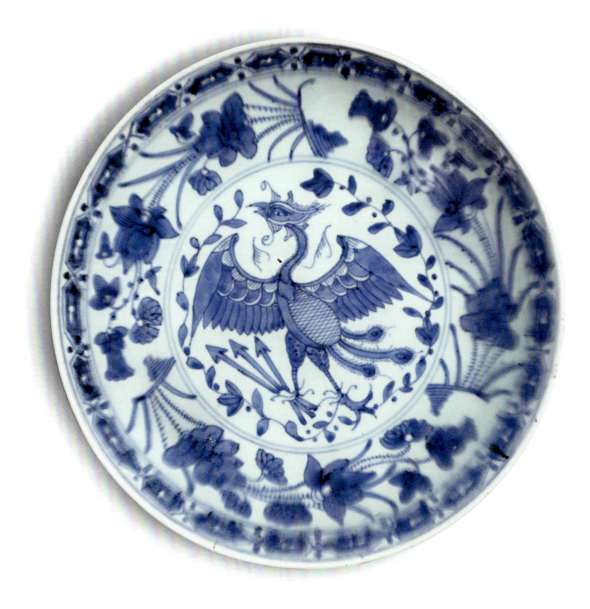

233.
REPUBLIC OF CHINA PLATE

Republic period (1912–49), c. 1920
9 ½ in. (24.1 cm) diameter

In the center of this plate are crossed the flag of the United States and the flag of the Republic of China rising from a diamond inscribed *CHINA* and with a sun and two stars. This version of the Chinese flag was used from 1912 to 1928, its five bands representing the five peoples of China: Han, Manchu, Mongol, Hui and Tibetan. This is one of a number of plates known with this intriguing decoration, which seems to reflect a moment of friendship between the two nations. The same crossed flags (without the diamond medallion) appear on a small number of pieces with 'Canton *famille rose*'-type borders.

REFERENCES Mudge 1986, p. 227 (*famille rose* version in the collection of the US State Department)

PROVENANCE James Galley, Lederach PA, 1987

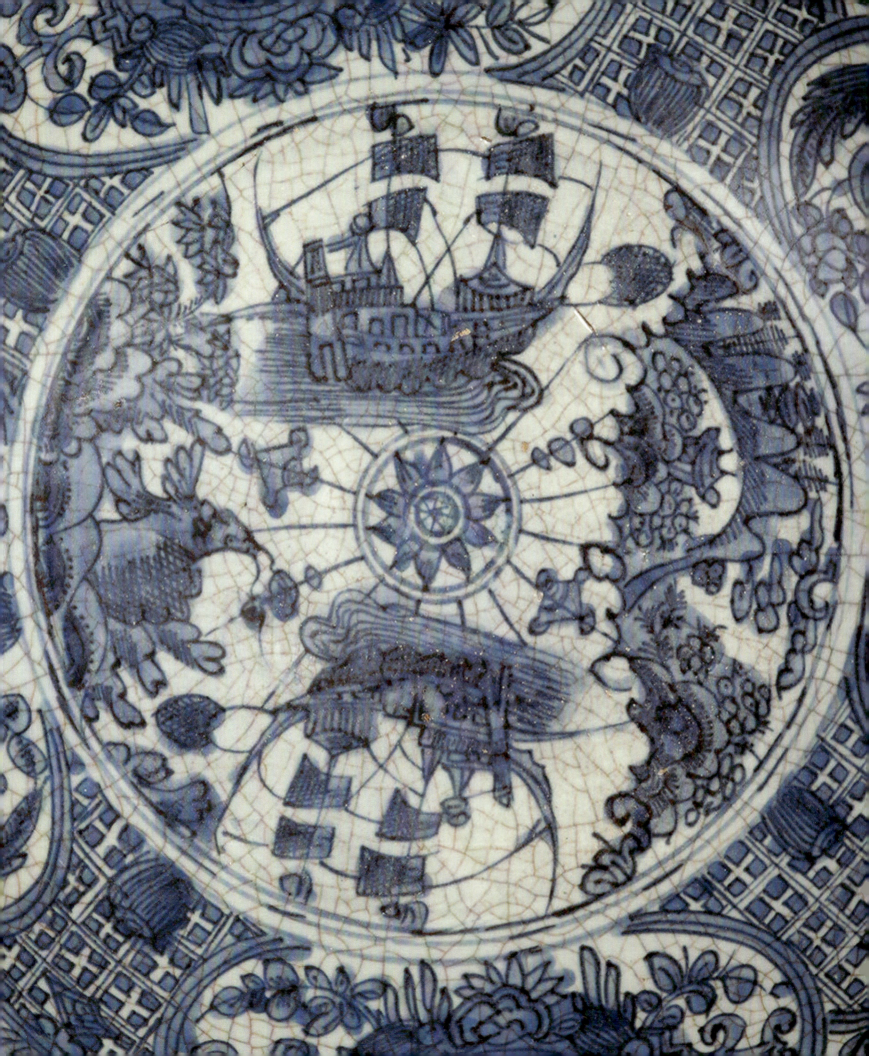

10.
SOUTHEAST ASIAN MARKET AND ZHANGZHOU

Ceramics from kilns in China were a major influence—and a major trade commodity—throughout the Southeast Asian world over many centuries. Lying between "the two giants of Asia, India and China,"[1] Southeast Asia (comprised of the land mass nations along China's southern border plus the long Indonesian archipelago) was destined to become a region of cultural convergence. Its cultures, its religions and its peoples are a unique and varied blend of the indigenous with Indian and Chinese. There were local ceramic kilns scattered throughout Southeast Asia, with a particularly sophisticated ware developing in Vietnam under the influence of Chinese blue and white from the Yuan dynasty (1279–1368). A famed Vietnamese blue and white jar decorated with classic Chinese peony scroll in the Topkapı Palace collection in Istanbul is dated to 1450 and is even inscribed with the potter's name.[2] But high-fired, lustrous porcelain from Jingdezhen dominated the region from its beginnings in the fourteenth century, including targeted designs and forms like the pouring vessels known as *kendi* (which were not used in China). Thailand had a particularly vigorous trading relationship with Chinese porcelain, and is discussed separately in Chapter Thirteen.

Ceramics from Chinese kilns beyond those of Jingdezhen were exported to Southeast Asia (as they were to Europe), including celadons, Dehua wares (so-called *blanc de Chine*) and the reddish-brown Yixing stoneware that eventually inspired early Meissen. And, for a time in the sixteenth and seventeenth centuries, a ware long known in the West as Swatow, made from heavily potted, coarse clays and boldly and freely painted, was also an important part of the export trade.

The term Swatow—like Bantam or Coromandel lacquer, Imari porcelain and the word porcelain itself (derived from the Italian word for cowrie shell)—was born of European misunderstanding. Swatow was the Dutch appellation for Shantou, a port town in northern Guangdong province. But archaeological excavations of the 1990s have shown that the so-called Swatow wares were actually made in a number of small private kilns scattered around the prefecture of Zhangzhou, 150 miles north of Shantou in Fujian province.[3]

The wares were gathered in the city of Zhangzhou and shipped from Yuegang, just downriver and an easy sail across the strait from Taiwan (Formosa). Yuegang had long been an active part of the flourishing maritime trade that took place up and down the Fujian coast, largely overlooked by Ming officials during the era of trade bans. Portuguese merchants arrived in the sixteenth century to join Chinese and Southeast Asian traders, and by 1600 a thriving trading route with Spanish Manila had been established.[4] The arrival of the Dutch in Asia coincided with the peak decades of Zhangzhou ceramics, and their occupation of Taiwan from 1624 to 1658 gave them proximity to the Yuegang exports.[5]

The Zhangzhou kilns were thus well situated to capitalize on foreign demand for Chinese ceramics with their unique production. Local clays differed from those at Jingdezhen and were not put through the same careful refining process. A simplified firing technique was also used: pieces were placed on coarse sand in the kiln and, as

Nicholas Comberford's map, color on vellum, c. 1665, National Maritime Museum, Greenwich

their foot rings were not wiped clean of glaze, the sand stuck to their bases. While there are many shared characteristics among the Zhangzhou wares, the products of the various small, family-owned kilns could differ in clay and glaze color as well as in the color of their cobalt or overglaze enamel painting.[6]

Never popular in China, where more refined porcelain was preferred, Zhangzhou ceramics were largely marketed to the Indonesian archipelago. Europeans like the VOC (Dutch East India Company) found the *grof porselein* (coarse porcelain) a highly profitable regional commodity, trading it for lucrative spices and exotic woods.[7] In the Muslim realms of Indonesia, the large dishes that were the main Zhangzhou product suited dining customs perfectly. An early European visitor to Southeast Asia, the Venetian Antonio Pigafetta, wrote a travel account (published in 1525) which described sumptuous Southeast Asian court banquets where large Chinese dishes were set out on palm mats on the ground.[8] Japan was another major market; the Japanese appreciated the free and imperfect Zhangzhou aesthetic.[9]

Chinese, Portuguese, Spanish and Dutch ships all carried Zhangzhou wares for the intra-Asian trade, often alongside *kraak* and other Jingdezhen porcelain, as Teresa Canepa shows us with her comprehensive census of thirty-nine salvaged Chinese and European shipwrecks of the late Ming period.[10] In smaller numbers they found their way to India, the African coast, the Middle East, Europe and New Spain.[11] There are Zhangzhou dishes in the famous porcelain-encrusted ceiling of the Santos Palace in Lisbon, for example.[12] European-influenced designs seen in the many dishes with Western ships (nos. 237–238) and a few pieces with a Portuguese heraldic device tell us that the Zhangzhou kilns were at least targeting European merchants, if not a larger, hoped-for Western audience.[13] Other pieces feature Islamic characters or motifs, presumably for the regional Muslim communities (no. 239).[14]

The Zhangzhou production faded away in the late seventeenth century. Having flourished, like Japanese kilns, amid the mid-century chaos in China that compromised Jingdezhen output, the Zhangzhou kilns then suffered from the Kangxi emperor's severe crackdown on Fujian province, which had become a refuge for Ming holdouts, and never recovered.[15]

Over the ensuing centuries Zhangzhou ware was not prized in the West as Jingdezhen porcelain was, though significant collections of Zhangzhou were formed in Japan.[16] Then, early in the twentieth century, several collectors from the Netherlands, with its longstanding ties to Indonesia, assembled major collections of Zhangzhou—two of the most important now in the Keramiekmuseum Princessehof in Leeuwarden. Today, Zhangzhou ware is appreciated as a part of the panoply of Chinese ceramics, and, with its preponderance of blue and white, Zhangzhou is, of course, a part of the story told by the Frelinghuysen collection.

1 Frasché 1976, p. 13.
2 Ibid., p. 98.
3 Strober n.d., p. 13.
4 Yu 2019, pp. 3–8.
5 Harrisson 1979, pp. 10–11.
6 Strober n.d., p. 14.
7 Harrisson 1979, p. 10.
8 Strober n.d., pp. 38–39.
9 Ibid., p. 10.
10 Canepa 2016, pp. 416–20.
11 Sargent 2012, p. 163.
12 Canepa 2016, p. 144.
13 Sargent 2012, p. 163.
14 Yang 2021.
15 Strober n.d., pp. 36–37.
16 Ibid., p. 10.

234.

PAIR OF SHADOW PUPPET DISHES

**Daoguang (1821–50) to Guangxu (1875–1908) period,
19th century**
9 ⅝ in. (24.4 cm) diameter

The very unusual subject matter of these dishes is Indonesian shadow puppets. Originating in Java in ancient times and usually transliterated from the Javanese dialect as *wayang,* the puppets are made from perforated leather that is then painted and gilt, the perforations enhancing the drama of their appearance under transmitted light. Shadow puppet plays are often derived from the famous Hindu epics, the *Ramayana* and the *Mahabharata,* and, though popular throughout Indonesia, are still particularly associated with the islands of Java and Bali.

PROVENANCE EastWest Gallery, Honolulu, 2013

235.

ZHANGZHOU BOX WITH RABBIT

**Jiajing (1522–66) to Wanli (1573–1620) period,
c. 1520–1620**
5 in. (12.7 cm) diameter

In the center of the cover is a roundel with a crouching rabbit; around him are leaping horses amid coral-like foliage, repeated on the base. The body is a warm gray-beige and the glaze is finely crackled, pulling in tiny spots on the base. A near identical box in the Powerhouse Museum is attributed to the Zhangzhou kilns, as is a small round box with an underglaze blue rabbit on its cover and plain ribbed sides in the collection of the Freer Gallery of Art. Curator Louise Cort notes that a number of Zhangzhou boxes from this period, some with rabbits, have been found in Indonesia.

REFERENCES Powerhouse Museum, Museum of Applied Arts & Sciences, Sydney (2011/100/13) (very similar box); Freer Gallery of Art (F1989.5a-b) (related box); Harrisson 1979, p. 81 (jarlet in this pattern)

PROVENANCE Thomaston Place Auction Galleries, Thomaston ME, November 2014, lot 122

236.

BETEL NUT BOX

**Zhengde (1506–21) to Chongzhen (1628–44) period,
c. 1500–1650**
5 ⅛ in. (13 cm) diameter

Lightly molded and decorated as a flowerhead, the cover of this box opens to an inner cover centered by a small round receptacle. Christiaan Jörg notes that a very similar box in the Rijksmuseum may have been made in a southern Chinese kiln for the burgeoning trade with Southeast Asia. Betel nut chewing was extremely popular throughout the region, and betel boxes were often shaped as small melons, as this one.

REFERENCES Jörg 1997, p. 34 (very similar box); Corrigan, Van Campen and Diercks 2015, p. 114 (betel boxes)

PROVENANCE Philip S. Dubey Antiques, Baltimore

237.

LARGE ZHANGZHOU DISH WITH COMPASS AND SHIPS

Jiajing (1522–66) to Shunzhi (1644–61) period, c. 1550–1650

16 in. (40.6 cm) diameter

Two European ships at full sail flank a small compass motif in the center of this large dish; in between them are sketchily painted scenes of a rocky shore and of a fish leaping from waves. The compass radiates faint lines out to the curving rim, which is decorated with four large panels reserved on a patterned ground. Portuguese or Dutch navigational maps were likely the source of the central design motifs.

REFERENCES Strober 2013, pp. 144–45 (very similar dish); Sargent 2012, p. 166 (very similar dish)

PROVENANCE Heirloom & Howard Ltd, Wiltshire, 2017; Rowley's Fine Art & Auctioneers, Cambridgeshire, 21 February 2017, lot 807

238.

LARGE ZHANGZHOU DISH WITH COMPASS, SHIPS AND FISH

Jiajing (1522–66) to Shunzhi (1644–61) period, c. 1550–1650
18 ¼ in. (46.4 cm) diameter

This dish is decorated in essentially the same pattern as the dish in the previous entry, though in a paler cobalt blue and with some small differences. Here, the leaping fish has become huge, almost dominating the center of the dish, while the rim features leaping horses and serpents. Very likely the numerous small Zhangzhou kilns shared or traded design sources or even workers during the decades of their output, with a resulting adaptation and evolution of patterns.

REFERENCES Harrisson 1979, pp. 79–80 (similar dishes); Strober 2013, pp. 144–45 (related dish); Sargent 2012, p. 166 (related dish)

PROVENANCE Chai Ma Antiques, Bangkok, 1981

239.

LARGE ZHANGZHOU DISH WITH DRAGONS AND HORSES

Jiajing (1522–66) to Shunzhi (1644–61) period, c. 1550–1650

15 ¾ in. (40 cm) diameter

A pair of sketchily painted dragons contend for the flaming pearl of wisdom in the center of this dish within an inner border of five leaping horses. Eight roundels on the patterned rim depict warrior figures alternating with Arabic script which may be translated as *God is Health; God is Healing*, reflecting the Islamic audience for much of the Zhangzhou production.

REFERENCES Yeo and Martin 1978, pp. 194–95 (similar dish); Harrisson 1979, p. 140 (similar dish)

PROVENANCE R & G McPherson Antiques, London

240.
LARGE ZHANGZHOU DISH WITH BIRD

Jiajing (1522–66) to Shunzhi (1644–61) period, c. 1550–1650
18 ¾ in. (47.6 cm) diameter

In the center of this dish, a large bird perches on the branch of a flourishing peony bush. The wide patterned border is interrupted by six panels of flowering plants. Barbara Harrisson illustrates several variations on this pattern, writing that the bird is probably meant to be a pheasant, and noting that a similar dish was found in the cargo of the *Witte Leeuw*, the VOC ship that sank in 1613.

REFERENCES Harrisson 1979, pp. 70–73 (similar group); Yeo and Martin 1978, pp. 196–97 (very similar dish)

PROVENANCE Chai Ma Antiques, Bangkok, 1981

241.
LARGE ZHANGZHOU ISLANDS OF BLISS DISH

Jiajing (1522–66) to Shunzhi (1644–61) period, c. 1550–1650
15 in. (38.1 cm) diameter

Barbara Harrisson named the subject of a group of Zhangzhou dishes depicting idealized landscape 'Islands of Bliss'. These depictions vary in detail—some with peaked mountains, some with small bridges—but they all portray a paradisal land in three horizontal planes. This example, which features particularly refined clay for the Zhangzhou kilns and a particularly bright blue, is decorated with large ribbon-tied symbols around the deep rim.

REFERENCES Harrisson 1979, pp. 76–78 (related group); Yeo and Martin 1978, pp. 194–95 (related dish)

PROVENANCE Philip S. Dubey Antiques, Baltimore

11.
JAPANESE MARKET

Separated by the Sea of Japan and vastly different in size, China and Japan are linked by a long history of cultural exchange, an exchange that waxed and waned over many centuries under varying political conditions. For the Chinese porcelain industry at Jingdezhen, it was the seventeenth century that brought a new and significant relationship with Japan. For several decades, special wares known as *ko-sometsuke* ('old blue and white') were produced at Jingdezhen for use in the Japanese tea ceremony; they represent a unique and fascinating moment in the history of Chinese porcelain. But the Japanese desire for Chinese ceramics didn't begin with *ko-sometsuke* and didn't end with it, either. Not only were other Chinese wares quite avidly collected in Japan, but an intriguing and much less well-known group of Chinese porcelains was also made for Japan in the nineteenth century.

Chinese ceramics were collected in Japan as early as the seventh century, as witnessed by Tang dynasty (618–907) finds at a number of Japanese archaeological sites.[1] Later, wares from provincial kilns like those of Zhangzhou (long called 'Swatow' in the West) were appreciated in Japan for their "imperfections and irregularities ... and seemingly careless designs," the very qualities that made them undesirable in China.[2] *Kraak* ware was another style of Chinese ceramics popular in Japan, so much so that, when Japanese kilns began producing true porcelain in the seventeenth century, they made pieces in the paneled-border *kraak* style, which they called *fuyo-de*.[3]

But the best-known Chinese porcelains for the Japanese market are the *ko-sometsuke* wares made for Japan's distinctive tea ceremony practice (known originally as *mushikui*, or moth-eaten; the term *ko-sometsuke* came later).[4] When this rarefied ritual for the preparation and taking of tea emerged in the sixteenth century, the most prized vessels were Song dynasty (960–1279) wares from old family collections.[5] As the century went on, highly influential tea masters promoted the uniquely Japanese *wabi* aesthetic that prized imperfection and rusticity, and this was reflected in the use of simple, utilitarian Korean and Japanese vessels. Naturally, enterprising Japanese kilns began producing these kinds of relatively unfinished, even pedestrian wares specifically for tea ceremony use.[6]

It is at this point that tremendous upheaval took place in Jingdezhen. The Wanli emperor's long reign (1573–1620) had seen both the peak of Ming prosperity and the beginning of its inexorable decline, a decline hastened by the emperor's withdrawal from administrative affairs after about 1589. In 1608, as a cost-cutting measure, the vast Imperial kilns at Jingdezhen were closed, resulting in a massive decrease in annual porcelain orders. A large number of potters, decorators and suppliers were unemployed as a result, although some were absorbed by the many private Jingdezhen kilns—which were now in need of growing markets to absorb their output.[7]

There had long been three main components of the market for Jingdezhen porcelain: the Imperial household, Chinese elite, and foreigners.[8] Now was a time for the second two to step up. And, very luckily for the Jingdezhen industry, Japan was poised to become a ready market: urbanization, commercialization, cottage industries, agricultural productivity—all were rising in Japan. The Tokugawa shogunate (founded in 1603) had brought in an era of growing prosperity.[9] Elite

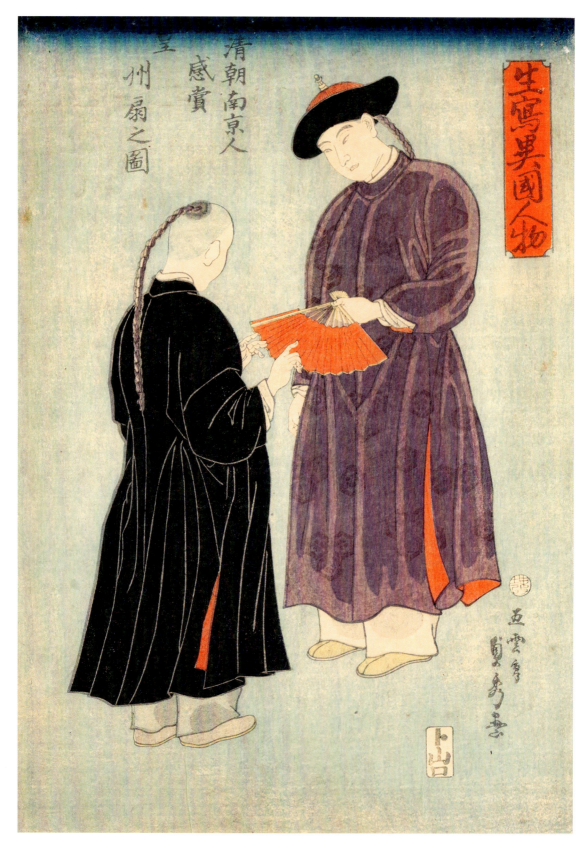

Japanese School, *Chinese Merchant and Servant in Japan*,
woodblock print, 19th century, Frelinghuysen collection

practitioners of the tea ceremony and wealthy merchants or farmers alike could covet Chinese porcelains.[10] In just one year of this period, 1645, it is estimated that 229,000 pieces of Chinese porcelain were sold to Japan.[11] Recent archaeological exploration has documented how Jingdezhen kilns successfully adapted to the shifting market conditions of this unstable period in China, turning up shards of *ko-sometsuke* porcelain in at least six major kiln sites.[12]

The tightly prescribed forms for the highly ritualized tea ceremony are the most distinctive of the seventeenth-century Chinese porcelains produced for Japan, made largely during the reigns of Tianqi (1621–27) and Chongzhen (1628–44), the last of the Ming emperors. Japanese kilns like Raku and Oribe had been making roughly finished tea wares to the *wabi* aesthetic, and Chinese kilns created their high-fired porcelains in this same tea ceremony taste. This included dishes for the *cha-kaiseki* meal that accompanies the tea ceremony, such as round plates and sets of small, naturalistically or asymmetrically shaped food dishes (*mukozuke*), as well as incense boxes (*kōgō*), charcoal braziers, water containers and flower vases.[13]

However, the production of these distinctive tea wares waned as Jingdezhen was increasingly affected by the last struggles of the Ming dynasty, which finally fell to the Qing in 1644. Under the Shunzhi emperor (r. 1644–61) and in the first two decades of the Kangxi emperor's reign (1662–1722), porcelain production was at a much-reduced scale. In the 1680s the kilns were finally revitalized, and the great flowering of Kangxi porcelain began, building on a foundation laid by the *ko-sometsuke* and Transitional wares of the previous decades—a testament to the creativity and flexibility of Jingdezhen private kilns in the seventeenth century.[14]

The regenerated Jingdezhen output found a ready audience in Dutch traders, soon joined by the English and later by French, Scandinavian and other European trading companies. But Chinese porcelain did not cease to travel to Japan. Intra-Asian trade was facilitated by a large Chinese merchant community in Nagasaki (the only Japanese port allowed to receive foreigners under the Tokugawa shogunate). When the Qing lifted trade bans in 1684, this Chinese community multiplied. By 1688 almost two hundred Chinese ships a year were calling at Nagasaki, inspiring the construction of an artificial island to confine the Chinese.[15] Not far from

Kawahara Keiga, *View of Deshima [and Tojin Yashiki] in Nagasaki Bay* (detail), ink and color on silk, c. 1836, Nationaal Museum van Wereldculturen

Dejima Island, which had been created for the Dutch for the same reasons almost fifty years earlier, the Chinese settlement—known as *Tojin Yashiki*, or 'Chinese Residence'—was much larger, accommodating at least several thousand merchants.[16] A short bridge led to a small, squarish island of warehouses—called *Shinchi*, or 'New Land'—for Chinese trade goods.[17]

Sugar from Batavia (Jakarta), silk thread and finished textiles were the main products brought to Nagasaki on Chinese ships in the eighteenth century, but porcelain seems to have been somewhat regularly shipped, if only for the Chinese community.[18] Officially, the import of foreign porcelain had been prohibited, but, as one writer put it, "it is quite clear … that contemporary Chinese porcelain must have been coming into Japan in the great junks."[19] Japanese scholar Koji Ohashi has reported on the large quantity of Jingdezhen blue and white excavated at *Tojin Yashiki*, including pieces with Kangxi, Yongzheng and Qianlong marks, as well as VOC (Dutch East India Company) dishes.[20] Volker cites the 1749 arrival of sixty-seven bundles of Chinese porcelain in Nagasaki.[21] Famed collector William Beckford, discussing a new

book on Japan in a letter dated 17 February 1819, wrote of porcelain, "The Japanese import much of theirs from China, their own products being horribly dear; they have very few makes of the best quality and it takes a long time to manufacture them."[22] An 1812 memorandum from VOC employee Van Braam notes, "… the Chinese (who excepting the Dutch, are the only foreigners allowed to trade with Japan) have taken advantage to enlarge their trade, being enabled, through the Viceroy of Canton, to supply all the wants of the Japanese."[23]

The tradition of collecting Chinese porcelain had persisted among Japanese connoisseurs. The well-known 'Peony Pavilion' collection of late Ming Chinese tea wares sold at Christie's in 1989 had been formed over six generations of a Japanese family, their first documented acquisition made in 1781. Stephen Little describes the *ko-sometsuke* pieces prized as *densei-hin* (handed-down objects) he encountered in Japan, many in old wooden boxes inscribed by earlier generations.[24] A set of five *mukozuke* dishes in the Frelinghuysen collection (no. 485) are held in a fitted box with old labels describing the dishes and reading "Osumi Collection/Purchased in the 12th year of Tenpō [1841]." A taste for Chinese wares is also reflected in the production of Japanese kilns in the later eighteenth and nineteenth centuries, which included numerous Chinese-style wares.[25]

There seems to be no evidence of eighteenth-century Chinese porcelains targeted specifically to the Japanese market. However, in the first half of the nineteenth century, a fascinating group of Japanese market porcelains was made at Jingdezhen, a group that is well represented in the collection (nos. 251–257). Reflecting the antiquarian interests of a conservative Japanese society, a society that had been closed to the outside world for almost two centuries, these porcelains were often decorated with late Ming-style landscapes and evocative Chinese poetry.[26] Many bear Chinese reign marks, a phenomenon found in the Tianqi *ko-sometsuke* wares of two centuries earlier.[27] Made in Japanese forms, some naturalistic and others for specific tea ceremony function, these pieces combine what has been described as meticulous painting with heavy potting. They often display spur marks.[28]

Another group made for Japan in the Jiaqing (1796–1820) and Daoguang (1821–50) eras revived seventeenth-century *Shonzui* wares, a subset of tea ceremony wares named for the eight-character inscription they bear.[29] These *Shonzui* revival pieces, called 'New Shipping' in Japan, have been excavated at datable Jingdezhen kiln sites.[30]

For the Jingdezhen kilns, the nineteenth century marked yet another shift in demand. Economic decline in China meant a slowdown in Imperial orders. On top of this, protectionist tariffs and changing tastes in Europe meant a waning of Western orders.[31] It seems that, once again, the Japanese market stepped into the breach, and this intriguing and handsome group of wares was the result.

1 Chang 2006, p. xii.
2 Rogers 2006, p. 7.
3 Strober 2013, p. 197.
4 Little 1983, p. 7.
5 Willmann 2011b, p. 1.
6 Ibid., p. 2.
7 Kerr 2019, p. 6.
8 Ayers 1991, p. 7.
9 Berg 2005, p. 59.
10 Rogers 2006, p. 21.
11 Berg 2005, p. 59.
12 Cao 2019, pp. 4–6.
13 Little 1983, p. 8.
14 Ibid., p. 28.
15 Koji 2018–19, p. 148.
16 Museum Volkenkunde n.d., p. 1.
17 Ibid., p. 2.
18 Mori n.d., p. 13.
19 Smith 1973, p. 66.
20 Koji 2019, pp. 149, 151, 154.
21 Smith 1971–73, p. 77.
22 Ibid., p. 51.
23 Ibid., p. 50.
24 Little 1983, p. 2.
25 Smith 1973, p. 66.
26 Ayers 1991, p. 9. Marchant 1991 is one of the few publications to discuss nineteenth-century Chinese wares made for the Japanese market.
27 Freedman 1991, p. 15.
28 Ibid., p. 16; see also Kips 2019, pp. 33–34, for a discussion of spur marks on Chinese porcelain.
29 Little 1983, pp. 14–15.
30 Cao 2019, p. 4.
31 Ayers 1991, p. 7.

242.

DUCK BOX

Tianqi (1621–27) to Chongzhen (1628–44) period
6 ⅜ in. (16.2 cm) high

The squat duck stands on a lotus leaf base further supported by two flowerheads. He turns his head back with a small morsel in his beak. He was probably used as an incense box, like the frog box discussed below and the quail box in the Asian Art Museum of San Francisco.

REFERENCES Marchant 1989, p. 12 (very similar duck box); Asian Art Museum of San Francisco (B69P91L.a-.b) (related duck box); Curtis 2006, pp. 44–45 (quail box)

PROVENANCE Polly Latham Asian Art, Boston

243.

TWO INCENSE BOXES (KŌGŌ)

Wanli (1573–1620) (square) and Tianqi (1621–27) to Chongzhen (1628–44) period (oval)
1 ¾ and 2 ⅝ in. (4.4 and 6.6 cm) long

The first is a chamfered square box decorated with a rabbit gazing at the moon; the second oval and freely painted with a contemplative scholar. On the sides of the square box is a basketweave pattern typical of *kraak* ware. In Japanese legend a rabbit is believed to live on the moon, where he can be seen pounding *mochi* (rice cakes). The oval box has a Japanese gold repair (*kintsugi*) to its rim. The square box has an apocryphal six-character Chenghua mark inside its cover, which slots into the conforming base.

PROVENANCE The collection of David S. Howard, Wiltshire (square). Robert McPherson Antiques, Friesland, 2021 (oval)

244.
FROG INCENSE BOX (KŌGŌ)

Tianqi (1621–27) to Chongzhen (1628–44) period
3 ¼ in. (8.3 cm) diameter

The cover of this small box is molded as if a frog has just settled on it, his head raised and his legs splayed, small clumps of lotus beside him. Boxes of this form were used for seal paste in China; in Japan it would have been used for small chunks of incense to add to the coals in a brazier. Its naturalistic quality and free painting are characteristic of *ko-sometsuke* wares.

REFERENCES Canepa 2019, pp. 336–37 (similar Lurie collection box); Curtis 2006, pp. 44–45 (related *kōgō*)

PROVENANCE CopperRed Antiques, Bangkok, 2015

245.
BUDDHIST MONKS ASSEMBLY BOWL

Tianqi period (1621–27)
6 ⅛ in. (15.5 cm) diameter

The interior of this shallow bowl is painted with an edge to edge scene showing a gathering of Buddhist monks in an assembly hall. With shaved heads and simple robes, the monks sit in rows on balconies and the main floor before a group of their leaders. A near-identical bowl from the collection of Julia and John Curtis is now in the Metropolitan Museum of New York, whose curators suggest that it may have been used either in a Buddhist context or during the tea ceremony.

REFERENCES Metropolitan Museum of Art (2015.270) (near-identical bowl); Seattle Art Museum (98.47.4) (related dish)

PROVENANCE Heirloom & Howard Ltd, London, 1979; Sotheby's London, 24 July 1979, lot 193 (one of two; the other the Metropolitan Museum bowl)

246.

TWO KO-SOMETSUKE DISHES

Tianqi period (1621–27)
8 ⅜ in. (21.3 cm) diameter

Each dish is painted with four water buffalo moving through a simple field, a small moon above them. In one a cowherd walks behind; in the other the cowherd rides a buffalo. This freely painted, asymmetrical and rustic subject with its ample use of white space is characteristic of Chinese wares for the tea ceremony.

REFERENCES Curtis 2006, p. 34 (water pot with scattered buffalo)

PROVENANCE J.A.N. Fine Art, London, 2018

247.
GINKGO LEAF TRAY

Tianqi (1621–27) to Chongzhen (1628–44) period
9 ¼ in. (23.5 cm) wide

Supported on three short pedestal feet, this tray is painted with a *qilin* seated in a garden and breathing flames. The very long-lived ginkgo biloba tree came to Japan from China along with early Buddhist monks. Their uniquely shaped leaves became symbols of longevity there. *Ko-sometsuke* trays were made in numerous naturalistic shapes.

REFERENCES Asian Art Museum of San Francisco (B69P97L, B69P99L and B69P98L) (gourd and mountain-shaped trays)

PROVENANCE Philip S. Dubey Antiques, Baltimore, 2014; Doyle New York, September 2014, lot 48

248.
WILD GOOSE DISH

Tianqi period (1621–27)
8 ⅝ in. (21.9 cm) diameter

Three geese stand on a riverbank while another flies above; in the distance the Wild Goose Pagoda of Xian is visible. An inscription in the sky can be read as *May your name be inscribed on the wall of the Wild Goose Pagoda in Chang'an*, while reflected in the water is an inscription that can be translated as *May you enjoy the imperial spring banquet in the Apricot Grove*. Built during the Tang dynasty (618–906) and still an important cultural landmark, the pagoda was dedicated to the study of Buddhist scriptures.

REFERENCES Groninger Museum (2018.0013); Butler and Canepa 2022, no. III.1.198 (near-identical dish)

PROVENANCE Heirloom & Howard Ltd, Wiltshire, 2015; Robert McPherson Antiques, London, 2015

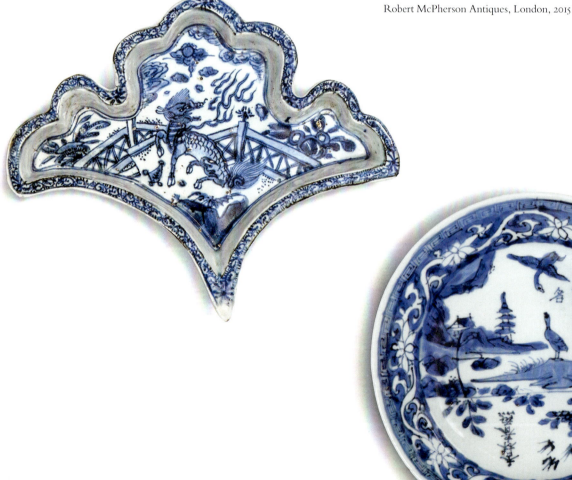

249.

TWELVE EARTHLY BRANCHES DISH

Chongzhen period (1628–44)
5 ⅞ in. (14.9 cm) diameter

In the center of this small, thickly potted dish is a small Chinese junk carrying three figures on a frothy sea. The junk is encircled by the characters for the Twelve Earthly Branches. An irregularly scalloped rim is edged in a patterned border. The reverse has an apocryphal Jiajing (1522–66) six-character mark. The ancient 'Earthly Branches and Heavenly Stems' ordering system could be used for astrology, astronomy, dating and time-keeping, but its navigational function is no doubt the most relevant to its use as decoration on trade ceramics.

REFERENCES Kaikodo LLC, Asia Week New York, 15–24 March 2018 (closely related dish)

PROVENANCE Heirloom & Howard Ltd, Wiltshire, 2021; Woolley & Wallis, Salisbury, 23 November 2021, lot 1047; the collection of G.R.A. Murray and thence by descent (exhibited *Chinese Exhibition*, National Gallery of South Africa, Cape Town, 953, no. 203)

250.

PAIR OF SAKE BOTTLES

Kangxi period (1662–1722)
5 ¾ in. (14.6 cm) high

Of typical Japanese form, these bottles have ovoid bodies painted with an overall pattern of chrysanthemum vine between borders of crosshatch and swirl pattern; the flat tops are centered by short nozzles. Like most bottles made to hold the potent rice liquor, this pair is small in size. An unusual form for Chinese porcelain, sake bottles do not seem to have been a regular part of the Jingdezhen production.

REFERENCES Jörg 2003a, p. 79 (bamboo-form Japanese sake bottle)

PROVENANCE Heirloom & Howard Ltd, London

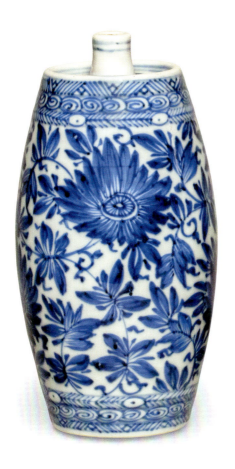
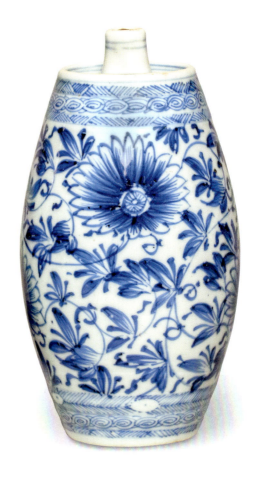

251.

TURTLE STRAINER

Jiaqing (1796–1820) to Daoguang (1821–50) period
8 ¼ in. (21 cm) wide

Reminiscent of the ginkgo leaf tray discussed above (no. 247) and with very similar pedestal feet, this strainer is shaped as a turtle, his four feet and his head all outstretched. The details of his shell, face and feet are picked out in tones of blue while each of his scales has a perforation. The sea turtle was a favored animal in Japanese art, symbolic of longevity.

REFERENCES Metropolitan Museum of Art (56.121.2) (Hokusai print of a sea turtle)

PROVENANCE Heirloom & Howard Ltd, London, 1987; Sotheby's London, 28 April 1987, lot 439

252.

SMALL TRAY WITH FISH

Jiaqing mark and period (1796–1820)
6 ⅛ in. (15.6 cm) wide

The galleried rim is decorated inside and out; the tray is supported on four short bracket feet. The top is painted with naturalistic fish swimming in opposite directions. Small trays were put to frequent use in Japan for the offering of small dishes of foods, often associated with the tea ceremony.

PROVENANCE Kevin's Fine Oriental Art, Hong Kong, 2015

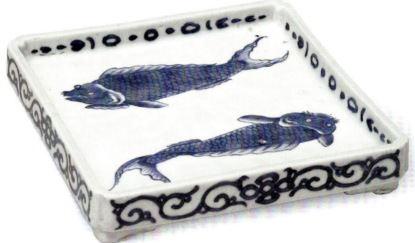

253.

BAMBOO-SIDED TRAY

Daoguang mark and period (1821–50)
8 ¾ in. (22.2 cm) wide

The straight sides and legs of this tray are in the form of blue bamboo while on the top a boatman takes two scholars by a waterfall cascading down cliffs growing pine trees. Above is painted *Chibi Ye Bo*, a verse by Ming-dynasty poet Luo Hongxian (1504–1564), though here the poem seems slightly garbled. Chibi, an ancient town in Hubei province, was known for its dramatic, craggy cliffs; Luo Hongxian wrote his poem to describe his sentiments on visiting Chibi, signing it "Dweller of the Bamboo Grove."

REFERENCES Sotheby's New York, 21 September 2021, lot 80 (Jiaqing mark and period landscape tray with poem from the collection of Bruce Dayton and Ruth Stricker Dayton)

PROVENANCE Heirloom & Howard Ltd, Wiltshire, 2014; Sworder's Auctioneers, Essex, 11 November 2014, lot 155

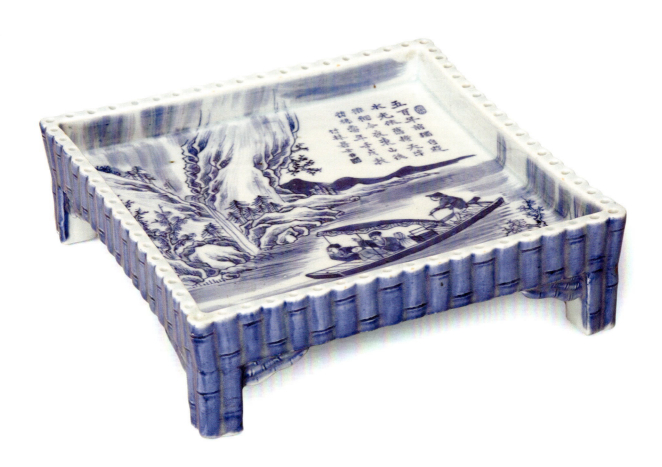

254.
FLOWER-SHAPED BOWL

Daoguang mark and period (1821–50)
5 ¾ in. (14.6 cm) diameter

A trading vessel is painted inside this small bowl, while a *ruyi*-head border decorates its flower-form rim. A small inscription on the inner rim can be translated as *May the tailwind see you off / [and] luck and wealth come promptly*. On the exterior is, more lyrically, *Oh moon-viewing companion, where art thou? / The moon shines bright as last year [yet thou art gone]*. These three elements taken together suggest the concerns of a merchant who must sail abroad for his fortune but misses his beloved back home. A four-character Daoguang mark can be found on the base.

REFERENCES Curtis 2006, cover and pp. 47–48 (compare the depiction of a sailing vessel)

PROVENANCE R & G McPherson Antiques, London, 2011

255.
CHRYSANTHEMUM TEAPOT

Jiaqing (1796–1820) to Daoguang (1821–50) period
6 ¾ in. (17.1 cm) wide

This unusual teapot is molded as a chrysanthemum bloom, its cover a chrysanthemum head. It has a short spout and high arched handle, a form known as *uwade kyūsu* or top hand(le) teapot in Japan. The flanged shape of the pot is reminiscent of Japanese ironwork pots (*tetsubin*) used for the brewing of *sencha* tea (tea from processed whole leaves). The pot was collected by Dr. James Ward Hall, an American dentist resident in Shanghai from 1878 who, according to newspaper reports, was dentist to the Guangxu emperor. A published letter, dated Shanghai May 16, 1907, reads, "… introduced us yesterday to Dr. Ward Hall, an American dentist who has lived here for years; he is a collector of old Chinese things and I never saw or imagined anything so filled to overflowing … as his house."

REFERENCES Walters Art Gallery (49.891) (related Japanese stoneware pot); Bonhams New York, 10–20 January 2022, lot 90 (Japanese iron pot)

PROVENANCE Heirloom & Howard Ltd, Wiltshire, 2018; Myers Auction Gallery, St. Petersburg FL, 21 January 2018, lot 286; the collection of Dr. James Ward Hall (1849–1908) and thence by descent

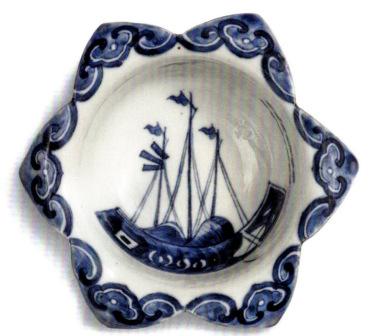

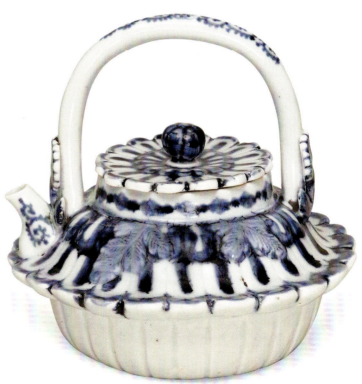

256.
LOW TABLE

Jiaqing (1796–1820) to Daoguang (1821–50) period
27 ½ in. (69.9 cm) wide

An ambitious form for the Jingdezhen potters, this table is painted on the top with what were known as the 'Five Birds of Li Fang'. Li Fang, a famous writer of the Song dynasty (960–1279), raised birds in his garden for the pleasure of his guests. As the Chinese inscription records, *Li Fang of the Song dynasty raised five birds: guest of leisure (silver pheasant), guest of snow (egret), guest of fairyland (crane), guest of the South (peacock), and guest of the West (parrot)*. The inscription goes on to explain that this rendering of Li Fang's birds is from a well-known ink-cake design: *Fang Yulu produced the ink and painted the design.*

The five birds of Li Fang also suggested the Five Ethics: good relations between father and son, husband and wife, elder and youth, friend and friend, ruler and official.

REFERENCES Christie's New York, 13 September 2019, lot 1124 (Jiaqing mark and period landscape tile for the tea ceremony)

PROVENANCE Philip S. Dubey Antiques, Baltimore; Hindman Auctions, Chicago

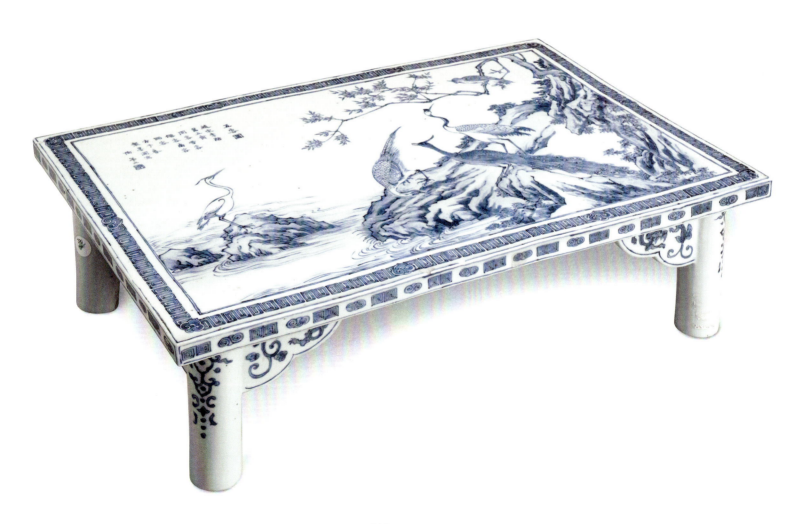

257.
LARGE SHELL DISH

Jiaqing (1796–1820) to Daoguang (1821–50) period
12 ⅝ in. (32.1 cm) wide

Another naturalistic form made in China to the conservative Japanese taste of the period, this large scallop shell dish is glazed a pale celadon green on its exterior. It is raised on three short ribbed feet. Inside is landscape in the style of seventeenth-century Chinese painting beneath a classic Chinese poem which may be translated as:

> My humble dwelling shuts out the autumn winds
> [which] enables me to dedicate my life in the mountains
> If I may leave any discernible trace in this world
> It would be for passing down Mi Nangong's legacy

PROVENANCE James Galley, Lederach PA, 1985

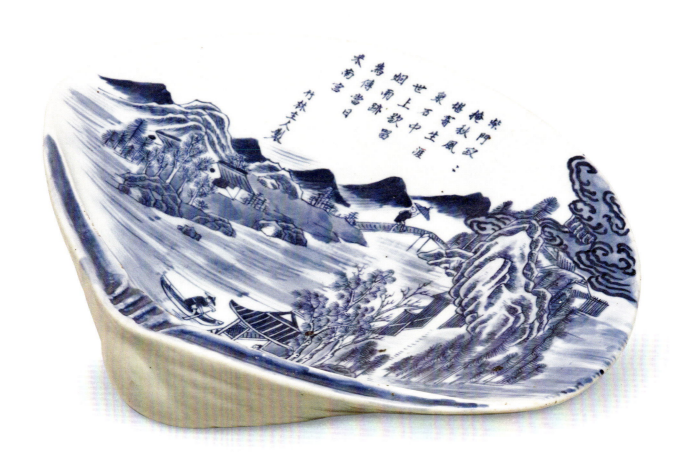

12.
MADE IN JAPAN

Anyone studying Chinese export art soon realizes that Japan is woven through its story like a contrapuntal melody. Japan was an important part of the earliest encounters between Westerners and Asians; its lustrous lacquer was one of the very first and most desirable export luxury goods. The Japanese market—and especially Japanese silver—were an integral part of the intra-Asian trading networks that Dutch, Portuguese and Spanish merchants developed. And once Japan began producing porcelain, its wares joined the stream of Chinese ceramics flowing to the West, swelling to their greatest importance in the seventeenth century during the decades of depressed output from Jingdezhen. Early in the eighteenth century, as Chinese porcelain reasserted its commercial dominance, Japanese export production began to dwindle. But during the long decades between the mid-eighteenth and mid-nineteenth centuries, when Japan was almost completely isolated from the outside world, an enduring Japanese fascination with the strange European foreigners they had encountered in the sixteenth and seventeenth centuries was reflected in their porcelain decoration, a phenomenon that was only enhanced when Western 'black ships' once again sailed into Japanese harbors beginning in 1853.

The Europeans who first came to Japan arrived from the south, via their outposts in places like Melaka (Malacca), Batavia (Jakarta), Manila or Macao, and in Japan they were known as *namban* (sometimes transliterated as *nanban*), or 'Southern Barbarians' (as were Southeast Asians).[1] The Dutch were also known as *komojin* (red-haired people), a feature of intrigue as apparent in numerous Japanese depictions.[2] Teresa Canepa quotes a 1639 Japanese text on the strange new foreigners: "From this [Southern Barbarian] ship … emerged an unnameable creature …. The length of his nose was the first thing that attracted attention: it was like a conch shell. His eyes were as large as spectacles and their insides were yellow."[3]

Portuguese merchants were the first of these Westerners in Japan, arriving in the early 1540s in a Chinese junk.[4] They were soon followed by Jesuit co-founder Francis Xavier, whose visit initiated what C.R. Boxer termed the 'Christian Century' in Japan (1549–1640).[5] The Portuguese, taking advantage of the Ming prohibition of Chinese–Japanese direct commerce, established themselves as intermediaries in the quite lucrative trade of Japanese silver for Chinese silks, while Portuguese missionaries established churches, schools and academies.[6] Japanese lacquer pieces with Christian forms or subjects—the intriguing gilt-ground 'black ship' screens, the European baroque-style paintings produced by Japanese artists and the many Japanese wood and ivory carvings of foreigners—all attest to the huge influence the interactions of the Christian Century had on Japanese culture.

A decade after the Portuguese had arrived in Japan, the Spanish established themselves in the Philippines and began their own Japanese trade. A Spanish ship reached Japan in 1584, and soon Japanese ships were bringing goods to Manila.[7] Spanish–Japanese relations peaked with the extraordinary 1613–20 Keicho embassy to Rome and Madrid, which set out just as the English established a foothold at Hirado—where they lasted only until 1623, never having secured good relations or profits.[8]

The renowned shogun Tokugawa Ieyasu united Japan in 1603 and soon became increasingly concerned

Japanese School, *Two European Soldiers*, ink and colors on paper, 19th century, Frelinghuysen collection

with the proselytizing zeal of the Counter-Reformation Catholic missionaries in Japan, who had converted more than 200,000 Japanese to Christianity.[9] A series of anti-Christian campaigns and proscriptions eventually led to the total rejection of the Spanish in 1624 and the expulsion of the Portuguese in 1639.[10] Dutch influence played into this decision; before finalizing it, the shogun sought VOC (Dutch East India Company) assurances that they would make up for the Portuguese trade.[11] So by 1640 the Protestant Dutch were the last Europeans standing in Japan, a situation that was to endure for more than two centuries.

The Dutch were forced from their outpost in Hirado and restricted to the man-made, fan-shaped, two-acre island of Dejima (sometimes transliterated as Deshima) in Nagasaki Bay, where they were allowed only a small settlement for living and trading.[12] Their isolation no doubt only increased the allure they held for the Japanese public, who are depicted in prints, paintings and even lacquer thronging the street outside the short Dejima causeway or lining the roads the Dutch took on their required annual pilgrimage to Edo.[13] Chinese traders were confined to a larger island in Nagasaki harbor, and numbered more than 2,500 at a time.[14]

The Japanese were not yet making high-fired porcelain in the sixteenth century, the period of their earliest European trading. Japanese porcelain kilns developed slightly later, near the western coast of Japan's southernmost large island, Kyushu, around the town of Arita. Conditions there were very similar to those of Jingdezhen, almost a thousand miles away across the China Sea: a geological history that produced the necessary clays, wood available to power the kilns, nearby waterways for transporting the finished porcelains and skilled potters.[15] In Japan, the first of these porcelain-experienced potters were probably Koreans, who arrived early in the seventeenth century.[16] For the previous century or so, the Kyushu kilns had been producing purposely imperfect ceramics made to the *wabi* aesthetic of the highly fashionable tea ceremony, but beginning around 1610 a growing number turned to porcelain production.[17] Eventually, about a dozen kilns in the Arita area made export porcelain, far fewer than in Jingdezhen.[18]

Japanese porcelain styles were initially inspired by their Korean neighbors', but by the 1630s and '40s Chinese styles predominated,[19] no doubt inspired by the masses of Chinese *ko-sometsuke* (old blue and white),[20] *kraak* and Zhangzhou (Swatow) wares then being imported to Japan by both Chinese and Dutch traders.[21] And just as the Arita kilns were beginning to prosper, political turmoil in China gave them an enormous commercial opportunity. Jingdezhen was affected first by the declining wealth and power of the Ming Imperial court, which closed the Imperial kilns in 1608, and then by actual warfare, which reached Jiangxi province in the later 1640s. In the 1670s, early in the reign of the Kangxi emperor, the Revolt of the Three Feudatories even included battles in Jingdezhen.[22]

Meanwhile, demand for Asian porcelain was growing. From its warehouses in Batavia, the Dutch were supplying markets in Southeast Asia, India and Iran (Persia) as well as in the Dutch Republic.[23] Official VOC orders of Japanese porcelain began in 1650 and eventually totaled several hundred thousand pieces, as documented by T. Volker and others, and Oliver Impey shows us convincingly that this volume was greatly supplemented by Japanese porcelain carried in the Dutch unofficial, or private, trade, from its beginnings well into the eighteenth century.[24] Chinese junk traders were also distributing Japanese porcelain. They sailed the Nagasaki to Batavia route for decades,[25] carrying as many as eighty thousand pieces to Batavia in a single year.[26] Chinese traders also sold to the Spanish in Manila (especially during the decades of the Dutch–Spanish war),[27] as well as to the English in Xiamen (Amoy).[28]

As the Dutch turned increasingly to Japan for their official orders of porcelain, their influence on it grew— and the industry in Arita grew to supply the foreigners.

Attributed to Kawahara Keiga, *The First Dutch Ship to Arrive at Nagasaki in 1818*, handscroll fragment: ink and color on silk, c. 1820–30, British Museum, London

By 1659 Dutch demand was so large that the VOC order took two years to fill and required a reorganization of the kilns.[29] The first Dutch special orders were for useful shapes: bottles (sometimes called gallipots) for wine or herbal medicines, jugs and ewers, mugs, cruet jugs, mustard pots, salts and inkpots and sanders.

Increasingly, decoration became tailored to Dutch taste, too. Not just the Chinese *kraak* and Transitional styles that the Japanese had been producing, but initials, inscriptions and coats of arms began to be requested, most of these personalized orders made for Dutch officials in Batavia who, on retirement, often returned to the Dutch Republic with their goods. Early in the eighteenth century, porcelain painted after Dutch engravings or in Delft styles also began to be commissioned. By this time, though, the Kangxi emperor (r. 1662–1722) had reorganized the Jingdezhen kilns and they were flourishing. Their larger scale and less costly production meant that the Chinese were soon once again the main trading partners for the Dutch (as well as for the other European trading nations). This was a blow to the Arita kilns, although until at least 1757 they continued to supply at least some wares to the Dutch, who were still selling Japanese porcelain on to the Middle East.[30]

The Arita kilns endured a slump from the 1740s until the 1770s, when they found their footing again, but largely as suppliers of porcelain to a domestic market.[31] This was a time when the Japanese, after more than a century of isolation, were more intrigued than ever with foreigners and hungry for knowledge of outside cultures. In 1720 the shogun had allowed the import of European books, and *rangaku* (foreign learning) became an intellectual fashion.[32] Woodblock prints depicting the exotic Dutch of Dejima Island (and Chinese, too) became popular; they were known as Nagasaki *miyage* (souvenirs of Nagasaki).[33] Figures of Dutchmen in their curious hats and breeches and also, of course, their huge ships were recurring subjects in the Nagasaki prints, which thrived from the mid-eighteenth to the mid-nineteenth century. And these same subjects appeared on Japanese porcelain of this period, the ships largely depicted as they had appeared around 1700 and the foreigners as mid-eighteenth-century Dutchmen. Not just figures of curiosity, the foreigners and the trade they signified meant prosperity and good fortune.[34]

After 1853, when the United States, through Admiral Perry, forced Japan to reopen foreign trade, Western 'black ships' (*kurofune*) once again sailed into Japanese

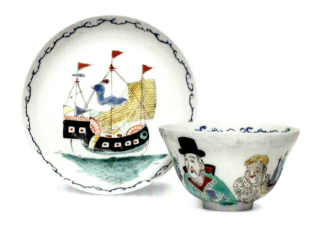

Japanese teabowl and saucer with Dutchman and ship, porcelain, first half 19th century, Frelinghuysen collection

harbors. Prints of foreigners and their ships (with a certain conflation of the nineteenth century with earlier types) proliferated, now published largely in Yokohama, where a large foreign community had settled, and known as *Yokohama-e*. Works of art from *netsuke* and *inro* to paper screens were decorated with Westerners. As the Meiji took over, Japanese modernization and global connections only increased, and the earlier *rangaku* tradition grew to include a fascination with Western scientific and technological advances. The first Japanese railway opened in 1872 and this, too, became a subject of prints as well as of porcelain decoration (no. 298),[35] along with paddle steamers and even dental surgery.[36]

The Frelinghuysen collection encompasses three centuries of Japanese blue and white porcelain as well as a representative group of related Japanese woodblock prints, largely *Yokohama-e* but also some earlier, rare examples. The porcelain is a comprehensive selection of Japanese wares, including *kraak*-style pieces (nos. 264–265, 271, 275 and 491), early examples of European shapes (nos. 261, 263–264, 267–269, 272, 284 and 489), armorial wares (nos. 272–276 and 506), pieces decorated after European prints (nos. 277–279) or Delft (nos. 271 and 283) and a wonderful variety of bowls, dishes and bottles painted with caricature-like figures of Dutchmen and/or their 'black ships' (nos. 277, 279–280, 287, 290–296, 498–501 and 508). Exotic animals were among the gifts requested as tribute from the VOC, and several pieces depict the elephants or camels that the Dutch managed to deliver to Japan, where they too became figures of great curiosity to the isolated Japanese (nos. 287–289 and 293–294).[37]

1 Okamoto 1972, p. 9.
2 French 1977, p. 31.
3 Canepa 2016, p. 29.
4 Ibid.
5 The title he gave to his seminal work, Boxer 1951.
6 Okamoto 1972, pp. 25, 66.
7 Canepa 2016, p. 33.
8 Ibid., p. 44.
9 Okamoto 1972, p. 66.
10 Batts 2017, p. 7.
11 Ibid., p. 300.
12 Ayers, Impey and Mallet 1990, p. 17.
13 V&A n.d., paras. 12–13.
14 Impey 2002, p. 20.
15 Mowry 2021.
16 Lerner 1976, p. 5.
17 Ford and Impey 1989, pp. 53, 61.
18 Impey 2002, p. 17.
19 Ford and Impey 1989, p. 62.
20 Impey 2002, p. 13.
21 Strober 2013, pp. 196–97.
22 Lam 2016, p. 13.
23 Lerner 1976, p. 9.
24 Impey 2002, p. 14.
25 Cheng 2018, p. 293.
26 Ayers, Impey and Mallet 1990, p. 20.
27 Espinosa and Takenori 2020, p. 51.
28 Impey 2002, p. 16.
29 Ayers, Impey and Mallet 1990, p. 19.
30 Impey 2002, p. 20.
31 Ayers, Impey and Mallet 1990, p. 24.
32 V&A n.d., para. 12.
33 French 1977, p. 31.
34 Shirahara 2007, pp. 153–56.
35 Cortazzi 2005, pp. 74–75.
36 French 1977, p. 46.
37 Jörg 1993, p. 3.

258.

LARGE JAPANESE BOTTLE VASE

Edo period, last quarter 17th century
14 ¾ in. (37.5 cm) high

This vase, a larger and more robust version of the vase in the following entry, is decorated overall with a characteristic Japanese pattern of scrolling vine known as *tako karakusa*—literally, 'octopus arabesque'. The pattern probably came from ancient Egypt via the Middle East, making its way along the Silk Road to Japan by the seventh century, where it was adopted and adapted, especially for textiles.

REFERENCES Bufton 1984, p. 71 (very similar vase); Fuchigami 2001, p. 37 (*karakusa* pattern); Jörg 2003a, p. 218 (related vase with variant overall pattern)

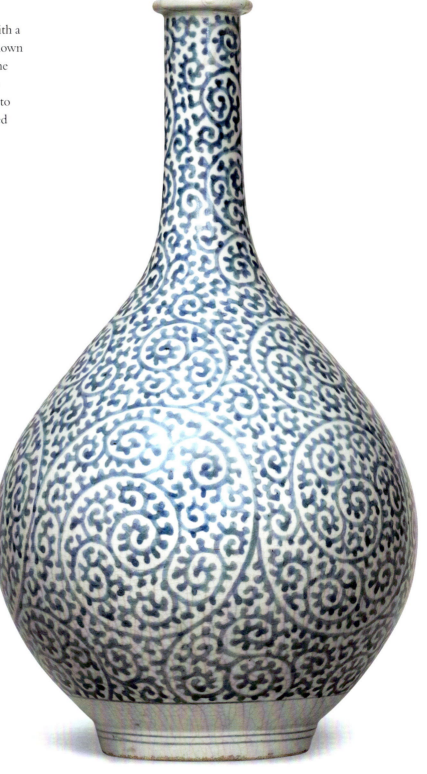

259.

JAPANESE BOTTLE VASE

Edo period, c. 1650–75
Three-character maker's mark on the base
9 ½ in. (24.1 cm) high

The pear-shaped body has horizontal rows of foliate scroll, while two leafy tendrils extend up the slender neck. Three large vertical characters on the base can be read as *Made by Bashō*. This attenuated form is particularly characteristic of Japanese vases of the later seventeenth century, though they more often feature panels of floral decoration. Christiaan Jörg illustrates an ovoid jar of very similar pattern.

REFERENCES Jörg 2003a, p. 26 (jar); Impey 2002, pp. 102–03 (bottle vases)

PROVENANCE Michael & Claire Higgins Antiques, Atlanta

260.

JAPANESE JAR WITH BIRD

Edo period, late 17th century
11 in. (27.9 cm) high

A large paradise flycatcher is perched on a gnarled branch on the front of this ovoid jar, his three long tailfeathers reaching up to the short neck, which is edged in a gadroon pattern. Another is on the back, with blossoming magnolia and chrysanthemum alongside. A small group of jars of this form with similar decoration is known; one is in the Saint Louis Art Museum, published by Richard S. Cleveland and John A. Pope.

REFERENCES Cleveland and Pope 1970, p. 35 (very similar jar); Tilley 1984, cover (very similar jar)

PROVENANCE Stallion Hill Gallery, Stamford CT

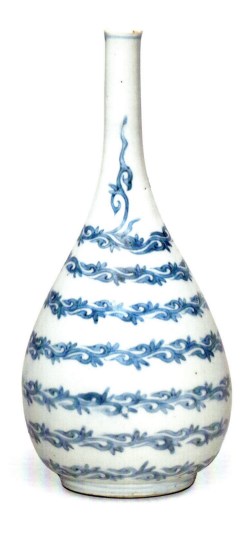
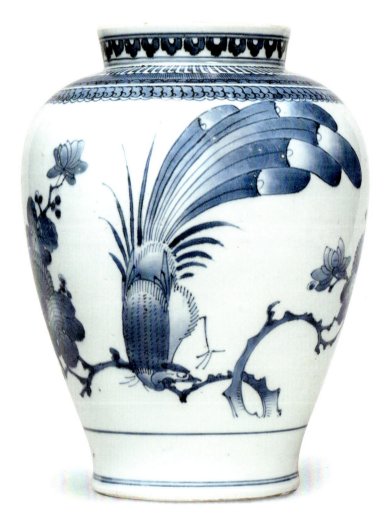

261.

SILVER-MOUNTED JAPANESE JUG

Edo period, c. 1660–80
9 ⅛ in. (23.2 cm) high

Modeled after European stoneware and mounted with chased Dutch silver, this jug was inspired both in form and decoration by Chinese models of the Transitional period (1621–61). It is painted with a continuous scene showing Asian figures walking in a garden, one carrying a vase and another with a pole; tulip motifs decorate the neck. An example of the Chinese prototype with period enameled gold mounts is in the Zilkha collection; Oliver Impey published a very similar Japanese jug along with an incomplete and broken example excavated at the Chokichidani kiln site.

REFERENCES Corrigan, Van Campen and Diercks 2015, pp. 146–48 (Chinese example); Impey 2002, p. 49 (very similar jug and shard); Jörg 2003a, p. 159 (similar jug)

PROVENANCE EastWest Gallery, Dorset, 2012

262.

PAIR OF JAPANESE JARS

Edo period, c. 1660–80
6 ⅞ in. (17.5 cm) high

Each of these ovoid jars is painted in washy cobalt blue with a scholar seated in landscape, a servant bringing dishes of food on a tray and trees growing from rock formations around them. The short necks have a chain border. A very similar jar, formerly in the collection of Gerald Reitlinger, is at the Ashmolean Museum in Oxford.

REFERENCES British Museum (1955.0427.1); Ashmolean Museum (1978.701) (very similar jar)

PROVENANCE EastWest Gallery, Dorset, 2015

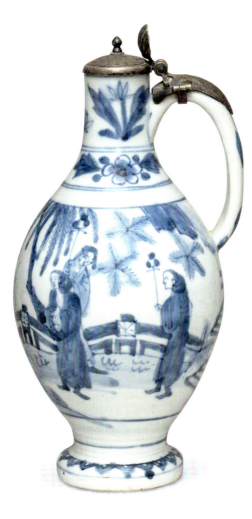
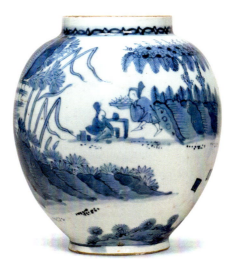
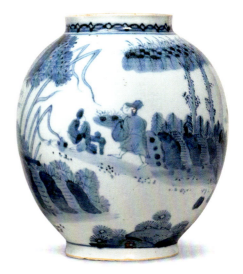

263.
JAPANESE INITIALED BOTTLE

Edo period, c. 1670–1700
7 ⅝ in. (19.4 cm) high

On the front of this bottle, the initial *B* is enclosed by a ribbon-tied laurel wreath. The sides are plain; the neck is ridged to take a leather-tied waxed cloth cover. An intriguing group of these bottles is known, some with floral decoration on the sides, a very few with two initials and one with initial and surname. Christiaan Jörg believes that they were private orders painted with their patron's initials, though he notes that in some cases the initial(s) could indicate contents, as on an apothecary bottle. He references two bottles in Dutch museum collections of identical pattern, with the same tasseled laurel wreath, but initialed *N.A.* Very interestingly, an early eighteenth-century Japanese porcelain saucer depicts two Japanese men picnicking with a bottle initialed *FW* at their side—possibly a gift or perhaps collected as a curiosity.

REFERENCES Jörg 2003a, pp. 221–22 (named bottle and N.A. bottles); Impey 2002, pp. 104–05 (initialed bottles); Fuchs 2017, p. 17 (Japanese saucer with initialed bottle)

PROVENANCE The collection of David S. Howard, Wiltshire, 1990

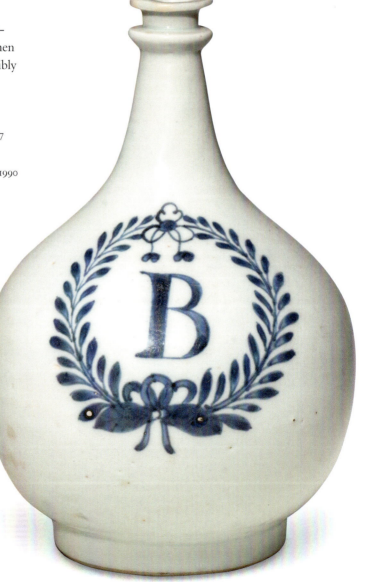

264.

PAIR OF JAPANESE JUGS IN KRAAK STYLE

Edo period, c. 1660–80
11 in. (27.9 cm) high

These large jugs are decorated in the style of Chinese *kraak* porcelain, bracketed panels of landscape around their sides and tulip motifs on their cup mouths, which are shaped with a pinched spout. This form, like the jug above (no. 261), derives from European stoneware; the jugs thus reflect a mixture of Chinese and European influence in Japanese ceramics.

REFERENCES Jörg 2003a, p. 159; Impey 2002, p. 54 (jugs of this form)

PROVENANCE EastWest Gallery, Dorset, 2021

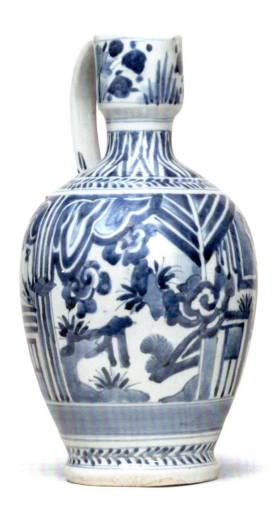
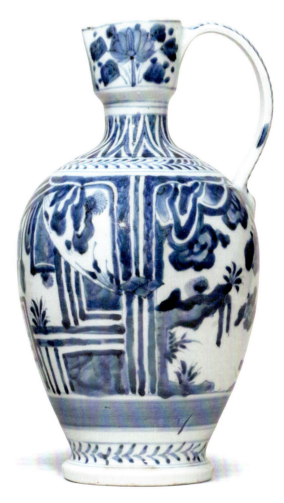

265.
JAPANESE DISH IN KRAAK STYLE

Edo period, c. 1670–90
12 in. (30.5 cm) diameter

The *kraak*-style wares made in Japan for Dutch traders featured the same set of central scenes as their Chinese prototypes: geese on riverbanks, crickets, potted plants and so forth. Here a man is fishing from a simple wooden bridge, two small animals beside him. The rim panels include figures of boys who appear to be foreigners. This pattern was made in some numbers and in various sizes; Christiaan Jörg published a version with slightly larger animals that appear to be cows.

REFERENCES Jörg 2003a, p. 28 (related dish)

PROVENANCE Rago Auctions, Lambertville NJ

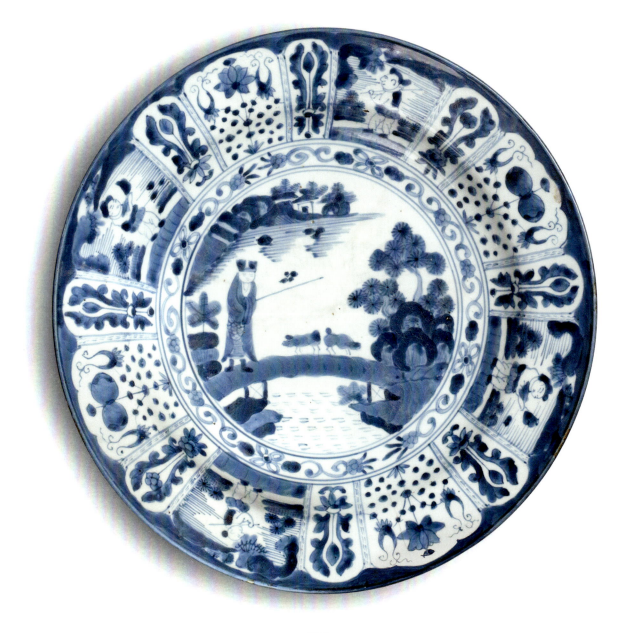

266.

SMALL JAPANESE FLASK

Edo period, c. 1670–90
5 ⅝ in. (14.3 cm) high

Modeled after European glass, bottles or flasks of this form were made in some number for Dutch traders, some this half-size and some tall. Meant to hold costly oils like that of nutmeg, cinnamon and clove, they formed sets of six or nine which would fit neatly into velvet-lined wooden cases, the sets known as *keldertje* (box with bottles). The pleasing pattern on this flask, known in both half and full size, shows alternating scenes on its sides: two Japanese ladies in landscape, a Japanese farmer carrying water buckets on a riverbank, flowering plants and a flower-filled porcelain jar (see detail, p. 312).

REFERENCES Corrigan, Van Campen and Diercks 2015, pp. 112–13 (Rijksmuseum complete set in fitted Indonesian calamander box); Jörg 2003a, p. 174 (very similar flask); Impey 2002, p. 99 (larger-scale version)

PROVENANCE Kee Il Choi, Jr., New York, 1987

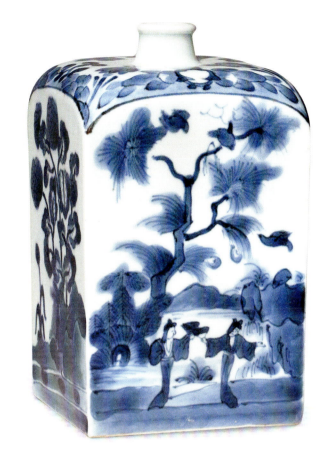

267.

TWO JAPANESE DESK ARTICLES

Edo period, c. 1680–1700
3 15/ and 3 13/ in. (10 and 9.7 cm) wide

This sand brick or sander and matching inkwell are decorated with peony blooms growing from slender curling stems. The inkwell would have been made with a simple cover and used with a glass or pewter insert to hold the ink; quill pens stood in its four holes, and fine sand to help dry the ink would be sprinkled from the sander. Christiaan Jörg published a near-identical brick and wrote that these sets were a true luxury item. *Intkokers* or *inctkookers* were among the earliest orders of the VOC (Dutch East India Company) from Japan.

REFERENCES Jörg 2003a, pp. 188–89 (near-identical sand brick)

PROVENANCE Robert McPherson Antiques, Friesland, 2019

268.

ORMOLU-MOUNTED JAPANESE COFFEE POT

Edo period, c. 1680–1700
12 ½ in. (31.8 cm) high (the porcelain)

A good-sized group of coffee pots of this form and pattern is known, all well painted with an exotic bird perched on rocks growing with lush peony. The porcelain form, derived directly from Dutch metalwork, was made with a hole in front for a spigot and a hole at the top of the handle to take a mount that would attach to the two small porcelain loops on its cover. The elegant ormolu mounts on this example demonstrate the regard in which these pots were held in Europe. A Sri Lankan (Ceylonese) engraved copper example dated to circa 1700 shows the same slender legs with animal paw feet as the ormolu here.

REFERENCES Metropolitan Museum of Art (79.2.176a, b) (similar pot); Jörg 2003a, p. 204 (similar pot and copper pot in Groninger Museum collection)

PROVENANCE Hindman Auctions, Chicago, May 2019, lot 12; Bluett & Sons, London (per label)

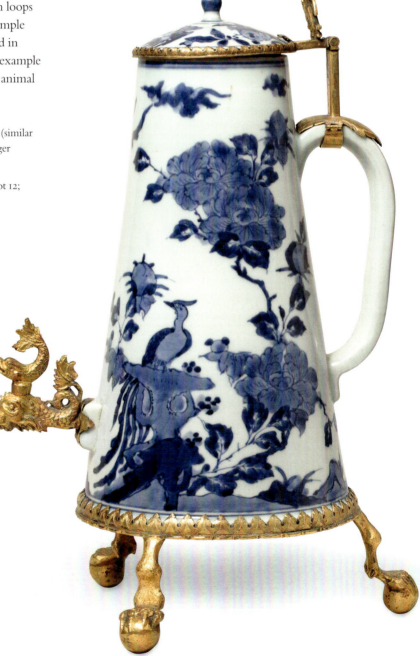

269.
JAPANESE MUG

Edo period, c. 1680–1700
7 ⅛ in. (18.1 cm) high

Beer mugs of this form and pattern are well known; they were made in several sizes. In the front panel a couple strolls in landscape, the man holding a parasol over them and their dog running ahead; waterbirds in landscape decorate the sides, and all is on a ground of scrolling vine. Christiaan Jörg reports that this form was made without a cover, noting that many would be mounted on arrival in the Netherlands.

REFERENCES Jörg 2003a, p. 169 (very similar mug); Ford and Impey 1989, p. 72 (very similar mug)

PROVENANCE Philip S. Dubey Antiques, Baltimore, 2015; Antiques & Art by Imeon, Houston

270.
JAPANESE DISH IN KRAAK STYLE

Edo period, late 17th–early 18th century
11 ½ in. (29.2 cm) diameter

This dish displays an interesting mix of Dutch and Japanese aesthetics. Its paneled border, the panels containing flowering plants and separated by vertical motifs, is very much in the style of the seventeenth-century *kraak* ware imported by the VOC (Dutch East India Company). But the spare, asymmetrical decoration in the center—a square vase sitting on rocks under a willow tree—is quite Japanese. Its brown-washed, barbed and lobed rim echoes the dish in the previous entry.

REFERENCES Jörg 2003a, p. 150 (related dish); Impey 2002, p. 117 (related dish)

PROVENANCE James Galley, Lederach PA

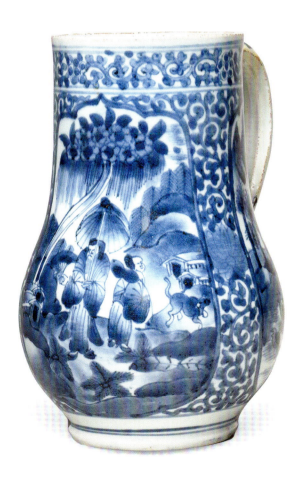

271.

TWO JAPANESE SCHEVENINGEN DISHES

Edo period, c. 1700–50
7 ⅜ and 8 in. (18.7 and 20.3 cm) diameter

These dishes are part of a broad group depicting European rural landscape and known as 'Scheveningen' after a Dutch fishing village on the coast near The Hague. The name was used as early as 1778 when it is found in an Amsterdam sale catalogue, notes Christiaan Jörg. Some of the scenes are after Frederik van Frijtom (1632–1702), a landscape artist and Delft pottery painter, and the group is also called 'Frijtom'. The left-hand dish has a *fuku* mark on its base.

REFERENCES Jörg 2003a, pp. 240–43 (dishes in each pattern and related examples)

PROVENANCE Heirloom & Howard Ltd, London, 1981; Sotheby's London, March 1981 (left). Heirloom & Howard Ltd, London, 1981 (right)

272.

JAPANESE ARMORIAL JUG

Edo period, c. 1675–1700
8 ⅞ in. (22.5 cm) high

Like the silver-mounted jug discussed above (no. 261), this example is modeled after German stoneware and displays elements of Chinese Transitional-style decoration. But here there is a European coat of arms in a shaped panel in front. Jugs of this form were made in Japan with the arms of several Dutch families—Valckenier, Geelvinck, Outshoorn—while another in the Victoria and Albert Museum, like this one, has unidentified arms that are probably Dutch. All of these examples are fairly plain aside from the coat of arms; here we have flowering plants and symbols along the sides as well as decorative borders.

REFERENCES Reeves Museum of Ceramics (2012.12.1) (Geelvinck); Cleveland Museum of Art (1970.46) (Geelvinck and Valckenier); Victoria and Albert Museum (C.65-1963) (unidentified)

PROVENANCE Galerie Bertrand de Lavergne, Paris

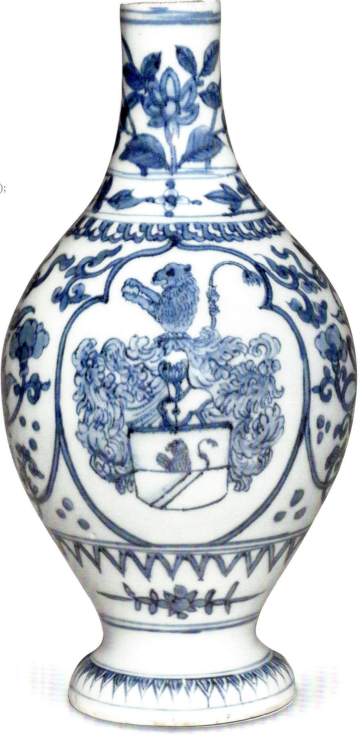

273.
VERY LARGE JAPANESE DISH WITH BLANK SHIELD

Edo period, c. 1675–1700
21 ⅝ in (55 cm) diameter

In the center of this very large dish is a blank armorial shield beneath a helmet and coronet and within baroque foliate mantling. A wide border around the rim features birds within scrolling foliate vine and four large roundels of flowering plants. Beneath the left- and right-hand roundels, small putto-like figures grasp the vine in a common Kangxi period motif. A small group of dishes of this same size and pattern is known, several blue and white and several decorated in enamel colors and gilt. The colored examples employ enamels for the basic elements of the design rather than simply adding color to a cobalt blue framework. A similar pattern was in use for large dishes; Christiaan Jörg illustrates a dish in the Keramiekmuseum Princessehof with closely related border but a vase of flowers in the center. It seems that an enterprising Dutch trader had a Japanese kiln make these dishes, intending to have arms added to order in the Dutch Republic. With their scale and unique design, the dishes must have been quite costly; it is curious that so few—and apparently none in blue and white—ended up with armorial decoration.

REFERENCES Rijksmuseum (AK-RBK-1972-232) (near-identical dish); Jörg 2003a, p. 138 (dish in related pattern) and pp. 231–32 (Rijksmuseum dish); Christie's Amsterdam, November 2002, lot 71 (near identical dish); Metropolitan Museum of Art (2002.447.79) (in colors with Dutch arms); Brooklyn Museum (2004.28.248) (in colors with French arms; possibly Samson); Ayers, Impey and Mallet 1990, p. 220 (in colors with blank shield)

PROVENANCE Heirloom & Howard Ltd, Wiltshire, 2015; R & G McPherson Antiques, London

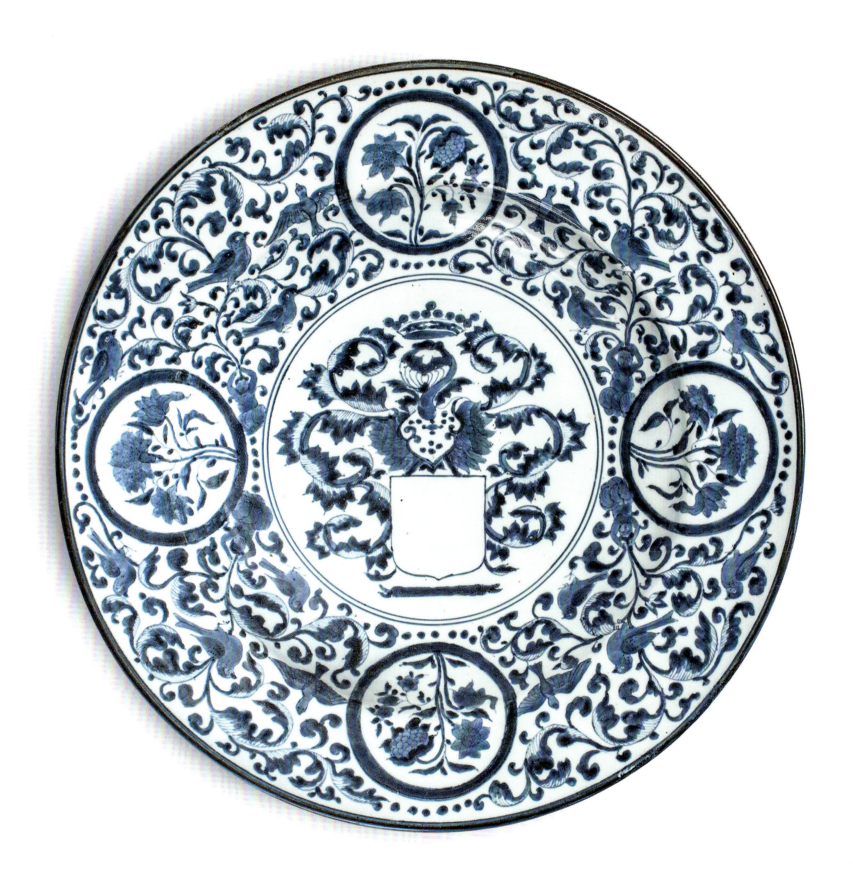

274.

JAPANESE DISH WITH ARMS OF VAN DER MEIJ

Edo period, c. 1710–30
8 ⅝ in. (21.9 cm) diameter

The arms of Van der Meij of Dordrecht are painted in the center against an arrangement of ginkgo leaves, while the scalloped rim is decorated with a wide border of flowering and fruiting stems. All is in white on a blue ground. The Van der Meij family also ordered a set of dishes with these arms in colored enamels against baroque gilt mantling and on a ground of edge to edge gilt flowering vine. As Christiaan Jörg notes, it was quite unusual to commission Japanese armorial porcelain at this time, when Chinese wares were more easily accessible and much more reasonably priced. There must have been a Van der Meij resident on Dejima Island at the time.

REFERENCES Metropolitan Museum of Art (2002.447.87) (colored enamel plate); Jörg 2003a, p. 236 (another)

PROVENANCE Christie's New York, 16 October 1990, lot 321

275.

JAPANESE ARMORIAL DISH WITH KRAAK-STYLE BORDERS

Edo period, late 18th century
8 ¾ in. (22 cm) diameter

This unusual dish belongs to a small group of varying sizes, all with the same coat of arms and rim decoration. The *kraak* style of the dish and the design of the shield, held by a winged angel, appear to be copied directly from a much earlier Chinese plate made for García Hurtado de Mendoza, 4th Marquis of Cañete, viceroy of Peru (1590–96), and his wife Teresa de Castro, daughter of Leonor de la Cueva y Girón. Here, the arms on the left (for the husband) are those of a branch of Castro impaling on the right (wife) the arms of Cueva; these both appear as 'quarterings' within the armorial bearings of Teresa de Castro on the Wanli period (1573–1620) plate. It would appear to have been made for a much later generation of Teresa's family, possibly for a marriage, in the style of the earlier Chinese service. However, it remains a mystery as to why it was ordered from Japan at this time, and by whom. —A.H.

REFERENCES Shirahara 2007, p. 146 (Kobe Art Museum example); Nantucket Historical Association (DBC 10498.1) (another); Reeves Ceramics Museum (2018.53.2.2) (pair); Canepa 2019, pp. 276–79 (Wanli dish in the Lurie collection)

PROVENANCE Heirloom & Howard Ltd, Wiltshire, 2022; R & G McPherson Antiques, London (per label)

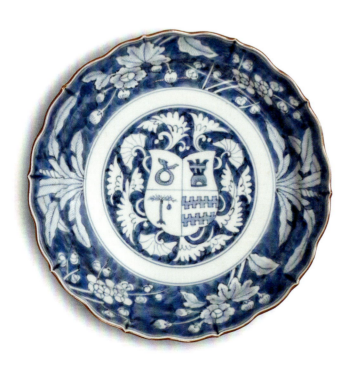
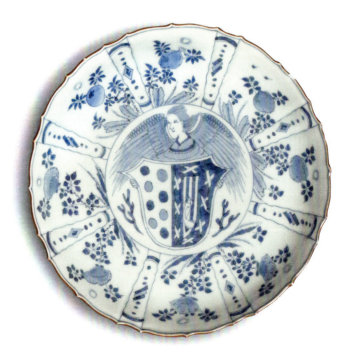

276.
JAPANESE ARMORIAL DISH

Edo period, c. 1750–1800
13 ½ in. (34.3 cm) diameter

In the center of this dish is a large coat of arms within a shaped cartouche with three bearded heads on a vertically hatched ground (indicating the color red in heraldry) and beneath a Dutch coronet. It is shown against asymmetrical mantling of ferns and flowers with a putto head at the bottom. The wide rim is decorated with three peony blooms growing from inky blue vine. A small number of dishes in different sizes in this pattern are in museums and have appeared on the art market; the arms have not been identified and may possibly be fictitious.

REFERENCES Groninger Museum (2019.0166) (another dish from the service)

PROVENANCE Heirloom & Howard Ltd, Wiltshire, 2011

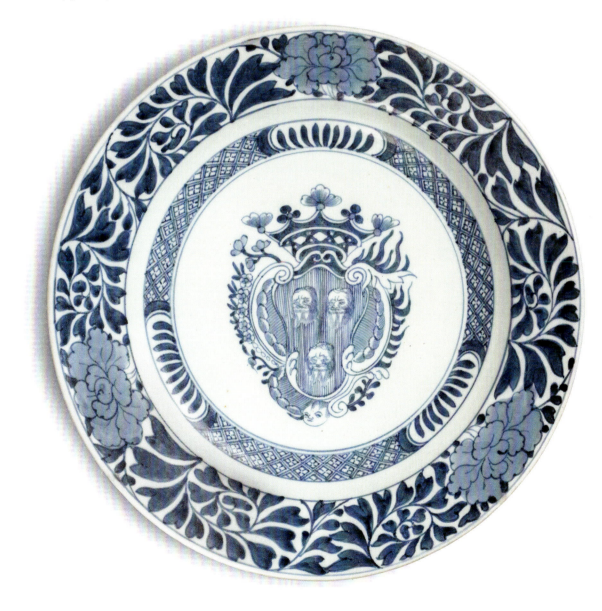

277.
TWO JAPANESE TEAPOTS AFTER EUROPEAN PRINTS

Edo period, early 18th century
5 ¾ and 4 ½ in. (14.6 and 11.4 cm) high

The first of these teapots is of melon form with lightly crackled glaze and painted with a continuous scene of rural European landscape with small figures of farmers working under tall trees; the second is octagonal and decorated with European sailing vessels on a calm sea. Both exhibit a level of detail and a style of painting that indicate as yet unidentified European engravings as their design sources. Easily transportable and reflecting popular subjects of the day, prints were a natural means of conveying desired designs to the Japanese potters. Each pot has an apocryphal six-character Chenghua reign mark on its base.

REFERENCES Jörg 2003a, p. 248 (shipping)

PROVENANCE Heirloom & Howard Ltd, Wiltshire, 2008; Christie's New York, 23 January 2008, lot 281; the collection of Doris and Leo Hodroff (left). Heirloom & Howard Ltd, Wiltshire, 2007; Christie's Amsterdam, 20–21 November 2007, lot 604; the collection of John A. Pope, no. 296 (per label) (right)

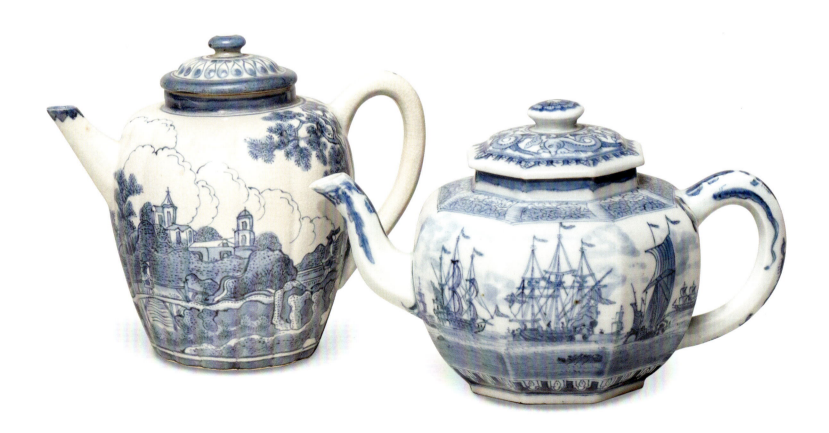

278.

TWO JAPANESE TEAPOTS AFTER OLFERT DAPPER

Edo period, early to mid-18th century
6 ½ and 6 ⅝ in. (16.5 and 16.8 cm) high

On each side of these large, rounded octagonal pots is a large chinoiserie scene. In between are white lotus sprays reserved on a blue ground. The scenes are copied almost exactly from views of China published by Olfert Dapper (c. 1635–1690) in Amsterdam in 1670 in a work entitled *Gedenkwaerdig bedryf der Nederlandsche Oost-Indische maetschappye*, which described notable sights observed on two Dutch embassies to China. The following year a translation by John Ogilby was published in London by Arnoldus Montanus under the title *Atlas Chinensis*. One view on each pot is of a temple atop an arched rock bridge that lay between villages the Europeans called Gotanga and Quotinha; on the other side is the ambassadors' welcome to Beijing, a tall pagoda visible inside the city walls. As Ronald W. Fuchs II observes, the pots embody three cultures: Japanese ceramics, Chinese sights and Dutch engraving.

REFERENCES Jörg 2003a, pp. 250–51 (teapot and prints); Fuchs 2005, pp. 110–111 (teapot and print details)

PROVENANCE Heirloom & Howard Ltd, London, 1987; Sotheby's London, 17–18 June 1987, lot 645; the collection of the Rt. Hon. Lord Home of the Hirsel and the Douglas-Angus Estates

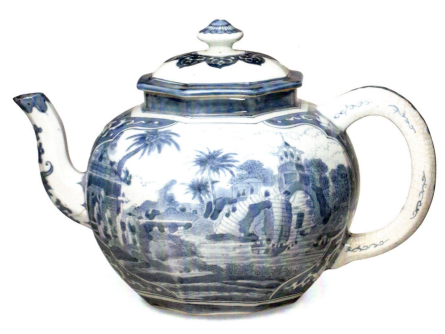

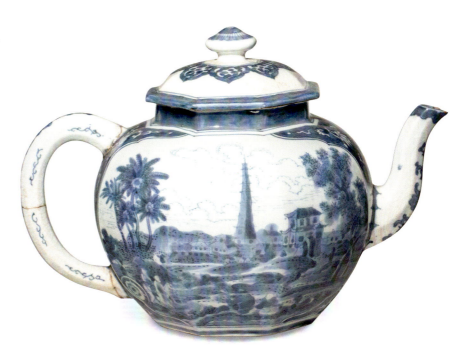

279.
JAPANESE BOWL WITH EUROPEAN SHIPS

Edo period, early 18th century
9 ¾ in. (24.8 cm) diameter

The octagonal sides of this bowl are decorated with a continuous scene of European ships in a harbor, city walls behind them and small Asian vessels nearby. The interior rim is painted with an unusual dentil border with oak leaves at the corners; a shipping vignette in the center echoes this border, while further oak leaves encircle the foot. A small group of these bowls is known; the composition of their motifs suggests that someone gave careful thought to their order, perhaps providing not just a print for the shipping scene but an overall design.

REFERENCES Castile 1986, pp. 176–77 (Burghley example); Jörg 2003a, p. 249 (Groninger example)

PROVENANCE Heirloom & Howard Ltd, London, 1984

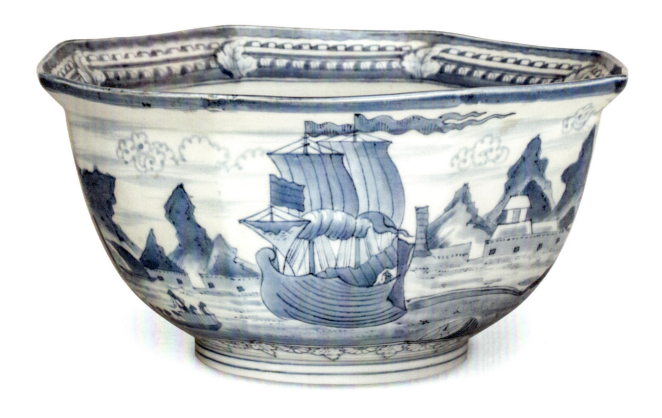

280.

TWO JAPANESE DISHES WITH SHIPS

Edo period, c. 1700 (left) and c. 1820 (right)
6 in. (15.2 cm) wide; 5 ½ in. (14 cm) diameter

On the left-hand dish a battle rages between two European ships, a longboat of sailors in the foreground and further ships in the distance. It is part of a small group in this pattern, one in the Groninger Museum and one in the collection at Burghley House. The thickly potted right-hand dish is well painted, with an Asian sailing vessel. Frothy waves decorate its straight-sided exterior.

REFERENCES Jörg 2003a, p. 247 (Groninger example); Castile 1986, pp. 174–75 (Burghley example)

PROVENANCE Heirloom & Howard Ltd, Wiltshire, 2021; Ewbank's Auctions, Surrey, 11 November 2021, lot 1051 (left). EastWest Gallery, Dorset, 2013 (right)

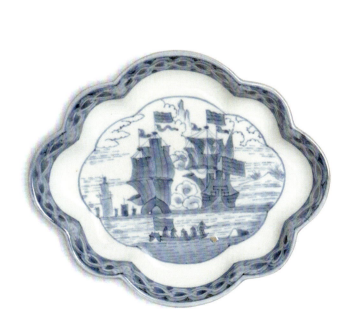
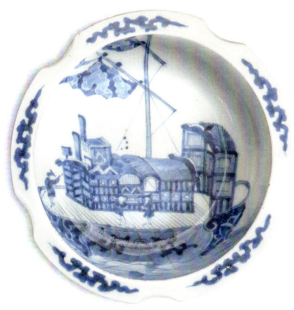

281.
JAPANESE TEA PRODUCTION PLATE

Edo period, mid-18th century
8 ½ in. (21.6 cm) diameter

This plate is an exact copy of a plate in the well-known Chinese tea production series discussed in no. 224, with the same *rocaille* borders inspired by Rouen faience. Numbered *16.* in underglaze blue on the back, it shows the same scene as the Chinese prototype (which is also numbered *16*): merchants in a shop overlooking a sampan being loaded with baskets of tea. A small number of Japanese plates are known with differing scenes from the Chinese series; the most likely explanation is that they were ordered as replacements, though it is also possible that a Dutch merchant had seen the Chinese service and simply wanted his own set.

REFERENCES Jörg 2003a, p. 254 (Japanese tea production plate with variant scene)

PROVENANCE Heirloom & Howard Ltd, Wiltshire, 1994; Christie's Amsterdam, October 1994, lot 432

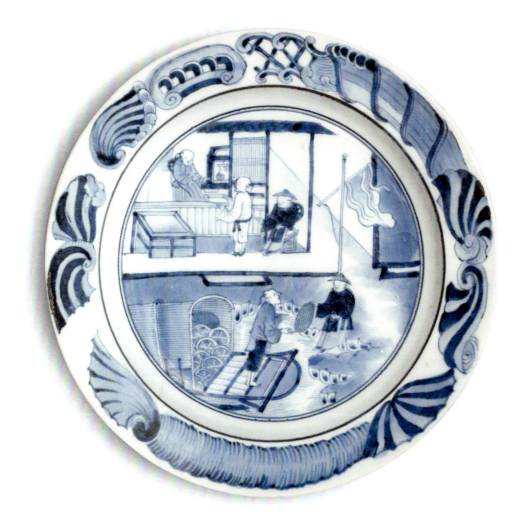

282.

JAPANESE DINNER SERVICE

Edo period, mid-18th century
8 ⅝ in. (21.9 cm) diameter (the plates)

This apparently unique Japanese dinner service shares a *rocaille* border with the tea production series discussed in the previous entry. Its scene bears some relation to the composition in the tea plate opposite but it has become much more Japanese. A Japanese-style sign hangs outside the open-air shop where a Japanese merchant seated before a bamboo screen holds a toy for a small boy. On the shore below, a Japanese worker lifts a barrel while his co-worker throws his arms up in his sampan, perhaps trying to balance himself. Each piece is numbered 2. in underglaze blue on its back (which does not comport with the Chinese tea production series); details are picked out in overglaze iron-red and gilt. Very few dinner services were made for export at the Arita kilns; Ayers, Impey and Mallet illustrate a sauceboat from another, noting their rarity. (Additional plates not shown.)

REFERENCES Jörg 2003a, p. 254 (dish from this service); Groninger Museum (1963-201) (same dish); Jörg 2003a, p. 179 (tureen of this form); Ayers, Impey and Mallet 1990, p. 226 (Japanese sauceboat)

PROVENANCE Sotheby's London, September 2002, lot 1

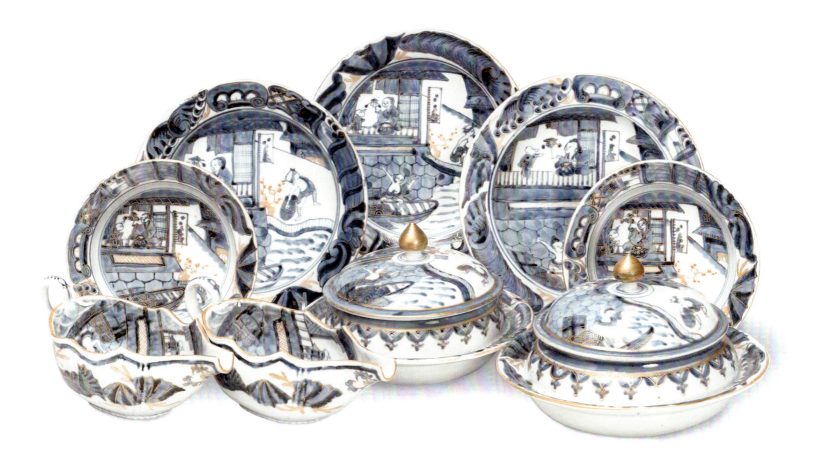

283.

JAPANESE STRAINER AND A PAIR OF JAPANESE FOOTED DISHES

Edo period, c. 1725–50 (left) and early 18th century (right)
9 ⅛ and 5 ½ in. (23.2 and 14 cm) diameter

The strainer has three short blue feet; the four blue motifs in the center might be fruits, reflecting its use on the table as a fruit strainer. The small dishes are direct copies of a Delft model (probably based, in turn, on Dutch silver), with rural cottages under trees painted in their centers.

REFERENCES Impey 2002, p. 111 (strainer) and 229 (dish); Jörg 2003a, p. 255 (dish)

PROVENANCE Edward Sheppard Antiques, New York, 1995 (strainer); EastWest Gallery, Dorset (dishes)

284.

SMALL OIL JUG WITH COVER AND A PAIR OF SOYA EWERS

Edo period, c. 1680–1700
4 ⅜ and 7 ⅛ in. (11.1 and 18.1 cm) high

A number of these cruet jugs were made in Japan for use on the Dutch dining table, labeled O for *olie* (oil), A for *azijin* (vinegar) and S or Z for *soya/zoja* (soya sauce). Modeled after Delft and known in both Japanese blue and white and colored enamels, they were not made in Chinese porcelain until the eighteenth century. Like most Japanese examples, the initialed roundel on these three pieces is surrounded by grasses and flowering plants. The oil jug retains its original cover, as does a matching soya jug in the Ashmolean Museum.

REFERENCES Impey 2002, p. 107 (matching jug); Ashmolean Museum (1978.718) (same); Jörg 2003a, pp. 176–77 (similar examples)

PROVENANCE Pater Gratia Oriental Art, Groningen, 2016 (oil). J.A.N. Fine Art, London, 2018 (soya)

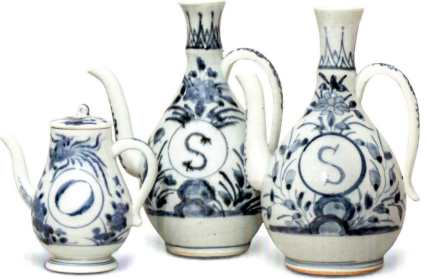

285.

PAIR OF JAPANESE PLANTERS

Edo period, late 18th–19th century
12 in. (30.5 cm) high

Each large planter has a flat everted rim and is painted around its tapering sides with a continuous riverscape, small figures in sampans on the river and huts under trees on the shore. A modified gadroon border surrounds the base, which is drilled for drainage. Japanese, Chinese and Europeans alike cultivated potted plants throughout the centuries of porcelain trade.

PROVENANCE James Galley, Lederach PA, 1992

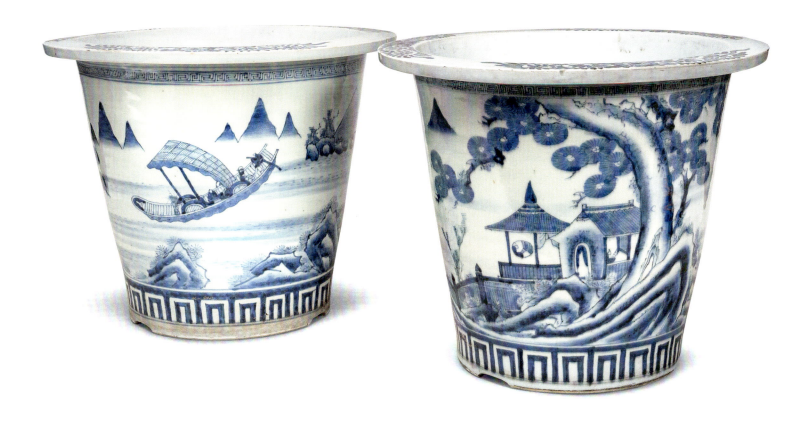

286.

PAIR OF JAPANESE INSCRIBED TEABOWLS

Edo period, first half 19th century
2 in. (5.1 cm) high

These finely potted octagonal teabowls are decorated around the sides with clumps of iris and berried branches. Carefully painted in script around the rim is the name *Jacob Duyff* on one and *Dieuke (?) Hofker* on the other. Each has a flower sprig in its center and a Japanese shop mark on its base. Jacob Duijff (1765–1844) is recorded as the captain of a mail boat that ran from Amsterdam to Batavia (Jakarta). He was married to Dieuwerke Hofker (d. 1842) and they had one daughter, who also married a merchant captain who worked a Batavia route. Japanese porcelain inscribed with a European name is extremely rare. Christiaan Jörg published a pair of Kangxi-style blue and white covered beakers inscribed with the name of a Dutch woman who married in Batavia in 1846; these two pairs may be the only examples recorded so far.

REFERENCES Jörg 2003a, pp. 220–21 (bottle); Jörg 2003b, pp. 72–75 (pair inscribed beakers); Maritiem-Historische Databank n.d. (Duijff and Hofker records). With thanks to Christiaan Jörg and William R. Sargent for their research.

PROVENANCE Heirloom & Howard Ltd, Wiltshire, 1998; Sotheby's Amsterdam, 7 December 1998, lot 580

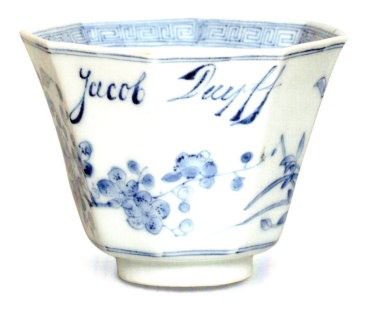

287.

JAPANESE BOWL INSCRIBED 'HOLLANDER'

Edo period, late 18th–early 19th century
6 ⅝ in. (16.8 cm) diameter

On this bowl there is no doubt that Dutchmen are being portrayed: inside the rim, the word *HOLLANDER* is inscribed twice, once misspelled as *HOLLDHDERA*. The exterior is painted with four blue-ground panels divided by wavy lines; there is a blue *kirin* in the interior. Four of the exterior panels contain a Dutchman reading a document or standing with a walking stick and two show large wrinkly elephants. Elephants were another foreign curiosity to the Japanese.

REFERENCES Tilley 1984, p. 68 (near-identical bowl); Christie's Amsterdam, 12 October 2005, lot 56 (very similar pair)

PROVENANCE Benjamin Ginsburg Antiquary, New York, 1981

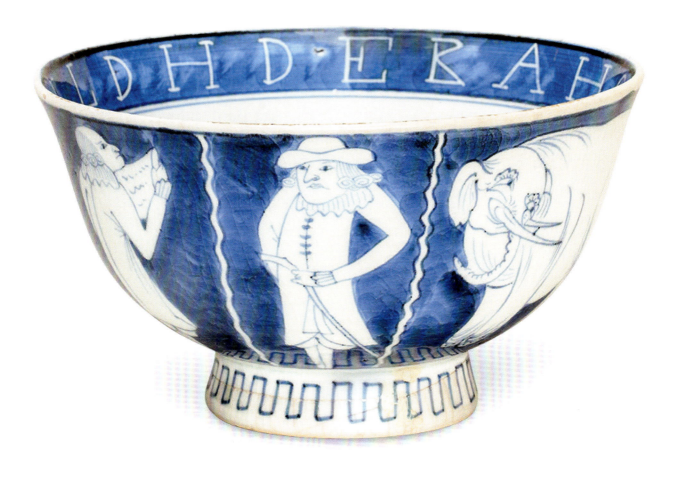

288.
JAPANESE MOLDED DISH

Edo period, c. 1760–70
8 ⅝ in. (21.9 cm) diameter

An elephant is lightly molded in the center of this dish, an inscription above him and another to his side. The lightly molded scalloped rim is edged in brown and decorated with a narrow border of light blue dots; there is a two-character seal mark on the base. Oliver Impey notes that press-molds were used in this period, and that some survive at the Kakiemon family kiln at Nangawara.

REFERENCES Impey 2002, p. 231

PROVENANCE Pater Gratia Oriental Art, Groningen, 2018

289.
JAPANESE DISH WITH ELEPHANT

Edo period, c. 1800–50
6 ⅝ in (16.8 cm) diameter

A wrinkly white elephant stands in a rocky landscape under pine trees in the blue-ground edge to edge scene on this lobed dish. Elephants are not native to Japan; they were brought by foreigners as diplomatic gifts in very small numbers, the first by the Portuguese in the fifteenth century. In 1728 Chinese merchants brought two elephants from Vietnam to Nagasaki at the request of the shogun; the Dutch brought another in 1813, both evidently quite exciting occasions for the region, which included the Arita kilns.

REFERENCES Tsuruoka 2016, pp. 49–53 (elephants in Japan); Shirahara 2007, p. 111 (print)

PROVENANCE Artisan Antiques and Fine Estates, San Jose CA, 2022

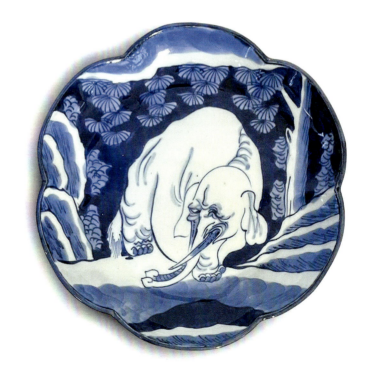

290.

TWO JAPANESE SCALLOPED DISHES

Edo period, late 18th–early 19th century
5 ⅛ and 6 in. (13 and 15.2 cm) diameter

With similar scalloped and brown-edged rims, these dishes also share a generous use of white space to set off their decoration. In the center of the right-hand dish, a flower-shaped medallion depicts two scholars seated outside; the left-hand dish shows a Westerner with large dog within a cavetto molded with chrysanthemum. Its base has a single character mark. The Westerner's jacket is strewn with buttons, which were a subject of fascination to the Japanese.

REFERENCES Impey 2002, p. 231 (very similar to right-hand dish)

PROVENANCE EastWest Gallery, Dorset

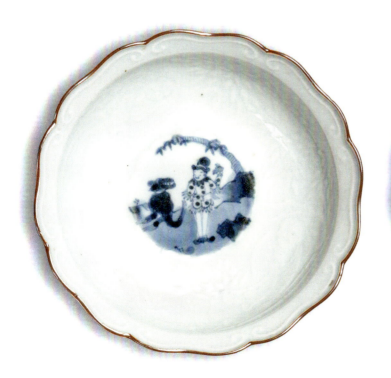
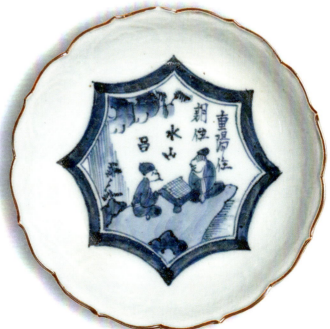

291.

TWO JAPANESE DISHES WITH FOREIGNERS

Edo period, late 18th–early 19th century
8 ¾ and 7 ¾ in. (22.2 and 19.7 cm) diameter

Both dishes—one scalloped, the other octagonal—are decorated with blue-ground panels of standing foreigners on a patterned ground. In the middle of the octagonal dish is a small low table set with antiques and a flower vase. The scalloped dish has a single character mark on the base; the other has a sketchily written seal mark. The figures, probably meant to be Dutchmen, wear curious jackets with large, randomly placed buttons as seen on the dish in the previous entry.

REFERENCES Victoria and Albert Museum (C.27–1951) (bowl in very similar pattern)

PROVENANCE Heirloom & Howard Ltd, London, 1986; Christie's London, 18 November 1986, lot 16

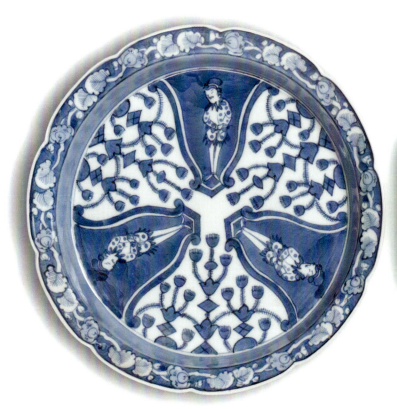

292.

JAPANESE SAKE BOTTLE WITH FOREIGNERS

Edo period, late 18th–early 19th century
7 ⅛ in. (18 cm) high

A curly-haired, hatted Dutchman wearing a frock coat over stockings and clogs stands on a blue background on each side of this square bottle. His coat has an incongruous set of buttonholes along its hem. In two panels he holds a pipe; in the other two he looks down at his small dog as if to offer a treat. Two different cell patterns border the panels; the flat top is painted with landscape and its small round spout is mounted in pewter. These particularly well-painted and lively renderings reflect the Japanese fascination with the only Europeans they encountered in this period. Like buttons, pipe-smoking was unknown to the Japanese until these encounters.

REFERENCES Victoria and Albert Museum (C.64–1963) (near identical bottle); British Museum (1954,1214.1) (near identical bottle); Tilley 1984, p. 69 (pair of sake bottles of similar scale and form)

PROVENANCE Moinat SA, Rolle, Switzerland, 2022

293.

SET OF JAPANESE BOWLS AND A SMALL JAPANESE BOWL WITH FOREIGNERS

Edo period, c. 1800–25
4 ⅝ to 6 ⅝ in. (11.7 to 16.8 cm) diameter

The small bowl at left is decorated with blue-ground panels of Dutchmen alternating with checkerboard and penciled dragons. There is an apocryphal Chenghua mark on the base and a blue *kirin* inside. At right is a graduated set of four bowls with molded rope-twist rims and blue-ground panels of Dutchmen alternating with camels or with rattan vases and characters (each with apocryphal *ken* mark for Qianlong).

REFERENCES Shirahara 2007, p. 155 (very similar set of graduated bowls in the Kobe City Museum)

PROVENANCE Sylvia Tearston Antiques, New York, c. 1980; the collection of Evangeline Bruce (left). EastWest Gallery, Honolulu, 2012 (center and right)

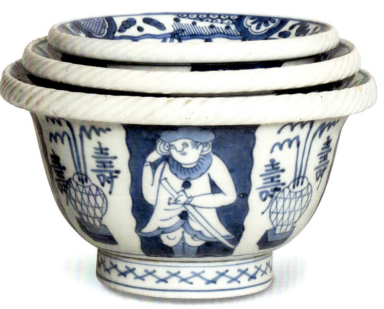

294.
JAPANESE DISH WITH CAMEL AND FOREIGNER

Edo period, c. 1800–50
7 in. (17.8 cm) diameter

A Dutchman wearing a tall hat stands holding the reins of a camel in the center of this dish. They are depicted between a rock formation and a gnarled pine tree; the rim is bordered with a modified gadroon pattern. Like the elephant, the camel was not native to Japan and was associated with foreigners. An anonymous Japanese woodblock print dated circa 1821 depicts a Dutchman with two camels and South Asian handlers under the large Dutch word *KAMEEL* and a long inscription in Japanese describing the animal.

REFERENCES Metropolitan Museum of Art (2012.33) (camel print)

PROVENANCE Heirloom & Howard Ltd, Wiltshire, 2022; Rob Michiels Auctions, Bruges, 14 May 2022, lot 173

295.
JAPANESE SCALLOPED DISH WITH FOREIGNER

Edo period, c. 1820–50
6 ¾ in. (17.1 cm) diameter

This dish displays a curious mixture of Chinese and Dutch elements—both, of course, foreign to the Japanese. In a Chinese garden with typical banana tree, lattice fence and banner sits a Dutchman at a writing table set with a Chinese-style inkstone. He holds a brush in his raised right hand as if deciding how to paint the garden scene. Christiaan Jörg writes of the fascination with exotic foreigners that continued its hold in Japan through the nineteenth century.

REFERENCES Groninger Museum (1985.0376) (near-identical dish); Jörg 1993–94, pp. 16–18

PROVENANCE Heirloom & Howard Ltd, Wiltshire, 1996; Sotheby's Amsterdam, 21 May 1996, lot 467

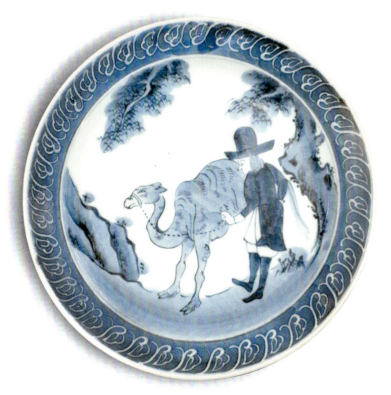
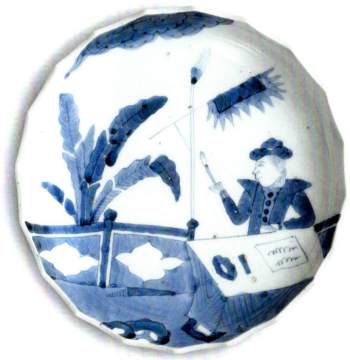

296.
JAPANESE FOOTED BOWL

Edo period, c. 1804–44
5 ¾ in. (14.6 cm) high

This wide-footed bowl is made of earthenware covered in white slip in the Delft manner. It is decorated with an overall European-style pattern of scrolling, flowering vine reserved with three roundels, one showing a Dutchman and his servant and the other two having European landscape vignettes. The painting seems to imitate transfer-printing. Made in kilns around the capital and known as Kyoto ware, ceramics in this style were prized for their similarity to the Delft that was imported to Nagasaki and sold to the Japanese.

REFERENCES Shirahara 2007, pp. 156–61 (discussion of this ware and various examples from the Kobe City Museum)

PROVENANCE Heirloom & Howard Ltd, London

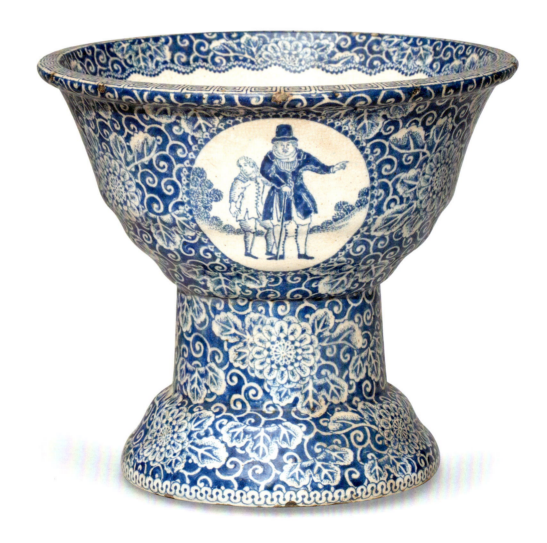

297.
TWO JAPANESE SOYA BOTTLES

Edo period, c. 1800–50
7 ⅜ and 6 ¾ in. (18.7 and 17.1 cm) high

Each bottle is inscribed *JAPANSCHZOYA*; the right-hand bottle also with *CPD* in front and on the back, where it is encircled by *COMPRADOO DESiMA* [sic] and seven Chinese characters. These functional bottles were known as 'comprador bottles' after the Portuguese word for buyer which, in Asia, came to mean local agent and also purveyor of practical goods. They were made to hold soya or sake for both transport and kitchen storage. Shards have been found at Hasami, which is assumed to have been their production center, as well as at Dejima where they would have been in use; the form was also made in Delftware. Soya sauce was long known in Asia when Europeans began to arrive in significant numbers in the seventeenth century. Anne Gerritsen quotes from a Dutch poem written in Batavia in 1669:

This is the sauce we need:
Soya, ginger, onion and peppers,
It may well feel sharp and fiery to the stomach,
But these are fires stoked for
A pot that cooks but very little.

Soya began to appear in European cookery books in the eighteenth century and is recorded in contemporary official VOC shipments.

REFERENCES Victoria and Albert Museum (c.633-1920) (similar soya bottle); British Museum (1963,0524.1) (similar *CPD* bottle); Jörg 2003a, pp. 224–25 (similar bottles); Gerritsen 2014b (soya bottle history)

PROVENANCE The Chinese Porcelain Company, New York, 2001 (left)

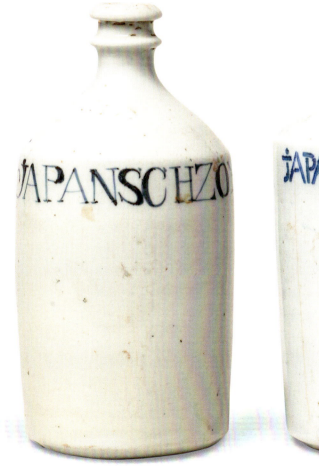
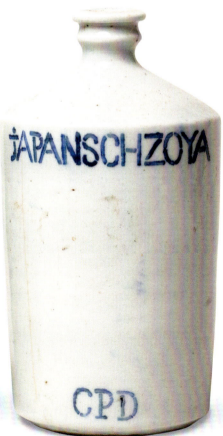

298.

JAPANESE LARGE DISH

Meiji period, c. 1875–1900
25 in. (63.5 cm) diameter

Small figures on a city wall look down at a steam locomotive, with Western clipper ships and a paddle steamer in the distance. Details are in puce, green and tones of cobalt blue, and all is on a field comprised of two overlapping squares against patterned grounds. The first train line in Japan opened in 1872; this choice of subject matter reflects Japanese enthusiasm for the modern developments of the new Meiji era. A triptych of woodblock prints by Utagawa Kuniteru dated 1873 depicts a steam locomotive.

REFERENCES Metropolitan Museum of Art (JP3270) (woodblock print)

PROVENANCE EastWest Gallery, Dorset

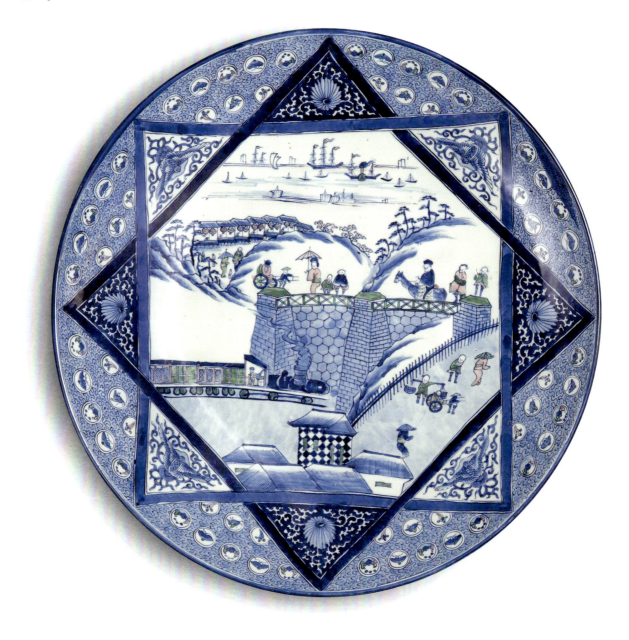

299.
JAPANESE HOT-AIR BALLOON EWER

Meiji period, c. 1875–1900
8 ½ in. (21.6 cm) high

The white balloon above a boat-shaped basket issuing the spout is probably after a print of the Robert brothers' balloon of the 1780s. A small group of late eighteenth-century ceramics was inspired by the development of hot-air balloons, and a keen interest in them seems to have lasted a century in Japan as part of their enthusiasm at entering the modern world. This ewer seems to be an updated version of a slightly more rudimentary model in plain white of the late eighteenth century. A woodblock triptych by Utagawa Yoshitora dated 1867 depicts three hot-air balloons flying over an American city.

REFERENCES Ford and Impey 1989 (dish); Shirahara 2007, pp. 212–13 (woodblock print); Jörg 1982b, pp. 71–72 (eighteenth century white model)

PROVENANCE The Jade Dragon, Ann Arbor MI, 1984

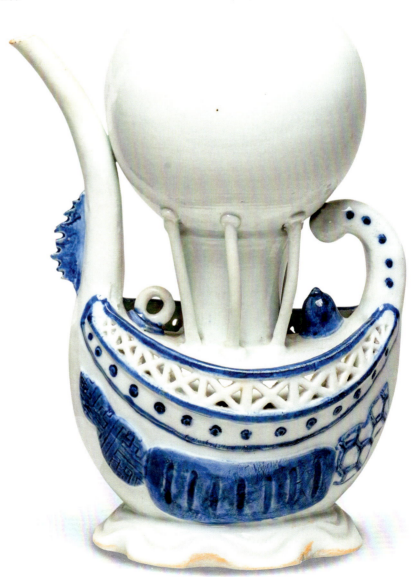

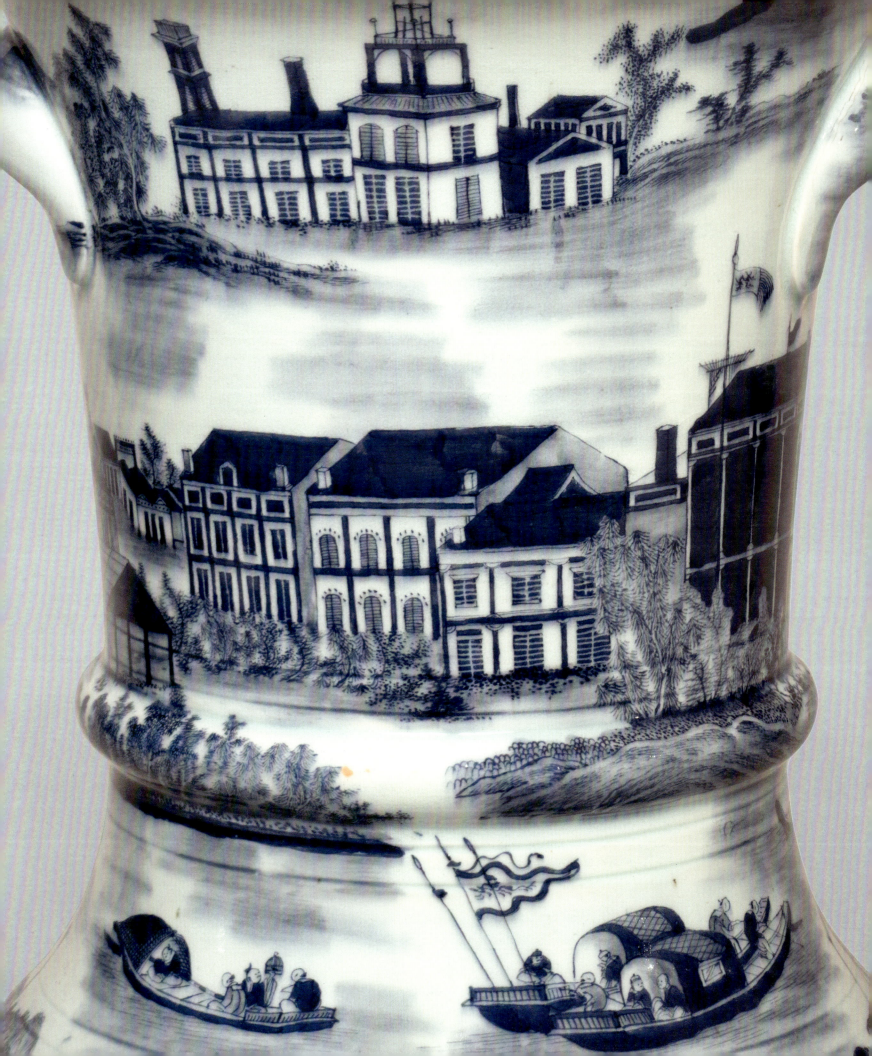

13.
THAI MARKET

Thailand, like so many of her Asian neighbors, had a long and complex relationship with China in which diplomacy and commerce were intricately intertwined. Known to foreigners as Siam until 1939 (probably from the Portuguese who, when they arrived in the region in the sixteenth century, referred to the Thai people with the Sanskrit word *syam*, or dark), Thailand was the only Southeast Asian country never colonized by Europeans, remaining an independent monarchy until 1932 and a constitutional monarchy to this day. Thailand's relative wealth and stability afforded a ready market for Chinese commodities and Chinese luxury goods, like silk and porcelain,[1] and its location made it a convenient stop for Chinese, Southeast Asian, Indian and European traders on the Maritime Silk Route.[2] The Portuguese arrived in the old Thai capital of Ayutthaya in 1511 and a small community settled there; by the early seventeenth century, when the Dutch were becoming the dominant Europeans in the region, the VOC (Dutch East India Company) established an Ayutthaya satellite post. English traders soon frequented the capital as well, welcomed by King Narai (r. 1656–88) in part to offset the increasing power of the Dutch.[3]

Official Thai–Chinese trade and official tribute—considered by the Thai to be a form of taxes, or just the cost of doing business—were accompanied by a private junk trade that waxed and waned through the late Ming and Qing periods as Chinese political conditions and trade policy fluctuated.[4] And Chinese porcelain arrived in Thailand via both official and unofficial routes. Ceramics from as early as the Tang dynasty (618–907) are found in Thailand; large quantities of late Ming dynasty (1368–1644) and early Qing dynasty (1644–1908) blue and white shards have been unearthed at Ayutthaya, which was sacked by the Burmese in 1767 and then abandoned.[5] In 1684 King Narai sent "14 tubs of China ware" to King James II of England,[6] and more than fifteen hundred Chinese porcelains were included in the famous Thai embassy to the court of King Louis XIV in 1686.[7]

Porcelain forms and decoration designed specifically for the Thai market had begun under the Ming,[8] but increased in quantity in the later seventeenth century with the resumption of production at Jingdezhen and the general increase in trade that followed South China's recovery from decades of strife.[9] Characteristic Thai forms included footed bowls and serving dishes for the table, often with distinctive foliate rims. Jars with straight sides and domed covers, many with stepped or tiered knops sometimes called stupa form,[10] were inspired by Thai metalwork (which was in turn inspired by Indian styles). These *toh* jars were multipurpose, used for food, cosmetics and perfume. They often came in a porcelain betel set, along with lime pots and betel boxes, all used for the chewing of the areca nut wrapped in leaves with lime paste, a habit particularly associated with Southeast Asia and practiced by royals and commoners alike.[11]

Much of this Chinese porcelain was, of course, blue and white, known as *kangsai* ware in Thailand, from a Thai dialect's word for Jiangxi, the province of Jingdezhen.[12] But late Ming colored wares were also made for the Thai market. The Thai name for colored wares, *bencharong* (sometimes transliterated as *benjarong*), comes from another Thai dialect's word for *wucai* (five colors), the Chinese term for the pre-*famille rose* set of

Thai manuscript cabinet, wood, Rama III period (1787–1851), Collection of the National Library, Bangkok

colored enamels.[13] Once the Chinese palette expanded in the eighteenth century, *bencharong* in *famille rose* colors became the preferred ware for the Thai court, supplanting blue and white as well as *wucai*.

Throughout these centuries of trade, not only Chinese goods but also Chinese people came to Thailand. Some fled difficult economic circumstances, some were Ming loyalists escaping the Qing, and others were skilled workers recruited by the Thai who, with their relatively small population, were often in need of administrators for the royal bureaucracy. Chinese, Iranians, Indians and Europeans held positions in the Krom Phrakhlang (the foreign trade ministry) as early as the seventeenth century, and a member of the growing Chinese community at Ayutthaya was routinely appointed to head the division that oversaw South China Sea trade.[14] Sarasin Viraphol quotes George White, an English merchant resident in Ayutthaya in the 1670s, who wrote in his 1691 pamphlet, *An Account of the Trade to the East-Indies*, "This place's merchants who are keepers and traders for the king are all Chinese."[15]

The Thai–Chinese fostered trade between the two countries which continued apace throughout the eighteenth century. Many commodities were shipped from Thailand to China, and the ships often returned full of Chinese porcelain. In the 1720s, for example, as tea-drinking became widely popular in Europe, the Chinese sought increasing amounts of tin from Thailand with which to line tea chests.[16] A Thai commodity of growing importance was rice. Beginning in 1722, rice became scarce and costly in China, and cheaper, widely available Thai rice became a significant factor in the official Chinese tribute trade.[17]

About a decade after the 1767 fall of Ayutthaya, a new dynasty was founded in Thailand with Bangkok as its capital. Under King Rama I, first Chakri dynasty ruler (r. 1782–1809), laws were codified, new palaces and temples were built, the arts were promoted and the stage was set for the new century. "The nineteenth century saw a brilliant efflorescence of all the arts in Thailand, under the patronage of both the aristocracy and wealthy merchant families," wrote Forrest McGill.[18]

Trade with China prospered and grew under the Chakri dynasty. In 1822 the British diplomat John Crawfurd recorded 140 Chinese junks arriving in Bangkok, loaded with ceramics, tea, silk and food; Thailand continued to export needed commodities and enjoyed a trade surplus with China.[19]

Throughout the reign of King Rama II (1809–24), large quantities of *bencharong* were imported from China. But King Rama III (r. 1824–51) and King Rama IV (r. 1851–68) ruled during decades when output at the Jingdezhen kilns was greatly compromised, first by decreased Imperial orders and then by destruction during the Taiping Rebellion. *Bencharong* and other Jingdezhen wares were no longer available, although some blue and white from other kilns in China was imported.[20]

It was during the long reign of King Rama V (r. 1868–1910) that Chinese porcelain made for the Thai market had its last, triumphant flowering. The Tongzhi emperor (r. 1862–74) had rebuilt the kilns at Jingdezhen; the Guangxu emperor's reign (1875–1908) saw a huge step up in quality; and, in Thailand, King Rama V was a great admirer of Chinese blue and white. In addition to his own collecting, he sponsored ceramic exhibitions

and competitions, leading a fashion for Chinese porcelain among the elite.[21]

King Rama V ruled at a time of prosperity and modernization in Thailand. Rice exports grew even greater alongside a raw materials trade generated by the West's increasing industrialization.[22] The king traveled to other Southeast Asian capitals and to British India to observe their administrations and used the insights he gained to reform Thai systems. Though Thailand was under pressure from both England, which had taken Myanmar (Burma) to its west, and France, with its Indochina possessions to the east, it managed to remain independent with relatively minimal concessions to the Europeans.

In 1888 King Rama V ordered a number of blue and white tea sets from Jingdezhen, each to be decorated with one of about a dozen different versions of his royal monogram.[23] According to an account written by historian Prince Damrong (1862–1943), the monograms were designed by a cousin of the king's, Prince Prawit Chumsai. Each piece had a royal reign mark and the date 1888 in Thai script.[24] They were intended for entertaining valued visitors such as the Buddhist monks who came regularly to the royal palaces and also as royal gifts.[25] The Frelinghuysen collection features five pieces from these royal sets (nos. 304–306).

Evidently, these tea sets were much admired, as a second group was commissioned by leading Thai–Chinese merchant *Phraya* (Lord) Bariboon Kosakorn. The wares in this second group, though with identical decoration, were marked with the brand name adopted by the family firm in 1879, 'Jin Tang Fa Ji'.[26] This firm was one of several important trading companies run by wealthy Thai–Chinese in Bangkok, one of which belonged to contemporary historian Pimphraphai Bisalputra's great-great-grandfather, *Phraya* Phisanpholpanich. The export of rice to China and the import of porcelain on the return voyage was a mainstay of these businesses,[27] which were responsible for the large quantities of Chinese blue and white made to Thai taste in the later nineteenth century, porcelain which often bore their respective marks or brand names.[28] The collection includes examples from a number of these merchants' wares (nos. 307–308, 311–314 and 515–516).

Customs had changed since the influx of blue and white and *bencharong* of earlier centuries, and thus desirable porcelain forms changed. Large water cisterns

John Thomson, King Chulalongkorn, Rama V (1853–1910) as a Young Prince, photograph, 1865, Private collection

(nos. 309 and 513–514) and water kettles (nos. 519 and 523), covered rice bowls and spoons, spittoons (no. 304) and candlesticks (no. 521) were made for the Thai market in the later nineteenth century as well as tea sets, which often came with a distinctive long-necked water bottle (nos. 305, 308 and 517). Oil lamp bases in Chinese blue and white were fashionable (nos. 317 and 524); electric power came to Thailand in the late 1880s but was not widespread until the 1910s.[29]

These Chinese porcelains were found in royal palaces, wealthy households and in the all-important Buddhist temples of Thailand. In the royal palaces, Buddhist ceremonies were held at least monthly, as noted by King Rama V in a book on the regular rituals performed by Thai kings.[30] The vast Buddhist temple complexes served not just as places of worship, but also as schools, universities, libraries and places of periodic retreat.[31] *Phra Dharma* Punya Bordi (1916–2014), chief abbot

at Thailand's most prestigious temple and one of its oldest, Wat Pho (or Wat Phra Chetuphon, known as the Temple of the Reclining Buddha) noted that the temple's holdings are "… mostly Chinese ceramics such as blue and white porcelains."[32] High-ranking monks collected Chinese porcelains; other pieces were gifts to the temple.[33] The vast Wat Pho collection includes numerous complete tea sets, altar sets of two dozen pieces or more, animals, figures, spittoons, vases, musical instruments and censers in Chinese blue and white, largely from the Rama V period and including many pieces from the king's monogrammed orders.[34]

By the Rama V period, Thailand and its works of art had been a subject of fascination for foreigners for centuries—from the first encounters of sixteenth-century Europeans in the age of exploration, to the French court's reception of the remarkable 1686 Thai embassy, to the Empress Eugénie's 'Chinese Museum' (featuring much Thai art) which opened at Fontainebleau Palace in 1863. In the twentieth century, a small group of influential American collectors inherited this fascination, notably heiress Doris Duke and Thai silk entrepreneur Jim Thompson. Both loved the exoticism of Bangkok's aging klongs (canals); Thompson famously built a traditional Thai residential compound on stilts beside a klong, open today as a museum, while Duke sought to construct a complete Thai village in Hawaii and began the construction of a royal Thai pavilion replica on her indoor tennis court at Duke Farms in New Jersey.[35]

Thompson collected Thai sculpture and porcelain to display in his house, while Duke formed a vast collection of Thai and Burmese art to fill her planned Thai village and to exhibit for the edification of the American public.[36] Having first visited Bangkok on her honeymoon in 1935, she returned in 1957 and began her collecting of Thai art and her village project in earnest. Southeast Asian art was largely obscured by the much better-known Chinese and Japanese art in the decades Duke collected, but a few American dealers were keen: Amos Shepard of East Haddam, Connecticut, his onetime business partner, J.A. Lloyd-Hyde of Newport, Rhode Island and Marie Whitney of Tolland, Massachusetts—all loosely connected to the same social circles as Thompson and Duke.

After Duke's death in 1993 her collections went to the Doris Duke Charitable Foundation, which dispersed the Thai and Burmese art to a number of American museums, primarily the Asian Art Museum of San Francisco and the Walters Art Museum in Baltimore, and also to the British Museum, the British Library, and the Victoria and Albert Museum.[37] Another large tranche was sold at Millea Bros. of New Jersey in May of 2009. A number of pieces in the Frelinghuysen collection came from that sale, while others came from Amos Shepard or Marie Whitney and still more were acquired in Bangkok. Today, the collection—with its large number of later nineteenth-century Thai market pieces in an extensive variety of forms and patterns—stands as a unique American testament to these fascinating porcelains made in Jingdezhen for Thailand.

Thai head of Buddha Shakyamuni in Sukhothai style,
bronze, 16th century, Frelinghuysen collection

1 Viraphol 1977, p. 4.
2 Orillaneda 2016, p. 83.
3 Ruangsilp and Wibulsilp 2017, p. 108.
4 Viraphol 1977, p. 2.
5 Bisalputra 2014, p. 105.
6 Shulsky 1989, p. 55.
7 Bisalputra 2017, p. 10.
8 Robinson 1985, pp. 114–15.
9 Bisalputra 2017, p. 10.
10 Robinson 1985, p. 117.
11 Bisalputra 2014, p. 108, where she notes the prestige of betel sets: "Nicholas Gervaise, a French missionary to King Narai's court, wrote that, 'He [the envoy] is presented with some betel in a golden betel box.'"
12 Bisalputra 2017, p. 19.
13 Ibid., p. 28.
14 Ruangsilp and Wibulsilp 2017, pp. 100–01.
15 Viraphol 1977, pp. 40–41.
16 Bisalputra 2017, p. 15.
17 Viraphol 1977, pp. 84–85.
18 McGill and Chirapravati 2009, p. xiii.
19 Ibid., p. 14.
20 Robinson 1985, pp. 125–26.
21 Punya Bordi 2002, p. 20.
22 Sng and Bisalputra 2015, pp. 218–19.
23 Sng and Bisalputra 2011, p. 253.
24 Bisalputra 2014, p. 114.
25 Ibid.; Sng and Bisalputra 2011, p. 263.
26 Bisalputra 2014, p. 114.
27 Sng and Bisalputra 2015, p. 225.
28 Ibid., pp. 125, 208.
29 Electricity Authority 2013.
30 McGill and Chirapravati 2009, p. 28.
31 Ibid., pp. 30–31, 67.
32 Punya Bordi 2002, p. 23.
33 Ibid., pp. 20–21.
34 Ibid., pls. 91–92.
35 Tingley 2003, pp. 12–17.
36 Ibid., p. 12.
37 Igunma 2016, p. 1.

300.

PAIR OF LARGE JARS WITH COVERS (*TOH*)

Kangxi (1662–1722) to Qianlong (1736–95) period, 18th century

11 ¼ in. (28.6 cm) high

Of deep U-shape with domed covers, these very large jars are painted with an overall pattern of scrolling lily vine. Bordering the rims and bases is a band of dots, diamonds and ovals; the elaborately modeled knops are decorated with blue leaf tips. *Toh* jars with tall stepped knops are particularly associated with Thailand, where they were used in different sizes and for different purposes. Numerous shards of blue and white *toh* jars have been found at the old Thai capital of Ayutthaya, sacked by the Burmese in 1767. This very large size is unusual and might have been used for holy water, Buddhist amulets or funerary purposes.

REFERENCES Bisalputra 2014, p. 106 (closely related eighteenth-century jar)

PROVENANCE Hong Antiques, Bangkok

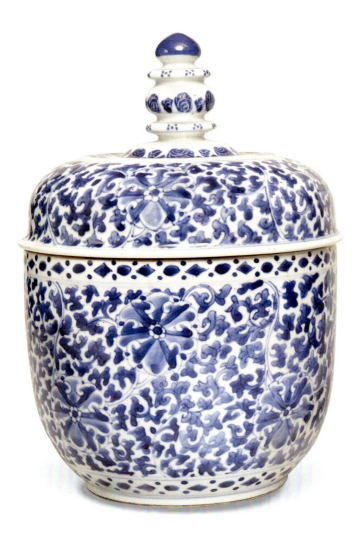 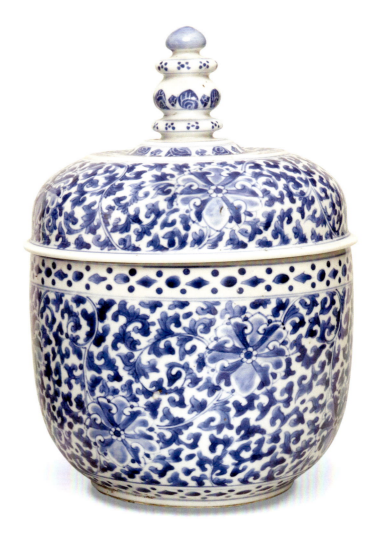

301.

PAIR OF RICE-GRAIN PATTERN JARS WITH COVERS (*TOH*)

Qianlong (1736–95) to Jiaqing (1796–1820) period
5 in. (12.7 cm) high

This pair of jars has pyramidal covers topped by blue finials. *Ruyi* heads border the rims and lappets encircle the bases; on the sides and covers is a pattern of small glazed piercings. This kind of patterning—known in China as *linglong*, rice-grain or sesame seed—is created by piercing the leather-hard clay body before firing and then applying repeated coats of glaze until the holes are filled. Smaller *toh* jars could be used for toiletries, sugar syrup, sweetmeats, or servings of soup or curry.

REFERENCES Sng and Bisalputra 2011, pp. 36–37 (eighteenth-century *toh* jars); Sargent 2012, p. 156 (rice-grain pattern)

PROVENANCE Chris Sheffield Ltd, London, 2021

302.

FOUR ELEMENTS JAR WITH COVER

Tongzhi (1862–74) to Guangxu (1875–1908) period
4 ½ in. (11.4 cm) high

This small covered jar with ring knop represents a common alternate form popular in Thailand. It is painted around its side with teardrop-shaped cartouches containing goddesses symbolic of the Four Elements. Here Mae Phra Kongka, the water goddess, rides a fish through waves, a lotus blossom in her outstretched hand. The cartouches are reserved on a ground of attendants amongst scrolling foliage.

REFERENCES Sng and Bisalputra 2011, pp. 188–89 (Four Elements set)

PROVENANCE Hong Antiques, Bangkok

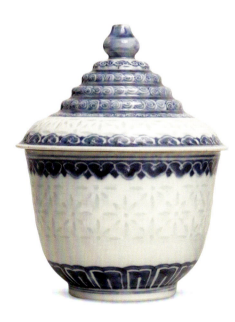
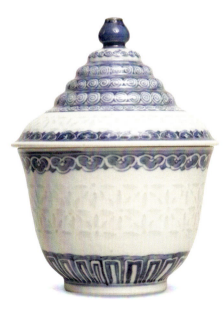
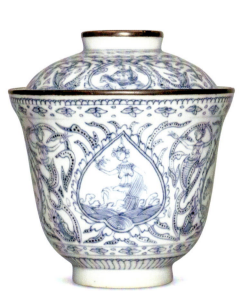

303.
TEA PIECES WITH THE REGENT'S INSIGNIA

Tongzhi period (1862–74), c. 1870
5 ⅛ in. (13 cm) diameter (stand)

This tea service was made for *Somdet Chao Phraya* Sri Suriyawongse (personal name Chuang Bunnag) (1808–1883), who served as regent of Siam (Thailand) from the ascent of fifteen-year-old Prince Chulalongkorn to the Thai throne in 1868 until 1873, when King Chulalongkorn (Rama V) reached maturity. Already a leading courtier under King Mongkut, Sri Suriyawongse was enormously powerful during his years of regency. The English personal emblem he used featured his portrait head radiating sun rays (Suriya meaning sun) encircled by his title and *REGENT OF SIAM*. Seemingly, he ordered his tea service in the tradition of the armorial porcelain made for Europeans.

REFERENCES Sng and Bisalputra 2011, pp. 252–53

PROVENANCE RCB Auctions, Bangkok, 10 December 2022, lot 155

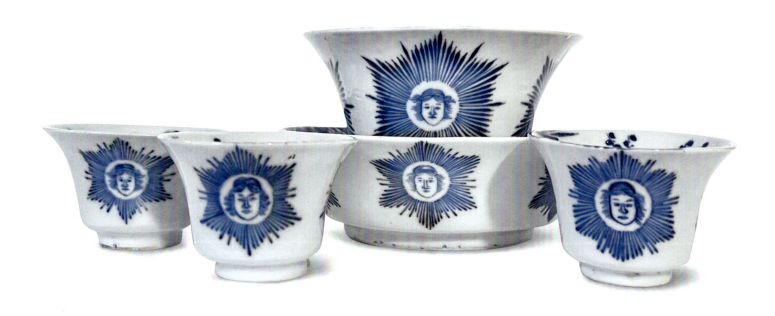

304.
SPITTOON WITH RAMA V MONOGRAM

Guangxu period (1875–1908), ordered 1888
Thai reign mark and dated 1888 on the base
7 ½ in. (19 cm) high

King Chulalongkorn, who ruled Thailand as Rama V (r. 1868–1910), was a passionate collector of Chinese blue and white. In 1888 he commissioned a remarkable group of tea wares decorated with twelve different versions of his royal monogram *Jor Por Ror*, the monograms designed by Prince Prawit Chumsai. *Phraya* Wissakam Silpa Prasit accompanied the order to Jingdezhen to ensure that it was carried out properly. Each piece in this royal order was marked with the Thai royal reign mark in a square and the date 1888 in Thai script. Here, in a motif called *Lai Att*, a bat suspends ribboned 1874 Thai coins, one side with the king's monogram and the other with the date.

REFERENCES Bisalputra 2014, pp. 113–14; Asian Art Museum of San Francisco (2006.27.98.a-.b) (teapot in this pattern)

PROVENANCE RCB Auctions, Bangkok

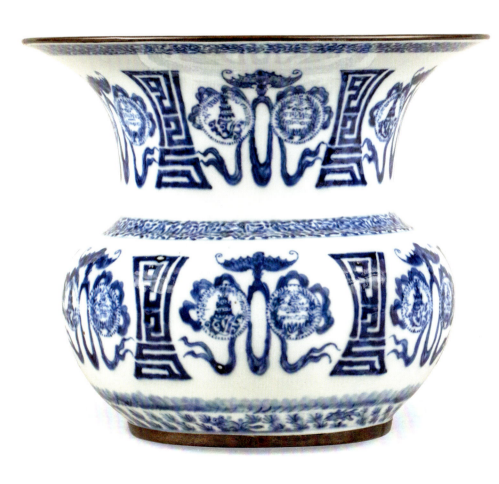

305.

TWO WATER BOTTLES WITH COVERS AND RAMA V MONOGRAMS

Guangxu period (1875–1908), ordered 1888
Thai reign mark and dated 1888 on the bases
12 ¼ and 12 ½ in. (31.1 and 31.8 cm) high

These distinctively shaped water bottles (*Khon Tho*) with their ridged necks and high domed covers were regular features of the Thai tea service, used to hold the cool water that was always offered alongside hot tea. Both these examples hail from the 1888 order of Rama V. On the left-hand bottle, five 'lucky bats' fly around the script monogram in a pattern known as *Lai Look Mai Khang Khao*; on the right a geometricized version of the *Jor Por Ror* royal monogram.

REFERENCES Philadelphia Museum of Art (2003-222-18) (spittoon in left-hand pattern); Bisalputra 2014, p. 114 (tea pieces in right-hand pattern)

PROVENANCE Hudson Valley Auctioneers, Beacon NY, January 2012 (left); Millea Bros Auctioneers, Boonton NJ, 2–3 May 2009, lot 31; the collection of Doris Duke, Hillsborough NJ (right)

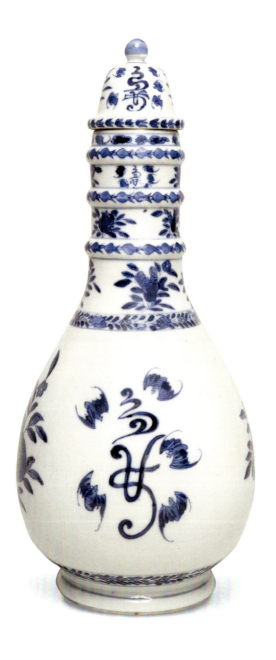
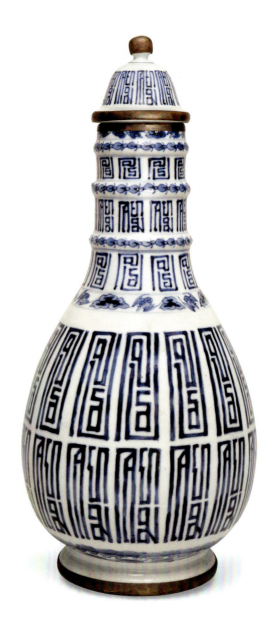

306.

RAMA V MONOGRAMMED JAR WITH COVER AND STAND AND JAR WITH COVER

Guangxu period (1875–1908), ordered 1888
Thai reign mark and dated 1888 on the bases
4 ¼ and 5 in. (10.8 and 12.7 cm) high

The left-hand jar repeats the double-coin *Lai Att* monogram of the spittoon above (no. 304), while the right-hand jar is decorated with the Rama V monogram design known as *Yi Khot*. Each tea service would have come with at least four covered jars of this form as well as a galleried bronze tray cast with decoration to match.

REFERENCES Sng and Bisalputra 2011, pp. 254–55 (*Lai Att* tea service with tray); Asian Art Museum of San Francisco (2006.27.99.a-b) (*Yi Khot* water bottle)

PROVENANCE Hong Antiques, Bangkok

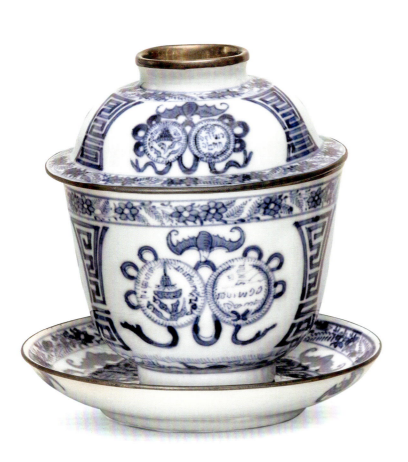
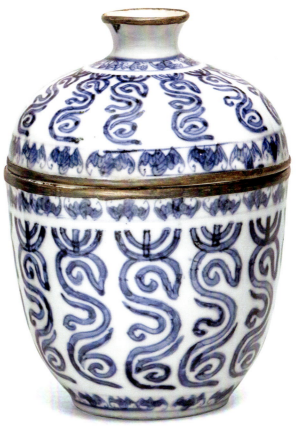

307.

TEAPOT AND TEA CANISTER WITH RAMA V MONOGRAMS

Guangxu period (1875–1908), c. 1888
Four-character merchant's mark *Jin Tang Fa Ji* on the bases
8 ½ in. (21.6 cm) high (pot including handle); 4 ⅝ in (11.7 cm) high (canister)

The Thai royal tea sets were apparently so admired that *Phraya* Bariboon Kosikorn, the Sino-Thai merchant who was a favorite of the king and had been tasked with overseeing the commission, ordered a second, unauthorized tranche. These additional sets—identical to the originals in form, design and quality—were marked with *Phraya* Bariboon Kosikorn's *Jin Tang Fa Ji* mark, the mark used on all the many Chinese porcelains he imported. The king was not at all pleased with the imitation royal sets and had them held in the Thai customs warehouse, where they remained until after his death. Here we have the royal monogram in script alternating with peach, pomegranate and finger citron sprigs.

REFERENCES Sng and Bisalputra 2011, p. 258; Bisalputra 2014, p. 114
PROVENANCE RCB Auctions, Bangkok

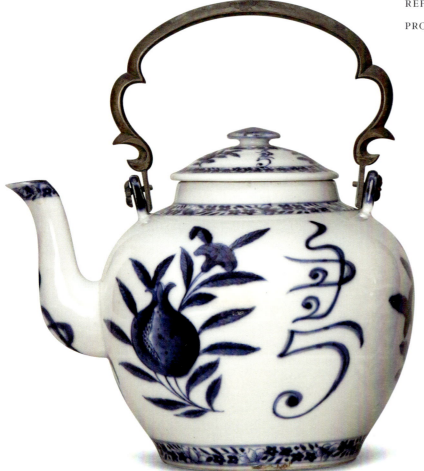

308.

TWO WATER BOTTLES WITH COVERS AND STANDS AND RAMA V MONOGRAMS

Guangxu period (1875–1908), c. 1888
Four-character merchant's mark *Jin Tang Fa Ji* on the bases
12 ¾ in. (32.4 cm) high

Nearly all pieces in the typical Chinese porcelain tea service for Thailand were made with saucer-like stands: water bottles, tall water cups, covered bowls and teapots.

These two water bottles (*Khon Tho*) retain their original stands. The left-hand bottle has a geometricized version of the monogram differing from that of the bottle in no. 305; on the right-hand bottle, a script monogram alternates with sprigs of peach, pomegranate and finger citron. Both hail from the second, merchant's order of monogrammed tea sets.

REFERENCES Tingley 2003, p. 82 (water bottle in righthand pattern)

PROVENANCE Hong Antiques, Bangkok

309.

WATER CISTERN WITH THE HONGS AT GUANGZHOU (CANTON)

Tongzhi (1862–74) to Guangxu (1875–1908) period
25 ½ in. (64.8 cm) high

Another favored subject of the Thai market in the second half of the nineteenth century was the Guangzhou waterfront. Guangzhou, the southernmost major Chinese port and thus the closest to Thailand, had been the port of Sino-Thai trade for at least two centuries by the time this water cistern was made. It was largely portrayed in these porcelains as it had been in the 1830s through the 1850s. Large cisterns like this were made for the ubiquitous tea-taking in Thai palaces and temples, where cool water was offered alongside hot tea. A removable porcelain filter inside and a bronze spigot in front made the cistern quite functional.

REFERENCES Compare nos. 513 and 514

PROVENANCE Marie Whitney Antiques, Tolland MA, 1981

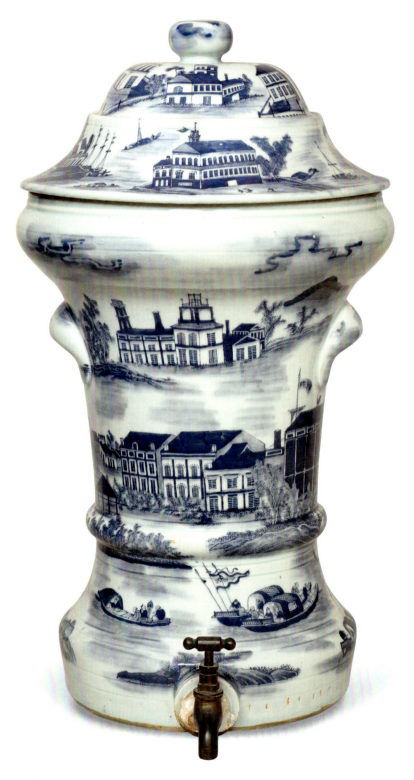

310.
ROOSTER TUREEN

Tongzhi (1862–74) to Guangxu (1875–1908) period
10 ½ in. (26.7 cm) long

This remarkable tureen is one of a small group of animal tureens and figures decorated with an iconic Chinese subject, the Pavilion of Prince Teng. All were made for the Thai market in the second half of the nineteenth century. The Pavilion of Prince Teng has been a famous site in Nanchang, capital of Jiangxi province and near Jingdezhen, since it was built in 653 during the Tang dynasty (618–907) for the prince, a brother of the emperor. Immortalized in a famous ode by Tang poet Wang Bo, the large hilltop pavilion, visible for miles, became a favored subject for paintings and prints and, now rebuilt, remains a tourist destination today. Presumably this classic Chinese subject appealed to the prosperous Chinese diaspora that was a significant part of the Thai market in the nineteenth century as well as to the Thai elite.

REFERENCES Christie's New York, May 1985, lot 140 (goat); Sargent 1991, pp. 240–42 (elephants and turtle reference); Christie's New York, 25 January 2006, lot 125 (elephant with pagoda); Pinto de Matos 2019, pp. 425–27 (pair of sows)

PROVENANCE Heirloom & Howard Ltd, Wiltshire, 2010; Duke's Auctioneers, Dorset, 22–24 September 2010, lot 105; collection of Timothy and Fran Lewis, Melplash Court, Dorset

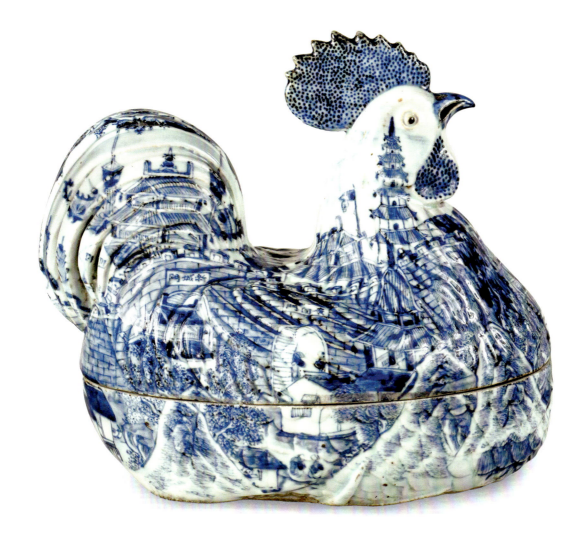

311.
BOTTLE VASE AND CUP, COVER AND STAND WITH THE HONGS AT GUANGZHOU (CANTON)

Tongzhi (1862–74) to Guangxu (1875–1908) period
Four-character merchant's mark *Po Chu Li Kee* on the bases
8 ½ in. (21.7 cm) high (vase); 5 ¼ in. (13.3 cm) wide (stand)

As mentioned in the discussion of the water cistern above (no. 309), the Guangzhou waterfront was a favorite subject of wealthy Sino-Thai merchants. The inscription above the buildings translates as *Thirteen Factories of Guangdong Province*; the scene seems to have been depicted as it was between the disastrous fire of 1822 and the late 1850s. These pieces all carry the *Po Chu Li Kee* mark of importer *Phraya* Phisanpholpanich, who took over the Gao family business in 1862, just as the Jingdezhen kilns were reopening. A bottle in the Mottahedeh collection with this same subject carried the same mark.

REFERENCES Howard and Ayers 1978, p. 210 (Mottahedeh bottle); Bisalputra 2014, pp. 110–11

PROVENANCE RCB Auctions, Bangkok (bottle). Fred B. Nadler Antiques, Bay Head NJ, 1989 (cup, cover and stand)

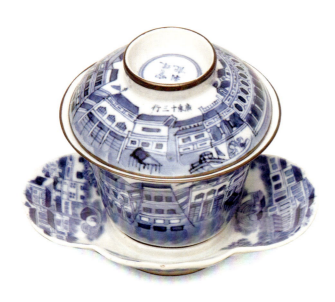
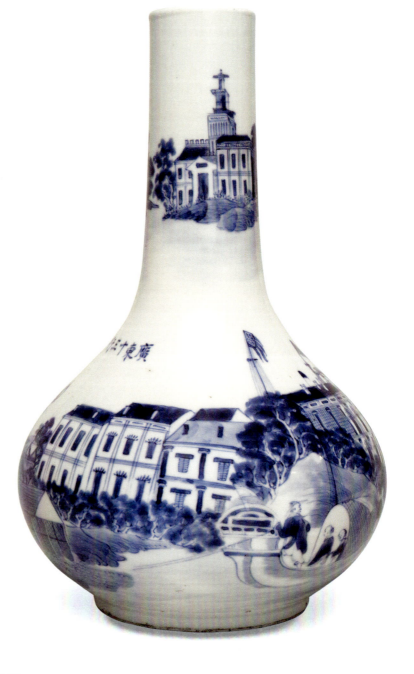

312.

BOTTLE VASE WITH AYUTTHAYA

Tongzhi (1862–74) to Guangxu (1875–1908) period
Four-character merchant's mark *Po Chu Li Kee* on the base
8 ½ in. (21.7 cm) high

A river scene encircles this vase, small sampans floating near the riverfront gate of a temple and a Siamese flag with white elephant flying above. An inscription reads *Da cheng si Zhuang* ([the] temple in Dacheng town). Dacheng was the Chinese name for Ayutthaya, capital of Thailand (then Siam) until it was sacked in 1767. When the Rattanakosin rulers re-established control, they moved the nation's capital down the Chao Praya River to Bangkok. The distinctive white elephant flag was used in Thailand from the mid-nineteenth century until 1916.

PROVENANCE Heirloom & Howard Ltd, Wiltshire, 1990s

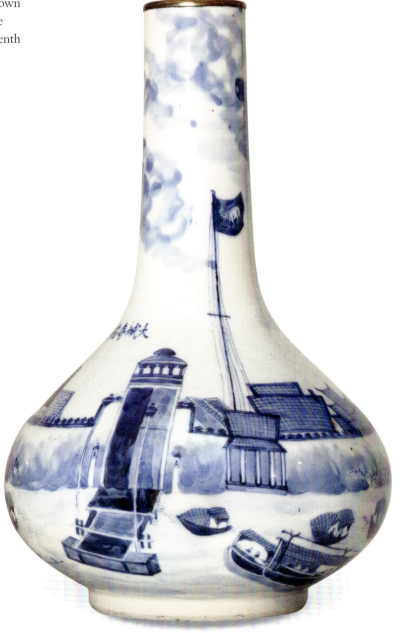

313.

HEXAGONAL ALTAR STAND (*CHANAB*)

Tongzhi (1862–74) to Guangxu (1875–1908) period, before 1879
Four-character merchant's mark *Jin Tang Fu Ji* on the base
10 ⅞ in. (27.6 cm) long

Altars piled high with Chinese blue and white porcelain were a feature of Thai palaces, temples and wealthy homes beginning under King Rama I (r. 1782–1809). During the reign of King Rama V (r. 1868–1910), a passionate collector of Chinese blue and white himself, competitions were held in altar decoration. Under a complicated scoring system, each altar had to include at least eight different forms of matching pattern: screen, flower vase, small flower vase, cylindrical vase, incense holder, censer, fruit offering bowl, pair of candlesticks. Other forms could add points. This stand has the pre-1879 mark used by the firm of Li Fa Zhou (later titled *Phraya* Bariboon Kosakorn).

REFERENCES Punya Bordi 2002, pp. 233–39 (numerous altar arrangements of Chinese blue and white); Bisalputra 2014, p. 114 (merchant's marks); RCB Auctions 2022 (altar competitions)

PROVENANCE CopperRed Antiques, Bangkok

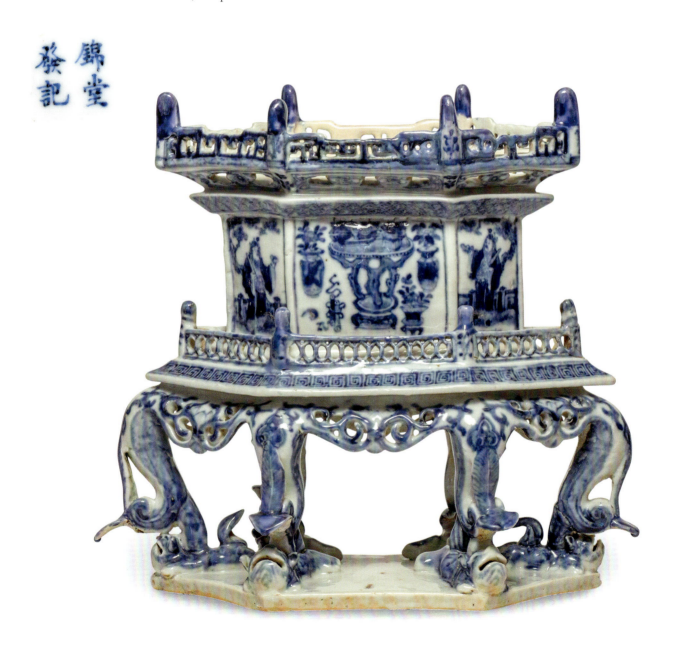

314.
ALMS BOWL WITH COVER AND STAND

Tongzhi (1862–74) to Guangxu (1875–1908) period
Four-character unidentified merchant's mark on the base
9 ⅛ in. (23.2 cm) high

This unique Thai market form was made to hold Buddhist amulets, holy water or icons: one of the many vessels piled high on Thai altars, which could feature more than forty pieces. This example is painted with ducks on a lotus pond; a dragonfly hovers above grasses on the flat cover, and flowering shrubs decorate the separately fired stand.

REFERENCES Sng and Bisalputra 2011, p. 249 (alms bowl in *famille rose* cabbage pattern)

PROVENANCE Millea Bros. Auctioneers, Boonton NJ, 2–3 May 2009, lot 187; the collection of Doris Duke, Hillsborough NJ

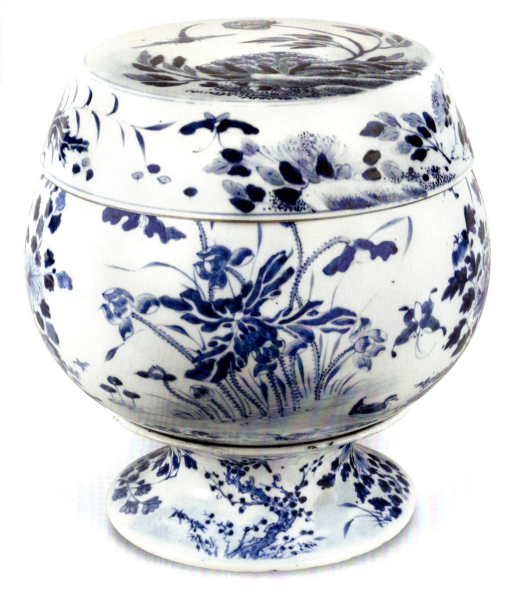

315.

TEAPOT WITH ELEPHANT

Tongzhi (1862–74) to Guangxu (1875–1908) period
5 ⅛ in. (13 cm) high

Attendants surround a wrinkly white elephant on this straight-sided teapot with bronze swing handle. He wears an elaborate saddle cloth and carries an offering vase on his back. A typical Thai market form, the bronze fitting is also characteristic of the practical Thai, who often added metal rims to their Chinese porcelains to both embellish and protect them. The white elephant was doubly auspicious in Thailand: a powerful Buddhist symbol as well as an emblem of Thai royal power. With fitted rattan basket.

REFERENCES Asian Art Museum of San Francisco (2006.27.97.a-.b) (*famille rose* teapot of same form and decoration)

PROVENANCE CopperRed Antiques, Bangkok

316.

MELON-FORM SWEETMEAT BOX

Daoguang (1821–50) to Guangxu (1875–1908) period, 19th century
11 ½ in. (29.2 cm) wide

A knop in the form of a small melon trailing curling stems is applied on the lobed cover of this box, which is decorated overall on its exterior with further melons growing from leafy vines on a blue ground. The divided interior is painted with fruit clusters, indicating its function as a serving dish for dried fruits and nuts. A four-character Daoguang mark (which may be apocryphal) is in underglaze blue on the base.

PROVENANCE Nadeau's Auction Gallery, Windsor CT

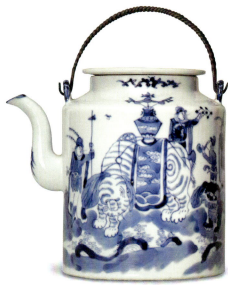

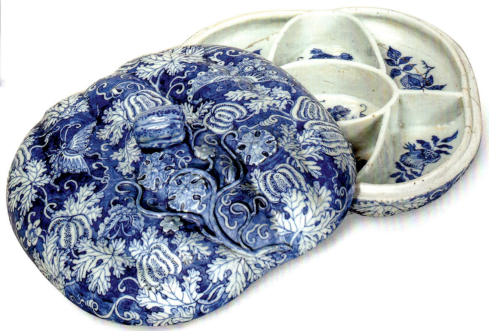

317.
PAIR OF OIL LAMPS WITH THE HONGS AT GUANGZHOU (CANTON)

Tongzhi (1862–74) to Guangxu (1875–1908) period
11 in. (27.9 cm) high (the porcelain)

Fashionable households of Thailand in the Rama V period (r. 1868–1910) featured much Chinese blue and white porcelain following the example of the king, who not only collected blue and white but also sponsored collector competitions. The king was also well-traveled and worldly; he brought European innovations to Thailand and likely made a degree of Westernization quite acceptable. These lamps, decorated with the Guangzhou scene discussed in no. 309, reflect a mixture of Victorian form and typical Thai pattern.

REFERENCES McGill and Chirapravati 2009, pp. 213–14 (Rama V collecting and competitions)

PROVENANCE Ian McLean Antiques, Hong Kong, 1978

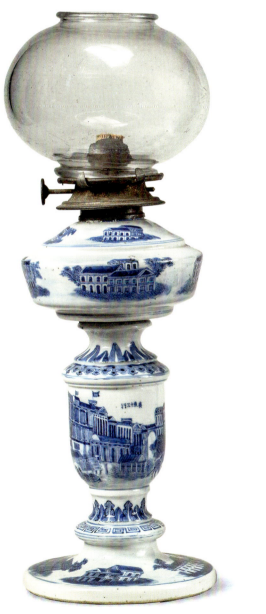
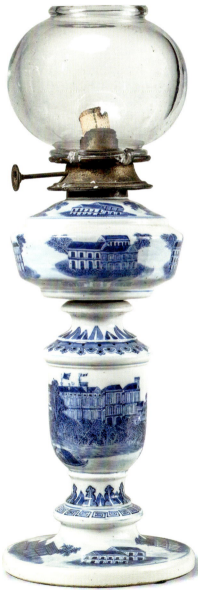

COMPENDIUM

FAITH

318.
A CRUCIFIXION BEAKER AND TEABOWL AND SAUCER

Kangxi period (1662–1722), c. 1690–1700
Christian cross motif on the base of teabowl and saucer
3 in. (7.6 cm) high (cup); 5 ¼ in. (13.3 cm) diameter (saucer)

PROVENANCE Silk Road Antiques, Hong Kong, 1980; the collection of the descendants of Ishida Mitsunari, Kyoto, by repute (cup)

319.
FRANCISCAN-RELATED JAR

Kangxi period (1662–1722)
10 ¼ in. (26 cm) high

PROVENANCE Santos London, 2019; Veritas Art Auctioneers, Lisbon, 15 April 2019, lot 589

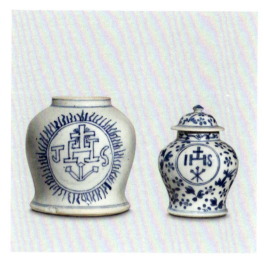

320.
TWO SMALL JESUIT JARS

Kangxi (1662–1722) to Yongzheng (1723–35) period
5 ⅛ and 4 ¾ in. (13 and 12.1 cm) high

PROVENANCE Heirloom & Howard Ltd, London, 1982; Christie's London, November 1982, lot 412 (left)

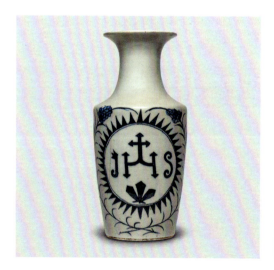

321.
JESUIT VASE

Guangxu (1875–1908) to Republic (1912–49) period

Seven-character mark on the base: *Shang hai [X] cheng quan jian zhi* (Overseen and produced by [X] Chengquan in Shanghai)

9 ⅞ in. (25.1 cm) high

PROVENANCE Kun Doa Knie Art Company, New York, 1988

322.
HOLY WATER FONT

Daoguang period (1821–50)
With carved wood support
7 ⅛ in. (18.1 cm) wide

PROVENANCE Hong Antiques, Bangkok

323.
METAL-MOUNTED DOUBLE-GOURD VASE WITH SANSKRIT INSCRIPTIONS

Daoguang (1821–50) to Tongzhi (1862–74) period
7 ½ in. (19.1 cm) high

PROVENANCE Artemis Gallery, Louisville CO, 2022; the collection of Nancy and E.F. Simpson, Los Angeles

IDENTITY

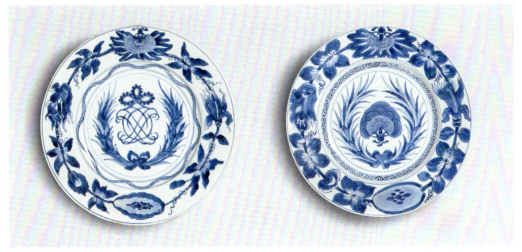

324.
MONOGRAMMED PLATE AND RELATED PLATE WITH PASSION FRUIT BORDERS

Kangxi period (1662–1722)
10 ½ in. (26.7 cm) diameter

PROVENANCE Heirloom & Howard Ltd, Wiltshire, 1995 (left). The Chinese Porcelain Company, New York, 1998 (right)

325.
PLATE WITH CREST POSSIBLY OF LETHIEULLIER

Yongzheng period (1723–35), c. 1725
8 ¾ in. (22.2 cm) diameter

PROVENANCE Heirloom & Howard Ltd, Wiltshire, 2007

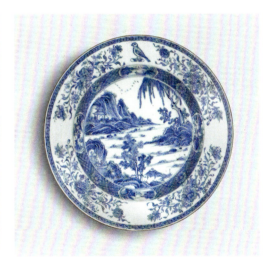

326.
PLATE WITH ARMS OF PALMER WITH PROBABLY DERWELL IN PRETENCE

Yongzheng period (1723–35), c. 1728
9 in. (22.9 cm) diameter

PROVENANCE Heirloom & Howard Ltd, Wiltshire, 2002; Stockholms Auktionsverk, Stockholm, May 1999, lot 1618

327.
CRESTED OCTAGONAL BASIN

Yongzheng period (1723–35), c. 1730
15 ¼ in. (38.7 cm) diameter

PROVENANCE Heirloom & Howard Ltd, Wiltshire, 1993

328.
PLATE WITH CREST OF LETHIEULLIER

Yongzheng period (1723–35), c. 1730
10 ¼ in. (26 cm) diameter

PROVENANCE Heirloom & Howard Ltd, Wiltshire, 2022; Woolley & Wallis, Salisbury, 18 May 2022, lot 911

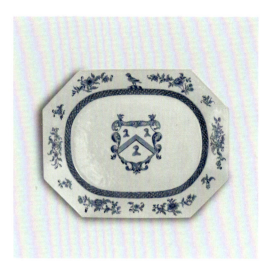

329.

LARGE PLATTER WITH ARMS OF LETHIEULLIER

Qianlong period (1736–95), c. 1750
16 in. (40.6 cm) wide

PROVENANCE Kee Il Choi, Jr., New York

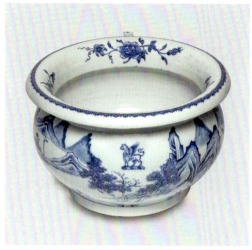

330.

CHAMBERPOT WITH CREST OF WENTWORTH

Yongzheng period (1723–35), c. 1730
9 ½ in. (24.1 cm) diameter

PROVENANCE Heirloom & Howard Ltd, London, 1989

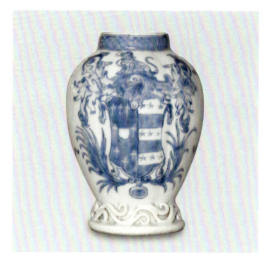

331.

TEA CANISTER WITH ARMS OF SUTTER IMPALING JESSOPE

Yongzheng period (1723–35), c. 1730
4 ⅛ in. (10.5 cm) high

PROVENANCE Kenneth R. Brown Antiques, Allentown NJ, 1990

332.

PLATE WITH ARMS OF SCHREUDER

Yongzheng (1723–35) to Qianlong (1736–95) period, c. 1735–40
9 in. (22.9 cm) diameter

PROVENANCE Heirloom & Howard Ltd, Wiltshire

333.

PLATE WITH ARMS OF VAN BEIJSSELAAR

Yongzheng (1723–35) to Qianlong (1736–95) period, c. 1735–40
10 ⅛ in. (25.7 cm) diameter

PROVENANCE Jan-Erik Nilsson, Gothenburg, 1985

334.

PLATE WITH ARMS OF CLIFFORD

Yongzheng (1723–35) to Qianlong (1736–95) period, c. 1735–40
8 ⅞ in. (22.5 cm) diameter

PROVENANCE Suchow & Seigel Antiques, New York, 2015

335.

THREE PAIRS OF ARMORIAL SALTS

Yongzheng (1723–35) to Qianlong (1736–95) period
With the crest of Peers, c. 1731, the crest of Garland, c. 1750, and the arms of Dalrymple, c. 1775 (top to bottom)
3 1/16 to 3 3/4 in. (7.8 to 9.5 cm) wide

PROVENANCE Philip Suval Ltd (Peers). The Chinese Porcelain Company, New York, 2006 (Garland). Heirloom & Howard Ltd, Wiltshire, 2012 (Dalrymple)

336.

DISH WITH CREST PROBABLY OF CHAMBERS

Qianlong period (1736–95), c. 1750
12 in. (30.5 cm) diameter

PROVENANCE Heirloom & Howard Ltd, Wiltshire, 2002; Sotheby's Sussex, March 1994, lot 3; the collection of E. Clive Rouse, Buckinghamshire

337.

SHELL DISH WITH CREST PROBABLY OF BILNEY OF NORFOLK

Qianlong period (1736–95), c. 1750
4 in. (10.2 cm) wide

PROVENANCE Heirloom & Howard Ltd, Wiltshire, 2007

338.

OCTAGONAL PLATE WITH CREST OF GARLAND

Qianlong period (1736–95), c. 1750
8 5/8 in. (21.9 cm) diameter

PROVENANCE Heirloom & Howard Ltd, London, 1985

339.

PLATE WITH CREST PROBABLY OF STAFFORD

Qianlong period (1736–95), c. 1755
9 1/8 in. (23.2 cm) diameter

PROVENANCE Heirloom & Howard Ltd

340.

PANCAKE PLATE WITH ARMS OF TOUSSAIN

Qianlong period (1736–95), c. 1750–52
9 1/8 in. (23.2 cm) diameter

PROVENANCE Heirloom & Howard Ltd, Wiltshire, 1990

341a.
DISH WITH CREST PROBABLY OF PARKER, LARGE PLATTER WITH CREST OF WINCH AND PLATE WITH UNIDENTIFIED CREST

Qianlong period (1736–95), c. 1755
13 ¾, 17 and 9 ⅞ in. (34.9, 43.2 and 25.1 cm) wide

PROVENANCE Heirloom & Howard Ltd (left and right). James Galley, Lederach PA, 1979 (center)

341b.

341c.

342.
SOUP PLATE WITH CREST OF WHELER

Qianlong period (1736–95), c. 1755
9 ⅛ in. (23.2 cm) diameter

PROVENANCE James Galley, Lederach PA, 1983

343.
LARGE PLATTER WITH CREST OF GIBBINGS OF CORK

Qianlong period (1736–95), c. 1755
16 ½ in. (41.9 cm) wide

PROVENANCE Heirloom & Howard Ltd, Wiltshire, 2010

344.
SMALL PLATTER WITH UNIDENTIFIED COCKEREL CREST

Qianlong period (1736–95), c. 1755
10 in. (25.4 cm) wide

PROVENANCE Heirloom & Howard Ltd, London, 1986

345.
OCTAGONAL PLATE WITH ARMS OF ERDESWICK QUARTERLY IMPALING CRICHTON

Qianlong period (1736–95), c. 1750
8 ⅜ in. (21.9 cm) diameter

PROVENANCE Heirloom & Howard Ltd, London, 1989; Christie's Monaco, 22 June 1989, lot 91

346.
OCTAGONAL PLATE WITH ARMS OF CRICHTON IMPALING FREKE

Qianlong period (1736–95), c. 1760
8 ¼ in. (21 cm) diameter

PROVENANCE James Galley, Lederach PA, 1979

347.
OCTAGONAL PLATE WITH ARMS OF CRICHTON

Qianlong period (1736–95), c. 1765
9 ¼ in. (23.5 cm) diameter

PROVENANCE Heirloom & Howard Ltd, London, 1979

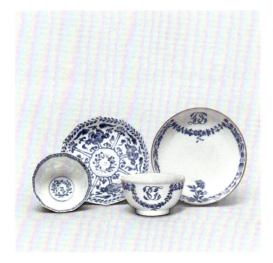

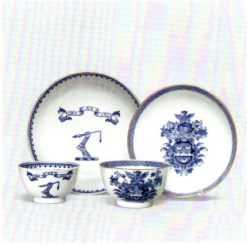

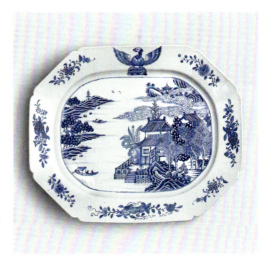

348.
TEABOWL AND SAUCER WITH CHARACTER OR INITIAL AND MONOGRAMMED TEABOWL AND SAUCER FOR DAVID SANDBERG, SWEDISH SUPERCARGO

Kangxi period (1662–1722), c. 1700–20 (character or initial) and Qianlong period (1736–95), c. 1760 (Sandberg)
4 ¼ and 5 ⅜ in. (10.8 and 13.7 cm) diameter

PROVENANCE Santos London, 1985 (left). Jan-Erik Nilsson, Gothenburg, 1985 (right)

349.
TEABOWL AND SAUCER WITH CREST OF FERGUSON AND TEABOWL AND SAUCER WITH ARMS OF GLOVER

Qianlong period (1736–95), c. 1760–65
5 ½ and 6 in. (14 and 15.2 cm) diameter

PROVENANCE Heirloom & Howard Ltd (left). Heirloom & Howard Ltd, London, 1985 (right)

350.
LARGE PLATTER WITH CREST OF PALK, PROBABLY FOR ROBERT PALK, GOVERNOR OF FORT ST. GEORGE, MADRAS, 1763–67

Qianlong period (1736–95), c. 1765
16 ½ in. (41.9 cm) wide

PROVENANCE Heirloom & Howard Ltd, Wiltshire, 2006

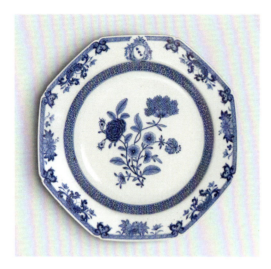
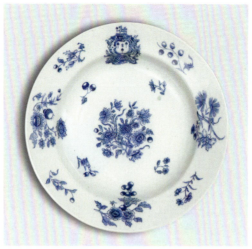
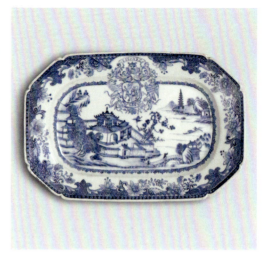

351.
OCTAGONAL PLATE WITH ARMS OF WEBB

Qianlong period (1736–95), c. 1770
8 ¾ in. (22.2 cm) diameter

PROVENANCE James Galley, Lederach PA, 1988

352.
PLATE WITH ARMS OF ADAMSON

Qianlong period (1736–95), c. 1770
8 ⅞ in. (22.5 cm) diameter

PROVENANCE Heirloom & Howard Ltd, Wiltshire, 2004

353.
SMALL PLATTER WITH ARMS OF DUNDAS IMPALING MAITLAND

Qianlong period (1736–95), c. 1770
9 ½ in. (24.1 cm) diameter

PROVENANCE The Chinese Porcelain Company, New York, 1991

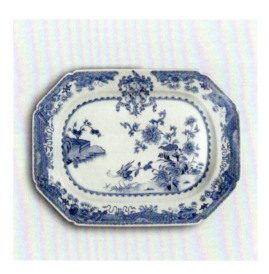
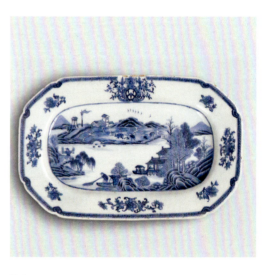

354.
PLATTER WITH ARMS OF LAROCHE WITH YEOMANS IN PRETENCE

Qianlong period (1736–95), c. 1770
12 ½ in. (31.8 cm) wide

355.
PLATTER WITH CREST OF UDNEY OF THAT ILK

Qianlong period (1736–95), c. 1770
12 ⅝ in. (32.1 cm) wide

PROVENANCE Heirloom & Howard Ltd, London, 1988; Christie's London, March 1988, lot 201

356.
SMALL PLATTER WITH ARMS OF RUSSELL OF ASHIESTEEL

Qianlong period (1736–95), c. 1775
10 in. (25.4 cm) wide

PROVENANCE Heirloom & Howard Ltd, London, 1983

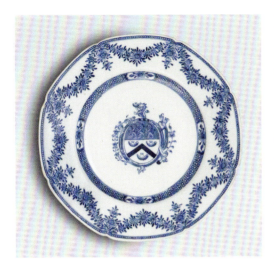

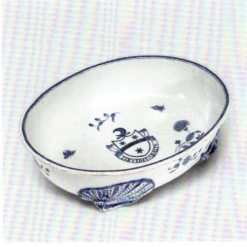

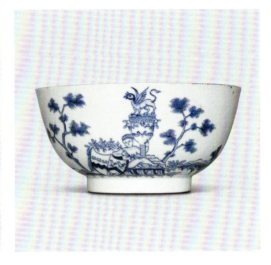

357.
PLATE WITH ARMS OF HENCHMAN

Qianlong period (1736–95), c. 1775
8 ⅛ in. (20.6 cm) diameter

PROVENANCE Heirloom & Howard Ltd, Wiltshire, 1999

358.
BASIN ON OYSTER FEET WITH ARMS OF DALLAS

Qianlong period (1736–95), c. 1775
12 in. (30.5 cm) wide

PROVENANCE Heirloom & Howard Ltd, London, 1986; Christie's London, 19 November 1986, lot 36

359.
SMALL BOWL WITH ARMS OF DEANE IMPALING HEATH OR MORE

Qianlong period (1736–95), c. 1780
5 ½ in. (14 cm) diameter

PROVENANCE Heirloom & Howard Ltd, London, 1985

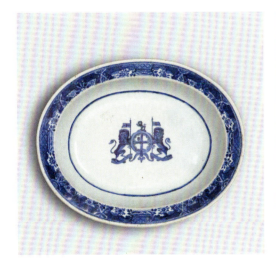

360.
OVAL DISH WITH ARMS OF THE BRITISH EAST INDIA COMPANY

Qianlong (1736–95) to Jiaqing (1796–1820) period, c. 1795
Incised collector's mark in the form of a fish on the front
11 ½ in. (29.2 cm) wide

PROVENANCE Honeychurch Antiques, Hong Kong, 1979

361.
OVAL BASKET STAND WITH CREST OF BEALE

Jiaqing period (1796–1820), c. 1800
13 ⅛ in. (33.3 cm) wide

PROVENANCE Heirloom & Howard Ltd, Wiltshire, 1990

362.
PLATE WITH ARMS OF ANTROBUS

Jiaqing period (1796–1820), c. 1800
9 ⅝ in. (24.4 cm) diameter

PROVENANCE Heirloom & Howard Ltd, Wiltshire, 1998

FOR THE TABLE

363.
WELL-AND-TREE PLATTER WITH CREST OF LARKINS

Jiaqing period (1796–1820), c. 1805
16 ⅛ in. (41 cm) wide

PROVENANCE Heirloom & Howard Ltd, London, 1988

364.
WELL-AND-TREE PLATTER WITH CREST OF KIDDELL OR ALEXANDER

Jiaqing period (1796–1820), c. 1805
17 ½ in. (44.5 cm) wide

PROVENANCE Herbert Schiffer Antiques, West Chester PA, 1989

365.
DIAMOND-SHAPED FOOTED STAND

Yongzheng period (1723–35), c. 1725
9 ½ in. (24.1 cm) wide

PROVENANCE The Chinese Porcelain Company, New York, 1994

366.
LEAF-SHAPED DISH AND INGOT-SHAPED DISH

Kangxi period (1662–1722)
5 ¼ and 7 in. (13.5 and 17.8 cm) long

PROVENANCE Heirloom & Howard Ltd, Wiltshire, 2019; Christie's London, 6 November 2019, lot 105; the collection of Albert and Leonie van Daalen, Switzerland; Vanderven Oriental Art, 's-Hertogenbosch (leaf)

367.
FOUR SILVER-MOUNTED ARTICLES: TWO MUSTARD POTS, MINIATURE VASE AND SCENT BOTTLE

Kangxi period (1662–1722)
5 ⅜ and 3 ⅛ in. (13.7 and 7.9 cm) high (pots); 6 ⅛ in. (15.6 cm) high (vase); 3 in. (7.6 cm) long (bottle)

PROVENANCE The Chinese Porcelain Company, New York, 2001; the collection of Rafi and Mildred Mottahedeh, New York (vase). Galerie Théorème, Paris, 2004 (bottle)

368.
A FOOTED BOWL AND A FOOTED DISH

Kangxi period (1662–1722)
5 ⅞ and 8 ½ in. (14.9 and 21.6 cm) diameter

369.
SQUARE CRUET OR BOTTLE STAND

Yongzheng (1723–35) to Qianlong (1736–95) period, c. 1725–50
7 ¾ in. (19.7 cm) wide

PROVENANCE Philip S. Dubey Antiques, Baltimore

370.
OYSTER OR SWEETMEAT DISH AFTER DELFT

Yongzheng (1723–35) to Qianlong (1736–95) period, c. 1725–50
10 ¾ in. (27.3 cm) diameter

PROVENANCE Heirloom & Howard Ltd

371.
THREE FOOTED STRAINERS

Qianlong period (1736–95), c. 1750
7 ¾ to 9 in. (19.7 to 22.9 cm) diameter

PROVENANCE Heirloom & Howard, Wiltshire, 2011 (left). Matthew & Elisabeth Sharpe Antiques, Conshohocken PA, 1993 (center). Kenneth R. Brown Antiques, Allentown NJ, 1991 (right)

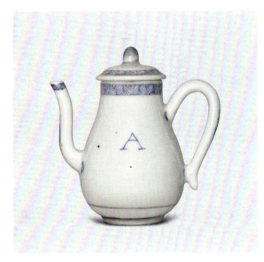

372.
SIX SMALL SHELL-SHAPED DISHES

Kangxi (1662–1722) to Qianlong (1736–95) period
3 ¾ to 6 ¼ in. (9.5 to 15.9 cm) wide

PROVENANCE Good & Hutchinson Inc., Sheffield MA (top center). Richard Gould Antiques, Santa Monica (left). Andrew Dando Antiques, Bradford on Avon (right)

373.
THREE CRUET JUGS WITH RABBIT FINIALS AND ASSOCIATED STAND

Yongzheng period (1723–35), c. 1725–30
7 ¼ in. (18.4 cm) wide

PROVENANCE Heirloom & Howard Ltd, Wiltshire, 2016

374.
CRUET JUG INSCRIBED 'A' FOR *AZIJN* (VINEGAR)

Kangxi period (1662–1722)
4 ½ in. (11.4 cm) high

PROVENANCE van Halm & van Halm, London, 2011

375.
TWO BOTTLE OR CRUET STANDS

Yongzheng period (1723–35), c. 1725–30
5 ⅜ and 7 in. (13.7 and 17.8 cm) wide

PROVENANCE Heirloom & Howard Ltd, Wiltshire, 2018; Stockholms Auktionsverk, Stockholm, 5 December 2018, lot 432 (left)

376.
CRUET STAND

Yongzheng period (1723–35), c. 1725–30
9 ⅜ in. (23.8 cm) wide

PROVENANCE Galerie Bertrand de Lavergne, Paris, 2008

377.
TWO PORRINGERS AND COVERS

Kangxi (1662–1722) to Yongzheng (1723–35) period
5 ½ and 4 ¾ in. (14 and 12.1 cm) wide

PROVENANCE Heirloom & Howard Ltd, Wiltshire, 2020; Rob Michiels Auctions, Bruges, November 2020, lot 360

378.
TWO-HANDLED BOWL AND COVER AND MOLDED BOWL AND COVER

Qianlong period (1736–95), c. 1750–65
4 ¾ and 4 ⅞ in. (12.1 and 12.4 cm) wide

PROVENANCE The Chinese Porcelain Company, New York (right)

379.
PAIR OF MOLDED SAUCE TUREENS AND COVERS

Qianlong period (1736–95), c. 1770–80
6 ¼ in. (15.9 cm) wide

PROVENANCE Sotheby's New York, 31 January 1992, lot 160; the collection of John A. McCone, Pebble Beach CA

380.
SOUP TUREEN LACKING OVERGLAZE ENAMELS

Qianlong period (1736–95), c. 1775
13 ½ in. (34.3 cm) wide

PROVENANCE Heirloom & Howard Ltd, Wiltshire, 2015; R & G McPherson Antiques, London, 2011

DRINKING AND POURING

381.
SOUP TUREEN WITH DRAGONS

Jiaqing (1796–1820) to Daoguang (1821–50) period, c. 1815–35
14 ½ in. (36.8 cm) wide

PROVENANCE CopperRed Antiques, Bangkok, 2015

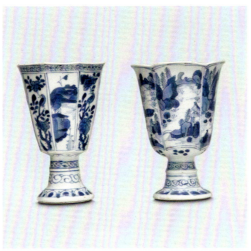

382.
TWO GOBLETS

Kangxi period (1662–1722)
4 ¼ and 4 ½ in. (10.8 and 11.4 cm) high

PROVENANCE A.R. Broomer Ltd, New York

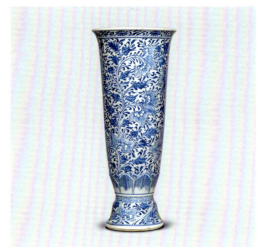

383.
FLUTED BEAKER

Kangxi period (1662–1722), c. 1690
11 ½ in. (29.2 cm) high

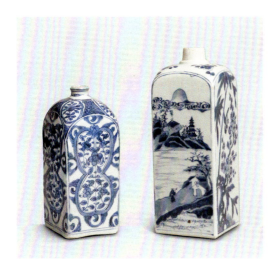

384.
TWO SQUARE BOTTLES

Wanli period (1573–1620), c. 1600–20 (left) and Kangxi period (1662–1722) (right)
8 ⅛ and 10 in. (20.6 and 25.4 cm) high

PROVENANCE Heirloom & Howard Ltd

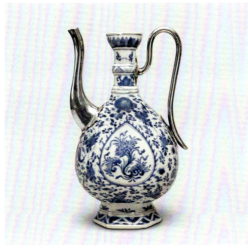

385.
SILVER-MOUNTED EWER

Kangxi period (1662–1722)
11 ½ in. (29.2 cm) high

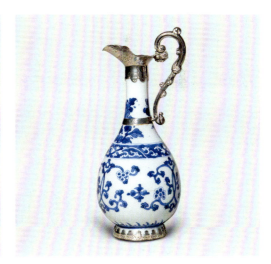

386.
VASE SILVER-MOUNTED AS A EWER

Kangxi period (1662–1722)
9 ⅛ in. (23.2 cm) high

PROVENANCE TBF Fine Art, Lisbon, 2018

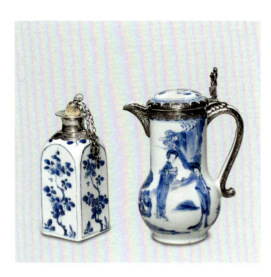

387.
SILVER-MOUNTED MINIATURE BOTTLE AND SMALL JUG

Kangxi period (1662–1722)
5 ⅛ and 6 ½ in. (13 and 16.5 cm) high

PROVENANCE Heirloom & Howard Ltd, Wiltshire, 2017; Rob Michiels Auctions, October 2017, lot 1218 (bottle). Frank Milwee Antiques, Washington DC, 2019; the collection of Jane and Gilbert Gude, Bethesda MD (jug)

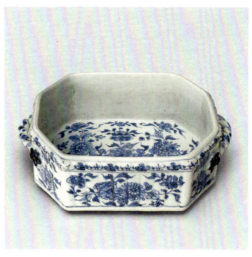

388.
OCTAGONAL TWO-HANDLED FOOTED BASIN

Yongzheng period (1723–35), c. 1730
9 ½ in. (24.1 cm) wide

PROVENANCE Heirloom & Howard Ltd, Wiltshire, 2010; Doyle New York, 13 April 2010, lot 251; the collection of Elinor Gordon

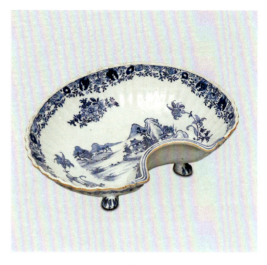

389.
SHELL-SHAPED FOOTED BASIN

Qianlong period (1736–95), c. 1750
15 ¼ in. (38.7 cm) wide

PROVENANCE Heirloom & Howard Ltd, London, 1984

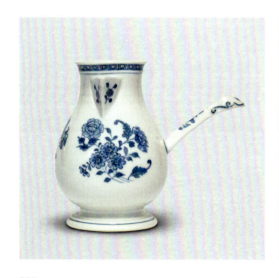

390.
LONG-HANDLED SMALL JUG

Qianlong period (1736–95), c. 1750
4 ½ in. (11.4 cm) high

PROVENANCE Kee Il Choi, Jr., New York

391.
FOUR SMALL MUGS

Kangxi period (1662–1722)
2 ⅞ to 3 ½ in. (7.3 to 8.9 cm) high

392.
MUG

Yongzheng period (1723–35), c. 1725–30
8 ¼ in. (21 cm) high

PROVENANCE Heirloom & Howard Ltd, Wiltshire, 2015; Christie's London, January 2015, lot 503

393.
THREE MUGS

Kangxi period (1662–1722) (left and center) and Qianlong period (1736–95), c. 1775 (right)
6 ½, 8 and 4 ¾ in. (16.5, 20.3 and 12.1 cm) high

PROVENANCE Heirloom & Howard Ltd, Wiltshire, 2015; Bonhams, Edinburgh, 8 July 2015, lot 186 (left; lacking overglaze enamels). Heirloom & Howard Ltd, Wiltshire, 2012 (center). Sylvia Tearston Antiques, New York, 1988 (right)

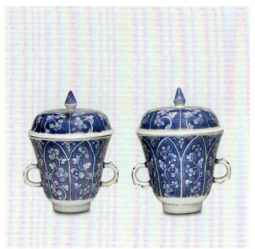

394.
PAIR OF TWO-HANDLED CUPS AND COVERS

Kangxi period (1662–1722)
4 ½ in. (11.4 cm) high

PROVENANCE The Chinese Porcelain Company, New York, 1998

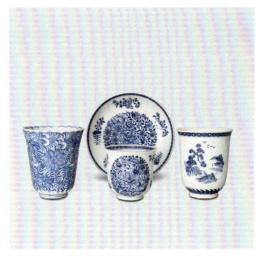

395.
TWO BEAKERS AND BEAKER AND SAUCER

Kangxi period (1662–1722)
4 ¼ in. (10.8 cm) high (largest beaker); 6 ⅜ in. (16.2 cm) diameter (saucer)

PROVENANCE Silk Road Antiques, Hong Kong, 1981 (left)

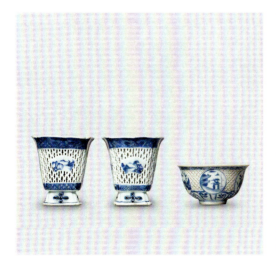

396.
PAIR OF DOUBLE-WALLED BEAKERS AND SMALL RETICULATED BOWL

Qianlong period (1736–95) (beakers) and Chongzhen period (1628–44) (bowl)
4 in. (10.2 cm) high (beakers); 4 ⅜ in. (11.1 cm) diameter (bowl)

PROVENANCE Polly Latham Asian Art, Boston (beakers). The collection of Peter H.B. Frelinghuysen, Jr. (bowl)

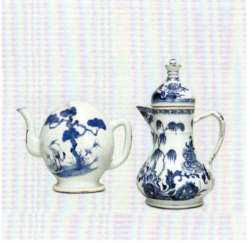

397.
PEACH-FORM CADOGAN POT AND CHOCOLATE POT

Kangxi period (1662–1722) (left) and Qianlong period (1723–35), c. 1750 (right)
6 ⅛ and 8 ¼ in. (15.6 and 21 cm) high

PROVENANCE Briggs Auction, Garnet Valley PA, December 2014, lot 58 (Cadogan). Heirloom & Howard Ltd (chocolate pot)

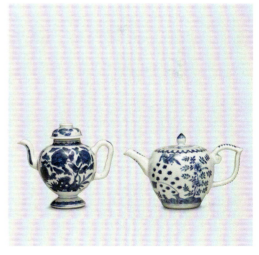

398.
FOOTED TEAPOT AND ROUND TEAPOT

Kangxi period (1662–1722) (left) and Qianlong period (1736–95), c. 1750 (right)
4 ¾ and 4 ⅛ in. (12.1 and 10.5 cm) high

PROVENANCE Polly Latham Asian Art, Boston (left). Heirloom & Howard Ltd, Wiltshire, 2016; Rob Michiels Auctions, Bruges, May 2016, lot 859 (right)

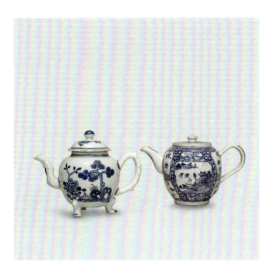

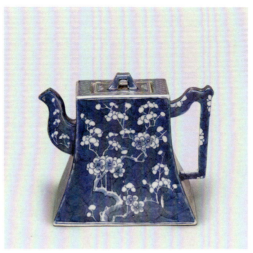

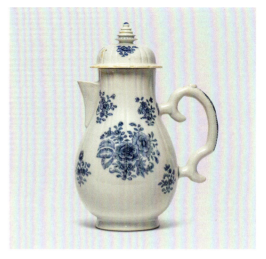

399.
TRIPOD TEAPOT AND LIGHTLY MOLDED TEAPOT

Kangxi (1662–1722) to Yongzheng (1723–35) period (left) and Qianlong period (1736–95), c. 1775 (right)
5 ⅜ and 5 ⅛ in. (13.7 and 13 cm) high

PROVENANCE Heirloom & Howard Ltd, London, 1981 (left). The Chinese Porcelain Company, New York, 1990 (right)

400.
SQUARE BLUE-GROUND TEAPOT

Guangxu (1875–1908) period
5 ¾ in. (14.6 cm) wide

PROVENANCE Heirloom & Howard Ltd, Wiltshire, 2017; Rob Michiels Auctions, Bruges, 28 October 2017, lot 248

401.
FLUTED COFFEE POT

Qianlong period (1736–95), c. 1765
8 ¾ in. (22.2 cm) high

FOR OTHER USES

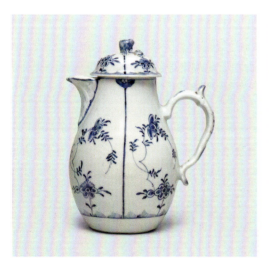

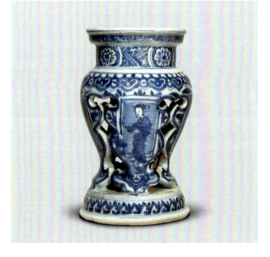

402.
COFFEE POT AFTER ROYAL COPENHAGEN MUSSELMALET PATTERN

Qianlong period (1736–95), c. 1775–95
7 in. (17.8 cm) high

PROVENANCE Kee Il Choi, Jr., New York, 1987

403.
TWO KNIFE HANDLES

Kangxi (1662–1722) to Qianlong (1736–95) period, first half 18th century
4 in. (10.2 cm) long

PROVENANCE The Chinese Porcelain Company, New York, 1993

404.
BALUSTER-FORM STAND

Wanli period (1573–1620)
6 ¾ in. (17.1 cm) high

PROVENANCE Benjamin Ginsburg Antiquary, New York

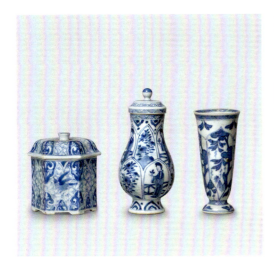

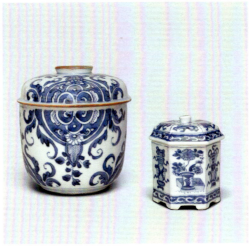

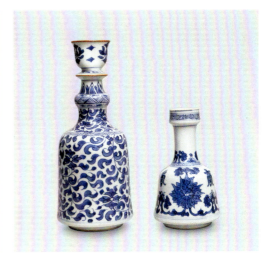

405.

SMALL SPICE OR SUGAR BOX WITH COVER, SMALL VASE WITH COVER AND SMALL FOOTED BEAKER

Kangxi period (1662–1722)
3 ⅜, 5 ⅜ and 4 ⅜ in. (8.6, 13.7 and 11.1 cm) high

PROVENANCE The collection of David S. Howard, Wiltshire (box)

406.

DEEP BOWL WITH COVER AND SMALL SPICE OR SUGAR BOX WITH COVER

Kangxi period (1662–1722)
5 ⅝ and 3 ⅛ in. (14.3 and 7.9 cm) high

PROVENANCE Philip S. Dubey Antiques, Baltimore (deep bowl) Heirloom & Howard Ltd, Wiltshire, 2021; Robert McPherson Antiques, Friesland; the collection of the Morpurgo family, Amsterdam (spice box)

407.

TWO MALLET-FORM HOOKAH BASES

Kangxi period (1662–1722)
Apocryphal six-character Chenghua mark on the base (taller)

10 and 6 ⅜ in. (25.4 and 16.2 cm) high

PROVENANCE Heirloom & Howard Ltd, Wiltshire, 1992 (left); Heirloom & Howard Ltd, Wiltshire, 2012; Duke's Auctioneers, Dorset, 9 February 2012, lot 267 (right)

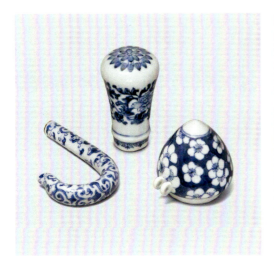

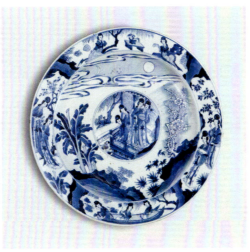

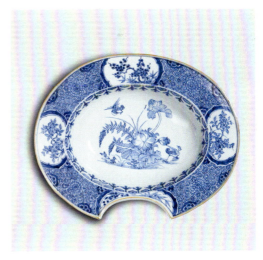

408.

SMALL CANE HANDLE, SCROLL OR PARASOL HANDLE AND BIRD FEEDER

Kangxi (1662–1722) to Qianlong (1735–95) period, 18th century
2 ¼ to 3 ¾ in. (5.7 to 9.5 cm) high

PROVENANCE Santos London, 2015 (cane handle). Malcolm Magruder, Millwood VA, 2012 (feeder)

409.

SYRUP OR BUTTER SAUCE DISH

Kangxi period (1662–1722)
14 in. (35.6 cm) diameter

PROVENANCE Heirloom & Howard Ltd, Wiltshire, 2016; Christie's New York, 15 September 2016, lot 854; Metropolitan Museum of Art, New York (accessioned 1920, Rogers Fund)

410.

SHAVING BOWL

Yongzheng (1723–35) to Qianlong (1736–95) period, c. 1725–50
13 ⅝ in. (34.6 cm) wide

PROVENANCE Heirloom & Howard Ltd, London, 1989

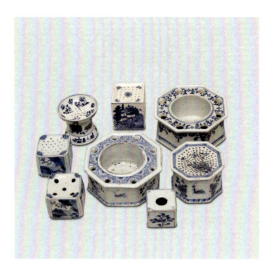

411.
THREE INK POTS, FOUR SANDERS AND A QUILL STAND

Kangxi period (1662–1722)
2 ¾ to 5 ¼ in. (7 to 13.3 cm) wide

PROVENANCE Santos London, 1987 (round sander). Van Halm & van Halm, London, 2016 (top center sander). Heirloom & Howard, Wiltshire, 1990 (top right ink pot). Heirloom & Howard, Wiltshire, 2014 (lower left sander and quill stand)

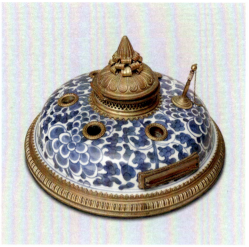

412.
LARGE JAR COVER MOUNTED AS AN INKSTAND

Kangxi period (1662–1722) (the porcelain)
11 in. (27.9 cm) diameter

PROVENANCE Bob Roth's Antique Hardware, Lancaster County PA, 1989

413.
LEAPING PEKINESE PLATTER AND TWO TEABOWLS MOUNTED AS AN INKSTAND

Qianlong period (1736–95), c. 1740–50 (the porcelain)
12 ⅞ in. (32.7 cm) wide

PROVENANCE Heirloom & Howard Ltd, Wiltshire, 2016; Rob Michiels Auctions, Bruges, 23–24 April 2016, lot 480

414.
OCTAGONAL JARDINIÈRE

Qianlong period (1736–95), c. 1750–75
14 ¾ in. (37.5 cm) diameter

PROVENANCE Heirloom & Howard Ltd, Wiltshire, 2016; Adam Partridge, Cheshire, 30 June 2016, lot 606; Geoffrey Waters, London (per label)

415.
SOFT-PASTE GOURD-SHAPED BOX

Qianlong period (1736–95), c. 1760–70
8 ¼ in. (20.9 cm) long

416.
VOMIT POT AND CHAMBERPOT WITH COVER

Qianlong period (1736–95), c. 1750–60
6 ⅛ and 9 in. (15.5 and 22.9 cm) wide with handles

PROVENANCE Heirloom & Howard Ltd, Wiltshire, 1991; Christie's Amsterdam, 28 April–2 May 1986, lot 1156; the Nanking Cargo (the *Geldermalsen*) (vomit pot)

417.
BOURDALOUE WITH COVER

Qianlong period (1736–95), c. 1775–85
10 in. (25.4 cm) high

PROVENANCE Heirloom & Howard Ltd, Wiltshire, 1992; Phillips West Midlands, March 1992

418.
PAIR OF DRAGON CARP SUPPORTS

Tongzhi (1862–74) to Guangxu (1875–1908) period
15 ⅞ in. (40.3 cm) high

PROVENANCE Northeast Auctions, Portsmouth NH, August 2004, lot 462

419.
PAIR OF BALUSTRADE SUPPORTS

Tongzhi (1862–74) to Guangxu (1875–1908) period
11 in. (27.9 cm) high

PROVENANCE Hong Antiques, Bangkok

FURNISHING AND DECORATION

420.
PICTURE FRAME

Guangxu period (1875–1908)
9 ¾ in. (24.9 cm) high

PROVENANCE Heirloom & Howard, Wiltshire, 2019; Woolley & Wallis, Salisbury, 13 November 2019, lot 652; the collection of Sir Thomas Jackson, 1st Baronet (1841–1915)

421.
BIRDCAGE

Tongzhi (1862–74) to Guangxu (1875–1908) period
15 in. (38.1 cm) high

PROVENANCE Philip S. Dubey Antiques, Baltimore, 2015; Waddington's Auctions, Toronto, June 2015

422.
TWO CHINESE SLIPPERS AND A MINIATURE PAIR OF CLOGS

Kangxi period (1662–1722)
4 and 4 ¼ in. (10.2 and 10.8 cm) long (slippers); 1 ⅝ in. (4.1 cm) long (clogs)

PROVENANCE John M. Davis, Harwinton CT (clogs)

393

423.

PAIR OF FOOTED AND MOLDED VASES

Kangxi period (1662–1722)
8 ⅛ in. (20.6 cm) high (the porcelain)

PROVENANCE Weschler's Auctions, Rockville MD, lot 73A (per label)

424.

PAIR OF BOTTLE VASES

Kangxi period (1662–1722)
7 ¼ in. (18.4 cm) high

PROVENANCE Imperial Oriental Art, New York

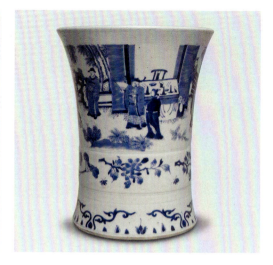

425.

WIDE–NECKED VASE

Kangxi period (1662–1722), last quarter 17th century
9 ¾ in. (24.8 cm) high

PROVENANCE Philip S. Dubey Antiques, Baltimore

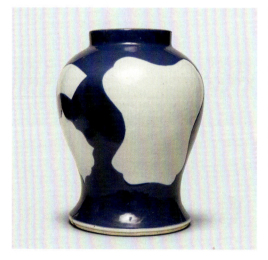

426.

LARGE BALUSTER JAR LACKING OVERGLAZE ENAMELS

Qianlong period (1736–95), c. 1770–80
13 ⅛ in. (33.3 cm) high

PROVENANCE Heirloom & Howard Ltd, Wiltshire, 2017; Chorley's Auctioneers, Gloucestershire, September 2017, lot 300; Charlotte Horstmann & Gerald Godfrey Ltd, Hong Kong (per label)

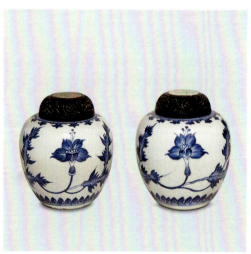

427.

PAIR OF JARS WITH LILY VINE DECORATION

Kangxi (1662–1722) to Yongzheng (1723–35) period
6 ½ in. (16.5 cm) high

PROVENANCE Tremont Auctions, Sudbury MA

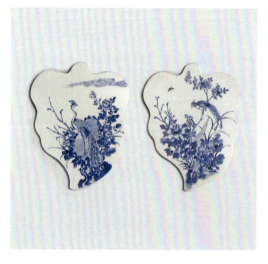

428.

PAIR OF LEAF-SHAPED PLAQUES

Jiaqing period (1796–1820)
10 ¾ in. (27.3 cm) high

PROVENANCE Heirloom & Howard Ltd, Wiltshire, 2011; Gardiner Houlgate Auctioneers, Wiltshire, March 2011, lot 300

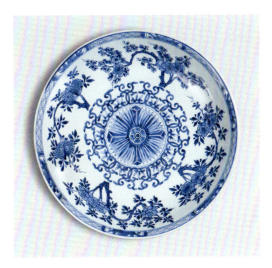

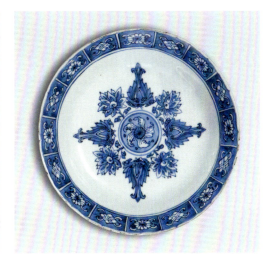

429.
LARGE DISH WITH BLOSSOMING BOUGHS

Yongzheng period (1723–35)
13 ½ in. (34.3 cm) diameter

PROVENANCE Heirloom & Howard Ltd, Wiltshire, 2007; Sotheby's London, 7 March 2007, lot 303; the Estate of the Dowager Lady Hesketh, London

430.
PAIR OF PARROT WALL VASES

Jiaqing (1796–1820) to Daoguang (1821–50) period
8 ⅝ in. (21.9 cm) high

PROVENANCE Gore Dean Antiques, Washington DC

431.
PLATE WITH ISLAMIC-INSPIRED DECORATION

Kangxi period (1662–1722)
8 ⅛ in. (20.6 cm) diameter

PROVENANCE Robert McPherson Antiques, Friesland

FIGURES AND ANIMALS

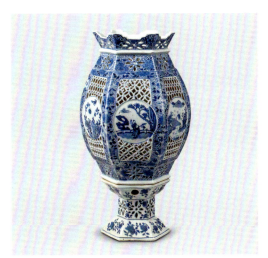
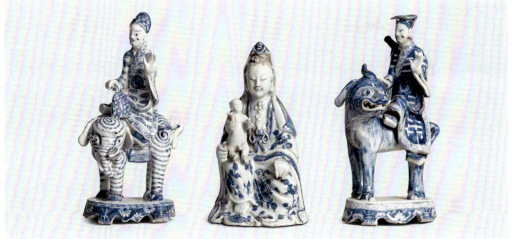

432.
HEXAGONAL LANTERN ON STAND

Jiaqing (1796–1820) to Daoguang (1821–50) period
12 ¼ in. (31.1 cm) high

PROVENANCE The Chinese Porcelain Company, New York

433.
SEATED GUANYIN WITH CHILD AND A PAIR OF IMMORTALS ON BEASTS

Jiaqing period (1796–1820) (Guanyin) and Guangxu period (1875–1908) (immortals)
6 ¾ and 9 ⅛ in. (17.1 and 23.2 cm) high

PROVENANCE Avery & Dash Collections, Stamford CT, 2019 (left). James Galley, Lederach PA, 1992 (center). Hong Antiques, Bangkok (right)

434.

SMALL PAIR OF LUDUAN CENSERS

Jiaqing (1796–1820) to Daoguang (1821–50) period
3 ⅞ in. (9.8 cm) high

PROVENANCE T.K. Oriental Antiques, Williamsburg VA, 1993

435a.

BOWL WITH BUDDHIST ELEPHANT, LIONS AND TREE SHREWS

Wanli (1573–1620) to Chongzhen (1628–44) period
9 in. (22.9 cm) diameter

PROVENANCE Santos London, 2019; Veritas Art Auctioneers, Lisbon, October 2019, lot 76

435b.

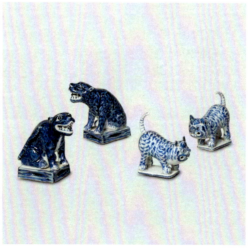
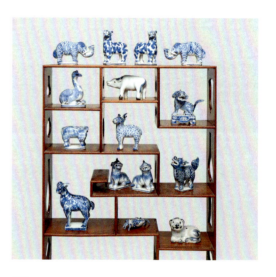

436.

DISH WITH RABBITS

Kangxi period (1662–1722)
13 ¾ in. (34.9 cm) diameter

PROVENANCE Kee Il Choi, Jr., New York, 1991

437.

SMALL PAIR OF LEOPARDS AND SMALL PAIR OF TIGERS

Tongzhi (1862–74) to Guangxu (1875–1908) period
4 in. (10.2 cm) high (leopards); 3 ½ in. (8.9 cm) long (tigers)

PROVENANCE Chai Ma Antiques, Bangkok (leopards). Marie Whitney Antiques, Tolland MA, 1985 (tigers)

438.

GROUP OF FOURTEEN MINIATURE ANIMALS

Jiaqing (1796–1820) to Guangxu (1875–1908) period, 19th century
The tallest 4 ¼ in. (10.8 cm) high
(goat at bottom left)

PROVENANCE Heirloom & Howard Ltd, Wiltshire, 1994; Christie's South Kensington, July 1994, lot 224 (goat). James Galley, Lederach PA, 1979 (pug). Marie Whitney Antiques, Tolland MA, 1985 (remainder)

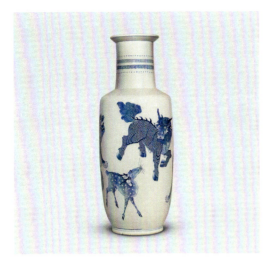

439.
ROULEAU (*BANGCHUIPING*) VASE WITH ANIMALS

Guangxu period (1875–1908)
23 ¾ in. (60.3 cm) high

PROVENANCE William Lipton Ltd, New York

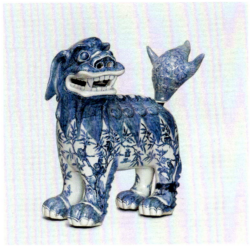

440.
LARGE BUDDHIST LION WITH MONKEYS IN BERRIED BRANCHES

Guangxu period (1875–1908)
14 ¾ in. (37.5 cm) long

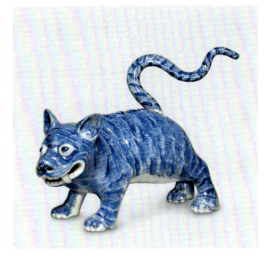

441.
LARGE STRIDING TIGER

Tongzhi (1862–74) to Guangxu (1875–1908) period
9 ⅞ in. (25.1 cm) long

PROVENANCE Santos London, 2020; Veritas Art Auctioneers, Lisbon, 10 December 2020, lot 733

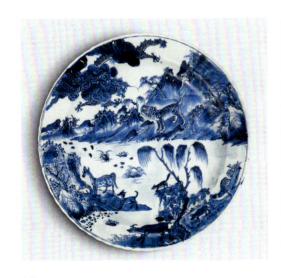

442.
DISH WITH TWELVE ANIMALS OF THE ZODIAC

Guangxu period (1875–1908)
10 in. (25.4 cm) diameter

PROVENANCE Heirloom & Howard Ltd, Wiltshire, 2017; Halls Fine Art Auctioneers, Shrewsbury, 19 July 2017, lot 109; the collection of Peter Wain, Anglesey, Wales

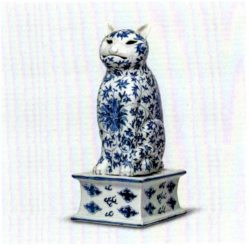

443.
CAT NIGHTLIGHT ON STAND

Guangxu period (1875–1908)
11 ½ in. (29.2 cm) high

PROVENANCE Heirloom & Howard Ltd, Wiltshire, 2013; J.A.N. Fine Art, London, 2013

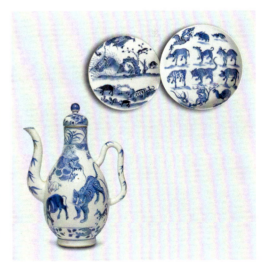

444.
TWO SMALL ZODIAC DISHES AND A ZODIAC EWER WITH COVER

Guangxu period (1875–1908)
The larger dish with four-character hall mark on its base
4 ⅜ and 5 in. (11.1 and 12.7 cm) diameter (dishes); 7 ½ in. (19 cm) high (ewer)

PROVENANCE Heirloom & Howard Ltd, Wiltshire, 2022; Lawrences Auctioneers, Somerset, 6 April 2022, lot 989 (ewer). Heirloom & Howard Ltd, Wiltshire, 2019; David Lay Auctions, Cornwall, July 2019, lot 244 (larger dish)

445.

PAIR OF LARGE ELEPHANTS DECORATED WITH JAPANESE MON

Guangxu period (1875–1908)
12 in. (30.5 cm) long

PROVENANCE Marie Whitney Antiques, Tolland MA, 1980s

446.

SET OF EIGHT LARGE IMMORTALS

Guangxu (1875–1908) to Republic (1912–49) period
10 ¾ to 12 in. (27.3 to 30.5 cm) high

PROVENANCE Millea Bros. Auctioneers, Boonton NJ, 2-3 May 2009, lot 257; the collection of Doris Duke, Hillsborough NJ

TO EUROPEAN DESIGN

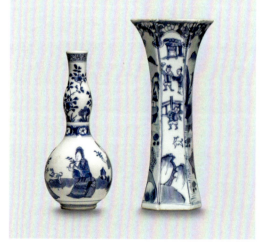

447.

PAIR OF LARGE FROG BOXES

Guangxu (1875–1908) to Republic (1912–49) period, c. 1880–1920
10 ½ in. (26.7 cm) long

PROVENANCE Heirloom & Howard Ltd, Wiltshire, 2012; Christie's New York, 23 January 2012, lot 418

448.

ROTTERDAM RIOT PLATE

Kangxi period (1662–1722), c. 1690–95
Six-character apocryphal Chenghua mark to the base
7 ⅞ in. (20 cm) diameter

PROVENANCE The collection of Peter H.B. Frelinghuysen, Jr.

449.

SMALL SENSE OF SMELL DOUBLE-GOURD VASE AND SMALL HEXAGONAL VASE WITH FOREIGNERS

Kangxi period (1662–1722), c. 1700–10
6 and 7 ⅛ in. (15.2 and 18.1 cm) high

PROVENANCE Santos London, 1992 (left)

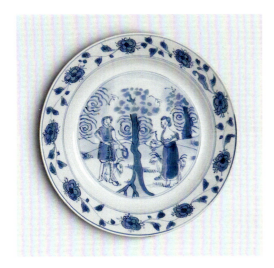
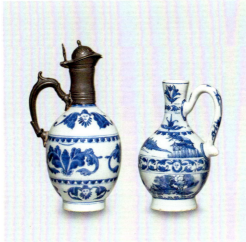
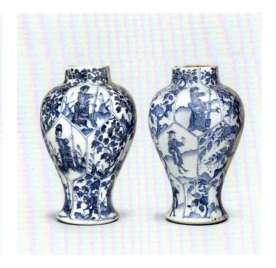

450.

ADAM AND EVE OR SHEPHERD AND SHEPHERDESS PLATE

Kangxi period (1662–1722), c. 1700
6 ½ in. (16.5 cm) diameter

PROVENANCE Heirloom & Howard Ltd, London, 1981

451.

TWO JUGS WITH PUTTO HEADS

Chongzhen period (1628–44)
11 ¼ and 8 ⅝ in. (28.6 and 21.9 cm) high

PROVENANCE Christie's New York, 23 January 2007, lot 16; the collection of Ira and Nancy Koger, Jacksonville FL; Ralph M. Chait Galleries, New York (pewter-mounted)

452.

PAIR OF VASES WITH EUROPEAN HUNTING AND HAWKING FIGURES

Kangxi period (1662–1722), c. 1700
Each base with *yu* (jade or precious thing) mark

7 ⅛ in. (18.1 cm) high

PROVENANCE Christie's London, 8 June 1983, lot 470 (left). Christie's New York, 21 January 1999, lot 85 (right)

453.

THREE SMALL DISHES WITH FIGURES AFTER FRENCH FASHION PRINTS

Kangxi period (1662–1722), c. 1700–10
3 ⅝ to 6 ⅛ in. (9.2 to 15.5 cm) diameter

PROVENANCE World Venture Ltd, Hong Kong, 1979 (left). Renee Carol Rush Antiques, Elkins Park PA, 1980 (center)

454a.

TWO DISHES WITH CUCKOO AND THE HOUSE SCENES

Yongzheng (1723–35) to Qianlong (1736–95) period, c. 1730–50
14 and 9 in. (35.6 and 22.9 cm) diameter

PROVENANCE Heirloom & Howard Ltd, London, 1980 (left)

454b.

399

455.
SCALLOPED DISH AFTER MEISSEN

Qianlong (1736–95) period, c. 1740–60
8 ⅞ in. (22.5 cm) diameter

PROVENANCE The Chinese Porcelain Company, New York, 1988

456.
TEA CANISTER PROBABLY AFTER MARIA SIBYLLA MERIAN

Qianlong (1736–95) period, c. 1740–45
4 in. (10.2 cm) high (the porcelain)

PROVENANCE Heirloom & Howard Ltd, Wiltshire, 2019; Chiswick Auctions, London, November 2019, lot 883

457.
PLATE AFTER PRONK LA DAME AU PARASOL PATTERN

Qianlong (1736–95) period, c. 1740–45
9 ⅛ in. (23.2 cm) diameter

458.
PARROT ON A PERCH TEABOWL AND SAUCER

Qianlong (1736–95) period, c. 1740–50
3 ½ in. (8.9 cm) diameter

PROVENANCE Heirloom & Howard Ltd, Wiltshire, 2016; Rob Michiels Auctions, Bruges, 23–24 April 2016, lot 801

459.
VASE WITH PARROT AND PRONK-STYLE BORDERS

Qianlong (1736–95) period, c. 1740–45
9 ¼ in. (23 cm) high

PROVENANCE Heirloom & Howard Ltd, London, 1985

460.
PAIR OF PLATES WITH PARROTS

Qianlong (1736–95) period, c. 1740–50
10 ½ in. (26.7 cm) diameter

PROVENANCE The Chinese Porcelain Company, New York; Bardith Ltd, New York

461.

MADAME DE POMPADOUR PLATE

Qianlong (1736–95) period, c. 1745
9 ⅛ in. (23.2 cm) diameter

PROVENANCE Heirloom & Howard Ltd, London, 1979

462.

TWO DISHES WITH VARIANT VALENTINE-PATTERN SCENES

Qianlong (1736–95) period, c. 1750–70
12 ¾ and 13 ¾ in. (32.4 and 34.9 cm) diameter

PROVENANCE Heirloom & Howard Ltd, London, 1985 (left). Heirloom & Howard Ltd, Wiltshire, 1992; Christie's Amsterdam, November 1992 (right)

463.

TWO COVERED BOWLS: VALENTINE PATTERN AND FOX HUNTING

Qianlong (1736–95) period, c. 1765–75
5 ¾ and 4 ⅜ in. (14.6 and 11.1 cm) wide

PROVENANCE Heirloom & Howard Ltd, London, 1978

464.

SIX EUROPEAN SUBJECT SALTS

Qianlong period (1736–95)
3 ¼ to 3 ⅝ in. (8.3 to 9.2 cm) high

PROVENANCE James Galley, Lederach PA, 1980 (Guangzhou). Heirloom & Howard Ltd, Wiltshire, 2017; Rob Michiels Auctions, Bruges, February 2017, lot 957 (Tea Production, marked 20). Heirloom & Howard Ltd, Wiltshire, 2015 (Folly Fort). Robert McPherson Antiques, Friesland, 2020 (Merian). The Chinese Porcelain Company, New York, 1990 (Neptune)

465.

SOFT-PASTE PLATE WITH EUROPEAN SHIP NEAR A ROCKY SHORE

Qianlong (1736–95) period, c. 1760–70
8 ⅞ in. (22.5 cm) diameter

PROVENANCE The Chinese Porcelain Company, New York, 1990

466.

TWO VASES WITH DUTCH CHILDREN AND NET MENDERS

Guangxu (1875–1908) period, c. 1900
Apocryphal four-character Kangxi mark to each base
9 ⅛ and 7 ¼ in. (23.2 and 18.4 cm) high

PROVENANCE Heirloom & Howard Ltd, London, 1984; Christie's London, 13 November 1984, lot 161 (larger); Heirloom & Howard Ltd, Wiltshire, 2007; Dreweatts, Berkshire, November 2007, lot 563 (smaller)

467.

PAIR OF SOFT-PASTE TEA CANISTERS AFTER MEISSEN

Yongzheng (1723–35) to Qianlong (1736–95) period, c. 1725–40
3 ¾ in. (9.5 cm) high

PROVENANCE Heirloom & Howard Ltd, Wiltshire, 1998; Christie's London, March 1998, lot 65

468.

SMALL PLATTER AFTER CHANTILLY

Qianlong (1736–95) period, c. 1750–75
Underglaze blue hunting horn mark on the base
10 ⅛ in. (25.7 cm) wide

PROVENANCE Santos London, 1986

469.

PAIR OF PLATES AFTER DELFT PEACOCK PATTERN

Qianlong (1736–95) period, c. 1750–95
8 ⅜ in. (21.3 cm) diameter

PROVENANCE Vallin Galleries, Wilton CT, 1994

470.

FRUIT STRAINER AND STAND AFTER WORCESTER PINECONE PATTERN

Qianlong (1736–95) period, c. 1775–85
8 ¼ in. (20.9 cm) diameter (stand)

PROVENANCE Fred B. Nadler Antiques, Bay Head NJ, 1980

471.

PLATE AFTER ENGLISH SHELL-EDGE CREAMWARE

Qianlong (1736–95) to Jiaqing (1796–1820) period, c. 1790–1815
9 ¾ in. (24.8 cm) diameter

PROVENANCE James Galley, Lederach PA, 1985

SOUTHEAST ASIAN MARKET AND ZHANGZHOU

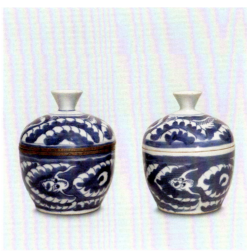

472.
TWO DISHES AFTER ENGLISH TRANSFER-PRINTED WARE

Jiaqing (1796–1820) to Daoguang (1821–50) period, c. 1815–50
6 ¼ and 6 ½ in. (15.9 and 16.5 cm) diameter

PROVENANCE Andrew Dando Antiques, Bradford on Avon (right)

473.
PAIR OF DEEP BOWLS WITH COVERS

Daoguang (1821–50) to Tongzhi (1862–74) period
5 in. (12.7 cm) high

PROVENANCE Marie Whitney Antiques, Tolland MA, 1985

474.
PAIR OF FOOD DISHES WITH COVERS

Daoguang (1821–50) to Tongzhi (1862–74) period
5 ¾ in. (14.6 cm) diameter

PROVENANCE Marie Whitney Antiques, Tolland MA, 1990

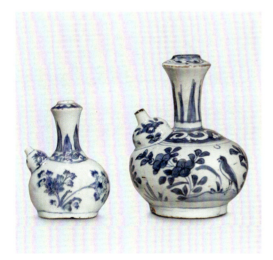

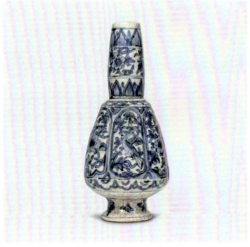

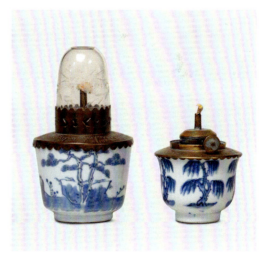

475.
TWO KENDI

Kangxi period (1662–1722) (left) and Tianqi (1621–27) to Chongzhen (1628–44) period (right)
5 ⅜ and 7 ½ in. (13.6 and 19 cm) high

PROVENANCE Benjamin Ginsburg Antiquary, New York (smaller). Heirloom & Howard Ltd, Wiltshire, 2014; Hawkes Asian Art, Somerset (larger)

476.
VASE OR HOOKAH BASE WITH CRACKLED GLAZE

Tianqi (1621–27) to Chongzhen (1628–44) period
9 ⅝ in. (24.4 cm) high

PROVENANCE Heirloom & Howard Ltd, Wiltshire, 2013; Woolley & Wallis, Salisbury, 22 May 2013, lot 315

477.
TWO CUPS MOUNTED AS OPIUM LAMPS

Kangxi period (1662–1722) (left) and Qianlong (1736–95) period (right) (the porcelain)
5 ¼ and 3 ⅛ in. (13.3 and 7.9 cm) high (overall)

PROVENANCE Philip S. Dubey Antiques, Baltimore, 2009; Angiepangie Antiques, Rochester MN (left). Frank Milwee Antiques, Washington DC, 2022 (right)

478.
GROUP OF ELEVEN GAMBLING COUNTERS (*PEE*)

Jiaqing (1796–1820) to Tongzhi (1862–74) period
⅞ to 1 ⅜ in. (2.2 to 3.5 cm) wide

PROVENANCE Senatus Consulto Coins and Antiquities, Copenhagen

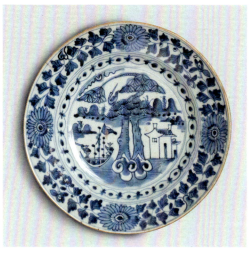

479.
DISH FROM A PROVINCIAL KILN

Jiaqing (1796–1820) to Daoguang (1821–50) period
9 ¼ in. (23.5 cm) diameter

PROVENANCE Heirloom & Howard Ltd, London

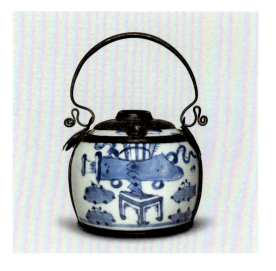

480.
OPIUM PIPE BASE

Daoguang (1821–50) to Tongzhi (1862–74) period
3 ¾ in. (9.5 cm) high (without handle)

PROVENANCE Philip S. Dubey Antiques, Baltimore

JAPANESE MARKET

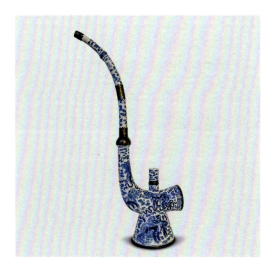

481.
OPIUM PIPE

Guangxu period (1875–1908)
12 ⅞ in. (32.5 cm) high

PROVENANCE RCB Auctions, Bangkok, 10 December 2022, lot 172

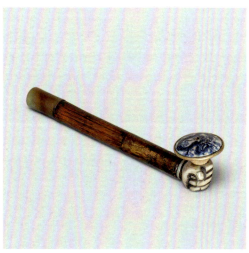

482.
BAMBOO, BONE, HARDSTONE AND PORCELAIN PIPE

Guangxu period (1875–1908)
12 ⅝ in. (32.1 cm) long

PROVENANCE Heirloom & Howard Ltd, Wiltshire, 2018; Catherine Hunt Oriental Antiques, Gloucestershire, 2018

483.
SMALL DISH WITH *RUYI*-HEAD MOTIFS

Tianqi (1621–27) to Chongzhen (1628–44) period
4 ½ in. (11.4 cm) diameter

PROVENANCE Heirloom & Howard Ltd, Wiltshire, 2016; Hawkes Asian Art, Somerset

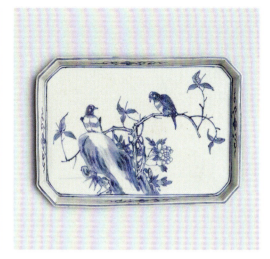

484.
DISH WITH TRIANGLE MOTIF

Wanli period (1573–1620)
8 ¼ in. (20.9 cm) diameter

PROVENANCE Heirloom & Howard Ltd, Wiltshire, 2021; Robert McPherson Antiques, Friesland, 2021

485.
SET OF FIVE KO-SOMETSUKE DISHES

Chongzhen period (1628–44)
With fitted wooden box

3 ⅛ in. (7.9 cm) wide (each dish)

PROVENANCE Frank Milwee Antiques, Washington DC, 2022

486.
TRAY WITH SONGBIRDS

Jiaqing (1796–1820) to Daoguang (1821–50) period
10 in. (25.4 cm) wide

PROVENANCE CopperRed Antiques, Bangkok

MADE IN JAPAN

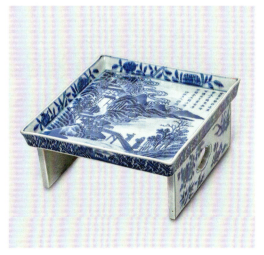
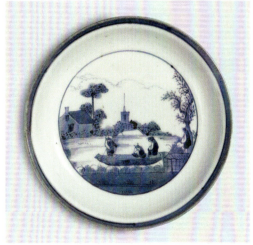

487.
FOOD STAND WITH MOUNTAINOUS LANDSCAPE

Jiaqing (1796–1820) to Guangxu (1875–1908) period, 19th century
With four-character Jiaqing mark on the base

11 in. (27.9 cm) wide

PROVENANCE Heirloom & Howard Ltd, Wiltshire, 2013; Northeast Auctions, 17 August 2013, lot 421

488.
JAPANESE DISH WITH SCHEVENINGEN-TYPE SCENE

Edo period, c. 1700
Apocryphal six-character Chenghua mark on the base

4 ⅞ in. (12.4 cm) diameter

PROVENANCE Heirloom & Howard Ltd

489.
JAPANESE COFFEE POT MOUNTED AS A TANKARD

Edo period, c. 1680–1700
10 in. (25.4 cm) high (the porcelain)

PROVENANCE Heirloom & Howard Ltd, Wiltshire, 2022; Hawkes Asian Art, Somerset

490.
JAPANESE SQUARE DISH WITH INCISED LIGHT BLUE BORDER

Edo period, c. 1660–80
8 ⅜ in. (21.3 cm) diameter

PROVENANCE Robert McPherson Antiques, Friesland, 2018

491.
JAPANESE DISH IN KRAAK STYLE

Edo period, c. 1660–80
13 ⅞ in. (35.2 cm) diameter

PROVENANCE Shreve, Crump & Low Co, Boston, 1977

492.
SMALL JAPANESE HEXAGONAL DISH WITH LANDSCAPE

Edo period, 18th century
5 ⅞ in. (14.9 cm) diameter

PROVENANCE Robert McPherson Antiques, Friesland

493.
JAPANESE DISH AND CHINESE DISH WITH PINWHEEL MOTIFS

Edo period, 18th century (left) and Tianqi (1621–27) to Chongzhen (1628–44) period (right)
6 in. (15.2 cm) diameter (each)

PROVENANCE Heirloom & Howard Ltd, Wiltshire, 1993 (right)

494.
PAIR OF OCTAGONAL JAPANESE DISHES WITH BLUE-GROUND FIGURAL BORDERS

Edo period, late 18th to early 19th century
8 ⅜ in. (21.3 cm) diameter

PROVENANCE EastWest Gallery, Dorset

495.
JAPANESE SCALLOPED DISH WITH LARGE BIRD ABOVE STORMY SEA

Edo period, 18th century
9 ⅞ in. (25.1 cm) diameter

PROVENANCE James Galley, Lederach PA, 1985

496.
TWO JAPANESE BOWLS WITH COVERS

Edo period, late 18th to early 19th century
10 ½ and 4 ⅜ in. (26.7 and 11.1 cm) diameter

PROVENANCE EastWest Gallery, Honolulu, 2012 (left)

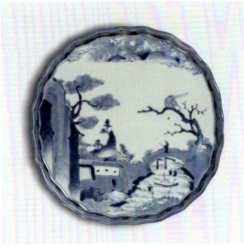

497.
JAPANESE CIRCULAR TRAY WITH LANDSCAPE

Edo period, first half 19th century
8 ¼ in. (20.9 cm) diameter

PROVENANCE Heirloom & Howard Ltd, Wiltshire, 2016; Dreweatts Auctioneers, Berkshire, November 2016, lot 243

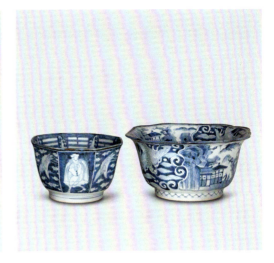

498.
TWO JAPANESE BOWLS: WITH DUTCHMEN AND TRIGRAMS AND WITH HAWKS AND LANDSCAPE

Edo period, late 18th to early 19th century
Apocryphal four-character Xuande mark on the base (right)

6 ½ and 9 ⅛ in. (16.5 and 23.2 cm) diameter

PROVENANCE Suchow & Seigel Antiques, New York (left)

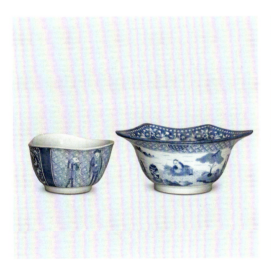

499.
TWO JAPANESE BOWLS: TRIANGULAR AND FAN-SHAPED

Edo period, late 18th to early 19th century
6 ¼ and 9 ⅞ in. (15.9 and 25.1 cm) wide

PROVENANCE Heirloom & Howard Ltd, London, 1984; Christie's London, November 1984, lot 2 (left)

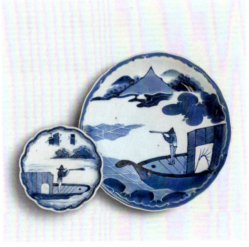

500.
TWO JAPANESE DISHES WITH MEN HOLDING TELESCOPES

Edo period, c. 1820–50
6 ⅛ and 11 ⅜ in. (15.6 and 28.9 cm) diameter

PROVENANCE Heirloom & Howard Ltd, Wiltshire, 2008; Christie's Amsterdam, 20–21 May 2008, lot 400

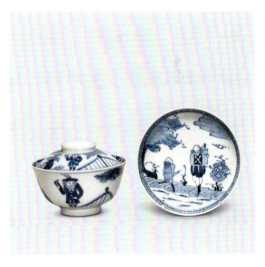

501.
JAPANESE COVERED BOWL AND DISH WITH DUTCHMEN

Edo period, 19th century
4 ⅜ and 4 ⅞ in. (11.1 and 12.4 cm) diameter

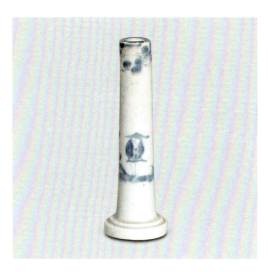

502.
JAPANESE BRUSH HOLDER

Edo period, late 18th to early 19th century
5 ½ in. (14.3 cm) high

PROVENANCE Antique Stone Japan, Tokyo, 2022

503.
JAPANESE FISH-SHAPED DISH

Edo period, 18th century
5 ⅞ in. (14.9 cm) long

504.
JAPANESE FISH-SHAPED WALL VASE

Edo period, 18th century
10 ½ in. (26.7 cm) high

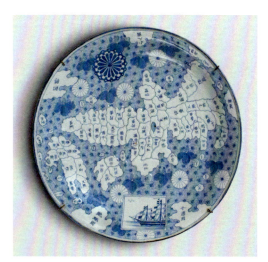

505.
JAPANESE MOLDED MAP DISH

Edo period, c. 1830–50
22 in. (55.9 cm) diameter

PROVENANCE Kee Il Choi, Jr., New York, 1985;
Christie's New York, December 1985, lot 255

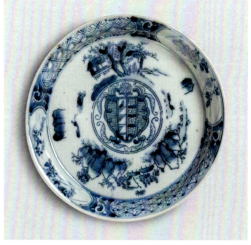

506.
JAPANESE TRANSFER-PRINTED PSEUDO-ARMORIAL DISH

Edo to Meiji period, second half 18th century
6 ⅜ in. (16.2 cm) diameter

PROVENANCE Heirloom & Howard Ltd, Wiltshire, 1996; Sotheby's Amsterdam, May 1996, lot 465

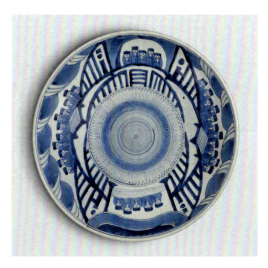

507.
LARGE JAPANESE DISH WITH BUDDHIST MONKS ON BALCONIES

Edo period, c. 1860
13 ¾ in. (34.9 cm) diameter

PROVENANCE Oriental Porcelain Gallery, San Francisco, 1981

THAI MARKET

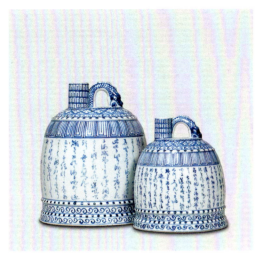
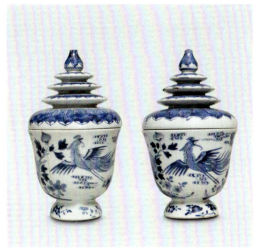

508.
VERY LARGE JAPANESE DISH WITH SHIPS AND DUTCHMEN

Meiji period, c. 1875–1900
17 ¾ in. (45.2 cm) diameter

PROVENANCE Zebregs & Röell Fine Art and Antiques, Amsterdam, 2022

509.
TWO JAPANESE SAKE BOTTLES IN THE FORM OF BRONZE BELLS

Meiji period, late 19th to early 20th century
7 ½ and 5 ¼ in. (19 and 13.3 cm) high

PROVENANCE Heirloom & Howard Ltd, Wiltshire, 2011; Gardiner Houlgate Auctioneers, Wiltshire, March 2011, lot 299 (left)

510.
PAIR OF COVERED JARS (*TOH*) WITH BIRDS

Tongzhi (1862–74) to Guangxu (1875–1908) period
7 in. (17.8 cm) high

PROVENANCE Hong Antiques, Bangkok

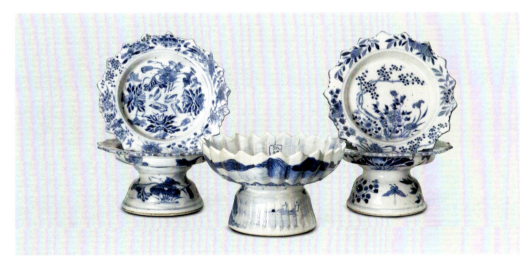
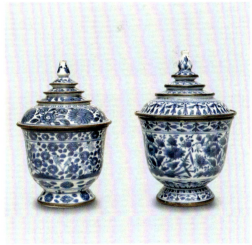

511.
GROUP OF FIVE FOOTED FOOD DISHES

Daoguang (1821–50) to Guangxu (1875–1908) period
5 ¾ in. (14.6 cm) diameter (each)

PROVENANCE CopperRed Antiques, Bangkok (right-hand pair)

512.
PAIR OF COVERED JARS (TOH) WITH STEPPED KNOPS

Daoguang (1821–50) to Guangxu (1875–1908) period
7 in. (17.8 cm) high

PROVENANCE Hong Antiques, Bangkok

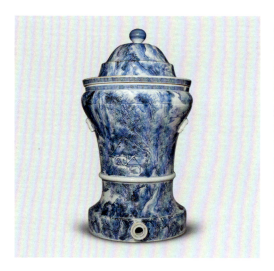
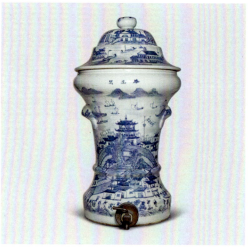
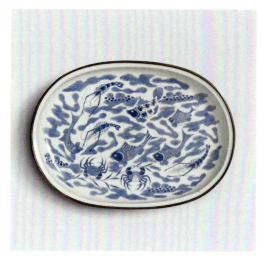

513.

WATER CISTERN WITH LANDSCAPE

Tongzhi (1862–74) to Guangxu (1875–1908) period
26 in. (66 cm) high

PROVENANCE Heirloom & Howard Ltd, Wiltshire, 2016; Woolley & Wallis, Salisbury, November 2016, lot 103

514.

WATER CISTERN WITH THE PAVILION OF PRINCE TENG

Tongzhi (1862–74) to Guangxu (1875–1908) period
23 ¼ in. (59 cm) high

PROVENANCE Heirloom & Howard Ltd, Wiltshire, 2012; Sotheby's New York, 21 January 2012, lot 299

515.

OVAL FOOTED TRAY WITH FISH

Tongzhi (1862–74) to Guangxu (1875–1908) period
Four-character *Po Chu Li Kee* merchant's mark on the base

11 ⅜ in. (28.9 cm) high

PROVENANCE RCB Auctions, Bangkok

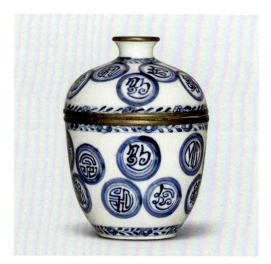
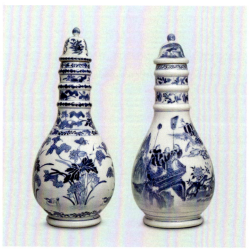
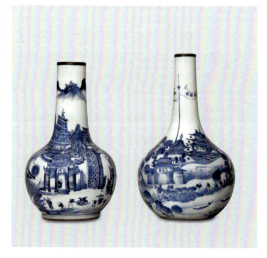

516.

JAR WITH COVER AND MONOGRAMS OF RAMA V, THE QUEEN AND CROWN PRINCE

Guangxu period (1875–1908), c. 1888
Four-character *Jin Tang Fa Ji* merchant's mark on the base
4 ½ in. (11.4 cm) high

PROVENANCE Heirloom & Howard Ltd, Wiltshire, 2017; Amersham Auction Rooms, Buckinghamshire, December 2017, lot 18

517.

TWO WATER BOTTLES WITH COVERS

Guangxu period (1875–1908)
12 ½ and 12 ¼ in. (31.7 and 31.1 cm) high

PROVENANCE CopperRed Antiques, Bangkok

518.

TWO BOTTLE VASES WITH THAI ROYAL PALACES

Guangxu period (1875–1908)
8 ⅞ and 9 ½ in. (22.5 and 24.1 cm) high

PROVENANCE CopperRed Antiques, Bangkok (left). Heirloom & Howard Ltd, Wiltshire, 1997 (right)

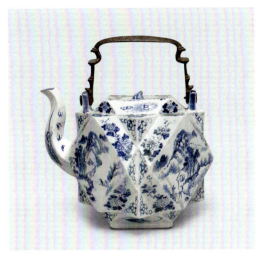

519.

FACETED TEAPOT WITH LANDSCAPE VIGNETTES

Guangxu period (1875–1908)
8 in. (20.3 cm) high (without handle)

PROVENANCE RCB Auctions, Bangkok

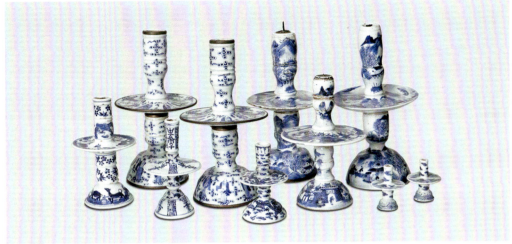

520.

GROUP OF TEN ALTAR CANDLESTICKS

Tongzhi (1862–74) to Guangxu (1875–1908) period
2 ⅝ to 10 in. (6.7 to 25.4 cm) high

PROVENANCE Michael Dunn Antiques, Wiscasset ME, 1987 (tall pair left). Marie Whitney Antiques, Tolland MA (tall pair at right and four medium-sized)

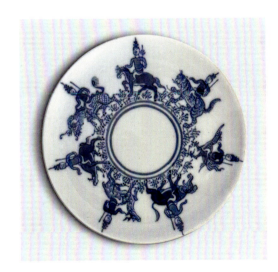

521.

SMALL DISH WITH DEITIES ON BEASTS OF THE HIMMAPAN FOREST

Guangxu period (1875–1908)
4 in. (10.1 cm) diameter

PROVENANCE RCB Auctions, Bangkok, 10 December 2022, lot 1

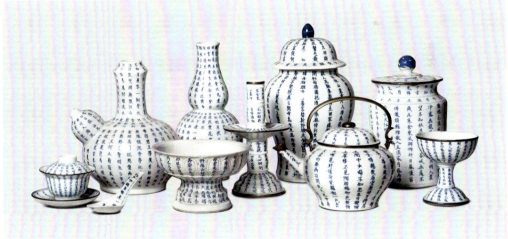

522.

VARIED GROUP OF PIECES INSCRIBED WITH CHINESE POETRY

Guangxu (1875–1908) to Republic (1912–49) period
10 ¼ in. (26 cm) high (baluster jar with cover)

PROVENANCE Heirloom & Howard Ltd, Wiltshire, 1993; Bristol Auction Rooms, Bristol, 5 October 1993 (candlestick). B & C Antiques, Trumbull CT (remainder)

411

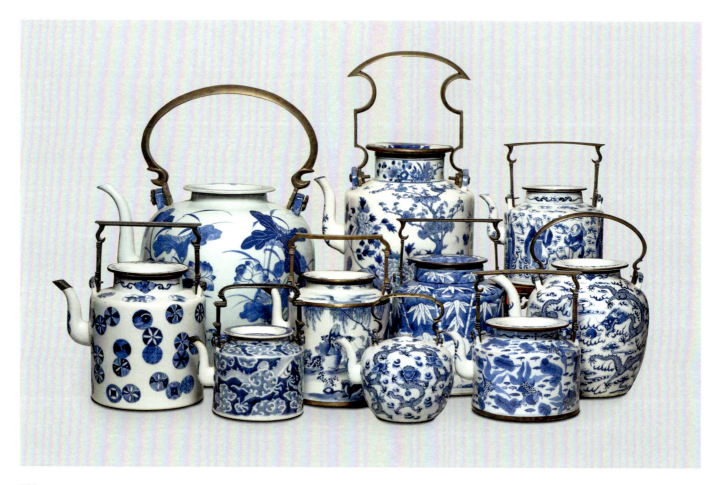

523.

GROUP OF TEN TEAPOTS AND HOT WATER POTS

Tongzhi (1862–74) to Guangxu (1875–1908) period
6 ½ in. (16.5 cm) wide to 12 in. (30.5 cm) high

PROVENANCE Marie Whitney Antiques,
Tolland MA (all)

BIBLIOGRAPHY

Adams and Redstone 1981
Elizabeth Adams and David Redstone, *Bow Porcelain*, London, 1981

Alafouzo, Liu and Gaeta 2021
Marjo Alafouzo, Shutong Liu and Valeria Gaeta (eds.), *Cross-Cultural Art*, Amir Mohtashemi Ltd catalogue, London, 2021

Alves 1998
Jorge M. dos Santos Alves, "The Quest to Convert China: 1550 – c. 1650," in João Rodrigues Calvão (ed.), *Caminhos da porcelana: Dinastias Ming e Qing / The Porcelain Route: Ming and Qing Dynasties*, Lisbon, 1998, pp. 78–86

Aronson n.d. (a)
Aronson Delftware, "The History of Sugar," https://www.aronson.com/the-history-of-sugar/, n.d.

Aronson n.d. (b)
Aronson Delftware, "VOC and the Asian Trading Routes," https://www.aronson.com/voc-asian-trading-routes/, n.d.

Aronson n.d. (c)
Aronson Delftware, "Blue White Tobacco Box and Cover," https://www.aronson.com/blue-white-tobacco-box-cover/, n.d.

Ayers 1991
John Ayers, "Introduction," in Marchant 1991, pp. 7–12

Ayers, Impey and Mallet 1990
John Ayers, Oliver Impey and J.V.G. Mallet, *Porcelain for Palaces: The Fashion for Japan in Europe*, London, 1990

Baarsen 1988
Reinier Baarsen et al., *Courts and Colonies: The William and Mary Style in Holland, England and America*, Cooper-Hewitt Museum exhibition, New York, 1988

Bailey 1999
Gauvin Alexander Bailey, *Art on the Jesuit Missions in Asia and Latin America*, Toronto, 1999

Bailey 2015
Gauvin Alexander Bailey, "Religious Orders and the Arts of Asia," in Carr 2015, pp. 91–109

Ball 1995
Dorian Ball, *The Diana Adventure*, Groningen, 1995

Barker and Impey 1997
Richard Barker and Oliver Impey, *Ko-Imari Porcelain from the Collection of Oliver Impey*, London, 1997

Batts 2017
Joshua Batts, *Circling the Waters: The Keicho Embassy and Japanese-Spanish Relations in the Early Seventeenth Century*, New York, 2017

Berg 2005
Maxine Berg, *Luxury and Pleasure in Eighteenth-Century Britain*, Oxford, 2005

Beurdeley 1962
Michel Beurdeley, *Porcelain of the East India Companies*, London, 1962

Bisalputra 2014
Pimphraphai Bisalputra, "Chinese Blue and White Ceramics with Siamese Motifs," *Arts of Asia*, vol. 44, no. 5, September–October 2014, pp. 104–16

Bisalputra 2017
Pimphraphai Bisalputra, "Ceramic Trade between Early Qing China and Late Ayutthaya, 1644-1767," *Journal of the Siam Society*, vol. 105, 2017, pp. 1–42

Bischoff 2014
Cordula Bischoff, "Women Collectors and the Rise of the Porcelain Cabinet," in Van Campen and Eliëns 2014, pp. 171–89

Boxer 1951
C.R. Boxer, *The Christian Century in Japan: 1549–1640*, London and Berkeley, 2015

Broomhall and Van Gent 2016
Susan Broomhall and Jacqueline Van Gent, *Dynastic Colonialism: Gender, Materiality and the Early Modern House of Orange-Nassau*, Abingdon, UK, 2016

Bufton 1984
Peter Bufton, "Japanese Blue and White Porcelain, Part II," *Arts of Asia*, vol. 14, no. 2, March–April 1984, pp. 67–71

Butler and Canepa 2022
Katharine Butler and Teresa Canepa, *Leaping the Dragon Gate: The Sir Michael Butler Collection of Seventeenth-Century Chinese Porcelain*, London, 2022

Canepa 2006
Teresa Canepa, *Zhangzhou Export Ceramics: The So-Called Swatow Wares*, London, 2006

Canepa 2009
Teresa Canepa, "Namban Lacquer for the Portuguese and Spanish Missionaries," *Bulletin of Portuguese-Japanese Studies*, vol. 18–19, June–December 2009, pp. 253–90

Canepa 2014
Teresa Canepa, "The Iberian Royal Courts of Lisbon and Madrid, and their Role in Spreading a Taste for Chinese Porcelain in 16th-Century Europe," in Van Campen and Eliëns 2014, pp. 17–35

Canepa 2016
Teresa Canepa, *Silk, Porcelain and Lacquer: China and Japan and their Trade with Western Europe and the New World, 1500–1644*, London, 2016

Canepa 2019
Teresa Canepa, *Jingdezhen to the World: The Lurie Collection of Chinese Export Porcelain from the Late Ming Dynasty*, London, 2019

Canepa and Curvelo 2009
Teresa Canepa and Alexandra Curvelo, *Art of the Expansion and Beyond*, London, 2009

Cao 2019
Jianwen Cao, "*Ko-sometsuke* and Shonzui Wares for the Japanese Market Discovered in Kiln Sites of Jingdezhen in Recent Years," *The Oriental Ceramic Society Newsletter*, no. 27, May 2019, pp. 3–5

Carpenter 1974
Francis Ross Carpenter, *The Classic of Tea*, Boston, 1974

Carr 2015
Dennis Carr, *Made in the Americas: The New World Discovers Asia*, Boston, 2015

Carswell 1985
John Carswell, *Blue and White: Chinese Porcelain and its Impact on the Western World*, University of Chicago exhibition catalogue, Chicago, 1985

Carswell 2000
John Carswell, *Blue & White: Chinese Porcelain around the World*, Chicago and London, 2000

Castile 1986
Rand Castile et al., *The Burghley Porcelains*, New York, 1986

Castro 1988
Nuno Álvares Pereira de Castro, *Chinese Porcelain and the Heraldry of the Empire*, Oporto, 1988

Castro 2007
Nuno Álvares Pereira de Castro, *Chinese Porcelain at the Time of the Empire*, Oporto, 2007

Chang 2006
Willow Weilan Hai Chang, "Foreword," in Curtis 2006, pp. xii–xiii

Cheng 2018
Weichung Cheng, "Linking the Visible Cities: The Chinese Junks Sailing between Nagasaki and Batavia (1665–1719)," *Academia Sinica-Institute of Taiwan History*, 2018, pp. 290–339

Chilton 1992
Meredith Chilton, "Rooms of Porcelain," in *The Haughton International Fine Art & Antique Dealers Fair*, catalogue, London, 1992, pp. 13–20

Chilton 2019
Meredith Chilton, *The King's Peas: Delectable Recipes and their Stories from the Age of Enlightenment*, Toronto, 2019

Choi 1998
Kee Il Choi, Jr., "Tea and Design in Chinese Export Painting," *The Magazine Antiques*, vol. 154, no. 4, October 1998, 1998, pp. 510–19

Choi 2018
Kee Il Choi, Jr., "'Partly Copies from European Prints': Johannes Kip and the Invention of Chinese Export Landscape Painting in Eighteenth-Century Canton," *The Rijksmuseum Bulletin*, vol. 66, no. 2, 2018, pp. 120–43

Chong 2016
Alan Chong (ed.), *Christianity in Asia: Sacred Art and Visual Splendor*, Singapore, 2016

Christie's 2016
Japanese Art and its Influence at the European Court, Christie's London sale catalogue, 7 July 2016

Clarke 2013
Jeremy Clarke, *The Virgin Mary and Catholic Identities in Chinese History*, Hong Kong, 2013

Cleveland and Pope 1970
Richard S. Cleveland and John A. Pope, *200 Years of Japanese Porcelain*, St. Louis, 1970

Clunas 1984
Craig Clunas, *Chinese Export Watercolours*, London, 1984

Cohen and Motley 2008
Michael Cohen and William Motley, *Mandarin and Menagerie: Chinese and Japanese Export Ceramic Figures*, Reigate, Surrey, 2008

Conroy n.d.
Rachel Conroy, "Drinking Punch in the Eighteenth Century," https://museum.wales/articles/1116/Drinking-punch-in-the-eighteenth-century-/, n.d.

Corrigan, Van Campen and Diercks 2015
Karina H. Corrigan, Jan van Campen and Femke Diercks (eds.), *Asia in Amsterdam: The Culture of Luxury in the Golden Age*, Peabody Essex Museum and Rijksmuseum exhibition catalogue, New Haven, 2015

Cortazzi 2005
Sir Hugh Cortazzi, "*Yokohama-e*: Japanese Prints of Foreigners in the Late 19th Century," *Arts of Asia*, vol. 35, no. 5, September–October 2005, pp. 64–65

Costelloe 1992
M. Joseph Costelloe, S.J., *The Letters and Instructions of Francis Xavier*, Rome, 1992

Coulon 2021
François Coulon et al., *Making Sense of the World: The Eighteenth-Century Cabinet of Curiosities of Christophe-Paul de Robien*, Rennes, 2021

Crespo and Gschwend 2018
Hugo Crespo and Annemarie Jordan Gschwend, *At the Prince's Table: Dining at the Lisbon Court (1500–1700)*, Lisbon, 2018

Curtis 2006
Julia B. Curtis, *Trade, Taste and Transformation: Jingdezhen Porcelain for Japan, 1620–1645*, China Institute Gallery exhibition catalogue, New York, 2006

Díaz 2010
Rocío Díaz, *Chinese Armorial Porcelain for Spain*, London, 2010

Drey 1978
Rudolf E.A. Drey, *Apothecary Jars: Pharmaceutical Pottery and Porcelain in Europe and the East, 1150–1850*, London, 1978

Du Boulay 1984
Anthony du Boulay, *Christie's Pictorial History of Chinese Ceramics*, Oxford, 1984

Electricity Authority 2013
Electricity Generating Authority of Thailand, "Thailand Electricity History," www.egat.co.th/en/information/thailand-electricity-history, 2013

Espinosa and Takenori 2020
Eladio Terreros Espinosa and Nogami Takenori, "Imari Porcelain Crossing the Pacific Ocean," *The Oriental Ceramic Society Newsletter*, no. 28, May 2020, pp. 50–52

Ferguson 2013
Patricia F. Ferguson, "Luxury Ceramics and Objets d'Art Formerly at Ham House," in Christopher Rowell (ed.), *Ham House: 400 Years of Collecting and Patronage*, New Haven, 2013, pp. 309–24

Ferguson 2017–18
Patricia F. Ferguson, "Chinese Armorial Ware for James Brydges, 1st Duke of Chandos: Self-Fashioning or Artifice?," *Transactions of the Oriental Ceramic Society*, vol. 82, 2017–18, pp. 37–47

Figgess 1990–91
John Figgess, "Japanese Heirloom Swatow Wares," *Transactions of the Oriental Ceramic Society*, vol. 55, 1990–91, pp. 103–04

Finlay 2020
John Finlay, *Henri Bertin and the Representation of China in Eighteenth-Century France*, Abingdon, UK, 2020

Finlay 2007
Robert Finlay, "Weaving the Rainbow: Visions of Color in World History," *Journal of World History*, vol. 18, no. 4, December 2007, pp. 383–431

Finlay 2010
Robert Finlay, *The Pilgrim Art: Cultures of Porcelain in World History*, Berkeley, 2010

Forbes 1978
H.A. Crosby Forbes, "A Rare View of Canton on China Trade Porcelain," *The Magazine Antiques*, vol. 114, no. 4, October 1978, pp. 784–87

Ford and Impey 1989
Barbara Brennan Ford and Oliver Impey, *Japanese Art from the Gerry Collection in the Metropolitan Museum of Art*, New York, 1989

Frasché 1976
Dean F. Frasché, *Southeast Asian Ceramics: Ninth through Seventeenth Centuries*, New York, 1976

Freedman 1991
D.S. Freedman, "Foreword," in Marchant 1991, pp. 3–6

French 1977
Cal French, *Through Closed Doors: Western Influence on Japanese Art, 1639–1853*, Rochester MI, 1977

Fuchigami 2001
Kiyoe Fuchigami, "Analysis of the Spiral Pattern *Karakusa*," *Journal for Geometry and Graphics*, vol. 5, no. 1, January 2001, pp. 35–43

Fuchs 2005
Ronald W. Fuchs II, *Made in China: Export Porcelain from the Leo and Doris Hodroff Collection at Winterthur*, Winterthur DE, 2005

Fuchs 2017
Ronald W. Fuchs II, *50 Treasures: Celebrating the 50th Anniversary of the Reeves Collection of Ceramics at Washington and Lee University*, Lexington VA, 2017

Fuchs 2021
Ronald W. Fuchs, II, "From Rehe, China, to Staffordshire, England: The Voyage of a Chinese Image," *American Ceramic Circle Journal*, vol. 21, 2021, pp. 53–63

Galerie Fournery n.d.
Galerie Nicolas Fournery, "A Rare Chinese Export Porcelain Armorial Plate (Bacelar)," www.galerienicolasfournery.com/collection/a-rare-chinese-export-porcelain-armorial-plate-for-the-portuguese-market-barcelar-kangxi-period/, n.d.

Gardellin 2016
Roberto Gardellin, "The Kangxi Bintan Shipwreck," *Oriental Ceramic Society Newsletter*, no. 24, May 2016, pp. 16–22

Gerritsen 2014 (a)
Anne Gerritsen, "Merchants in 17th-Century China," in Van Campen and Eliëns 2014, pp. 87–95

Gerritsen 2014 (b)
Anne Gerritsen, *The Global Life of a Soya Bottle*, Leiden, 2013

Gerritsen 2020 (a)
Anne Gerritsen, *The City of Blue and White: Chinese Porcelain and the Early Modern World*, Cambridge, 2020

Gerritsen 2020 (b)
Anne Gerritsen, "'A Place Full of Trade': Placing an Early Modern Chinese Town in Global Cultural History," *Cultural History*, vol. 9, no. 2, 2020, pp. 171–94

Ginori Lisci, Lucini and Perotto 1988
Marchese L. Lorenzo Ginori Lisci, Franco Arese Lucini and L. and M.L. Perotto, *Il Servito Ginori*, Milan, 1988

Gommans 2015
Jos Gommans, "Merchants among Kings: Dutch Diplomatic Encounters in Asia," in Corrigan, Van Campen and Diercks 2015, pp. 32–38

Gordon 1977
Elinor Gordon, *Collecting Chinese Export Porcelain*, New York, 1977

Guy 2010
John Guy, "Quanzhou: Cosmopolitan City of Faiths," in James C.Y. Watt (ed.), *The World of Khubilai Khan: Chinese Art in the Yuan Dynasty*, New York, 2010, pp. 159–78

Hall 2015
Andrew Hall, "Chinese Porcelain from an Eighteenth Century Cambridge Coffeehouse," *The Oriental Ceramic Society Newsletter*, no. 23, May 2015, London, pp. 25–29

Hansen 2000
Valerie Hansen, *The Open Empire: A History of China to 1600*, New York, 2000

Harrisson 1979
Barbara Harrisson, *Swatow in Het Princessehof*, Leeuwarden, 1979

Hart 2015
Vaughan Hart, "Chinese Porcelain in the Topkapi Museum, Istanbul," *The Oriental Ceramic Society Newsletter*, no. 23, May 2015, pp. 22–24

Hay 1995
Jonathan Hay, *Art of the Qing Dynasty (1644–1911)*, https://www.academia.edu/25755333/Art_of_the_Ming_Dynasty_1368_1644_Art_of_the_Qing_Dynasty_1644_1911_?email_work_card=title, 1995

Hervoüet 1986
François Hervoüet, with Nicole and Yves Bruneau, *La Porcelaine des Compagnies des Indes à décor occidental*, Paris, 1986

Hong 2021
Kuan Chon Hong, "St. Paul's College in Macao and the Porcelain Trade," *The Oriental Ceramic Society Newsletter*, no. 29, May 2021, pp. 45–49

Honour 1961
Hugh Honour, *Chinoiserie: The Vision of Cathay*, London, 1961

Hood 2017
Suzanne Findlen Hood, "Williamsburg, Virginia," in Robert Hunter and Angelika R. Kuettner (eds.), *Ceramics in America 2017*, Milwaukee, 2017, pp. 220–47

Hornstrand 2013
Cleive Hornstrand, *The Family Grill East Indian Porcelain*, Stockholm, 2013

Howard and Ayers 1978
David Howard and John Ayers, *China for the West: Chinese Porcelain and other Decorative Arts for Export illustrated from the Mottahedeh Collection*, London, 1978

Howard 2013–14
Angela Howard, "The English and their Taste for Chinese Armorial Porcelain," *Transactions of the Oriental Ceramic Society*, vol. 78, 2013–14, pp. 47–64

Howard 1974
David Sanctuary Howard, *Chinese Armorial Porcelain*, London, 1974

Howard 1994
David Sanctuary Howard, *The Choice of the Private Trader: The Private Market in Chinese Export Porcelain illustrated from the Hodroff Collection*, London, 1994

Howard 1997
David Sanctuary Howard, *A Tale of Three Cities: Canton, Shanghai and Hong Kong*, Sotheby's non-selling exhibition catalogue, London, 1997

Howard 2000
David Sanctuary Howard, "Blue-and-White Porcelain for Export before the 18th Century," *Oriental Art*, vol. 46, no. 3, 2000, pp. 37–41

Howard 2003
David Sanctuary Howard, *Chinese Armorial Porcelain*, vol. II, London, 2003

Howard forthcoming
David Sanctuary Howard and Angela Howard, *Chinese Armorial Porcelain*, vol. III, London, forthcoming

Igunma 2016
Jana Igunma, "Asian and African Studies Blog," British Library, blogs.bl.uk/asian-and-african/2016/06/exploring-thai-art-doris-duke.html, 2016

Impey 2002
Oliver Impey, *Japanese Export Porcelain: Catalogue of the Collection of the Ashmolean Museum, Oxford*, Amsterdam, 2002

Jackson 2013
John M. Jackson, "Barbarians at the Gate: Sino-Portuguese Relations, 1513–1522," *EWIAS Viewpoints*, no. 1, December 2013, pp. 137–50

Jackson-Stops 1988
Gervase Jackson-Stops, "The Court Style in Britain", in Baarsen 1988, no. 176

Jacob-Hanson 2000
Charlotte Jacob-Hanson, "Maria Sibylla Merian: Artist and Naturalist," *The Magazine Antiques*, vol. 158, no. 2, August 2000, pp. 174–83

Jörg 1980
Christiaan J.A. Jörg, *Pronk porselein: porcelain naar ontwerpen van Cornelis Pronk / Pronk Porcelain: Porcelain after Designs by Cornelis Pronk*, Groningen, 1980

Jörg 1982 (a)
Christiaan J.A. Jörg, *Porcelain of the Dutch China Trade*, The Hague, 1982

Jörg 1982 (b)
Christiaan J.A. Jörg, *Oosterse keramiek uit Groninger kollekties*, Groningen, 1982

Jörg 1986
Christiaan J.A. Jörg, *The Geldermalsen: History and Porcelain*, Groningen, 1986

Jörg 1989
Christiaan J.A. Jörg, *Chinese Export Porcelain: Chine de Commande from the Royal Museums of Art and History in Brussels*, Brussels, 1989

Jörg 1993
Christiaan J.A. Jörg, "Chinese Porcelain for the Dutch in the Seventeenth Century: Trading Networks and Private Enterprise," in Rosemary E. Scott (ed.), *The Porcelains of Jingdezhen: Colloquies on Art & Archaeology in Asia No. 16*, London, 1993, pp. 183–205

Jörg 1993–94
Jörg, Christiaan J.A. "Exoticism in Japan: Japanese Interest in Dutch Ceramics and Other Curiosities," *Transactions of the Oriental Ceramic Society*, vol. 58, 1993–94, pp. 1–21

Jörg 1997
Christiaan J.A. Jörg, *Chinese Ceramics in the Collection of the Rijksmuseum, Amsterdam*, London, 1997

Jörg 2002
Christiaan J.A. Jörg, "A Pattern of Exchange: Jan Luyken and *Chine de Commande* Porcelain," *Metropolitan Museum Journal*, vol. 37, 2002, pp. 171–76

Jörg 2003 (a)
Christiaan J.A. Jörg, *Fine and Curious: Japanese Export Porcelain in Dutch Collections*, Amsterdam, 2003

Jörg 2003 (b)
Christiaan J.A Jörg, "Chinese thee uit Japanse kopjes," *Vormen uit Vuur*, vols. 184–85, nos. 5–6, 2003, pp. 72–75

Jörg 2007
Christiaan J.A. Jörg, "The Portuguese and the Trade in Chinese Porcelain from the Beginning until the End of the Ming Dynasty," in Alberto Varela Santos (ed.), *Portugal na porcelana da China: 500 anos de comércio / Portugal in Porcelain from China: 500 Years of Trade*, vol. I, Lisbon, 2007, pp. 47–71

Jörg 2016
Christiaan J.A. Jörg, "A Beaker of Transitional Porcelain: The First *Chine de Commande* for the Dutch?," *Vormen uit Vuur*, vol. 232, no. 3, 2016, pp. 16–21

Jörg et al. 2003
Christiaan J.A. Jörg, with Alessandra Borstlap, Jan van Campen and Titus M. Eliëns, *Oriental Porcelain in the Netherlands: Four Museum Collections*, Groningen, 2003

Jörg and Flecker 2001
Christiaan J.A. Jörg and Michael Flecker, *Porcelain from the Vung Tau Wreck: The Hallstrom Excavation*, London and Singapore, 2001

Jörg and Würmell 2019
Christiaan J.A. Jörg and Cora Würmell, "News about the Dresden Porcelain Project," *The Oriental Ceramic Society Newsletter*, no. 27, May 2019, pp. 27–28

Kerr 2012
Rose Kerr, "'The Porcelain City': Jingdezhen in the Sixteenth through Nineteenth Centuries," in Sargent 2012, pp. 33–41

Kerr 2016
Rose Kerr, "The Countess and her Chinese Lions," *Vormen uit Vuur*, vol. 232, no. 3, 2016, pp. 22–29

Kerr 2019
Rose Kerr, "Preface," in Teresa Canepa, *Jingdezhen to the World: The Lurie Collection of Chinese Export Porcelain from the Late Ming Dynasty*, London, 2019, pp. 6–7

Kips 2019
Hester J.E.M.C. Valckenier Kips, "There are Two Sides to Every Dish," *The Oriental Ceramic Society Newsletter*, no. 27, May 2019, pp. 33–35

Koji 2018–19
Ohashi Koji, "Ceramics Excavated From the Dutch Trading Post and Chinese Settlement Sites in Nagasaki," *Transactions of the Oriental Ceramic Society*, vol. 83, 2018–19, pp. 147–62

Krahe and López 2019
Cinta Krahe Noblett and Mercedes Simal López, "Ornament and Household Goods from 'China of Japan' during the Reign of Philip V and Elisabeth Farnese of Spain (1700–1766)," *Art in Translation*, vol. 11, no. 3, 2019, pp. 286–333

Krahl 1986 (a)
Regina Krahl, *Chinese Ceramics in the Topkapi Saray Museum, Istanbul: A Complete Catalogue*, vol. II, *Yuan and Ming Dynasty Porcelains*, London, 1986

Krahl 1986 (b)
Regina Krahl, *Chinese Ceramics in the Topkapi Saray Museum, Istanbul: A Complete Catalogue*, vol. III, *Qing Dynasty Porcelains*, London, 1986

Krahl 2015
Regina Krahl, "Porcelain Diplomacy: The Mahin Banu 'Grape' Dish," Sotheby's New York sale catalogue, 18 March 2015, pp. 6–17

Krahl and Harrison-Hall 1994
Regina Krahl and Jessica Harrison-Hall, *Ancient Chinese Trade Ceramics from the British Museum, London*, Taipei, 1994

Kroes 2007
Jochem Kroes, *Chinese Armorial Porcelain for the Dutch Market*, Zwolle and The Hague, 2007

Kroes 2012
Jochem Kroes, "The Grill Family from Sweden and the Netherlands and their Chinese Armorial Services," *Jaarboek van het Centraal Bureau voor Genealogie*, vol. 66, 2012, pp. 75–101

Lam 2016
Peter Lam, "The Kangxi Longevity Case Revisited," *The Oriental Ceramic Society Newsletter*, no. 24, May 2016, pp. 12–15

Le Corbeiller 1973
Clare Le Corbeiller, *China Trade Porcelain: A Study in Double Reflections*, New York, 1973

Le Corbeiller and Frelinghuysen 2003
Clare Le Corbeiller and Alice Cooney Frelinghuysen, "Chinese Export Porcelain," *The Metropolitan Museum of Art Bulletin*, Winter 2003, pp. 7–60

Leidy and Pinto de Matos 2016
Denise Patry Leidy and Maria Antónia Pinto de Matos, *Global by Design: Chinese Ceramics from the R. Albuquerque Collection*, Metropolitan Museum of Art exhibition catalogue, London, 2016

Lerner 1976
Martin Lerner, *Blue & White: Early Japanese Export Ware*, New York, 1976

Li & Fung n.d.
"Our History – Li & Fung," https://www.lifung.com/about-lf/our-history/, n.d.

Lion-Goldschmidt 1978
Daisy Lion-Goldschmidt, *Ming Porcelain*, New York, 1978

Lion-Goldschmidt 1984
Daisy Lion-Goldschmidt, "Les porcelaines chinoises du palais de Santos," *Arts Asiatiques*, no. 39, 1984, pp. 5–72

Lion-Goldschmidt 1984–85
Daisy Lion-Goldschmidt, "Ming Porcelains in the Santos Palace Collection, Lisbon," *Transactions of the Oriental Ceramic Society*, vol. 49, 1984–85, pp. 79–93

Little 1983
Stephen Little, *Chinese Ceramics of the Transitional Period: 1620–1683*, New York, 1983

Litzenburg and Bailey 2003
Thomas V. Litzenburg, Jr. and Ann T. Bailey, *Chinese Export Porcelain in the Reeves Center Collection at Washington and Lee University*, London, 2003

Loureiro 1998
Rui Manuel Loureiro, "Portugal at the Gateway to China: A Brief History of an Exemplary Relationship," in João Rodrigues Calvão (ed.), *Caminhos da Porcelana: Dinastias Ming e Qing / The Porcelain Route: Ming and Qing Dynasties*, Lisbon, 1998, pp. 45–58

Lu 2012
Zhangshen Lu (ed.), *Passion for Porcelain: Masterpieces of Ceramics from the British Museum and the Victoria and Albert Museum*, National Museum of China exhibition catalogue, Beijing and London, 2012

Lunsingh Scheurleer 1974
D.F. Lunsingh Scheurleer, *Chinese Export Porcelain: Chine de Commande*, New York, 1974

Manginis 2012
George Manginis, "Chinese Porcelain for the Armenian Market," *The Oriental Ceramic Society Newsletter*, no. 20, May 2012, pp. 14–16

Manners 2014
Errol Manners and Christian Jörg, "Schlossmuseum Arnstadt and Other Collections in Thuringia, Germany," *The Oriental Ceramic Society Newsletter*, no. 22, October 2014, pp. 19–22

Marchant 1989
S. Marchant & Son, *Transitional Wares for the Japanese and Domestic Markets*, exhibition catalogue, London, 1989

Marchant 1991
S. Marchant & Son, *Nineteenth Century Mark and Period Porcelain*, exhibition catalogue, London, 1991

Marchant 1998
S. Marchant & Son, *Two Hundred Years of Chinese Porcelain, 1522–1722*, exhibition catalogue, London, 1998

Maritiem-Historische Databank n.d.
Stichting Maritiem-Historische Databank, "Captain," https://www.marhisdata.nl/gezagvoerder&id=3300, n.d.

Marx, Bauman and Bowen 2007–08
Barbara Marx, Johanna Bauman and Deborah Anne Bowen, "Medici Gifts to the Court of Dresden," *Studies in the Decorative Arts*, vol. 15, no. 1, Fall–Winter 2007–08, pp. 46–82

McGill and Chirapravati 2009
Forrest McGill and M.L. Pattaratorn Chirapravati, *Emerald Cities: Arts of Siam and Burma, 1775–1950*, San Francisco, 2009

Meier 2009
Prita Meier, *Objects on the Edge: Swahili Coast Logics of Display*, Cambridge MA, 2009

Motley n.d.
William Motley, "Ref. no. 6375, Chinese Export Porcelain European Subject Blue and White Plate," www.cohenandcohen.co.uk/objectdetail/772587/17665/chinese-export-porcelain-european-subject, n.d.

Mori n.d.
Mori Storehouse Museum, https://www.city.nagasaki.lg.jp/sumai/660000/669001/p006909_d/fil/eng.pdf, n.d.

Mowry 2021
Robert Mowry, "China, Korea and Japan: Separate but Overlapping Ceramic Traditions," lecture, Connecticut Ceramics Circle, New York, 11 October 2021

Mudge 1986
Jean McClure Mudge, *Chinese Export Porcelain in North America*, New York, 1986

Mukharji 2019
Projit Bihari Mukharji, "The Promethean Parsi," *Calcutta by Gaslight*, https://web.sas.upenn.edu/mukharji/2019/11/16/the-promethean-parsi/, 2019

Museum Volkenkunde n.d.
Museum Volkenkunde, "The Chinese Compound, Tojin Yashiki," https://www.volkenkunde.nl/en/our-collection/look-behind-scenes-keiga-folding-screen/blogpost-006-chinese-compound-tojin-yashiki, n.d.

Nilsson 2010
Jan-Erik Nilsson, "Selected Passages from the Letters of Père d'Entrecolles," https://gotheborg.com/letters/#:~:text=The%20letters%20of%20P%C3%A8re%20Fran%C3%A7ois,lived%20from%201664%20to%201741, 2010

Okamoto 1972
Yoshitomo Okamoto, *The Namban Art of Japan*, New York and Tokyo, 1972

Orillaneda 2016
Bobby C. Orillaneda, "Maritime Trade in the Philippines during the 15th Century CE," *Moussons*, no. 27, 2016, pp. 83–100

Orillaneda 2020
Bobby C. Orillaneda, "Crescent-Shaped *Kendi* from the *Santa Cruz* Shipwreck," https://www.nationalmuseum.gov.ph/2021/12/13/crescent-shaped-kendi-from-the-santa-cruz-shipwreck/, 2020

Ostkamp 2011
Sebaastian Ostkamp, "Krekels, kikkers en een lang en voorspoedig leven," *Vormen uit Vuur*, vols. 212–13, no. 1, 2011, pp. 2–31

Ostkamp 2014
Sebaastian Ostkamp, "The Dutch 17th-Century Porcelain Trade from an Archaeological Perspective," in Van Campen and Eliëns 2014, pp. 53–85

Padilla 2012
Carmella Padilla, "The Great Seal of the State of New Mexico," *El Palacio: Art, History and Culture of the Southwest*, vol. 117, no. 1, Spring 2012, pp. 88–90

Perczel 2016
István Perczel, "Monuments of Indian Christian Art: Problems of Genres, Dating, and Context," in Alan Chong (ed.), *Christianity in Asia: Sacred Art and Visual Splendor*, 2016, pp. 38–51

Pergamon Museum 2012
Pergamon Museum, "Fascinated by Blue and White," www.smb.museum/en/exhibitions/detail/fascinated-by-blue-and-white/, 2012

Petrovska 2012
Biljana Bauer Petrovska, "Historical Review of Medicinal Plants' Usage," *Pharmacognosy Review*, vol. 6, 2012, pp. 1–5

Pierson 2013
Stacey Pierson, *From Object to Concept: Global Consumption and the Transformation of Ming Porcelain*, Hong Kong, 2013

Pinto de Matos 1998
Maria Antónia Pinto de Matos, "From Royal Gifts to Commercial Products" and catalogue, in João Rodrigues Calvão (ed.), *Caminhos da Porcelana: Dinastias Ming e Qing / The Porcelain Route: Ming and Qing Dynasties*, Lisbon, 1998, pp. 109–79

Pinto de Matos 2000
Maria Antónia Pinto de Matos, "Chinese Porcelain in Portuguese Public Collections," *Oriental Art*, vol. 46, no. 3, Singapore, 2000, pp. 2–12

Pinto de Matos 2011 (a)
Maria Antónia Pinto de Matos, *The RA Collection of Chinese Ceramics: A Collector's Vision*, vol. I, London, 2011

Pinto de Matos 2011 (b)
Maria Antónia Pinto de Matos, *The RA Collection of Chinese Ceramics: A Collector's Vision*, vol. II, London and Lisbon, 2011

Pinto de Matos 2011 (c)
Maria Antónia Pinto de Matos, *The RA Collection of Chinese Ceramics: A Collector's Vision*, vol. III, London and Lisbon, 2011

Pinto de Matos 2019
Maria Antónia Pinto de Matos, *The RA Collection of Chinese Ceramics: A Collector's Vision*, vol. IV, London and Lisbon, 2019

Pinto de Matos and Dias 1996
Maria Antónia Pinto de Matos, Pedro Dias et al., *Reflexos: símbolos e imagens do Cristianismo na porcelana chinesa / Symbols and Images of Christianity on Chinese Porcelain*, Museu da São Roque exhibition catalogue, Lisbon, 1996

Pinto de Matos and Kerr 2016
Maria Antónia Pinto de Matos and Rose Kerr, *Tankards and Mugs: Drinking from Chinese Export Porcelain*, London and Lisbon, 2016

Piper 1981
David Piper (ed.), *Eastern Ceramics and Other Works of Art from the Collection of Gerald Reitlinger*, London, 1981

Pomper 1995
Linda R. Pomper, "The 'Fountain' Ewers: An Explanation for the Motif," *Bulletin of the Museum of Far Eastern Antiquities*, no. 67, 1995, pp. 51–78

Pomper 2021
Linda R. Pomper, "The Ceiling of the Santos Palace in Lisbon and its Importance as a Historical Document," *The Digital Archaeological Record*, 2021, https://core.tdar.org/document/459330/the-ceiling-of-the-santos-palace-in-lisbon-and-its-importance-as-a-historical-document

Pope 1956
John Alexander Pope, *Chinese Porcelains from the Ardebil Shrine*, Washington DC, 1956

Punya Bordi 2002
Phra Dharma Punya Bordi, *Khruangthuai Wat Pho: Ceramics of Wat Pho*, Bangkok, 2002

RCB Auctions 2022
RCB Auctions, "Siamese Altar Table Decorations: How Worshipping Ancestors Became a Competition," https://www.rcbauctions.com/siamese-altar-table-decorations/, 2002

Reid 2015
Jennifer Reid, *Religion, Postcolonialism and Globalization: A Sourcebook*, London, 2015

Robinson 1985
Natalie Robinson, "Sino-Thai Ceramics," *Journal of the Siam Society*, vol. 73, 1985, pp. 113–31

Rogers 2006
Mary Ann Rogers, "'The Wild Bunch': Chinese Porcelain Expatriates in Seventeenth-Century Japan," in Curtis 2006, pp. 5–15

Rondot 1999
Bertrand Rondot (ed.), *The St. Cloud Manufactory ca. 1690–1766*, New York, 1999

Roxburgh 2005
David J. Roxburgh (ed.), *Turks: A Journey of a Thousand Years, 600–1600*, Royal Academy of Arts exhibition catalogue, London, 2005

Royal Collection n.d.
Royal Collection Trust, "Mary II, Queen of Great Britain (1662–94)," www.rct.uk/collection/people/mary-ii-queen-of-great-britain-1662-94#/type/subject, n.d.

Ruangsilp and Wibulsilp 2017
Bhawan Ruangsilp and Pimmanus Wibulsilp, "Ayutthaya and the Indian Ocean in the 17th and 18th Centuries: International Trade, Cosmopolitan Politics, and Transnational Networks," *Journal of the Siam Society*, vol. 105, 2017, pp. 97–114

Santos 2007
A. Varela Santos (ed.), *Portugal na Porcelana da China: 500 Anos de Comércio / Portugal in Porcelain from China: 500 Years of Trade*, vol. I, Lisbon, 2007

Sargent 1991
William R. Sargent, *The Copeland Collection: Chinese and Japanese Ceramic Figures*, Salem MA, 1991

Sargent 2010
William R. Sargent, "Porcelains with the Arms of the Order of Saint Augustine: For New Spain? A Theory," in Donna Pierce and Ronald Otsaka (eds.), *At the Crossroads: The Arts of Spanish America and Early Global, Trade 1492–1850*, Denver, 2010, pp. 53–66

Sargent 2012
William R. Sargent, *Treasures of Chinese Export Ceramics from the Peabody Essex Museum*, Salem MA, 2012

Sargent 2014
William R. Sargent, *Chinese Porcelain in the Conde Collection*, Mexico City, 2014

Sheaf and Kilburn 1988
Colin Sheaf and Richard Kilburn, *The Hatcher Porcelain Cargoes: The Complete Record*, Oxford, 1988

Shirahara 2007
Yukiko Shirahara (ed.), *Japan Envisions the West: 16th–19th Century Japanese Art from Kobe City Museum*, Seattle, 2007

Shulsky 1989
Linda Rosenfeld Shulsky, "Queen Mary's Collection of Porcelain and Delft and its Display at Kensington Palace," *American Ceramic Circle Journal*, vol. 7, 1989, pp. 51–74

Simonis 2018
Ruth Sonja Simonis, "The King's Personal Shopper: Count Lagnasco's Porcelain Acquisitions in the Netherlands for Augustus the Strong, 1716/1717," https://porzellansammlung.skd.museum/forschung/porcelain-circling-the-globe/#c15669, 2018

Smith 1971–73
Laurence Smith, "Japanese Porcelain in the First Half of the 19th Century," *Transactions of the Oriental Ceramic Society*, vol. 39, 1971–73, pp. 43–82

Sng and Bisalputra 2011
Jeffrey Sng and Pimphraphai Bisalputra, *Bencharong and Chinaware in the Court of Siam*, Bangkok, 2011

Sng and Bisalputra 2015
Jeffrey Sng and Pimphraphai Bisalputra, *A History of the Thai-Chinese*, Singapore, 2015

Staehelin 1966
Walter A. Staehelin, *The Book of Porcelain: Manufacture, Transport and Sale of Export Porcelain in China during the 18th Century*, London, 1966

Stamen and Volk 2017
Jeffrey P. Stamen and Cynthia Volk, with Yibin Ni, *A Culture Revealed: Kangxi-Era Chinese Porcelain from the Jie Rui Tang Collection*, Bruges, 2017

Strober 2013
Eva Strober, *Ming: Porcelain for a Globalised Trade*, Stuttgart, 2013

Strober n.d.
Eva Strober, "The Collection of Zhangzhou Ware at the Princessehof Museum, Leeuwarden, Netherlands," https://docplayer.net/30723870-The-collection-of-zhangzhou-ware-at-the-princessehof-museum-leeuwarden-netherlands-dr-eva-strober.html, n.d.

Tan 2007
Rita C. Tan, *Zhangzhou Ware Found in the Philippines: "Swatow" Export Ceramics from Fujian, 16th–17th Centuries*, Makati City, Philippines, 2007

Teggin 2020
Edward Owen Teggin, "East India Company Career of Sir Robert Cowen in Bombay and the Western Indian Ocean, c. 1719–35," PhD thesis, Trinity College Dublin, 2020

Terwiel 2019
Barend J. Terwiel, "De Marees and Schouten Visit the Court of King Songtham, 1628," *Journal of the Siam Society*, vol. 107, pt. 1, Bangkok, 2019, pp. 25–48

Thompson 2003
Wendy Thompson, "The Printed Image in the West: History and Techniques," Heilbrunn Timeline of Art History, The Metropolitan Museum of Art, http://www.metmuseum.org/toah/hd/prnt/hd_prnt.htm, 2003

Tilley 1984
William Tilley, "Japanese Blue and White Porcelain, Part I," *Arts of Asia*, vol. 14, no. 2, March–April 1984, pp. 62–66

Tingley 2003
Nancy Tingley, *Doris Duke: The Southeast Asian Art Collection*, New York, 2003

Toussaint-Samat 1994
Maguelonne Toussaint-Samat, *A History of Food*, Oxford, 1994

Tribeca n.d.
Tribeca Printworks, "History of Printmaking," https://www.tribecaprintworks.com/history-of-printmaking/, n.d.

Tsuruoka 2016
Hisashi Tsuruoka, "Shoguns and Animals," *Japanese Medical Association Journal*, vol. 59, no. 1, 2016, pp. 49–53

Tudor-Craig 1925
Algernon Tudor-Craig, *Armorial Porcelain of the Eighteenth Century*, London, 1925

Vainker 1991
S.J. Vainker, *Chinese Pottery and Porcelain from Prehistory to the Present*, London, 1991

Van Campen 2014
Jan van Campen, "Chinese and Japanese Porcelain in the Interior," in Van Campen and Eliëns 2014, pp. 191–211

Van Campen 2018–19
Jan van Campen, "Signifiers of Wealth and Status: Chinese Porcelain in Early 17th Century European Paintings," *Transactions of the Oriental Ceramic Society*, vol. 83, 2018–19, pp. 129–46

Van Campen and Eliëns 2014
Jan van Campen and Titus Eliëns (eds.), *Chinese and Japanese Porcelain for the Dutch Golden Age*, Amsterdam, 2014

Viallé 2014
Cynthia Viallé, "Camel Cups, Parrot Cups and Other Chinese *Kraak* Porcelain Items in Dutch Trade Records, 1598–1623," in Van Campen and Eliëns 2014, pp. 37–51

V&A n.d.
Victoria and Albert Museum, "Japan's Encounter with Europe, 1573–1853," https://www.vam.ac.uk/articles/japans-encounter-with-europe-1573-1853, n.d.

Vinhais and Welsh 2014
Luísa Vinhais and Jorge Welsh, *Out of the Ordinary: Living with Chinese Export Porcelain*, London, 2014

Vinhais and Welsh 2016
Luísa Vinhais and Jorge Welsh, *A Time and a Place: Views and Perspectives on Chinese Export Art*, London and Lisbon, 2016

Viraphol 1977
Sarasin Viraphol, *Tribute and Profit: Sino-Siamese Trade, 1652–1853*, Cambridge MA, 1977

Volker 1959
T. Volker, *The Japanese Porcelain Trade of the Dutch East India Company after 1683*, Leiden, 1959

Warren 1968
William Warren, *House on the Klong*, New York, 1968

Watson and Whitehead 1991
Sir Francis Watson and John Whitehead, "An Inventory Dated 1689 of the Chinese Porcelain in the Collection of the Grand Dauphin, Son of Louis XIV, at Versailles: In Memoriam Pierre Verlet, *le maître suprême*," *Journal of the History of Collections*, vol. 3, no. 1, 1991, pp. 13–52

Weng 2022
Yanjun Weng, "The Excavation of Luomaqiao Kiln Site in Jingdezhen," *The Oriental Ceramic Society Newsletter*, no. 30, May 2022, pp. 26–32

Willis 2012
Clive Willis, "Captain Jorge Álvares and Father Luís Fróis S.J.: Two Early Portuguese Descriptions of Japan and the Japanese," *Journal of the Royal Asiatic Society*, vol. 2, no. 22, April 2012, pp. 391–438

Willmann 2011 (a)
Anna Willmann, "Edo-Period Japanese Porcelain," Heilbrunn Timeline of Art History, The Metropolitan Museum of Art, *http://www.metmuseum.org/toah/hd/jpor/hd_jpor.htm*, 2001

Willmann 2011 (b)
Anna Willmann, "The Japanese Tea Ceremony," Heilbrunn Timeline of Art History, The Metropolitan Museum of Art, https://www.metmuseum.org/toah/hd/jtea/hd_jtea.htm, 2001

Wirgin 1998
Jan Wirgin, *Från Kina till Europa: kinesiska konstföremål från de ostindiska kompaniernas tid*, Stockholm, 1998

Xiao 2021
Dashun Xiao, "16th Century Porcelain for Early Sino-Portuguese Trade Discovered on Shangchuan Island," *The Oriental Ceramic Society Newsletter*, no. 29, May 2021, pp. 60–61

Yang 2021
Xiaoyi (Diana) Yang, "Zhangzhou Ware," *Decorative Arts Trust Virtual Dialogue*, https://decorativeartstrust.org/in-the-field/lectures/, 3 June 2021

Yeo and Martin 1978
S.T. Yeo and Jean Martin, *Chinese Blue & White Ceramics*, Singapore, 1978

Yu 2019
Chunming Yu, "Bound for America: A Historical and Archaeological Investigation in Yuegang (Crescent) Seaport as the Main Origin of Galleon Cargo," in Chunming Yu, Roberto Junco Sanchez and Miao Liu (eds.), *Archaeology of Manila Galleon Seaports and Early Maritime Globalization*, Singapore, pp. 3–27

Zebregs & Röell n.d.
"An Important Chinese Blue and White Porcelain Bottle," https://www.zebregsroell.com/chinese-kangxi-porcelain-bottle, n.d.

INDEX

Page numbers refer to both text and illustrated catalogue items.

Abbas the Great, Shah of Iran (Persia), 185
Abeleven, Abraham, 54, 84
Adams, Margaret, 77
Adams, Mehitable, 162
Adolf, Prince Frederik, Duke of Östergötland, 282
Albert (Albrecht) V, Duke of Bavaria, 104
Albuquerque, Gaspar de Saldanha de, 118
Alexander VI, Pope, 'Doctrine of Discovery', 26–27
altar stand, 370
Álvarez, Jorge, 51, 52, 56–57
animals
 bats, 361, 362
 camels, 347
 cats, 215, 224, 227, 397 (C443)
 deer, 116, 228, 231
 discussion, 207–09
 dogs, 36
 dolphins, 121, 126
 elephants, 208, 211, 213, 214, 216, 217, 230, 341, 342, 372, 398 (C445)
 introduction to Japan, 342
 motifs, 211, 214, 216, 341, 342, 372
 significance in Buddhism, 208
 fish, 226, 292, 307, 410 (C515)
 foxes, 62, 410 (C463)
 frogs, 212, 302
 goats, 226
 horses, 290, 293
 lambs, 96
 leopards, 221, 396 (C437)
 lions, 139, 146, 159, 211, 214, 238–39, 396 (C435), 397 (C440)
 monkeys, 201
 rabbits, 67, 197, 290, 301, 396 (C436)
 rams, 55, 85
 sea turtles, 307
 snake/serpent, 120, 139, 204, 256–57
 squirrels, 110
 stag trophy heads, 231
 tigers, 397 (C441)
 tortoises, 72
 water buffalo, 303
apothecary jars, 165–72
Arabic inscriptions, 26, 47, 293
architectural motifs, 238–39, 274, 279, 280–82, 333, 366, 367, 368, 373
Ardebil Shrine, 185, 196, 212, 224
Ardebili, Sheikh Safi al-Din, 185
Arita (Japan), porcelain production and trade, 166, 314, 315
armorial porcelain
 discussion, 51–55
 services, Chinese porcelain, 56–94, 377–84 (C324–64)
 services, Japanese porcelain, 327–31
armorial porcelain, British services
 Adamson arms, 382 (C352)
 Antrobus arms, 383 (C362)
 Beale crest, 383 (C361)
 Bilney crest, 379 (C337)
 Caulfeild, James, Earl of Charlemont, 55, 95
 Chambers crest, 379 (C336)
 Crichton, 381 (C347)
 Crichton impaling Freke, 381 (C346)
 Clifford arms, 378 (C334)
 Cowan, Sir Robert, 54, 77
 Dallas arms, 383 (C358)
 Dalrymple crest, 379 (C335)
 Dalrymple, William, 89
 Deane impaling Heath (or More), 383 (C359)
 Decker, Sir Matthew, and Watkins, Henrietta, 54, 75
 Dundas impaling Maitland, 382 (C353)
 East India Company, British, 383 (C360)
 Erdeswick impaling Crichton, 379 (C339)
 Faxon or Lovell or Fisher, 62
 Ferguson crest, 381 (C349)
 Garland crest (salts and plate), 379 (C335, 338)
 Gibbings crest, 380 (C343)
 Glover arms, 381 (C350)
 Gold impaling Thayer, 78
 Gough, Harry, and Hynde, Elizabeth, 53–54, 76
 Grote, Andrew, 55, 92
 Grote, Joseph, 55, 92
 Harrison, Edward, 54, 72
 Henchman arms, 383 (C357)
 Hughes, Admiral Sir Edward, 93
 Johnson, Sir Henry, and Lovelace, Martha, 53, 64–65, 175
 Johnstone, Sir William, 5th Baronet of Westerhall, 89
 Kiddell (or Alexander) crest, 384 (C364)
 Larkins crest, 384 (C363)
 Laroche with Yeomans in pretence, 382 (C354)
 Lethieullier, John, 81
 Lethieullier crest (two variants) 377 (C325, C328)
 Lethieullier arms, 378 (C329)
 Lowther, Richard, and Adams, Margaret, 77
 Lyons, John, and Harman, Jane, 54–55, 83
 Metge, Peter, 55, 94
 Palk arms, 381
 Palmer with Derwell in pretence, 377 (C326)
 Parker crest, 380 (C341a)
 Peers, Sir Charles, 54, 80
 Peers crest, 379 (C335)
 Prescott, George William, 55, 92
 Roberts, John, 53, 96
 Russell arms, 382 (C356)
 Sayer, Exton, and Talbot, Catherine, 68–69
 Stafford crest, 381 (C345)
 Sutherland, Eric, 4th Lord Duffus, 84
 Sutter impaling Jessope, 178 (C331)
 Sykes, Richard, with bookplate, 54, 90
 Talbot, William, Bishop of Oxford, 68–69
 Udney crest, 382 (C355)
 Unidentified cockerel crest, 380 (C344)
 Unidentified bird crest, 377 (C327)
 Unidentified animal head crest, 380 (C341c)
 Walpole, Horatio, and Cavendish, Rachel, 55, 86
 Webb arms, 382 (C351)
 Wentworth crest, 378 (C330)
 Wheler crest, 380 (C342)
 Whistler family, 54, 79
 Winch crest, 380 (C341b)
 Wolff, Croachrod or Pemberton, 81
armorial porcelain, Dutch services
 Abeleven, Abraham, 54, 84
 Beijsselaar, van, arms 378 (C333)
 Bevere, Gerard de, 61

423

Bleijswijk, Abraham van, 71
Bleijswijk, Abraham van, and Hemert, Anna van, 71
Camphuys, Johannes, 53–54, 60
Does, Gerard van der, and Gollenesse, Dorothea (van) Stein van, 88
Feith, Arnold Hendrik, 74
Greven, Casparus, and Gronard(t), Anna, 91
Haze, Elias de, 83
Haze, Elias de, and Sonmans, Sara, 83
Meij, van der, family (Japanese), 330
Pelgrom, Jacob, 70
Pinto, de, family, 59
Potken, Gerardus, 73
Schreuder arms, 378 (C332)
Stel, van der, 74
Toussain, Reijnier, 88
Toussain arms, 379 (C340)
Unidentified arms (Japanese), 327
Unidentified arms beneath Dutch coronet (Japanese), 327
Unidentified, blank pseudo-armorial (Japanese), 328
Valckenier, Adriaan, 54, 82
armorial porcelain, Italian and Spanish services
Castro, de, impaling Cueva, de la (Japanese), 330
Ginori, Lorenzo, of Florence, 53, 67
Mendoza, García Hurtado de, 4th Marquis of Cañete, Viceroy of Peru, and Castro, Teresa de (as comparison) 55, 58, 330
Spanish Royal Arms (Castile and León), 51, 58
armorial porcelain, Portuguese services
Álvarez, Jorge, 51, 52, 56–57
Bacelar, Pedro Vaz Soares, 67
Coelho de Carvalho, Antonio de Albuquerque, 52, 67
Costa, Rodrigo da, 52, 63
Lancastre, Luís de, 4th Count of Vila Nova de Portimão, 66
Silva, Manuel Joaquim da, 93
armorial porcelain, Swedish services
Grill family, 54, 87
Sandberg, David, initials, 381 (C348)
Ashmolean Museum, Oxford, collection, 319, 338
Asian Art Museum (San Francisco), 356
Atlas Chinensis (Dapper), 333
Augustinian Order, 25, 58, 238–39, 265
Augustus the Strong, King of Poland and Elector of Saxony
inventory mark, 112, 251
porcelain collection, 112, 179, 187, 202, 251
auspicious motifs, 34–35, 72, 106, 109, 151, 197, 208, 211, 231, 352
Ayat an-Nur (Verse of Light), 49
Ayutthaya, 11, 353, 354, 358, 369

Bacelar, Pedro Vaz Soares (Governor of Mombasa), 70

balustrade supports, 393 (C419)
bamboo-sided tray, 308
baroque ornament, 40, 52, 68, 81, 108, 146, 201, 202–03
basins, *see* bowls and basins
Batavia (Jakarta)
commissions, 52, 54, 60, 67, 82, 84, 89, 91, 131, 314, 340
Bateson Wright, Dr G.H., 99
beakers and tankards, 134, 136–39, 376 (C318), 387 (C383), 389 (C395, C396)
bearded head motif, 153, 158, 331
beasts, 395 (C433), 411 (C521)
Beckford, William, 299–300
beer-drinking, 130, 135, 153
bencharong ware, 353–54, 354
betel nut boxes, 290, 353
Bevere, Gerard de, 61
bidets, 96, 167
birdcage, slippers, 393 (C421)
birds and insects, 161, 218, 219, 301, 324
butterfly and caterpillar, 258
cuckoo, 399 (C454)
crane, 40, 72, 87, 176, 310
dove, 41, 125
dragonfly, 371
ducks, 116, 301, 371
eagle, 66, 238–89, 283
egret, 310
geese, 304
heron, 87
paradise flycatcher, 318
parrots, 81, 310, 395 (C430), 400 (C458–60)
peacock, 262, 310, 402 (C469)
pheasant, 155, 294, 310
songbirds, 191, 219
waterbirds, 70, 123, 325
'black ships', 315
'*blanc de Chine*' porcelain, 207, 224, 287
Boas, Álvaro Vilas, e Faria, 140
Bonnart brothers, 244–46, 247
bookplate designs, for coats of arms, 55, 84, 86, 90
bottle vases, *see* vases
bottles, 36, 140–41, 306, 320, 345, 349, 362, 365, 368, 369, 384, 409
Asian market, 306, 362, 365, 368, 369
comprador bottles, 349
'Damascus bottles' (drug jars), 165
drinking and pouring vessels, 134, 140
European designs, 248
furnishing and decoration, 191
Japanese, 315, 317, 318, 320, 345, 349
Jorge Álvarez bottle, 56–57
Rama V monogrammed water bottles, 362, 365
religious themes, 36
sake bottles, 306, 345, 409 (C509)
scent bottle, 384 (C367)
soya bottles, 349
square bottles, 140
wine bottles, 141

Bow (London) porcelain factory, 126
bowls and basins, 62, 77–79, 81, 85, 89, 113, 154, 162, 177, 240, 302, 309, 334, 340–41, 346, 348, 371, 377, 388, 396, 407
alms bowl, 371
Asian market, 302, 309, 371
Buddhist monks assembly bowl, 302
domestic uses, 177
elephant bowl, Buddhist, 396 (C435)
European designs, 240, 255
flower-shaped bowl, 309
'Hollander' bowl, 341
Japanese bowls, 407 (C496, C498, C499, C500, C501)
with European ships, 334
with foreigners, 346
footed bowl, 348
teabowl, 340
kraak bowl, 240
Monteith bowl, 154
octagonal basin, 377 (C327), 388 (C388)
punch bowls, 77, 79, 85, 162
shaving bowls, 177, 391 (C410)
shell-shaped footed basin 388 (C389)
siren teabowl and saucer, 255
sugar bowls (spice bowls), 113
boxes, 110, 111, 174, 178, 263, 290, 301–2, 372
bourdaloue, 393 (C417)
Brazil, coffee plantations, 132
Breakfast Still Life (Boelema de Stomme), salt cellar portrayed, 107
Brewin, Arthur Winbolt, 99
Brinckle, Dr Thomas Rodney, 227
brush holder, Japanesea, 408 (C502)
Brydges, James, 1st Duke of Chandos, 147
Buddhism
in China, 25
Eighteen Lohan, 229
significance of animals, 208
Thailand temples and palaces, 355–56
Buddhist subjects
deities, 32–33, 42, 46, 207, 220
Eighteen Lohan, 229
elephant, 211, 213, 214, 216, 230, 341, 342, 372
lion, 139, 146, 159, 211, 214, 238–39
lotus flower, 46, 49, 79, 83, 108, 118–19, 142, 144, 151, 178, 198, 200, 201, 221, 254, 284, 359, 371
mandorla, 46
monks, 302
Burghley House, 281, 335
butter churns, 182–83
butter tubs, 82, 125

café au lait glaze, 138, 150, 151
camel motif, 347
Camphuys, Johannes (Governor-General, Dutch East Indies), 53–54, 60
candlesticks, 192, 204, 219, 223, 411 (C520)

Canton, *see* Guangzhou (canton)
cartomancy, 260
Castiglione, Giuseppe (Lang Shining), 28
'Cathay' (china), Western view of, 208, 265–66
Catherine of Austria, 166, 185
Catherine of Braganza, 130
Catton, Charles, the Elder R.A., 95
Caulfeild, James, Earl of Charlemont, 55, 95
Cavendish, Rachel, 86
censers, 46, 396 (C434)
chain of office motif, 94, 95
cha-kaiseki wares (in tea ceremony), 299
Chakri dynasty, 354
chamberpots, 378 (C330), 392 (C416)
chambersticks, 204
Charles II, 131
Charlottenburg Palace, Germany, porcelain collection, 187
Chaulnes, Louis August d'Albert d'Ailly, duc de, 159
'Chinamania', 188
'Chinese Imari', 111, 115, 147, 150, 158, 235, 257
Chinese junk traders, 56, 193, 248, 255, 299, 313–14, 353–54
Chinese ladies (*Lange Lijzen*) motif, 118
Chinese landscape motifs, 54, 83, 88, 109, 121, 124, 177, 182, 183, 194, 204, 245, 266, 295, 311, 321, 322, 323, 333, 360 (*see also* riverscape motifs)
 for Japanese market, 300
Chinese paintings in ceramic designs, 266–67, 268, 274
Chinese Rites Controversy, 36
Chinese trading communities, 266, 299, 353, 366
Chinese trading laws, 270
chīnīkhāne, 186, 188
chirugijnwinkel (surgeon's shops), 165
chocolate drinking, 132–33
chocolate pot, 389 (C397)
'Christian Century' (Japan), 313
Christian I, Elector of Saxony, 207
Christian subjects
 angels, 32–33, 36, 171
 baptism, 29, 41
 crosses, 32–33, 37, 38, 40, 42, 43, 49
 Crown of Thorns, 36
 Crucifixion, 29, 36, 38
 fountains, 34–35
 Holy House of Nazareth, 39
 Instruments of the Passion, 241
 IHS, 26, 42
 INRI, 38
 Magic Fountain, 34–35
 Resurrection, 36
 sacred heart, 43
Church of the East Christians (Nestorians), 25–26, 32
cisterns, 256–57, 366, 410 (C513–14)
clogs, 393 (C422)
coat of arms, *see* armorial porcelain

cobalt, 19, 26, 288
Coelho de Carvalho, Antonio de Albuquerque, 52, 67
coffee plantations, 132
coffee pots, 151, 160–61, 252, 324, 405 (C489)
coffee-drinking, 131–32
collections, Japanese
 'Peony Pavilion' collection, 300
 Osumi Collection, 300
collections, museums and historic houses
 Abbas the Great, Shah of Iran (Persia), 185, 196, 212, 213
 Ardebil Shrine (*see also* Sheikh Safi al-Din Ardebili shrine), Iran (Persia), 185, 196, 224
 Ashmolean Museum, Oxford, 319, 338
 Asian Art Museum, San Francisco, 356
 Burghley House, Lincolnshire, 12, 281, 335
 Charlottenburg Palace, Germany, 187
 Drottningholm Palace, Stockholm, 188, 274
 Fontainebleau Palace, Chinese Museum, 356
 Freer Gallery of Art, Washington DC, 290
 Groninger Museum, Groningen, 335
 Ham House, Surrey (Dysart, 4th Earl of), 224
 Keramiekmuseum Princessehof, Netherlands, 274, 288, 328–29
 Neues Palais, Arnstadt, porcelain collection, 188
 Peabody Essex Museum, Salem, 99, 106, 205, 224, 274
 Peacock Room, Freer Gallery of Art, 188–89
 Petworth House, Sussex, 202
 Powerhouse Museum, Sydney, 290
 Rijksmuseum, Amsterdam, 194, 196, 236, 290
 Royal Pavilion, Brighton, 188
 Saint Louis Art Museum, St Louis, 318
 Sanssouci Palace, Potsdam, 188
 Santos Palace, Lisbon, 187, 198, 288
 Schloss Favorite, Rastatt, 188
 Schönbrunn Palace, Vienna, 188
 Sledmere House, Yorkshire, 90
 Wat Pho (Buddhist Temple) collection, 356
 Wat Pho (Temple of the Reclining Buddha), Bangkok, 228, 356
collections, private
 Brinckle, Dr Thomas Rodney, 227
 Curtis collection, 196, 302
 Duke, Doris, 356, 362, 371
 Edwards, Benjamin F., III, 111, 115
 Frelinghuysen, Peter H.B., Jr, 273
 Hervouët collection, 235, 260
 Hall, Dr James Ward, 309
 Lewis, Fran and Tim, 231
 Mottahedeh (Mildred and Rafi), 284
 Thompson, Jim, 231, 356
collections, royal and noble
 Arundel, Aletheai Howard, Countess of, 186
 Augustus the Strong, Elector of Saxony, 112, 179, 187, 202, 251
 Frederick I of Prussia, 186, 187

Grand Dauphin, Le (*see also* Louis XIV, King of France), 188, 186
Maria Theresa, Empress of Austria, 188
Philip V of Spain, 188
Solms-Braunfels, van, Amalia, Princess of Orange, 186, 213
Sibylla Augusta, Margravine of Baden-Baden, 188
Trianon de Porcelaine, 187
William III and Mary II, Hampton Court and Kensington Palace, 187
Compagnie des Indes (Brittany), 261
Costa, Rodrigo da (Viceroy of Portuguese India), 52, 63
Cowan, Sir Robert (Governor of Bombay), 54, 77
cross motif, 30, 32–33, 36, 37, 38, 40, 42, 43
cross-cultural exchange, 236, 287
 evident in ceramic art, 30, 55
 role of missionaries, 25
cruet set, four piece, 115
cruets, 114–15, 142, 241
cuisine, influence on Chinese ceramic design, 101, 102, 105
cups, 39, 151, 255, 389 (C394), 403 (C477)
cups with stands, 151
cupstands, 151
Curtis collection, 196, 302
cylindrical jars, 179

Dalrymple, William, 89
Daoist immortals, 220
Dapper, Olfert (Dutch engraver), 333
De Griecksche A (factory), 197
Decker, Sir Matthew (Director, East India Company), 54, 75
deities
 Buddhist, 32–33, 42, 46, 207
 Chinese, 174, 220
 Hindu, 32–33
 Roman, 243
 Thai, 359
Dejima Island, 60, 299, 314–15, 330, 349
Delft, 338
 influence in Chinese ceramic design, 29, 41, 63, 127, 144, 172, 178, 190, 196, 197, 224, 226, 243, 251, 252, 275, 275–77, 326, 348
 influence in Japanese ceramic design, 315
d'Entrecolles, Père François-Xavier, 165, 224, 266
desk sander and inkwell (Japanese), 323
dining, *see* tableware
dinner services, 88, 91, 97, 104–05, 111, 118, 268, 273–76, 281–82, 337 (*see also* armorial services)
dishes, *see* plates and dishes
'Doctrine of Discovery', 26–27
Does, Gerard van der, 88
dolphin three shell pickle stand, 126
Dominican Order, 25, 36, 58, 265
Doris Duke Charitable Foundation, 356
dragon 45, 77, 95, 159, 346

Drottningholm Palace (Stockholm), 188, 274–75
drug jars, *see* apothecary jars
duck box, 301
Duke, Doris, Thai village replica and collection, 356
Dutch East India Company (VOC), 60, 135
 and Cornelis Pronk, 236
 commercial orders, 109, 190, 191, 204, 226, 233, 240
 dominance in trade with Asia, 29, 51–52
 Geldermalsen shipwreck, 125
 porcelain as percentage of trade, 233
 spice and soya trade, 101, 349
 supply of tableware, 102, 104
 surgeon's shop, 165
 tea imports, 130, 131
 trade with England, 52
 trade with Japan, 29, 314–15
 trade with Thailand, 353
 vineyards, 141
 Zhangzhou porcelain trade, 288
Dutch Protestants, 25
Dutch Republic, collecting and display, 187

East Africa, merchant collections, 188
East India Company (EIC) (England), 131
 armorial service commissions, 53–55
 discovery of punch, 133
 founding, revival and dominance, 52–55
 generic designs, 105
 importing of tea and monopoly, 131
 porcelain as percentage of trade, 233–34
 porcelain trade with Amsterdam, 52
 private trade, 52, 131, 233
East Indies (*see also* Dutch East India Company (VOC); East India Company (EIC) (England))
 perception in Europe, 265
ecuelles, 112
Edwards, Benjamin F., III, collection, 111, 115
Ekeberg, Gustav, 272
elephants, *see* animals
England, porcelain collections, 186
English porcelain, influence in Chinese ceramic design, 126
English silver, influence on Chinese ceramic design, 127
epitaph memorial, 47
errors in design, 72
Europa and the bull coffee pot, 252
European designs, 233–37
 after Delftware, 168, 180, 196, 224–25, 226, 243, 251, 252, 275, 315, 326, 338, 348
 coin model, 263
 earthenware models, 172
 glass models, 129, 140, 141, 193
 influence in Chinese ceramic design, 102, 111, 112, 114, 121, 123, 177, 193, 205, 233, 237–63, 288
 from literature, 224
 from maps, 292
 metalwork models, 55, 118, 130, 136, 146, 148, 158, 160, 189, 192, 202–03, 204
 porcelain models, 108, 262
 from prints and engravings, 234, 234–35, 243, 252, 253, 280, 332
 silver models, 117, 154, 194, 243
 stoneware models, 143, 319, 327
European huntress jar, 244
European landscape motifs, 237, 332
European tableware commissions, 102
ewers, 32–33, 142, 241, 338, 351
 hot air balloon ewer, 351
 peach-form ewer, 142
 silver-mounted ewer, 387 (C385)
 soya ewers, 338
 vase silver-mounted as a ewer, 387 (C386)
 zodiac ewer, 397 (C444)
exotic animals
 capture and importing by explorers, 208
 as gifts to Japanese, 316

famille rose porcelain, 54, 167, 354
famille verte porcelain, 54, 167, 197, 235
Faxon, Lovell or Fisher, 62
Feith, Arnold Hendrik, 74
Ferdinando I, de' Medici, Grand Duke of Tuscany, 207
'Fitzhugh' pattern, 274
Five Birds of Li Fang, 310
Five Ethics, 310
five labeled jars set, 173
'Five Senses' print series, 247
flag motifs, 285
flasks, 37, 45, 51, 58–59, 157, 323
flowers
 carnation, 190, 240
 chrysanthemum, 141, 175, 306, 309, 343
 fleur-de-lis, 89
 iris, 258
 lily, 78, 110, 168, 197, 199, 240, 258
 lotus 46, 49, 79, 83, 108, 118–19, 142, 151, 178, 198, 200, 201, 221, 254, 284, 359, 371
 peony, 40, 42, 77, 78, 79, 91, 118–19, 141, 174, 175, 191, 198, 201, 294, 324, 331
 tulip, 190, 240, 319, 321
Fontainebleau Palace, Chinese Museum, 356
food trade, influence on Chinese ceramic design, 101
footed salts, 108
foreign attendant candleholders, 223
foreign attendant figures, 210, 223
'foreigner' motifs, 223, 322, 343–48
Fort William, Kolkata (Calcutta), 280
Fountain of Life/Fountain of Waters motifs, 34–35
'Four Elements' motifs, 245, 359
'Four Elements' print series, 247
Four Rivers of Paradise motif, 34–35
France
 porcelain collecting and display, 186–87
Franciscan Order, 25, 27, 29, 40, 58, 207, 265, 376 (C319)
Frederick I of Prussia, 186, 187
Frederick II (the Great), King of Prussia, 188
Frelinghuysen, Peter H.B., Jr, collection, 273
French cuisine development, 102–04
French fashion prints, 244–47, 398 (C449), 399 (C452–453)
Frijtom, Frederik van, 326
frog incense box, 302
fruit
 passion fruit, 377 (C324)
 peach, 142
 pear, 135, 145, 194, 318
 pineapple, 75, 259
 pumpkin, 122
Fung Pak-Liu, 99
fuyo-de porcelain, 297
Fuzhou Fu, 270–71

Gama, Vasco da, 208
garden scene motifs, 60, 108, 117, 118, 144, 158, 202–03, 319, 347
garden seat with Hongs of Guangzhou, 273
garnitures, 189, 267, 279
Garuda (Hindu god), 32–33
ginger pots, 179
gingko (longevity) motif, 304, 330
gingko leaf tray, 304
Ginori, Carlo Andrea, founder of Doccia porcelain, 67
Ginori, Lorenzo, of Florence, 53, 67
Goa
 commissions through missionaries, 67
 conversion to Christianity, 27
goat sculptures, 226
goblets, 151, 193, 387 (C382)
Gold of Somerset crest, 78
Gollenesse, Dorothea (van) Stein van, 88
Gough, Harry (East India Company Chairman), 53–54, 76
Grand Dauphin, Le (*see also* Louis XV, King of France)
 and Chinese porcelain collection, 186
Grill, family, 54, 87
Grote, Joseph, 92
Guangzhou (canton)
 as key export port Song dynasty on, 267
 depicted on porcelain, 273, 366, 368, 373
 described by Ibn Battuta, 26, 265
 enameling workshops, 54, 233, 236
 European trading companies, 52, 131
 painting workshops, 268, 275
 trading system, 266
Guanyin, 46, 207
guglets, 84
Gui Xing 174

Hall, Dr James Ward, collection, 309
hand washing cistern, 256–67
happiness and longevity motif, 34–35
Harrison, Edward (Governor of Madras), 54, 72
hat raising motif, 242
Haze, Elias de, 83
Heda, Willem Claesz, paintings, 103, 134, 136, 191
Hehe Erxien, 220
heraldic, *see* armorial porcelain
hexagonal altar stand, 370
hexagonal salts, pair, 106
Hinduism, deities, 32–33
Holstein-Gottorp, 282
Holy House of Nazareth cup, 39
Holy Nails motif, 42
holy water font, 42, 376 (C322)
Hongs of Guangzhou (canton)
 bottle vase, 368
 garden seat, 373
 oil lamps, 373
 water cistern, 366
horse motifs, 290, 293
horse figures, 208, 222
houses motif, 116
Howard, Aletheia, Countess of Arundel, 186
Hughes, Admiral Sir Edward, 93
human figure motifs, 109, 117, 177, 190, 196, 202–03, 242, 256, 256–57, 262, 341
 Chinese ladies (*Lange Lijzen*), 118
 fashion and society, 244–47
 foreign attendants, 210
 'foreigner' motifs, 34–38, 223, 322
 lohan figures, 229
 Mr. Nobody, 224–25
 putto figures, 241, 328–29, 331
 scholars, 58, 190, 191, 240, 301, 308, 319, 343

Iberian Union, 51
Ibn Battuta (explorer in China), 26, 265
ice pattern motif, 179
immortals, 220, 395 (C433), 398 (C446)
incense boxes, 301–02
India Temple pearlware pattern, 234
Indonesia
 appeal of Zhangzhou porcelain, 288
 shadow puppet tradition, 289
initial and cypher motifs, 84, 320, 338
inkpots, 392 (C411)
inkstands, 174, 323, 392 (C412, C413)
Iran (Persia)
 influences on design, 48
 'Muslim blue' (*hui quing*), 26
ironwork motif, 92
Islamic design
 influence in Chinese ceramics 25, 26, 44, 48, 48–49, 129, 157, 199, 234, 288
Islamic food practices, 102
Islamic motifs
 arabesque motifs, 81, 317

calligraphic motifs, 47
crescent motif, 44
Islamic-inspired decoration, 395 (C431)
inscriptions, 26, 47, 49, 293
palmette motif, 199, 234
Islamic oil lamp, 48
Islamic tile, 47
Italy, trade with Asia, 25

James I of England, 130
Japan
 anti-Christian campaigns, 314
 Christian churches and missionaries, 29
 Christianity, spread of, 313
 fuyo-de porcelain, 297
 influence on Chinese ceramic design, 72, 172, 236, 250
 interest in foreign culture, 315–16
 as market for porcelain, 288, 297, 297–300
 porcelain production, 166, 314, 315–16
 trade with, 28, 29, 267, 313–16
 wabi aesthetic, 297
Japanese Palace (Dresden), 187
Japanese porcelain, 330–31, 327, 318, 318, 346, 334, 324, 323, 337, 350, 347, 342, 344, 335, 323, 348, 338, 341, 351, 320, 319, 322, 325, 321, 342, 325, 338, 339, 345, 343, 347, 326, 328–29, 319, 349, 338, 338, 336, 340, 332, 333
jardinières and planters, 64–65, 76, 175, 339, 392 (C414)
jars, 38, 40, 168–73, 179, 190, 194, 199, 214, 216, 218, 241, 244, 247, 318, 319, 358–59, 363, 376, 394
 albarelli (drug jars), 165, 166–67, 172
 animals, 214
 baluster jar lacking overglaze, 394 (C426)
 birds, with, 318, 409 (C510)
 domestic use, 168–72, 173, 179
 European designs, 241, 244, 247
 footed jar, 190
 Franciscan jar, 376 (C319)
 furnishing and decoration, 190, 194, 199
 Japanese, 318, 319
 jars with lily vine decoration, 394 (C427)
 Jesuit jars, 376 (C320)
 kraak auspicious animals jar, 214
 palmettes jar, 199
 pear-shaped jar, 194
 religious themes, 38, 40
 Thai market, 358–59, 363
Java, shadow puppet tradition, 289
Jesuits (Society of Jesus), 25, 27, 29, 36, 39, 42, 56, 58, 165, 207, 224, 234, 265–66, 313, 376 (C320)
Jingdezhen
 closure and reopening of kilns, 297, 299, 354
 destruction of kilns, 283
 porcelain production, 26, 54, 102, 116, 129, 165, 185, 193, 265–66
 specialization of kilns, 235

Johnson, Sir Henry (EIC shipbuilder), 53, 64–65, 175
Johnstone, Sir William, 5th Baronet of Westerhall, 89
Jor Pol Ror royal monogram, 361, 362
Jörg, Christiaan, 29, 113, 142, 151, 165–66, 181, 194, 196, 225–26, 235, 241, 261, 290, 318, 320, 322–23, 325, 328, 330, 340, 347
jugs, 89, 142–50, 152–53, 327, 338, 388
 armorial jug, 327
 chilong handle jugs, 152
 Chokichidani kiln site jug, 319
 cream jug, 158
 double-necked cruet jugs, 114
 drinking and pouring vessels, 143–50, 152, 153, 158
 fluted baluster jug, 150
 helmet jugs, 146–47
 Japanese, 319, 321, 327, 338
 kraak-style jugs, 321
 long-handled small jug, 388 (C390)
 mask spout jug, 153
 pear-shaped jug, 145
 puzzle jugs, 144
 silver-mounted jug, 319
 small jugs, pair, 142
 square jugs, pair, 149
 tableware, 114
Julius II, Pope, 27

kangsai ware, 353
kendis, 44, 45, 212–13, 287, 403 (C475)
Keramiekmuseum Princessehof (Netherlands), collection, 274, 288, 328–29
Kirk, Sir John, 188
Kocx, Adrianus, 197
Kosakorn, Bariboon, Phraya, 355, 364, 370
ko-sometsuke wares, 221, 297, 299, 303, 304
kraak style, 135, 212, 216, 240, 297, 301, 321, 322, 325, 330
Kyoto ware, 348

La Varenne, François Pierre de, 104
Lagnasco, Count, 187
Lai Att royal monogram, 361, 363
Lai Look Mai Khang Khao monogram, 361, 362
Lancastre, Luís de, 4th Count of Vila Nova de Portimão, 66
Lancastre family, 187, 198
Landscape, *see* Chinese landscape; European landscape; garden scene; riverscapes; rural landscape
Lange Lijzen (Long Elizas), 118
lantern, parrot wall vases, 395 (C432)
leaf tip border motif, on apothecary jars, 168–69, 171
legal motifs, 94
L'empire de la vertu cup, 255
Les Métamorphoses d'Ovide, 253

Lethieullier, John, 81
Lewis, Fran and Tim, collection, 231
light of faith motif, 36
lighthouse coffee pot design, 161
lighting items, 189
linglong design, 359
lions, significance in Buddhism, 208
Lisbon trade embargo, 51
literary Chinese motifs, 61
lohan set, 229
Long, Sarah. 92
longevity, motifs for, 34–35, 72
Loreto Holy House, 39
Louis XIV, King of France, 186, 353
Louis XV, King of France, 111, 159
Lovelace, Martha, 64–65
low table, 310
Lowther, Rev. Richard, 77
Luo Hongxian (poet), 308
Luyken, Jan, 29
Lyons, John, 55, 85

Macao
 commissions, 43, 96, 233
 production of ceramics with Christian motifs, 28
 tea shipments, 130
Madras, commissions, 89
Mae Phra Kongka (water goddess), 359
mancerinas, 133, 151
Manila
 production of ceramics with Christian motifs, 27
 trading, 314
Maria Theresa, Empress of Austria, porcelain collecting, 188
Marieberg faience factory, 205
maritime motifs, 288, 291–92, 305, 309, 315, 332, 334, 335, 350
Maritime Silk Route, 265, 353
marks, 242
 AK, 197
 Augustus the Strong, 112, 251
 Chenghua, 191, 242, 269, 301, 332, 346
 Daoguang, 309, 372
 fuku, 326
 G, 196
 Jiajing, 305
 Jin Tang Fa Ji, 355, 364, 365, 370
 Kangxi, 116
 ken, 346
 Made by Bashō, 318
 Po Chu Li Kee, 368, 369
 Song bai chang qing, 46
 Thai reign, 361–63
 Wan fu you tong, 34–35
Marot, Daniel, 187–88
meat covers (dish covers), 118–19
Medici porcelain factory (Florence), 114

medicinal plants, 165–66
Mehta, Merwanjee Nanabhoy (Bombay trader), 98
Meij, van der, family, 330
Melaka (Malacca), 26, 233
melon-form sweetmeat box, 372
Mendoza, García Hurtado de, 4th Marquis of Cañete, Viceroy of Peru, 55, 58, 330
Merian, Maria Sibylla, 236, 258
metal mounts 38, 138, 150, 158, 167, 174, 186, 188, 324
metalwork models, 189
 European, 124, 130, 136, 146, 148, 154, 158, 160, 202–03, 204
 Middle-Eastern, 142, 192, 196
 silver models, 201
 South Asian, 142, 196, 353
Metge, Peter (Baron of Irish Exchequer), 55, 94
Metropolitan Museum of New York, 302
missionaries
 in Japan, 58
 role in cross-cultural developments, 25
 role in development of trade, 265
 use of religious imagery, 234
Mongolian empire, 26
Mottahedeh collection, 284
Mr. Nobody figure, 224–25
mugs and tankards, 134, 135, 138–39, 315, 388 (C391, C392), 389 (C393)
Musées Royaux d'Art et d'Histoire (Brussels), 241
Muslims, *see* Islamic faith
mythical creatures
 dragon, 45, 77, 95, 159, 346
 phoenix, 174, 201, 212, 284
 qilin, 34–35, 214, 304
Mythological subjects, 235
 Bacchus, 243
 Dircetis and Naïs, 253
 Europa and the Bull, 252
 Fall of Phaethon, 254
mythological tray and teapot, 253

Nagasaki, foreign trading communities, 299, 314
Nagasaki *miyage* prints, 315
namban decoration, 236, 250
Nanan Fu (Ganzhou), 270–71, 272
narrative motifs, 109, 174
Native Americans motif, 123, 147
neoclassical style, 162, 205
Nestorians (church of the East Christians), 25–26, 32–33
Netherlands (*see also* Dutch East India Company (VOC); Dutch Republic)
 armorial services, 52
 ceramic art influences, 29, 315
Neues Palais (Arnstadt), porcelain collection, 188
New Mexico territory dishes, 283–84
'New Shipping' wares, for Japanese market, 300

Newhailes House, Scotland, 89
Nieuhof, Johan, 208
 engraving model for plate, 278
 influence on Western view of China, 265, 278
nightlights, 224

oil lamps
 mosque lamps, 48–49
 oil lamps with Hongs at Guangzhou (canton), 373
opium pips, 404 (C480–82)
Oranienburg Palace (Germany), porcelain collection, 187
ormolu mounts, 38, 138, 167, 174, 186, 188, 324
Osumi Collection, 300
Ottoman Empire styles, 45

palmette motif, 199, 234
Pavilion of Prince Teng motif, 127, 367
Peabody Essex Museum, Salem, collection, 99, 107, 215, 224, 275
peach motif, 142
pee (gambling counters), 404 (C478)
Peers, Sir Charles (East India Company Chairman and Mayor of London), 54, 80
pekinese dogs, mistaken for cats, 209
Pelgrom, Jacob, 70
'Peony Pavilion' collection, 300
Persian cross, 32–33
Persian influences on design, 48
Petworth House, porcelain collection, 202
pharmacies, 165, 171
Philip II of Spain
 collection, 213
 Iberian union of Spain and Portugal, 51
Philip V of Spain, porcelain collection, 188
Philippines, establishment of Spanish trade, 27
phoenix motif, 174, 201, 212, 284
picnic motif, 177
picture frame, slippers, 393 (C420)
Pigafetta, Antonio, 288
Pinto, de, family, 59
Pinto de Matos, Maria Antónia, 38, 106, 121, 170, 239, 246, 261
pipe smoking, 345
planters, 339 (*see also* jardinières and planters)
plaques, 43, 266, 394 (C428)
plates and dishes, 41, 46, 59, 60, 61, 63, 67–77, 80–81, 83, 84, 86–88, 90–93, 97, 99, 116–18, 197–98, 200–01, 211, 221, 238–39, 242–43, 245, 246, 250–51, 254–56, 258–61, 274–78, 280–85, 289, 291–95, 303–05, 311, 321, 322, 325, 326, 328–31, 335, 342–44, 347, 350, 377, 379, 381, 382, 384, 395, 398, 399, 400 401, 405, 400, 406, 408
 Adam and Eve or shepherd and shepherdess plate, 399 (C450)
 Air Nouveau plate, 236, 261
 arbor plate, 256
 Armenian monogram dish, 97

Asian market, 291–95, 302, 304–05, 311
Batavia New Gate plate, 278
Bleijswijk, Abraham van, plate 71
blossoming boughs, with, 395 (C429)
botanical dishes, 258–59
Buddhist animals dish, 211
Buddhist dish, 46
compass and ships dishes, 291–92
duck pond plates, 116
Eight of Spades plate, 236, 260
enameled dish, 197
European designs, 117, 242, 243, 245–46, 250–51, 253, 256, 258–61
figures and animals, 211, 218, 221, 226
fish-shaped dish (Japanese), 408 (C503)
flat-rim plates, 116
furnishing and decoration, 197, 198, 200–01
hot water dish, 274
ingot-shaped dish, 384 (C366)
Islands of Bliss dish, 295
Japanese dishes, 350, 406 (C490–95), 408 (C505–07)
 armorial dishes, 330–31
 dishes with foreigners, 344
 dishes with ships, 335, 408 (C508)
 dish with camel and foreigner, 347
 dish with elephant, 342
 scalloped dishes, 343, 347
 Scheveningen dishes, 326
 shield dish, 328–29
Jiangxi province checkpoint plates, 270–71
Ko-Sometsuke dishes, 405 (C485)
kraak-style dishes, 322, 325, 406 (C491)
kraak dish with elephant, 216
leaf-shaped dish, 384 (C366)
leopard lotus dish, 221
lotus medallion dish, 198
Meissen, after (scalloped dish), 400 (C455)
molded dish, 342
mukozuke dishes, 299, 300
mythological lotus dish, 254
mustard pots, 109
namban ship dishes, 250
New Mexico territory dishes, 283–84
octagonal plates, 117, 381 (C345, C346), 382 (C351)
pancake plate, 379 (C340)
passion fruit plate, 377 (C324)
playing card plate, 260
rabbits, with, 396 (C437)
radiating flower stem dishes, 200
religious themes, 41, 46
Republic of China plate, 285
Rotterdam riot plate, 398 (C448)
saucer dishes, 82, 91
shadow puppet dishes, pair, 289
shell dish, 311, 379 (C337)
spiral fluted dish, 201
tea production dishes, 275–77

tea production plate, 336
topographical themes, 270–03, 274, 275–78, 280–83
valentine dish, 401 (C462)
zodiac dishes, 397 (C442, C444)
platters, 94–95, 98, 226, 272–73, 381, 382, 384
 Dutch folly fort platter, 272
 herring platter, 226
 pekinese platter, 392 (C413)
 well-and-tree platter, 384 (C363, C364)
Po Chu Li Kee mark, 368–69
poetry, inscriptions, 522 (C411)
Polo, Marco
 on China, 208
 on Quanzhou, 265
 on spittoons, 176
Pomet, Pierre, *Compleat History of Druggs*, 259
Pompadour pattern, 236
porcelain production
 Arita, 166
 Jingdezhen, 26, 54, 102, 116, 129, 165, 185, 193
 motifs, 266, 267, 268, 269, 270–01
 techniques, 26, 54, 265–66
 Zhangzhou, 287–78
porringers, 112
portrait box and cover, 263
Portugal and Portuguese
 'awarded' lands under papal bull, 27
 commissions for Christian motifs, 26, 27
 presence in Thailand, 353
 trade with Asia, 25
 trade with Japan, 313, 314
Porzellankabinette, 185, 187, 188
Potken, Garardus, 73
Powerhouse Museum, Sydney, 290
Poyang Lake, 267, 269–70
Prescott, George William, 92
Prescott, Grote, Culverden & Hollingsworth (bankers), 55
Prince Regent (later George IV of England), Royal Pavilion design, 188
prints and engravings, source of designs, 214, 234, 234–35, 243, 252, 253, 280, 315, 316, 351
Pronk, Cornelis, porcelain designs, 236, 256–57, 400 (C457, C459)
Protestants
 communities, 43
 and spread of trade, 25, 29
pudding molds, 182
Pulteney, Sir William, *see* Johnstone, Sir William
punch-drinking, 133
putto motif, 241, 328–29, 331

qilin, 34–35, 214, 304
Quanzhou (Zaiton/Zayton)
 as key export port, 26, 265, 267
 described by Ibn Battuta, 26, 265, 267

Muslim community, 32, 49, 265
Nestorian tombstone, 32
Quranic texts, 26, 47, 49

Rama I, Phutthayotfa Chulalok, King of Siam (Thailand), 354
Rama V, Chulalongkorn, King of Siam (Thailand), 248–49, 354–55, 360, 370
 monogrammed ceramics, 361–65
Raupenbuch (Merian), 258
Regent of Siam (Thailand), Somdet Chao Phraya Sri Suriyawongse, 360
religious motifs, *see* Buddhist motifs; Christian motifs; Islamic motifs
repurposing of items, 189
Resurrection subject, 36
Ricci, Matteo, 28, 29
rice-grain pattern jars, 359
Ridgway, John and William, 234
Ripa, Matteo, 234
river transportation of porcelain, 267
riverscapes, 88, 99, 115, 116, 117, 124, 156, 161, 163, 322, 323, 339, 369
Roberts, John (EIC chairman), 53, 96
rocaille decoration, 336, 337
rococo style, 54, 86, 90, 104, 121, 122, 275
Rouen faience, 81, 120, 149, 336
round footed box, 178
royal monograms and insignia, 26, 51
 King Rama V, 355, 361–65
Royal Pavilion (Brighton), 188
Ruizhou Fu (Gao'an), 270–71
rural landscape motifs, 177, 240, 251, 252, 262, 326, 332, 338
ruyi motif, 46, 195, 198, 215, 309, 359

Sacred Heart plaque, 43
Saint Louis Art Museum, collection, 318
salt containers, 106–08, 315, 379 (C335), 401 (C464)
salt supply, influence on ceramic design, 101
salts pair, 108
sanders, 323
Sanssouci Palace (Potsdam), garden pavilions, 188
Santos Palace (Lisbon), 198
 porcelain collection, 187, 288
Sargent, William R., 58, 183, 209, 220, 238, 272
Sayer, Exton, lawyer, 68–69
Scales of Justice, 94
Scheveningen village landscape, 326
Schloss Favorite (Rastatt), 188
scholar motif, 58, 190, 191, 240, 301, 308, 319, 343
Schönbrunn Palace (Vienna), 188
sconces with shades, 202–03
Sense of Taste (Rubens/Brueghel the Elder), salt cellar portrayed, 107
Shah Abbas, *see* Abbas the Great, Shah of Iran (Persia)
Shangchuan Island, 27, 56, 233
shell motifs, 126, 311

shipwrecks
 Amsterdam, 82
 Bintan, 248
 Concepción, 238
 Diana, 163
 Geldermalsen, 125, 176
 Hatcher Cargo, 109, 142, 155, 224
 Oosterland, 166
 San Diego, 165
 Santo Alberto 212
 Vung Tau Cargo, 137, 139, 151, 193, 233, 255, 267, 279
 Witte Leeuw, 294
Shonzui revival pieces, 300
shrine memorials, 47, 185, 196, 212, 224
Sibylla Augusta, Margravine of Baden-Baden, 188
Silva, Manuel Joaquim da, Canon of Lisbon Cathedral, 93
silver mounts, 319, 384 (C367), 387 (C385–86), 388 (C387)
Simphonie du tympanum, du luth et de la flûte d'Allemagne (engraving), 246
Singer Sargent, John, 188
Sledmere House, Yorkshire, 90
slippers, 393 (C422)
small footed jars, 241
societal change, effect on cuisine and ceramic design, 101, 102–04
Solms-Braunfels, Amalia, porcelain collection, 186, 213
Songzi Guanyin, 207
Sonmans, Sara, 83
South Asia
 influence in Chinese ceramic design, 145, 196, 199
Southeast Asia
 ceramic market and production, 287–78
soya trade, 349
Spain
 'awarded' lands under papal bull, 27
 establishment of trade in Phillipines, 27
 source of chocolate drinking, 132–33
 trade with Asia, 25
 trade with Japan, 313–14
Spanish armorial insignia, 51
Spanish Royal Arms (Castile and León), 51, 58
spice boxes, 110, 111, 113, 174, 391 (C405)
spice motifs, 259
spice trade, influence on ceramic design, 101
spittoon with monogram, 361
spittoons, 176, 361
sponge technique, 224, 227, 251
spoons, 180
spotted horses, 222
square box, 178
Sri Suriyawongse, Somdet Chao Phraya (Chuang Bunnag) Regent of Siam (now Thailand), 360
St Thomas cross, 32–33
Stel, van der, family, 74

strainers
 fruit strainer, 402 (C470)
 Japanese strainer, 338
 round strainers, 181
 star-shaped strainer spoons, 180
 tea strainers, 181
 turtle strainer, 307
sugar casters, 158
sugar supply, influence on ceramic design, 101–02
sun and moon motifs, 43
Sun King, *see* Louis XIV, King of France
sun ray emblem, 360
Sutherland, Eric, 4th Lord Duffus, 84
Swatow ceramics, 287
Swedish East India Company, 54, 84, 87, 90
Sykes, Richard, 90
syrup jars, 165

tables, 310
tableware
 discussion, 102–05
 items, 106–27
tafeltabaksdoos, 178
tako karakusa motif, 317
Talbot, William, Bishop of Oxford, 68–69
Talbot, Catherine, 68–69
tankards, *see* beakers and tankards
Taparelli d'Azeglio, Luigi, Count Lagnasco, 187
tea canisters, 156, 163, 364, 378 (C331), 400 (C456), 402 (C467)
tea ceremony ceramics (Japan), 297, 314
tea-drinking, 130, 133
tea pieces with Regent's insignia, 360
tea services, 131, 158, 354–55, 360
tea trade, 129, 130, 274, 275
teapots, 157, 159, 253, 309, 332–33, 364, 372, 389, 390, 412
 landscape vignettes, with, 411 (C519)
 footed teapots, 159, 389 (C398)
 peach-form Cadogan pot, 389 (C397)
 teapots after European prints, 332, 333
 teapot with elephant, 372
 teapots, set of ten, 412 (C523)
 tripod teapot, 390 (C399)
technological motifs, 316, 350, 351
temple epitaph tile, 47
Temple of the Reclining Buddha (Bangkok), collection, 228
Teodósio I, 5th Duke of Braganza, 185
textile influence on design, 38, 199
Teyler, Johannes, *Fall of Phaethon* print, 253
Thai design motif, 127
Thailand
 development of arts in 19th century, 354
 international interest in Thai art, 356
 as market for porcelain, 228, 229, 230, 231, 353–56
 modernization and reform under Rama V, 354–55
 trade with China, 353, 354

Thompson, Jim, collection, 231, 356
Three Graces' print series, 247
tiles, 47
tobacco smoking and boxes, 178
toh jars, 353, 358–59
Tojin Yashiki (Chinese Residence, Nagasaki), 299
Tokugawa Ieyasu, Shogun of Japan, 297, 299, 313
tomb pottery, 207, 210
Tombac mounts, 45
Topkapı Palace (Istanbul), 34–35, 45, 102, 200, 213, 287
topographical motifs, 267, 269, 270–73, 279, 280–82, 366, 367, 368, 373
Toussain, Reijnier, 88
trade motifs, 267, 269, 270–71
trade routes, 101, 102, 185, 265
 Sante Fe Trail, 284
transportation to ports, 267
trading laws (China), 270
Transitional period, 58, 134, 135, 143, 191, 199, 237, 319, 327
tray with fish decoration, 307
trays, 253, 304, 307, 308
'treasure ships' motif (Japan), 250
Trianon de Porcelaine, porcelain collections, 187
Tullgarn Palace 282
tureens, 118–127, 268, 280, 281, 367
 chapeaux chinois tureen covers, 122
 game pie tureen, 125
 porcelain production tureen stand, 268
 rococo tureen, 122
 rooster tureen, 367
 sauce tureens, 124
 ship's tureen, 118–19
 snake-handled tureen, 120
 soup tureen with dragons, 387 (C381)
 vegetable tureen set, 127
twin immortals of harmony, 220

underglaze blue, technique 19, 26, 54
unidentified arms (Japanese), 327
unidentified arms beneath Dutch coronet (Japanese), 327
unidentified, blank pseudo-armorial (Japanese), 328
urinals, 227
urns, 205

Valckenier, Adriaan (Governor-General Dutch East Indies), 54, 82
vases, 66, 191, 193, 195–97, 199, 237, 248–49, 262–63, 269–71, 317, 318, 368–69, 376, 394, 397, 400, 402, 408
 bottle vase, 191, 394 (C424)
 bottle vases (Japanese), 317
 bottle vase with Ayutthaya, 369
 bottle vase with Hongs at Guangzhou (Canton), 368
 'dragoon' vases, 187

domestic use, 191
double-gourd vase, 376 (C323)
English rural landscape bottle vases, 262
European designs, 248–49, 262
European rural landscape vase, 237
fish-shaped wall vase (Japanese), 408 (C504)
floor-standing vases, 202
furnishing and decoration, 193, 195, 196, 197, 199
G mark vases, 196
Japanese, 317, 318
Jesuit vase, 376 (C321)
Magic Fountain vases, 29, 34–35
melon-form vase, 199
namban scenes vase, 248–49
net menders, with, 402 (C464)
parrot, with, 395 (C430), 400 (C459)
pear-shaped vase, 318
religious themes, 34–35
rouleau vase with animals, 397 (C439)
rural scene bottle vases, 248
'soldier' vases, 187
Thai market, 368–69
topographical theme, 279
wall vase, 191
wide-necked vase, 394 (C425)

Venetian glass, 193
Vietnamese ceramics, 287
View of the imperial kiln at Jingdezhen, 266
village scene motifs, 37, 116, 337
Virgin Mary symbolism, 34–35
VOC Verenigde Oostindische Compagnie, *see* Dutch East India Company (VOC)
vomit pot, 392 (C416)

wabi aesthetic, 297, 314
wall lights, 202–03
Walpole, Horatio (1st Earl of Orford), 55, 86
warrior motif, 293
Wat Pho (Buddhist Temple), 356
water goddess motif, 359
water motifs
 fountains, 34–35
 lakes, 269
 riverscapes, 88, 99, 115, 116, 117, 124, 156, 161, 163, 322, 323, 339, 369
 waterfalls, 211, 308
Watkins, Henrietta, 75
Wedgwood creamware, 124
Whampoa Anchorage, 267, 273–274
Whistler, James McNeill, *Harmony in Blue and Gold: The Peacock Room*, 188, 189

Whistler family, 54, 79
Wild Goose Pagoda, 304
William III and Mary II (English joint reign), period in England, 52
 collecting and display, 186–87
wine-drinking, 129
wine funnels, 150
Wolff, Croachrod or Pemberton, 81
Worcester porcelain, 262

Xavier, Francis, Saint, 27, 29, 56
Xi'an Stele monument, 26

Yi Khot monogram, 363
Yokohama-e (woodblock prints), 316
Yuan dynasty, spread of trade, 26
Yuanzhou Fu (Yichun), 270–71
Yuzhi Gengzhi tu (paintings), 266, 274

Zaiton/Zayton (*see also* Quanzhou (Zaiton/Zayton))
Zhangzhou ceramics, 287–88, 290–95
Zheng family, 102
Zheng He (Admiral), voyages and distribution of ceramics, 19, 26, 188

All object, *in situ* and interiors photography: David Schlegel

Front endpapers: © National Maritime Museum, Greenwich, London; back endpapers: © Archives Charmet / Bridgeman Images; p. 16 (top): © Angela Howard; p. 27: Collection of the Asian Civilisations Museum, Singapore; p. 28: © Christie's Images / Bridgeman Images; p. 52: Rijksmuseum, Amsterdam; p. 53: © National Maritime Museum, Greenwich, London; p. 55: Leeds Museums and Galleries, UK / Bridgeman Images; p. 56: Musée de la Compagnie des Indes, Lorient; p. 90: David S. Howard; p. 103: National Gallery, London (presented by Frederick John Nettlefold, 1947); p. 130: Bridgeman Images; p. 132: Victoria and Albert Museum, London; p. 166: Bridgeman Images; p. 167: The Stapleton Collection / Bridgeman Images; p. 186: © Fitzwilliam Museum, University of Cambridge; p. 188: Rijksmuseum, Amsterdam; p. 189: Freer Gallery of Art; p. 235: Luisa Ricciarini / Bridgeman Images; p. 288: © National Maritime Museum, Greenwich, London / Bridgeman Images; p. 299: Collection Nationaal Museum van Wereldculturen Coll.nr. 7141-1 (with thanks to Vereniging Rembrandt, Themafonds Toegepaste kunst en Design, Fonds van de Utrecht & Gooi Cirkel, Mondriaan Fonds, VSBfonds and VriendenLoterij); p. 315: © The Trustees of the British Museum; p. 354: Photo © Luca Tettoni / Bridgeman Images; p. 355: Pictures from History / Bridgeman Images

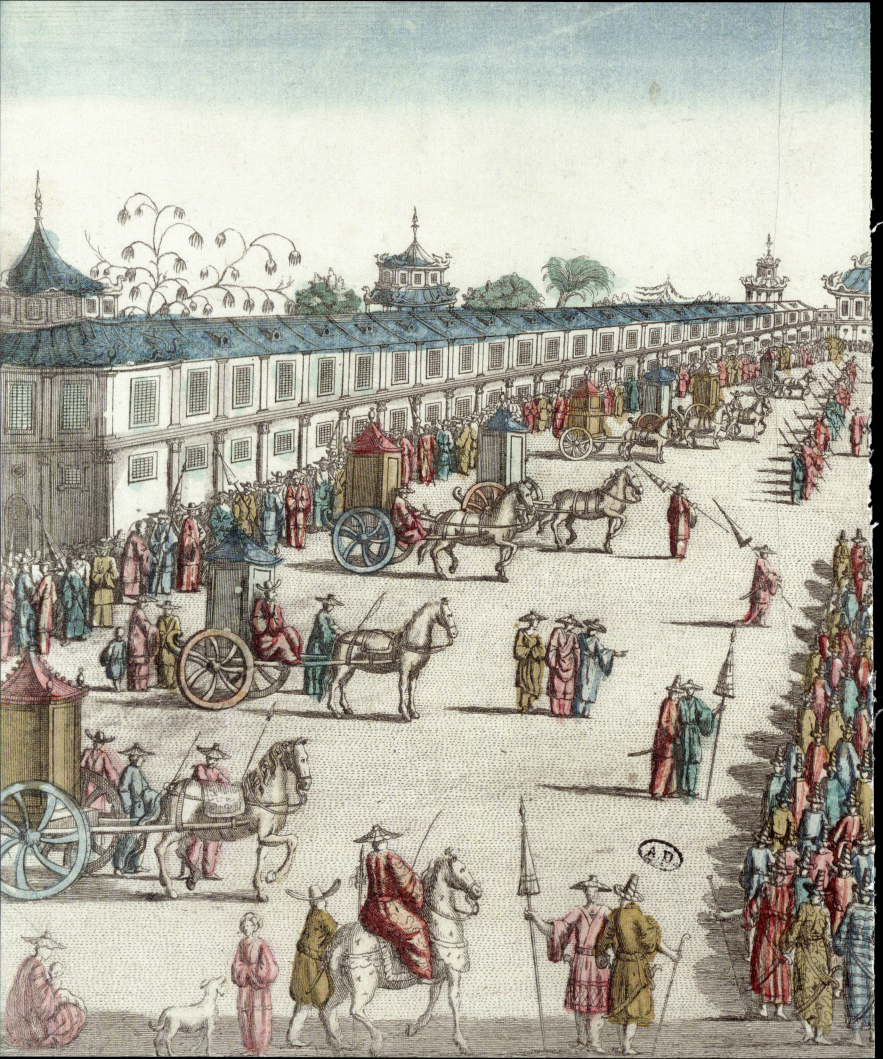